T0216775

Lecture Notes in Artificial Intelligence 671

Subseries of Lecture Notes in Computer Science
Edited by J. Siekmann

Lecture Notes in Computer Science

Edited by G. Goos and J. Hartmanis

Hans Jürgen Ohlbach (Ed.)

GWAI-92: Advances in Artificial Intelligence

16th German Conference on Artificial Intelligence
Bonn, Germany, August 31 - September 3, 1992
Proceedings

Springer-Verlag

Berlin Heidelberg New York
London Paris Tokyo
Hong Kong Barcelona
Budapest

Series Editor

Jörg Siekmann
University of Saarland
German Research Center for Artificial Intelligence (DFKI)
Stuhlsatzenhausweg 3, W-6600 Saarbrücken 11, FRG

Volume Editor

Hans Jürgen Ohlbach
Max-Planck-Institut für Informatik
Im Stadtwald,W-6600 Saarbrücken 11, FRG

CR Subject Classification (1991): I.2

ISBN 3-540-56667-8 Springer-Verlag Berlin Heidelberg New York
ISBN 0-387-56667-8 Springer-Verlag New York Berlin Heidelberg

This work is subject to copyright. All rights are reserved, whether the whole or part
of the material is concerned, specifically the rights of translation, reprinting, re-use
of illustrations, recitation, broadcasting, reproduction on microfilms or in any other
way, and storage in data banks. Duplication of this publication or parts thereof is
permitted only under the provisions of the German Copyright Law of September 9,
1965, in its current version, and permission for use must always be obtained from
Springer-Verlag. Violations are liable for prosecution under the German Copyright
Law.

© Springer-Verlag Berlin Heidelberg 1993
Printed in Germany

Typesetting: Camera ready by author
45/3140-543210 - Printed on acid-free paper

Preface

The sixteenth German AI Conference, traditionally called GWAI (German Workshop on Artificial Intelligence), was held from 13 August to 3 September 1992 in the Gustav Stresemann Institute in Bonn. In previous years the proceedings appeared in the Springer Series 'Informatik Fachberichte' and contributions were predominantly in German. Following a general trend, this year we decided to publish the proceedings in an international series. Accordingly, we asked authors to submit their work in English.

This volume contains 24 papers presented in the technical sessions, eight papers selected from the workshop contributions and one invited talk.

Our invited speakers were Harald Ganzinger, who spoke of 'New Concepts for Refutational Theorem Proving', Dov Gabbay, who discussed the problem of 'How to Build a Logic' (the paper is the first one in this volume), Steven Feiner, who talked about 'Knowledge-Based Graphics and Virtual Worlds', and Jörg Siekmann, who gave an overview of the history of AI research in Germany in his talk 'Quo Vadis, Unde Venis AI' (originally intended to be an after dinner talk).

Through the early years the format of the annual GWAI gradually changed from that of a workshop on AI research in Germany to a full-fledged AI conference. In recent years, however, the trend went back towards something similar to the original format giving workshops much greater prominance. Apart from the usual technical sessions nine special workshops were held. They were (the organizers are given in parenthesis): Control of Problem Solving Procedures (Karl Hans Bläsius, Jutta Eusterbrock, Manfred Kerber), Criteria for the Selection of Alternatives in Natural Language Generation (Helmut Horacek, Wolfgang Hoeppner), Terminological Logics (Jochen Heinsohn, Bernhard Hollunder, Albrecht Schmiedel), Distributed AI (Birgit Burmeister, Kurt Sundermeyer), Logic & Change (Bertram Fronhöfer, Alexander Herold, Remo Pareschi), Experiences from Early Phases of Expert System Development Projects (Brigitte Bartsch-Spörl, Heinz Marburger), Supporting Collaborative Work Between Human Experts and Intelligent Cooperative Information Systems (Stefan Kirn, Donald Steiner), Rule Based and Case Based Legal Reasoning (Thomas F. Gordon and Lothar Philipps), Impacts of AI—Analysis of a Discussion (Lena Bonsiepen, Wolfgang Coy). In fact, the workshops constituted a mini conference by themselves. Participants were invited on the basis of submitted abstracts. Some of the participants were invited to submit full paper versions of which the workshop organizers selected eight for inclusion in this volume. Proceedings of some of the workshops will be published separately.

It has become customary to start the conference with a day or two of 2–3 hour tutorials and introductory lectures. This year's topics included (the lecturers are given in parenthesis): Natural Language Processing (Martin Schröder), Coordination of Distributed AI Systems (Stefan Kirn), Inference Systems for Equationally Defined Structures (Rolf Socher-Ambrosius), Terminological Knowledge Representation (Franz Baader), Application of Machine Learning in Robotics (Rüdiger Dillmann, Hans-Werner Hein and Jürgen Kreuziger), Qualitative and Model Based Reasoning (Sabine Kockskämper and Klaus Nökel), and Constraint

Logic Programming (Alexander Herold).

As usual the major German AI Centers used the opportunity and presented themselves with talks and demonstrations. Present were: the Bavarian Research Centre for Knowledge-Based Systems (FORWISS), the German Research Centre for Artificial Intelligence (DFKI), Kaiserslautern and Saarbrücken, AI-Labs from Hamburg, the European Computer Industry Research Centre (ECRC), the research co-operation 'Artificial Intelligence Applications in Nordrhein-Westphalen' (KI-NRW), the 'Gesellschaft für Mathematik und Datenverarbeitung' (GMD) and the Research Institute for Application Oriented Knowledge Processing (FAW). I would like to thank the colleagues from these organizations who spent considerable time in preparing their presentation and who deserved a larger audience than they sometimes had.

I am indebted to the program committee for their effort and thought in organizing the program, to the invited speakers, to the workshop organizers and to the presenters of the tutorials. My special thanks go to the local organizers Thomas Christaller and, in particular, Christine Harms who has been an invaluable help ensuring that the event ran smoothly.

March 1993 Hans Jürgen Ohlbach

Program Committee

Brigitte Bartsch-Spörl
Hans-Jürgen Bürckert
Thomas Christaller
Rüdiger Dillmann
Christopher Habel
Joachim Hertzberg
Steffen Hölldobler

Klaus-Peter Jantke
Hans Jürgen Ohlbach
Jürgen Müller
Heinrich Niemann
Frank Puppe
Gudula Retz-Schmidt
Harald Trost

Additional Reviewers

A. Albrecht
F. Baader
R. Backofen
Braun
U. Egly
J. Eusterbrock
D. Fensel
K. Fischer
U. Gappa
U. Goldammer
K. Goos
S. Gottwald
J. Grabowski
H.W. Güsgen
P. Hanschke
M. Hein
B. Hollunder
A. Horz
L. Hotz
D. Hutter
U. Junker
M. Kerber
J. Köhler
N. Kuhn
S. Lange

R. Letz
M. Matzke
R. Möller
J. Müller
G. Neugebauer
W. Nutt
U. Petermann
M. Pischel
U. Pletat
K. Pöck
M. Protzen
C. Reddig
N. Reithinger
R. Scheidhauer
M. Schmidt-Schauss
S. Schönherr
A. Schroth
A. Schupeta
R. Socher-Ambrosius
J. Stuber
B. Tausend
B. Thalheim
J. Wedekind
T. Zeugmann

The conference was supported by

Addison Wesley Publishing Company
DFKI Kaiserslautern and Saarbrücken
IBM Germany
SUN Microsystems
Symbolics Germany

Contents

Workshop Contributions

How to Construct a Logic for Your Application

D. M. Gabbay*
Department of Computing
Imperial College of Science, Technology and Medicine
180 Queens Gate, London SW7 2BZ

Abstract. The purpose of this note is to present and evaluate the options available to a researcher wishing to use logic for representation, reasoning and computation in his application area. We examine two case studies, modal logic and resurce logics and show that in both cases neither classical logic nor its alternatives modal logic or substructural logic are completely satisfactory. We argue that there is a need for a new discipline and introduce and discuss the discipline of *Labelled Deductive Systems* (*LDS*). The approach is to see what is needed from the application area upward into the theory, without imposing any pre-determined concepts.

1 Introduction

The purpose of this note is to present and evaluate the options available to a practically minded researcher wishing to use logic for the representation, reasoning and computation in his application area. We begin by listing the properties of classical logic against the needs of a typical case study.

The basic notions involved in classical logic are the following:

1. The notion of a well formed formula, which is the basic declarative unit available for the representation of the knowledge of the case study.
2. The notion of a database Δ or a theory, which is the aggregation of declarative units. In this case it is a set of wffs.
3. The consequence relation \vdash of the form $\Delta \vdash A$ between databases and declarative units. This can be presented in various forms, semantically, proof theoretically, etc. Some systems are formulated using consequence relations between two databases $\Delta \vdash \Gamma$. This notion for arbitrary Γ can be defined in some cases from the fragment consequence where there is a single declarative unit in Γ.

Different logics, such as intuitionistic or many valued logics, share with classical logic the notions of a declarative unit and a database, but differ on the consequence relation.

In contrast to the above, a typical case study may indeed have identifiable basic semantic declarative units, but these declarative units are naturally organised in a structure. This structure is external to the declarative units. Thus the

* SERC Senior Research Fellow. I am grateful to H.-J. Ohlbach for stimulating discussions and for going through an earlier version of the paper.

notion of a database as a set is not found in applictions, but rather the notion
of a database as a structured constellation/network of formulas seems more ap-
propriate. The following are examples of sources of structures imposed natrually
on declarative units of application areas:

- Time stamps, earlier-later relations among data items.
- Sources of the data. The structure is inherited from the social relationships
 among the sources.
- Causal relations among data (in e.g. medical networks).
- Accessibility relations among formulas holding in different possible worlds.
- Priorities among data.
- Artificial structuring among data clauses for the purpose of efficient compu-
 tation.
- Numerical stamps, giving reliability or plausibility. The structure is induced
 from numerical relationships.

The above are enough widespread examples to justify focussing our discussion
on a typical case study where the declarative units are structured, say in a graph
form with nodes and several types of edges. Fig 1 illustrates such a structure.

[ht]

Fig. 1.

t and s are two nodes and the arrow is one relation between them. $A(x)$
and $B(x, y)$ are semantic declarative units associated with t and s, involving the
objects x and y. We are 'semantic' because we are not yet committed to how we
formalise this situation.

We need a logic to describe and reason about the above structure. Suppose we
choose to use classical logic to represent the knowledge in A and B. So assume
that A and B themselves are already in classical logic. How do we represent
the structure of t and s? In the case of classical logic we need to be able to
talk directly about t and s. Thus we need to add a new slot to any predicate
$P(x_1, \ldots, x_n)$ of classical logic, for the sort of t, s, turning it into $P^*(t, x_1, \ldots, x_n)$
and represent the nodes $t : A(x)$ and $s : B(x, y)$ as $A^*(t, x)$ and $B^*(s, x, y)$
respectively. We need to represent by a special predicate tRs the relation 'arrow'
between the nodes. Thus the situation in Fig 1 becomes the following database:
$\{tRs, A^*(t, x), B^*(s, x, y)\}$. We need the following features:

1. Augment classical logic into two sorted logic. A new first coordinate is added to each atom to allow for the node elements.
2. Introduce new predicates to express relationships among nodes.
3. Extend classical proof theory to such two (or many) sorted systems.

The many sorted logic is no longer classical logic but a classical logic look-alike. It has more convenient expressive power[2] and seems ideal for our purposes. It has many advantages:

- We can use the power of the quantifiers to express relationships among the nodes such as

$$\forall s(tRs \rightarrow \exists x(A^*(s, x) \wedge \forall u(tRu \wedge sRu \rightarrow \exists y B^*(u, x, y)))).$$

- We can use existing powerful classical theorem provers to get (either directly or after modification) automated deduction for the new two sorted logics. Special unification algorithms can also be used.
- The logic is familiar in principle, being a variant of classical logic.
- The method can act as a universal method for many application areas.

At this stage, it looks like that we have answered the question in the title of this paper and we can therefore conclude the paper and proceed to give the references. Unfortunately this is not the case. To explain the flaw in this rosy picture, let us examine and analyse a particular temporal example.

Case Study 1:
Temporal Logic in Two-sorted Classical Logic

We consider a linear flow of time $(T, <)$. Predicates of the form $A(x), B(x, y)$. $<$ is irreflexive transitive and linear. We pass into two sorted predicate logic with $A^*(t, x), B^*(t, x, y)$. We translate the basic declarative statements of temporal logic as follows:

1. $A(x)$ holds at t is translated into $A^*(t, x)$.
2. Relations among points t, s are expressed directly using $<$ and the quantifiers and connectives of classical logic.
3. Properties of $(T, <)$ are expressed in classical logic.
4. Reasoning is done in classical logic.

Figure 2 represents a typical temporal database.
Dictionary

[2] I suppose the sorts can be expressed by unary predicates and domain axioms and so mathematically we remain within first order logic. However sublanguages of classical logic become more expressive when sorts are allowed, while their 'spirit' is maintained.

[ht]

J

$J \wedge \text{Past } (E \wedge M) \rightarrow \text{Future } C$

E

$E \wedge \text{Future } J \rightarrow M$

t

s

Fig. 2.

E = Institute doing well in publications
J = John McCarthy visits Institute
M = Institute gets lots of funds
C = Institute holds an international conference
The translation of the above into two sorted classical logics yields the following in Horn clauses (variables are universally quantified):

1. $E^*(t)$
2. $E^*(t) \wedge t < y \wedge J^*(y) \rightarrow M^*(t)$
3. $J^*(s)$
4. $J^*(s) \wedge x < s \wedge E^*(x) \wedge M^*(x) \rightarrow s < u_0$
5. $J^*(s) \wedge x < s \wedge E^*(x) \wedge M^*(x) \rightarrow C(u_0)$
6. $t < s$
7. $x < y \wedge y < z \rightarrow x < z$
8. $\sim (x < x)$
9. $x < y \vee x = y \vee y < z$

Clauses 1–6 describe the data structure and clauses 7–9 are axioms for the linearity of time.

Consider the query ? Future C, asked at time t. In classical logic (Horn clause) we are asking

$$?\exists v(t < v \wedge C(v))$$

The compuation will proceed along Prolog lines and will probably terminate. The computation follows a machine oriented depth first strategy.

How would a human reason in such a situation?

Let us write $t : A$ to mean A holds at time t.

1. $t :$ Future J (because $t < s$ and $s : J$)
2. $t : E$ (as given)
3. $t : E \wedge$ Future $J \rightarrow M$ (as given)
4. $t : M$ (by modus ponens)

5. $t : E \wedge M$ (by Adjunction)
6. $s : J$ (as given)
7. $S : \text{Past } (E \wedge M)$ (because $t < s$ and $t : E \wedge M$)
8. $s : J \wedge \text{Past } (E \wedge M) \rightarrow \text{Future } C$ (as given)
9. $s : \text{Future } C$ (by modus ponens)
10. So for some u_0 such that $s < u_0$ we must have $u_0 : C$.
11. Since $t < s < u_0$ and $u_0 : C$, we get $t : \text{Future } C$.

Note that we reason locally and separately in each node, together with the mechanism of passing formulas (information) from one node to the other.

The inescapable conclusion is that the classical reasoning mechanism is not intuitive and does not correspond to natural human temporal reasoning.

Another major approach to temporal and modal reasoning recognises the need for a more intuitive compatibility of the reasoning process. It allows for the use of temporal connectives representing patterns relative to a temporal point where the reasoning is located. Such patterns are expressed in natural language by words like *Tomorrow, Since, Until, Will, Was*, etc.

Figure 3 represents a structure around the world which the reasoner inhabits

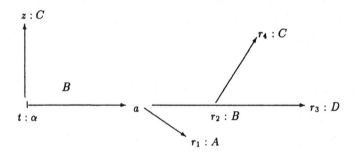

Fig. 3.

The straight line connection is temporal and the broken line is modal. The notation $t : A$ means that A holds at t and the notation $t \overset{A}{\longrightarrow} S$ means that A holds at all points between t and s. If the actual world (point where the reasoner stands) is a, then the above pattern can be expressed as:

$$S(\alpha \wedge \lozenge C, \beta) \wedge \lozenge (B \wedge \lozenge C \wedge \lozenge D) \wedge \lozenge A$$

The pattern of Figure 2 can be expressed as:

$$E \wedge (E \wedge FJ \rightarrow M) \wedge F(J \wedge (J \wedge P(E \wedge M) \rightarrow FC))$$

from the point of view of the point t. The query at t is $?FC$.

If modal connection $t \rightsquigarrow s$ is expressed by tRs and temporal connection by $t < s$, then the patterns F, P, \Diamond, S are as follows:

- FA holds at t means: $(\exists s > t)A^*(s)$
- PA holds at t means: $(\exists s < t)A^*(s)$
- $\Diamond A$ holds at t means: $\exists s(tRs \wedge A^*(s))$
- $S(A, B)$ holds at t means:

$$\exists s < t[A^*(s) \wedge \forall u(s < u < t \rightarrow B^*(u))]$$

- A (atomic) holds at t is represented by $A^*(t)$.

If we adopt the view of doing temporal reasoning in the actual world (i.e. the world where the reasoner is located) using the above patterns, we need a proof system in that language. Such systems exist., A Hilbert system for linear temporal logic for F and P has the following axioms and rules, (with $G = \sim F \sim$ and $H = \sim P \sim$):

1.

$$\frac{\vdash A}{\vdash GA}, \quad \frac{\vdash A}{\vdash HA}, \quad \frac{\vdash A, \vdash A \rightarrow B}{\vdash B}$$

2.

$$GA \rightarrow GGA$$
$$HA \rightarrow HHA$$

3.

$$A \rightarrow GPA$$
$$A \rightarrow HFA$$

4.

$$FA \wedge FB \rightarrow F(A \wedge B) \vee F(A \wedge FB) \vee F(FA \wedge B)$$
$$PA \wedge PB \rightarrow P(A \wedge B) \vee P(A \wedge PB) \vee P(PA \wedge B).$$

5.

$$G(A \wedge B) \leftrightarrow GA \wedge GB$$
$$H(A \wedge B) \leftrightarrow HA \wedge HB.$$

6.

$$FFA \rightarrow FA$$
$$PPA \rightarrow PA$$

The deduction of the case study is valid if we can prove in the above system that

$$\vdash E \wedge (E \wedge FJ \rightarrow M) \wedge F(J \wedge (J \wedge P(E \wedge M) \rightarrow FC)) \rightarrow FC$$

We need to show that $1 \wedge 2 \wedge 3 \vdash 4$ below, where

1. E
2. $E \wedge FJ \to M$
3. $F(J \wedge (J \wedge P(E \wedge M) \to FC)$
4. FC

To prove this we need several lemmas

- $\vdash F(\alpha \wedge \beta) \to F\alpha$
- $\vdash FF\alpha \to F\alpha$
- $\vdash G\alpha \wedge \vdash \beta \to \vdash (\alpha \wedge \beta)$
- $\vdash \alpha \to \beta$ implies $\vdash F\alpha \to F\beta$

Thus from 3 we can get FJ which together with 1 and 2 yields $E \wedge M$.

Since $E \wedge M \to GP(E \wedge M)$ we get $GP(E \wedge M)$

Also since $\vdash J \wedge (J \wedge P(E \wedge M) \to FC) \to P(\wedge M) \to FC$ we get from 3 that

$$F(P(E \wedge M) \to FC).$$

From the last two we get

$$F(P(E \wedge M) \wedge (P(E \wedge M) \to FC))$$

which yields FFC which yields FC.

Again the above proof is not completely intuitive, since all reasoning steps have to be done at the actual world and propagated to far away worlds. Serious difficulties arise in predicate logic where Skolemization is not possible in the actual world for formulas with modalities governing nested quantifiers. Such an example is $\forall x G \exists y (A(x,y))$. The quantifier '$\exists y$' depends not only on the '$\forall x$' but also on the 'G', because for different worlds there may be a different y.

It is obvious that we naturally think in terms of worlds and time points and imagine at any given step of reasoning some layout or graph of such points, with different formulas holding at these points. Some points are perceived to have certain predicates holding at some temporal patterns around them, and some have no patterns, but simply hold at the point itself. Natural language is very revealing of how we perceive time. A sentence like 'since 1981 I have not had a holiday' uses both temporal patterns ('since') and specific points.

In terms of patterns around the actual world, we can say that we allow several worlds to act as 'local' actual worlds and express patterns around them. An additional graph shows the temporal relationship of these local actual worlds.[3] So we are adopting a compromise position. We accept the local point of view of describing patterns around an actual world, except that we want to allow for several 'local' actual worlds. The relationships between the local actual worlds is described in classical logic. This is a compromise between the two approaches. If we have only one actual world we have the modal approach, but if we have enough 'actual' worlds with only atomic (patterns) formulas describing them, we would be back in the classical logic approach. It is hoped that reasoning with

[3] This is a typical KL-one A-Box.

such mixed representation will have the benefits of both approaches without their problems.

The following is a possible definition.

Definition 1. 1. A Future-past temporal language KV has its well formed formulas built up from the classical connectives and quantifiers, predicates, variables and constants and the temporal connectives P and F (with $G =\sim F \sim$ and $H =\sim P \sim$).

2. Let D be a finite directed graph i.e. D is a set of points connected by directed edges. Let $c_1(t), c_2(t), \ldots$ be a list of one variable function symbols. t ranges over D.

3. A temporal **KV** theory is a tuple $\tau = (D, \mathbf{f}, d, U)$ where D is a graph, $d \in D$, \mathbf{f} a function associating with each $t \in D$ a formula of $K_t, \mathbf{f}(t) = A_t$, and U as a function associating with each $t \in D$ a set of closed terms U_t. $c(s) \in U_t$ means that the constant $c(s)$ exists at the node t in the graph D. the label s in $c(s)$ is supposed to mean that c was 'created' at label (world) s.

 So for example at time t John may love a woman called $c(s)$. This woman was born at time s. She may or may not exist at t. If she exists at t (she may have died but John still loves her) we write $c(s) \in U_t$.

 John may love an imaginary woman whom he introduces at time s. This means that we reserve the right to allow that $c(s) \notin U_s$. We have no committment at this stage.

 d is the global actual world, as opposed to the other elements of D which are local actual worlds.

4. Let (S, R', aV, h) be a Kripke model, that is S is a non empty set, $a \in S, R \subseteq S \times S$ and for each set $s \in S, V_s$ is a non empty domain. h assigns to each atomic predicate **P** of arity n and each t a subset $h(t, \mathbf{P}) \subseteq V_t^n$, and for each variable constant x an element $h(x) \in \bigcup_{t \in S} V_t$. h can be used to define satisfaction for all wffs in the usual way:

$$s \vDash \exists y A(y) \text{ iff } \exists y \in V_w \text{ such that } s \vDash A(y)$$
$$s \vDash FA \text{ iff } \exists s'(sRs' \text{ and } s' \vDash A)$$
$$s \vDash PA \text{ iff } \exists s'(s'Rs \text{ and } s' \vDash A).$$

 We say (D, \mathbf{f}, d, U) holds at a Kripke model (S, R, a, V, h) iff there exists functions $g_1 : D \to S$ and $g_2 : U \to V$ such that

 (a) g_1 is one to one with $g_1(d) = a$

 (b) If x and y are directionally (not) connected then (not) $g_1(x) R g_1(y)$

 (c) If $\mathbf{f}(x) = A(u_1 \ldots, u_k)$ then $g_1(x) \vDash A(g_2(u_1), \ldots, g_2(u_k))$ (i.e. if A is the wff labelled by $x \in D$ then $g_1(x) \vDash A$ in the model).

 The meaning of the definition is that we want the 'configuration' τ to be realised in the model.

5. Let $\tau_1 = (D_1, \mathbf{f}_1, d_1, U_1)$ and $\tau_2 = (D_2, \mathbf{f}_2, d_2, U_2)$ be two configurations. We write $\tau_1 \vDash \tau_2$ iff for all Kripke models (S, R, a, V, h) and all $g_1^1 : D_1 \to S, g_2^1 : U_1 \to V$ for which τ_1 holds at (S, R, a, V, h) we have that for some extensions $g_1^2 : D_1 \cup D_2, g_2^2 : U_2 \to V$ the database τ_2 holds in $(S, R, a, V, h, g_1^2, g_2^2)$.

In other words, in any model in which the configuration τ_1 holds the configuration τ_2 can be made to hold.

6. We say τ is valid iff $\{d : \text{Truth}, U_d\} \vDash \tau$, where d is the actual world of τ.

Example 1. Let τ_1 be as in Fig. 4. and let τ_2 be $d_2 : FA$

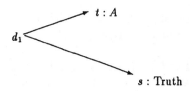

Fig. 4.

Clearly $\tau_1 \vDash \tau_2$.

However there is no way in which any wff B can have $d_2 : B \vdash \tau_1$.

If we choose B to be $FA \wedge F \top$, we cannot force $s \neq t$. What we need is a 2nd order wff B of the form

$$B = \exists Q[F(A \wedge Q) \wedge F \sim Q].$$

1. Run time Skolemization visas across worlds.
2. Different worlds can have differnt reasoning systems (time dependent reasoning).

Case Study 2: Logic Programming

Our second case study involving structure is propositional Horn clause computation without negation by failure. If Δ is a set of Horn clauses and q an atom then the non-deterministic procedural interpretation of $\Delta?q$ should mean $\Delta \vdash_c q$, where \vdash_c is provability in classical logic. Thus since the database $\{q, q \rightarrow q\}$ proves q, the computation of $?q$ from this database should succeed. In practice, i.e. in any Prolog implementation, the database is represented as a list, i.e. either Δ_1

1. q
2. $q \rightarrow q$

or Δ_2

1. $q \rightarrow q$
2. q

and the computation is deterministic, searching the list either top down or bottom up, unifying with the head of a clause asking for the body. Thus if the implemenation scans the clauses top down, we have that $\Delta_1?q$ succeeds while $\Delta_2?q$ loops.

Can we characterise the notion of $\Delta?q$ = success for the top down interpretation?

We can enumerate the database Δ_2 but obviously a translation into classical logic like the one of the modal logic case is not easily available.

It is no use translating Δ_2 into $\{q(1) \rightarrow q(1), q(2)\}$ and trying to figure out a truth table for \rightarrow much in the same way we did for \Diamond in the previous case study. I don't think we can find some natural translation. Of course one can always translate into classical logic using meta predicates like **database** ('Δ'), **succeed** ('Δ', 'A') etc. but this is not a direct translation. To make our case study more tractable let us change slightly the way the computation works. This will no longer yield classical logic programming computation but another familiar logic. The reason for doing so is simply that at this stage I do not know how to handle the Prolog case. There is, however, a Gentzen system for it by J, van Benthem [7]. The change we make is that we ask the pointer to continue moving in one direction only. Thus $?q$ from

1. $q \rightarrow q$
2. q

succeeds, because after clause 1 the pointer continues to clause 2.

On the other hand $?q$ from

1. $p \rightarrow q$
2. r
3. $r \rightarrow p$

fails, because the pointer, having passed clause 2, cannot go back to it.

The above discussion presented an example where the database was a list. The list was needed for technical reasons, having to do with the implementation strategies of Prolog interpreters. We would like our case study to be based on an application where the list structure in the database comes intuitively and naturally and has an obvious meaning. We find such a case in legal reasoning.

Consider the area of Esprit projects with which we are all familiar. There are rules for claiming expenses following an Esprit project meeting. These rules may vary slightly from country to country and from university to university. A typical rule could be of the form

$$C(x, d) \rightarrow S(x, d, 50)$$

which reads:

x spent the day d at a conference \rightarrow x gets subsistence of DM 50 for d

This is a time dependent rule in the sense that it is valid at any time s *after* it was introduced. Thus if the rule was introduced at time t, we can put it at the database as

$$t : C(x, d) \rightarrow S(x, d, 50)$$

If Dov has been to a conference at time s then the database will contain

$$s : C(\text{Dov}, d)$$

To ask the query $?S(\text{Dov}, d, 50)$ we unify with the first clause and get $?C(\text{Dov}, d)$. However we can use the clause $s : C(\text{Dov}, d)$ only if $t < s$.

The above control mechanism is not *temporal control* (as was the case in the previous case study) but rather *prioritized control*, and although the priorities come from temporal considerations, the time does not enter into the computation, only the control strategy of the 'prolog pointer'. In fact there are cases where exceptions are made by the commission allowing to claim for conferences before the start time of the rule. In terms of labelled deduction, the rule is that to perform modus ponens on $t : A \rightarrow B$ with $s : A$, we must have $t < s$, i.e. the 'fact' must come after the 'rule', where 'after' is not necessarily real 'after' but virtual 'after' including special permission.

Turning back to the application at hand, obviously we are supposed to claim expenses only once for each conference we attend. Thus if there is another rule, say university rule, introduced at time t' which says:

$$t' : C(x, y) \rightarrow UP(x, y, 150)$$

where $UP(x, y, 150)$ means university participation of DM 150, we are not expected to use both rules and get a total of DM 200. Either we claim from Esprit or we claim from the university.

The system may be flexible enough to allow us to claim DM 50 from Esprit and get the rest (DM 100) from the university, but not all systems are like that. The important point is that the assumption $s : C(x, d)$ can be used *only once* in the computation.

Let us summarise the properties we have so far:

– The database is structured with labels which are ordered.
– Modus ponens is allowed only when the ticket (i.e. the implication) is earlier than the minor premiss (i.e. the fact)
– Minor premisses (facts) can be used at most once.

Let us now consider another complication arising in the application area. The above rules are only valid for conferences held in European Communicy countries. For a conference in America, one needs permission from the project coordinator in Burssels. So we can write a more accurate rule:

$$t'' : AC(x, d) \wedge \text{Per}(x, d) \rightarrow S(x, d, 100)$$

x participates at an American conference at day d and x has permission then x can get DM 100.

The problem with the above is that Brussels insists that permission be asked *before* conference participation, and not *after* the event. Thus to represent the rule we cannot use ordinary conjunction, but we need the 'first A then B' connective, which we denote by $A \otimes B$. Our rule becomes

$$t'' : \text{Per}(x, d) \otimes C(x, d) \rightarrow S(x, d, 100)$$

Consider the query $?S(a, d, 100)$. We unify with the above rule and get the query ? $\text{Per}(a, d) \otimes C(a, d)$. To succeed with that query we need to look at facts after t, succeed with $\text{Per}(a, d)$ first and then succeed with $C(a, d)$ with label bigger than that of $\text{Per}(a, d)$.

We thus get the following additional property for our system

– To show $A \otimes B$ we must succeed with A and with B, but must show A from an earlier part of the database than B.

So far, we made a distinction between 'facts' and 'rules'. In a full scale logic (not Horn clause) a rule can serve as a 'fact' for another rule. Take for example, the following:

t_2: If subsistence per day is only DM 100, we must appeal to the commission.

This has the form

t_2: $\forall x[C(x, d) \rightarrow S(x, d, 100)] \rightarrow q$

If $t < t_2$ then the rule can be used to derive q. At time r, how do we know whether the antecedent of t_2 holds? In our case it is explicitly stated as a rule, but in general it may be derivable from a group of rules. How do we check the implicational goal $?\forall x[C(x, d) \rightarrow S(x, d, 50)$? We have to use hypothetical reasoning. We add $C(x_0, d_0)$ to the database and try and derive $S(x_0, d_0, 100)$, with x_0 and d_0 a new Skolem constant. We thus get an additional principle.

There are two questions to be settled. First is when we we add A, i.e. with what priority label? Intuitively the answer is at t, i.e. we add $t : A$. This is not so simple. A may have the form $A_1 \otimes A_2$. Do we add $t : A_1 \otimes A_2$ or do we add $t_1 : A_1, t_2 : A_2$, with t_1, t_2 new priority points with the restriction $t < t_1 < t_2$. It makes sense to choose the latter, in which case, if $t < s$ do we also require $t_2 < s$. (i.e. do we put t_2 immediately after t but before anything which comes after t?)

The second question is how do we compute with the additional $t : A$? Do we use the part of the database after $t : A$? or do we say that since our purpose was to determine $t : A \rightarrow B$ then 'future data' is not relevant. The validity of $t_1 : A \rightarrow B$ now means that data up to now together with t must yield B?. These issues we leave for later.

Meanwhile note that rules can be used at any time after they are introduced, and as many times as necessary, while facts can be used only once. Thus the rule $A(x) \rightarrow B(x)$ can be used as often as need, but the fact $A(d)$ can be used only once. This is a bit misleading because we can regard the rule as a family of rules for each instantiation of x. Thus we could write a family of rules.

$$A(d) \rightarrow B(d)$$
$$A(e) \rightarrow B(e)$$
$$\vdots$$

If $A(d)$ as a fact can be used only once and $A(d) \rightarrow B(d)$ can be fired only with $A(d)$ then the rule can be used only once anyway. We get

– Without a real loss of generality we can assume that propositional instances of rules can be used at most once

We are now ready for an example

Example 2 Esprit Travel Expenses. **Database**

$$t_1 : \forall x[\ \text{Per}(x, d) \otimes C(x) \to S(x, d, 200)$$
$$s_1 : \ \text{Per}(x, d)$$
$$s_2 : C(x, d)$$
$$t' : \forall x[C(x, d) \to \ \text{UP}(x, d, 150)]$$
$$t_2 : \forall x[C(x, d) \to S(x, d, 100)] \to q$$

Prioirty

$$t_1 < s_1 < s_2 < t' < t_2.$$

Computation Pointer

At any time the pointer resides at some priority label t goals can unify with any rule with label s and the pointer continues with label $\max(t, s)$. Formally

– $\Delta?t : q$ succeeds if $s : q \in \Delta, t < s$.
– $\Delta?t : q$ succeeds if for some $s : A \to q \in \Delta, s < t$ and $\Delta?t : A$ succeeds.
– $\Delta?t : A \to q$ succeeds if $\Delta \cup \{t : A\}|?t : q$ succeeds.
– $\Delta?t : A \otimes B$ if for some $s > t, \Delta?t : A$ and $\Delta?s : B$ succeeds.

Let us ask the query $?s : q$, with $t_2 < s$. We can thus unify with rule t_2 and ask $?C(x_0, d_0) \to S(x_0, d_0, 100)$. We add to the database $s : C(x_0, d_0)$ and ask $?s : S(x_0, d_0, 100)$. This unifies with t_1 and we ask $?s : \ \text{Per}(x_0, d_0) \otimes C(x_0, d_0)$. The last query fails.

If at some future time a general permission is given, then of course the computation will succeed.

It is possible to develop the model further. One can add integrity constraints, to make the database more realistic. Once we have integrity constraints we can deal with conditions $?t : A \to B$ as a goal is computed by letting $t : A$ into the database, which may violate integrity constraints, so some truth maintenance has to be done. We will not go into the details of all our options. A Martelli, L Giordano and myself have a paper on this [4]. Our purpose here is just to illustrate a realistic use of labels which is purely syntactical. For this purpose our discussion so far is quite sufficient.

Let us give a simplified version of the computation so far in the form of propositional directional N-Prolog. The version is a stylised, simplification of the above legal database problem, but it also happens to be a fragment of the Lambek calculus, exactly suited for linguistic application and implemented by Esther Köning [6].

Definition 2 Directional N-Prolog. Let our langauge contain \otimes and \to.

1. Clauses and Goals

(a) A is a clause if A is an atom

(b) A is a body if A is an atom

(c) If A_i are clauses and q an atom then $(A_1 \otimes \ldots \otimes A_n) \to q$ is a clause with body $A_1 \otimes \ldots \otimes A_n$ and head q

Note that \otimes need not be commutative

(d) A database is a list of clauses. We present a database Δ as

$t_1 : A_1, \ldots, t_n : A_n, t_1 < t_2 < \ldots < t_n$. A_i are clauses.

2. Let Δ be a database and B a goal. We recursively define the notion of $\Delta \vdash \alpha : B$ where α is a sequence of elements from $\{t_1, \ldots, t_n\}$.

(a) $\Delta \vdash \alpha : B$ if B is atomic and $\alpha : B \in \Delta$

(b) $\Delta \vdash \alpha : B_1 \otimes \ldots \otimes B_k \to q$ iff the database

$$\Delta' = \Delta, x_1 : B_1, \ldots x_k : B_k \vdash \alpha * \beta : q$$

where $t_1 < \ldots t_n < x_1 < \ldots < x_k$ and β is a subsequence of (x_1, \ldots, x_k).

(c) $\Delta \vdash \alpha : B$ iff B is an atomic q and for some

$$t_i : A_i \in \Delta, \text{ we have } A_i = C_1 \otimes \ldots \otimes C_k \to q$$

and $\alpha = (t_i) * \alpha'$ and

$$\{t_{i+1} : A_{i+1}, \ldots, t_n : A_n\} \vdash \alpha : C_1 \otimes \ldots \otimes C_k$$

(d) $\Delta \vdash \alpha : C_1 \otimes \ldots \otimes C_k$ iff Δ can be partitioned into k segments $\Delta = \Delta_1 * \ldots * \Delta_k$ and $\Delta_j \vdash \alpha_j : C_j$ and $\alpha = \alpha_1 * \ldots * \alpha_k$

Example 3.

$$t_1 : A \to B$$
$$t_2 : C$$
$$t_3 : A$$
$$t_1 < t_2 < t_3$$

proves $t_1 t_3 : B$

Note that we require the pointer to continue to go in the same direction. Thus $s_1 : A$

$s_2 : A \to B$

does not prove B.

We need not use all clauses.

The following can be proved

Lemma 3. *1. If $t : A \in \Delta$ then $\Delta \vdash t : A$*

2. If $\Delta \vdash t : A$ and $\Delta \subseteq \Delta'$ then $\Delta' \vdash t : A$
3.

$$\frac{\Delta \vdash t : A \qquad}{\Delta' \vdash s : A \to B}$$

$$\Delta' + \Delta \vdash s * t : B$$

Lemma 4. *Let* **DH** *be the Hilbert system with the following axioms and rules*

$$A \to A$$
$$(A \to B) \to (C \to A) \to (C \to B)$$
$$A \to (B \to A)$$

$$MP \quad \frac{\vdash A, \vdash A \to B}{\vdash B}$$

$$RT \quad \frac{\vdash A \to B}{\vdash (B \to C) \to (A \to C)}$$

Then $t_1 : A_1, \ldots, t_n : A_n \vdash \alpha : B$ *for some* α*, which is a seubsequence of* (t_1, \ldots, t_n) *iff*

$$\mathbf{DH} \vdash A_1 \to \ldots \to (A_n \to B).$$

2 Algebraic LDS

This section will formally define the notions of algebraic LDS, Fibred Semantics, and Labelled proof rules.

Definition 5. 1. A labelling algebra is a first order theory in a language with function symbols f_1, \ldots, f_k with respective arities and relation symbols R_1, \ldots, R_m with respective arities, and with constants t_1, t_2, t_3, \ldots.
 We call such a language an 'algebra' because its role is mainly algebraic in our conceptual framework. We assume we always have a sequence $c_1(x), c_2(x)$, ... of function symbols with one variable (for elements for the domains associated with labels).

2. A (finite) diagram D of the algebra is a set containing terms of the algebra and (finite) atomic expressions of the form $\pm R_i(t_1, \ldots, t_k)$ where t_i are terms.

3. Let D be a diagram and ψ a closed formula of the language of \mathcal{A}. We say that ψ holds at D iff $D \vdash \psi$ in classical logic.

4. A logical language \mathbf{L} is a predicate language with variables and predicates, a set of connectives $\natural_1, \ldots, \natural_n$ with appropriate arities and the quantifiers \forall and \exists. The notion of a wff with free variables is defined in the traditional manner. The language may also contain function symbols and constants.

5. The language of an algebraic labelled deductive system is a pair $(\mathcal{A}, \mathbf{L})$ where \mathcal{A} is an algebra and \mathbf{L} is a logical language. The algebra and the language share the set of free variables and may share some of the constants and function symbols.

6. A declarative unit is a pair $t : A$, where t is a term of the algebra and A is a wff of the logic. t and A may share free variables and constants.

7. A database is a tuple $\tau = (D, \mathbf{f}, d, U)$ where D is a diagram of the labelling algebra and \mathbf{f} and U are functions associating with each term in D a wff $A_t = \mathbf{f}(t)$ and a set of terms U_t. The functions \mathbf{f} and U can also be displayed by writing $\{t : A, t : x_i\} t \in D$. Note that D may contain also some relations $\pm R(t_2, \ldots, t_n)$. $d \in D$ is the 'actual' world of D.

Example 4. A possible world **LDS** language can be as follows. The language is the first order language of modal logic with connectives \square and \Diamond. The labelling algebra is the first order language of a binary relation R. We have no function symbols in the algebra but we do have an infinite stock of constants. A diagram D has the form $\{t_1, \ldots, t_n, \pm R(s_i, s_j)\}$ where s_i, s_j are terms in D. This can be graphically displayed as a proper geometric diagram such as where arrows

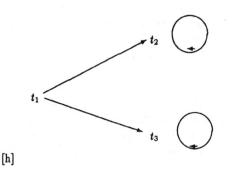

[h]

Fig. 5.

display the relation R. Thus D in this case is

$$\{t_1, t_2, t_3, R(t_1, t_2), R(t_1, t_3), R(t_3, t_3), \sim R(t_2, t_2)\}.$$

A database is a tuple (D, \mathbf{f}, d, U), where $d \in D$ and \mathbf{f} associates with each term $t \in D$ a wff $\mathbf{f}(t) = A_t$ of predicate modal logic, and U_t is a set of terms for $t \in D$. The following is a database based on the diagram of Fig. 5.

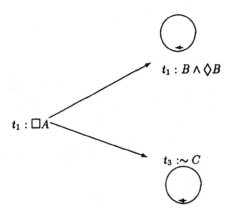

Fig. 6.

Definition 6. Let X be a first order language. Let $Monadic(X)$ be the language X enriched by an infinite number of new monadic predicate symbols. If ψ is a formula of the monadic language with exactly the new monadic predicates Q_1, \ldots, Q_k and exactly the free varaibles x_1, \ldots, x_m, we write $\psi(x_1, \ldots, x_m, Q_1, \ldots, Q_k)$ to indicate this fact.

Definition 7 Semantics for algebraic LDS. Let $(\mathcal{A}, \mathbf{L})$ be an LDS language. Let $\sharp_1, \ldots, \sharp_n$ be the connectives of the language, with arities $r(i), i = 1, \ldots, n$ respectively. A possible world semantical interpretation for $(\mathcal{A}, \mathbf{L})$ has the form $(\tau, \psi_1, \ldots, \psi_n, \psi)$ where τ is a theory (axioms) in the language of \mathcal{A} and each ψ_i is a wff of the monadic extension of the language of \mathcal{A}, containing $r(i)$ new monadic predicates and one free variable x, and ψ is a closed wff of the language with one monadic predicate and the constant a.

A structure of the semantics has the form (\mathbf{M}, a, V, h) where \mathbf{M} is a classical model of the theory τ of the algebra \mathcal{A}, $V_m, m \in M$ is a nonempty domain and h is an assignment associating with each n-place atomic P of \mathbf{L} and each $m \in M$ a subset $h(m, P) \subseteq V_m^n, a \in M$ and where M is the domain of \mathbf{M}.

Satisfaction \vDash_h can be defined for arbitrary wffs of \mathbf{L} via the inductive clauses $(V = \bigcup_{m \in M} V_m)$

0. $m \vDash P(x_1 \ldots, x_n)$ iff $\bar{x} \in h(m, P)$
1. $m \vDash \neg A$ iff $m \nvDash A$
2. $m \vDash A \wedge B$ iff $m \vDash A$ and $m \vDash B$
3. $m \vDash \sharp(A_1, \ldots, A_k)$ iff $\mathbf{M} \vDash \psi_\sharp(m, \{n \mid n \vDash A_i\})$
4. $m \vDash \exists y A(y))$ iff for some $y \in V_m, m \vDash A(y)$.
5. We say that the structure (\mathbf{M}, a, V, h) satisfies a formula A of \mathbf{L} iff $\mathbf{M} \vDash \psi(\{m \mid m \vDash A\}$.
6. A database $\tau = (D, \mathbf{f}, d, U)$ is said to hold at a structure (\mathbf{M}, a, V, h) iff there exist functions $g_1 : D \to M$ and $g_2 : U \to V$ such that g_1 validates the diagram D in $M, g_1(d) = a$, and for every $t : A(x_1, \ldots, x_n)$ in D we have $g_1(t) \vDash A(g_2(x_1), \ldots, g_2(x_n))$.
7. We say $\tau_1 \vDash \tau_2$ iff for every structure and every g_1^1, g_2^1 which validate τ_1 in the structure, there exists extensions g_1^2 and g_2^2 of g_1^1 and g_2^1 respectively, which validate τ_2.
8. We say the model validates τ if $\mathbf{f}\{d : U_d\} \vDash \tau$, for $d \in \tau$.

We are now ready to provide a proof theory for algebraic LDS. The basic declarative database is an algebraic constellation of labelled formulas. The rules allow us to manipulate one constellation into another constellation. So for example a modal logic constellation might have the form in Fig. 7.

The modal axioms and the meaning of \square dictate to us that in the above constellation, A must hold at s. Further the meaning of \lozenge tells us that there should exist a point r with $s < r$ such that $r : B$.

We can thus state two rules for manipulating modal databases.

$$(*1) \qquad \frac{t : \square A; t < s}{s : A}$$

$$t : \Box A \qquad\qquad\qquad s : \Diamond B$$

Fig. 7.

and

$$(*2) \qquad \frac{s : \Diamond B}{\text{create } 4, s < r \text{ and } r : B}$$

using the first rule we manipulate the figure into

$$t : \Box A \qquad\qquad\qquad s : \Diamond B$$
$$s : A$$

Fig. 8.

and using the second rule we further manipulate the figure into: The second

$$t : \Box A \qquad\qquad s : \Diamond B \qquad\qquad r : B$$
$$s : A$$

Fig. 9.

rule is good for modal logics like **K, S4**, etc.

The axiom of Löb:

$$\Box(\Box A \rightarrow A) \rightarrow \Box A$$

corresponds to the modification rule

$$(*3) \qquad \frac{s : \Diamond B}{\text{create } r, s < r \text{ and } r : B \wedge \Box \sim B}$$

thus in the logic with the Löb axiom we get the configuration in Fig. 9.

It is clear now how the rules work. They allow us to move from one configuration to another and the consequence relation is between configurations. For example, we have Fig. 7 ⊨ Fig. 9.

$t : \Box A$ $s : A \wedge \Diamond B$ $r : B \wedge \Box \sim B$

Fig. 10.

The above rules are elimination.rules. We still need introduction rules

$$(*4) \qquad \frac{s : A, t < s}{t : \Diamond A}$$

$$(*5) \qquad \frac{\text{create an arbitrary } s, t < s}{\text{and show } s : A}$$
$$\overline{\qquad\qquad\qquad\qquad}$$
$$t : \Box A$$

Example for \Box introduction:

> Given $t : \Box(A \to B) \wedge \Box A$
> Create $s, t > s$
> Show $s : B$
> Deduce $t : \Box B$

The picture however is not as simple as it seems. In the usual formulations of modal logics, axioms correspond to conditions on the possible world relation.

In our presentation, axioms correspond to any one of a variety of features. Table 1 below offers a selection.

Remark. Suppose we deal with the modal logic for linear frames. Then the configuration in Fig. 11. can be expanded in three ways.

$t : \Diamond A$ $s : B$ $r : B$
$t : \Box B$

Fig. 11.

By rule (*2) we can create a point $u : A$, with $t < u$. In a non linear modal logic such as **K, S4**, etc. this would lead us to the configuration of Fig. 12.

one more step would allow us to have $u : A \wedge B$ and hence by \Diamond introduction we get $t : \Diamond(A \wedge B)$.

However in the case of linear modal logic, Fig. 12. is not allowed. We need to consider five possibilities.

Axioms	LDS Features
K axioms $\Box(A \rightarrow B) \rightarrow (\Box A \rightarrow \Box B)$ $\vdash A \Rightarrow \vdash \Box A$ $\Diamond A \equiv \text{def} \neg\Box\neg A$	The notion of basic constellation and some simple rules for \Box and \Diamond some of which were illustrated in the figure above, rules (*1), (*2)
$\Box A \rightarrow \Box\Box A$	Transitivity of R in the constellation
$\Box(\Box A \rightarrow A) \rightarrow \Box A$	In modal semantics the axiom has no first order condition. It corresponds to the finiteness of the frame. In LDS it corresponds to the modified rule (*3).
$\Diamond A \wedge \Diamond B \rightarrow \Diamond(A \wedge B) \vee \Diamond(A \wedge \Diamond B) \vee \Diamond(B \wedge \Diamond A)$	Corresponds to the linearity of the relation R. This affects the basic rule (*2) as explained in Remark 2.5

Table 1.

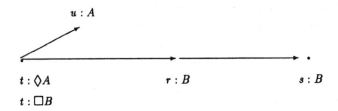

Fig. 12.

1. $t < u < r < s$
2. $t < u = r < s$
3. $t < r < u < s$
4. $t < r < u = s$
5. $t < r < s < u$

If, as a result of *each* of these possibilities, we end up with $t : \Diamond(A \wedge B)$ then we can conclude $t : \Diamond(A \wedge B)$.

We have to do that because our databases are linear and the above five configurations are all the minimal possible extensions in which u can be accommodated.

We thus have to modify all the rules with 'create' in them to mean:

Given initial configuration

Split proof into n branches according to all
minimal allowed extensions in which the created u
can be accommodated.

$(*3)$ becomes$(**3)$

$t : \Diamond A$ in a configuration

create u, consider all allowed minimal
$(**3)$ extensions of D with u in them. Put
$u : A$ in and branch the proof. The ultimate
goal of the overall proof must succeed in
all branches

The above is computationally very expensive. In the example previously
given, we need to go to five configurations in order to make the simple move

$$(*6) \qquad \frac{t : \Box A \wedge \Diamond B}{t : \Diamond(A \wedge B)}$$

However our *LDS* proof discipline does not stop us from adopting (*6) as
a rule. Recall that the *LDS* discipline tries to enjoy both worlds – the classical
world through the labels and the special non-classical world through the language
of the formulas in the labels. For each appliction, desired balance can be sought.

We now come to quantifier rules. We have already assumed that different
labels will have different sets of elements in them. To appreciate what this means,
we take our clue from modal logic. Consider Fig. 13.

$t : \exists x \Diamond A(x, y)$ $\qquad\qquad\qquad\qquad$ $s : \exists x B(x)$

Fig. 13.

At the label t, an x exists such that $t : \Diamond A(x)$ holds. This x depends on t
and on y. We therefore need a Skolem function $c^t(y)$. The index t is read as
c^t was created at t. We thus get $t : \Diamond A(c^t(y), y)$. Hence we can create a node
$s : A(c^t(y), y)$. We also must indicate whether $c^t(y)$ 'exists' at the node s. If it
does exist at s (probably because of some rules) then we write $s : c^t(y)$. The
difference comes out in extential introduction. Suppose we have $s : E(c^t(y))$, can

we infer $s : \exists x E(x)$? The answer depends whether $c^t(y)$ exists at s or not. Here are some rules

$$(*7) \qquad \frac{s : c, s : E(c)}{s : \exists x E(x)}$$

$$(*8) \qquad \frac{t : \exists x A(x, y_1, \ldots, y_n)}{t : A(c^t(y_1, \ldots, y_n), y_1, \ldots, y_n)}$$

$$(*9) \qquad \frac{t : \forall x A(x)}{t : A(u^t), u^t \text{ a new universal variable}}$$

$$(*10) \qquad \frac{s : u^t, s : A(u^t), s : c^r}{s : A(c^r)}$$

$$(*11) \qquad \frac{s : A(u^t)}{s : A(c^t)}$$

$$(*12) \qquad \frac{s : u^t, s : A(u^t)}{s : \forall x A(x)} u^t \text{ 'arbitrary variable}$$

The logic must tell us how elements skolemised in one label can be transported to another label. These are called *visa rules*. Here are two sample rules corresponding to the Barcan and converse Barcan formulas:

$$(b1) \qquad \frac{t : c^r, t < s}{s : c^r}$$

$$(b2) \qquad \frac{t : c^r, s < t}{s : c^r}$$

Example 5 Barcan Formula. Use (b1) to show that

$$t : \forall x \Box A(x) \vdash t : \Box \forall x A(x)$$

1. Start $t : \forall x \Box A(x)$
2. \forall-Elimination at t yields $t : \Box A(u^t), t : u^t$
3. Create an arbitrary $s, t < s$.
4. $s : A(u^t), s : u^t$ by \Box elimination rule and visa rule (b1).
5. $s : \forall x A(x)$, by (*12)
6. $t : \Box \forall x A(x)$, since s was arbitrary.

It is interesting to see what happens with our visa system when the labels are priorities.

Consider $t : \exists x A(x)$. We Skolemise and get $A(c^t)$ with $t : c^t$. If we allow c^t to exist in $s : c^t$, for s higher priority, we will get $s : \exists x A(x)$ by \exists introduction and the priority of $\exists x A(x)$ will go up.

We thus have

– In prioritised logics, all elements are dependent on a priority (or labelled with priority). Elements of lower priority do not exist at higher priority.

So for example the statement

t: Every homeless person is to have a home

Write it as
$$t : HL(x) \rightarrow \exists y \ \text{Home}(x, y)$$

Skolemise and get $t : c^t(x)$, where c^t is the home of x. Its existence depends on the priority factor of the statement above.

Suppose we have
$$s : \text{Home}(z) \rightarrow \exists u \ \text{Janitor}(z, u)$$

with priorty s, every home has a Janitor. Skolemising we get $d^s(z)$. Thus by putting both arguments together (assuming x is homeless), we get $d^s(c^t(x))$. This means that we have people walking around not with passports, indicating as to where they were born (as is the case in modal logic) but with a priority label indicating to which priority they exist (or if we take a clue from modern society, how important they are).

We are now ready for the definition of proof theory for LDS.

Definition 8 Proof Theory for Algebraic LDS. 1. Let $(\mathcal{A}, \mathbf{L})$ be an algebraic LDS. An elimination rule for a connective $\sharp(A_1, \ldots, A_n)$ has the form

$$\frac{\varphi, t_1 : B_1, \ldots, t_n : B_n, s : \sharp(A_1, \ldots, A_n)}{\psi, r_1 : C_1, \ldots, r_m : C_m}$$

The terms r_1, \ldots, r_m are new atomic constants.

Where $\varphi(t_1, \ldots, t_n, s)$ is a formula of \mathcal{A} called the condition for the (fibring of the) rule and $\psi(t_1, \ldots, t_n, s, r_1, \ldots, r_m)$ is a formula of A called the post condition. ψ may contain equality.

The rule is to be understood as saying:

If we have proved the wffs above the line with labels satisfying φ then we can deduce the formulas below the lines and the labels satisfy ψ.

2. Introduction rules in LDS are defined in terms of elimination rules and hence need not be introduced separately. Their use will be properly defined when we give the notion of a proof. Intuitively, when we are in the middle of a proof and we want to introduce a connective $t : \sharp(A_1, \ldots, A_n)$ with label t, we are really saying 'we already have this connective'. If this is indeed true, then

for an aritrary elimination rule of this connective (e.g. like in (1) above), if we assume the antecedent, without the connective, we must be able to prove the consequent of the rule. If we can demonstrate this capability for each elimination rule, then we can introduce the connective. Take for example

$$\frac{A, A \to B}{B}$$

we show we already have $A \to B$ (i.e. introduce $A \to B$) by showing we can assume A and get B. Another example is $\frac{A \wedge B}{A}$ $\frac{A \wedge B}{B}$. To introduce $A \wedge B$ we must show we can get the conclusions of each rule, without the connective, namely Assume \emptyset and get A and assume \emptyset and get B.

3. **Quantifier Rules**

These include the usual classical quantifier rules and visa rules

$$(a) \quad \frac{t : \forall x A(x)}{t : A(u^t); t : u^t, u^t \text{ a universal variable}}$$

$$(b) \quad \frac{t : \forall x A(x); t : c^s}{t : A(c^s)}$$

$$(c) \quad \frac{t : c^s; t : A(c^s)}{t : \exists x A(x)}$$

$$(d) \quad \frac{t : \exists x A(x, y)}{t : A(c^t(y), y); t : c^t(y)}$$

$t : c^t(y)$ is optional in (d). It may not be adopted in modal logic but may be adopted in numerical or priority logics.

(e) To introduce $t : \forall x A(x)$ we prove $t : A(u_0^t)$, for any rbitrary new constant u_0^t. Some important side conditions may be involved.

3.2 **Visa Rules**

These have the form

$$\frac{t_i : A_i, t_i : c^{s_i}, r_j : B_j, \psi(t_i, s_i, r_j)}{r_j : c^{s_j}} \quad j = 1 \ldots k \text{ and } i = 1, \ldots, n$$

where $s_j' \in \{s_i\}$.

The meaning of the visa rule is that if c^{s_i} exist at t_i where A_i holds and if ψ holds and B_j holds at r_j then $c^{s_j'}$ exist at r_j.

- Sample visa rule from modal logic:

$$\frac{t : c^s; t < r, r : \Box \bot}{r : c^s}$$

The rule says that if c exists at t then it exists at any endpoint above c. It happens to correspond to the following refinement of the Barcan formula.

$$\forall x \Box A(x) \to \Box(\Box \bot \to \forall x A(x)).$$

4. A proof π_0 of level 0 from a database (D, \mathbf{f}, d) is a sequence of labelled databases (D_n, \mathbf{f}_n, d) and justification function \mathbf{J}^0 satisfying the following:

4.1 $(D_0, \mathbf{f}_o, d) = (D, \mathbf{f}, d)$ and $\mathbf{J}^0(0) = $ 'assumption'.

4.2 $(D_{n+1}, \mathbf{f}_{n+1}, d)$ is obtained from (D_n, f_n, d) by applying an Elimination rule and adding the consequent of the Elimination rule to (D_n, f_n) to obtain (D_{n+1}, f_{n+1}). The elimination rule is applicable iff $D_n \vdash \varphi \rightarrow \mathbf{J}^0(n+1) = $ name of the elimination rule.

We write $(D, \mathbf{f}, d) \vdash_0 (D', \mathbf{f}', d)$ iff there exists a proof π_0 of level 0 leading from one to the other.

5. A proof of level $\leq n$ has the form of linked sequences of databases with a main sequence π, and justification function \mathbf{J}. The first element of the main sequence π is (D, \mathbf{f}, d). Each element of the sequence is obtained from a previous one either according to one of the cases of a proof of level 0 or according to the following case

Introduction Case

For some connective $\sharp(A_1, \ldots, A_n)$ let

$$\frac{\varphi_j, t_1^j : B_1^j, \ldots, t_{n(j)}^j : B_{n(j)}^j, s_j : \sharp(A_1, \ldots, A_n)}{\psi_j, r_1^j : C_1^j, \ldots, r_{m(j)}^j : C_{m(j)}^j}$$

$j = 1 \ldots k$, be all the elimination rules involving \sharp. Suppose we also have that for some s, we have that for each j there is a proof π_j of level $\leq n-1$ of each $(D_n, \mathbf{f}_n, d) + \{\psi_j, r_i^j : C_i^j\}$ from $(D_n, f_n, d) + \{\varphi_j, t_i^j : B_i^j\}$ (e.e. we can prove the consequent of each rule from the antecedent of the rule without the use of $s : \sharp(A_1, \ldots, A_n)$, as if we already have it) then the introduction step allows us to move onto $(D_{n+1}, f_{n+1}, d) = (D_n, \mathbf{f}_n, d) + \{s : \sharp(A_1, \ldots, A_n\}$, we link the proofs π_j into the proof π at line n, via the justification function, $\mathbf{J}(n+1) = \{\text{proofs } (\Pi_j, \mathbf{J}_j)\}$.

We write $(D, \mathbf{f}, d) \vdash_n (D', \mathbf{f}', d)$ if there is a proof of level $\leq n$ of the consequent from the antecedent. We write $(D, \mathbf{f}, d) \vdash (D', \mathbf{f}', d)$ if there is a proof of any level of the consequent from the antecedent.

3 Concluding Remarks: Evaluation and Recipes

We now summarise and evaluate the evolution steps in our thinking.

3.1 The need for Labelled Deductive Systems

- The first step was the realisation that practical applications which lend themselves to possible logical analysis, contain several independent and related structures. These structures must be recognised by any logic which we use to describe and reason about the application.
- The second step is that we have an option, either to use classical logic to represent these structures or to use specialised logics. Careful analysis of two case studies shows that we are better off using specialised logics.

– The third step is to look for a good framework which could give us the kind of logics we want for applications. The proposed framework was Labelled Deductive Systems, where the declarative units are labels: Formulas. The technical details are developed in a book on the subject. The important intuitive point is that we agree to manipulate the existing natural structures of the application together, side by side, without reduction or translation.

Our case studies showed that additional structure can come from semantics (bringing semantics into the logic, as in the case of temporal logic) or from resource or proof theoretic considerations (bringing priorities as labels). In either case the formalism (Algebraic *LDS*) is very similar. In fact, some successful wide spread formalisms such as the A-Box reasoning of KL-one is already a example for an *LDS* in our sense. Therefore we propose to use this formalism (*LDS*) in application areas where logic is needed. The practical usefulness and applicability of such a program has to be demonstrated. We are currently trying to do exactly that. The reader can reflect upon his own personal experience to see how useful the labels can be.

3.2 Advantages of LDS

The advantage of *LDS* is that it is a natural and adaptable way of doing logic. We consider a logical system as basically a discipline for databases and labels, giving structures and mechanisms for deduction. The mechanisms could be either proof theory or other mechanisms, such as abduction or circumscription, or explanation, etc. This scenario is very natural and can be adapted to a variety of application areas. To use *LDS* in an application area we need to

1. Recognise underlying structures in the application. These include
 (a) the declarative information to be manipulated and reasoned with.
 (b) The units (objects) to be manipulated and their relative structure. (e.g. semantic objects such as worlds or individuals, syntactic objects such as priorities or probabilities).
 (c) Recognise any compatibility or conflict in natural manipulative movement between (a) and (b).
2. Having recognised in (1) the natural components of the system, we devise an *LDS* to represent and reason about them. Note that *LDS* is not a single logic, but a family of logics.

The above process needs to be applied anyway for any use of traditional logic. What I am saying to the reader is that he should *not* approach the problem with a pre-determined pre-fabricated logic (such as classical logic) and therefore be compelled to force all representation into it.

In fact, what many researchers often do in parctice is to use labels as side effects (implementation tricks) to *retain* distinctions that their (first order) logic forces them to abandon.

My favourite analogy is that of a person who has a wife (husband) and a mistress (lover). Obviously they are there for a reason and have considerable

influence (good or bad)! There is a need for them much in the same way that there is a need for the label. Rather than supress them and treat them as a side effect, I am proposing that we bring them forward into the open, and recognise their influence. We should openly declare that a declarative unit is a formula and a label (or several labels) and analogously we should admit that a 'family' unit is a husand/wife and a mistress/lover (read Balzac!). We should recognise the structure involved so that we can handle it better.

Once we adopt the discipline of *LDS*, we see that there are other advantages.

- The labels can be formally used to bring into the object level metalevel features of the logic. A simple example would be to use the labels to trace the proof of the current goal. Conditions on the label can restrict the next move. These conditions are basically metalevel, but such metalevel features can be incorporated into an object level algebraic labelled proof rule.
- *LDS* allows for a uniform method for bringing the semantics into the syntax. See my paper [1] as a striking example of that, with a connection with situation theory.
- *LDS* is a unified framework for monotonic and non-monotonic logics.
- *LDS* is more computationally transparent (through the labels) and hence more receptive to meaningful optimisations.
- The proof theory of *LDS* can be more flexible. In classical logic, there is proof theory and there are tableaux systems which can be considered as model building systems. One is syntax based and the other is semantically based. In *LDS*, a tableaux procedure is just another *LDS*. The basic notion of consequence in *LDS* is that of a database proving a labelled formula for example $t_1 : A_1, t_2 : A_2 \ldots \vdash s : B$. A tableaux refutation for an *LDS* consequence relation will start with

$$\text{True } [t_i : A_i], \text{ False } [s : B]$$

and manipulate that. But such a system is just another *LDS*!
Thus we have: $\Delta_1 \vdash_{LDS_1} \alpha : A$ iff in the tableaux system $\Delta_2 \vdash_{LDS_2}$ 'closed' where LDS_2 is an *LDS* system dealing with *signed* labelled formulas.

3.3 Limitations of LDS

The main limitation is that an *LDS* logic needs to commit itself. Take for example S4. This logic has one modality which is reflexive and transitive. Presented as a Hilbert system, we write a certain number of axioms:

$$\Box A \rightarrow A$$
$$\Box A \rightarrow \Box\Box A$$
$$\Box(A \wedge B) \leftrightarrow (\Box A \wedge \Box B)$$
$$\vdash A \Rightarrow \vdash \Box A$$

The above system is not committed to any interpretation. $\Box A$ means any of the following:

- A holds in all accessible worlds.
- A is a set in the Euclidean plane and $\Box A$ is its topological interior.
- A is provable
- \Box represents the progressive of English (e.g. if A is 'John walks', then $\Box A$ is 'John is walking').
- \Box can mean some algebraic operation.

In any *LDS* interpretation, we need to identify the labels, in order to state what the declarative units are. The nature of t, the algebra of t, will commit us to some - if not exactly one - of the possible interpretations. We thus loose generality. We gain power, but we have to sacrifice our semantic options. When we are applying *LDS*, we may not mind that because the application area already dictates the interpretation. Thus we must be careful to choose the right level of labelling. Not too detailed to be able to remain within the realm of logic, avoiding turning the system into an implementation.

By the way, this limitation is equally valid when we use classical logic. \Box has to be translated into classical logic and the translation requires commitment.

3.4 Conclusion

We conclude with further comparison with classical logics.

- Any *LDS* system can be translated into classical logic, in a technical sense. Take two sorted classical logic with one sort for the algebra of labels and turn $t : A$ into $A^*(t)$. This is the same process as the translation of modal logic.
- It is an interesting mental exercise to realise that classical logic itself can be turned into an *LDS* in a non trivial way. Take any predicate of classical logic, say $\mathbf{P}(x, y, z)$ and imagine a classical theory τ for \mathbf{P}. Examining the classical models of τ, we might find that most of the models of τ may have some distinguished elements in them in terms of which \mathbf{P} can be described. It may be worth our while perception-wise to write $x : \mathbf{P}^*(y, z)$ instead of $\mathbf{P}(x, y, z)$ and bring out *semantically* this special structure. This process is inverse to the translation method of (1) and intends to stress the semantical properties of the x coordinates. The x-labels will be manipulated separately, according to the model theory, and may result in a proof theory for τ which is much clearer. This would be an *LDS* formulation of τ.

References

[1] D. M. Gabbay, *Labelled Deductive Systems and Situation Theory*, to appear Proc STA III, CSLI, 1992.

[2] D. M. Gabbay, *Labelled Deductive Systems, Vol 1*, to appear, Oxford University Press. First draft 1989, seventh draft 1992

[3] D. M. Gabbay, *Theory of Algorithmic Proof*, in S. Abramsky, D. M. Gabbay and T. Maibaum *Handbook of Logic in Computer Science, Vol 2*, Oxford University Press, 1992.

[4] D. M. Gabbay, L. Giordano and A. Martelli, *Conditional Logic Programming*, manujscript, University of Turin and Imperial College.

[5] M. D'Agostino and D. M. Gabbay, *Labelled Refutation Systems*, Draft, 1992, Imperial College.

[6] E. Köning. *A Hypotheitcal Reasonin Algoirthm for Linguistic Analysis*, Paper submitted to JLC, 1992.

[7] J. van Benthem. *The Logic of Programming*, to appear in Fundamenta Informatica, 1992.

A Model Elimination Calculus
with Built-in Theories

Peter Baumgartner
Universität Koblenz
Institut für Informatik
Rheinau 3-4
5400 Koblenz

Net: peter@infko.uucp

Abstract. *The* model elimination calculus *is a linear, refutationally complete calculus for first order clause logic. We show how to extend this calculus with a framework for* theory *reasoning. Theory reasoning means to separate the knowledge of a given domain or theory and treat it by special purpose inference rules. We present two versions of theory model elimination: the one is called* total theory model elimination *(which allows e.g. to treat equality in a rigid E-resolution style), and the other is called* partial theory model elimination *(which allows e.g. to treat equality in a paramodulation style).*

1 INTRODUCTION

The *model elimination calculus* (ME calculus) has been developed already in the early days of automated theorem proving ([Lov78b]). It is a linear, refutationally complete calculus for first order clause logic. In this paper, we will show how to extend model elimination with theory reasoning.

Technically, *theory reasoning* means to relieve a calculus from explicit reasoning in some domain (e.g. equality, partial orders) by taking apart the domain knowledge and treating it by special inference rules. In an implementation, this results in a universal "foreground" reasoner that calls a specialized "background" reasoner for theory reasoning. Theory reasoning comes in two variants ([Sti85]): *total* and *partial* theory reasoning. Total theory reasoning generalizes the idea of finding complementary literals in inferences (e.g. resolution) to a semantic level. For example, in theory resolution the foreground reasoner may select from some clauses the literal set $\{a < b, b < c, c < a\}$, pass it to the background reasoner (assume that $<$ is interpreted as a strict ordering, i.e. as a transitive and irreflexive relation) which in turn should discover that this set is contradictory. Finally the theory resolvent is built as in ordinary resolution by collecting the rest literals. The problem with total theory reasoning is that in general it cannot be predicted what literals and how many variants of them constitute a contradictory set. As a solution, partial theory reasoning tries to break the "big" total steps into more managable smaller steps. In the example, the background reasoner might be passed $\{a < b, b < c\}$, compute the logical consequence $a < c$ and return it as a new subgoal, called "residue", to

the foreground reasoner. In the next step, the foreground reasoner might call the background reasoner with $\{a < c, c < a\}$ again, which detects a trivial contradiction and thus concludes this chain. It is this *partial* theory reasoning we are mostly interested in.

Theory reasoning is a very general scheme and thus has many applications, among them are *reasoning with taxonomical knowledge* as in the Krypton system ([BGL85]), *equality reasoning* as by paramodulation or E-resolution, building in *theory-unification*, and building in the axioms of the "reachability" relation in the translation of modal logic to ordinary first order logic.

The advantages of theory reasoning, when compared with the naive method of supplying the theories's axioms as clauses, are the following: for the first, the theory inference system may be specially tailored for the theory to be reasoned with; thus higher efficiency can be achieved by a clever reasoner that takes advantage of the theories' properties. For the second, a lot of computation that is not relevant for the overall proof plan is hidden in the background. Thus proofs become shorter and are more compact, leading to better readability.

Of course, theory reasoning is not new. It was introduced by M. Stickel within the general, non-linear resolution calculus ([Sti85, Sti83]). Since then the scheme was ported to many calculi. It was done for matrix methods in [MR87], for the connection method in [Bib87, Pet90], and for the connection graph calculus in ([Ohl86, Ohl87]). In ([Bau92a]) we showed that total theory reasoning is compatible to ordering restrictions.

However there are significant differences between these works and the present one: for the first, model elimination is a *linear* calculus, which roughly means that an initially chosen goal clause is stepwise processed until the refutation is found. Being a very efficient restriction, we want to keep it in our theory calculus. However none of the theory extensions of the above calculi makes use of linear restrictions. As a consequence we also need a new completeness proof and cannot use e.g. Stickel's proof. This new proof is our main result.

Another difference is our emphasis on partial theory reasoning. The completeness of the overall calculus depends from the completeness of the background reasoner for partial theory reasoning. Except Stickel ([Sti85]), the above authors do not supply sufficient completeness preserving criteria for the background reasoner. Again, since Stickel's calculus is nonlinear, his criteria cannot be applied in our case. Below we will define a reasonable criteria that meets our demands. This criteria also captures a treatment of equality by "linear paramodulation". Since linear paramodulation is complete ([FHS89]) we obtain as a corollary the completeness of model elimination with paramodulation.

We will differ from Loveland's original ME calculus in two aspects: for the first, we have omitted some efficiency improvements such as factoring, and also we do not disallow inference steps that yield identical literals in a chain. This happens because in this paper we want to concentrate on the basic mechanisms of theory reasoning. We will adopt the efficiency improvements later. For the second we made a change in data structures: instead of *chains* we follow ([LSBB92]) and work

in a tree-like setting in the tradition of analytic tableaux. This happens because we are mostly interested to implement our results in the SETHEO theorem prover(see also ([LSBB92])), which is based on that tableaux.

2 A Brief Introduction to Model Elimination

As mentioned above, we will follow the lines from [LSBB92] and define the inference rules as tree-transforming operators. Since we should not assume this format to be well-known, we will supply a brief and informal introduction.

In our format, model elimination can be seen as a restriction of semantic tableaux with unification for clauses (see [Fit90]). This restriction will be explained below. A *tableau* is, roughly, a tree whose nodes are labelled with literals in such a way that brother nodes correspond to a clause in the given clause set. A *refutation* is the construction of a tableau where every branch is contradictory. For this construction we have to start with an initial tableau consisting of a single clause, and then repeatedly apply the inference rules *extension* and *reduction* until every branch is checked to be contradictory. Consider the unsatisfiable clause set $\{A \lor B, \neg A \lor C, \neg C \lor \neg A, \neg B\}$. and the following refutation:

1. Initial tableau with $A \lor B$	2. Extension with $\neg A \lor C$	3. Extension with $\neg C \lor \neg A$ 4. Reduction	5. Extension with $\neg B$

In step 1, the tableau consisting of $A \lor B$ is built. In step 2 the branch ending in A is extended with $\neg A \lor C$ and marked with a \star (such branches are called *closed*); in general, extension is only allowed if the *leaf* of the branch is complementary to a literal in the clause extended with. Step 3 is an extension step with $\neg C \lor \neg A$, and the branch ending in $\neg C$ is closed. Step 4 depicts the reduction inference: a branch, in this case $AC\neg A$, may be closed if the leaf is complementary to one of its ancestors. Finally, in step 5 the last open branch is closed by extension with $\neg B$.

Note that a closed branch contains complementary literals A and $\neg A$ and thus is unsatisfiable. If all branches are closed then the input clause set is unsatisfiable.

As usual, the ground case is lifted to the general case by taking variants of clauses, and establishing complementarism by means of a most general unifier. It should be noted that this unifier has to be applied to the entire tableau.

There is a close correspondance to linear resolution (see e.g. [CL73]): the set of open leafs corresponds to the near parent clause, extension corresponds to input resolution, and reduction corresponds to ancestor resolution. This correspondance also explains why model elimination is called "linear". If the restriction "the *leaf*

(and not just any other literal in the branch) must be one of the complementary literals" is dropped, the calculus is no longer linear.

Lovelands original chain-notation ([Lov78a]) with A- and B-literals can be seen as a linear notation for our tableaux. More precisely, the open branches can bijectively be mapped to a chain, where the leafs are B-literals and the inner nodes are A-literals. If in the tableau model elimination always the "rightmost" branch is selected for extension or reduction, then there exist corresponding inference steps in chain model elimination. See ([BF92]) for a detailled comparison.

3 THEORY UNIFIERS

A *clause* is a multiset of literals written as $L_1 \vee \ldots \vee L_n$. A *theory* \mathcal{T} is a satisfiable set of clauses.[1] Concerning model theory it is sufficient to consider Herbrand-interpretations only, which assign a fixed meaning to all language elements short of atoms; thus we define a *(Herbrand-) interpretation* to be any total function from the set of ground atoms to $\{true, false\}$. A *(Herbrand-) \mathcal{T}-interpretation* is an interpretation satisfying the theory \mathcal{T}. An interpretation (resp. \mathcal{T}-interpretation) I *satisfies* (resp. \mathcal{T}-satisfies) a clause set M iff I simultaneously assigns *true* to all ground instances of the clauses in M. (\mathcal{T})-(un-)satisfiability and $(\mathcal{T}$-)validity of clause sets are defined on top of this notion as usual.

As with non-theory calculi the refutations should be computed at a most general level; this is usually achieved by most general unifiers. In the presence of theories however, unifiers need not be unique, and they are replaced by a more general concept:

Definition 3.1 Let $S = \{L_1, \ldots, L_n\}$ be a literal set. S is called \mathcal{T}-*complementary* iff the \forall-quantified disjunction $\forall(\overline{L_1} \vee \ldots \vee \overline{L_n})$ is \mathcal{T}-valid. By abuse of language, we will say that a substitution σ is a \mathcal{T}-*unifier* for S iff $S\sigma$ is \mathcal{T}-complementary. A "partial" variant is as follows: a pair (σ, R), where σ is a substitution and R is a literal, is a \mathcal{T}-*residue of* S iff $S\sigma \cup \{\overline{R}\}$ is minimal \mathcal{T}-complementary. *(End definition)*

There is a subtle difference between the \mathcal{T}-complementary of a literal set and the \mathcal{T}-unsatisfiability of S when S is read as a set of unit clauses. These notions are the same only for ground sets. Consider, for example, a language with at least two constant symbols a and b and the "empty" theory \emptyset. Then $S = \{P(x), \neg P(y)\}$ is, when read as a clause set, \emptyset-unsatisfiable, but S is not \emptyset-complementary, because the clause $P(x) \vee \neg P(y)$ is not \emptyset-valid (because the interpretation with $I(P(a)) = false$ and $I(P(b)) = true$ is no model). However, when applying the MGU $\sigma = \{x \leftarrow y\}$ to S the resulting set $S\sigma$ is \emptyset-complementary.

The importance of "complementary" arises from its application in inference rules, such as resolution, which have for soundness reasons be built on top of

[1] This restriction is motivated by the intended application of a Herbrand-Theorem, which only holds for universally quantified theories

"complementarism", but not on "unsatisfiablitity". Since we deal with theory inference rules, we had to extend the usual notion of "complementarism" to "\mathcal{T}-complementarism". As an example consider the theory \mathcal{E} of equality. Then $S = \{P(x), y = f(y), \neg P(f(f(a)))\}$ is \mathcal{E}-unsatisfiable but not \mathcal{E}-complementary. However with the \mathcal{E}-unifier $\sigma = \{x \leftarrow a, y \leftarrow a\}$, $S\sigma$ is \mathcal{E}-complementary. In this context it might be interesting to known that our notion of theory unifier generalizes the notion of *rigid E-unifier* ([GNPS90]) to more general theories than equality (see ([Bau92a]) for a proof).

The semantics of a residue (L, σ) of S is given as follows: L is a logical consequence of $S\sigma$; operationally L is a new goal to be proved. For example let $S' = \{P(x), y = f(y)\}$. Then $(\{x \leftarrow y\}, P(f(y)))$ is an \mathcal{E}-residue of S', since $S' \{x \leftarrow y\} \cup \{\neg P(f(y))\} =$
$\{P(y), y = f(y), \neg P(f(y))\}$ is minimal \mathcal{E}-complementary.

4 CALCULUS

Theory reasoning calculi require the computation of theory unifiers. Of course, any implementation of theory-unification in the traditional sense (see [Sie89]), e.g. AC-unification, performs a stepwise computation. Since we are interested in partial theory reasoning (see the introduction), this computation shall not remain hidden for the foreground reasoner; instead, intermediate results shall be passed back from the background reasoner to the foreground reasoner in the form of *residues*.

Let us informally describe this on the ground level with the aid of an example. Consider the clause set $S = \{a < b \lor d < e, b < c \lor \neg a < b, c < a, e < d\}$. S is unsatisfiable in the theory of strict orderings ($<$ is transitive and irreflexive), and this is a theory model elimination proof:

1. Initial tableau 2. Partial extension 3. Total extension with 4. Reduction
with $a<b \lor d<e$ with $b<c \lor \neg a<b$ $c<a$ 5. Total extension
with $e<d$

In step 1, the tableau consisting of $a < b \lor b < c$ is built. In step 2 the branch ending in $a < b$ is *partially extended* with the clause $b < c \lor \neg a < b$ and the *residue* $a < c$ (in this ground example no substitutions appear). The literals of the extending clauses which are relevant for the extension step, here solely $b < c$, are called *extending literals*. This step is sound, because $a < c$ is a logical consequence of its ancestors $a < b$ and $b < c$. The literals that semantically justify the inference step

in this way are called the *key set* (here $\{a < b, b < c\}$). Since the branch resulting from this step is not contradictory, it is not closed (marked with a star). Besides partial extension, there exists another inference rule called *total extension*. Step 3. serves as an example: the extension with $c < a$ yields a theory-contradiction with $a < c$. Thus the branch may be closed. The ancestor literals that justify the total inference step, i.e. the contradictory set $\{c < a, a < c\}$ is also called a "key set", and $c < a$ is also called "extending literal". Step 4. is an ordinary reduction step, and step 5 is a total extension step again.

The inference steps are restricted in such a way that their key sets must consist a) of the leaf and b) possibly some other literals of the old branch, and c) of all extending literals. Condition c) implies that *all* new clauses are needed, and condition b) is the generalization of the condition "the *leaf* must be one of the complementary literals" in non-theory model elimination (section 2) to theory model elimination.

Let us now come to a formal treatment. We are concerned with ordered, labelled trees with finite branching factor and finite length. A *branch b of length k* is a sequence $b = n_0 \circ n_1 \circ \cdots \circ n_k$ of nodes, where n_0 is the root, n_{i+1} is a son of n_i and n_k is a leaf, and a tree is represented as a multiset of branches. A *literal tree* is a tree whose nodes are labelled with literals, except the root, which remains unlabelled. For our purpose it is convenient to confuse a branch $n_0 \circ n_1 \circ \cdots \circ n_k$ with the sequence of its labels $L_1 \circ \cdots \circ L_k$ or with its literal set $\{L_1, \ldots, L_k\}$. A substitution is applied to a branch by applying it to its labels in the obvious way; similarly it is applied to a tree by application to all its branches. A literal tree T' is obtained from a literal tree T by *extension with a clause* $L_1 \lor \ldots \lor L_n$ *at a branch b* iff

$$T' = T - \{b\} \cup \{b \circ l_i \mid i = 1 \ldots n \text{ and } l_i \text{ is labelled with } L_i\}$$

In this case we also say that T' contains a clause $L_1 \lor \ldots \lor L_k$ rooted at b.

The term "to close a branch" means to attach an additional label "\star" to its leaf in order to indicate that the branch is proved to be \mathcal{T}-complementary. A branch is *open* iff it is not labelled in that way.

Definition 4.1 (\mathcal{T}-model elimination) Let M be a clause set and \mathcal{T} be a theory. An *initial model elimination tableau for M with top clause C* is a literal tree that results from extending the empty tree (the tree that contains only the empty branch) with the the clause C.

A *model elimination tableau (ME tableau) for M* is either an initial ME tableau or a literal tree obtained by a single application of one of the following inference rules to a ME tableau T:

Partial extension step: (cf. figure 1) Let $b = L_1 \circ \ldots \circ L_{k-1} \circ L_k$ be an open branch in T. Suppose there exist new variants $C_i = K_i^1 \lor \ldots \lor K_i^{m_i}$ $(i = 1 \ldots n)$ of clauses in M. These clauses are called the *extending clauses* and the sequence $K_1^1 \circ \cdots \circ K_n^1$ is called the *extending literals*.

In order to describe the appending of the extending clauses, we define the literal tree T_n and the "actual branch to extend", b_n, recursively as follows:

if $n = 0$ then $T_0 := T$ and $b_0 := b$, else T_n is the literal tree obtained from T_{n-1} by extending with the clause C_n at b_{n-1} and $b_n := b_{n-1} \circ K_n^1$.

Let \mathcal{K} be a subset of the literal set of b_n with $L_k, K_1^1, \ldots, K_n^1 \in \mathcal{K}$. Borrowing a notion from ([Sti85]), \mathcal{K} is called the *key set*. If there exists a \mathcal{T}-residue (σ, R) of \mathcal{L}, then partial theory extension yields the tree T_n', where T_n' is obtained from $T_n \sigma$ by extension with the unit clause R at $b_n \sigma$.

Total extension step: This is similar to "partial extension step"; instead of appending a residue, the branch is closed. Let b, C_i, T_n and b_n and \mathcal{K} as in "partial extension step". If there exists a \mathcal{T}-unifier σ for \mathcal{K}, and $\mathcal{K}\sigma$ is minimal \mathcal{T}-complementary, then total theory extension yields the literal tree $T_n \sigma$, and the branch $b_n \sigma \in T_n \sigma$ is closed.

A total extension step with $n = 0$ is also called **reduction step**.[2] A *derivation from M with top clause C and length n* is a finite sequence of ME tableaux T_0, T_1, \ldots, T_n, where T_0 is an initial tableau for M with top clause C, and for $i = 1 \ldots n$ T_i is the tableau obtained from T_{i-1} by one single application of one of the above inference rules with new variants of clauses from M. If additionally in T_n every branch is closed then this derivation is called a *refutation of M*. The *partial theory model elimination calculus (PTME-calculus)* consists of the inference rules "partial extension step" and "total extension step"; the *total theory model elimination calculus (TTME-calculus)* consists of the single inference rule "total extension step" *(End definition)*

The key sets \mathcal{K} play the role of a semantical justification of each step. The condition $L_k \in \mathcal{K}$ generalizes the condition "the *leaf* must be one of the complementary literals" from non-theory model elimination (section 2).

In practice it is important that the key sets and residues may be restricted to some typical, syntactical form. For example, if the theory is equality, and the calculus shall be instantiated with "paramodulation", then in the ground case the key sets \mathcal{K} in partial steps are of the form $\mathcal{K} = \{L[t], t = u\}$[3] or $\mathcal{K} = \{L[t], u = t\}$, and the residues are of the form $(\emptyset, L[t \leftarrow u])$; in total steps it suffices to restrict the key set to the form $\mathcal{K} = \{L, \overline{L}\}$ or $\mathcal{K} = \{\neg a = a\}$. In lifting these paramodulation steps to the first-order level, it is neccessary to allow instantiating before paramodulation (see e.g. [FHS89]). For example, if $\{P(x, x), a = b\}$ is a key set, then for completeness reasons it might be neccessary to instantiate first with $x \leftarrow f(y)$, which yields $P(f(y), f(y))$ and then paramodulate into y which finally yields $P(f(b), f(a))$. Since instantiating is not neccessary in a non-linear setting, this example also shows that inference systems for partial theory reasoning must *in principle* be designed differently than for non-linear calculi.

It should be noted that the *order* of the extending clauses is immaterial for completeness.

[2]This notion is kept for historical reasons

[3]$L[t]$ means that the term t occurs in the literal L, $L[t \leftarrow u]$ is the literal that results from replacing one occurence of t with u

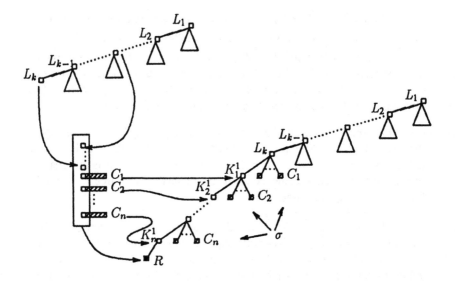

Figure 1: Partial extension step

5 COMPLETENESS

Besides soundness, which is usually easy to prove, *(refutational) completeness* is the most important demand for a logic calculus. In order to establish such a result for partial theory reasoning, the theory reasoning component must be taken care of.

In our viewpoint, the computation of the residues in partial extension steps, and the computation of the substitutions in total extension steps should be described by a "theory calculus" with two respective inference rules: the one derives from a key set a residue, and the other derives from a key set a theory-unifier. In order to establish the completeness of the overall calculus, the theory calculus itself must be "complete". However, in order to formulate this we do not want to fix to a certain calculus; instead we will use the following abstract characterization.

Definition 5.1 Let T be a theory, S_1 be a ground T-unsatisfiable literal set and $L_0 \in S_1$. Then a *linear and liftable T-refutation of S_1 with top literal L_0* consists of the three sequences

$$
\begin{array}{llll}
S_1, & \cdots & S_n, & S_{n+1} \qquad \text{and} \\
K_1, & \cdots & K_n, & K_{n+1} \qquad \text{and} \\
(L_1, \sigma_1), & \cdots & (L_n, \sigma_n), & \sigma_{n+1}
\end{array}
$$

such that for $i = 1 \ldots n$:

1. $L_{i-1} \in K_i$, $K_i \subseteq S_i$ and (L_i, σ_i) is a T-residue of K_i.

2. $S_{i+1} := S_i \sigma_i \cup \{L_i\}$.

3. $L_n \in K_{n+1}$, $K_{n+1} \subseteq S_{n+1}$, and $K_{n+1}\sigma_{n+1}$ is minimal T-complementary.

4. For every[4] $K_i' \leq K_i$ there exists a residue $(L_i'\sigma_i')$ such that $L_i' \leq L_i$ and $\sigma_i' \leq \sigma_i$.

5. For every $K_{n+1}' \leq K_{n+1}$ there exists a T unifier $\sigma_{n+1}' \leq \sigma_{n+1}$ for K_{n+1}'.

Such a refutation is called *total* instead of linear iff $n = 0$. *(End definition)*

The idea behind items 1. – 3. is to stepwisely modify an initially chosen goal L_0, leading to L_1, L_2, \ldots, L_n until a contradiction is obvious (The presence of unifiable and syntactical complementary literals might be such a case, or, in equational reasoning, the presence of a literal $\neg s = t$ where s and t are unifiable). The K_is have the same meaning as the key sets in the definition of theory model elimination. In the first chain of the introductory example in the previous section, $n = 1$, $S_1 = \{a < b, b < c, c < a\}$, $L_0 = a < b$, $K_1 = \{a < b, b < c\}$, $(\sigma_1, L_1) = (\emptyset, a < c)$, $S_2 = \{a < b, b < c, c < a, a < c\}$, $K_2 = \{c < a, a < c\}$ and $\sigma_2 = \emptyset$. This strategy can also be roughly explained in linear resolution terminology: L_1 plays the role of the top clause, and the L_{i+1} are derived from the near parent L_i and a collection of far parent clauses $K_i \subseteq S_i$.

Note that although S_1 is a ground set, substitutions are involved. This is, because \forall-quantified variables might be introduced in the residues and thus the S_j $(j > 1)$ might no longer be ground. Items 4. is the lifting requirements for the residues, and item 5. is the lifting requirement for the concluding unifier.

Now we can turn to completeness of theory model elimination. In an attempted model elimination refutation it is essential to pick a suitable clause for the initial tableau. For example, if $S = \{A, B, \neg B\}$ then no proof can be found when the initial tableau is built from A. What we need is expressed in the completeness theorem:

Theorem 5.1 (Completeness of partial theory model elimination) *Let T be a theory. Suppose that for every minimal T-unsatisfiable ground literal set S and every $L \in S$ there exists a linear and liftable T-refutation of S with top literal L.*
Let M be a T-unsatisfiable clause set. Let $C \in M$ be such that C is contained in some minimal T-unsatisfiable subset of M. Then there exists a PTME refutation of M with top clause C.

The completeness of TTME follows as a corollary of PTME if the theory reasoner can find a T-unifier in one step, or, more technically:

Corollary 1 *Let T be a theory. Suppose that for every minimal T-unsatisfiable ground literal set S there exists a total and liftable T-refutation of S.*
Let M be a T-unsatisfiable clause set. Let $C \in M$ be such that C is contained in some minimal T-unsatisfiable subset of M. Then there exists a TTME refutation of M with top clause C.

[4] $K' \leq K$ iff $\exists \delta : K'\delta = K$ and $\sigma' \leq \sigma$ iff $\exists \delta : \sigma'\delta|dom(\sigma) = \sigma$

The completeness proof employs the standard technique of proving first the ground case and then lifting to the variable case. Thus we apply a theory-version of the Skolem-Herbrand-Gödel theorem. Such a theorem only holds for universally quantified formula. This fact explains our restriction to *clausal* theories.

Since the main difficulties are in the ground proof, we will omitt lifting here. For the ground proof we need the following notion: a clause $C \in M$ in an T-unsatisfiable clause set M is called *essential in* M iff $M - \{C\}$ is not T-unsatisfiable. Note that not every T-unsatisfiable clause set has an essential literal, e.g. $\{A, \neg A, B, \neg B\}$ is \emptyset-unsatisfiable but deleting any element results in a still \emptyset-unsatisfiable set. However every literal in a *minimal* T-unsatisfiable set is essential.

Lemma 5.1 *Let M be a T-unsatisfiable ground clause set, with $L, L_1 \vee \ldots \vee L_n \in M$ being essential. Define $M_i = M - \{L_1 \vee \ldots \vee L_n\} \cup \{L_i\}$ (for $i = 1 \ldots n$). Then every M_i is T-unsatisfiable and the clauses L and L_i are essential in some M_j ($1 \leq j \leq n$).*

This lemma is needed in the proof of the following ground completeness lemma:

Lemma 5.2 *Let T be a theory and M be a T-unsatisfiable ground clause set with essential clause C. Then there exists a PTME refutation of M with top clause C.*

Proof. For convenience some terminology is introduced: if we speak of "replacing a clause C_1 in a derivation by a clause C_2" we mean the derivation that results from replacing some specific occurence of C_1 by C_2, which must be a superset of $C1$, in every tableau in the derivation. By a "derivation of a clause $L_1 \vee \ldots \vee L_n$" we mean a derivation that ends in a tableau which in turn contains n open branches ending in brother leafs L_1, \ldots, L_n. Furthermore, if D_1 is a derivation of a clause C and D_2 is a derivation with top clause C, then by "appending D_1 and D_2" we mean the derivation that results from extending D_1 with the inferences of D_2 in order, where one specific occurence of C in D_1 takes the role of the top clause C in D_2.

Let $k(M)$ denote the number of occurences of literals in M minus the number of clauses in M ($k(M)$ is called the *excess literal parameter* in ([AB70])). Now we prove the claim by induction on $k(M)$.

In the induction base $k(M) = 0$. Then M must be a set of unit clauses, i.c. a literal set. Now set $L_0 = C$ and consider definition (5.1). The sequences defined there can be mapped to a refutation as follows: the initial tableau consists of L_0. The T-residues $(\sigma_1, L_1), \ldots, (\sigma_n, L_n)$ of the respective sets K_1, \ldots, K_n are mapped to n partial extension steps as follows: in step i choose as the key set K_i, as extending literals $K_i - \{L_{i-1}\}$, and as residue (σ_i, L_i). A final total extension step with key set K_{n+1} and extending literals $K_{n+1} - \{L_n\}$ and substitution σ_{n+1} yields the desired refutation.

To complete the induction assume now that $k(M) > 0$ and that the result holds for sets M' with $k(M') < k(M)$. We need a further case analyses.

Case 1: C is a non-unit clause of the form $C = L \vee R_1 \vee \ldots \vee R_n$. Define

$$M'_L = (M - \{C\}) \cup \{L\} \tag{1}$$
$$M'_R = (M - \{C\}) \cup \{R_1 \vee \ldots \vee R_n\} \tag{2}$$

Both M'_L and M'_R are unsatisfiable, since otherwise a model for one of them were a model for M, which contradicts the assumption that M is unsatisfiable. Find a minimal T-unsatisfiable $M_L \subset M'_L$ that contains L. Such a set must exist, because otherwise $M'_L - \{L\} \subset M$ were T-unsatisfiable, and with $C \notin M'_L$ it follows that C is not essential in M. Since M_L is minimal T-unsatisfiable L is essential in M_L. Since $k(M_L) < k(M)$ we can apply the induction hypothesis and obtain a refutation D_L of M_L with top clause L. We may assume that D_L is in the following normal form: in every extension or reduction step, L does not occur as an extending clause. Such a normal form can always be achieved, since L is the top clause, and thus in every step the extending clause L can be replaced by the ancestor clause L.

By the same argumentation as for L, the clause $R_1 \vee \ldots \vee R_n$ is essential in M_R, and since $k(M_R) < k(M)$ we can apply the induction hypothesis again and obtain a refutation D_R of M_R with top clause $R_1 \vee \ldots \vee R_n$.

Now replace in D_R every occurence of the clause $R_1 \vee \ldots \vee R_n$ by $L \vee R_1 \vee \ldots \vee R_n$. Call this derivation D'_R. D'_R is derivation of several occurences of a clause L from M with top clause $L \vee R_1 \vee \ldots \vee R_n$. Now append D'_R with D_L as many times until all these occurences of the clause L are closed. Since D_L is in the above normal form, the clause L is no longer used in this final derivation. Thus we obtain the desired refutation of M.

Case 2: C is a unit clause $C = K$. Since $k(M) > 0$, M contains a non-unit clause D. We distinguish two cases. In the first (and trivial) case, D is not essential in M. Thus $M' = M - \{D\}$ is T-unsatisfiable. But C is still essential in M', because otherwise it were not essential in M either. Since $k(M') < k(M)$ the refutation as claimed exists by the induction hypothesis.

In the other case D is essential in M. By lemma (5.1) D contains a literal L such that $M_L = (M - \{D\}) \cup \{L\}$ is T-unsatisfiable, and K and L are essential in M_L. It holds that $k(M_L) < k(M)$. Thus by the induction hypothesis there exists a refutation D_K of M_L with top clause K. D is of the form $D = L \vee R_1 \vee \ldots \vee R_n$. Since L is essential in M_L and $k(M_L) < k(M)$ there exists by the induction hypothesis a refutation D_L of M_L with top clause L. As for D_L in case 1 above, the set D_L here can be assumed to be in the same normal form, i.e. L is not used as an extending clause in any inference step.

Let $M_R = (M - \{D\}) \cup \{R_1 \vee \ldots \vee R_n\}$. By the same argumentation as in case 1, M_R is T-unsatisfiable and $R_1 \vee \ldots \vee R_n$ is essential in M_R, and by the induction hypothesis there exists a refutation D_R of M_R with top clause $R_1 \vee \ldots \vee R_n$.

Now we can put things together. First replace in D_K every occurence of the clause L by D. The result is a derivation D'_K of several occurences of a clause $R_1 \vee \ldots \vee R_n$ from M with top clause K. Now append D'_K with D_R as many times until all occurences of $R_1 \vee \ldots \vee R_n$ in D'_K are closed. Since $R_1 \vee \ldots \vee R_n$ may be used in D_R several times, the result is a refutation D''_K of $M \cup \{R_1 \vee \ldots \vee R_n\}$ with top clause K. In order to turn D''_K into a refutation of M first replace in D''_K every occurence of the clause $R_1 \vee \ldots \vee R_n$ by D. This results in a derivation D'''_K of several occurences of the clause L from M. In order to turn this into a refutation, append D'''_K with D_L as many times until all occurences of L are closed. Since D_L

is in the above normal form, the clause L is no longer used in this final derivation. Thus we obtain the desired refutation of M. □

6 CONCLUSIONS

We have developed a partial and a total variant of the model elimination calculus for theory reasoning and proved their completeness. For this purpose we gave a sufficient completeness criterion for the theory reasoning system, but left open the question how such a system can be obtained from given theory axioms. This is currently being investigated ([Bau92b]). Finally I would like to thank U. Furbach for reading an earlier draft of this paper.

REFERENCES

[AB70] R. Anderson and W. Bledsoe. A linear format for resolution with merging and a new technique for establishing completeness. *J. of the ACM*, 17:525–534, 1970.

[Bau91] P. Baumgartner. A Model Elimination Calculus with Built-in Theories. Fachbericht Informatik 7/91, Universität Koblenz, 1991.

[Bau92a] P. Baumgartner. An Ordered Theory Resolution Calculus. In *Proc. LPAR '92*, 1992. (To appear).

[Bau92b] P. Baumgartner. Completion for Linear Deductions. (in preparation), 1992.

[BF92] P. Baumgartner and U. Furbach. Consolution as a Framework for Comparing Calculi. (in preparation), 1992.

[BGL85] R. Brachman, V. Gilbert, and H. Levesque. An Essential Hybrid Reasoning System: Knowledge and Symbol Level Accounts of Krypton. In *Proc. IJCAI*, 1985.

[Bib87] W. Bibel. *Automated Theorem Proving*. Vieweg, 2nd edition, 1987.

[CL73] C. Chang and R. Lee. *Symbolic Logic and Mechanical Theorem Proving*. Academic Press, 1973.

[FHS89] Ulrich Furbach, Steffen Hölldobler, and Joachim Schreiber. Horn equational theories and paramodulation. *Journal of Automated Reasoning*, 3:309–337, 1989.

[Fit90] M. Fitting. *First Order Logic and Automated Theorem Proving*. Texts and Monographs in Computer Science. Springer, 1990.

[GNPS90] J. Gallier, P. Narendran, D. Plaisted, and W. Snyder. Rigid E-unification: NP-Completeness and Applications to Equational Matings. *Information and Computation*, pages 129–195, 1990.

[Lov78a] D. Loveland. *Automated Theorem Proving - A Logical Basis*. North Holland, 1978.

[Lov78b] D. W. Loveland. Mechanical Theorem Proving by Model Elimination. *JACM*, 15(2), 1978.

[LSBB92] R. Letz, J. Schumann, S. Bayerl, and W. Bibel. SETHEO: A High<-Performace Theorem Prover. Journal of Automated Reasoning, 1992.

[MR87] N. Murray and E. Rosenthal. Theory Links: Applications to Automated Theorem Proving. *J. of Symbolic Computation*, 4:173–190, 1987.

[Ohl86] Hans Jürgen Ohlbach. The Semantic Clause Graph Procedure – A First Overview. In *Proc GWAI '86*, pages 218–229. Springer, 1986. Informatik Fachberichte 124.

[Ohl87] Hans Jürgen Ohlbach. Link Inheritance in Abstract Clause Graphs. *Journal of Automated Reasoning*, 3(1):1–34, 1987.

[Pet90] U. Petermann. Towards a connection procedure with built in theories. In *JELIA 90*. European Workshop on Logic in AI, Springer, LNCS, 1990.

[Sie89] Jörg H. Siekmann. Unification Theory. *Journal of Symbolic Computation*, 7(1):207–274, January 1989.

[Sti83] M.E. Stickel. Theory Resolution: Building in Nonequational Theories. SRI International Research Report Technical Note 286, Artificial Intelligence Center, 1983.

[Sti85] M. E. Stickel. Automated deduction by theory resolution. *Journal of Automated Reasoning*, pages 333–356, 1985.

A New Sorted Logic

Christoph Weidenbach*

Max-Planck-Institut für Informatik
Im Stadtwald
D-6600 Saarbrücken 11, Germany

Abstract. We present a sound and complete calculus for an expressive sorted first-order logic. Sorts are extended to the semantic and pragmatic use of unary predicates. A sort may denote an empty set and the sort structure can be created by making use of the full first-order language. Technically spoken, we allow sort declarations to be used in the same way than ordinary atoms. Therefore we can compile every first-order logic formula into our logic.

The extended expressivity implies an extended sorted inference machine. We present a new unification algorithm and show that the declarations the unification algorithm is built on have to be changed dynamically during the deduction process. Deductions in the resulting resolution calculus are very efficient compared to deductions in the unsorted resolution calculus. The approach is a conservative extension of the known sorted approaches, as it simplifies to the known sorted calculi if we apply the calculus to the much more restricted input formulas of these calculi.

1 Introduction

It is widely accepted that the introduction of "sorts", e.g. see [11, 8, 13, 3, 4, 1] in first-order logic results in a more efficient resolution calculus and a more natural representation of problems. Although the second statement depends on the personal taste, there are many examples in the literature, where a sorted formalization of a problem leads to shorter proofs and a less branching search space. In all of the approaches mentioned above, sorts correspond to unary predicates in unsorted first-order logic. For example in the logic of [13] the sort "declaration" $f(x_S) \leqslant S$ is logically equivalent to the clause $S(x) \Rightarrow S(f(x))$. This simple example shows the advantages of a sorted formalization: less literals and less resolution possibilities. In particular, for this simple example there are infinitely many (self) resolution possibilities in the unsorted version, whereas there are no possible resolution steps in the sorted version.

The logic presented in this paper follows the lines of [11, 8, 13]. It extends the work of Schmidt-Schauß [8] in three directions

- We allow conditioned declarations, i.e. declarations can be used as ordinary atoms, e.g. the conditioned declaration $i(x_P, y_\top) \leqslant P \Rightarrow y_\top \leqslant P$ expresses that

* This research was supported by the ESPRIT project MEDLAR (3125) of the European Community

if x is a theorem and y a proposition and x implies y, then y is a theorem. The sort P denotes the set of all theorems and the function i denotes implication (see Example 2.4).

- Sorts may denote empty sets, i.e. we also have to consider interpretations where the empty set is assigned to a sort.
- We have a fixed sort symbol \top which denotes the topsort "Any".

Our way of reasoning is the same as in [11, 8]. We choose a set of declarations which is fixed in [11, 8] from the beginning but dynamic in our approach. We exploit the declarations in a sorted unification algorithm and modify standard deduction rules (e.g. resolution) by considering sorted unifiers only.

Compared to our own work [13] we have simplified the semantics by considering total functions only and we have established an optimal result concerning the number of declarations that have to be taken into account for the sorted unification algorithm.

The difference between our approach and the work of [3, 4, 1] is that we do not separate formulas containing declarations only from the rest of the formulas. This allows for a more efficient calculus, because we incorporate all declarations in sorted reasoning, whereas [3, 4, 1] do not consider declarations occurring in the formula part (in fact [4] does not allow for such declarations) in the sorted reasoning process. Therefore they need more and less restrictive inference rules. Besides they only give algorithms for simple or elementary [8] sort structures, whereas our approach applies to arbitrary sort structures.

Because of the generality of our approach, we are able to compile every formula of first-order logic into a formula of our sorted logic, i.e. in general we get a smaller set of formulas (but never larger) and are able to apply our much more efficient calculus. In subsection 2.3 we will give the foundations of this compilation.

We have tried to keep the theory in this paper simple. Technical lemmas and proofs have been skipped. They can be found in [12]. Instead, we provide key examples in order to justify our results. The paper now first explains the syntax and semantics of the logic and relates the logic to unsorted first-order logic. Then we introduce our sorted unification algorithm and the rules of the resolution calculus. We end with a solution to an example (see Example 2.4) and some conclusions.

2 The Logic \mathcal{L}_S

2.1 Syntax

A signature $\Sigma := (\mathbf{S}, \mathbf{V}, \mathbf{F}, \mathbf{P})$ contains a set of sort symbols in addition to the usual sets \mathbf{V} of variable symbols, \mathbf{F} of function symbols and \mathbf{P} of predicate symbols. The fixed sort \top is always in \mathbf{S} and the 2-place predicate \leqslant is always in \mathbf{P}. Variables are indexed with their sort, e.g. x_S, y_W.

Terms and atoms are built in the usual unsorted way with the addition that if t is a term and S a sort symbol, then $t \leqslant S$ is an atom. Atoms of the form $t \leqslant S$ are

called *declarations*. Atoms of the form $t \prec \top$ are forbidden, because they are not useful and complicate the theory. From atoms we construct literals and formulas using the logical connectives. A clause is a set of literals which is interpreted as the universal closure of the disjunction of the literals.

The set of all terms is denoted by \mathbf{T}_Σ. Substitutions are total functions $\sigma: \mathbf{V} \to \mathbf{T}_\Sigma$ such that the set $DOM(\sigma) := \{x_S \mid \sigma(x_S) \neq x_S\}$ is finite. The application of substitutions can be extended to terms, formulas, and clauses in the usual way. With $COD(\sigma)$ we denote the codomain of σ, $COD(\sigma) := \sigma(DOM(\sigma))$. Concrete substitutions are described by their variable-term pairs, e.g. $\{x_S \mapsto a\}$ denotes the substitution that maps x_S to a.

Finally, we assume that there is a function V which maps terms, formulas and sets of such objects to their variables and a function *Sorts* which maps terms, formulas and sets of such objects to the sorts assigned to the variables occurring in these objects.

For a sequence of terms t_1, \ldots, t_n we use the abbreviation \bar{t}_n. The abbreviation is also used for sequences of equations of terms, i.e. $t_1 = s_1, \ldots, t_n = s_n$ is abbreviated by $\bar{t}_n = \bar{s}_n$.

2.2 Semantics

In order to define the semantics for \mathcal{L}_S, we have to assign a set of objects from the non-empty universe to every sort symbol and a total function to every function symbol. \prec is interpreted as the membership relation and we interpret predicates and the logical connectives as in unsorted first-order logic.

Let Σ be a signature. An *interpretation* \Im consists of a non-empty carrier set \mathbf{A}, a total function $f_\Im: \mathbf{A}^n \to \mathbf{A}$ for every function symbol $f \in \mathbf{F}_n$, a set $S_\Im \subseteq \mathbf{A}$ for every sort S, and $\top_\Im := \mathbf{A}$. The interpretation \Im assigns an element of S_\Im to every variable x_S. An interpretation $\Im\{x_S/a\}$ is like \Im except that it maps x_S to a, if $a \in S_\Im$. Furthermore, \Im assigns an n-ary relation $P_\Im \subseteq \mathbf{A}^n$ to every n-place predicate symbol P and the membership relation to \prec, such that for every formula \mathcal{F}, $t \in \mathbf{T}_\Sigma, S \in \mathbf{S}$, and $P \in \mathbf{P}_n$:

$\Im \models P(t_1, \ldots, t_n)$	iff	$(\Im_h(t_1), \ldots, \Im_h(t_n)) \in P_\Im$.
$\Im \models t \prec S$	iff	$\Im_h(t) \in S_\Im$
$\Im \models \forall x_S\ \mathcal{F}$	iff	for all $a \in S_\Im, \Im\{x_S/a\} \models \mathcal{F}$
$\Im \models \exists x_S\ \mathcal{F}$	iff	there exists an $a \in S_\Im, \Im\{x_S/a\} \models \mathcal{F}$

The logical connectives are interpreted in the usual way.

2.3 Relativization

In this subsection we show how to transform formulas of \mathcal{L}_S into unsorted first-order logic. We can use the equivalences

$$\forall x_S\ \mathcal{F} \Leftrightarrow \forall y_\top\ (y_\top \prec S \Rightarrow \{x_S \mapsto y_\top\}(\mathcal{F}))$$
$$\exists x_S\ \mathcal{F} \Leftrightarrow \exists y_\top\ (y_\top \prec S \land \{x_S \mapsto y_\top\}(\mathcal{F}))$$

where y_\top is a new variable, in order to eliminate variables of sorts different from \top, then erase the sorts of the variables and transform each atom $t \leqslant S$ into $S(t)$. The unsorted first-order formula obtained is logically equivalent to the sorted formula [12].

If we use these steps in reverse order, we can also translate every unsorted first order logic formula into our logic. For arbitrary formulas this process might not be useful, but it works fine for clauses.

2.4 Example: Condensed Detachment

Condensed detachment is an inference rule that combines modus ponens and instantiation [7]. The general technique is to code various problems into the term structure of first-order logic. Thus we only need one predicate symbol P expressing "is a theorem". Solving examples of this form with an automated theorem prover can be arbitrarily hard [6]. The example presented in the following is from the two-valued sentential calculus where the 2-place function i denotes implication and the 1-place function n negation. We start with an unsorted formalization.

(1) $\forall x, y \, (P(i(x, y)) \land P(x) \Rightarrow P(y))$
(2) $\forall x, y, z \, P(i(i(i(x, y), i(i(y, z), i(x, z)))))$
(3) $\forall x \, P(i(i(n(x), x), x))$
(4) $\forall x, y \, P(i(x, i(n(x), y)))$
(5) $\forall x \, P(i(x, x))$

We will prove that $((1) \land (2) \land (3) \land (4)) \Rightarrow (5)$. But first we compile the unsorted formalization into our sorted logic. As there is only one 1-place predicate symbol P, we select P and turn it into a sort, attach the sort \top (any) to all variables and rewrite atoms of the form $P(t)$ to $t \leqslant P$.

(1) $\forall x_\top, y_\top \, (i(x_\top, y_\top)) \leqslant P \land x_\top \leqslant P) \Rightarrow y_\top \leqslant P$
(2) $\forall x_\top, y_\top, z_\top \, i(i(i(x_\top, y_\top), i(i(y_\top, z_\top), i(x_\top, z_\top)))) \leqslant P$
(3) $\forall x_\top \, i(i(n(x_\top), x_\top), x_\top) \leqslant P$
(4) $\forall x_\top, y_\top \, i(x_\top, i(n(x_\top), y_\top)) \leqslant P$
(5) $\forall x_\top \, i(x, x) \leqslant P$

So far the changes have not affected the structure of the formulas, only the syntax. The only candidate for applying the relativization backwards is the literal $x_\top \not\leqslant P$ in the first clause. As we have $P \sqsubseteq \top$ (\sqsubseteq denotes the subsort relation, P is a subsort of \top by definition of \top. In general the subsort relation is decided with respect to a set of declarations, see Section 3.1. The compilation process can be automatized [12].), we change the sort of the variable x_\top into x_P, delete the literal, negate formula (5), compute clause normal form (see [13]) and finally result in the compiled clause set

(1) $\{i(x_P, y_\top)) \not\leqslant P, y_\top \leqslant P\}$
(2) $\{i(i(i(x_\top, y_\top), i(i(y_\top, z_\top), i(x_\top, z_\top))) \leqslant P\}$
(3) $\{i(i(n(x_\top), x_\top), x_\top) \leqslant P\}$
(4) $\{i(x_\top, i(n(x_\top), y_\top)) \leqslant P\}$
(5) $\{i(a, a) \not\leqslant P\}$

It seams that the effect of the compilation is quiet small (in fact for other examples we can save more literals), because we have saved one literal only. But we will show that the proof using the compiled clause set is unique whereas the proof using the original unsorted clause set requires search in an infinite search space.

Note that the problem cannot be represented as sort information in any other known sorted logic [11, 8, 3, 4, 1], i.e. the occurring declarations can not be processed by their sorted inference mechanisms. Therefore applying these sorted calculi to the example is like applying the unsorted resolution calculus.

3 The Calculus \mathcal{CL}_S

We will present a resolution based calculus for \mathcal{L}_S. In [12] we have shown how to transform sentences of \mathcal{L}_S into clauses. So our starting point here is a set of clauses CS.

The difference between a sorted and an unsorted calculus is the different processing of unary predicates. The corresponding atoms are either viewed as declarations or the name of the predicate is attached as a sort to a variable. For example, the unsorted clause $\{\neg S(x), P(x, a)\}$ can be compiled to the sorted clause $\{P(x_S, a)\}$. If we want to instantiate a sorted variable, we have to check the well sortedness of the instantiation. Therefore we need a different (sorted) unification algorithm. For example, in order to perform a resolution step between the literals $P(x_S, a)$ and $\neg P(a, a)$ we must guarantee that a has sort S. The declaration $a \lessdot S$ would provide the necessary information. Thus the unification algorithm checks well sortedness of assignments to variables with respect to a set \mathbf{L}_\lessdot of declarations.

In our approach the interesting question is which declarations we must consider during unification. Note that declarations may not only occur in unit clauses (e.g. $\{a \lessdot S\}$) but also mixed with other literals (e.g. $\{a \lessdot S, P(a, a)\}$ or $\{a \lessdot S, a \lessdot T\}$).

In the calculi of [11, 8], declarations occurred only in the declaration part of the logic. This corresponds to unit clauses containing a declaration as their literal in \mathcal{L}_S. We will see that it is not sufficient to only consider declarations occurring in unit clauses during unification. Instead, we must also consider declarations occurring in non unit clauses in order to obtain a complete calculus. The following example demonstrates this fact.

Consider the clause set $CS = \{\{P(x_A)\}, \{P(x_B)\}, \{\neg P(a)\}, \{\neg P(b)\}, \{a \lessdot A, b \lessdot B\}\}$. If we only take unit declarations into account, we have $\mathbf{L}_\lessdot = \emptyset$ and therefore all sorts are considered to be empty. There is no well sorted resolution step, but CS is unsatisfiable.

We will now develop the necessary notions for the presentation of our unification algorithm. The example shows that we have to consider declarations which occur in non unit clauses, i.e. declarations which are "conditioned". Thus we introduce the notion of a *conditioned declaration* (*conditioned term, conditioned substitution*) which is a pair $(t \lessdot S, C)$ $((t, C), (\sigma, C))$ where C is a set of literals.

3.1 The Unification Algorithm

Definition 1 Conditioned Well Sorted Terms. Let \mathbf{L}_{\leqslant} be a set of conditioned declarations. Then the set of conditioned well sorted terms (we use the abbreviation "cws." for conditioned well sorted) $\mathbf{T^C_{L_{\leqslant},S}}$ of sort S is recursively defined by:

- for every variable $x_S \in \mathbf{V}$, $(x_S, \emptyset) \in \mathbf{T^C_{L_{\leqslant},S}}$
- for every conditioned declaration $(t \leqslant S, C) \in \mathbf{L}_{\leqslant}$, $(t, C) \in \mathbf{T^C_{L_{\leqslant},S}}$
- for every conditioned well sorted term $(t, C) \in \mathbf{T^C_{L_{\leqslant},S}}$ $(S \neq \top)$, substitution $\sigma := \{x_{S_1} \mapsto t_1, \ldots, x_{S_n} \mapsto t_n\}$, with $(t_i, C_i) \in \mathbf{T^C_{L_{\leqslant},S_i}}$, $(\bigcup C_i) \subseteq D$ for some finite set of literals D, $(\sigma(t), \sigma(C) \cup D) \in \mathbf{T^C_{L_{\leqslant},S}}$
- for every term t we have $(t, \emptyset) \in \mathbf{T^C_{L_{\leqslant},\top}}$

We define $\mathbf{T_{L_{\leqslant},S}} := \{(t, \emptyset) \mid (t, \emptyset) \in \mathbf{T^C_{L_{\leqslant},S}}\}$. With $\mathbf{T^C_{L_{\leqslant},gr,S}}$ we denote the set of cws. ground terms of sort S. Obviously $\mathbf{T^C_{L_{\leqslant},gr,S}} = \{(t, C) \mid (t, C) \in \mathbf{T^C_{L_{\leqslant},S}}$ and t is ground $\}$. Thus we always have $\mathbf{T_{L_{\leqslant},gr,\top}} = \mathbf{T^C_{L_{\leqslant},gr,\top}} \neq \emptyset$, $\mathbf{T^C_{L_{\leqslant},gr,S}} \subseteq \mathbf{T^C_{L_{\leqslant},S}}$, and $\mathbf{T_{L_{\leqslant},S}} \subseteq \mathbf{T^C_{L_{\leqslant},S}}$.

Often we are not interested in the condition part of a conditioned object. We say that $t \in \mathbf{T^C_{L_{\leqslant},S}}$, if there is a set of literals C such that $(t, C) \in \mathbf{T^C_{L_{\leqslant},S}}$. Similarly we say that a declaration $(t \leqslant S) \in \mathbf{L}_{\leqslant}$, if there is a set of literals C such that $(t \leqslant S, C) \in \mathbf{L}_{\leqslant}$ and (if not necessary) we do not mention the conditioned part of a conditioned substitution.

A cws. substitution $\sigma^C = (\sigma, C)$ (with respect to a set of declarations \mathbf{L}_{\leqslant}) consists of a substitution σ and a finite set of literals C such that for every $x_{S_i} \in DOM(\sigma)$, $(\sigma(x_{S_i}), C_i) \in \mathbf{T^C_{L_{\leqslant},S_i}}$ and $(\bigcup C_i) \subseteq C$.

For the unification algorithm it is useful to define a binary relation \sqsubseteq^C which denotes the subsort relationship. If S and T are sorts, we define $S \sqsubseteq^C T$ iff there exists a variable x_S with $x_S \in \mathbf{T^C_{L_{\leqslant},T}}$. Using $\mathbf{T_{L_{\leqslant},T}}$ we define the relation \sqsubseteq in the same way.

We use the standard notations [9, 8] for the presentation of our unification algorithm: a *unification problem* Γ is a set of equations $\Gamma = \{t_1 = s_1, \ldots, t_n = s_n\}$. A substitution σ *solves* a unification problem $\Gamma = \{t_1 = s_1, \ldots, t_n = s_n\}$, iff $\sigma(t_1) = \sigma(s_1), \ldots, \sigma(t_n) = \sigma(s_n)$. A unification problem Γ is called *solved*, iff $\Gamma = \{x_{S_1} = t_1, \ldots, x_{S_n} = t_n\}$, each x_{S_i} is a variable, $x_{S_i} \notin V(t_j)$, and $x_{S_i} \neq x_{S_j}$ for every i and j and $t_i \in \mathbf{T^C_{L_{\leqslant},S_i}}$.

Algorithm 2 The Sorted Unification Algorithm. The input of the algorithm is a unification problem Γ which is changed by the following thirteen rules until it is solved or the problem is found to be unsolvable:

(1) Tautology	$$\frac{\{x_S = x_S\} \cup \Gamma}{\Gamma}$$
(2) Decomposition	$$\frac{\{f(t_1, \ldots, t_n) = f(s_1, \ldots, s_n)\} \cup \Gamma}{\{t_1 = s_1, \ldots, t_n = s_n\} \cup \Gamma}$$
(3) Application	$$\frac{\{x_S = t\} \cup \Gamma}{\{x_S = t\} \cup \{x_S \mapsto t\}\Gamma}$$ if x_S is a variable, t a non-variable term and $x_S \notin V(t), x_S \in V(\Gamma)$
(4) Orientation	$$\frac{\{t = x_S\} \cup \Gamma}{\{x_S = t\} \cup \Gamma}$$ if x_S is a variable and t a non-variable term
(5) Clash	$$\frac{\{f(t_1, \ldots, t_n) = g(s_1, \ldots, s_m)\} \cup \Gamma}{\text{STOP.FAIL}}$$ if $f \neq g$
(6) Cycle	$$\frac{\{x_S = t\} \cup \Gamma}{\text{STOP.FAIL}}$$ if $x_S \in V(t)$
(7) Empty Sort	$$\frac{\Gamma}{\text{STOP.FAIL}}$$ if there exists a variable $x_S \in V(\Gamma)$ such that $\mathbf{T^c_{L_\prec, gr, S}} = \emptyset$
(8) Sorted Fail VV	$$\frac{\{x_S = y_T\} \cup \Gamma}{\text{STOP.FAIL}}$$ if $S \neq T$, $T \neq \top$, $y_T \notin \mathbf{T^c_{L_\prec, S}}$ and $x_S \notin \mathbf{T^c_{L_\prec, T}}$ and there is no common subsort of S and T and there are no conditioned declarations $(f(s_1, \ldots, s_n) \prec S') \in \mathbf{L_\prec}$, $S' \sqsubseteq^c S$ and $(f(t_1, \ldots, t_n) \prec T') \in \mathbf{L_\prec}$, $T' \sqsubseteq^c T$
(9) Sorted Fail VT	$$\frac{\{x_S = f(t_1, \ldots, t_n)\} \cup \Gamma}{\text{STOP.FAIL}}$$ if $S \neq \top$, $x_S \notin V(f(t_1, \ldots, t_n))$, $f(t_1, \ldots, t_n) \notin \mathbf{T^c_{L_\prec, S}}$ and there is no declaration $(f(s_1, \ldots, s_n) \prec S') \in \mathbf{L_\prec}$, $S' \sqsubseteq^c S$
(10) Weakening VT	$$\frac{\{x_S = f(t_1, \ldots, t_n)\} \cup \Gamma}{\{x_S = f(t_1, \ldots, t_n)\} \cup \{t_1 = s_1, \ldots, t_n = s_n\} \cup \Gamma}$$ if $S \neq \top$, $x_S \notin V(f(t_1, \ldots, t_n))$, $f(t_1, \ldots, t_n) \notin \mathbf{T_{L_\prec, S}}$ and there is a conditioned declaration $(f(s_1, \ldots, s_n) \prec S') \in \mathbf{L_\prec}$, $S' \sqsubseteq^c S$

(11) Subsort	$\dfrac{\{x_S = y_T\} \cup \Gamma}{\{y_T = x_S\} \cup \Gamma}$ if $x_S \in \mathbf{T}^{\mathbf{C}}_{\mathbf{L}_{\ll},T}$ and $y_T \notin \mathbf{T}_{\mathbf{L}_{\ll},S}$
(12) Common Subsort	$\dfrac{\{x_S = y_T\} \cup \Gamma}{\{x_S = z_V\} \cup \{y_T = z_V\} \cup \Gamma}$ if $S \neq \top$, $T \neq \top$, $x_S \notin \mathbf{T}_{\mathbf{L}_{\ll},T}$ and $y_T \notin \mathbf{T}_{\mathbf{L}_{\ll},S}$ and V is a maximal sort with $V \sqsubseteq^{\mathbf{C}} S$ and $V \sqsubseteq^{\mathbf{C}} T$
(13) Weakening VV	$\dfrac{\{x_S = y_T\} \cup \Gamma}{\{x_S = f(\bar{s}_n)\} \cup \{y_T = f(\bar{t}_n)\} \cup \{\bar{s}_n = \bar{t}_n\} \cup \Gamma}$ if $S \neq \top$, $T \neq \top$, $y_T \notin \mathbf{T}_{\mathbf{L}_{\ll},S}$ and $x_S \notin \mathbf{T}_{\mathbf{L}_{\ll},T}$ and there are conditioned declarations $(f(s_1, \ldots, s_n) \ll S') \in \mathbf{L}_{\ll}$, $S' \sqsubseteq^{\mathbf{C}} S$ and $(f(t_1, \ldots, t_n) \ll T') \in \mathbf{L}_{\ll}$, $T' \sqsubseteq^{\mathbf{C}} T$ and $S' \not\sqsubseteq T'$ and $T' \not\sqsubseteq S'$

Every declaration $t \ll T$ taken from \mathbf{L}_{\ll} must be completely renamed with new variables before it is used in a unification step. The rules (1)-(6) implement the unsorted Robinson unification algorithm.

In order to compute a cws. substitution from a solved unification problem, we have to do the following. Let $\Gamma = \{x_{S_1} = t_1, \ldots, x_{S_n} = t_n\}$ be the solved unification problem, then $\sigma := \{x_{S_1} \mapsto t_1, \ldots, x_{S_n} \mapsto t_n\}$ is the corresponding unconditioned unifier. $\sigma^{\mathbf{C}} := (\sigma, C_1 \cup \ldots \cup C_n)$ is a most general cws. unifier, if we have $(t_i, C_i) \in \mathbf{T}^{\mathbf{C}}_{\mathbf{L}_{\ll},S_i}$. Therefore a solved unification problem may lead to several (but only finitely many if \mathbf{L}_{\ll} is finite) cws. mgu's.

The presented algorithm is a complete and correct unification algorithm. Complete means that for every cws. ground substitution $\tau^{\mathbf{C}} = (\tau, C)$ solving a unification problem Γ (where $DOM(\tau)$ is restricted to $V(\Gamma)$) the unification algorithm computes a cws. substitution $\sigma^{\mathbf{C}}$ such that there exists a cws. ground substitution $\lambda^{\mathbf{C}}$ with $\lambda^{\mathbf{C}}(\sigma^{\mathbf{C}}) = \tau^{\mathbf{C}}$. As the presented unification algorithm is an extension of the unification algorithm of Schmidt-Schauß [8] it may produce infinitely many unifiers and the problem whether two terms can be unified is undecidable. Questions of the form $t \in \mathbf{T}^{\mathbf{C}}_{\mathbf{L}_{\ll},S}$, $\mathbf{T}^{\mathbf{C}}_{\mathbf{L}_{\ll},gr,S} = \emptyset$ are decidable in quasi-linear time [12].

3.2 The Inference Rules

In order to apply the inference rules, we need a function *Empty* which computes from a set of sorts a set of sets of literals (conditions), such that each set of literals guarantees the sorts to be non empty. We assume that *Empty* computes a minimal, finite set of conditions with respect to set inclusion. This can be done by constructing appropriate ground terms according Definition 1.

Definition 3 Factorization Rule. Let $C = \{L_1, \ldots, L_n\}$ be a clause, $\{L_i, L_j\} \subseteq C$ $(i \neq j)$, and $\sigma^{\mathbf{C}} = (\sigma, D)$ a cws. mgu of $\{L_i, L_j\}$, i.e. $\sigma(L_i) = \sigma(L_j)$, then

$$\sigma(C) \cup D$$

is called a *factor* of C.

Definition 4 Resolution Rule. Let C_1 and C_2 be two clauses with no variables in common, $L \in C_1$ and $K \in C_2$. We define $C_1' := C_1 \setminus \{L\}$ and $C_2' := C_2 \setminus \{K\}$. If there exists a cws. mgu $\sigma^{\mathbf{C}} = (\sigma, D)$ of L and K such that $\sigma(L)$ and $\sigma(K)$ become two complementary literals, $E \in Empty(Sorts(C) \setminus Sorts(\sigma(C_1' \cup C_2')))$, then

$$\sigma(C_1' \cup C_2') \cup D \cup E$$

is a *resolvent* of C_1 and C_2.

The correctness of the rules follows immediately from their form and the correctness of the unification algorithm [12].

Now the remaining question is which declarations we have to take into account for the unification algorithm in order to preserve completeness. The general idea is to reduce the number of declarations, because this restricts the applicability of inference rules, whence the search space. The previous example shows that we have to consider at least one of the literals $\{a \leqslant A, \, b \leqslant B\}$. In general we must choose one declaration from each clause containing declarations only. We call such clauses *declaration clauses*. Choosing the declarations has to be done dynamically during the derivation process, i.e. if we have derived a new declaration clause, we have to extend the well sorted terms using one of these declarations.

Theorem 5 Completeness Theorem. Let CS be a clause set. We choose $\mathbf{L}_\leqslant := \{(t_i \leqslant S_i, C_i')\}$ such that for each declaration clause $C_i \in CS$ we choose exactly one declaration $t_i \leqslant S_i$ with $C_i = \{t_i \leqslant S_i\} \cup C_i'$.

If CS is unsatisfiable, there exists a derivation of the empty clause using resolution and factorization. The set \mathbf{L}_\leqslant must be updated every time a new declaration clause is derived.

Again we consider the clause set of the previous example. $CS = \{\{P(x_A)\}, \{P(x_B)\}, \{\neg P(a)\}, \{\neg P(b)\}, \{a \leqslant A, b \leqslant B\}\}$. If we choose $\mathbf{L}_\leqslant := \{(a \leqslant A, \{b \leqslant B\})\}$ then there is only one possible resolution step between $\{P(x_A)\}$ and $\{\neg P(a)\}$ with cws. mgu $(\{x_A \mapsto a\}, \{b \leqslant B\})$ and $Empty(\{A\}) = \{\{b \leqslant B\}\}$ resulting in $\{b \leqslant B\}$. This clause subsumes the clause $\{a \leqslant A, b \leqslant B\}$ and we obtain the new clause set $\{\{P(x_A)\}, \{P(x_B)\}, \{\neg P(a)\}, \{\neg P(b)\}, \{b \leqslant B\}\}$. We have to change \mathbf{L}_\leqslant into $\mathbf{L}_\leqslant := \{(b \leqslant B, \emptyset)\}$. Again only one resolution step between $\{P(x_B)\}$ and $\{\neg P(b)\}$ with cws. mgu $(\{x_B \mapsto b\}, \emptyset)$ and $Empty(\{B\}) = \{\emptyset\}$ is possible which yields the empty clause.

3.3 Solving the Example

We solve the problem using a set of support strategy. The problem is not a hard problem, e.g. OTTER [5] can solve the problem in less than one second. But we will show that in the sorted formalization the problem can be solved without any search. Here is the compiled clause set

(1) $\{i(x_P, y_T)) \notin P, y_T \lessdot P\}$
(2) $\{i(i(x_T, y_T), i(i(y_T, z_T), i(x_T, z_T))) \lessdot P\}$
(3) $\{i(i(n(x_T), x_T), x_T) \lessdot P\}$
(4) $\{i(x_T, i(n(x_T), y_T)) \lessdot P\}$
(5) $\{i(a, a) \notin P\}$

The initial set of support consists of the clause $\{i(a, a) \notin P\}$ only. Following Theorem 5 we choose the set of declarations $\mathbf{L}_{\lessdot} = \{(2)1, (3)1, (4)1\}$ (We use the format $(clause)literal$ to refer to literals in clauses). As no conditioned declarations need to be considered, we have $\mathbf{T}_{\mathbf{L}_{\lessdot}, P} = \mathbf{T}^{\mathbf{C}}_{\mathbf{L}_{\lessdot}, P}$ and thus the additional notations needed to represent conditioned objects are skipped. The only applicable inference step is resolution with (1)2, because unification with one of the literals (2)1, (3)1 or (4)1 results in a function symbol clash. The corresponding unification problem is

$$\Gamma_0 = \{y_T = i(a, a)\}$$

which is still in solved form, as $i(a, a) \in \mathbf{T}_{\mathbf{L}_{\lessdot}, T}$. Thus we add the new clause

(6) $\{i(x_P, i(a, a)) \notin P\}$

to the set of support. The new clause cannot be resolved with clauses (2) and (4) because of a function symbol clash and unification with the literal (3)1 results in the unification problem

$$\Gamma_1 = \{x_P = i(n(x_T), x_T), x_T = i(a, a)\}$$

which cannot be well sorted solved, because $i(n(i(a, a)), i(a, a)) \notin \mathbf{T}_{\mathbf{L}_{\lessdot}, P}$ and the term $i(n(i(a, a)), i(a, a))$ cannot be further weakened. Thus again the only possible step is resolution with clause (1) giving

(7) $\{i(x_P, i(x'_P, i(a, a))) \notin P\}$

Trying to build a resolvent between (7) and (3) or (4) again leads to unification problems which cannot be well sorted solved. Resolution with clause (2) results in the unification problem

$$\Gamma_2 = \{x_P = i(x_T, y_T), x'_P = i(y_T, z_T), x_T = a, z_T = a\}$$

Applying the rule Application of the unification algorithm using the equations $x_T = a$ and $z_T = a$ twice, we obtain

$$\Gamma_3 = \{x_P = i(a, y_T), x'_P = i(y_T, a), x_T = a, z_T = a\}$$

We don't have $i(a, y_T) \in \mathbf{T}_{\mathbf{L}_{\lessdot}, P}$ or $i(y_T, a) \in \mathbf{T}_{\mathbf{L}_{\lessdot}, P}$. Application of Weakening VT to the equation $x_P = i(a, y_T)$ using the declaration $i(x_T, i(n(x_T), y_T)) \lessdot P$ gives

$$\Gamma_4 = \{x_P = i(a, y_T), x'_P = i(y_T, a), x_T = a, z_T = a, \\ y_T = i(n(x'_T), y'_T), x'_T = a\}$$

Following the rule Application we use the new equations $y_T = i(n(x'_T), y'_T)$ and $x'_T = a$ as substitutions and result in

$$\Gamma_5 = \{x_P = i(a, i(n(a), y'_T)), x'_P = i(i(n(a), y'_T), a),$$
$$x_T = a, z_T = a, y_T = i(n(a), y'_T), x'_T = a\}$$

The first equation is now well sorted solved, i.e. $i(a, i(n(a), y'_T)) \in \mathbf{T_{L_{\leqslant}},P}$. But for the second equation we still have $i(i(n(a), y'_T), a) \notin \mathbf{T_{L_{\leqslant}},P}$. Applying Weakening VT using the declaration $i(i(n(x_T), x_T), x_T) \leqslant P$ solves this last problem.

$$\Gamma_6 = \{x_P = i(a, i(n(a), y'_T)), x'_P = i(i(n(a), y'_T), a),$$
$$x_T = a, z_T = a, y_T = i(n(a), y'_T), x'_T = a,$$
$$i(i(n(a), y'_T), a) = i(i(n(x''_T), x''_T), x''_T)\}$$

After application of the rules Decomposition, Orientation, and Application to the equation $i(i(n(a), y'_T), a) = i(i(n(x''_T), x''_T), x''_T)$ and it's descendants we finish in the solved problem

$$\Gamma_7 = \{x_P = i(a, i(n(a), a)), x'_P = i(i(n(a), a), a),$$
$$x_T = a, z_T = a, y_T = i(n(a), a), x'_T = a,$$
$$y'_T = a, x''_T = a)\}$$

and derive

(8) \square

Note that the solution of the unification problem Γ_2 is unique and computationally simple. Comparing our solution to the proof found by OTTER (Version 2.0, binary resolution), we needed only 3 steps to refute the clause set, while OTTER made 5 steps. The missing 2 steps occur in the solution of the unification problem Γ_2. The most important difference is that the sorted proof was found without any search (neither during unification nor during the application of the inference rules), i.e. we have not generated useless resolvents. OTTER produced 60 clauses to find the empty clause.

4 Discussion

We have presented a sound and complete calculus $\mathcal{CL_S}$ for a new sorted first-order logic $\mathcal{L_S}$. The resolution calculus established by Theorem 5 is the most general, most restrictive (with regard to the number of applicable inference steps), completely given calculus we know for sorted logics. Note that the indeterminism of Theorem 5, i.e. which declarations to choose for $\mathbf{L_{\leqslant}}$ is not really an indeterminism. It corresponds to a case analysis. Thus if a declaration clause is needed in a proof, all declarations will be dynamically chosen during the deduction process. Nevertheless there are a lot questions left open, e.g. how to extend this calculus by equality reasoning.

Compared to the frameworks of Stickel [10] and Bürckert [2] the presented calculus is not an instance of them. Both frameworks require the a priori, static separation of a background theory, in our case the sort theory. Completeness of the calculus $\mathcal{CL_S}$ relies on the dynamic change of the sort theory during the deduction process.

References

1. C. Beierle, U. Hedstück, U. Pletat, and J. Siekmann. An order-sorted logic for knowledge representation systems. *Artificial Intelligence*, 55:149–191, 1992.
2. H.J. Bürckert. *Constraint resolution*. Lecture Notes in Artificial Intelligence. Springer Verlag, 1991.
3. A.G. Cohn. A more expressive formulation of many sorted logic. *Journal of Automated Reasoning*, 3(2):113–200, 1987.
4. A.M. Frisch. A general framework for sorted deduction: Fundamental results on hybrid reasoning. In *Proceedings of the First International Conference on Principles of Knowledge Representation and Reasoning*, pages 126–136, May 1989.
5. W. McCune. Otter 2.0. In *10th International Conference on Automated Deduction*, pages 663–664. Springer Verlag, 1990.
6. W. McCune and L. Wos. Experiments in automated deduction with condensed detachment. In *11th International Conference on Automated Deduction*, pages 209–223. Springer Verlag, 1992.
7. D. Meredith. In memoriam carew arthur meredith (1904-1976). *Notre Dame Journal of Formal Logic*, 18(513-516), 1977.
8. M. Schmidt-Schauß. *Computational aspects of an order sorted logic with term declarations*. Lecture Notes in Artificial Intelligence. Springer Verlag, 1989.
9. J. Siekmann. Unification theory. *Journal of Symbolic Computation, Special Issue on Unification*, 7:207–274, 1989.
10. M. Stickel. Theory resolution. *Journal of Automated Reasoning*, 1(4):333–355, 1985.
11. C. Walther. *A Many-sorted Calculus based on Resolution and Paramodulation*. Research Notes in Artificial Intelligence. Pitman Ltd., 1987.
12. C. Weidenbach. A sorted logic using dynamic sorts. MPI-Report MPI-I-91-218, Max-Planck-Institut für Informatik, Saarbrücken, December 1991.
13. C. Weidenbach and H.J. Ohlbach. A resolution calculus with dynamic sort structures and partial functions. In *Proceedings of the 9th European Conference on Artificial Intelligence*, pages 688–693. Pitman Publishing, London, August 1990.

An Explanatory Framework for Human Theorem Proving

Xiaorong Huang [*]

Fachbereich Informatik, Universität des Saarlandes
Im Stadtwald, D-6600 Saarbrücken 11, Germany
huang@cs.uni-sb.de

Abstract. Along the line of the science of reasoning proposed by Alan Bundy [8], we present in this paper a computational theory accounting for human formal deductive competence. Our goal is primarily twofold. For one thing, it is aimed to establish an explanatory framework for human theorem proving. Devised as a computational theory, for another thing, it should also set up a theoretical foundation for deductive systems which simulate the way in which human beings carry out reasoning tasks. As such, the hope is to arrive at systems which learn and plan, which share their experiences with human users in high level communications. The last requirement, we believe, makes such systems ultimately useful. As a computational model, we cast the cognitive activities involved in theorem proving as an interleaving process of metalevel planning and object level verification. Within such a framework, emphasis is put on three kinds of tactics concerning three kinds of declarative knowledge structures. We also account for the acquisition of new tactics and methods, as well as the modifications of existing tactics and methods to suit novel problems. While the fundamental framework is sketched out formally, the mechanisms manipulating tactics and methods are only intended to be suggestive, achieved with the help of examples.

Introduction

this paper, we propose a new computational theory accounting for human mal deductive competence, as opposed to theories accounting for human daily soning. As such, it is a response to Alan Bundy's call for a science of reasoning . As our second goal, it should also provide a basis for computational systems ich reveal many desirable qualities currently lacking in most of the automated soning systems. These include, for instance, being able to explain a proof in more human oriented manner; being able to benefit from its successful or successful experiences, and thus displaying an evolving reasoning ability; and on.

Statically, we cast a reasoning being as a knowledge based system. His reasing competence is exclusively ascribed to the declarative knowledge of various

This work was supported by the Deutsche Forschungsgemeinschaft, SFB 314 (D2, D3)

sorts, and a set of special purpose reasoning procedures. In this first draft of our theory, declarative knowledge includes *rules of inference, assertions*, and a collection of *proof schemata*, as well as diverse *metalevel knowledge*. Since it is the combinations of chunks of declarative knowledge and reasoning procedures that are planned as unit to solve various reasoning tasks, we define these combinations as *tactics*. The total amount of tactics constitutes the *basic reasoning repertoire* at the disposal of a reasoner. The specifications of tactics, which serve as an assessment help in the planning process for a proof, are referred to as *methods*.

Dynamically, we assume the entire process from the analysis of a problem to the completion of a proof, to be an *interleaving process* of metalevel planning and object level verification. In addition, this process is centered around a representational structure called a *proof tree*, which records the current state of the development.

After setting up a general framework for our computational theory in section 2, emphasis is laid on three kinds of object-level tactics and methods in section 3, which are best understood and the concepts of metalevel tactics and methods. While the former concepts are treated formally, discussions on metalevel tactics and methods are intended to be more suggestive rather than formal. We turn to a brief description of the dynamic behavior of the interleaving process as a whole in section 4. Finally, an outlook of the future development and a discussion on possible applications in section 5 concludes this paper.

2 A Static Description

In this section, we first categorize the mental objects accommodated in our computational model, together with the corresponding procedures operating on them. They are briefly listed below.

2.1 A Proof Tree

As a theory conceiving theorem proving as an interleaving process of planning and verification, we use a structure of mental representation called a proof tree, to uniformly accommodate notions like proof sketches, proof plans and finally, proofs themselves. Formally, a proof tree is a tree where every node has four slots, usually represented as:

$$< Label, \Delta \vdash Derived - Formula, Tactic >$$

This means that the derived formula is (can or might be, respectively) derived using the tactic indicated, from the children of a node. Δ stands for the set of hypothesis the derived formula depends on. All of the last three slots of a node may have the value "*unknown*", indicating a proof sketch node. The tactic slot, in addition, may have the value *<the name of a tactic, plan>*, indicating a planned node; or just the name of a tactic, indicating a verified node.

2.2 Declarative Knowledge

The following is a listing of the different kinds of declarative knowledge accommodated in our model:

- rules of inference, including a kernel of rules innate to human being, usually referred to as the *natural logic* (NL);
- mathematical formulas collectively called *assertions*, including axioms, definitions, and theorems, interrelated in a certain conceptual structure [18];
- proof schemata, mainly evolving from proofs previously found;
- metalevel declarative knowledge, specifying possible manipulations on objectlevel knowledge, in particular proof schemata.

Clearly, our theory is a logic based one, built on top of the central hypothesis of the existence of a natural logic. Although there are psychological investigations which argue against this as a general hypothesis [16, 17], we believe it appropriate to assume at least, that the major mode of mathematical reasoning is a logical one.

2.3 Procedures

Procedures of diverse varieties are incorporated in our computational model:

- procedures serving as constituents of tactics and thus called by the planning procedures:
 - a small set of elementary procedures carrying out various standard *object level* reasoning tasks, via interpreting declarative knowledge;
 - an open-end set of special purpose object level reasoning procedures. The knowledge needed is interwoven in their algorithms;

 Procedures of this type usually run on a syntactic basis; neither planning nor heuristic searching is involved. These procedures are usually called as *"basic tools"* by procedures constructing proofs by planning;
- procedures not involved in the planning process per se, but partially responsible for the increase of the reasoning repertoire, examples are procedures accounting for the remembrance of proofs or rules of inference. They behave similar to perceptive procedures in a theory of general cognition [20];
- autonomous procedures responsible for more complex tasks, such as proof construction or proof checking as a whole. Usually, they are animated by relevant intentions, and handle by planning, heuristic searching as well as trial-and-error to fulfill the intentions. We have to admit that not much is known yet about these procedures, and further investigation is needed;
- other book-keeping procedures, widely ignored in this study (see [22, 20]).

3 Tactics and Methods

3.1 General Concepts and Classifications

The task of tactics is the construction of proof trees. In [8], a tactic can be conceived as a well defined computational procedure. Since the concept of declarative knowledge plays an important role in our theory, we define tactics to be pairs represented as:

<a reasoning procedure, a collection of declarative knowledge>

In some cases, such as the special purpose tactics of Bundy [7], the collection of knowledge may be empty. In contrast, the three general levels of tactics to be introduced below are supported by elementary procedures interpreting standard knowledge structure. In the rest of this subsection, we discuss some general features along which tactics and methods may vary:

- A tactic is *cognitively primitive*, if it does not call other tactics and if its application leads to the insertion of an atomic node in the proof tree. We further assume, that a verified proof is a tree consisting only cognitively primitive tactics. Otherwise, a tactic is *cognitively compound*;
- given a goal to be proved and a collection of preconditions, *a partial* tactic only suggests a proof tree with sketch nodes.

Tactics are usually associated with one or more methods, serving as the specifications of the reasoning ability of a particular tactic [8]. In general, a method has the following slots: a *preconditions* slot specifying the the leaves of the proof trees the tactic is intended to construct; and a *postconditions* slot specifying the root of the proof trees.

Again, we distinguish between complete and partial methods: while the execution of the corresponding tactic of a *complete method* will certainly bring about the postconditions, if the preconditions are satisfied; this is only likely yet not guaranteed, when working with *partial methods*.

3.2 Three Levels of General Purpose Tactics and Methods at the Object Level

Within the framework set up so far, we are going to introduce three reasoning procedures, which are actually knowledge interpreters. Coupled with chunks of declarative knowledge of the corresponding type, they form tactics at different levels of reasoning power. In addition, we suggest some plausible accompanying methods consulted by the planning procedures, while trying to put tactics together into a proof.

A Primitive Procedure Applying Rules of Inference First and foremost, we are going to introduce a procedure which *applies* rules of inference. To simplify the situation for the current study, we advance a second minor hypothesis which assumes the order sorted predicate logic of higher-order as the working language. As the natural logic, we have adopted the *natural deduction* system first proposed by Gerhard Gentzen [12, 1]. The following are several most important rules:

$$\frac{}{\Delta, F \vdash F}\text{HYP}, \quad \frac{\Delta \vdash \exists_{x:S1} Fx, \ \Delta, F_{a:S2} \vdash H, \ Subsort(S2, S1)}{\Delta \vdash H}\text{CHOICE}$$

$$\frac{\Delta, F \vdash G}{\Delta, F \Rightarrow G}\text{DED}, \quad \frac{\Delta \vdash F \vee G, \ \Delta, F \vdash H, \ \Delta, G \vdash H}{\Delta \vdash H}\text{CASE}$$

Reasoning by applying rules in NL, and rules associated with them in a certain pattern [14], are referred to as reasoning at the *logic level*. While the cognitive status of the rules of inference included in the natural logic are said to be *elementary* and *innate*, a human reasoner may learn new, domain-specific rules. For example, a rule about subset might be learned: $\frac{a \in S_1, S_1 \subset S_2}{a \in S_2}$ where "a", "S_1" and "S_2" are metavariables of sort "*Element*" and "*Set*", respectively. These ~~~~ ~~~~ ~~ ~~~~ ~~ ~~ ~~~~~~~ ~~~ ~~~~~~~~ ~~~ ~~~ ~~~~~~~~ ~~~~~~~~~ see [14].

Now for every rule of inference, we have a tactic which applies it, defined by the usual matching process.

Applications of Assertions The second kind of important declarative knowledge concerns objects such as axioms, definitions, lemmata and theorems, and even intermediate results achieved during proof searching. They are, in our theory, collectively called *assertions*. Moreover, assertions are interrelated in complex conceptual structures [18]. The notion of the application of an assertion, though never defined precisely, bears a central role in various reasoning activities. One prima facie evidence is that proofs found by mathematicians are almost exclusively documented in terms of the applications of some assertions, i.e. at the *assertion level*, which is one level above the logic level, yet still *cognitively elementary*.

Although no introspection is possible to reveal the internal structure of the procedure applying assertions, in [14], we pinned down this notion after making a crucial observation, that every application of an assertion can be expanded to a logic level proof segment, referred to as its *natural expansion* (NE). By studying the natural expansions, we came up with a precise *characterization* of the input-output relation for the primitive procedure applying assertions. Formally, the reasoning ability of a tactic applying a certain assertion equals to that of the applications of a set of *finite* compound rules of inference, this makes this concept practically useful [14]. In this paper, it suffices to understand this notion intuitively. For example, given an assertion defining subset:

$$\forall_{S_1, S_2 : Set} S_1 \subseteq S_2 \Leftrightarrow \forall_{x : Element} x \in S_1 \Rightarrow x \in S_2$$

We may derive $a \in S_2'$ from $a \in S_1'$ and $S_1' \subseteq S_2'$;

A Primitive Procedure Applying Rules of Inference First and foremost, we are going to introduce a procedure which *applies* rules of inference. To simplify the situation for the current study, we advance a second minor hypothesis which assumes the order sorted predicate logic of higher-order as the working language. As the natural logic, we have adopted the *natural deduction* system first proposed by Gerhard Gentzen [12, 1]. The following are several most important rules:

$$\frac{}{\Delta, F \vdash F}\text{HYP}, \quad \frac{\Delta \vdash \exists_{x:S1} Fx, \quad \Delta, F_{a:S2} \vdash H, \quad Subsort(S2, S1)}{\Delta \vdash H}\text{CHOICE}$$

$$\frac{\Delta, F \vdash G}{\Delta, F \Rightarrow G}\text{DED}, \quad \frac{\Delta \vdash F \vee G, \quad \Delta, F \vdash H, \quad \Delta, G \vdash H}{\Delta \vdash H}\text{CASE}$$

Reasoning by applying rules in NL, and rules associated with them in a certain pattern [14], are referred to as reasoning at the *logic level*. While the cognitive status of the rules of inference included in the natural logic are said to be *elementary* and *innate*, a human reasoner may learn new, domain-specific rules. For example, a rule about subset might be learned: $\frac{a \in S_1, S_1 \subseteq S_2}{a \in S_2}$ where "a", "S_1" and "S_2" are metavariables of sort "*Element*" and "*Set*", respectively. These new rules are said to be *acquired* and *compound*. For the learning mechanism, see [14].

Now for every rule of inference, we have a tactic which applies it, defined by the usual matching process.

Applications of Assertions The second kind of important declarative knowledge concerns objects such as axioms, definitions, lemmata and theorems, and even intermediate results achieved during proof searching. They are, in our theory, collectively called *assertions*. Moreover, assertions are interrelated in complex conceptual structures [18]. The notion of the application of an assertion, though never defined precisely, bears a central role in various reasoning activities. One prima facie evidence is that proofs found by mathematicians are almost exclusively documented in terms of the applications of some assertions, i.e. at the *assertion level*, which is one level above the logic level, yet still *cognitively elementary*.

Although no introspection is possible to reveal the internal structure of the procedure applying assertions, in [14], we pinned down this notion after making a crucial observation, that every application of an assertion can be expanded to a logic level proof segment, referred to as its *natural expansion* (NE). By studying the natural expansions, we came up with a precise *characterization* of the input-output relation for the primitive procedure applying assertions. Formally, the reasoning ability of a tactic applying a certain assertion equals to that of the applications of a set of *finite* compound rules of inference, this makes this concept practically useful [14]. In this paper, it suffices to understand this notion intuitively. For example, given an assertion defining subset:

$$\forall_{S_1, S_2:Set} S_1 \subseteq S_2 \Leftrightarrow \forall_{x:Element} x \in S_1 \Rightarrow x \in S_2$$

We may derive $a \in S_2'$ from $a \in S_1'$ and $S_1' \subseteq S_2'$;

$S_1' \not\subseteq S_2'$ from $a \in S_1'$ and $a \notin S_2'$;

$\forall_{x:Element} x \in S_1' \Rightarrow x \in S_2'$ from $S_1' \subseteq S_2'$

and so on; by *applying* this definition.

Although the reasoning power of the application of an assertion can be precisely defined [14], it is however not plausible to suggest that the planning decisions are made based on this time consuming information. The kind of *partial methods* we believe as one viable approximation can be defined in the following pattern (check the example above):

Method: *Application of Assertion A*

- **Preconditions:** the premises are all either a subformula of A, a specialization[2] thereof, or, thirdly, a negation of the first two cases,
- **Postconditions:** the result is either a subformula of A, a specialization thereof, or, thirdly, a negation of the first two cases.

A Procedure Instantiating Proof Schemata The third level of tactics is tied to a more novel kind of knowledge structure called *proof schemata*, and a procedure *instantiating* them. Initially, they might contain a complete or partial proof found for a previous problem without metavariables. A (partial) specification of the corresponding problem can serve as the associated method. Since proof schemata are assumed to be represented mentally as proof trees using exclusively cognitively elementary tactics, their applications are usually *compound* tactics. The following is an example.

Example 1

After learning a proof showing that the power set $P(M)$ of a set M has a greater cardinality than the set itself, by proving that there is no surjective function $f : M \mapsto P(M)$, the following tactic-method pair might be added to the reasoning repertoire.

Method:Diagonalization-Power-Set-1

- **Precondition:** none
- **Post Condition:** $\neg \exists_{f:M \mapsto P(M)} Surj(f)$
- **Tactic:** Applying Schema-Diagonalization-Power-Set-1(see below)

1. $\Delta \vdash Theo; IP$
 1.1. $\Delta' = \Delta + \neg(Theo) \vdash \perp;?$
 1.1.1. $\Delta' \vdash \forall_{x \in P(M)} \exists_{y \in M} f(y) = x; def.Surj$
 1.1.2. $\Delta' \vdash \exists_{S \in P(M)} \forall_{y \in M} f(y) \neq S; Choice$
 1.1.2.1. $\Delta' \vdash \exists_{S \in P(M)} \forall_{x \in M} x \in S \Leftrightarrow x \notin f(x), Comprehension Axiom$
 1.1.2.2. $\Delta' + \forall_{x \in M} x \in S \Leftrightarrow x \in M \wedge x \notin f(x),$
 $(abr.S = \{x \in M / x \notin f(x)\}$
 $\vdash \exists_{S \in P(M)} \forall_{y \in M} f(y) \neq S;?$

[2] P_a is defined as the specialization of both $\forall_x P_x$ and $\exists_x P_x$

Notice that the numbering of label serves only to represent the tree structure. For example, node 1.1.2 has two children 1.1.2.1 and 1.1.2.2, and node 1.1.2 is also derived from its children, by applying the choice rule, as indicated in the tactic slot. The tactic slot of each node has the following possible values: the name of a rule in the natural logic, like *IP*, standing for indirect proof; the name of an assertion of various sorts, like *def.surj* or *Comprehension Axiom*, standing for the application of the definition of surjectivity and the comprehension axiom, respectively; or "?", standing for "unknown".

3.3 Metalevel Tactics and Methods

Our theory is also devised to account for the phenomena that reasoners benefit from their successful or unsuccessful experiences. In addition to those more perceptual procedures [15], this is achieved mainly through the metalevel tactics. When a reasoner is confronted with a novel problem, proof schemata evolving from previous proofs are modified to cope with the new problem. Now, we illustrate two types of metalevel tactics informally. Guided by declarative knowledge of different kinds, they are carried out by two procedures which *generalizes* or *reformulates* existing proof schemata, respectively.

Assuming the acquisition of the tactic-method pair in Example 1, we illustrate how it can be of use in handling a new problem. For space restriction, only the operations will be given, while the intermediate tactics omitted.

Problem 2

The interval $[0, 1]$ is not countable, that is, there is no surjective function: $f : N \longmapsto [0, 1]$.

We now show, how a proof sketch can be arrived at by successive manipulations on the tactic gained above. The first step is a *reformulation*. More exactly, the notion of a set is axiomatized now in terms of its characteristic predicate, instead of as an object. This reformulation is enabled by a truth-preserving mapping, a metalevel declarative knowledge structure coming into play at this point. Concretely in our example, the following truth-preserving mapping is used:

$$x \in S \longmapsto S(x), \qquad Subsort(Set, Object) \longmapsto Subsort(Set, Predicate)$$

where "x" and "S" are metavariables of sort *Element* and *Set*. Thus, the definition of subset used in our example

$$Subsort(Set, Object), \qquad \forall_{S1,S2:Set} S1 \subseteq S2 \Leftrightarrow \forall_{x:Element} x \in S1 \Rightarrow x \in S2$$

is replaced by

$$Subsort(Set, Predicate), \qquad \forall_{S1,S2:set} S1 \subseteq S2 \Leftrightarrow \forall_{x:Element} S1(x) \Rightarrow S2(x)$$

The second reformulation is based on the knowledge that predicates are special functions:

$$Subsort(Predicate, Function), \qquad \forall_{P:Predicate} \forall_{x:Any} P(x) \in \{t, f\}$$

This guarantees the truth-preserving property of the mapping below:

$$P(x) \longmapsto P(x) = t, \qquad \neg P(x) \longmapsto P(x) = f$$

where "P" is a metavariable of sort *Predicate*, and "x" has the sort of the argument sort of P. Formulas resulting from this mapping usually undergo some further simplifications, such as replacing $(P = t) \Leftrightarrow (Q = t)$ by $P = Q$, and $(P = t) \Leftrightarrow (Q = f)$ by $P = neg(Q)$ where the function *neg* is defined as

$$neg : \{t, f\} \longmapsto \{t, f\}, \qquad neg(x) = \begin{cases} t & : & x = f \\ f & : & x = t \end{cases}$$

After applying this mapping on the predicate \in, a manipulation called *generalization* is possible, which is of more heuristic nature and no more truth-preserving. In our case, term $P(M)$ may be generalized to a metavariable N of sort *Set* satisfying:

$$\forall_{x \in M, y \in N} y(x) \in \{t, f\} \tag{1}$$

which in fact defines $P(M)$. Notice that this restriction is added to the set of preconditions. As will be illustrated in the next step, a *generalization* usually adds a precondition which is a property weaker than the definition.

There is apparently still a gap between the precondition of the problem, $\forall_{x \in [0,1]} \forall_{n \in N} x(n) \in \{0, 1, 2, \cdots, 9\}$ and the precondition in (1). This can be bridged by a generalization of the two constants $\{0,1\}$ and $\{0, 1, 2, \cdots, 9\}$ into a metavariable U of sort *Set*.

A new tactic-method pair is achieved based on the mapping: $\{0, 1\} \longmapsto U$

Method: *Diagonalization* $- N \longmapsto [0, 1]$

- **Precondition:** $\exists_{U : |U| \geq 2} \forall_{y \in N} \Leftrightarrow \forall_{x \in M} y(x) \in U$
- **Post Condition:** $\neg \exists_{f : M \mapsto N} Surj(f)$
- **Tactic:** Applying Schema-Diagonalization-$N \longmapsto [0, 1]$(see below)

1. $\Delta \vdash Theo; IP$
 1.1. $\Delta' = \Delta + \neg Theo \vdash \bot; ?$
 1.1.1. $\Delta' \vdash \forall_{x \in N} \exists_{y \in M} f(y) = x; def.Surj$
 1.1.2. $\Delta' \vdash \exists_{S \in N} \forall_{y \in M} f(y) \neq S; 2 * Choices$
 1.1.2.1. $\Delta' \vdash \exists_{g \in U \longmapsto U} \forall_{x \in U} g(x) \neq x, ?$
 1.1.2.2. $\Delta'' = \Delta' + g \in U \longmapsto U \wedge \forall_{x \in U} g(x) \neq x \vdash \exists_S \forall_{x \in M} S(x) = g(f(x)(x)), Comp.Axiom$
 1.1.2.3. $\Delta'' + \forall_{x \in M} S(x) = g(f(x)(x)) \vdash \exists_{S \in N} \forall_{y \in M} f(y) \neq S$;

Instantiation for $N \longmapsto [0, 1]$ example: $M \longmapsto N, N \longmapsto [0, 1], U \longmapsto \{0, 1, \cdots, 9\}$. The precondition is satisfied, since $\forall_{x \in N} \forall_{y \in [0,1]} x(y) \in \{0, 1, \cdots, 9\}$

While the introduction of U may be easily ascribed to the existence of heuristic knowledge of some sort, the creation of the new function g is a step demanding real human creativity. We probably have to appeal to analogical reasoning.

A property of the original sets is added as a precondition: $|U| \geq 2$. We want to mention again, that we still do not know much about metalevel tactics and methods, still less how they are employed by the planner. Much investigation is needed.

4 A Dynamic Description of Theorem Proving

Since our emphasis is laid more on the static part of the theory, and since we still do not know much about the dynamic behavior, this discussion is tentative and aimed to be suggestive. For a more detailed discussion, see [15].The basic assumption is, that there is an autonomous procedure responsible for the planning process. The task of this procedure is to analyze the problem, and on the ground of the information contained in methods, to recursively break down the problem into subproblems, and call tactics sequentially to solve the subproblems. Since most methods are partial, some of the thus planned proof steps have to be verified subsequently. The current state of such a dynamic development is always reflected in an internal structure which is a proof tree. The planning mode and the verification mode may converge, when the methods employed are complete. Whenever an existing plan fails, a replanning phase usually begins.

There are also metalevel activities. In our theory, a procedure or tactic is at the metalevel if it causes changes in the knowledge base, rather than the proof tree. Metalevel tactics are usually invoked by the intention to solve a specific problem, and their application require concentration and effort, as opposed to those more perceptual procedures, like the remembrance of a proof or of a rule [15].

We can account for the acquisition of all the three kinds of declarative knowledge: in the first case it is fairly simple. If a particular subproof is carried out repeatedly, its input-output specification may be put together into a new *acquired* rule of inference and remembered. The total amount of inference rules at the disposal of a reasoner is referred to as his *natural calculus*, which contains the natural logic as a subset. Second, new axioms and definitions are constantly incorporated into the conceptual structure of a reasoner, as well as proved theorems [18]. Third, the initial proof schemata are simply proofs of some problems *learned* by the reasoner, by reading mathematical text books, for instance, or by being taught. The problem specifications can be taken over as the initial methods. Afterwards, new tactics and methods are accumulated, built by metalevel tactics in the attempts to deal with novel problems.

5 Conclusion

In this section, we examine our theory from the perspective of the two roles it is supposed to play, and sketch an outlook of further development.

As an explanatory framework, as far as we know, it is the first attempt to set up a full-fledged computational model for human formal reasoning, as opposed

to daily casual reasoning studied by psychologists [6, 16, 19, 22]. For an overview, see [17]. As such, however, we must point out that much empirical studies still have to be made to substantiate the framework in general, on the one hand, and to settle the remaining unsolved problems, on the other. Among the most important are the planning process itself, and the repertoire of metalevel tactics. And as a natural consequence, they provide an excellent basis for explaining proofs found [13].

Within the community of automated deduction in AI, there are mainly two approaches pursued to build intelligent and efficient inference systems. The first paradigm uses a more human oriented framework, involving primarily operations understandable by human beings. Researches along this line can be found in [5, 11, 21, 3, 7]. More recently, Alan Bundy has called on to start a full-scaled investigation of what he calls a science of reasoning. This paper can be viewed as an initial response to this call. Compared with the way compound inference rules are generated to enhance the reasoning ability in interactive deduction systems [9], the three precisely defined levels of object level tactics are much better psychologically supported and provide a more natural way of organizing our deductive repertoire.

The second paradigm [23, 2, 4, 10] may be characterized as using the enormous computational power of the modern computers to solve problems through relatively blind searching. Despite this deep gap, some concepts developed in our framework turn out to be useful even for this type of systems, especially the notion of the applications of assertions. With its naturalness and abstractness, it provides a an adequate level of intermediate representation in the process of transforming machine generated proofs into natural language. The length of *assertion level* proofs are normally only one third of that of natural deduction proofs at the logic level [14].

References

1. P. B. Andrews. Transforming Matings into Natural Deduction Proofs. *LNCS*, 87, 1980.
2. P. B. Andrews. Theorem Proving via General Matings. *JACM*, 28, 1981.
3. J. Bates. The architecture of prl: A mathematical medium. Technical Report CMU-CS-90-149, School of Computer Science, CMU, July 1990.
4. W. Bibel. *Automated Theorem Proving*. Vieweg, Braunschweig, 1983.
5. R. S. Boyer and J. S. Moore. *A Computational Logic*. Academic Press, 1979.
6. M. D. Braine. On the Relation Between the Natural Logic of Reasoning and Standard Logic. *Psychological Review*, 85(1), Jan 1978.
7. A. Bundy. The Use of Explicit Plans to Guide Inductive Proofs. In *Proc. of 9th International Conference on Automated Deduction*, 1988.
8. A. Bundy. A Science of Reasoning: Extended Abstract. In *Proc. of 10th International Conference on Automated Deduction*. Springer, 1990.
9. P. T. David Basin, Fausto Giunchiglia. Automating meta-theory creation and system extension. Technical Report DAI No. 543, Univ. of Edinburgh, 1991.
10. N. Eisinger and H. J. Ohlbach. The markgraf karl refutation procedure. In *Lecture Notes in Comp. Sci.*, 230 (CADE 86), 1986.

11. R. L. C. et al. *Implementing Mathematics with the Nuprl Proof Development System*. Prentice Hall, Inc., 1986.

12. G. Gentzen. Untersuchungen über das logische Schließen I. *Math. Zeitschrift*, 39, 1935.

13. X. Huang. Reference Choices in Mathematical Proofs. In *Proc. of ECAI-90, L. C. Aiello (Ed)*. Pitman Publishing, 1990.

14. X. Huang. An Extensible Natural Calculus for Argument Presentation. Technical Report SEKI SR-91-3, Uni. Kaiserslautern, 1991.

15. X. Huang, M. Kerber, and M. Kohlhase. Theorem proving as a planning and verification process. Technical Report to appear as SEKI Report, Uni. des Saarlandes, 1992.

16. P. Johnson-Laird. *Mental Models*. Harvard Univ. Press, Cambridge, Massachusetts, 1983.

17. P. Johnson-Laird and R. Byrne. *Deduction*. Ablex Publishing Corporation, 1990.

18. M. Kerber. On the representation of mathematical knowledge in frames and its consistency. In *WOCFAI '91*, 1991.

19. G. Lakoff. Linguistics and natural logic. *Syntheses*, 22, 1970.

20. A. Newell. *Unified Theories in Cognition*. Harvard University Press, Cambridge, MA, 1990.

21. L. C. Paulson. *Logic and Computation*. Cambridge university Press, 1987.

22. L. J. Rips. Cognitive Processes in Propositional Reasoning. *Psychological Review*, 90, 1983.

23. J. Robinson. A machine-oriented logic based on the resolution principle. *J. of ACM*, 12, 1965.

Towards First-order Deduction Based on Shannon Graphs *

Joachim Posegga & Bertram Ludäscher

Universität Karlsruhe

Institut für Logik, Komplexität und Deduktionssysteme

Am Fasanengarten 5, 7500 Karlsruhe, Germany

Email: {posegga,ludaesch}@ira.uka.de

March 19, 1992

Abstract

We present a new approach to Automated Deduction based on the concept of Shannon graphs, which are also known as Binary Decision Diagrams (BDDs). A Skolemized formula is first transformed into a Shannon graph, then the latter is compiled into a set of Horn clauses. These can finally be run as a Prolog program trying to refute the initial formula. It is also possible to precompile axiomatizations into Prolog and load these theories as required.

Keywords: Automated Deduction, Shannon Graphs, Binary Decision Diagrams

1 Introduction

Logical formulae are usually defined using some or all of the connectives $\{\neg, \vee, \wedge, \rightarrow, \leftrightarrow\}$. Alternatively, one can use a ternary *if-then-else* operator "sh", which can be viewed as an abbreviation: $sh(A, S_0, S_1) \equiv (\neg A \wedge S_0) \vee (A \wedge S_1)$. Thus, $sh(A, S_0, S_1)$ corresponds to an expression of the form "if A then S_1 else S_0". Formulae using only this operator are called *Shannon graphs* (introduced by Shannon in [Shannon, 1938]) or *Binary Decision Diagrams* [Lee, 1959]. BDDs have been successfully used for Boolean function manipulation [Bryant, 1986, Brace *et al.*, 1990], for example in the context of hardware verification [Kropf & Wunderlich, 1991] or for processing database queries [Kemper *et al.*, 1992].

Up to now, this method has hardly influenced research in Automated Deduction, probably because it has not yet been extended to full first-order logic[1]. We will show how this can be done and argue that the concept of Shannon graphs is indeed a useful framework for implementing a first-order deduction system.

The underlying idea for the proposed proof procedure is to transform a formula into a Shannon graph and compile this graph into Horn clauses. When run as a

*This paper was published in *Proc. German Workshop on Artificial Intelligence 1992, Springer Verlag*.

[1]Only Orlowska [Orlowska, 1969] has described an extension to a decidable subset of first-order logic.

Prolog program the clauses simulate traversing the Shannon graph. This process tries to show properties of the graph which are equivalent to the fact that the formula cannot have a model.

An experimental Prolog-implementation of a propositional prover based on these principles proved to be quite efficient (see Section 3.1); so, the extension of the principle to first-order logic, which is currently being implemented seems promising.

The paper is organized as follows: in Section 2, Shannon graphs and their semantics are given together with a transformation from formulae to Shannon graphs. Properties relating to the soundness and completeness of our proof method are stated. Section 3 describes how one can implement the proof procedure by generation of Horn clauses and gives some test results for propositional logic.

2 First-order Shannon Graphs

Let \mathcal{L} be the language of first-order calculus defined in the usual way; \mathcal{L}_{At} are the atomic formulae of \mathcal{L}. "sh" is a new ternary connective, which can be regarded as an abbreviation: $sh(A, S_0, S_1) \equiv (\neg A \wedge S_0) \vee (A \wedge S_1)$.

Definition 1 *The set of Shannon graphs is denoted by* \mathcal{SH} *and defined as the smallest set such that*

(1) $0, 1 \in \mathcal{SH}$

(2) if $S_0, S_1 \in \mathcal{SH}$ *and* $A \in \mathcal{L}_{At}$ *then* $sh(A, S_0, S_1)$ *is in* \mathcal{SH}*.*

The **truth-value** $\mathrm{val}_{\mathcal{D},\beta}$ *of a Shannon graph* S *in a given structure* \mathcal{D} *with a fixed variable assignment* β *is defined as follows:*

$$
\mathrm{val}_{\mathcal{D},\beta}(S) = \begin{cases} \text{false} & \text{if } S = 0 \\ \text{true} & \text{if } S = 1 \\ \mathrm{val}_{\mathcal{D},\beta}(sh_-) & \text{if } S = sh(A, sh_-, sh_+) \text{ and } \mathrm{val}_{\mathcal{D},\beta}(A) = \text{false} \\ \mathrm{val}_{\mathcal{D},\beta}(sh_+) & \text{if } S = sh(A, sh_-, sh_+) \text{ and } \mathrm{val}_{\mathcal{D},\beta}(A) = \text{true} \end{cases}
$$

∎

We can visualize the formulae of \mathcal{SH} as binary trees with leaves 0 and 1. Each nonterminal node is labeled with the atomic formula occurring in the first argument of a "sh"-term. Nodes have a negative and a positive edge leading to subtrees representing the second or third argument of the corresponding "sh"-term, respectively. Consider the formula $a \wedge b$: its Shannon graph $S_1 = sh(a, 0, sh(b, 0, 1))$ is shown in Figure 1.

Semantically, a Shannon graph can be regarded as a case-analysis over the truth-values of atoms occurring in a formula. Assume there is a sequence of nodes and edges from the root to an arbitrary leaf of a Shannon graph. We prefix each atomic

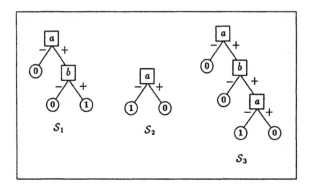

Figure 1: Shannon Graphs for $a \wedge b$, $\neg a$, and $a \wedge b \wedge \neg a$

formula with the sign of the corresponding node's outgoing edge: for example in S_1 in Figure 1, $[+a, +b]$ is such a sequence leading to a 1-leaf. We will call such a sequence a *path*.

If the atoms of some path can be consistently interpreted with the truth-value that their prefix suggests (ie **true** for a positive and **false** for a negative edge), then the path represents an interpretation. Under this interpretation the whole formula will have the truth-value with which the leaf is labeled.

Conversely, if an atomic formula and its complement occur on a path as in $[+a, +b, -a]$ in S_3, then the path is called *inconsistent* or *closed* and there is no need to investigate it any further.

Let us assume henceforth that a Skolemized formula $F(X_1, \ldots, X_n)$ (or $F(\bar{X})$ for short) with the free variables X_1, \ldots, X_n is given[2].

In order to prove the unsatisfiability of the universal closure $Cl_\forall F(\bar{X})$ of $F(\bar{X})$, we proceed by constructing a logically equivalent Shannon graph $\mathcal{F}(\bar{X})$ and try to show that it contains no consistent path to a 1-leaf.

The construction is done in the following way: obviously, an atomic formula A is logically equivalent to $sh(A, 0, 1)$. If we already have two Shannon graphs \mathcal{A} and \mathcal{B} representing the formulae A and B, we construct the Shannon graph for $A \wedge B$ by replacing all 1-leaves of \mathcal{A} with \mathcal{B}. This replacement is denoted $\mathcal{A}[\frac{1}{\mathcal{B}}]$. In Figure 1, S_3 is the result of replacing the 1-leaf in S_1 with S_2. Analogously, disjunctions are handled by replacing 0-leaves.

Now the transformation $conv : F(\bar{X}) \mapsto \mathcal{F}(\bar{X})$ which maps a formula to its Shannon graph is given by

[2]Actually Skolemization can easily be integrated into the function *conv*, below.

Definition 2

$$conv(F) = \begin{cases} sh(F, 0, 1) & \text{if } F \in \mathcal{L}_{At} \\ conv(A)[\frac{1}{conv(B)}] & \text{if } F = A \wedge B \\ conv(A)[\frac{0}{conv(B)}] & \text{if } F = A \vee B \\ conv(A)[\frac{0}{1}, \frac{1}{conv(B)}] & \text{if } F = A \rightarrow B \\ conv(A)[\frac{0}{1}, \frac{1}{0}] & \text{if } F = \neg A \end{cases}$$

■

One easily verifies that the time and space complexity of the above transformation *conv* as well as the size of the resulting Shannon graph are proportional to the size of the input formula if *structure sharing* is used for the replacement of leaves. Ie, if several leaves are replaced by the same graph, we do not copy this graph but introduce edges to a single instance of it. Therefore, *conv* constructs a directed, acyclic graph, and not a tree.

Remark 1 *Note, that there is a cheap way to optimize the generated graph: assume we are to construct a graph for $A \wedge B$; we can either construct $conv(A)[\frac{1}{conv(B)}]$, or the logically equivalent graph $conv(B)[\frac{1}{conv(A)}]$. Although both graphs do not differ in size, the trees they represent generally do. As those trees are the potential search space for a proof, it is of course desirable to construct the graph representing the smallest of those trees. Fortunately, this comparison is easy:*

Assume that $\#_1, \#_0,$ and $\#_{at}$ denote the number of 1-leaves, 0-leaves, and (nonterminal) nodes of the tree represented by a Shannon graph. If A and B are Shannon graphs, then the size of the tree for $\mathcal{G} = A[\frac{1}{B}]$ will be:

$$\#_{at}(A) + \#_0(A) + \#_1(A) \cdot (\#_{at}(B) + \#_0(B) + \#_1(B))$$

or, equivalently,

$$\underbrace{\#_0(A) + \#_1(A) \cdot \#_0(B)}_{\#_0(\mathcal{G})} + \underbrace{\#_{at}(A) + \#_1(A) \cdot \#_{at}(B)}_{\#_{at}(\mathcal{G})} + \underbrace{\#_1(A) \cdot \#_1(B)}_{\#_1(\mathcal{G})}$$

The size of the tree in case of a disjunction can be determined analogously. Although this heuristic works only locally and does not guarantee to generate the best global result, it has proven to be very useful in practice. ■

Let us call $\mathcal{F}(\bar{X})\sigma$ *closed* if all paths to 1-leaves in $\mathcal{F}(\bar{X})\sigma$ are inconsistent, where σ substitutes the free variables \bar{X} of $\mathcal{F}(\bar{X})$. Now a basic property of Shannon graphs can be stated:

Proposition 1 *Let $\mathcal{F}(\bar{X}) = conv(F(\bar{X}))$. If there is a grounding substitution σ such that $\mathcal{F}(\bar{X})\sigma$ is closed then $F(\bar{X})\sigma$ is unsatisfiable.* ■

How do we find such a σ? We traverse a Shannon graph building a path. If a path contains two unifiable atoms $A_1\sigma = A_2\sigma$ with complementary signs then σ will close that path.

Consider the following example:

Let $P_0(X) := p(a)\wedge\neg p(f(f(a)))\wedge(p(X)\rightarrow p(f(X)))$. We want to show that $Cl_\forall P_0(X)$ is unsatisfiable. The equivalent Shannon graph $\mathcal{P}_0(X) = conv(P_0(X))$ is shown on the left in Figure 2:

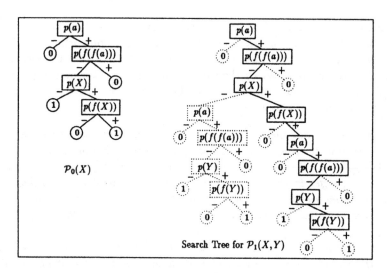

$\mathcal{P}_0(X)$

Search Tree for $\mathcal{P}_1(X,Y)$

Figure 2: Proving inconsistency of $Cl_\forall P_0(X) := p(a)\wedge\neg p(f(f(a)))\wedge\forall X(p(X)\rightarrow p(f(X)))$

The path $[+p(a), -p(f(f(a))), -p(X)]$ to the leftmost 1-leaf in $\mathcal{P}_0(X)$ can be closed with the substitution $\sigma = [X/a]$. Unfortunately there is no substitution such that *both* paths to 1-leaves become inconsistent, so we cannot prove the unsatisfiability of $Cl_\forall P_0(X)$ with $\mathcal{P}_0(X)$. To do this we need to consider a consequence of the compactness of first-order logic:

Proposition 2 $Cl_\forall F(\bar{X})$ *is unsatisfiable iff* $\exists k \in I\!N, \exists\sigma : (F(\bar{X}_0)\wedge\ldots\wedge F(\bar{X}_k))\sigma$ *is unsatisfiable.*

σ *maps variables to ground terms, ie to terms from the Herbrand-universe* U_F *of* F *and each* \bar{X}_i *is a new variable vector* $X_{i,1},\ldots,X_{i,n}$ *distinct from all* \bar{X}_j *with* $j < i$.

∎

Since there is no σ such that $\mathcal{P}_0(X)\sigma$ can be closed (cf. Figure 2), we **extend** $\mathcal{P}_0(X)$ by replacing its 1-leaves with an instance of \mathcal{P}_0 with renamed variables. The result $\mathcal{P}_1(X,Y) := \mathcal{P}_0(X)[\frac{1}{\mathcal{P}_0(Y)}]$ is by Definitions 1 and 2 logically equivalent to $P_1(X,Y) := P_0(X)\wedge P_0(Y)$. Now the substitution $\sigma = [X/a, Y/f(a)]$ yields

a closed Shannon graph $\mathcal{P}_1(X,Y)\sigma$. Hence $P_1(X,Y)\sigma$ is unsatisfiable and by Proposition 2 so is $Cl_\forall P_0(X)$.

Note that the dotted subtree rooted at the negative edge of $p(X)$ can be pruned from the search space: all paths going through this edge are closed with the substitution $[X/a]$. Additionally, all edges to 0-leaves are actually never considered during the proof search.

For the general case, consider the sequence of Shannon graphs

$$\begin{aligned}
\mathcal{F}_0(\bar{X}_0) &= conv(F(\bar{X}_0)) \\
\mathcal{F}_{i+1}(\bar{X}_0,\ldots,\bar{X}_{i+1}) &= \mathcal{F}_i(\bar{X}_0,\ldots,\bar{X}_i)[\tfrac{1}{\mathcal{F}_0(\bar{X}_{i+1})}]
\end{aligned}$$

Starting from the initial Shannon graph $\mathcal{F}_0(\bar{X}_0)$ of a Skolemized formula $F(\bar{X}_0)$ we construct an *extension* \mathcal{F}_{i+1} of \mathcal{F}_i by replacing its 1-leaves with an instance of the initial graph with new variables. This corresponds to constructing the conjunction of Proposition 2.

From the Definitions 1 and 2 it follows that $val_{v,\sigma}(\mathcal{F}_k(\bar{X}_0,\ldots,\bar{X}_k)) = val_{v,\sigma}(F(\bar{X}_0)\wedge\ldots\wedge F(\bar{X}_k))$, so if $Cl_\forall F(\bar{X}_0)$ is unsatisfiable (cf. Proposition 2) we will eventually arrive at a \mathcal{F}_k which can be closed for some σ.

3 Generating Horn clauses

To show the unsatisfiability of a formula $Cl_\forall F(\bar{X})$, we have to traverse its Shannon graph $\mathcal{F}_0(\bar{X})$ trying to find a substitution that closes all paths from the root to 1-leaves; if there is no such substitution, we extend $\mathcal{F}_0(\bar{X})$. For implementing the above method, we propose to compile $\mathcal{F}_0(\bar{X})$ into a set of Horn clauses, which simulate the Shannon graph traversal.

Remember that $\mathcal{F}_0(\bar{X})$ has a representation which is proportional to the size of the input formula. We proceed as follows:

For leaves no clauses are generated; for every *nonterminal* node in \mathcal{F}_0 we generate exactly one Prolog-clause, which must accomplish one or more of the following tasks :

- find a substitution that closes the current path

- extend a 1-leaf

- transfer control to the clauses for child nodes

Therefore we supply the clause with the current variable binding, the path constructed so far, and a designator of the current extension (level). A clause succeeds if at each 1-leaf reachable from the corresponding node the path can be made inconsistent. To get a more definite idea, we will briefly discuss a simplified clause for the node $p(X)$ of \mathcal{P}_0, cf. Figure 2:

```
node_3(Binding,Path,Level):-                                            (1)
    nth(Level,Binding,[X]),                                             (2)
    (close([-p(X)|Path])                                               (3)
    ; (NLevel is Level+1,node_1(Binding,[-p(X)|Path],NLevel))),        (4)
    node_4(Binding,[+p(X)|Path],Level).                                (5)
```

In line (2), all free variables occurring in the atomic formula with which the current node is labeled, are bound (in this case only X). Technically, this can be done in the following way: since each level has its own set of variables, the variable bindings are level-dependent. It is assumed that Binding is a list of such variable bindings where the *n-th* element stores the binding for the *n-th* level. Each binding itself is also a list, which holds the value of each variable at a certain position; during compile time, a list is constructed that matches these position(s) in order to extract the required bindings. As our example contains only one variable, the matching list is just [X].

The predicate close in line (3) tries to make Path together with -p(X) inconsistent as we reach a 1-leaf at the negative edge; if this fails, line (4) extends the graph by increasing the level counter and calling the clause for the root-node again. So extending the graph is modeled without asserting new Prolog clauses. This is correct since each level establishes its own variable bindings.

Calling the clause for the root-node again will succeed if all paths to 1-leaves in one of the next extensions can be made inconsistent.

Finally, we have to show that all paths to 1-leaves reachable from the positive edge of $p(X)$ are also inconsistent therefore we call the child node_4 at the positive edge.

Our proposed proof procedure will be complete if we use bounded depth-first search with iterative deepening and force the predicate close to enumerate all possible solutions (ie ways to close paths) on backtracking. Another, more efficient approach is to implement a *fair* selection scheme for close.

It should be noted that the example clauses are not a particular efficient way to code the problem in Prolog; clearness and readability has been preferred over efficiency.

3.1 Propositional Logic

The method described above has been implemented for propositional logic; a first-order version is currently under development. In the propositional case, the structure of the generated Prolog clauses can be kept much simpler, since no extensions take place and no variable bindings need to be considered. The maximal length of the generated paths is also known in advance, so much more efficient data-structures can be used for representing paths. Performance figures for pigeon hole formulae with a propositional version of the prover are shown in Table 1:

		Search Space			CPU Time [msec]		
Problem	Graph Nodes	Potential	Explored	Closed Paths	Preproc	Compile	Proof
pig2	4	9	3	2	17	83	< 17
pig3	18	2,045	60	37	100	300	< 17
pig4	48	$6.4 \cdot 10^7$	882	644	233	683	< 17
pig5	100	$3.0 \cdot 10^{15}$	9,677	7,351	466	1,417	83
pig6	180	$1.5 \cdot 10^{27}$	156,756	124,265	816	2,533	1,717
pig7	294	$5.7 \cdot 10^{43}$	2,961,695	2,414,873	1,383	4,050	28,733

The CPU times are measured on a Sun-4 with Quintus Prolog 3.0.; it was not possible to measure times less than 17 msec.

Table 1: Some Test Results.

"pig n" stands for "n pigeons do not fit into $n - 1$ holes"; "Graph Nodes" shows the size of the initial graph. The columns labeled "Search Space" give the potential search space, ie, the size of the tree represented by the initial graph, and the number of nodes that have actually been visited. "Closed Paths" is the number of paths that have been constructed and closed, which corresponds to the number of partial models that have been generated and ruled out.

"Preproc" is the time for computing the initial graph and generating the Prolog clauses; "Compile" gives the time required by the Prolog System to compile the latter. "Proof" is the time used for executing the generated Prolog clauses, ie, the search for a model.

4 Conclusions and Outlook

We have described a method to compile first-order formulae via Shannon graphs into Horn clauses. The method differs from other approaches to deduction by Horn clause generation (e.g. [Stickel, 1988]), in that the generated clauses have no logical relation to the formula that is to be proven (ie are not a logically equivalent variant of the formula), but that they are *procedurally* equivalent to the search for a model. This is reflected by the fact that Prolog's SLD-resolution can be used and no meta-level inference is required.

It is straightforward to compile Shannon graphs into other target languages. This has already been done for C and i386-Assembler in the case of propositional logic. The performance of the version generating C code is roughly comparable to the Prolog version. This is basically due to the fact that the generated Prolog clauses have a very simple structure and can be efficiently handled by Prolog. For a first-order version, however, C can be expected to perform better, since some optimizations are hard to encode in Prolog.

The version of the prover compiling to Assembler is clearly the fastest one, yielding results about 20–30 times better than those presented in Table 1 for Prolog. If an application requires very short run-times, it would even be possible to by-pass the use of an Assembler and generate machine language, directly.

Note that the compilation process can also be done in advance for a set of axioms. Such precompiled theories can then be loaded into a deduction system and used for inference. In this context it is also reasonable to *reduce* a Shannon graph before compiling it into Prolog. Reduction is a well-known operation on Shannon graphs, which often decreases its size considerably. Though reduction may add to the cost of preprocessing, the resulting search space at run-time will be smaller.

Several liberalizations and refinements of the proof procedure described at the end of section 2 are possible:

When constructing an extension \mathcal{F}_{i+1} of \mathcal{F}_i it is not mandatory to replace each 1-leaf of \mathcal{F}_i with the same renamed copy of the initial graph. Instead the copies can be distinct in that each maintains its own set of variables. In general graphs can be closed with fewer extensions using this modification; additionally the handling of variable bindings is simplified.

Finally there is no need to investigate the complete (renamed) initial graph when constructing an extension. Only \forall-quantified sub-formulae of the initial formula have to be inserted at the 1-leaves of \mathcal{F}_i. Details how this can be done are elaborated in a forthcoming paper.

References

[Brace et al., 1990] Karl S. Brace, Richard L. Rudell, & Randal E. Bryant. Efficient implementation of a BDD package. In *Proc. 27th ACM/IEEE Design Automation Conference*, pages 40 – 45. IEEE Press, 1990.

[Bryant, 1986] Randal Y. Bryant. Graph–based algorithms for Boolean function manipulation. *IEEE Transactions on Computers*, C–35:677 – 691, 1986.

[Kemper et al., 1992] A. Kemper, G. Moerkotte, & M. Steinbrunn. Optimization of boolean expressions in object bases. In *Proc. Intern. Conf. on Very Large Databases*, 1992.

[Kropf & Wunderlich, 1991] T. Kropf & H.-J. Wunderlich. A common approach to test generation and hardware verification based on temporal logic. In *Proc. Intern. Test Conf.*, pages 57–66, Nashville, TN, October 1991.

[Lee, 1959] C. Lee. Representation of switching circuits by binary decision diagrams. *Bell System Technical Journal*, 38:985–999, 1959.

[Orlowska, 1969] Ewa Orlowska. Automatic theorem proving in a certain class of formulae of predicate calculus. *Bull. de L'Acad. Pol. des Sci., Série des sci. math., astr. et phys.*, XVII(3):117 – 119, 1969.

[Posegga, 1992] Joachim Posegga. First-order shannon graphs. In *Proc. Workshop on Automated Deduction / Intern. Conf. on Fifth Generation Computer Systems*, ICOT TM–1184, Tokyo, Japan, June 1992.

[Shannon, 1938] C. E. Shannon. A symbolic analysis of relay and switching circuits. *AIEE Transactions*, 67:713 – 723, 1938.

[Stickel, 1988] Mark E. Stickel. A Prolog Technology Theorem Prover. In E. Lusk & R. Overbeek, editors, *9th International Conference on Automated Deduction*, Argonne, Ill., May 1988. Springer-Verlag.

SUCCESS AND FAILURE OF EXPERT SYSTEMS IN DIFFERENT FIELDS OF INDUSTRIAL APPLICATION[1]

Reinhard Bachmann, Thomas Malsch and Susanne Ziegler
Lehrstuhl Technik und Gesellschaft, Fachbereich 11, Universität Dortmund,
Postfach 500 500, 4600 Dortmund 50

Abstract

The euphoric period in the history of expert systems has definitely come to an end. It is presently time to review the efforts which have been made in this field. Oriented to our conceptual framework of knowledge transformation, some trip wires which can seriously jeopardize the success of expert-system-developing projects are described in the following.

1 Introduction

Our research interests focus on the following questions: (a) Which are the application fields where expert system technology can be regarded as successful and where does it fail? (b) What are the dimensions we have to refer to in order to explain success and failure of expert-system-developing projects?

Of course we are not the first to ask these questions (Coy, Bonsiepen 1989; Daniel, Striebel, Clemens-Schwartz 1989; Lutz, Moldaschl 1989; Hillenkamp 1989; Bullinger, Kornwachs 1990; Christaller 1991). But there are four reasons why we find expert system technology worth to be reexamined thoroughly. (a) The unrealistic euphoria of the 1980s has vanished. (b) There is still a lack of explanation of the discouragingly high rate of failed systems. (c) The greatest part of research

[1] This contribution is a sketch of intermediate results of a current empirical research project which is financed by the German Ministry for Research and Technology and conducted by the University of Dortmund/Dept. Technology and Society. Our findings are predominantly based on first-hand information we have gathered in 56 interviews on 22 expert systems.

in this field focuses on merely technical or economic issues and does not reflect social and organizational preconditions. (d) And if the studies do explicitly deal with these contexts (Hillenkamp 1989; Lutz, Moldaschl 1989) they do not go beyond the application side and only reflect the social impacts of technology without examining development processes. In our view it is necessary to avoid limitations of this kind.

The application fields we have investigated are all industrial ones and are listed as follows:

– Customer–specific product configuration
– Machinery fault–diagnosis
– Synthesis and analysis in the chemical laboratory
– Engineering of production processes
– Determination of manufacture planning

We have concentrated on these fields because they are considered to be major industrial application areas in Germany as well as worldwide (Mertens, Borkowski, Geis 1990). 15 of the 22 expert systems we studied in total were apt for detailed analysis. Although we have focused on systems described as "running systems" in German expert system literature it became obvious that many of these systems were anything but successful running systems. As the following table shows, 8 expert systems failed either in the stage of development or later in practice. Only 6 systems can be considered successful in that they were technically functionable. (Only 4 of them, in our view, have definitely proved to be successful also in the commercial sense).

Table 1: The distribution of success and failure over the application fields

AREAS	SUCCESS-FUL	FAILED	IN DEVELOP-MENT	TOTALS
CONFIGURATION	4	-	-	4
MACHINERY FAULT-DIAGNOSIS	-	5	-	5
CHEMICAL LABORATORY	1	2	-	3
PROCESS ENGINEERING	1	1	-	2
MANUFACTURE PLANNING	-	-	1	1
TOTALS	6	8	1	15

This table shows a second remarkable finding: Success and failure are distributed unevenly over the studied fields. In the configuration area, all systems which we have examined were successful whereas in the area of diagnosis (which is according to common opinion a "classic" area of application for knowledge-based systems) no system in our sample of 5 was successfully implemented. In chemical laboratory and process control we evaluated one successful and one failed system in each area. The manufacture planning system we studied was at the testing stage of application. At present we do not know of its effectiveness.

As we do not only want to classify systems in regard to their success, we shall give some explanations for the distribution of success and failure within as well as across the application fields. In other words we want to identify trip wires on the way to success. For this purpose we will adopt the theoretical concept of knowledge transformation (Malsch 1987), which serves us as a conceptual framework for the reconstruction of the process of the development and application of expert systems. The process of knowledge transformation can be segmented in three stages: (1) knowledge acquisition, (2) the "objectivation" of knowledge in the form of a technical artefact and (3) the reintegration of the knowledge represented in the expert systems into the context of application. Each of these stages contains specific risks of failure. In the following we will refer to the crucial points in the process of knowledge transformation, seemingly appropriate for revealing some important aspects in the question of success and failure of expert system projects.

2 The process of knowledge transformation

(1) The phase of knowledge acquisition involves the risk of losing or distorting knowledge. We have located several neuralgic points on the level of knowledge acquisition: Among others they concern (a) the problem of finding out which expert knowledge is relevant for acquisition purposes; (b) the form of cooperation between knowledge engineer and expert; (c) the possibility of eliciting the knowledge by the expert himself.

Re (a): In our 5 areas of application we came across experts who belonged to various professional groups, their formal qualifications greatly differing. An obstacle for expert system development can be seen in the fact that often, due to pragmatism or simple negligence, certain professional groups are not recognized as experts. Subsequently certain pieces of expert knowledge are carelessly excluded.

This happened in the fields of diagnosis and process engineering, though the reasons for excluding knowledge are not identical in both areas.

In the area of process engineering one expert system built to supervise a complex process failed because the practical experiential knowledge ("Erfahrungswissen"; Böhle, Milkau 1988) which operators had acquired "on the job" was ignored. In the field of process engineering in chemical industry the experience of semi-skilled or unskilled operators necessarily has to be incorporated into the expert system (Mill 1991). In one project in this field, the operators' experiential knowledge was considered to be the dominant source of knowledge, and this system turned out to be a successfully running one.

Also in the field of machine diagnosis the intuitive knowledge of the maintenance staff has to be regarded as most important. Several expert system projects in this area were doomed to fail from the beginning as the developers underestimated the importance of the workers' experiential knowledge. To give an example, a machine manufacturer's attempt to equip his machines with a built-in diagnosis system failed, because the maintenance workers in the firm implementing the machine, who were disposing of the most important diagnostic knowledge regarding frequent minor machinery-failures, have been ignored by the knowledge engineers. On the other hand the machine producer's engineers and service technicians, whose knowledge was used exclusively, could not provide sufficient relevant knowledge (Malsch 1991).

Re (b): In cases of successful development of expert systems based on experiential knowledge, we found this to a great extent to be due to social-communicative orientations in the knowledge acquisition process. In many failed projects knowledge acquisition was organized as a one-sided extraction process in which communicative problems between experts and knowledge engineers were ignored. This may prove fatal because both groups of actors do not a priori speak the same language as they represent different disciplines and different formal qualifications. Before they are able to communicate and exchange their knowledge, they first have to find a common level of communication. Some experts have never been in a situation requiring communication of their experiential knowledge, especially those with few formal qualifications, who therefore feel uncertain regarding their own competence. These communication problems lead to misunderstandings, to a lack of cooperation and subsequently to deficient knowledge bases. However, these problems can be avoided if knowledge acquisition is considered as a process in which the experts' interests and competences are taken seriously. This was the basis of success for one process engineering expert-system. What the knowledge engineers had extracted from the interviews with the experts again and

again was returned to the experts for validation and refinement. Thus, the experts felt themselves acknowledged by academically trained knowledge engineers. It was also interesting to note that the experts were, in the process, brought to discuss their experience in their own group and to develop a more elaborate understanding of their own work (Mill 1991).

Re (c): "Self-acquisition" means that the expert acts as his own knowledge engineer. Its chances are subject to great dispute. Our empirical findings show clearly that successful self-acquisition depends greatly on the social status and the professional qualifications of the experts involved. Academically trained experts were capable of eliciting their own experience, whereas skilled or semi-skilled workers were not. In some expert system projects, self-acquisition was never taken into consideration. In projects in the fields of manufacture planning and process engineering, where experts have few formal qualifications, no attempt was made to involve them in trial activities of this kind. There is some small chance for self-acquisition in the field of machinery maintenance, where the experts are skilled workers who are handed over robust and easy-to-handle, simplified shells. But these shells inevitably augment the risk of developing trivial systems. Self-acquisition only succeeded when experts were involved with high formal qualifications. In the field of configuration, for example, the developing engineers of a highly complex product sucessfully built their own expert system in order to configure more effectively and also avoided to use any prefabricated tools (Bachmann 1992).

These experiences are not, in our opinion, advocating the view that high formal qualifications can be considered a guarantee for successful self-acquisition. The risk of circular self-observation and tautological self-validation of the expertise by the expert himself is obvious. There is no one to evaluate the experts' knowledge from a different, critical point of view. As bystanders ("Fremdbeobachtung"; Luhmann 1984) can generate productive irritations, close cooperation between knowledge engineers and experts is in many cases of irrefutable value as a development method.

All in all we were rather astonished to see that in the phase of knowledge acquisition, which Feigenbaum once called the "bottle neck" of knowlegde engineering, the practical working experts were very often ignoring advanced theoretical discussions (Diederich 1987; Becker 1990) and were far away from employing elaborated methodologies like KADS (Wielinga, Breuker 1986).

(2) In the phase of knowledge "objectivation" the acquired knowledge is transformed into a piece of software technology. Here we came across two dominant problems. They concern the use of prefabricated shells (a) and the

choice between – what we call borrowing from Puppe (1989) – the heuristic and the model–based representation approach (b).

Re (a): It is frequently ignored by the developers of expert systems that shells already represent important assumptions related to the task the expert system is to be built for. Parts of the problem solving strategy applied by experts in the field of configuration or machinery diagnosis are not represented in the knowledge base of the system but in its inference engine. This is totally ignored if highly specified ready–made shells are used. In the context of government–funded large–scale research projects, great efforts were made to develop application area–specific reusable tools, for example the configuration shell PLAKON (Cunis, Günther, Strecker 1991). This shows that attention was paid to the fact that shells also represent domain knowledge. But today these tools are hardly of any practical importance and any efforts made are more or less considered to have failed. In practice to the present time, only self–made shell–concepts work satisfactorily. The following table shows what kind of tool/language was used in the different fields we have investigated.

Table 2: Shells and programming languages used in the different fields of application

	SHELL		AI-LANGUAGE	C, FORTRAN
	SPECIFIC	GENERAL		
CONFIGURATION			+	+
MACHINERY FAULT-DIAGNOSIS	+	+	+	+
CHEMICAL LABORATORY				+
PROCESS ENGINEERING				+
MANUFACTURE PLANNING		+	+	

The configuration expert systems were programmed in C or an AI–language like LISP or PROLOG. The successful systems in the fields of the chemical laboratory and process engineering were programmed in FORTRAN, a mere technical language. In the field of machinery diagnosis, prefabricated shells were frequently used, but the results were disillusioning.

Re (b): The choice between the heuristic and the model–based approach of knowledge representation is controversial among expert system developers. And this does not only concern the field of diagnosis where this differentiation is most

present. According to our results, heuristic representation, meaning to collect a sample of important thumb rules of the domain, is appropriate if complete and thorough knowledge of the causal relations and interdependencies between the elementary components of the real–world object which is to be modelled does not exist. If it does exist, however, model–based knowledge representation, meaning to gather all available causal relations of the domain, is preferable, as the successfully running configuration systems show. Moreover the complexity of the domain is to be considered a main criterion in order to decide in favor of one of these representation concepts. In the fields of machinery diagnosis and process engineering several model–based systems failed due to formal complexity which could not be represented in the model–oriented paradigm. Although at present heuristic diagnosis systems do not succeed either, these efforts appear more promising to us. In the field of process engineering we even found one system which is heuristic and can be regarded as successful.

Considering modelling concepts in the field of the chemical laboratory, we must distinguish between chemical synthesis and analysis. A heuristic expert system supporting synthesis planning proved to be too complex and intransparent. The proposals generated by the system could not be put into practice. The system was representing a mixture of idiosyncratic strategies of several experts in chemical synthesis planning. But this turned out to be of little use for highly specialised chemists working in very narrow problem fields requiring their own specific methods. Attempts to develop model–based synthesis planning– programs did not succeed. Their application is limited to such functions as brainstorming and idea generation. In the field of analysis, a model–based expert system linked to large–scale databases was successful, whereas heuristic attempts did not prove to be relevant in any practical sense (Jonas 1992).

In the configuration area, the option between heuristic and model–based systems was never taken into consideration by developers. Only the model–based approach has gained importance in practice. Discussions about "associative configuration" (Hein, Tank 1990) are at present still limited to very basic research efforts. The reason is obvious: The portion of vague knowledge and intransparent causal interdependencies is rather small in the field of configuration, whereas formal descriptions of modules and combination rules are the main part of configuration knowledge.

In the field of manufacture planning, the model–based approach seems to be appropriate if the expert system also contains a function allowing the system–user to simulate the consequences of different possible planning decisions. On the other hand, there exist complex interdependencies which can hardly be totally repre

sented. At present we can only speculate which pathway will turn out to be the more successful in this field of application (Weißbach, Ziegler 1992).

The following table once more condenses our findings concerning the inter-relation of knowledge representation concept and success or failure in the different fields of application.

Table 3: Success and failure in relation to knowledge representation approach

	MODEL-BASED	HEURISTIC
SUCCESSFUL	Configuration Chemical Laboratory	Process Engineering
FAILED	Machinery Fault-Diagnosis Process Engineering	Machinery Fault-Diagnosis

(3) In the phase of reintegration, the knowlege which has been incorporated in the expert system returns to its context of application. This firstly means to adapt the system to the organizational application context. But the problems arising at this stage are not exclusively of technical or software ergonomic nature. Focussing only on technical problems ignores that the expert system as technical artefact is no longer a precise mirror-image of the extracted human experts' knowledge, and reintegration does not mean simply to reimplant technically transformed knowledge into the application context, which could remain untouched. This kind of logic neglects the fact that applying expert systems successfully and effectively also requires adaption or rather creation of an adapted organizational application context. Furthermore, social and cultural patterns of cooperation are highly affected and need rearranging simultaneously with the implementation of the technology.

In the phase of reintegration, even the successful configuration systems, having overcome the obstacles in the preceding stages of knowledge transformation, are exposed to serious risks. We have found systems which have perfectly met all technical requirements, but were not accepted by the users, as they represented, from the users' point of view, a kind of logic they did not understand, being incompatible with the strategies they were familiar with. As long as a salesman is convinced that order acquisition in the case of modular-structured complex products, above all other abilities, requires a certain "feeling" of what will fulfil the

customer's wishes best, he will not easily accept the formal module combination strategy of the expert system.

Expert systems aiming exclusively at the increase of technical efficiency can generally be expected to produce severe problems of acceptance. The ignorance of the application context may entail serious obstacles for systems which appear convincing from a mere technical point of view. In our opinion, the application context with its specific organizational, social and cultural requirements should be included in the process of knowledge transformation.

3 Results: Future Migration Pathways

Despite the present scenery of software ruins and wasted money, which is certainly not an exclusive phenomenon of the AI-field, in our view two pathways will crystallize along which the technology of expert systems could move.

There is a future for heuristic expert systems as systems designed for application in narrowly confinable environments where it is their task to support humans' capabilities in a very particular application context. Impacts on more distant areas within the organization and more so on the initiation of dynamic processes of restructuring the social and cultural dimensions of work organization are being avoided by designers as far as possible. Since their reach is confined to their specific application context only, a problem in transferring sensitive information can not occur. Systems of this kind make sense and could be applicable in the areas of machinery maintenance and process engineering as well as in the area of chemical synthesis.

It is the particular strength of the model-based systems that they are not based so much on knowledge gained by experience, but on formal and complex knowledge structures. In general these systems possess a larger range of impact compared to the heuristic systems. Therefore they can play an important role in the creation of new information and communication networks within organisations. It was in the field of configuration that we were confronted with considerations to hand over the expert system to the customer, thus enabling him to configure his own product. This would trigger off dynamic processes of reorganization, which even go beyond the organizations' boundaries raising the patterns of modernization and the strategies of market oriented innovations to a new level (Bachmann, Möll 1992).

4 Literatur

Bachmann R. (1992): Konfigurationsexpertensysteme in der industriebetrieblichen Anwendung. Information & Kommunikation Heft 14. Dortmund.

Bachmann R., Möll G. (1992): Alles neu ... ? Rationalisierung von industriellen Innovationsprozessen. Eine Herausforderung für die industriesoziologische Analyse? In: Malsch Th., Mill U. (Hg.): ArBYTE. Modernisierung der Industriesoziologie? Berlin.

Becker B. (1990): Die Veränderung von (Experten-)Wissen durch den Prozeß der Wissensakquisition. Exkurs 1. In: KI 2/90.

Böhle F., Milkau B. (1988): Vom Handrad zum Bildschirm. Eine Untersuchung zur sinnlichen Erfahrung im Arbeitsprozeß. Frankfurt, New York.

Bullinger H.-J., Kornwachs K. (1990): Expertensysteme. Anwendungen und Auswirkungen im Produktionsbetrieb. München.

Christaller Th. (1991): Expertensysteme in der Praxis - Was leisten sie und welche Zukunft haben sie? In: ZwF 11/86.

Coy W., Bonsiepen L. (1989): Erfahrung und Berechnung. Kritik der Expertensystemtechnik. Berlin u.a.

Cunis R., Günther A., Strecker H. (1991): Das PLAKON-Buch. Berlin u.a.

Daniel M., Striebel D., Clemens-Schwartz B. (1989): Künstliche Intelligenz, Expertensysteme - Anwendungsfelder, neue Dienste, soziale Folgen, Projektbericht eines Projektes im Rahmen des Programms "Sozialverträgliche Technikgestaltung", 3 Bde. Karlsruhe.

Diederich J. (1987): Wissensakquisition. Arbeitspapier der GMD. St.Augustin.

Hein M., Tank W. (1990): Assoziative Konfigurierung. In: Marburger H. (Hg.): GWAI-90, 14th German Workshop on Artificial Intelligence. Proceedings. Eringerfeld September 1990. Berlin u.a.

Hillenkamp U. (1989): Expert Systems - Present State and Future Trends: Impact on Employment, Working Life and Qualifications of Skilled Workers and Clerks. Bericht des ILO/FRG Project on Expert Systems and Qualification Changes. Geneva.

Jonas M. (unter Mitarbeit von U. Mill) (1992): Expertensysteme und konventionelle Informationssysteme in der chemischen Forschung. Information & Kommunikation Heft 16. Dortmund.

Luhmann N. (1984): Soziale Systeme. Frankfurt/M.

Lutz B., Moldaschl M. (1989): Expertensysteme und industrielle Facharbeit. Frankfurt, New York.

Malsch Th. (1987): Die Informatisierung des betrieblichen Erfahrungswissens und der "Imperialismus der instrumentellen Vernunft". Kritische Bemerkungen zur neotayloristischen Instrumentalismuskritik und ein Interpretationsvorschlag aus arbeitssoziologischer Sicht. In: Zeitschrift für Soziologie 2/87.

Malsch Th. (1991): Wissensbasierte Diagnosesysteme in der Instandhaltung - Empirische Untersuchungsbefunde und Potentialabschätzungen. Information und Kommunikation Heft 12. Dortmund.

Mertens P., Borkowski V., Geis W. (1990): Betriebliche Expertensystem-Anwendungen. 2.,völlig neu bearbeitete und erweiterte Auflage. Berlin, Heidelberg.

Mill U. (1991): Expertensysteme und konventionelle Informationssysteme in der Prozeßleittechnik der Chemieindustrie. Information und Kommunikation Heft 11. Dortmund.

Puppe F. (1989): Modellgestützte Diagnostik. In: KI 3/89.

Weißbach H.-J., Ziegler S. (1992): Expertensysteme und konventionelle Systeme in der Produktionsplanung und -steuerung. Information & Kommunikation Heft 17. Dortmund.

Wielinga B.J., Breuker J.A. (1986): Models of Expertise. In: ECAI 86.

Viewing Knowledge Engineering as a Symbiosis of *Modeling to Make Sense* and *Modeling to Implement Systems*

Marc Linster

AI Research Division, GMD
D-5205 St. Augustin 1
email: marc.linster@gmd.de

Abstract. We view knowledge engineering as a constructive activity that encompasses both *model building to make sense* and *model building to implement systems*. We list four properties that we feel are important for environments that support this view on modeling and that exploit the symbiosis of both facets: *epistemological modeling primitives*, *reusable templates*, *multi-faceted modeling*, and *formal languages*. We use the framework of these requirements to introduce the operational modeling language OMOS and to show how it copes with them. Finally, we compare OMOS to two important current developments: PROTÉGÉ-II and SBF (Spark, Burn, Firefighter). This allows us to situate our work and put it into the context of current research.

1 Introduction

In knowledge acquisition research one can observe a shift in perspective—away from a transfer point of view towards a model-building point of view [5; 20]. In Section 2 of this paper we introduce a view on knowledge engineering, where we try to merge advantages of the conceptual modeling approaches such as KADS [26; 27], with those of operational, tool-oriented approaches such as PROTÉGÉ [21] or CLASSIKA/D3 [7]. In Section 3 we introduce a set of requirements that we consider relevant for the evaluation of modeling environments. Section 4 discusses the operational modeling language OMOS in the light of these requirements, using data of an application for clamping tool selection. The last section puts our work into the context of current research and evaluates it.

This article concentrates on the interaction resulting from the two kinds of modeling; other aspects of OMOS are presented elsewhere: life cycle issues are discussed in [12]; design decisons are reported in [14]; applications are described in [11; 16; 15]; consequences of the chosen formalism are discussed in [13; 15].

[0] This article is a revised and shortened version of [14]. Whereas the latter article gives a broad presentation of OMOS, this paper focusses on the modeling requirements that we derive from our view of knowledge engineering and on OMOS' ways to fulfill them.

2 Our View On Knowledge Engineering

We view knowledge engineering as an activity that encompasses both *model building to make sense* and *model building to implement systems.*

Model building to make sense assumes a constructive point of view of knowledge engineering, that is, we do not presume that the knowledge can be extracted from an expert's head, but that it is being developed in the creative interaction between the knowledge engineer and the expert. Thus, modeling to make sense is a process of building a structured understanding; a process that deserves study in its own right, independently from the aspect of building automated knowledge-based systems.

Model building with the goal to implement systems is the classical facet of knowledge engineering. For example specialized tools, such as PROTÉGÉ or CLASSIKA, help a knowledge engineer build operational models of a real-world task in the tool's framework (i.e., episodic skeletal-plan refinement or heuristic classification).

If we assume that knowledge engineering encompasses both flavors of model building, then this implies that (1) the concerns of the system-implementing facet must be ubiquitous during the making-sense activities; and (2) that the formal constructs for the system building must provide the facilities that encourage a process of understanding.

The next section develops these requirements in more detail.

3 Requirements for Modeling Environments

Epistemological Modeling Primitives A process of understanding is best supported by a set of epistemological modeling (or knowledge structuring) primitives [3] that can be used to construe a real-world situation to be modeled in a bottom-up fashion.

Reusable Templates Reusable templates provide frameworks for often recurring knowledge structures. For example it is useful to specify heuristic classification as a reusable template, because it appears in the domains of medicine, biology, process control, etc. Furthermore, reusable templates allow a discussion of these structures independently of their concrete manifestations. Thus one could develop a theory.

Multi-Faceted Modeling The task of building a model of a complex real-world task can be tackled from several different points of view. For example one can focus on the entities of the domain, or one can look at the processes that are involved. A knowledge engineering environment should allow a multi-faceted approach. Most of all, it should exploit the interactions that exist between the points of view. To that purpose, it must provide different specialized primitives for the different points of view.

Formal Languages Formal properties of the modeling language help the knowledge engineer in the elaboration and extension of a model. Formal properties are required for focussed feedback through model-analysis tools or for computer interpretation of the model. They are the basis for the constructive interaction between the human as a creative agent and a computer as a rigorous agent.

4 The Operational Modeling Language OMOS

We developed the operational modeling language OMOS to assess whether it is possible to fulfill the requirements of Section 3, and to evaluate their scope and utility. OMOS describes models on two levels: a generic problem-solving method and a domain. Methods are described in terms of inference actions (comparable to mechanisms [24] or KADS knowledge sources [27]) and roles that domain knowledge elements play (comparable to KADS metaclasses). Domains are described in terms of concepts and relations. OMOS is part of a larger venture to explore knowledge-modeling aspects [9]. Due to space limitations we cannot give a description of OMOS' internals. It has been used to develop a number of applications, for example office allocation [16], clamping tool selection [11], and to implement a KADS model of cancer-chemotherapy administration [17; 15].

We will briefly describe an application of OMOS and use it to show how OMOS handles the requirements listed in Section 3.

4.1 The Application Example

Clamping tool selection for lathe turning is part of a larger task of generating production plans for the manufacturing of rotational parts [2]. A clamping tool centers a workpiece in the lathe and transmits the rotational forces. Among others one distinguishes lathe dogs, lathe centers, clamping jaws, and collet chucks.

Clamping tools are characterized by the ways they fasten the workpiece in the lathe and the types of access that they allow the cutting tools. For example, lathe dogs hold the workpiece from the side and allow free access to all surfaces except the left and the right vertical planes. The types of access define the kinds of turning operations that can be effectuated to shape the workpiece.

Besides the accessibility of different sections of the workpiece surface there are other criteria. We consider the set-up time, that is, the time that is needed to mount the clamping tool on the lathe, and the clamping time, that is, the time that it takes to close the clamping tool when a new mold is inserted into the lathe. See [11; 14] for a detailed presentation of the task and the resulting model.

4.2 OMOS and the Requirements

Epistemological Modeling Primitives OMOS structures knowledge along two dimensions: the domain and the problem-solving method. For both it pro-

vides a set of KADS oriented representation primitives[1]that, in the sense of Brachman [3] are epistemological knowledge structuring primitives.

The Model of the Domain The model of the domain uses frames with instances, and relations with tuples as knowledge representation primitives. Frames provide structured definitions with inheritance, methods, attributes, default values, and possible value annotations; instances can be manipulated by the problem-solving process.

Table 1. The domain relation `optimal-clamping-tool` with two of its tuples.

```
(DEFINE-DOMAIN-RELATION Optimal-Clamping-Tool
 WITH ARITY = 2
     TYPE-SEQUENCE = (((INSTANCE Clamping-Tool)
                      (EXTENSION-* Turning-Requirement)))
     ARGUMENT-SEQUENCE =
                    ((Clamping-Tool Important-Turning-Requirements))
     TUPLES = ((
               ((Optimal-Clamping-Tool
                 Collet-Chuck
                  ((Transverse-Turning-P Required-Value = Yes)
                   (Inside-Turning-P Required-Value = No))))

                ((Optimal-Clamping-Tool
                  Lathe-Dog
                  ((Axial-Turning-p Required-Value = Yes)
                   (Inside-Turning-P Required-Value = No))))
                    ...
```

Associations between several instances are expressed through relations. Relations consist of a declaration of arity and argument types, and of a list of tuples (or a predicate that corresponds to such a list). For example in Table 1, the first tuple of the relation **optimal-clamping-tool** (linking clamping tools with turning requirements) states that the clamping tool *collet-chuck* is a good choice if transverse turning is required and inside turning will not be needed.

The Model of the Problem-Solving Method The problem-solving method is phrased in terms of changes and (intermediary) states. Changes are expressed as inference actions; (intermediary) states are called roles. Inference actions work on roles. They have *input*, *control*, and *output* roles. Input roles are consumed when they are read; control roles are not modified when read; output roles are

[1] For sake of readability, we use special type setting conventions for *domain concepts*, **domain relations**, INFERENCE ACTIONS, and roles.

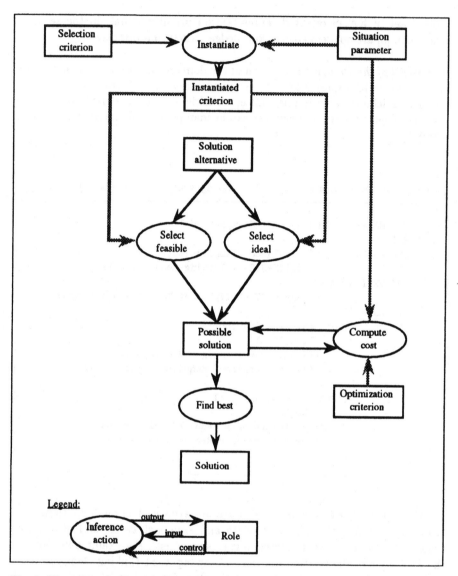

Fig. 1. The inference structure for the problem-solving method *selection by elimination and optimization* (adapted from [11]).

accessed for write operations only. The data-dependency diagram of roles and inference actions is called *inference structure*.

The description of the problem-solving method is generic, that means it is coined in terms like *select, specify, parameter, solution alternative*, etc. The elements of the method must be linked explicitly to their domain equivalents before an execution of the method can have any effect.

Figure 1 renders the inference structure for the problem solving method *selection by elimination and optimization*, used to solve the problem of clamping tool selection. Using the terms of that domain one obtains the following description. The choice of a good clamping tool to turn a workpiece is a selection process that observes (1) discrete selection criteria that eliminate unsuitable alternatives from the set of possible clamping tools (e.g., inside turning is a knock-out criterion for collet chucks); and (2) optimization criteria, which are used to single out a best choice on the basis of numerical ratings (e.g., best set-up time).

The use of the discrete criteria happens in two ways: (1) criteria can be used rigorously to select an ideal clamping tool; or (2) criteria can be relaxed somewhat to make a less-than-optimal choice, which is called a feasible choice. The second alternative is used if the first one does not result in a solution.

In the abstract terms of the inference structure of Figure 1 the method proceeds as follows: (1) in a first step, the description of the workpiece to be turned (i.e., the situation parameter) is used to instantiate a set of criteria, which will be the basis for the selection of the clamping tool; (2) in a next step, SELECT-IDEAL tries to make an optimal choice of those clamping tools (i.e., the solution alternatives) that fulfill the instantiated criteria; (3) if this fails to produce possible solutions, a less-than-optimal choice is made through the inference action SELECT FEASIBLE. (4) on the basis of the workpiece description (i.e., the situation parameters), numerical costs are computed for all the possible solutions. This involves factors such as set-up time, clamping time, etc; and finally (4) the inference action SELECT BEST selects the clamping tool with the lowest costs.

In OMOS, change is described in terms of two primitives: (1) value assignment, and (2) role assignment. If an inference action *assigns a value*, then a domain instance that is denoted by the input role of the inference action can be assigned a new value. If the inference action performs a *role assignment*, then one of the domain instances that is described by its input role is assigned to another role. Note that this means that in OMOS every problem-solving method is described on the basis of these two elementary kinds of change (see Table 2 for the definition of an inference action). This typology of inferences and the consequences on the applicability of the language are discussed elsewhere [13; 15].

Reusable Templates Both models—domain and method—are described in a special terminology, independently of each other. Thus, theoretically parts of the domain and of the method could be reused. However, this has only been done for method definitions up to now. The core of the problem-solving method *selection by elimination and optimization*, which consists of first selecting a set of suitable

Table 2. The definition of the inference action SELECT-IDEAL with its corresponding roles (Lines 1, 2, and 3), value- and role-assignment descriptions (Lines 4 and 5).

```
      DEFINE-INFERENCE-ACTION Select-Ideal
(1)     WITH INPUT-ROLE = Solution-Alternative
(2)          OUTPUT-ROLE = Possible-Solution
(3)          CONTROL-ROLES = ((Instantiated-Criterion))
(4)          VALUE-ASSIGNMENT = FALSE
(5)          ROLE-ASSIGNMENT = TRANSFER
```

alternatives on the basis of several discrete criteria (*elimination*) followed by a single choice on the basis of a continuous criterion (*optimization*) has been reused for the modeling of the office allocation task (see also [14] for a discussion of this issue).

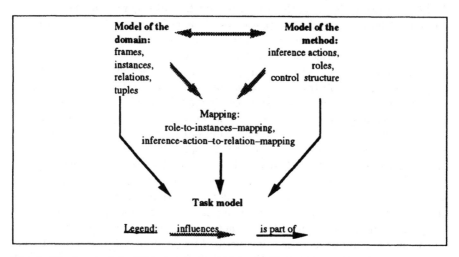

Fig. 2. The interaction of the domain, method, and task model in OMOS.

Multi-Faceted Modeling OMOS models real-world tasks from two perspectives: (1) the domain view concentrates on the structures of the phenomenon to be modeled, that is, it focusses on the types, their entities, and the relations among these entities; and (2) the method view focusses on processes, represented as changes and (intermediate) states. [17] discuss how this interaction helps the knowledge engineer in the process of making sense of a new, not yet fully understood phenomenon.

The domain view is represented in the domain model; the method view is

described in the method model. Both models are phrased independently of each other, but nevertheless there are strong interdependencies between them. The problem-solving method uses those distinctions that the domain model provides, and vice versa, the elaboration of the domain model is guided by the distinctions that the method requires. For example, we can make good use of the problem-solving method *hierarchical classification* only if the domain provides suitable hierarchical structures for the solution elements.

In OMOS the domain model and the method model must be congruent, as they merge into the *model of the task*. A simple mapping is established from roles to instances of frames, and from inference actions to domain relations. The model of the task is directly operational without any manual coding. Figure 2 shows the interaction of the models and their modeling primitives.

Formal Languages For each of its partial models OMOS provides a set of language constructs that are handled directly by the underlying interpreters. The domain language is an excerpt of formalisms provided by the object-oriented hybrid knowledge-representation environment BABYLON V2.2 [6; 4].

The language for the method model consists of object-oriented constructs that are instantiated at need. For example the definition of the inference action SELECT-IDEAL in Table 2 is an instantiation of the class *inference action.*

Besides being an implementation technology, the object-oriented approach allows us in this case to provide abstract interpreters for the inference actions, roles, control structures, instances, and domain relations. They are instantiated and parameterized when a developer creates an OMOS knowledge base. The advantages of this procedure are discussed in [8].

Thus on the one hand we obtain directly operational knowledge bases. On the other hand, due to the low-level primitives that we use to describe *all* inferences in the knowledge base (i.e., *value assignment* and *role assignment*) we can analyze important facets of the knowledge bases. OMOS provides two kinds of analysis tools. Some tools look at the domain knowledge only. The most useful tools however, look at the domain knowledge in the framework of the task model. They analyze the use of the tuples and instances by the method, and provide feedback such as the one given in Table 3. [11] show how this information guides the ongoing model elaboration, for example by filling the agenda for focussed interviews.

Note that the representation languages that OMOS provides for its various models are not *formal* in the sense of languages such as ML^2 [25], that is, they do not have formal semantics. They are analysable, and from the description of an OMOS model one can derive properties of the model.

5 Evaluation

To highlight the innovative aspects of our approach and to put our work in context we compare OMOS to two other approaches that are currently being developed and that share some of OMOS' goals, that is knowledge-base analysis

Table 3. The result of a dead-end analysis for the role solution alternative. It states that a certain intermediary result (i.e., a role assignment) can be computed, but that none of the follow-up inferences use this result. The analysis then proposes ways to change this by extending the knowledge of a certain domain relation.

```
The domain concept CLAMPING-JAW can be assigned to the role
SOLUTION-ALTERNATIVE, but it is not used by any of the inference
actions SELECT-IDEAL, SELECT-FEASIBLE that use
SOLUTION-ALTERNATIVE as control- or as input-role.

To change this do AT LEAST ONE of the following:

    Add a tuple to the relation OPTIMAL-CLAMPING-TOOL, which is used
    by the inference action SELECT-IDEAL. CLAMPING-JAW must be
    mentioned in the O. argument of the tuple, which is of type
    (INSTANCE CLAMPING-TOOL) and is called CLAMPING-TOOL.
    ...
```

to guide knowledge acquisition and integration of knowledge acquisition with system operation after system delivery: PROTÉGÉ-II [22; 23; 24] and SBF (Spark, Burn, Firefighter) [10; 18]. We are not comparing OMOS to KADS operationalization approaches such as KARL [1], Model-K [9] or ML^2 [25] because they have been built with a different purpose in mind, such as high-level knowledge-based systems specifications with well-defined semantics or KADS based, knowledge-level prototyping.

There are two major differences between our approach and the ones in SBF and PROTÉGÉ-II. Whereas OMOS allows a modeling from two facets (domain and method), SBF and PROTÉGÉ-II view the domain knowledge only in the light of the predefined knowledge structures that the methods—configured from mechanisms—provide. This means that one cannot start to model the entities of the domain before having chosen a suitable method. This has three implications. First, an analysis of initial protocols, texts, or interview data must be done outside the framework of the tool's knowledge structuring primitives, as a minimal amount of knowledge must be acquired about the real-world task before a method of problem solving can be phrased.

Second, the creative interaction between varying points of view, such as method and domain, is not supported.

Third, the domain knowledge appears to be represented as object-oriented refinement, respectively instantiation of method-depending building blocks. This may imply that a change in the method definition requires a re-coding of the domain knowledge.

However, the fact that PROTÉGÉ-II and SBF view the knowledge of a real-world task solely in the light of the method is advantageous, too.

In OMOS, the connection between method knowledge and domain knowledge

is established *after* the definition of both partial models. The connection is defined as a *mapping* relation between structures (e.g., between inference actions and domain relations; see Figure 2). In PROTÉGÉ-II and SBF it is a refinement, respectively instantiation relation. This is much *stronger* in McDermott's [19] terms. It defines precisely the structure and the kind of domain knowledge needed by the method. p-OPAL-like editors [21] can then be used to acquire it. A mapping relation—as OMOS provides—is much weaker. It can only be used to point out that the domain model must provide certain distinctions for the method (e.g., the domain must provide a relation that can be used by an abstraction inference). A mapping relation does not define the format for the representation of these distinctions.

The second difference lies in the ways mechanisms (or inference actions) are phrased. In PROTÉGÉ-II and in SBF, mechanisms are black boxes. In OMOS we defined simple knowledge structuring primitives. All actions are phrased uniformly in terms of value assignments and role assignments. We assume that such uniform representation makes it easier to derive coherent knowledge needs from a complex method. This will prevent redundant acquisition or representation of domain knowledge.

6 Conclusions

We developed OMOS as an experimental modeling language to show that the requirements of Section 3 can be fulfilled and that this leads to good knowledge engineering support. Thus the goal of OMOS is different from the goals of the PROTÉGÉ-II and SBF projects, which aim at the large-scale development of broadly usable tools. In the latter projects much effort has been invested into interface development and usability of the tools. OMOS, however is a programming environment that we have only used internally for experimental purposes.

Furthermore, OMOS is limited. It represents inference actions as value assignments and role assignments. Even though it has been used for the modeling of several applications, we know that additional primitives are needed, such as structure manipulation or instance creation.

Nonetheless, we claim that in the discussion about the role of explicit models in knowledge engineering, we have made two points. First, one can combine multifaceted modeling to make sense—as it is done in the KADS conceptual models, which are not operational—with directly operational systems and knowledgeable tool support for the acquisition of the detailed knowledge—as it is done in PROTÉGÉ-II or SBF.

Second, it is not absolutely necessary to structure the knowledge of a real-world task only along pre-defined structures of a problem-solving method if one wants to obtain operational models. A parallel modeling of the domain and the method is not only possible, but advantageous—provided that both models converge.

Thus, we have shown one way of supporting knowledge engineering as an activity that encompasses both *modeling to make sense* and *modeling to build*

systems with an operational modeling language, that on the one hand side is a suitable tool to construe new situations, and on the other hand side is operational and provides focussed feedback for the ongoing knowledge engineering process.

Acknowledgement

Wolfgang Gräther, Werner Karbach, Karin Lagrange, and Angi Voß provided useful comments on earlier versions of this paper. Gabi Schmidt and Otto Kühn helped me in the development of the clamping tool example.

References

1. Jürgen Angele, Dieter Fensel, Dieter Landes, and Rudi Studer. KARL: An executable language for the conceptual model. In John H. Boose and Brian R. Gaines, editors, *Proceedings of the 6th Banff Knowledge Acquisition for Knowledge-Based Systems Workshop*, pages 1/1 – 1/20, Calgary, 1991. AAAI, University of Calgary.

2. Ansgar Bernardi, Harold Boley, Christoph Klauck, Philip Hanschke, Knut Hinkelmann, Ralf Legleitner, Otto Kühn, Manfred Mayer, Michael Richter, Franz Schmalhofer, Gabi Schmidt, and Walter Sommer. ARC-TEC: Acquisition, representation and compilation of technical knowledge. In Jean-Paul Haton and Jean-Claude Rault, editors, *Proceedings of Avignon 91*, volume 1, pages 133 – 145, Avignon, France, 1991. EC2.

3. Ronald J. Brachman. On the epistemological status of semantic networks. In N.V. Findler, editor, *Associative Networks: Representation and Use of Knowledge by Computers*, pages 3 – 50 50. Academic Press, New York, 1979.

4. Thomas Christaller, Franco di Primio, and Angi Voß. *Die KI-Werkbank BABYLON*. Addison Wesley, Bonn, 1989.

5. William J. Clancey. The knowledge level reinterpreted: Modeling how systems interact. *Machine Learning, Special Issue on Knowledge Acquisition*, 4(3, 4):285 – 292, 1989.

6. Franco di Primio and Karl Wittur. BABYLON, a meta-interpretation model for handling mixed knowledge representations. In *Proceedings of the 7th International Workshop on Expert Systems and Their Applications*, volume 1, pages 821 – 833, Avignon, 1987.

7. Ute Gappa and Karsten Poeck. Common ground and differences of the KADS and stong-problem-solving shell approach. In Thomas Wetter, Klaus-Dieter Althoff, John Boose, Brian Gaines, Marc Linster, and Franz Schmalhofer, editors, *Current developments in knowledge acquisition-EKAW92*, volume 599 of *LNAI*, pages 75 – 94, Heidelberg, 1992. Springer-Verlag.

8. Werner Karbach, Marc Linster, and Angi Voß. Models, methods, roles and tasks: Many labels - one idea? *Knowledge Acquisition*, 2(4):279 – 300, 1990.

9. Werner Karbach, Angi Voß, Ralf Schukey, and Uwe Drouven. MODEL-K: Prototyping at the knowledge level. In *Proceedings of the First International Conference on Knowledge Modeling and Expertise Transfer*, Sophia Antipolis, France, 1991.

10. Georg Klinker, Carlos Bhola, Geoffroy Dallemange, David Marques, and John McDermott. Usable and reusable programming constructs. In John H. Boose and Brian R.

Gaines, editors, *Proceedings of the 5th Banff Knowledge Acquisition for Knowledge-Based Systems Workshop*, pages 14/1 – 14/20, Calgary, 1990. AAAI, University of Calgary.

11. Otto Kühn, Marc Linster, and Gabi Schmidt. Clamping, COKAM, KADS and OMOS. In *Proceedings of EKAW91*. University of Strathclyde, 1991. Also published as Technical Memo TM-91-03 of DFKI, Kaiserslautern.

12. Marc Linster. Explicit and operational models as a basis for second generation knowledge-acquisition tools. In Jean-Marc David, Jean-Paul Krivine, and Reid Simmons, editors, *Second generation expert systems*. Springer, 1992. Forthcoming.

13. Marc Linster. *Knowledge acquisition based on explicit methods of problem-solving*. PhD thesis, University of Kaiserslautern, Kaiserslautern, February 1992.

14. Marc Linster. Linking modeling to make sense and modeling to implement systems in an operational environment. In Thomas Wetter, Klaus-Dieter Althoff, John Boose, Brian Gaines, Marc Linster, and Franz Schmalhofer, editors, *Current developments in knowledge acquisition: EKAW92*, volume 599 of *LNAI*, pages 55 – 74, Heidelberg, 1992. GI, ECCAI, Springer-Verlag.

15. Marc Linster. Using OMOS to represent KADS conceptual models. In Guus Schreiber, Bob Wielinga, and Joost Breuker, editors, *KADS: A principled approach to knowledge-based system development*, pages 357 – 382. Academic Press, 1992.

16. Marc Linster. Using the operational modeling language OMOS to tackle the Sisyphus'92 office-planning problem. In Marc Linster, editor, *Sisyphus'92: Models of problem solving*, volume 630 of *Technical report of GMD*, St. Augustin, 1992. GMD.

17. Marc Linster and Mark Musen. Use of KADS to create a conceptual model of the ONCOCIN task. *Knowledge Acquisition*, 4(1):55 – 88, 1992.

18. David Marques, Georg Klinker, Geoffroy Dallemange, Patrice Gautier, John McDermott, and David Tung. More data on reusable programming constructs. In John Boose and Mark Musen, editors, *Proceedings of the 6th Banff Knowledge Acquisition for Knowledge-Based Systems Workshop*, pages 14/1 – 14/19, University of Calgary, 1991. AAAI, University of Calgary.

19. John McDermott. Preliminary steps toward a taxonomy of problem-solving methods. In Sandra Marcus, editor, *Automating Knowledge Acquisition for Expert Systems*, pages 225 – 256. Kluwer Academic, Boston, 1988.

20. Katharina Morik. Underlying assumptions of knowledge acquisition and machine learning. *Knowledge Acquisition*, 3:137 – 156, 1991.

21. Mark A. Musen. *Automated Generation of Model-Based Knowledge Acquisition Tools*. Research Notes in Artificial Intelligence. Pitman Publishing, London, 1989.

22. Mark A. Musen and Samson W. Tu. A model of skeletal-plan refinement to generate task-specific knowledge acquisition tools. Knowledge systems laboratory ksl-91-05, Stanford University, 1991.

23. Angel Puerta, John Edgar, Samson Tu, and Mark Musen. A multiple-method knowledge-acquisition shell for the automatic generation of knowledge-acquisition tools. In John Boose and Brian Gaines, editors, *Proceedings of the 6th Banff Knowledge Acquisition for Knowledge-Based Systems Workshop*, pages 20/1 – 20/19, University of Calgary, 1991. AAAI, University of Calgary.

24. Samson Tu, Yuval Shahar, John Dawes, James Winkles, Angel Puerta, and Mark Musen. A problem-solving model for episodic skeletal-plan refinement. In John Boose and Brian Gaines, editors, *Proceedings of the 6th Banff Knowledge Acquisition for Knowledge-Based Systems Workshop*, pages 34/1 – 34/20, University of Calgary, 1991. AAAI, University of Calgary.

25. Frank van Harmelen and Jan Balder. (ML)2: A formal language for KADS models of expertise. *Knowledge Acquisition*, 4(1):127 – 161, 1992.
26. Bob Wielinga and Joost Breuker. Models of expertise. In *European Conference on AI*, Brighton, 1986.
27. Bob Wielinga, Guus Schreiber, and Jost Breuker. KADS: A modelling approach to knowledge engineering. *Knowledge Acquisition*, 4(1):5 – 54, 1992.

Cases as a Basis for Knowledge Acquisition in the Pre-Formal Phases of Knowledge Engineering

Sonja Branskat

Department of Computer Science,The University of Calgary, 2500
University Drive N.W.
Calgary, Alberta, Canada T2N 1N4

Marc Linster

AI Research Division, GMD, PO Box 1316, 5205 St. Augustin 1, Germany

Abstract. Modelling and formalizing knowledge are fundamental issues of
knowledge acquisition. We argue that this process must be documented. The
media break in the knowledge acquisition process—occurring in the
transition from the informal knowledge to a formalized knowledge base—is
one reason for lacking documentation. The system UFA supports and
documents knowledge modelling and formalization of case-based
knowledge. The knowledge engineer formalizes a case starting with an
informal case description and transforms it, step by step, into a formal one.
The case descriptions are based on a domain independent case model that has
five components: context, problem, solution trace, solution and evaluation
of the solution. They are instantiated and refined as the formalization
proceeds.

I. Introduction

The construction of knowledge-based systems can be sub-divided into several phases:
(1) initial knowledge elicitation and acquisition; (2) knowledge interpretation and
structuring; (3) detailed knowledge acquisition; (4) operationalization (see for
example Karbach & Linster, 1990). In the first phase, the knowledge engineer goes
through knowledge acquisition interviews (LaFrance, 1987); he protocols the expert's
utterances when he thinks aloud when solving a problem (Diederich, 1987; Ericsson
& Simon, 1984), and he acquires knowledge from documents, such as technical
manuals or background literature (Schmidt & Schmalhofer 1990). All these
techniques produce semi-structured documents. In the second phase, the knowledge
engineer identifies higher level structures, such as a domain ontology or problem
solving methods (Puppe, 1990), and transforms the acquired knowledge in the
representation formalisms required by these higher-level structures.

This paper discusses support for the knowledge engineer in the first two phases of
the development process. We concentrate on one special knowledge acquisition
technique: the acquisition of knowledge from cases (Bartsch-Spoerl, 1987). We
discuss the importance of cases for knowledge acquisition, and we identify techniques

and formalisms that can be used to extract higher-level structures from cases, without loosing the contact between the original knowledge documents (e.g., tape recordings, pictures, texts, video footage) and the formalized knowledge representation, resulting from the second phase. We briefly present the system UFA, that has been built to provide practical support for the knowledge engineer in the transition from informal to formal knowledge representations.

2. The Media Break and the Lack of Documentation

Many knowledge elicitation techniques are based on interviewing, observing, or protocoling how an expert solves a problem, that is, they are recordings of cases from the expert's experience (Neale, 1988). Interview protocols recorded on audio or video tape are the closest and most detailed knowledge representations of the expertise. We refer to these tapes as the *informal knowledge base*. The knowledge engineer formalizes the informal knowledge base, step by step, going through a sequence of *pre-formal knowledge bases*. Interviews and observations recorded on audio and video tapes are clustered into relevant snap shots. Transcripts are written, analyzed and visualized using diagrams. Concepts and their relationships are extracted from the transcripts to create a formal knowledge base, which uses representation formalisms offered by expert system shells. The different knowledge bases on tape, paper and disk contain the different versions of the same information, which vary in the degree of formalization and detail which are stored on different media. This phenomenon is called the *media break* (Karbach & Linster, 1990).

In general, the original data—represented as transcripts, pictures, or video footage—are not part of the formal knowledge base, and what is even more relevant, there is no documentation of the formalization process. There is no link back from a rule to the document that motivated the knowledge engineer to create the rule, or select a special problem-solving method. However, the documentation is essential, as there exists no theory and no commonly used procedure to construct knowledge bases, and experience shows that revisions are frequent in the design process. One technical reason, why this process cannot be documented is attributed to the media break.

The idea of our approach is to integrate the pre-formal knowledge bases into the expert system. Concentrating on case-based knowledge, we propose a case model that provides guidelines for modelling and formalizing cases. A hypermedia system is used to store and access informal, pre-formal and formal knowledge. Thereby, the formalization process is supported and documented, and the media break does not occur.

3. Cases

Cases are an important source of knowledge in the knowledge acquisition process. Techniques, such as observations and interviews are based on cases (Neale, 1988). In a complex world, where it is not possible or practical to specify all rules, cases are elementary (Riesbeck, 1989).

> *"In fact, in very difficult cases, where the situation is not so clear-cut, experts frequently cite previous cases that they have worked on that the current case reminds them of" (Riesbeck, 1989) p 10*

Cases, as opposed to rules, provide aspects of context of the applied problem solving knowledge (Becker, 1988). If we know about the context, then certain problems are easier to solve, for example the selection of an appropriate problem solving method or the resolution of ambiguity of terms used. Furthermore, there is strong evidence that knowledge exists only in context and that it is knowledge only in relationship to other knowledge (Winograd, 1986; Becker, 1988; Compton & Janssen, 1990; Shaw & Woodward, 1990).

3.1 Case-Based Reasoning Systems

Case-Based Reasoning systems (CBR) are knowledge-based systems that solve new problems or cases based on previous experiences. The actual case is compared to the cases stored in the knowledge base and a similar case is determined. A solution for the actual case is derived by modifying the solution of the selected case. CBR systems use a wide variety of representation formalisms and indexing mechanisms to store and retrieve cases. There exists, however, no unique case model (Branskat, 1990).

"The best answer to this is that, in a broad sense, everything is a case. The word case just refers to an experience" (Riesbeck, 1989) p 11

"There remains a lack of consensus as to exactly what information should be represented in a case." (Hammond & Converse, 1989) p 15

3.2 Case Model

In order to model cases and to support a standardized formalization, we need a domain independent (i.e., generic) case model. As the knowledge engineer describes an actual case he refines the generic case model to create a domain dependent case description.
Influenced by CBR systems (Kolodner, 1988), the proposed case model identifies several components of a case: (1) problem, (2) solution path, and (3) solution. Furthermore, we add (4) context and (5) evaluation of the solution to these components.

As argued before, the context is an important knowledge source used to resolve ambiguities, to select a problem solving method and to understand the solution. Therefore, the context of a case is regarded as a necessary case component. We can never capture all the context, but we try to situate the case as much as possible.

An evaluation of the solution is included due to the following reasons:

- In one of our domains of application—business graphics, e.g., charts, diagrams—the expert included an evaluation of the solution as an integrated part of his case description. The evaluation revealed case specific problem solving knowledge, such as "in general, this a not a good a solution, however in this specific case ...".

- The CBR system CHEF (Hammond & Converse, 1989) stores a classification of the solutions (successful or not successful) with the cases to avoid repetitions of unsuccessful solutions.

In summary, the case model defines five components for each case: *context, problem, solution path, solution* and *evaluation of the solution*. Cases from two domains of application *Office Planning* and *Business Graphs* show that this case model

provides a complete description of cases and vice versa that the case components contribute essentially to a case description (Branskat, 1990).

Example: An abstract of the initial description of a graph illustrates the case components (see figure 2). *Context:* The graph was originally published in 1989 in the weekly journal, "Der Spiegel". The graph illustrates an article that emphasizes automobiles as an important cause for air pollution. Its size is 10 * 6 cm. *Problem:* The graph points out that compared to households, industry and power plants, automobiles are the main contributor to air pollution, especially for the poisonous carbon monoxide. *Solution path:* The contribution of two groups in four different classes are compared: sulfuric oxides, nitrous oxides, hydro-carbons and carbon monoxide. Both, bar graphs and multiple pie charts is appropriate. For values just above 0% and 50% pie charts show the contribution more clearly than bar graphs.*Solution:* Four pie charts, one for each substance, show the contributions. The substances are ordered form left to right with increasing toxicity. Pollution by automobiles is starting at the 12 o'clock line. See graph. *Evaluation:* This is a good visualization for the following reasons: 1) the 3% and 54% of pollution are expressed clearly, and 2) the substance description fits well beneath the pie charts.

3.3 Formalizing Cases

In this paper we concentrate on formalizing cases, as opposed to CBR systems that deal with generalizing cases. Formalization means eliminating ambiguities and misunderstandings in case descriptions and structuring cases systematically (Brockhaus, 1989). In detail, formalization includes:

1) describing a case verbally,

2) structuring case descriptions,

3) standardizing the case descriptions, to reach a systematic appearance of case descriptions,

4) resolving misunderstandings due to ambiguous formulations.

Formalization is a prerequisite for generalization since an unambiguous, systematic, and well-structured representation is a requirement for generalization. Generalization applies case based knowledge to new cases developing general rules.

3.4 Representation Formalism for Cases

Based on an overview of representation formalisms used for cases (Branskat, 1990), memory organization packages (MOPs) (Schank, 1985) were chosen as a basic formalism. In principle, MOPs are scripts (Schank & Abelson, 1977) that are related by typed links forming a network. The link types are scene links, abstraction links, index links, exemplar links and failure links. These links are used to navigate through the knowledge base and to retrieve information. MOPs are designed to handle generalizations of cases. MOPs form a hierarchy of increasing generalized case descriptions using abstraction and index links. Formalization, however, results in a linear sequence of increasingly formalized descriptions of the same case. Therefore, we

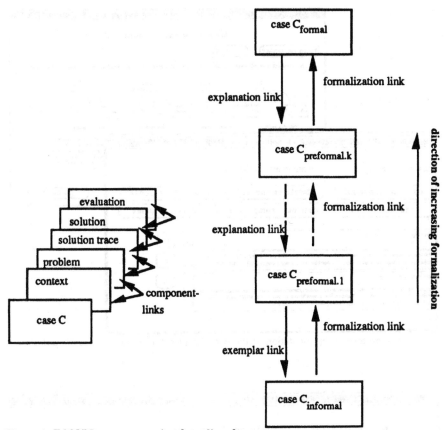

Figure 1: F-MOPS, a representation formalism for cases.

extended the definition of MOPs by adding another link and defined *formalization MOPs* (F-MOPs).

F-MOPs have four link types (see Figure 1):

- Component links organize the hierarchical decomposition of cases into components and sub-components.

- Formalization links point from the informal or a pre-formal case description to the next, more formalized description.

- Explanation links point from a more formalized description to the next, less formalized description.

- Exemplar links point from the first pre-formal description to the informal one.

Figure 2: A preformal representation of the component *solution* for the case *air pollution*.

air pollution		
case: air pollution	**Component: solution**	
add subcomponent	delete subcomponent	move subcomponent
add annotation	goto next component	attribute / value

charttype : (chart multiple-circle)

choose-of-colors : (main-statement black) (subordinate-statement white)

label : (circle-segments relative-value) (additional-to-circles glossary-entry-below)

order-of-data : (order increasig-importance)

Figure 3: The component *solution* of the case *air pollution*: a complete formalized version.

The formalization sequence: The informal knowledge base is formed by the interview protocols recorded on audio or video tapes. The five case components context, problem, solution path, solution, and evaluation are identified on the tapes

and stored as the informal, but structured, case description (see Figure 1: caseC$_{informal}$).

In the next step, a new case description is created, by further structuring sections of tapes that describe the case components. They are decomposed into sub-components described by key scenes. The scenes may be annotated textually and graphically.

In the following case descriptions, sub-components are themselves structured into sub-components (see Figure 1: caseC$_{preformal.k}$). Each sub-component is described by a piece of tape, a graph, or text. With an increased formalization level, the descriptions become increasingly structured. Figure 2 shows part of a pre-formal description that use text and graphics. The top card is the component card *solution* containing the textual description, the annotation card in the back shows the graph as the graphical description of the chart type and the labeling. Functions such as *add, move, delete, rename* a sub-component and *declare as attribute/value pair* etc. are provided. Finally, purely textual descriptions are used, which are subsequently reduced to an attribute/value pair. The attribute/value representation is a commonly used representation for CBR systems (Kolodner, 1988). Figure 3 shows a formal description of the *solution*. Here, the subcomponents are declared as attribute/value pairs which allow for further functionality such as *specify the value range for the attribute* and *check if values are in the specified range*.

4. The System UFA[1] for Stepwise Case Formalization Without Media-Break

UFA (Branskat, 1990; Branskat, 1991) is a hypermedia-based system to represent and structure cases at varying levels of formalization. It is implemented in HyperCard (2.0) on the Macintosh. The system allows the knowledge engineer to represent non-formalized cases as pictures, graphics, and free text. The current version does not support video or tape access. At a more formal level of representation, it supports a structured attribute/value description of cases. The system is implemented and has been tested in the domain of business graphs. It meets the following objectives:

- **Domain independence.** Using the domain independent case model, UFA requires a knowledge engineer to structure each case into the components context, problem, solution path, solution and evaluation of the solution. Each further structuring is domain dependent and remains a task of the knowledge engineer.

- **Avoiding the media break.** To integrate informal, pre-formal and formal knowledge bases using different media, such as texts, graphics, and bitmaps UFA is implemented in a hypermedia environment.

- **Supporting functions for the formalization process.** 1) A *synonym dictionary* collects synonyms. 2) A *replace function* allows the user to replace terms for selected cases in order to obtain a standardized case description on all formalization levels. 3) A *concept dictionary* stores multi-media descriptions of concepts. 4) A user can work simultaneously on as many case descriptions as necessary.

[1]UFA is an acronym for Unterstützung fallbasierter Wissensakquisition

- **Documenting the formalization process.** The comprehensive documentation features of UFA encourage the knowledge engineer to document the formalization process. He can copy an actual description into the next formalization level and change it by editing. There is no limitation on the number of successive case descriptions expressing various degrees of formalization.

5. Conclusions

The aim of this paper was to present a support system for formalizing case-based knowledge and for documenting the knowledge transformation process. At the outset, we developed a case model and a data structure to represent different descriptions of a case at varying degrees of formalization, starting out from informal descriptions on text, pictures or sounds, and ending up with a formal description in the terms of operational knowledge representation environments. The system supports the formalization process. The formalized case representation is common for CBR systems and for conventional expert systems. It can be used to initiate further knowledge elicitation with tools like KSS0 (Shaw & Gaines, 1987).

Further Work

- The case model must be extended to cope with aggregate cases that are composed from sub-cases.

- UFA is a prototype and this study has shown that it is promising to extend it to integrate film sequences into the system.

- UFA should be integrated with an expert system workbench. An example is the HYPER-KSE system, which integrates a knowledge acquisition tool and the expert system workbench BABYLON (Christaller, DiPrimio and Voß, 1990) in a hypermedia environment to combine an informal non-interpretable and a formal, interpretable knowledge base (Gaines & Linster, 1990). The integration with an expert system workbench is desirable as the running expert system provides feedback if the case descriptions are appropriate or if they have to be refined.

6. Acknowledgment

We are grateful to Barbara Becker, Thomas Christaller and the other members of the Artificial Intelligence Research Division of GMD who participated in the discussions that were relevant for this paper. Brian Gaines made valuable comments on a previous version of this article.

7. References

Bartsch-Spoerl, Brigitte (1987) Ansätze zur Behandlung von fallorientiertem Erfahrungswissen in Expertensystemen. *Künstliche Intelligenz 4*, pp.: 32–36.
Becker, Barbara (1988). Towards a concept for case-based knowledge-acquisition; In *Proceedings of the European Knowledge Acquisition Workshop (EKAW'88)*.

Branskat, Sonja (1990) *Fallbasierte Wissensakquisition: Akquisition und Repräsentation von Fällen in der präformalen Phase der Wissensakquisition* Diplomarbeit, FernUniversität-Hagen.

Branskat, Sonja (1991) Case-based knowledge acquisition in a pre-formal phase. In: *Proceedings of the 6th knowledge-acquisition for knowledge-based systems workshop (Banff91)*, Boose, J, & Gaines, B. (eds). University of Calgary, Calgary.

Brockhaus-Enzyklopädie 19. Auflage (1989); Mannheim: Brockhaus.

Christaller, Thomas, DiPrimio Franco, and Voß, Angi (eds) (1990) *Die KI-Werkbank BABYLON;.* Addison Wesley, Bonn

Compton, P. and Jansen, R. (1990) A philosophical basis for knowledge acquisition; *Knowledge Acquisition 2* , 241-257.

Diederich, Joachim (1987): *Wissensakquisition,* Tech. Rept. 245, Arbeitspapier der GMD, GMD, März 1987.

Ericsson, A., and Simon, H. (1984) *Protocol analysis: Using verbal reports as data.* MIT Press, Cambridge.

Gaines, Brian, and Linster, Marc (1990) Integrating a Knowledge Acquisition Tool, an Expert System Shell and a Hypermedia System. *International Journal of Expert Systems,* 3, pp.: 105 – 129.

Karbach, Werner and Linster, Marc (1990) *Wissensakquisition für Expertensysteme: Techniken, Modelle und Softwarewerkzeuge;* Hanser Verlag.

Hammond, Kristian and Converse, Timothy (1989) Panel discussion on case representation; In *Proceedings of a Workshop on Case-Based Reasoning,* Morgan Kaufmann Publisher, Inc.

HyperCard (1988) *HyperCard Script Language Guide The HyperTalk Language;* Addison-Wesley (July 1988)

Kolodner Eds. (1988) *Proceedings of a Workshop on Case-Based Reasoning*

LaFrance, M.(1987) The Knowledge Acquisition Grid: A Method for Training Knowledge Engineers; *Int. Journal of Man-Machine Studies 26* , pp. 245-255

Neale, I.M. (1988) First generation Expert Systems: a review of Knowledge Acquisition Methodologies; *The Knowledge engineer review 3* , pp. 105-146.

Puppe, Frank (1990) *Problemlösungsmethoden für Expertensysteme*. Springer Verlag, Heidelberg.

Riesbeck Ch. (1989) Inside *Case-Based Reasoning;* Lawrence Erlbaum Associates, Hillsdale, New Jersey.

Schank, R.C. and Abelson, R.P.(1977) *Scripts, plans, goals, and understanding;* Hillsdale: Lawrence Erlbaum .

Schank, Roger C. (1985) *Dynamic memory;* Cambridge University Press.

Schmidt, Gabi, and Schmalhofer, Franz (1990) Case-oriented knowledge acquisition from texts. In Wielinga, B., Boose, J., Gaines, B., Schreiber, G. and von Someren, M. (eds.) *Current trends in knowledge acquisition (EKAW'90)*. Amsterdam, IOS Press, pp. 302–312.

Shaw, Mildred L.G. and Gaines, Brian (1987) An Interactive Knowledge Elicitation Technique Using Personal Construct Technology; In *Knowledge Acquisition for Expert Systems*; Plenum Press; ed. Kidd, A.; New York.

Shaw, Mildred L.G. (1988) Problems of Validation in a Knowledge Acquisition System using Multiple Experts; In *Proceedings of EKAW88*, ed. Boose, John H., Gaines, Brian R., and Linster, Marc, GMD, St. Augustin, pp. 5/1 - 5/15.

Shaw, Mildred L. and Woodward, Brian (1990) Modelling expert knowledge; *Knowledge Acquisition 2*, pp. 179-206.

Winograd, Terry and Flores, Fernando (1986) *Understanding Computers and Cognition;* Ablex Publishing, New Jersey.

Controlling generate & test in any time

Carl-Helmut Coulon$^\diamond$ and Frank van Harmelen° and Werner Karbach$^\diamond$ and
Angi Voß$^\diamond$

$^\diamond$German National Research Institute for Computer-Science (GMD)
P.O. Box 1316, D-5205 Sankt Augustin
°University of Amsterdam
Roeterstraat 15, NL-1018 WB Amsterdam
e-mail: avoss@gmdzi.gmd.de

Abstract. Most problem solvers have a one-dimensional stop criterion:
compute the correct and complete solution. Incremental algorithms can
be interrupted at any time, returning a result that is more accurate the
more time has been available. They allow the introduction of time as a
new dimension into stop criteria. We can now define a system's utility in
terms of the quality of its results and the time required to produce them.
However, optimising utility introduces a new degree of complexity into
our systems. To cope with it, we would like to separate the performance
system to be optimised from utility management.
Russell has proposed a completely generic precompilation approach
which we show to be unsatisfactory for a generate & test problem solver.
Analysing this type of systems we present four different strategies, which
require different information and result in different behaviours. The strat-
egy most suitable to our application requires on-line information, and
hence had to be implemented by a meta-system rather than a precom-
piler. We conclude that universal utility managers are limited in power
and are often inferior to more specialised though still generic ones[1].

1 Motivation

KBS must take time into account: Knowledge-based systems are often built
to cope with really hard problems. Although AI is famous for tackling NP-hard
problems, its systems usually do not consider the time that any benevolent user
may be ready to wait. They are designed and fine-tuned to achieve a fixed stop
criterion. For example, most diagnosis systems stop when they reach a leaf in the
diagnosis hierarchy. However, if the problem space of such systems is equipped
with a notion of incomplete, approximate or partial solutions, the user might
sometimes prefer a quick, though approximate, solution.

[1] The research reported here was carried out in the course of the REFLECT project.
This project is partially funded by the Esprit Basic Research Programme of the
Commission of the European Communities as project number 3178. The partners
in this project are the University of Amsterdam (NL), the German National Re-
search Institute for Computer-Science GMD (D), the Netherlands Energy Research
Foundation ECN (NL), and BSR Consulting(D).

Entering a new dimension of utility: Real time systems have recently been defined to be systems whose utility gracefully decreases the shorter they are run [2] [1]. They are based on incremental or interruptible anytime-algorithms whose quality of the output increases over time. These are by no means rare creatures. In principle, every loop is a candidate to be turned into an incremental procedure. Incremental, interruptible, or anytime algorithms introduce a new degree of freedom when defining system utility. Instead of concentrating on the ultimate, most correct solution, we can try to obtain maximal quality within a given time span, or try to reach a minimum quality as quickly as possible, or combine both. Thus, the utility of a system becomes a function of time $U(t)$.

Utility should be handled orthogonally: This new degree of freedom must be used carefully, so as not to introduce a new dimension of complexity into our systems. Ideally, a KBS should be designed as before, and utility optimisation should be handled by a separate component. Beside the utility function to be achieved, such a utility manager needs certain information about the performance of the underlying system. If all relevant information is available before run time, a precompiler would do perfectly.

A utility manager for generate & test: Generate & test is a frequently employed problem solving method in AI: in diagnosis, hypotheses are generated and tested; in search, successor states are generated and evaluated; in design, solutions are proposed & revised; in planning plans are generated and tested by execution. In this paper, we present the principles of generic utility management for the class of generate & test problem solvers. We elaborate four strategies of switching between generation and test in order to maximise the number of solutions given a maximal time limit. The goal of this paper is *not* to present sophisticated strategies for controlling generate & test. In fact, with the possible exception of the fourth strategy, the strategies we discuss are rather obvious. Instead, the goal of this paper is to present a method of comparing such strategies, and to introduce the parameters that are involved in such comparisons.

A comparison to Russell and colleagues will round off the paper. Although developed independently, their motivation on utility is very similar to our's. In [4] they propose a precompiler separating the algorithmic design of real-time systems from optimising their utility. The latter task is automated based on so-called performance profiles for the basic algorithms. Although we appreciate their intention, we doubt the practicality of their assumptions. While they derive the overall performance profile of a system from those of its basic algorithms, we would like to specify the overall performance profile without having to supply any profiles for the basic steps. Moreover, we have several potential overall performance profiles, but cannot determine the right one statically, so that precompilation is not suitable. In the meantime Russel's & Zilberstein's system maintains several performace profiles and introduces a monitoring component which switches between them at run-time[2]. But we still see the problem of determining which profile to apply in a specific situation.

[2] Personal communication.

2 A utility function for generate & test

We consider a class of object systems that employ a generate & test problem solving method to produce all possible solutions.

Definition of generate & test algorithms: The generate-phase of such algorithms generates candidates for a full solution which are subsequently tested on their correctness. The characteristics that candidates for *full* solutions must be generated excludes an algorithm as propose & refine from our analysis since it proposes a *partial* solution which is subsequently refined on the basis of the test results.

Importance of generate & test algorithms: Although generate & test algorithms are among some of the oldest AI, and feature in every text book, they are in general regarded as not very efficient. It is true that non-heuristic generate & test algorithms of the kind discussed in this paper do not scale up to very large search spaces. Nevertheless, generate & test algorithms were the basis of such programs as DENDRAL [3], one of the few successful early AI programs that were ever used in practice. The crucial insight there was to first use a planning process that uses constraint-satisfaction techniques to create lists of recommmended candidates. The generate & test procedure than uses those lists so that it can explore only a fairly limited set of candidates. This shows that even the fairly simple version of non-heuristic generate & test that we study in this paper can be of interest in full scale application systems.

Both generate and test are conceived as incremental algorithms that can be called repeatedly in order to generate resp. test a next hypothesis. We thus have the following data flow of the underlying system:

$$input \Longrightarrow GENERATE \Longrightarrow hypotheses \Longrightarrow TEST \Longrightarrow solutions$$

As a stop criterion we want to impose upon such systems a lower bound on the number of solutions to be produced, and an upper bound on the time to be spent:

$$stop(sol, t) := sol \geq sol_{min} \lor t \geq t_{max} \tag{1}$$

with sol $:=$ number of solutions produced by the system
 $sol_{min} :=$ minimum number of solutions desired
 t $:=$ time needed by the system
 t_{max} $:=$ upper bound on the run-time of the system

The parameterised stop criterion specifies the minimally required quality of the system output. Often, only one solution may be necessary (i.e. $sol_{min} = 1$), but sometimes the system does not have all knowledge, e.g. because it is too difficult to represent. Then the human user may want to see alternative solutions to choose among using his additional knowledge, which may be too difficult to represent in the system. We have also considered other stop criteria: simpler ones such as $stop(sol) := sol \geq sol_{min}$, and more complex ones that additionally

impose an upper limit on the number of solutions desired. Stop criterion (1 is a moderately complex one, whose analysis is sufficiently interesting for the purpose of this paper.

The stop criterion alone does not yet ensure the desired behavior. For instance, in formula (1) the system might just wait until the given time has passed (i.e. until $t > t_{max}$). The precise goal of the system is to reach the minimally required quality *as fast as possible* within the given time. That means, we want to minimise the time and maximise the number of solutions while observing the stop criterion:

$$U(sol, t) := \max\{\frac{sol}{t}|stop(sol, t)\} \tag{2}$$

To analyze this function we will refine its parameters, computation time t and solutions sol. In the most general case, the generate method may be invoked several times, followed by some invocations of the test method, and these two phases may be iterated a number of times. Additionally, switching between the two methods may cost additional time to store respectively reinstall the current state. The time spent is thus defined by:

$$t := \sum_{i=1}^{n} (\sum_{j=1}^{h_{gen_i}} t_{gen_{ij}} + t_{switch_i}^{gen \mapsto test} + \sum_{j=1}^{h_{test_i}} t_{test_{ij}} + t_{switch_i}^{test \mapsto gen}) \tag{3}$$

with

n := the number of times the system switches from generate to test;
h_{gen_i} := the number of hypotheses generated in the ith call to generate;
h_{test_i} := the number of hypotheses tested in the ith call to test;
$t_{gen_{ij}}$:= time to generate one hypothesis;
$t_{test_{ij}}$:= time to test one hypothesis;
$t_{switch_i}^{gen \mapsto test}$:= time to switch from generate to test;
$t_{switch_i}^{test \mapsto gen}$:= time to switch from test back to generate with $t_{switch_n}^{test \cdot gen} = 0$.

The number of solutions produced by the system corresponds to the sum of the probabilities p_{ij} of all tested hypotheses:

$$sol := \sum_{i=1}^{n} \sum_{j=1}^{h_{test_i}} p_{ij} \tag{4}$$

3 Analysis of four strategies for utility management

Simplifying assumptions. Before we will discuss four different strategies for controlling a generate & test system, we will introduce some assumptions that will simplify equations (3) and (4). We will assume that all generated hypotheses are tested (A1), that the times for switching from generation to test and vice versa

are constant and equal (A2), that the time to generate resp. test a hypothesis are equal for all hypotheses (A3), and that solutions are distributed uniformly among the hypotheses (A4).

$$(A1) \quad \forall i, 1 \leq i \leq n : h_{gen_i} = h_{test_i} = h_i$$

$$(A2) \quad \forall i, 1 \leq i \leq n : t_{switch_i}^{gen \mapsto test} = t_{switch_i}^{test \mapsto gen} = \frac{t_{switch}}{2}$$

$$(A3) \quad \forall i, j : t_{gen_{ij}} = t_{gen}; t_{test_{ij}} = t_{test}$$

$$(A4) \quad \forall i, j : p_{ij} = p$$

Justifying the assumptions Assumption (A1) no longer allows us to test only the most promising hypotheses. This assumption is automatically fulfilled in domains where all hypotheses *must* be tested, for instance because an exhaustive solution is required, or because the best solution is required. In many domains, no easy ranking of the hypotheses is possible, or more precisely: such ranking is often considered to be part of the test phase of the system, rather than as a way to control the behaviour of the overall cycle.

Assumption (A2), forces switching in both directions to be equally expensive and constant for all cycles. It seems rather realistic to assume switching time to be constant, since the switching cost is likely to be independent from the particular hyptheses that have just been generated or tested. The assumption that switching times in both directions are equal could easily be dropped, and our model could be trivially extended to deal with different switching times in both directions. We will however not present this extension in this paper since it only complicates matters without offering any new insights.

Besides motivating the constant and equal values of the switching times, we should also motivate why we consider switching time at all, in other words, why would $t_{switch} > 0$? The value of t_{switch} should be interpreted as the overhead of starting a new series of generating or testing steps, and there are many applications in which this overhead is indeed a considerable factor. In medical or mechanical diagnosis forinstance, the generation of new hypotheses often involves new measurements (on a patient or a device), and the overhead of starting a new series of observations (getting the patient in the lab, or halting and opening the machine) is often high compared to the cost of making the observations themselves.

Assumption (A3) states that generation and test times are equal for all hypotheses. This is an assumption that will hold in some domains and not in others. In game playing for instance, the costs of generating new board positions and evaluating them are indeed roughly independend from the particular board position. In other domains however, the testing time in particular is likely to vary for different hypotheses: the cost of testing solutions to a design problem may vary significantly across different solutions, because inconsistencies with the design constraints may show up immediately or only very late during the testing phase.

In such case, the parameter t_{test} should be regarded as the "average" cost of testing a hypothesis.

Of all our assumptions, (A4) is the most restrictive. It assumes that solutions are uniformly distributed across the hypothesis space, and this will often not be the case in realistic applications. In game playing for instance, the entire section of the search space below a losing move will be devoid of solutions, making the value of p in that section of the search space much lower then in other sections. It is mainly because of this assumption that our model must be seen as a first approximation of the behaviour of real systems, rather than as a model that captures the precise behaviour of these systems.

Applying the assumptions A1-A3 simplify equation (3) for the time required by the system to make n iterations as follows[3]:

$$t := \sum_{i=1}^{n} (h_i \cdot (t_{gen} + t_{test})) + n \cdot t_{switch} \tag{5}$$

We will now define different strategies for the generate & test algorithm by giving different definitions for the numbers h_i in this equation. They will lead to a different switching behavior between the generate and test phases. We will first concentrate on the time required to met the fist condition of the stop criterion ($sol \geq sol_{min}$) and in section 5 compare the number of solutions if $t \leq t_{max}$ is reached first.

The first part of the stop criterion requires that we compute at least sol_{min} solutions. This implies that the expected number of iterations between generate and test that are to be made in order to achieve the stop criterion is the lowest number n such that

$$sol_{min} \leq p \cdot \sum_{i=1}^{n} h_i \tag{6}$$

3.1 Strategy 1 - directly generate the right number of hypotheses

If we assume we know the probability p of a generated hypothesis to pass the test, we can estimate how many hypotheses we will need to obtain sol_{min} solutions in the first iteration, namely $\frac{sol_{min}}{p}$ hypotheses. There will be no need to switch back:

$$(S1) \ h_1 = \lceil \tfrac{sol_{min}}{p} \rceil \text{ implying } n = 1.$$

[3] This formula is not entirely correct since it assumes a last switch back from test to generation. To obtain the correct times for the strategies, half of t_{switch} should be subtracted in the time formulae given below. But we preferred to keep our formulae more readable, and the constant does not affect our comparison of the strategies.

This means that the expected time needed to compute sol_{min} solutions will be:

$$t_{sol_{min}} = \lceil \frac{sol_{min}}{p} \rceil \cdot (t_{gen} + t_{test}) + t_{switch} \tag{7}$$

This strategy is optimal since both the number of hypotheses generated and the number of switches is minimal. To implement the strategy, only h_1 must be computed, which can be done statically. The major problem with this strategy is of course that the probability p of a generated solution to pass the test is often not known.

3.2 Strategy 2 - eager generation:

This strategy exhaustively generates all possible hypotheses in the first call to generate (h_1), and then tests all of them. It, too, does not switch back. If we write h_{all} for the number of all possible hypotheses and sol_{all} for the number of all possible solutions, this strategy is defined by:

$$(S2) \ h_1 = h_{all} = \lceil \tfrac{sol_{all}}{p} \rceil \text{ implying } n = 1.$$

The formula for the runtime of the system is:

$$t_{sol_{min}} = \lceil \frac{sol_{all}}{p} \rceil \cdot (t_{gen} + t_{test}) + t_{switch} \tag{8}$$

The number of switches is minimal, but usually too many hypotheses are generated, since $sol_{all} \geq sol_{min}$, causing S2 to be more expensive than S1. Therefore, S2 can be recommended only when switching costs are very high, and $sol_{all} \approx sol_{min}$, so that not too many unnecessary hypotheses are generated. The advantage is that we need not have to know p. Notice that this strategy assumes that h_{all} is finite (since otherwise the first phase of the algorithm never terminates).

3.3 Strategy 3 - lazy generation:

The third strategy generates hypotheses one by one and directly tests each:

$$(S3) \ \forall i : h_i = 1 \text{ implying } n = \lceil \tfrac{sol_{min}}{p} \rceil$$

The expected time to compute sol_{min} hypotheses is:

$$t_{sol_{min}} = \lceil \frac{sol_{min}}{p} \rceil \cdot (t_{gen} + t_{test}) + \lceil \frac{sol_{min}}{p} \rceil \cdot t_{switch} \tag{9}$$

This strategy will not generate unnecessary hypotheses, but abounds in switches. It can be recommended only when switching time is low. If $t_{switching} = 0$ its behavior is equal to S1 and hence optimal.

3.4 Strategy 4 - generate the number of missing solutions:

The fourth strategy always generates as many hypotheses as there are solutions still missing:

$$(S4) \; \forall i : h_i = sol_{min} - sol_{i-1}$$

where sol_i is the total number of solutions found after completing the ith iteration and $sol_0 = 0$.

Applying (A1) and (A4) to (4) gives $sol_i = \lceil p \cdot \sum_{k=1}^{i} h_k \rceil$ which leads to $(1 - p)^{i-1} sol_{min}$ as an approximation for h_i, with which we can derive the following approximation for the expected run time:

$$t_{sol_{min}} \approx \frac{sol_{min}}{p} \cdot (1 - (1 - p)^n) \cdot (t_{gen} + t_{test}) + n \cdot t_{switch} \tag{10}$$

Again no superfluous hypotheses are generated. S4 will always behave at least as good as S3 because in comparing (10) and (9) we see that $(1 - (1 - p)^n) < 1$, and $n \leq sol_{min} \leq \frac{sol_{min}}{p}$. To implement S4 we have to compute the numbers h_i dynamically, whereas these numbers could be computed statically for S1-S3.

4 Comparison of the strategies when reaching $sol \geq sol_{min}$ first

S1 has optimal run-time, but requires knowledge of p, which is usually not available. It requires no additional computation during the execution of the generate & test algorithm.

S2 guarantees that $n = 1$, and is therefore good for $t_{switch} \gg (t_{gen} + t_{test})$. The extra costs of S2 are limited if $sol_{all} \approx sol_{min}$. S2 does not require p, and involves no additional computations.

S3 is the opposite of S2. S3 switches many times, and is therefore only good for $t_{switch} \ll (t_{gen} + t_{test})$ (S3 is in fact optimal if $t_{switch} = 0$). Again, as with S2, S3 requires neither p nor any additional computation.

S4 is a compromise strategy: it makes more switches than S2 but less than S3, it generates more hypotheses than S3 but less than S2, and its run-time is more than S1 but less than S3. However, S4 is the only strategy which requires an additional, though simple computation of h_i as $sol_{min} - sol_{i-1}$.

Thus, the choice of strategy depends on p and on the ratios $t_{switch} : (t_{gen} + t_{test})$ and $sol_{all} : sol_{min}$. We have an optimal strategy only if p is known.

5 Comparison of the strategies when reaching $t \leq t_{max}$ first

So far, we have compared the strategies S1-S4 on the basis of their overall run-time. There is, however, another dimension along which we can compare them,

namely on the basis of how uniformly they compute their solutions over time. This is important because the stop criterion (1) says that the system will stop when t_{max} has been reached, which may be before sol_{min} solutions have been computed (if $t_{max} < t_{sol_{min}}$). In general, we will not know this inequality in advance, since $t_{sol_{min}}$ depends on p which may not be known. Because of this, it becomes important that the composite behavior produced by the strategy is *interruptible* [4]. Below we will investigate this propery for each of the strategies S1-S4. We will do this on the basis of the graphs in figure 1, which indicate for each strategy how the computation of solutions proceeds over time. For each of these strategies, we will establish the number of solutions produced per time-unit, in other words: $sol_i/time$.

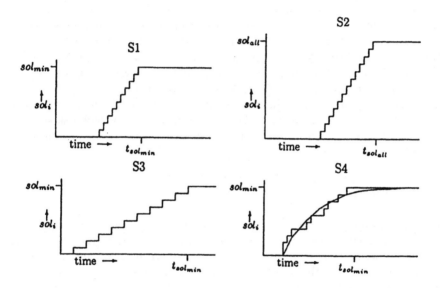

Fig. 1. Distribution of solutions over time for S1-4

S1, S2 will not produce any solutions for a long time, and then suddenly pro-
 duce all solutions at once, namely after the first (and final) call to *test*. This
 means that $sol_i/time = 0$ for a long time, and then jumps to sol_{min} at
 $t_{sol_{min}}$ for S1 and to sol_{all} at $t_{sol_{all}}$ for S2.
S3 produces solutions incrementally, and at a constant rate, namely on the
 average 1 solution per $1/p$ iterations. Thus, the value of $sol_i/time$ is constant

over time, at $p/(t_{gen} + t_{test} + t_{switch})$.

S4 also produces its solutions incrementally, but in ever decreasing chunks: at each iteration, nothing happens for $h_i \cdot (t_{gen} + t_{test}) + t_{switch}$ time units, and then $h_i \cdot p$ solutions are produced. Thus, the number of solutions per time is a step function with a decreasing angle, namely $p \cdot (t_{gen} + t_{test} + (t_{switch}/h_i))^{-1}$, and with ever decreasing steps both horizontally, namely $h_i \cdot (t_{gen} + t_{test}) + t_{switch}$, and vertically, namely $h_i \cdot p$). This step function can be approximated by a function asymptotically approaching sol_{min}.

We are now in a position to compare the different strategies with respect to their production of solutions over time.

S1 is a strategy with minimal run-time, but is not interruptible: if it gets interrupted because $t_{max} < t_{sol_{min}}$, we get no solutions at all. Thus, S1 is a *high-risk/high-pay* strategy.

S2 is not interruptible either. It takes longer than S1, but ensures that no switching back is required. We get no solutions when it is interrupted.

S3 on the other hand is an anytime algorithm, which will have produced some solutions when it gets interrupted prematurely. However, this is at the price of making many switches. Thus, S3 is *low-risk/low-pay*.

S4 is a compromise strategy. In the beginning, it looks like S1 and later on more like S3. This gradual change in behavior from a high-pay/high risk strategy to a low-pay/low-risk one makes sense, since the chance of running into t_{max} increases with time.

6 Problems with Russell's approach

In [4] the authors presented an approach for utility management by composing elementary anytime algorithms. To cite from their paper: "...the user simply specifies how the total real-time system is built by composing and sequencing simpler elements, and the compiler generates and inserts code for resource subdivision and scheduling given only the PPs of the most primitive routines"[4]. The time allocated to the primitive routines are pre-compiled from the utility function $U^*(t)$ of the composite system which is determined by the individual PPs $U_i(t)$ of the basic components.

How can we accomplish our utility function and strategies in this framework? First of all, we have to compose the generate & test method from the generate, switch and test steps: (LOOP generate switch test switch).

Next we have to define utility in terms of the PPs for the basic steps. However, it turns out that we cannot come up with a unique PP for the generate and the test steps because they are highly dependent on the input, in particular on the probability p of hypotheses being solutions, which cannot be estimated statically in every application. Figure 2 shows the bands of potential PPs of the basic inference steps. This is why we doubt Russel and Zilberstein's basic assumption

[4] PP is short for performance profile.

that the input can be partitioned into classes whose elements have the same PP (p. 213 in [4]). However, if we know the probability p, their approach would indeed lead to the optimal strategy S1.

To cope with the missing information in our application, we chose the fourth strategy which allows us to replace p by information gathered on-line. We implemented it by a meta-system, since a precompiler as suggested by Russell and Zilberstein would not have done.

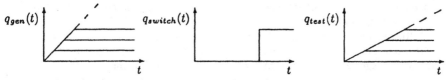

Fig. 2. Performance profiles for generate, switch & test

The main difference, however, between Russel's & Zilberstein's approach and ours is that they will always produce a single time schedule, while in our approach, choosing another strategy will result in different performance profiles of the compound system as depicted in figure 1. Moreover, to use their terminology, our strategies S1 and S2 result in *contract algorithms*, which must know the available time in advance, while S3 and S4 yield *interruptible algorithms* which produce meaningful results whenever they are interrupted and without being told when they will get interrupted. Their approach results in contract algorithms which then have to be transformed to interruptible ones slowing them down by factor 4 at most[5]. Our strategies S3 and S4 do not suffer from a slowdown.

Since our strategies depend on the information available, and differ in the overall performance profiles, in the risk vs. pay ratio, and in the interruptability of the composite system, our approach is much more flexible. This however, is at the cost of being specialised to generate & test methods.

7 Conclusion

For the class of generate & test methods we defined a utility function that involves a lower bound on the number of solutions and an upper bound on the time to be spent. We analyzed four different strategies and compared them with respect to the information needed, their temporal behaviors and their interrruptability. Our results should be easy to carry over to simpler or more complex utility functions.

[5] In the meantime, they have developed compilation methods for a loop which directly lead to interruptible algorithms.

References

1. T. Dean and M. Boddy. An analysis of time-dependent planning problems. In *Proceedings of the 7th National Conference on Artificial Intelligence*, volume 1, pages 49 – 54, San Mateo, 1988. Morgan Kaufmann.

2. E.J. Horvitz. Reasoning about beliefs and actions under computational resource constraints. In L.N. Kanal, T.S. Levitt, and J.F. Lemmer, editors, *Uncertainty in Artificial Intelligence 3*, pages 301–324. Elsevier, Amsterdam, 1987.

3. R.K. Lindsay, B.G. Buchanan, E.A. Feigenbaum, and J. Lederberg, editors. *Applications of Artificial Intelligence for Organic Chemistry: The DENDRAL Project*. McGraw-Hill, New York, 1980.

4. S.J. Russell and S. Zilberstein. Composing real-time systems. In *Proceedings of the 12th International Joint Conference on Artificial Intelligence, Sydney, Australia*, volume 1, pages 212 – 217, San Mateo, 1991. Morgan Kaufmann.

Efficient Computation of Solutions
for
Contradictory Time Interval Networks

Achim Weigel & Rainer Bleisinger

German Research Center for Artificial Intelligence (DFKI),
P.0. Box 20 80, D-6750 Kaiserslautern, Germany
e-mail: {weigel, bleising}@dfki.uni-kl.de

Abstract. In Computer Science, especially in AI, the treatment of temporal information is very important. For example, temporal restrictions for actions play a central role in planning. Mostly, qualitative constraints between actions, i.e. between time intervals assigned to actions, are represented in so called time interval networks. But humans involved often specify inconsistent networks. Thus, to support these people in converting contradictory networks into contradiction-free ones, a new efficient method is proposed.

The discussed method directly searches for solutions of the contradictions in the user-defined networks. Thereby, consistent time interval networks are constructed, so called elementary solutions which contain a maximal number of user-defined assumptions.

In this paper, a basic algorithm for computing elementary solutions is presented, and for reasons of efficiency a modification of this algorithm is explained. In this way, we get an efficient computation of elementary solutions for contradictory time interval networks.

1 Introduction

Today in many domains of Computer Science, especially in AI the necessity to treat time is fundamental, e.g. in natural language processing and planning. For that purpose several forms of temporal knowledge have to be incorporated: temporal order and duration in a quantitative (numeric) and a qualitative (relational) manner ([Bleisinger 91]). The most popular idea concerning qualitative temporal order is the time interval logic proposed in [Allen 83]. For the proposed time interval network representation special test algorithms have been developed which check the networks for temporal inconsistency (e.g. [Allen 83], [Vilain & Kautz 86], [Valdez-Perez 87], [van Beek 90]).

We use a time interval based approach in the area of planning, especially in computer aided software engineering ([Bleisinger et al 91]). In this context, a software development project is mainly influenced by temporal constraints which provide a basis for automatically monitoring the development process. After the user specifies temporal constraints, the result of the consistency test may state that the time interval network is contradictory. In this case, the correction of the contradictory network is necessary.

In the context of planning it is not satisfying only to report: "network is inconsistent". The user needs more information focussing on the question how to resolve the inconsistency, i.e. which assumptions have to be modified. Especially, if time interval networks have a complexity hardly manageable by humans they need aids for the elimination of contradictions. In [Weigel & Bleisinger 92] two approaches were proposed. One detects minimal contradictory subsets of assumptions, so called *reasons*, while the other computes maximal assumption sets representing consistent networks.

This paper focuses on an *efficient* method for transforming contradictory time interval networks into consistent ones. For practical reasons, the modifications should thereby be as small as possible, maintaining most of the original assumptions.

In the next section we give some necessary definitions. In Section 3 we propose a basic method which computes maximal consistent subsets of the assumptions given in an inconsistent network, so called *elementary solutions*. As a preparation for a speedup of the computation of elementary solutions, we introduce a modified version of Allen's constraint propagation algorithm in Section 4.1. After that, in Section 4.2 the efficient determination of elementary solutions is explained and its realization is discussed afterwards. First results about improved efficiency are reported in Section 5. Remarks about our proposed method as well as future work conclude the paper.

2 Basic Definitions

The main foundation of this work is Allen's time interval logic ([Allen 83], [Allen 84]). The basic elements are time intervals related to anything of the real world and 13 time relations describing all possible temporal order relationships between two time intervals. Within a time interval network the intervals are represented by nodes and the connecting arcs are labeled with relations. The set R consists of the 13 mutually exclusive elementary time relations (the abbreviations are noted in parenthesis):

> before (<), meets (m), overlaps (o), starts (s), during (d), finishes (f),
> equal (=), after (>), met-by (mi), overlapped-by (oi), started-by (si),
> contains (di), finished-by (fi).

Note that the last six relations are inverse to the first six; given $r \in R$ then r^{-1} denotes the inverse relation to r.

Example 1: Let I_1, I_2 and I_3 be time intervals. Assume, I_1 is before or after I_2 and I_3 is during I_2. Between I_1 and I_3 no temporal order restriction is given, i.e. the whole set of relations R is possible. The resulting time interval network is presented in Fig. 1.

Fig. 1: Graphical representation of a time interval network.

A network can be represented by a function mapping all interval pairs to the corresponding sets of relations. Usually, the relations describe the allowed temporal order relationships between the intervals. Unfortunately, these relations can exclude one another by further inferences. Therefore, it is more convenient for us to look at the relations not allowed between intervals (see [Hrycej 88]). This inverse view homogeneously represents the assumptions made by the user in a conjunctive form. Therefore, the function defined next is based on the relations not allowed between two time intervals.

Definition 1: (relationship function)

A function $v: I \times I \rightarrow$ Pot (R), where Pot (R) is the power set of R, is called *relationship function* or r-s-function, when:

a) $\forall \ I_x \in I: v(I_x, I_x) = \{<, >, d, di, s, si, f, fi, o, oi, m, mi\}$

b) $\forall \ I_x, I_y \in I$ with $I_x \neq I_y, \forall \ r \in R: r \in v(I_x, I_y) \Leftrightarrow r^{-1} \in v(I_y, I_x)$

Example 2: The network shown in Fig. 1 is described by the r-s-function v with:

$v(I_1, I_1) = v(I_2, I_2) = v(I_3, I_3) = \{<, >, d, di, s, si, f, fi, o, oi, m, mi\},$

$v(I_1, I_2) = v(I_2, I_1) = \{d, di, s, si, f, fi, o, oi, m, mi, =\},$

$v(I_1, I_3) = v(I_3, I_1) = \{\},$

$v(I_2, I_3) = \{<, >, d, s, si, f, fi, o, oi, m, mi, =\},$

$v(I_3, I_2) = \{<, >, di, s, si, f, fi, o, oi, m, mi, =\}.$

The assumption set defining a network or a r-s-function is given next. The assumptions are the relations not allowed between the interval pairs of the network.

Definition 2: (assumption set M_v of v)

Let v be a r-s-function. The *assumption set* of v, denoted by M_v, is the set with:

$\forall \ I_a, I_b \in I, \forall \ r \in R: [A_{r,I_a,I_b} \in M_v \Leftrightarrow r \in v(I_a, I_b)]$ and

no further elements are in M_v.

Thereby, A_{r,I_a,I_b} represents the assumption that r is a temporal relationship not allowed between the time intervals I_a and I_b.

3 Elementary Solutions of a Contradictory Network

First we explain what is meant by a contradictory time interval network. In general, the contradiction is defined in dependency of the test algorithm used.

There are several kinds of control strategies. Some of them check the consistency of the entire network. These are complete but NP-hard ([Vilain & Kautz 86],

[Valdez-Perez 87]) and are therefore intractable for most applications. Other ones check local consistency by looking at all groups of only three [Allen 83] or four [vanBeek 90] intervals of the whole network. This means that the entire network may be still contradictory because of the local, incomplete examination. However, the advantage is the polynomial time consumption. In the following, "test" denotes any function that examines a network represented by its r-s-function v for consistency. The simplified result is the answer "yes" when a contradiction is found and "no" otherwise. Here, a network is called consistent, if the function "test" cannot find a contradiction (even the strategy used is incomplete).

With this background it is possible to start the discussion how to support the solution of contradictory networks in an elegant and effective manner.

Therefore, we compute a consistent network directly from the original one. Here, the consistent network should maintain as many assumptions of the original one as possible. Subsequently, consistent networks will be defined by r-s-functions and a corresponding algorithm will be presented to compute them. The original contradictory networks will also be described by r-s-functions.

Definition 3: (elementary solution of a r-s-function)

Let v be a r-s-function with test(v) = "yes" describing the original network. A r-s-function v_{es} will be called *elementary solution* of v when:

a) $\forall\ I_x, I_y \in I: v_{es}(I_x, I_y) \subseteq v(I_x, I_y)$

b) test(v_{es}) = "no"

c) there exists no r-s-function $v' \neq v_{es}$ with:

 i) $\forall\ I_x, I_y \in I: v_{es}(I_x, I_y) \subseteq v'(I_x, I_y) \subseteq v(I_x, I_y)$

 ii) test(v') = "no"

Assume, v describes the contradictory network. An elementary solution v_{es} of v describes a time interval network where all the contradictions in v recognized by "test" are solved. The only difference between v_{es} and v is, that v_{es} represents a minimal set of assumptions less than v.

Obviously, many different elementary solutions of a r-s-function v may exist. We leave it to the user whether he is interested in more than one and, if so, which one is best to use. But the computation of the all solutions forces an exponential time complexity.

Note that no objective optimality criteria is defined for an elementary solution. Therefore, it is impossible to prefer any particular elementary solution as an optimal one. To achieve this it is necessary to introduce a quality measurement, e.g. the maximal number of user-given assumptions or the importance of lost assumption sets.

The Algorithm 1 presented next constructs and returns one elementary solution v_{es} of a given inconsistent r-s-function v.

Algorithm 1: (construction of one elementary solution)

let v_{es} be a r-s-function with: \forall $I_x, I_y \in I$ with $I_x \neq I_y$ is $v'(I_x, I_y) = \{\}$

vhelp := v_{es}

for each $I_x, I_y \in I$ with $I_x \neq I_y$, for each $r \in R$ do

 if $r \in v(I_x, I_y)$ then

 build r-s-function v_{es} with: $M_{ves} := M_{ves} \cup \{A_{r,I_x,I_y}, A_{r-1,I_y,I_x}\}$

 b := test(v_{es})

 if b = "no" then vhelp := v_{es}

 else v_{es} := vhelp

return v_{es}

Algorithm 1 computes only one elementary solution v_{es} of v, even when more than one exist. The elaboration of all elementary solutions of v can be done with the following strategy (for details see [Weigel 91]). Assume, $v_1, ..., v_n$ are the elementary solutions of v already found. Now search for a set M_{vn+1} of assumptions that contains at least one assumption from every of the following assumption sets $M_v - M_{v1},..., M_v - M_{vn}$. Additionally the r-s-function v_{n+1} defined by M_{vn+1} has to be consistent. Beginning with this r-s-function as the initial v_{es} in Algorithm 1 results in a new elementary solution of v. But, the time needed increase exponentially with the number of different solutions computed.

4 Efficient Computation of Elementary Solutions

Using a test strategy having a time border of $O(m)$ the time consumption of Algorithm 1 is $O(n^2 * m)$ when n is the number of intervals. For example, if the test function is Allen's constraint propagation algorithm, a time border of $O(n^5)$ results.

This complexity arises from both the frequent call and the inefficient use of the test function. These problems will be tackled by efficiently using a modified version of Allen's algorithm. The basic idea of Allen's algorithm and the modifications made are discussed in Section 4.1. Section 4.2 introduces the overall algorithm to efficiently compute one elementary solution.

4.1 Modified Allen Algorithm

This section is a first step towards the realization of an efficient algorithm to elaborate elementary solutions of a r-s-function v using a modified version of Allen's constraint propagation algorithm for the test of consistency.

In principle, the algorithm developed by Allen propagates the assumptions over the network. The assumptions are the constraints in the temporal relationships between two intervals. The propagation is done by repeatedly inferring additional con-

straints between two intervals I_x and I_y from the constraints between intervals I_x, I_z and I_z, I_y. The modified version of this algorithm will be described in the following.

Let "propagate" be the function that infers from two sets of relations R_1 and R_2 a set of relations R_3. When R_1 contains the not allowed temporal relations between intervals I_x and I_z and R_2 the not allowed temporal relations between intervals I_z, I_y then R_3 contains all the relations between I_x, I_y forbidden according to R_1 and R_2. The following relationship exists between our function "propagate" and the function "constraints" originally given in [Allen 83]: (remember, R is the set of the 13 time relations)

$$\text{propagate}(R_1, R_2) = R_3 \quad \text{iff} \quad \text{constraints}(R - R_1, R - R_2) = R - R_3$$

The modified version of the constraint propagation algorithm has two arguments, a r-s-function v and a set S which contains interval pairs referring to the corresponding constraints. In the sense of Allen's algorithm, S describes all the interval pairs with initially constrained relationships in v, i.e. $S := \{\{I_x, I_y\} \mid I_x \neq I_y \text{ and } v(I_x, I_y) \neq \{\}\}$. The modified algorithm, Algorithm 2, returns (v´, bool); v´ is the r-s-function resulting from v computed in the constraint propagation process; bool is "yes" when a contradiction is found and otherwise "no".

Algorithm 2: (modified Allen algorithm)

test-allen (v, S)

while S is not empty do

 take $\{I_x, I_y\}$ from S

 for all I_z with $I_z \neq I_y$ and $I_z \neq I_x$ do

 Rprop := propagate(v(I_x, I_y), v(I_y, I_z))

 construct v´ identical to v except that v´(I_x, I_z) := Rprop \cup v(I_x, I_z)

 when v \neq v´ then S := S \cup $\{I_x, I_z\}$ and v := v´

 when v(I_x, I_z) = R then exit with (v, yes)

 Rprop := propagate(v(I_y, I_x), v(I_x, I_z))

 construct v´ identical to v except that v´(I_y, I_z) := Rprop \cup v(I_y, I_z)

 when v \neq v´ then S := S \cup $\{I_y, I_z\}$ and v := v´

 when v(I_y, I_z) = R then exit with (v, yes)

return (v, no)

Up to now we have no speedup for the computation of elementary solutions, but we have created the possibility for an advantageous use of the modified test function. In this way, we are now prepared for the discussion of an efficient version of Algorithm 1.

4.2 The Efficient Algorithm for Computing Solutions

The new construction algorithm resembles Algorithm 1 but has some important improvements. First of all, it calls Algorithm 2, the modified test function, only with a one element set as its second argument. Second, Algorithm 2 needs not be called as often as by Algorithm 1, and third it uses the constraints elaborated in consistency checks before. The main differences in comparison to Algorithm 1 are emphasized with italic print.

The more efficient construction algorithm returns one elementary solution v_{es} to a given inconsistent r-s-function v.

Algorithm 3: (efficient construction of one elementary solution)

1) let v' be a r-s-function with: $\forall I_x, I_y \in I$ with $I_x \neq I_y$ is $v'(I_x, I_y) = \{\}$

2) vhelp := v'; $M_{ves} := \{\}$

3) for each $I_x, I_y \in I$ with $I_x \neq I_y$, for each $r \in R$ do

4) if $r \in v(I_x, I_y)$ then

5) *if $r \in v'(I_x, I_y)$*

6) *then $M_{ves} := M_{ves} \cup \{A_{r,I_x,I_y}, A_{r-1,I_y,I_x}\}$*

7) else build r-s-function v' with $M_{v'} := M_{v'} \cup \{A_{r,I_x,I_y}, A_{r-1,I_y,I_x}\}$

8) $(v', b) :=$ test-allen$(v', \{\{I_x, I_y\}\})$ %see Algorithm 2%

9) if b = no then vhelp := v'

10) *$M_{ves} := M_{ves} \cup \{A_{r,I_x,I_y}, A_{r-1,I_y,I_x}\}$*

11) else $v' :=$ vhelp

12) return v_{es}

In Algorithm 3 the r-s-function v' represents the actual propagation result, the r-s-function vhelp keeps the propagation result one step before the actual one, and the assumption set M_{ves} samples all the assumptions needed in the elementary solution. Initially, the r-s-functions v' and vhelp describe networks without any constraints (line 1) and M_{ves} is empty (line 2). For all assumptions given by v, the algorithm tries to add these assumptions to M_{ves} (line 3 to 11). Therefore, if the assumption is "already in" the actual propagation result v' then the assumption is added to M_{ves} (line 6). When the actual assumption is not "already in" v' then a check of the consistency of v' extended by the assumption is performed with Algorithm 2 (line 8). Thereby, it is only necessary to call "test-allen" with a set of one element as its second argument because at the call time only the further constrained interval pair has to propagate its new assumption.

The resulting v' contains all restrictions possible to be propagated over three intervals in the network. If v' is consistent the elaborated constraints in this network can be used from now on without inferring them again (line 9). Additionally, the actual assumption is added to the elementary solution assumption set M_{ves} (line 10).

When Algorithm 2 discovers an inconsistency, the resulting v' cannot be used for further work. In this case the situation before the call of Algorithm 2 must be restored (line 11).

In the algorithm further assumptions given by v will be added to v', if not "already in" because of earlier applications of Algorithm 2 (line 3 to 7). If "already in", it is not necessary to test this network again. This means that many tests can be avoided. Unless "already in", again it is only necessary to call Algorithm 2 with a set of one element $\{\{I_x, I_y\}\}$ as its second argument (line 8), because the other constraints between intervals have been already propagated through the network in the tests before.

The advantage of Algorithm 3 over Algorithm 1 is, that there will be not so many intermediate r-s-functions v' achieved by the addition of one assumption needed to be tested. Here, the tests with Algorithm 2 additionally infer not allowed temporal relations between the intervals. It is not necessary to add the corresponding assumptions to the r-s-function in work, because they are already entailed and used in the consistency checks. Therefore, many tests can be avoided. Moreover, it is only necessary to call Algorithm 2 with a set of one element $\{\{I_x, I_y\}\}$ as its second argument, because the other constraints between intervals have been already propagated through the network in the tests before. This further speeds up the construction algorithm for elementary solutions.

With Algorithm 3 it is possible to compute an elementary solution v_{es} of a r-s-function v with a time border of $O(n^3 * L)$, where L is the number of assumptions in $M_{v_{es}}$ subtracted from the number of assumptions in M_v. This is because in the loop in lines 3) to 11) up to the moment when v' becomes contradictory Algorithm 3 needs only $O(n^3)$ time, because every interval pair only propagates its constraints at most 13 times. Every propagation of one arc needs $O(n)$ time. Further there are $O(n^2)$ interval pairs in the network so the total amount of time is $O(n^3)$. When v' becomes contradictory you have to restart at a previous point. The amount of lost propagation steps by a backtrack step is of a magnitude of $O(n^3)$. Because L is exactly the number of possible backtracks so Algorithm 3 has a time border of $O(n^3 * L)$.

Though L is constrained by $O(n^2)$ it is normally small so that the elaboration of v_{es} needs not much more time than a check of v with Allen's original algorithm, that only looks for contradiction.

5 First Results

Now, some empirical results of the computation of elementary solutions are presented. The test algorithm used in Algorithm 1 is the constraint propagation algorithm proposed in [Allen 83]. The example networks are randomly generated.

At first, we look at the quality of the firstly generated solutions of contradictory networks obtained from both Algorithm 1 as well as Algorithm 3. Therefore, in Table 1 we describe the differences in the number of assumptions between some inconsistent r-s-functions v and elementary solutions v_{es} of v. The first column shows the number of intervals, the second and third contains the number of assumptions in M_v and $M_{v_{es}}$ respectively, and the fourth points to the number of eliminated assumptions.

Table 1: Size of elementary solutions.

intervals	assumptions in v	assumptions in v_{es}	modifications
3	35	34	1
4	69	68	1
5	107	105	2
6	120	119	1
7	175	172	3
8	200	196	4

Notice, there are only small differences between the number of the original, user-defined assumptions and the number of the assumptions in the first computed elementary solution. This means, extreme small modifications of v already result in a consistent r-s-function v_{es}.

Remember, that the time border of Algorithm 3 is $O(n^3 * L)$. The variable L is determined by the number of modifications in Table 1. Hence, it is very small resulting in a good temporal behaviour of Algorithm 3 in our experiments. Moreover, users has the aim of a correct specification of a time interval network and therefore the modifications will be very small mostly.

Second, the advantages of Algorithm 3 where examined with the result of a significant speedup. Therefore, the time needed by Algorithm 1 and by Algorithm 3 for computing an elementary solution is compared. This shows Table 2. The first column contains the number of intervals, the second the number of assumptions in M_v, and the third the speedup factor of Algorithm 3 in relation to Algorithm 1. The speedup factor is calculated as follows: time of Algorithm 3 multiplied by 100 divided by time of Algorithm 1.

Table 2: Time relationship between Algorithm 1 and Algorithm 3.

intervals	assumptions in v	speedup
3	35	55,6 %
4	69	38,5 %
5	107	33,3 %
6	120	30,3 %
7	175	23,3 %
8	200	16,1 %

In general, the advantage of speedup by efficient construction of an elementary solution grows significantly with the number of involved assumptions.

6 Conclusions

We have described an efficient method for the solution of contradictions in time interval networks, especially necessary in planning. Thereby, temporal constraints of plan actions are represented in a time interval network. After identifying a contradiction in a network consistent replanning is supported by our proposed technique.

Extensions of Concept Languages for a Mechanical Engineering Application

Franz Baader[1]* Philipp Hanschke[2]**

[1] DFKI, Stuhlsatzenhausweg 3, W-6600 Saarbrücken 11, Germany
baader@dfki.uni-sb.de
[2] DFKI, Postfach 2080, W-6750 Kaiserslautern, Germany
hanschke@dfki.uni-kl.de

Abstract. We shall consider an application in mechanical engineering, and shall show that the adequate modelling of the terminology of this problem domain in a conventional concept language poses two main representation problems. The first requires access to concrete domains, such as real numbers, while the second asks for a construct which can be used to represent sequences of varying length. As shown in recent papers by the authors there exist extended concept languages—equipped with sound and complete reasoning algorithms—that satisfy the respective representation demands separately.

The main result presented in this paper is that the combination of both extensions leads to undecidable terminological inference problems. In particular, the important subsumption problem is undecidable. It should be noted that the need for these extensions is not particular to the considered problem domain; similar representation demands are likely to occur in other non-toy applications.

1 Introduction

Concept languages based on KL-ONE [Brachman and Schmolze, 1985] are mostly used to represent the terminological knowledge of a particular problem domain on an abstract logical level. To describe this kind of knowledge, one starts with atomic concepts and roles, and defines new concepts using the operations provided by the language. Concepts can be considered as unary predicates, which are interpreted as sets of individuals, and roles as binary predicates, which are interpreted as binary relations between individuals. Examples for atomic concepts may be Human and Female, and for roles child. If the logical connective conjunction is present as language construct, one may describe the concept Woman as "humans who are female", and represent it by the expression Human ⊓ Female. Many languages provide quantification over role fillers which allows for example to describe the concept Mother by the expression Woman ⊓ ∃child.Human.

 KL-ONE was first developed for the purpose of natural language processing [Brachman et al., 1979], and some of the existing systems are still mostly used in this context

* Supported by BMFT Research Project AKA-WINO (grant ITW 8903 0)
** Supported by BMFT Research Project ARC-TEC (grant ITW 8902 C4)

The basic concept proposed generates elementary solutions for an inconsistent network. During the construction of elementary solutions the test for consistency is often performed. This fact leads to a modification of the overall behavior as well as the used test function for reasons of efficiency.

The method of elementary solutions is efficient, but elementary solutions are rigid. They exactly determine the assumptions the user has to eliminate. One consequence can be the loss of user-important assumptions. To overcome this, all or at least many different elementary solutions have to be computed. Then the user can choose his best alternative. Only small modifications of Algorithm 3 are necessary to compute all elementary solutions one after another, but there is the problem of time needed. The time grows exponentially with the number of elementary solutions already constructed. Additionally, a possibly too big number of different elementary solutions can make it impossible to compute all or to find a right one among them. Therefore, the user normally has no large collection of solutions.

But the incorporation of domain knowledge, one point for future work, can help to compute mostly good ones. For example, the processing sequence of the assumptions defined by a r-s-function v can be guided by priority values. This enables a controlled computation of elementary solutions of v and so, the loss of important assumptions can be prevented. In this way, the determination of only a few (perhaps one) but good elementary solutions can be sufficient and the user does not need to choose from a possibly large number of uninteresting solutions.

References

[Allen 83] J. Allen: *Maintaining Knowledge about Temporal Intervals*, Communications of the ACM, 26, No. 11, Nov. 1983, pp 832-843.

[Allen 84] J. Allen: *Towards a General Theory of Action and Time*, Artificial Intelligence, 23, No. 2, July 1984, pp 123-154.

[Bleisinger 91] R. Bleisinger: *TEMPO - an Integrative Approach for Modeling Qualitative and Quantitative Temporal Information* (in German), Proc. of the 15th GWAI, Bonn, Sept. 1991, pp 167-176.

[Bleisinger et al 91] R. Bleisinger, P. Knauber, W. Schramm, M. Verlage: *Software Process Description and Enactment Considering Temporal Constraints*, Proc. of the 4th International Symposium on AI, Cancun, Mexico, 1991, pp 416-422.

[Hrycej 88] T. Hrycej: *A Transitivity-Based Algorithm for Temporal Constraint Propagation*, In: Technische Expertensysteme: Wissensrepräsentation und Schlußfolgerungsverfahren, 1988, pp 397-414.

[Valdez-Perez 87] R. Valdez-Peres: *The Satisfiability of Temporal Constraint Networks*, Proc. of the 6th AAAI, 1987, pp 256-260.

[van Beek 90] P. van Beek: *Reasoning about Qualitative Temporal Information*, Proc. of the 8th AAAI, 1990, pp 728-734.

[Vilain 82] M. Vilain: *A System for Reasoning about Time*, Proc. of the 3rd AAAI, 1982, pp 197-201.

[Vilain & Kautz 86] M. Vilain, H. Kautz: *Constraint Propagation Algorithms for Temporal Reasoning*, Proc. of the 5th AAAI, 1986, pp 377-382.

[Weigel 91] A. Weigel: *Solution of Contradictions in Time Interval Networks* (in German), Diploma Thesis, University of Kaiserslautern, 1991.

[Weigel & Bleisinger 92] A. Weigel, R. Bleisinger: *Support for Resolving Contradictions in Time Interval Networks*, Proc. of the 10th ECAI, Wien, 1992, pp 379-383.

(see e.g., SB-ONE [Kobsa, 1989]). However, its success in this area has also led to applications in other fields (see e.g., MESON [Edelmann and Owsnicki, 1986] which is used for computer configuration tasks, CLASSIC [Borgida *et al.*, 1989] which is, e.g., used for retrieval in software information systems, or K-REP [Mays *et al.*, 1987; Mays *et al.*, 1988] which is used in a financial marketing domain).

In this paper we shall investigate how concept languages can be used in a mechanical engineering domain. More precisely, we shall consider the representation of concepts that are related to lathe workpieces. We shall describe this application in more detail in Section 2. There it will be pointed out that the adequate formalization of these concepts demands two substantial extensions of conventional concept languages. On the one hand, reference to concrete notions such as real numbers is mandatory to represent, for example, the geometric aspects of a lathe workpiece. On the other hand, the abstraction in this domain requires to describe classes of lathes which are sequences of geometric primitives. These sequences have a finite, but varying and not a priori bounded length.

The extensions needed to satisfy these demands have separately been considered in recent papers by the authors. Section 4 summarizes the schematic extension by concrete domains proposed in [Baader and Hanschke, 1991]. An instantiation of this scheme appropriate for representing the geometric aspects in our problem domain is obtained by taking the concrete domain "real numbers." In Section 5 we recall the extension of a conventional concept language by a transitive closure operator as proposed in [Baader, 1991]. This can be used to deal with the varying length aspect. Both papers not only introduce the extended formalisms, but also describe decision procedures for the common terminological inference problems such as subsumption.

In contrast to these positive results we shall show in the present paper (Section 6) that the subsumption problem in a concept language combining both extensions is undecidable. The paper concludes with some remarks on how this algorithmic problem can be circumvented in a hybrid knowledge representation architecture. As the common base for both extensions the concept language \mathcal{ALCF} is introduced in Section 3. It provides abstract concept-forming operators as used in the introductory examples above.

2 Motivation and Problem Domain

The domain we want to consider is production planning for CNC lathe machines. More precisely, our work has been motivated by the following application:

> Given the geometry of a rotational-symmetric workpiece, generate abstract NC macros for turning the workpiece on a CNC lathe machine.

Reasoning in this application follows a scheme (Figure 1) that is inspired by William J. Clancey's *heuristic classification*: The input to the system is a CAD drawing describing the workpiece in terms of primitive surfaces and basic technological data. The *abstraction* phase generates a schematic description of the workpiece in terms of *(CAD/CAM) features* [Klauck *et al.*, 1991]. Such features are often associated with parts of the workpiece that are characteristic with respect to how these parts (or the whole lathe) may be manufactured. The second phase associates *skeletal*

(production) plans to the features (i.e. to the nodes in the feature DAG). Finally, the third phase *refines* and merges the skeletal plans to a complete numerical control (NC) program.

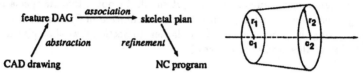

Figure 1: Planning Scheme Figure 2: A Truncated Cone

This problem domain requires, among other things, the representation of geometric primitives used in the CAD drawing and of technological data of the workpiece. It also contains the features which characterize the workpiece. If this could be done with a concept language, the abstraction phase could be mapped naturally into a terminological framework:

- Arrange the features represented as concepts in a generalization hierarchy using the subsumption service of the terminological system.
- Represent a particular CAD drawing of the workpiece with its geometric and technological information as instances of appropriate concepts.
- Employ the so-called realization service [Nebel, 1990] to compute the most specific concepts that apply to the particular lathe. The features corresponding to these concepts are then the output of the abstraction phase to which the skeletal plans can be associated.

However it is easy to see that conventional concept languages cannot be used to adequately represent this problem domain. Consider, for example, the concept of a truncated cone (see Figure 2). Since we consider geometric objects as fixed to an axis, a truncated cone can be characterized by four real numbers, two for its radii and two for the corresponding centers. But of course not all quadruples of real numbers represent a truncated cone. So we have to restrict the values such that the radii are positive. In addition, one has to exclude cases where the truncated cone degenerates to a line, a circle, or even a point. It seems to be impossible to represented this using only "abstract" concept terms without reference to predicates over, for example, real numbers, which shows the need for an integration of concrete domains.

Another problem is due to the fact that one has to describe classes of lathes which are sequences of geometric primitives. The problem is that these sequences have a finite, but varying and not a priori bounded length. It is quite simple to define concepts for features such as

> '1 truncated cone', '2 truncated cones', ...

Assume, for example, that the following two concepts are already defined: Truncone, which stands for the class of truncated cones, and Neighboring, which characterizes when two truncated cones fit together. We shall see later how these concepts could be defined using our first extension. Then the mentioned sequence of concepts can be defined as follows:

$$\text{One} = \exists\text{head.Truncone} \sqcap \forall\text{tail.Bottom}$$
$$\text{Two} = \exists\text{head.Truncone} \sqcap \exists\text{tail.One} \sqcap \text{Neighboring}$$
$$\cdots$$

Here Bottom, as usual, stands for the empty concept.

But it remains the problem to represent the most specific generalization (union) of these *infinitely* many features (concepts). The resulting concept could be termed a 'sequence of neighboring truncated cones'. It should be noted that its specialization 'ascending sequence of truncated cones' (see the definition in Section 6) is essential for characterizing the production classes of lathes. In Section 6 we shall give a formal representation of this kind of sequences.

3 The Concept Language ALCF

This section introduces the language \mathcal{ALCF} as a prototypical conventional concept language. It will be the starting point for the two extensions described in the next two sections.

Definition 1 (syntax of \mathcal{ALCF}). *Concept terms* are built from concept, role, and attribute[3] names using just the concept-forming operators

$$negation\ (\neg C),\ disjunction\ (C \sqcup D),\ conjunction\ (C \sqcap D),$$
$$exists\text{-}in\ restriction\ (\exists R.C),\ and\ value\ restriction\ (\forall R.C).$$

Here C and D are syntactic variables for concept terms and R is a role or attribute name.

Let A be a concept name and let D be a concept term. Then $A = D$ is a *terminological axiom*. A *terminology (T-box)* is a finite set T of terminological axioms with the additional restrictions that *(i)* no concept name appears more than once as a left hand side of a definition, and *(ii)* T contains no cyclic definitions.[4]

Please note that the exists-in and the value restrictions are not only defined for roles but also for attributes. The next definition gives a model-theoretic semantics for the language introduced in Definition 1.

Definition 2 (semantics of \mathcal{ALCF}). An *interpretation* \mathcal{I} for \mathcal{ALCF} consists of a set $dom(\mathcal{I})$ and an interpretation function. The interpretation function associates with each concept name A a subset $A^{\mathcal{I}}$ of $dom(\mathcal{I})$, with each role name R a binary relation $R^{\mathcal{I}}$ on $dom(\mathcal{I})$, i.e., a subset of $dom(\mathcal{I}) \times dom(\mathcal{I})$, and with each attribute name f a partial function $f^{\mathcal{I}}$ from $dom(\mathcal{I})$ into $dom(\mathcal{I})$.

For such a partial function $f^{\mathcal{I}}$ the expression $f^{\mathcal{I}}(x) = y$ is sometimes written as $(x, y) \in f^{\mathcal{I}}$. The interpretation function—which gives an interpretation for atomic terms—can be extended to arbitrary concept terms as follows: Let C and D be concept terms and let R be a role or attribute name. Assume that $C^{\mathcal{I}}$ and $D^{\mathcal{I}}$ are already defined. Then

1. $(C \sqcup D)^{\mathcal{I}} = C^{\mathcal{I}} \cup D^{\mathcal{I}}$, $(C \sqcap D)^{\mathcal{I}} = C^{\mathcal{I}} \cap D^{\mathcal{I}}$, and $(\neg C)^{\mathcal{I}} = dom(\mathcal{I}) \setminus C^{\mathcal{I}}$,

[3] To avoid confusion with the 'CAD/CAM features' of the application domain we refer to the functional roles as attributes and not as features as, e.g., in [Baader and Hanschke, 1991].

[4] See [Nebel, 1989; Baader, 1990] for a treatment of cyclic definitions in concept languages.

2. $(\forall R.C)^{\mathcal{I}} = \{x \in dom(\mathcal{I}); \text{ for all } y \text{ such that } (x,y) \in R^{\mathcal{I}} \text{ we have } y \in C^{\mathcal{I}}\}$ and
$(\exists R.C)^{\mathcal{I}} = \{x \in dom(\mathcal{I}); \text{ there exists } y \text{ such that } (x,y) \in R^{\mathcal{I}} \text{ and } y \in C^{\mathcal{I}}\}$.

An interpretation \mathcal{I} is a *model* of the T-box \mathcal{T} iff it satisfies $A^{\mathcal{I}} = D^{\mathcal{I}}$ for all terminological axioms A = D in \mathcal{T}.

An important service terminological representation systems provide is computing the subsumption hierarchy, i.e., computing the subconcept-superconcept relationships between the concepts of a T-box. This inferential service is usually called classification. The model-theoretic semantics introduced above allows the following formal definition of subsumption.

Definition 3 (subsumption). Let \mathcal{T} be a T-box and let C, D be concept terms. Then D *subsumes* C with respect to \mathcal{T} iff $C^{\mathcal{I}} \subseteq D^{\mathcal{I}}$ holds for all models \mathcal{I} of \mathcal{T}.

In addition to the formalism defined so far, terminological systems usually provide for an assertional component, and corresponding reasoning services [Nebel, 1990]. Because of the space limitations we shall not address this aspect in the present paper.

4 Integrating Concrete Domains

In this section we introduce a formalism that is capable to deal with the first representational problem mentioned in the introductory sections. Before we can define this extended language, we have to formalize the notion "concrete domain" which has until now only been used in an intuitive sense.

Definition 4. A *concrete domain* \mathcal{D} consists of a set $dom(\mathcal{D})$, the domain of \mathcal{D}, and a set $pred(\mathcal{D})$, the predicate names of \mathcal{D}. Each predicate name P is associated with an arity n, and an n-ary predicate $P^{\mathcal{D}} \subseteq dom(\mathcal{D})^n$.

An important example for our application is the concrete domain \mathcal{R} of real arithmetic. The domain of \mathcal{R} is the set of all real numbers, and the predicates of \mathcal{R} are given by formulae which are built by first order means (i.e., by using logical connectives and quantifiers) from equalities and inequalities between integer polynomials in several indeterminates.[5] For example, $x + z^2 = y$ is an equality between the polynomials $p(x,z) = x + z^2$ and $q(y) = y$; and $x > y$ is an inequality between very simple polynomials. From these equalities and inequalities one can e.g. build the formulae $\exists z(x + z^2 = y)$ and $\exists z(x + z^2 = y) \vee (x > y)$. The first formula yields a predicate name of arity 2 (since it has two free variables), and it is easy to see that the associated predicate is $\{(r,s); r \text{ and } s \text{ are real numbers and } r \leq s\}$. Consequently, the predicate associated to the second formula is $\{(r,s); r \text{ and } s \text{ are real numbers}\}$ $= dom(\mathcal{R}) \times dom(\mathcal{R})$.

To get inference algorithms for the extended concept language, which will be introduced below, the concrete domain has to satisfy some additional properties.

For technical reasons we have to require that the set of predicate names of the concrete domain is *closed under negation*, i.e., if P is an n-ary predicate name in

[5] For the sake of simplicity we assume here that the formula itself is the predicate name. In applications, the users will probably take their own intuitive names for these predicates.

$pred(\mathcal{D})$ then there has to exist a predicate name Q in $pred(\mathcal{D})$ such that $Q^{\mathcal{D}} = dom(\mathcal{D})^n \setminus P^{\mathcal{D}}$. In addition, we need a unary predicate name which denotes the predicate $dom(\mathcal{D})$.

The property which will be formulated now clarifies what kind of reasoning mechanisms are required in the concrete domain. Let $P_1, ..., P_k$ be k (not necessarily different) predicate names in $pred(\mathcal{D})$ of arities $n_1, ..., n_k$. We consider the conjunction

$$\bigwedge_{i=1}^{k} P_i(\underline{x}^{(i)}).$$

Here $\underline{x}^{(i)}$ stands for an n_i-tuple $(x_1^{(i)}, ..., x_{n_i}^{(i)})$ of variables. It is important to note that neither all variables in one tuple nor those in different tuples are assumed to be distinct. Such a conjunction is said to be *satisfiable* iff there exists an assignment of elements of $dom(\mathcal{D})$ to the variables such that the conjunction becomes true in \mathcal{D}.

For example, let $P_1(x, y)$ be the predicate $\exists z(x + z^2 = y)$ in $pred(\mathcal{R})$, and let $P_2(x, y)$ be the predicate $x > y$ in $pred(\mathcal{R})$. Obviously, neither the conjunction $P_1(x, y) \wedge P_2(x, y)$ nor $P_2(x, x)$ is satisfiable.

Definition 5. A concrete domain \mathcal{D} is called *admissible* iff *(i)* the set of its predicate names is closed under negation and contains a name for $dom(\mathcal{D})$, and *(ii)* the satisfiability problem for finite conjunctions of the above mentioned form is decidable.

The concrete domain \mathcal{R} is admissible. This is a consequence of Tarski's decidability result for real arithmetic [Tarski, 1951; Collins, 1975]. However, for the linear case (where the polynomials in the equalities and inequalities have to be linear) there exist more efficient methods (see e.g. [Weispfenning, 1988; Loos and Weispfenning, 1990]). We are now ready to define the extension $\mathcal{ALCF}(\mathcal{D})$ of \mathcal{ALCF} which is parametrized by an admissible concrete domain \mathcal{D}.

Definition 6 ($\mathcal{ALCF}(\mathcal{D})$). The concept formalism of \mathcal{ALCF} is extended by one new construct, called predicate restriction. Assume that f_1, \cdots, f_m are $m > 0$ attributes. Then $f_1 \cdots f_m$ is called an attribute chaining. If u_1, \cdots, u_n are attribute chainings and P is an n-ary concrete predicate then $P(u_1, \cdots, u_n)$ *(predicate restriction)* is a concept term.

The only differences between interpretations \mathcal{I} of $\mathcal{ALCF}(\mathcal{D})$ and \mathcal{ALCF} are:

- The *abstract domain* $dom(\mathcal{I})$ is required to be disjoint from $dom(\mathcal{D})$.
- Attributes f are interpreted as partial functions $f^{\mathcal{I}} : dom(\mathcal{I}) \longrightarrow dom(\mathcal{I}) \cup dom(\mathcal{D})$. They establish the link between the abstract and the concrete domain.

The semantics of the predicate restriction is defined as

$$P(u_1, ..., u_n)^{\mathcal{I}} = \{x \in dom(\mathcal{I}); \text{ there exist } r_1, ..., r_n \in dom(\mathcal{D}) \text{ such that}$$
$$u_1^{\mathcal{I}}(x) = r_1, ..., u_n^{\mathcal{I}}(x) = r_n \text{ and } (r_1, ..., r_n) \in P^{\mathcal{D}}\}.$$

Here the application of the interpretation function to the attribute chainings u_i is the composition of the respective partial functions.

Under the assumption that the concrete domain is admissible [Baader and Hanschke, 1991] describes sound and complete algorithms for all reasoning services for this extended language that are usually provided for terminological systems. In particular, for two concept terms C and D and a terminology \mathcal{T} over $\mathcal{ALCF}(\mathcal{D})$ it is decidable whether C subsumes D w.r.t. \mathcal{T}. The basic algorithm relies on a form of tableaux calculus and is an extension of the procedures in [Schmidt-Schauß and Smolka, 1991; Hollunder et al., 1990; Hollunder, 1990; Donini et al., 1991] that have been designed for concept languages without a concrete domain.

The following sample terminology shows how a part of the problem domain of lathes can be formalized using $\mathcal{ALCF}(\mathcal{R})$.

$$
\begin{aligned}
\text{Truncone} &= \text{truncone-condition}(r_1, r_2, c_1, c_2) \\
\text{Ascend} &= \text{Truncone} \sqcap (r_1 \leq r_2) \\
\text{Cylinder} &= \text{Truncone} \sqcap (r_1 = r_2) \\
\text{Neighboring} &= \exists\text{head}.\text{Truncone} \sqcap \exists\text{tail}.\exists\text{head}.\text{Truncone} \sqcap \\
&\qquad (\text{head } r_2 = \text{tail head } r_1) \sqcap (\text{head } c_2 = \text{tail head } c_1) \\
\text{Last} &= \forall\text{tail}.\text{Bottom} \\
\text{One} &= \exists\text{head}.\text{Truncone} \sqcap \text{Last} \\
\text{Two} &= \exists\text{head}.\text{Truncone} \sqcap \exists\text{tail}.\text{One} \sqcap \text{Neighboring}
\end{aligned}
$$

In this terminology r_1, r_2, c_1, c_2, head, and tail are attributes. The concrete predicate truncone-condition restricts the attribute fillers for r_1, r_2, c_1, and c_2, according to the requirements mentioned in Section 2. For the concrete predicates $=$ and \leq we have used infix notation to increase readability. The expression

$$(\text{head } r_2 = \text{tail head } r_1) \sqcap (\text{head } c_2 = \text{tail head } c_1)$$

in the definition of Neighboring ensure that the 'right' co-ordinates of the 'left' truncated cone coincide with the 'left' co-ordinates of the 'right' truncated cone.

5 Adding Transitive Closure

This section introduces an extension \mathcal{ALCF}^+ of \mathcal{ALCF} that can satisfy the demands of the problem domain for representing concepts which contain objects that are sequences of finite but previously unknown length (varying length aspects). The basic idea of this extension is to allow role and attribute *terms* in value-restrictions and exists-in restrictions instead of just allowing role and attribute *names* as in \mathcal{ALCF}.

Definition 7 (syntax of \mathcal{ALCF}^+). The *role/attribute terms* are built from role and attribute names with

$$\text{union } (R \sqcup S), \quad \text{composition } (R \circ S), \text{ and } \quad \text{transitive closure } (\text{trans}(R))$$

of roles and attributes. Concept terms in \mathcal{ALCF}^+ are defined as in \mathcal{ALCF} with the only difference that role/attribute terms can be used in value-restrictions and exists-in restrictions.

For example, a sequence of truncated cones can be defined as follows:

$$\text{Sequence} = \exists\text{head}.\text{Truncone} \sqcap \forall\text{trans}(\text{tail}).\exists\text{head}.\text{Truncone}$$

Since \mathcal{ALCF}^+ provides no concrete domains Truncone is a primitive (i.e., not further defined) concept in this terminology and we have not expressed that the truncated cones are neighboring.

Definition 8 (semantics of \mathcal{ALCF}^+). The interpretation can be extended to attribute/role terms in the obvious way: $(R \sqcup S)^\mathcal{I} = R^\mathcal{I} \cup S^\mathcal{I}$, $(R \circ S)^\mathcal{I} = \{(x,y); \exists z : (x,z) \in R^\mathcal{I} \text{ and } (z,y) \in S^\mathcal{I}\}$, and $\text{trans}(R)^\mathcal{I} := \bigcup_{n \geq 1} (R^\mathcal{I})^n$.

In [Baader, 1991] it is shown that for \mathcal{ALC}^+ (i.e., \mathcal{ALCF}^+ *without* attributes) the subsumption problem is decidable. A close look at the algorithm for \mathcal{ALC}^+ (which is much too complex to be sketched here) reveals that the result also holds for \mathcal{ALCF}^+, that means, for concept terms C, D and a terminology \mathcal{T} over \mathcal{ALCF}^+ (with attributes and roles) it is decidable whether C subsumes D.

6 Combining the Extensions

Up to now we have considered two different extensions of our base language \mathcal{ALCF}: The extension by concrete domains and the extension by role/attribute terms involving transitive closure. Now we consider the language $\mathcal{ALCF}^+(\mathcal{D})$ which we obtain if we combine both extensions.

As mentioned in the introductory sections we should like to have both representational facilities available to solve our representation problems. With \mathcal{R} as the concrete domain this language is expressive enough to define concepts that are of great importance in our application domain, such as a 'sequence of neighboring truncated cones' (Seq-tc) and its specialization 'ascending sequence of truncated cones' (Aseq-tc):

$$\begin{aligned}\text{Seq-tc} = &\ \text{Sequence} \sqcap (\text{Last} \sqcup \text{Neighboring}) \sqcap \\ &\ \forall\text{trans}(\text{tail}).(\text{Last} \sqcup \text{Neighboring}) \\ \text{Aseq-tc} = &\ \text{Seq-tc} \sqcap \forall\text{head}.\text{Ascend} \sqcap \forall\text{trans}(\text{tail}) \circ \text{head}.\text{Ascend}\end{aligned}$$

where the other concepts are as in the sample terminology of Section 4.

The price we have to pay for this expressiveness is that we cannot decide in general whether a concept C subsumes a concept D in this language.

This will be shown by reducing the Post Correspondence Problem to the subsumption problem for this language. The reduction will use only very simple predicates from real arithmetic, namely equalities between linear polynomials in at most two variables.

First, we recall the definition of the Post Correspondence Problem. Let Σ be a finite alphabet. A *Post Correspondence System* (PCS) over Σ is a nonempty finite set $S = \{(l_i, r_i); i = 1, ..., m\}$ where the l_i, r_i are words over Σ. A nonempty sequence $1 \leq i_1, ..., i_n \leq m$ is called a *solution* of the system S iff $l_{i_1} \cdots l_{i_m} = r_{i_1} \cdots r_{i_m}$. It is well-known that the *Post Correspondence Problem*, i.e., the question whether there

exists a solution for a given system, is in general undecidable if the alphabet contains at least two symbols [Post, 1946].

A solution of a PCS is a sequence of pairs of words with a previously unknown size. The varying size is represented with the help of the transitive closure on the abstract level, whereas the words and their concatenation is modeled by predicates of the concrete domain \mathcal{R}.

The words are encoded into \mathcal{R} as follows. For $B := |\Sigma| + 1$ we can consider the elements of Σ as digits $1, 2, ..., B - 1$ of numbers represented at base B. For a given nonempty word w over Σ we denote by \overline{w} the nonnegative integer (in ordinary representation at base 10) it represents at base B. We assume that the empty word ε represents the integer 0. Obviously, the mapping $w \mapsto \overline{w}$ is a 1–1-mapping from Σ^* into the set of nonnegative integers. Concatenation of words is reflected on the corresponding numbers as follows. Let v, w be two words over Σ. Then we have $\overline{vw} = \overline{v} \cdot B^{|w|} + \overline{w}$, where $|w|$ denotes the length of the word w.

We are now ready to define names for the predicates of the concrete domain \mathcal{R} we shall use in our reduction. For $i = 1, ..., m$,

$$C_l^i(x, y, z) \iff y = \overline{l_i} \wedge z = y + x \cdot B^{|l_i|},$$
$$C_r^i(x, y, z) \iff y = \overline{r_i} \wedge z = y + x \cdot B^{|r_i|},$$
$$E(x, y) \iff x = y, \quad \text{and} \quad L(x) \iff x = 0.$$

Let $l, r, w_l, w_r,$ and f be attribute names. The concept term $C(S)$ corresponding to the Post Correspondence System S is now defined as follows:

$$
\begin{aligned}
C(S) = {} & \bigsqcup_{i=1}^{m} \left(C_l^i(w_l, l, f\, w_l) \sqcap C_r^i(w_r, r, f\, w_r) \right) \sqcap \\
& L(w_l) \sqcap L(w_r) \sqcap \\
& \forall \text{trans}(f). \left(\bigsqcup_{i=1}^{m} \left(C_l^i(w_l, l, f\, w_l) \sqcap C_r^i(w_r, r, f\, w_r) \right) \right) \sqcap \\
& \exists \text{trans}(f). E(w_l, w_r).
\end{aligned}
$$

A concept term D is satisfiable iff there is a interpretation such that $D^{\mathcal{I}}$ is not empty. Obviously, a concept term D is satisfiable iff Bottom does not subsume D. Thus, undecidability of satisfiability implies undecidability of subsumption.

Theorem 9. *The concept term $C(S)$ is satisfiable if and only if the Post Correspondence System S has a solution. Consequently, satisfiability is in general undecidable for concept terms which may contain transitive closure of attributes and predicate restrictions of an admissible concrete domain.*

Proof. Assume that S has a solution $i_1, ..., i_n$ of length n. We extend this sequence to an infinite sequence $i_1, ..., i_n, i_{n+1}, i_{n+2}, ...$ by choosing arbitrary indices $1 \leq i_{n+1}, i_{n+2}, ... \leq m$. This new sequence is used to define an interpretation \mathcal{I} as follows:

$$dom(\mathcal{I}) := \{k; k \geq 1\}, \text{ and for all } k \geq 1,$$
$$f^{\mathcal{I}}(k) := k + 1,$$
$$l^{\mathcal{I}}(k) := \overline{l_{i_k}} \text{ and } r^{\mathcal{I}}(k) := \overline{r_{i_k}},$$
$$w_l^{\mathcal{I}}(k) := \overline{l_{i_1} \cdots l_{i_{k-1}}} \text{ and } w_r^{\mathcal{I}}(k) := \overline{r_{i_1} \cdots r_{i_{k-1}}}.$$

Please note that for $k = 1$, the word $l_{i_1} \cdots l_{i_{k-1}}$ is the empty word, and thus $\overline{l_{i_1} \cdots l_{i_{k-1}}} = 0$. It is now easy to show that $1 \in C(S)^{\mathcal{I}}$. Obviously, this implies that $C(S)$ is satisfiable.

On the other hand, assume that $C(S)$ is satisfiable, and let \mathcal{I} be an interpretation such that $C(S)^{\mathcal{I}} \neq \emptyset$. This interpretation can be used to find a solution of S. Consider an arbitrary element c of $C(S)^{\mathcal{I}}$. Obviously, $c \in (L(w_l) \sqcap L(w_r))^{\mathcal{I}}$ yields $w_l^{\mathcal{I}}(c) = 0 = w_r^{\mathcal{I}}(c)$. Since

$$c \in \left(\bigsqcup_{i=1}^{m} \left(C_l^i(w_l, l, f\, w_l) \sqcap C_r^i(w_r, r, f\, w_r) \right) \right)^{\mathcal{I}},$$

we know that there exists an index between 1 and m, say i_1, such that

$$c \in \left(C_l^{i_1}(w_l, l, f\, w_l) \sqcap C_r^{i_1}(w_r, r, f\, w_r) \right)^{\mathcal{I}}.$$

By the definition of the concrete predicates we get that $l^{\mathcal{I}}(c) = \overline{l_{i_1}}$ and $r^{\mathcal{I}}(c) = \overline{r_{i_1}}$, and $(f\, w_l)^{\mathcal{I}}(c) = \overline{l_{i_1}}$ and $(f\, w_r)^{\mathcal{I}}(c) = \overline{r_{i_1}}$.

Similarly, one can show by induction on k that for all $k \geq 0$ there exists an index i_{k+1} between 1 and m such that

$$(f^k\, l)^{\mathcal{I}}(c) = \overline{l_{i_{k+1}}}, \qquad (f^k\, r)^{\mathcal{I}}(c) = \overline{r_{i_{k+1}}},$$
$$(f^{k+1}\, w_l)^{\mathcal{I}}(c) = \overline{l_{i_1} \cdots l_{i_{k+1}}}, \quad (f^{k+1}\, w_r)^{\mathcal{I}}(c) = \overline{r_{i_1} \cdots r_{i_{k+1}}}.$$

From $c \in (\exists trans(f).E(w_l, w_r))^{\mathcal{I}}$ we can now deduce that there exists a positive integer n such that $(f^n\, w_l)^{\mathcal{I}}(c) = (f^n\, w_r)^{\mathcal{I}}(c)$, and thus we have $\overline{l_{i_1} \cdots l_{i_n}} = \overline{r_{i_1} \cdots r_{i_n}}$. Consequently, $l_{i_1} \cdots l_{i_n} = r_{i_1} \cdots r_{i_n}$, which shows that the sequence $i_1, ..., i_n$ is a solution of S. $\qquad \Box$

7 How to Live with this Undecidability Result

Since terminological systems are only subsystems in larger representation architectures (which usually have incomplete reasoners or provide only semidecision procedures), there are two possible ways to avoid undecidable inference problems in the concept language:

- Take $\mathcal{ALCF}(\mathcal{D})$ and deal with the varying length aspects in the surrounding formalism.
- Take \mathcal{ALCF}^+ and provide for concrete domains in the surrounding system.

The first approach has been taken in the ARC-TEC project at DFKI, where the varying size aspects are shifted to a rule formalism [Hanschke and Hinkelmann, 1992; Hanschke and Baader, 1991].

References

[Baader and Hanschke, 1991] F. Baader and P. Hanschke. A scheme for integrating concrete domains into concept languages. In *Proceedings of the 12th International Joint Conference on Artificial Intelligence*, 1991. A long version is available as DFKI Research Report RR-91-10.

[Baader, 1990] F. Baader. Terminological cycles in KL-ONE-based knowledge representation languages. In *Proceedings of the Eighth National Conference on Artificial Intelligence*, volume 2, pages 621–626. AAAI, 1990. A long version is available as DFKI Research Report RR-90-01.

[Baader, 1991] F. Baader. Augmenting concept languages by transitive closure of roles: An alternative to terminological cycles. In *Proceedings of the 12th International Joint Conference on Artificial Intelligence*, 1991. A long version is available as DFKI Research Report RR-90-13.

[Borgida et al., 1989] A. Borgida, R. J. Brachman, D. L. McGuinness, and L. A. Resnick. CLASSIC: A structural data model for objects. In *International Conference on Management of Data*. ACM SIGMOD, 1989.

[Brachman and Schmolze, 1985] R. J. Brachman and J. G. Schmolze. An overview of the KL-ONE knowledge representation system. *Cognitive Science*, 9(2):171–216, 1985.

[Brachman et al., 1979] R. J. Brachman, R. J. Bobrow, P. R. Cohen, J. W. Klovstad, B. L. Webber, and W. A. Woods. Research in natural language understanding, annual report. Technical Report No. 4274, Cambrige, MA, 1979. Bolt Beranek and Newman.

[Collins, 1975] G. E. Collins. Quantifier elimination for real closed fields by cylindrical algebraic decomposition. In *2nd Conference on Automata Theory & Formal Languages*, volume 33 of *LNCS*, 1975.

[Donini et al., 1991] F. Donini, B. Hollunder, M. Lenzerini, A. M. Spaccamela, D. Nardi, and W. Nutt. The complexity of existential quantificatoin in concept languages. Research Report RR-91-02, DFKI, 1991.

[Edelmann and Owsnicki, 1986] J. Edelmann and B. Owsnicki. Data models in knowledge representation systems: a case study. In *GWAI-86 und 2. Östereichische Artificial-Intelligence-Tagung*, volume 124 of *Informatik-Fachberichte*, pages 69–74. Springer, 1986.

[Hanschke and Baader, 1991] Ph. Hanschke and F. Baader. Terminological reasoning in a mechanical-engineering domain. In *Workshop on Terminological Logics, Berlin*. KIT-Report, 1991.

[Hanschke and Hinkelmann, 1992] Ph. Hanschke and K. Hinkelmann. Combining terminological and rule-based reasoning for abstraction processes. In *GWAI'92*. Springer, 1992.

[Hollunder et al., 1990] B. Hollunder, W. Nutt, and M. Schmidt-Schauß. Subsumption algorithms for concept description languages. In *9th European Conference on Artificial Intelligence (ECAI'90)*, pages 348–353, 1990.

[Hollunder, 1990] B. Hollunder. Hybrid inferences in KL-ONE-based knowledge representation systems. In *GWAI-90; 14th German Workshop on Artificial Intelligence*, volume 251 of *Informatik-Fachberichte*, pages 38–47. Springer, 1990.

[Klauck et al., 1991] Ch. Klauck, R. Legleitner, and A. Bernardi. FEAT-REP: Representing features in CAD/CAM. In *4th International Symposium on Artificial Intelligence: Applications in Informatics*, Cancun, Mexiko, 1991. A long version is available as DFKI Research Report RR-91-20.

[Kobsa, 1989] A. Kobsa. The SB-ONE knowledge representation workbench. In *Preprints of the Workshop on Formal Aspects of Semantic Networks*, 1989. Two Harbors, Cal.

[Loos and Weispfenning, 1990] R. Loos and V. Weispfenning. Applying linear quantifier elimination. Technical Report, Wilhelm Schickard-Institut für Informatik, Universität Tübingen, Germany, 1990.

[Mays et al., 1987] E. Mays, C. Apté, J. Griesmer, and J. Kastner. Organizing knowledge in a complex financial domain. IEEE *Expert*, 2(3):61–70, 1987.

[Mays et al., 1988] E. Mays, C. Apté, J. Griesmer, and J. Kastner. Experience with K-Rep: an object centered knowledge representation language. In *Proceedings of* IEEE CAIA-88, pages 62–67, 1988.

[Nebel, 1989] B. Nebel. Terminological cycles: Semantics and computational properties. In *Proceedings of the Workshop on Formal Aspects of Semantic Networks*, 1989. Two Harbors, Cal.

[Nebel, 1990] Bernhard Nebel. *Reasoning and Revision in Hybrid Representation Systems*, volume 422 of *LNAI*. Springer, 1990.

[Post, 1946] E. M. Post. A variant of a recursively unsolvable problem. *Bull. Am. Math. Soc.*, 52:264–268, 1946.

[Schmidt-Schauß and Smolka, 1991] M. Schmidt-Schauß and G. Smolka. Attributive concept descriptions with complements. Journal of Artificial Intelligence, 47, 1991.

[Tarski, 1951] A. Tarski. *A Decision Method for Elementary Algebra and Geometry*. U. of California Press. Berkley, 1951.

[Weispfenning, 1988] V. Weispfenning. The complexity of linear problems in fields. *J. Symbolic Computation*, 5:3–27, 1988.

Combining Terminological and Rule-based Reasoning for Abstraction Processes*

Philipp Hanschke and Knut Hinkelmann

DFKI, Postfach 2080,
W-6750 Kaiserslautern, Germany
{hanschke,hinkelma}@dfki.uni-kl.de

Abstract. Terminological reasoning systems directly support the abstraction mechanisms generalization and classification. But they do not bother about aggregation and have some problems with reasoning demands such as concrete domains, sequences of finite but unbounded size and derived attributes. The paper demonstrates the relevance of these issues in an analysis of a mechanical engineering application and suggests an integration of a forward-chaining rule system with a terminological logic as a solution to these problems.

1 Introduction

In [11] *heuristic classification* has been identified as a widespread problem-solving method underlying various expert systems. Heuristic classification is comprised of three main phases (cf. Fig. 1): *Abstraction* from a concrete, particular problem description to a problem class, *heuristic match* of a principal solution (method) to the problem class, and *refinement* of the principal solution to a concrete solution for the concrete problem.

Fig. 1. Heuristic Classification Inference Structure

In this paper we suggest a hybrid, declarative formalism for the abstraction phase. It is commonly agreed that *generalization* of concepts (*is-a* relation or subsumption), *classification* of entities (*instance-of* relation), and *aggregation* of objects

* Supported by BMFT Research Project ARC-TEC (grant ITW 8902 C4).

(*part-of* relation) are the most important abstraction operations (see for example [9], and [17]). The presented formalism supplements the generalization, specialization and classification services of terminological knowledge representation languages by dealing with aggregation as an abstraction operation explicitly. This is achieved by a tight coupling of terminological and rule inferences.

As described in [7] production planning can be determined as an instance of the inference structure of heuristic classification (Fig. 1). The objective of production planning is to derive a working plan describing how a given workpiece can be manufactured. The input to a production planning system is a very 'elementary' description of a workpiece as it comes from a CAD system. Geometrical descriptions of the workpiece's surfaces, topological neighbourhood relations, and technological data are the central parts of this product model representation. If possible at all, production planning with these input data starting from (nearly) first principles would require very complex algorithms. Thus, planning strategies on such a detailed level are neither available nor do they make sense. Instead, human planners have a library of *skeletal plans* in their minds [18]. Each of these plans is accessed via a more or less abstract description of a characteristic (part of a) workpiece, which is called a *workpiece feature* [14]. A feature thus associates a workpiece model with corresponding manufacturing methods. Therefore, the first step in production planning is the generation of an abstract feature description from the elementary workpiece data. In the second step, skeletal plans are associated with each of the features before they are merged and instantiated in the third step, ruling out unsuitable combinations.

In the following section we shall define concepts comprising (a part of) the terminological knowledge of our sample application in a terminological formalism and illustrate how terminological systems support generalization, specialization, and classification. Section 3 will then show how aggregation can be managed by incorporating rules, which at the same time supports the solution of some other representation and reasoning problems in terminological systems. Section 4 makes the formalism more precise and discusses the operational semantics of the proposed hybrid system.

2 Abstraction in Terminological Languages

In the T-box formalism of terminological systems concepts are defined intensionally. This is done by the use of concept terms that partially describe entities. The language we are using provides in addition to the usual concept operators concrete domains such as predicates over rational numbers [4]. This is especially useful in our technical domain where we deal with geometric entities. The geometry, as the main ingredient of a CAD drawing, is given in our application as a collection of rotational-symmetric surfaces that are fixed to the symmetry axis of the lathe work. An important geometric element is the truncated cone. Since the surfaces are fixed to an axis, they can be characterized by four rational numbers r_1, r_2, c_1, and c_2 (Fig. 2). But not all quadruples represent a truncated cone. So we have to restrict their values such that the radii are positive and the quadruples do not correspond to a line, a circle, or even a point. These restrictions are expressed by the four place predicate truncone-condition over the concrete domain of rational numbers

$$\text{truncone} = \text{truncone-condition}(r_1, r_2, c_1, c_2).$$

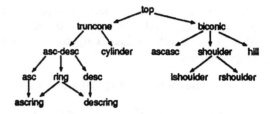

Fig.2. A truncated cone **Fig.3.** A subsumption graph

This definition can be specialized to a cylinder by further restricting the radii as being equal using equality on rational numbers and the *conjunction* operator \sqcap. Similarly, the definitions of ascending and descending truncated cones, rings, etc. can be obtained by specialization.

$$
\begin{array}{ll}
\text{cylinder} = \text{truncone} \sqcap (r_1 = r_2), & \text{ring} \quad = \text{truncone} \sqcap (c_1 = c_2), \\
\text{asc} \quad = \text{truncone} \sqcap (r_1 < r_2), & \text{ascring} = \text{ring} \sqcap \text{asc}, \\
\text{desc} \quad = \text{truncone} \sqcap (r_1 > r_2), & \text{descring} = \text{ring} \sqcap \text{desc}
\end{array}
$$

Conversely, the truncone generalizes the concepts obtained through specialization. Generalization can also be expressed using the *disjunction* operator \sqcup. For example, truncated cones that are not cylinders can be defined as the most specific generalization of ascending and descending truncated cones: asc-desc = asc \sqcup desc.

Since features comprise in general more than one surface, it is necessary to aggregate the primitive surfaces. For instance, a biconic is comprised of two neighbouring truncated cones.

biconic = \existsleft.truncone \sqcap \existsright.truncone \sqcap (left c_2 = right c_1) \sqcap (left r_2 = right r_1)

Here the attributes left and right play the role of *part-of* attributes linking a biconic to its components. The semantics of the *exists-in restriction* in \existsleft.truncone is that an object is a member of this concept iff it has a truncated cone as a filler for left. The expression (left c_2 = right c_1) forces the right center of the left truncated cone to be equal to the left center of the right truncated cone.

Specializations of biconic are defined using the *value restriction* operator \forall. An object belongs to \forallleft.cylinder if it has no attribute filler or a cylinder as attribute filler for left.

$$
\begin{array}{ll}
\text{ascasc} & = \text{biconic} \sqcap \forall\text{left.asc} \sqcap \forall\text{right.asc}, \\
\text{hill} & = \text{biconic} \sqcap \forall\text{left.asc} \sqcap \forall\text{right.desc}, \\
& \dots \\
\text{rshoulder} & = \text{biconic} \sqcap \forall\text{left.cylinder} \sqcap \forall\text{right.ascring}, \\
\text{lshoulder} & = \text{biconic} \sqcap \forall\text{right.cylinder} \sqcap \forall\text{left.descring}, \\
\text{shoulder} & = \text{lshoulder} \sqcup \text{rshoulder}
\end{array}
$$

Terminological reasoning systems provide an interesting service called *concept classification* that arranges the introduced concepts in a subsumption graph (Fig. 3).

To represent a particular lathe workpiece in a terminological system, the assertional formalism, called A-box, is employed. It allows to instantiate the concepts with objects and to fill in their attributes. A single truncated cone could for example be represented as:

$$\text{truncone(tc)}, c_1(tc) = 0, r_1(tc) = 10, c_2(tc) = 5, r_2(tc) = 10.$$

The *object classification*[2] of the A-box computes the most specific concept(s) an object belongs to. In the example it would detect that tc is a cylinder. Now we consider a second truncated cone neighbouring the first one:

$$\text{truncone(tc')}, c_1(tc') = 5, r_1(tc') = 10, c_2(tc') = 5, r_2(tc') = 15.$$

The object classification would derive that tc' is an ascending ring. But it **cannot** detect that they both form a 'biconic'—unless tc and tc' are aggregated to a **single** instance. Once there is an object bi with assertions

$$\text{left(bi)} = tc, \text{right(bi)} = tc'$$

bi can be classified as a rshoulder. But this generation of a new instance is not a standard operation in terminological reasoning systems. The selection of instances that are composed to a new object does not depend on terminological knowledge. On the contrary, knowledge about aggregation of instances is part of the assertional box. This can easily be seen in the case that the aggregation is not unique. To illustrate this, let us consider a simple configuration example. Let a terminal be defined as a keyboard connected to a screen. Suppose there are two keyboards k_1 and k_2 and two screens s_1 and s_2. If and how screens and keyboards are put together is not part of the terminological but of the assertional component. So there must be a rule which describes under which particular circumstances (for example because of customer requirements) k_1 and s_2 are connected to form a terminal t_1.

3 Abstraction with Rules

Analyzing the above examples we see that terminological systems directly support generalization, specialization, and classification operations. These operations are based on the subsumption relation between concept definitions. Aggregation, however, is not directly supported by terminological reasoning systems. Instead of enhancing the terminological system with an additional aggregation service it is coupled with a general-purpose rule system, which also allows to overcome other restrictions of terminological reasoning.

3.1 Aggregation

Remember the example in Section 2: it is impossible to derive that the two neighbouring truncated cones tc and tc' form a left shoulder, unless there is an object

[2] This service is sometimes also called *realization* [16]

bi with tc and tc' as attribute fillers for left and right. This suggests to add an aggregation rule:

$$\forall x, y : [(\text{truncone}(x), \text{truncone}(y), c_2(x) = c_1(y), r_2(x) = r_1(y))$$
$$\rightarrow \exists z : (\text{left}(z) = x, \text{right}(z) = y)]$$

Aggregation rules collect objects or values to form a new object if certain conditions hold for the constituent parts: "If there are two neighbouring truncated cones, then aggregate them using the attributes left and right". The truncated cones x and y are left and right parts of a new object z, which depends on its constituents. This becomes clear when looking at the skolemized version of the rule (all occurring variables are universally quantified, see Section 4):

$$(\text{truncone}(x), \text{truncone}(y), c_2(x) = c_1(y), r_2(x) = r_1(y))$$
$$\rightarrow (\text{left}(f(x, y)) = x, \text{right}(f(x, y)) = y) \tag{1}$$

Note that it is not necessary to repeat the definition of a rule for every concept in the terminology which describes an aggregate. The automatically computed subsumption graph helps the knowledge engineer to find the most general level on which he can formulate a rule. For example, instead of defining aggregation rules for hill, lshoulder, rshoulder etc. separately, it is sufficient to do so only for a biconic, the most general composition of two neighbouring truncated cones.

3.2 Derived Attribute and Role Fillers

Now we turn to a further difficulty associated with assertional reasoning in terminological systems. Consider the following concept definitions for regular, tall, and flat shoulders:

$$
\begin{aligned}
\text{rshoulder-with-hw} &= \text{rshoulder} \sqcap \ (\text{height} = \text{right } r_2 - \text{right } r_1) \\
&\quad \sqcap \ (\text{width} = \text{left } c_2 - \text{left } c_1) \\
\text{regular-rshoulder} &= \text{rshoulder-with-hw} \sqcap (\text{height} = \text{width}) \\
\text{tall-rshoulder} &= \text{rshoulder-with-hw} \sqcap (\text{height} > \text{width}) \\
\text{flat-rshoulder} &= \text{rshoulder-with-hw} \sqcap (\text{height} < \text{width})
\end{aligned}
$$

Note that (height $= \text{right } r_2 - \text{right } r_1$) is the application of a three-place predicate to the attribute chainings height, right r_2, and right r_1. The object classification cannot identify the aggregate $f(\text{tc}, \text{tc}')$ of the above example as a regular shoulder. This is only possible if the attribute fillers for height and width are available. This could be achieved by the following rule:

$$\text{rshoulder}(x) \rightarrow (\text{height}(x) = r_2(\text{right}(x)) - r_1(\text{right}(x)),$$
$$\text{width}(x) = c_2(\text{left}(x)) - c_1(\text{left}(x)))$$

3.3 Varying Size Aspects

Integrating a terminological reasoning system with a rule-based system can also eliminate a third restriction. Because terminological systems provide decision procedures for their reasoning problems, it cannot be avoided that they have a restricted expressiveness. For example, in general it is not possible to deal with concrete domains (e.g. real numbers in the truncated-cone condition of Section 2) and varying size aspects (e.g. sequences) in *one* concept language in a reasonable way, without having an undecidable subsumption problem [5]. Our way out of this problem is to exclude varying size aspects from the terminological formalism and deal with them in the rule language.

Example 1. To represent an ascending sequence of neighbouring truncated cones, the varying length of the sequence together with the restrictions on the attributes over rational numbers have to be considered. In the combined formalism we define a sequence of truncated cones as a rule relying on the terminology:

$$\text{truncone}(x) \rightarrow \text{asc-list}([x])$$
$$\text{truncone}(x), \text{asc-list}([y|r]), (c_2(x) = c_1(y)), (r_2(x) = r_1(y)) \rightarrow \text{asc-list}([x, y|r])$$

The predicate asc-list is not a concept treated by the terminological inferences, it is solely defined by these two rules much as it would have been done in Prolog ($[x, y|r]$ denotes a list of two elements x, y, and a rest r). This rule allows us to detect sequences of neighbouring truncated cones in the incoming elementary geometric data. Please note that we do not intend to solve an undecidable problem here. The knowledge engineer has to make sure that the intended inferences involving the rules terminate. □

4 The Rule Formalism

In this section we are going to make the syntax and the semantics of the overall formalism more precise.

4.1 Syntax

An *A-box expression with terms* is a conjunction of expressions, each of which is of one of the following forms:

1. *Membership assertion:* $C(t)$, where C is a concept (possibly not defined in the terminology such as asc-list above) and t is a (Herbrand) term possibly containing variables.
2. *Predicate assertion:* $P(u_1(t_1), \cdots, u_n(t_n))$, where the u_i are possibly empty compositions of attributes, the t_i are terms, and P is an n-ary predicate from the concrete domain.
3. *Role-filler assertion:* $R(s, t)$, where R is a role and s, t are terms.
4. *Attribute-filler assertion:* $F(s) = t$, where F is an attribute or a chaining of attributes, and s, t are terms.

5. *Atom:* $P(t_1, \cdots, t_n)$, where P is a predicate only defined by rules and the t_i are terms.

We shall refer to sets of these assertions as (generalized) A-boxes, too. The expression $G \to H$ is a *rule* if G and H are A-box expressions with terms. The variables that occur only in H are considered as existentially quantified, whereas all other variables are considered as universally quantified at the rule level. An expression is *ground* iff it does not contain any variable.

4.2 Semantics

The extension of the abstract concept language by a concrete domain is formally presented in [4], and it is shown that if the concrete domain is *admissible*, then there exist sound and complete reasoning algorithms for the reasoning problems of the terminological formalism, in particular, for concept classification and object classification. The model-theoretic semantics of the extended concept language given there induces a mapping ψ from concept definitions and A-box assertions into logical formulas. It maps concepts to unary predicates, roles and attributes to binary predicates, where the latter are restricted to be functional in their first argument, and predicate symbols from the concrete domains to fixed interpretations determined by the concrete domain. This mapping easily extends to the rule formalism if the arrow "\to" is interpreted as logical implication, the "," as logical conjunction, and the quantifiers as logical quantifiers.

Let an A-box expression G and a ground A-box \mathcal{A} be given. Then \mathcal{A} *constructively implies* G by (the substitution) σ iff (i) $G\sigma$ is ground, and (ii) $G\sigma$ is logically implied by \mathcal{A} and the current terminology. This kind of implication can be effectively tested by a generalized membership test.

For the existentially quantified variables in a head H of a rule $G \to H$ new objects should be generated. For that purpose we substitute skolem terms $f(x_1, \cdots, x_n)$ for these variables. By choosing a new function symbol per existentially quantified variable, and by using all universally quantified variables of the respective rule as arguments, different ground instantiations of a rule lead to different new objects. We assume without loss of generality that from now on all rules are skolemized and, thus, all variables occurring in the head also occur in the body.

The *operational semantics* of a set of rules \mathcal{R} can now be defined by a monotonic operator T (depending on \mathcal{R}) that maps a ground A-box \mathcal{A} to an enlarged A-box

$$T(\mathcal{A}) = \mathcal{A} \cup \{h_j\sigma; \text{ there is a rule } G \to H \text{ in } \mathcal{R} \text{ such that}$$
$$\mathcal{A} \text{ constructively implies } G \text{ by } \sigma,$$
$$H = h_1, \ldots, h_n, \text{ and } 1 \le j \le n\}.$$

Given a ground A-box \mathcal{A}_0 we call $T^\omega(\mathcal{A}_0) := \bigcup_{i=0,1,2,\ldots} T^i(\mathcal{A}_0)$ the *output*. It is straightforward to show that this semantics is correct with respect to the model-theoretic semantics. I.e., each element of the output is logically implied by \mathcal{R} and \mathcal{A}. The situation is more complicated for the converse direction as the following discussion shows.

(1) Hidden objects in the A-box: Consider a rule $C(x) \to B(x)$ and an A-box $(\exists R.C)(a)$. Here, no substitution σ can be found such that $C(x\sigma)$ is implied.

But, according to the semantics of the exists-in restriction there is an (unknown) object, say b, satisfying the premise of the rule. So, the A-box can be transformed into the logically equivalent A-box $R(a, b), C(b)$ and the rule fires.

(2) Case distinctions in the A-box: Consider the A-box $((\exists R.C) \sqcup (\exists S.C))(a)$ and the rule $C(x) \rightarrow B(x)$. Here also an anonymous object satisfying the premise must exist. Unfortunately, whether this object is related to a via R or S depends on the particular interpretation. A similar situation may also occur in the absence of explicit disjunctions as the following example shows: Consider the concept definitions male $= \neg$female, and ma-of-boy $=$ female $\sqcap \exists$child.male and an A-box consisting of female(mary), male(bob), child(mary, x), and child(x, bob).[3]

None of the objects can be classified as being a ma-of-boy. But it is not possible that both x and mary are at the same time not members of ma-of-boy. Hence, it could be logically concluded that there is a ma-of-boy, but no single instance can be found until the sex of x is known. This is one of the main reasons why we have chosen 'constructive implication' to test the premises. If the concept language would contain attribute agreements and disagreements it would even be undecidable whether an A-box \mathcal{A} implies $\exists x C(x)$ [3].

(3) Constructive character of rules: A classical implication $A \rightarrow B$ can be inverted: $\neg B \rightarrow \neg A$. These hidden rules are not captured by the operational semantics above. This source of incompleteness can be avoided by careful use of the rules. For example, the aggregation rules, the derived-parameter rules, and the rules for varying size aspects above, contain only 'positive' expressions in the head, and in the abstraction process their negative counterparts do not occur in the A-box.

A fourth source of incompleteness comes from (2) and (3), together. Consider the A-box $(A \sqcup B)(a)$, and the rules $A(x) \rightarrow C(x)$ and $B(x) \rightarrow C(x)$. Logically $C(a)$ holds, but it is not in the output.

4.3 Refining the Operational Semantics

An implementation of the system can refine the above operational semantics in several directions.

Optimize Premise Instantiation The semi-naive strategy known from deductive databases can be adopted. This strategy fires a rule only if new assertions participate in its instantiation. In the process of instantiating a single rule shared variables lead to partially instantiated expressions which constrain the search for the remaining part of the premise. Finding a good sideway information passing strategy [6] can optimize rule instantiation. It finds a substitution σ for a rule $G \rightarrow H$ incrementally by ordering G.

Other optimizations rely on the terminological structure of the abstraction knowledge. Each object in the A-box is classified and the resulting information is used to build an index structure. During the instantiation of a rule's premise this structure provides quick retrieval of objects for membership expressions.

[3] The idea to this example is due to Maurizio Lenzerini.

Example 2. At compile time rule (1) can be rearranged to

$$(\text{truncone}(x), c_2(x) = c_1(y), r_2(x) = r_1(y), \text{truncone}(y)) \\ \rightarrow (\text{left}(f(x, y)) = x, \text{right}(f(x, y)) = y). \tag{2}$$

At runtime the index structure is used to find an instance tc of truncone(x). Sideway information passing yields a 'neighbouring' object tc' such that $c_2(\text{tc}) = c_1(\text{tc}')$, $r_2(\text{tc}) = r_1(\text{tc}'))$. If, finally, tc' is a truncone, the rule fires and a new instance $f(\text{tc}, \text{tc}')$ is created, which has tc and tc' as attribute fillers for left and right, respectively. The aggregate $f(\text{tc}, \text{tc}')$ will then be classified. An analysis of the premise of the rule reveals that instantiations of $f(x, y)$ will always be a member of a specialization of biconic.

If the truncated cones tc and tc' of Section 2 are used to instantiate the rule then $f(\text{tc}, \text{tc}')$ will be classified as an rshoulder (which is subsumed by biconic), because tc is a cylinder and tc' is an ascending ring (cf. the definition of rshoulder in Section 2). Thus, $f(\text{tc}, \text{tc}')$ can trigger any rule with a membership expression $C(x)$ in its premise where C subsumes rshoulder.

Optimizing the Object Classification Each time assertions are added to the A-box all "affected" objects—in particular newly generated objects—are (re)classified and the index structure is updated. In general, determining which objects are affected and may have a more specific classification and computing the classification is very expensive [16]. This section explores the characteristics of an 'abstraction' to reduce the costs of the (re)classifications.

Our goal is to understand how the classification of an object depends on axioms that are added to the A-box by a rule and which subsets of an A-box are necessary to compute a classification.

Our first observation is that the terminological formalism is *directed*: All concepts in \mathcal{T} are inductively defined in terms of the operators

$$\neg_- \quad (negation), \qquad _\sqcap_ \quad (conjunction), \qquad _\sqcup_ \quad (disjunction)$$
$$\forall_{-\cdot-} \quad (value\text{-}restrictions), \qquad\qquad \exists_{-\cdot-} \quad (exists\text{-}in\ restriction)$$
$$P(_, \ldots, _) \quad (concrete\ domain\ predicate\ restriction)$$

So, essentially, an object a qualifies as a member of a concept only by belonging to simpler concepts and by properties of its attribute and role fillers. It does not matter whether a is a role or attribute filler by its own, say $R(\text{b}, \text{a})$. Only if the R-role fillers of b are constrained, the assertion $R(\text{b}, \text{a})$ may influence the classification of a. For instance, the object a has classification \top w.r.t. the A-box $\{\top(\text{a})\}$. It remains the same if we add $R(\text{b}, \text{a})$ to the A-box. Whereas w.r.t. $\{(\forall R.Q)(\text{b}), \top(\text{a})\}$ its classification will change from \top to Q if we add $R(\text{b}, \text{a})$, and Q is defined in the terminology.

In general, adding a predicate assertion with a concrete domain predicate can change a realization, too. For example, let a terminology be given by $C = (f < 5)$, f an attribute, and a definition of \top. Then w.r.t. the A-box $\{f(\text{b}) = \text{a}\}$ the object b has classification \top whereas w.r.t. $\{f(\text{b}) = \text{a}, \text{a} < \text{c}, \text{c} = 5\}$ it has classification C. But consider the case of an object a that is already constrained to a single element

of the concrete domain by an A-box. So, a has become a constant and there is no consistent extension of the A-box that further constrains the interpretation of a.

What do these observations imply for the (re)classifications in an abstraction process? The abstraction process starts with a concrete description. The corresponding A-box \mathcal{A} can be split into A-boxes of the form $\{C(a), R_i(a, b_i), P_i(b_i); i = 1, \ldots, n\}$ containing the membership and role/attribute assertions of a. R_i are attributes and roles and the P_i restrict the b_i to constants.[4] Thus, the classification of an a w.r.t. \mathcal{A} can be reduced to a classification w.r.t one of the above small A-boxes—provided the A-box is consistent.

An *aggregation rule* asserts only axioms $R_i(n, a_i)$ where the R_i are roles or attributes and the premise of the rule only refers to objects that can be reached from one of the a_i through a directed path of role/attribute assertions in the premise. For these rules it suffices to (re)classify the aggregated object n, if the following side conditions hold:

C1. The A-box remains consistent,
C2. there is no role/attribute assertion $R(c, n)$, and
C3. there is no membership assertion $C(n)$ constraining the R_i-role fillers of n.

A similar observation can be made for the rules dealing with the varying-size aspect.

A rule for *derived fillers* only asserts axioms of the form $P(u(a), v_1(a), \ldots, v_n(a))$ and, analogue to aggregation rules, the premise of the rule only refers to objects that can be reached from an a in its head through a directed path of role/attribute assertions. The predicates P also have the property that for each tuple (a_1, \ldots, a_n) of the concrete domain there is an element b such that $P(b, a_1, \ldots, a_n)$. So, $u(a)$ is the derived filler and only a has to be reclassified, if

C4. the A-box remains consistent,
C5. there is no role/attribute assertion $R(c, a)$, and
C6. the attribute fillers $v_1(a), \ldots, v_n(a)$ already exist.

How can the side conditions be ensured? To satisfy (C2) and (C5) we choose a particular strategy of the forward chaining. Note that possible rule applications to the initial A-box satisfy these two side conditions. In successive rule firings the strategy does not fire a rule that adds a new object a with an assertion $R(a, b)$ if it can fire another rule that just adds new *role* or *attribute fillers* (e.g. for b). This means that the strategy applies derived-filler rules before aggregation rules.

To ensure consistency the initial A-box is checked for consistency. This is sufficient because the aggregation rules do not cause inconsistencies and if only one rule is responsible for one derived attribute or role they do not produce inconsistencies either. The other side conditions are satisfied without additional requirements on the abstraction process.

Note that we have assumed that only rules of the mentioned kinds participate in the abstraction and that the abstraction starts with an A-box of a particular form. Together with the above strategy this enables a further optimization. The (re)classification of an a w.r.t \mathcal{A} can be reduced to a classification w.r.t. $\mathcal{A}_a \subseteq \mathcal{A}$

[4] To increase readability, in the examples in the previous sections $P_i(b_i)$ has always been omitted and b_i has directly been written as a constant.

where, roughly, \mathcal{A}_a is the set of assertions that can be reached from a through a directed path of attributes or roles. Formally, \mathcal{A}_a can be defined as follows: \mathcal{A}_a is the smallest subset of \mathcal{A} such that for every object b occurring in \mathcal{A}_a

1. if $R(b, c) \in \mathcal{A}$, R a role or attribute, then $R(b, c) \in \mathcal{A}_a$,
2. if $C(b) \in \mathcal{A}$, then $C(b) \in \mathcal{A}_a$, and
3. if $P(\cdots, b, \cdots) \in \mathcal{A}$, then $P(\cdots, b, \cdots) \in \mathcal{A}_a$.

If we drop the requirement of the initial A-box that the $P_i(b_i)$ restrict the b_i to a single constant, the restriction to \mathcal{A}_a is no longer possible, but still no more (re)classifications are necessary.

Discussion In this subsection we observed that terminological languages as presented here are 'directed' from objects to fillers — from abstract to concrete. For rules that respect this 'directionality' several optimizations concerning the (re)classification are possible. More precisely, the optimizations explore the fact that the rules describe abstraction, i.e., they preserve the existing, more concrete part of a (problem) description and extend it towards a more abstract description without constraining the initial description modulo the 'directionality' of the concept language.

5 Conclusions

The paper has shown how a terminological system can be integrated in a rule formalism for which we have presented an operational semantics based on forward chaining and terminological inferences. It turned out that this hybrid formalism is suitable to deal with aggregation (in addition to generalization and classification), derived attributes, and varying length aspects in the abstraction phase of heuristic classification. The decision procedures for the terminological inferences together with the conceptual simplicity of forward chaining have led to a powerful representation formalism with transparent inferences.

Our approach is based on a decidable concept language. This enables us to automatically compute the generalization hierarchy from intensional concept definitions. This is different from related work in logic programming (LOGIN [2]) and query languages for databases [13]. In these formalisms the rule inferences take a fixed taxonomy given as a semi lattice of sorts into account. LOGIN's feature logic provides no relational roles and a query is answered by strict top-down, left-to-right reasoning, which is less appropriate for the abstraction application compared to our data-driven approach.

Probably the most closely related work is the query language presented in [1]. They deal with bottom-up execution of rules, too, and in particular, they also generate new objects (they call it object identities) for variables that occur only in the head of a rule. But there are certain differences: they employ the closed-world assumption, they have no quantification over role and attribute fillers, they deal with a fixed taxonomy, they do not have concrete domains, and they do not identify an decidable subformalism such as our concept formalism.

LOOM [15], MESON [12], and CLASSIC [10] are terminological reasoning systems that provide rules of the following restricted form: $C(x) \rightarrow D(x)$, where C and D are concepts, which are not expressive enough to represent aggregation.

A reasoning system along the lines of this paper that also deals with the other phases of heuristic classification has been implemented in Common Lisp and has been tested with the mentioned prototypical production planning application [8].

References

1. S. Abiteboul and P. C. Kanellakis. Object identity as a query language primitive. In *ACM SIGMOD*, pages 159–173, 1989.
2. H. Ait-Kaci and R. Nasr. LOGIN: A logic programming language with built-in inheritance. *JLP*, 3:185–215, 1986.
3. F. Baader, H.-J. Bürckert, B. Nebel, W. Nutt, and G. Smolka. On the expressivity of feature logics with negation, functional uncertainty, and sort equations. Research Report RR-91-01, DFKI, 1991.
4. F. Baader and Ph. Hanschke. A scheme for integrating concrete domains into concept languages. Research Report RR-91-10, DFKI / Kaiserslautern, 1991.
5. F. Baader and Ph. Hanschke. Extensions of concept languages for a mechanical engineering application. In *GWAI-92*, 1992.
6. C. Beeri and R. Ramakrishnan. On the power of magic. *Journal of Logic Programming*, 10:255–299, 1991.
7. A. Bernardi, H. Boley, K. Hinkelmann, Ph. Hanschke, C. Klauck, O. Kühn, R. Legleitner, M. Meyer, M.M. Richter, G. Schmidt, F. Schmalhofer, and W. Sommer. ARC-TEC: Acquisition, Representation and Compilation of Technical Knowledge. In *Expert Systems and their Applications: Tools, Techniques and Methods*, Avignon, France, 1991.
8. H. Boley, Ph. Hanschke, K. Hinkelmann, and M. Meyer. COLAB: A hybrid konwoledge compialtion laboratory. submitted for publication, January 1991.
9. A. Borgida, J. Mylopoulos, and H. K. T. Wong. Generalization/spezialization as a basis for software specification. In *On Conceptual Modelling*. Springer, 1984.
10. R. Brachman, D. McGuinness, P. Pate-Schneider, and L. Resnick. Living with CLASSIC: When and how to use a KL-ONE-like language. In *Principles of Semantic Networks*. Morgan Kaufmann, 1991.
11. J. Clancey, W. Heuristic classification. *Artificial Intelligence*, 27:289–350, 1985.
12. J. Edelmann and B. Owsnicki. Data models in knowledge representation systems: A case study. In *GWAI-86 and 2. Österreichische Artificial-Intelligence Tagung*, pages 69–74. Springer, 1986.
13. M. Kifer and G. Lausen. F-logic: A higher-order language for reasoning about objects, inheritance, and scheme. In *ACM SIGMOD*, pages 134–146, 1989.
14. Ch. Klauck, R. Legleitner, and A. Bernardi. FEAT-REP: Representing features in CAD/CAM. In *4th International Symposium on Artificial Intelligence: Applications in Informatics*, 1991.
15. R. MacGregor. A deductive pattern matcher. In *AAAI*, pages 403–408, 1988.
16. B. Nebel. *Reasoning and Revision in Hybrid Representation Systems*. Springer, 1990.
17. A. Nixon, B., L. Chung, K., and D. Lauzon. Design of a compiler for a semantic data model. In *Foundations of Knowledge Base Management*. Springer, 1989.
18. F. Schmalhofer, O. Kühn, and G. Schmidt. Integrated knowledge acquisition from text, previously solved cases, and expert memories. *Applied Artificial Intelligence*, 5:311–337, 1991.

Forward Logic Evaluation: Compiling a Partially Evaluated Meta-Interpreter into the WAM

Knut Hinkelmann[*]

DFKI, Postfach 2080, W-6750 Kaiserslautern, Germany
hinkelma@dfki.uni-kl.de

Abstract. Forward chaining of a logic program is specified by a meta-interpreter written in Prolog. Premises of forward rules are verified by Prolog's backward proof procedure. Since meta-interpreters in general suffer from the overhead of the additional meta-layer, a well-known technique, partial evaluation of the meta-interpreter wrt the object-level program, is applied to reduce this overhead. Still several sources of inefficiency can be identified after this transformation. To compile the forward program into the Warren Abstract Machine (WAM) in an efficient way, the WAM is modified by splitting the code area into a backward and forward code area and by adding a new stack to record derived facts. This shows how an efficient implementation of meta-interpreters can have an effect on compilation and even on the design of the target machine.

1 Introduction

Horn logic is a declarative knowledge representation formalism for logic programming systems. Interpreting Horn clauses as implications leads to the view of a logic program as a declarative rule system. In principle there are two reasoning directions for Horn clauses. While top-down reasoning starts with a query applying the clauses in *backward* direction until a fact is reached for a goal, bottom-up strategies start with the facts and apply the rules in *forward* direction. Backward reasoning of Horn clauses is the basis for most logic programming languages (e.g. Prolog). It can be implemented rather efficiently by compilation into the Warren Abstract Machine (WAM, [War83]). Especially for deductive databases many effort has been involved in developing efficient bottom-up reasoning strategies (cp. [Ban88], \mathcal{LDL} [Naq89]).

Several attempts have been made to integrate forward chaining into Prolog. Common to most of these approaches is that they use disjoint sets of rules for both reasoning directions ([Mor81], [Cha87], [Fin89]). While separate forward and backward interpreters would make the system more complex, a meta-interpreter is rather inefficient, because it interprets the original program as data. But it can be made more efficient by program transformation techniques like partial evaluation (also called partial deduction in [Kom82]). This approach will be presented here.

[*] Supported by BMFT Research Project ARC-TEC (grant ITW 8902 C4)

Initially there are an *object-level* program P and a *meta-level* program M specifying an interpreter for applying the clauses of P in forward direction. The meta-interpreter is presented in Section 2. In Section 3 the partial evaluation of M wrt to P is described. By analyzing the partially evaluated meta-interpreter, we identify two remaining sources of inefficiency. These can be overcome in the compilation phase after introducing some modification of the WAM (Section 4).

2 Forward Reasoning Horn Rules

Horn-clause programs have a unique minimal model, which can be regarded as the intended meaning of the program. In [Emd76] it is shown that fixpoint semantics and model-theoretic semantics coincide. A monotonic operator to construct the minimal model is presented, which corresponds to a bottom-up derivation. Instead of generating the complete model, the particular forward reasoning approach presented here derives only a subset of this minimal model. In particular, forward chaining starts with a set of initial facts $p_1(x_1,...,x_{n1}),...,p_m(x_1,...,x_{nm})$. Only consequences of these facts are computed, i.e. each of the derived facts depends on at least one of these initial facts.

Algorithm 2.1 (Forward Chaining)

1. Start with a set of initial facts $\mathcal{F} = \{p_1(x_1,...,x_{n1}), ...,p_m(x_1,...,x_{nm})\}$

2. Select one fact $p(x_1,...,x_n) \in \mathcal{F}$ to be the actual fact F. Stop if there are no (more) facts.

3. Find the next potentially applicable rule: a rule $C:- P_1,...P_k$ is triggered, if any $P_i, 1 \le i \le k$, is unifiable with F, i.e. there is a substitution σ such that $P_i \sigma = F\sigma$.

 If no rule is applicable go to 2.

4. Test the rule's premises: the remaining premises $P_1,...,P_{i-1}, P_{i+1},...,P_k$ are verified by backward reasoning giving a substitution $\tau \ge \sigma$.

 If the premises are not satisfiable go to 3.

5. Apply the rule: record the instantiated conclusion $C\tau$ as a derived fact in the set of facts $\mathcal{F} := \mathcal{F} \cup \{C\tau\}$

 Proceed with 2. □

Steps 3, 4 and 5 describe the application of one rule in forward direction. The forward reasoning strategy depends on the order in which the actual fact is selected from the list of facts \mathcal{F} in step 2. Reasoning *breadth first*, the actual fact F is kept until there is no further rule for it. Then F is set to the oldest not already expanded fact. By *depth-first* reasoning F is set to the most recently derived fact $C\tau$ for which there are any rules to be applied.

```
% Applying one rule in forward direction:

forward(Fact,Head) :- clause(Head,Body), trigger(Fact,Body,ToProve),
                      provelist(ToProve), retain(Head).

trigger(Fact,[Fact|Prem],Prem).
trigger(Fact,[P|Prem],[P|ToProve]) :- trigger(Fact,Prem,ToProve).

provelist([]).
provelist([First|Rest]) :- call(First), provelist(Rest).

retain(Conclusion) :- not_reached(Conclusion),
                      asserta(reached(Conclusion)),
                      assertz(open_node(Conclusion)).
```

Fig. 1. Part of a forward reasoning meta-interpreter

In [Hin91] a meta-interpreter for forward chaining of Horn clauses comprising several reasoning strategies is described. Fig. 1 presents part of this meta-interpreter specifiying steps 3 to 5 of the above algorithm. The `forward` clause selects and applies one Horn rule in forward direction. Its arguments are the actual fact (bound when called) and the conclusion of the applied rule (a free variable): a goal `? - forward(Fact, Conclusion)` succeeds, if `Conclusion` is a one-step derivation of `Fact`. The built-in predicate `clause` selects one rule at a time[1]. The goal `trigger(Body,Fact,ToProve)` succeeds, if one premise in Body is unifiable with the actual fact (step 3 of Algorithm 2.1). Then the variable `ToProve` is instantiated with the list of the remaining premises, which have to be proved. These premises are verified by `provelist` just making a call on them, i.e. they are satisfied by Prolog's SLD-resolution [Llo87] (step 4). If all the premises are satisfied, the conclusion of the rule is asserted (step 5) by a call to `retain/1`.

The assertion of derived facts has two reasons. First, it is necessary for control purposes to select a fact as the next actual fact in step 2. Second, to avoid loops, the conclusion is accepted only if it is not *subsumed* by any previously derived fact. This is necessary, if non-ground facts and unsafe rules ([Ull89]) are allowed. The subsumption test is performed by the predicate `not_reached`, which is not listed here because of space limitations (for details see [Hin91]). The principle of the subsumption test is very simple: a term $p(x_1,...,x_n)$ subsumes a term $p(y_1,...,y_n)$ if the ground term $p(x_1,...,x_n)\sigma$ - instantiated with *new* constants - is unifiable with $p(y_1,...,y_n)$. If the conclusion is not subsumed by any previously derived fact, it is asserted as `reached` and `open_node`. An open node is a reached node that has not already been selected as a trigger for breadth-first reasoning.

[1] In our implementation of the logic programming language (RELFUN [Bol90]) `clause` can be called with two unbound arguments. For implementations requiring the first argument to be bound (as most Prolog implementations) assume that all clauses are represented in the form `clause(Head,Body)` for use by the meta-interpreter.

3 Partially Evaluating the Meta-Interpreter

Meta-interpreters in general suffer from the overhead that is incurred by the additional meta-layer. A well-known technique to reduce this overhead is to specialize the meta-level theory for a particular object theory by partial evaluation (cp. [Har89]). Partial evaluation is a program transformation technique which, given a normal program P and a goal G, produces from P and G a specialized program P_G which will evaluate G more efficiently ([Kom82], [Tam84]).

To increase efficiency of our meta-interpreter we partially evaluate the interpreter clause forward wrt to a logic program. The predicate forward has the actual fact as parameter, which is bound when forward is called. But it is not known at compile time and thus does not help for partial evaluation. A second input to forward is the whole logic progam, which is accessed by a call to the predicate clause. So our partial evaluation procedure specializes forward wrt the whole program by unfolding the clause on this premise with the whole object-level program. This approach is called data-driven partial evaluation in [Cos91].

By this partial evaluation procedure every object-level rule A :- $B_1,...,B_n$ is transformed into a sequence of forward clauses following this pattern:

$$forward(B_1,A) :- B_2,...,B_n, retain(A).$$

$$forward(B_2,A) :- B_1,B_3,...,B_n, retain(A).$$

...

$$forward(B_n,A) :- B_1,B_2,...,B_{n-1}, retain(A).$$

A clause $forward(B_1,A)$:- $B_2,...,B_n, retain(A)$ has the intended meaning, that A can be derived from B_1, if the remaining premises $B_2,...,B_n$ of the rule can be proved. Because forward evaluation of a Horn rule can be triggered by a fact unifying any premise of the rule, for every premise $B_1,...,B_n$ of the original rule a forward clause is generated. This is an important distinction to Yamamoto and Tanaka's translation for production rules [Yam86].

Example: Let the object-level program contain the following rules:

```
ancestor(X,Y) :- parent(X,Y).
ancestor(X,Z) :- parent(X,Y), ancestor(Y,Z).
```

Then the partial evaluation process results in three forward clauses:

```
forward(parent(X,Y),ancestor(X,Y)) :- retain(ancestor(X,Y)).
forward(parent(X,Y),ancestor(X,Z)) :- ancestor(Y,Z),
                                       retain(ancestor(X,Z)).
forward(ancestor(Y,Z),ancestor(X,Z)) :- parent(X,Y),
                                         retain(ancestor(X,Z)).
```

□

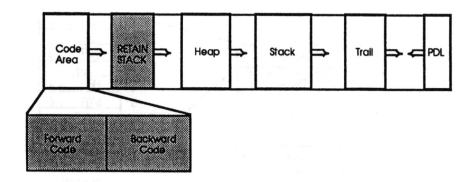

Fig.2. WAM Extensions: Splitting Code Area and new Retain Stack

After the partial evaluation phase we have a "bidirectional" program consisting of three parts:

- the original object-level program P for backward reasoning
- the forward clauses FP for applying a single rule in forward direction
- the remaining clauses of the meta-interpreter M' specifying the forward chaining strategy

Details of the partial evaluation process and an example can be found in [Hin91b].

4 Vertical Compilation into WAM Code

After this horizontal transformation phase the clauses of P, FP and M' are compiled vertically into code for the Warren Abstract Machine (WAM [War83]). Although the efficiency has been increased by partial evaluation of the meta-interpreter, we can still identify two remaining sources for inefficieny:

1. All clauses in FP have the same predicate symbol forward. This means that there is one large procedure with costly search for an applicable rule.

2. Recording derived facts is implemented by assertion, which is costly, because it changes the code. Additionally, on WAM-level this would result in recompilation of all facts for the affected predicates reached/1 and open_node/1 at every time a new fact has been derived.

To overcome these deficiencies some modifications of the WAM are suggested: first, the code area is split into the usual backward code area and a new special code area for forward clauses; a new stack for storing derived facts, called *retain stack*, is introduced (see Fig. 3). These changes are only for enhancing efficiency compared to the ordinary WAM and are not as complex as those of [Gra89]. The modifications are described in more detail in the following subsections. First the retain stack is explained, because knowledge about its implementation is necessary to understand the compilation of forward clauses.

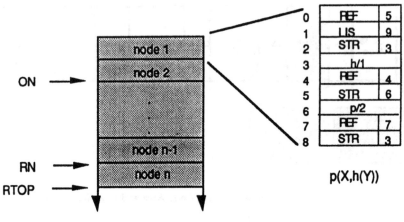

Fig. 3. Retain Stack

4.1 The Retain Stack

Derived facts must not be destroyed by backtracking. This is the reason, why they are asserted in the meta-interpreter (see Fig. 1). However, such assertions are inefficient, because program code itself is altered dynamically. Information about derived facts can be held more compactly at machine level in a special data area which will be called the *retain stack* (Fig. 3).

All entries of the retain stack are reached nodes. Register RTOP points to the top of the stack and register RN refers to the fact, which has been pushed onto the stack most recently. The register ON refers to the open node (see Section 2), which is selected next as an actual node to trigger a forward rule.

The WAM code for the predicate retain/1 (Fig. 1) is:

```
retain/1:   not_r_subsumed A1      % Test for subsumption
            push_fact_retain A1    % Copying fact to retain
```

Its argument is the derived fact, referenced by A1. The instruction push_fact_retain A1 pushes the fact onto the retain stack, if it is not subsumed by any structure already existing on the stack. The new operation not_r_subsumed A1 performs the subsumption test. The derived fact is matched against *every* entry on the retain stack. The clause fails, if subsumption of the derived fact with any previously derived fact succeeds. The subsumption test can be made rather efficient by appropriate data structures. Additionally, it would also be possible to delete facts from the stack that are subsumed by the new fact. But we regard the advantages lower than the additional costs of the reverse subsumption test.

The values on the retain stack are "more persistent" than values on the heap or the stack. While values on the heap and the stack may be destroyed by backtracking, no reference from the retain stack to any other memory cell is permitted. This is why a derived fact is *copied* onto the retain stack. In our current implementation cyclic

structures are not treated specially, except for unbound REF cells. Thus, copying of cyclic structures could lead to non-terminating loops.

Several new instructions are needed to manage the retain stack:

`get_recent_node Xi`	loads the value of RN into register Xi. Then Xi refers to the most recently derived fact
`get_open_node Xi`	loads the value of ON into register Xi. Then Xi refers to the open node.
`next_open_node`	changes the value of register ON, such that ON points to the next open node. For the breadth-first strategy of forward reasoning the nodes are selected in the order in which they are generated. This order is identical to the order of the nodes on the retain stack. Thus, for breadth-first reasoning ON is simply increased to point to the next node on the retain stack.
`fc_initialize`	resets registers RN, ON and RTOP

The retain stack will not be changed by backtracking, because the environment does not contain any information about the retain stack. The only way to remove entries from the retain stack is by evaluating the instruction `fc_initialize`, which resets the retain stack as soon as the forward chaining process is started (see Fig. 1).

4.2 The Forward Code Area

The clauses obtained by partially evaluating the `forward` procedure of the meta-interpreter have one fundamental drawback: they are represented with a single predicate `forward`. A special code area for forward clauses can make this predicate implicit and clauses with the same trigger can be grouped together into one procedure. The principle of this special forward code can be explained as follows. A `forward` clause

$$forward(B_1,A) :\text{-} B_2,...,B_n, retain(A).$$

is applied, if the actual fact is unifiable with B_1. Then the remaining premises $B_2,...,B_n$ are tested. If they are satisfied, the conclusion A is retained. This can be achieved in principle by the following clause:

$$B_1 :\text{-} B_2,...,B_n, retain(A).$$

The head B_1 is the trigger of the forward clause. Please note that this clause is not called to prove B_1 but to derive A, if B_1 is already known. The advantage of this compilation is that the single large `forward` procedure is decomposed into one procedure for each trigger predicate. By applying the indexing techniques of the WAM the applicable clauses can be found efficiently. Fig. 4 shows the code for the three sample forward clauses of Section 3. It shows, that clauses are grouped into one procedure according to the trigger of the forward clause. There are two clauses for parent and one for ancestor.

```
parent/2:     try_me_else L1
              put_structure ancestor/2 A3
              unify_value_temp X1            Code for the clause
              unify_value_temp X2            forward(parent(X,Y),ancestor(X,Y)) :-
              put_value_temp X3 A1              retain(ancestor(X,Y)).
              execute retain/1
    L1  :     trust_me_else_fail
              allocate 2
              get_variable_perm X2 A1        Code for the clause
              get_variable_temp X1 A2        forward(parent(X,Y),ancestor(X,Z)) :-
              put_variable_perm X1 A2           ancestor(Y,Z),
              call ancestor/2 2                 retain(ancestor(X,Z)).
              put_structure ancestor/2 A1
              unify_value_perm X2
              unify_local_value_perm X1
              deallocate
              execute retain/1
ancestor/2:   allocate 2
              get_variable_perm X2 A2
              get_variable_temp X2 A1
              put_variable_perm X1 A1        Code for the clause
              call parent/2 2                forward(ancestor(Y,Z),ancestor(X,Z)) :-
              put_structure ancestor/2 A1       parent(X,Y),
              unify_local_value_perm X1         retain(ancestor(X,Z))
              unify_value_perm X2
              deallocate
              execute retain/1
```

Fig. 4. WAM code for forward clauses

Since the premises of forward clauses are verified by ordinary backward reasoning, the code in Fig. 4 is equivalent to that of the backward code area. In particular, the `call` instructions refer to procedures in the backward code area. But to call the clauses in the forward code area we need a new instruction `mcall_fw`. Let us explain this with an example. Consider a query

```
?-forward(parent(peter,mary),Conc)
```

This query is compiled into a sequence of WAM instruction, which first make a call into the forward code area by `mcall_fw A1` with the first argument `parent(peter,mary)` as trigger. A successful application of a forward rule pushes the conclusion (say `ancestor(peter,mary)` as in the above example) onto the retain stack and register RN points to it (Section 4.1). Then the instruction `get_recent_node A2` is evaluated and the recent node is unified with the second argument of `forward` binding Conc to the conclusion `ancestor(peter,mary)` of the applied rule.

6 Summary and Relation to other Work

A two-phase implementation of a forward chaining extension of logic programs has been presented. In the first phase, an object-level program has been transformed into a specialized forward reasoning program by partially evaluating part of a meta-interpreter. In the second phase the transformed program is compiled into the WAM, which has been extended by a specialized forward code area and a new stack to record the derived facts.

The plain control strategy of forward reasoning is induced by the SLD-resolution procedure of logic programming. It is very similar to the Prolog implementation of the KORE/IE production system [Shi88]. Forward rules are selected for execution in a strictly sequential manner and also a rule's premises are tested sequentially. But implementation methods for production systems like TREAT [Mir87] or Rete [For82] algorithms are not appropriate, since premises are proved by backward reasoning in our approach. In the presented approach the strategies are themselves represented as Horn clauses, so they can be adapted for specific applications. Besides breadth-first and depth-first strategies, more sophisticated control strategies are conceivable, especially in larger applications, where rules reflect an expert's heuristics. So, for instance, it is possible to have non-ground patterns as initial facts or filters for the derivations. More specialized domain-specific strategies could restrict forward rules to be applied only if the triggering actual fact satisfies particular conditions.

The presented meta-interpreter has been implemented in the relational/functional language RELFUN [Bol90]. The RELFUN interpreter, the partial evaluator, and the extended WAM are implemented in Lisp.

References

[Ban88] Bancilhon, F. and Ramakrishnan, R. Performance Evaluation of Data Intensive Logic Programs. In *Foundations of Deductive Databases and Logic Programming*. Morgan Kaufmann Publishers, Minker, J., pp. 441-517, Los Altos, CA, 1988.

[Bol90] Boley, H. A relational/functional Language and its Compilation into the WAM. SEKI Report SR-90-05, Universität Kaiserslautern, 1990.

[Cha87] Chan, D., Dufresne, P., and Enders, R. Report on PHOCUS. Technical Report TR-LP-21-02, ECRC, Arabellastraße, München, April, 1987.

[Cos91] Cosmadopoulos, Y., Sergot, M., and Southwick,R.W. In *PDK'91 - International Workshop on Processing Declarative Knowledge*, 1991.

[Emd76] Van Emden and Kowalski, R. The Semantics of Predicate Logic as a Programming Language *Journal of the ACM, Vol. 23, No. 4*, October 1976.

[Fin89] Finin, T., Fritzson, R., and Matuszek, D. Adding Forward Chaining and Truth Maintenance to Prolog. In *Artificial Intelligence Applications Conference*, IEEE, Miami, March 1989, pp. 123-130.

[For82] Forgy, C.L. Rete: A Fast Algorithm for the Many Pattern / Many Object Pattern Match Problem. Artificial Intelligence *19*(1982), pp. 17-37.

[Fur89] Furukawa, K., Fujita, H., and Shintani, T. Deriving an Efficient Production System by Partial Evaluation. In *NACLP 89*, 1989, pp. 661-671.

[Gra89] Raisonment sur les contraintes en programmation Logique, PhD Thesis, University of Nice, 1989,

[Har89] van Harmelen, F. On the Efficiency of Meta-level Inference. PhD Thesis, University of Edinburgh, 1989.

[Hin91] Hinkelmann, K. Bidirectional Reasoning of Horn Clause Programs: Transformation and Compilation. Technical Memo TM-91-02, DFKI GmbH, January, 1991.

[Hin91b] Hinkelmann, K. Forward Logic Evauation: Developing a Compiler from a Partially Evaluatred Meta-Interpreter. Technical Memo TM-91-13, DFKI GmbH, 1991.

[Kom82] Komorowski, H.J. Partial Evaluation as a means for Inferencing Data Structures in an Applicative Language: A Theory and Implementation in the Case of Prolog. In *POPL 82*, 1982, pp. 255-267.

[Llo87] Lloyd, J.W. *Foundations of Logic Programming*, Springer-Verlag, Berlin, Heidelberg, New York (1987).

[Mir87] Miranker, D.P. TREAT: A Better Match Algorithm for AI Production Systems. In *Proc. of AAAI-87*, Philadelphia, PA, 1987, pp. 42-47.

[Mor81] Morris, P. A Forward Chaining Problem Solver. Logic Programming Newsletter 2(Autumn 1981), pp. 6-7.

[Naq89] Naqvi, S.A. and Tsur, S. *A Logical Language for Data and Knowledge Bases*, W.H. Freeman (1989).

[Shi88] Shintani, T. A Fast Prolog-Based Production System KORE/IE. In *Proceedings of the Fifth International Conference and Symposium on Logic Programming*, 1988, pp. 26-41.

[Tam84] Tamaki, H. and Sato, T. Unfold/Fold Transformations of Logic Programs. In *Proceedings of the Second International Conference on Logic Programming*, Uppsala, 1984, pp. 127-138.

[Ull89] Ullman J. *Principles of Database and Knowledge Base Systems*, Computer Science Press (1989).

[War83] Warren, D.H.D. An Abstract Prolog Instruction Set. Technical Note 309, SRI International, Menlo Park, CA, October, 1983.

[Yam86] Yamamoto, A. and Tanaka, H. Translating Production Rules into a Forward Reasoning Prolog Program. New Generation Computing 4(1986), pp. 97-105.

Concept Support as a Method for Programming Neural Networks with Symbolic Knowledge

Erich Prem,[1] Markus Mackinger,[1] Georg Dorffner,[1] G.Porenta[2] and H.Sochor[2]

[1] Austrian Research Institute for Artificial Intelligence, Schottengasse 3,
A-1010 Vienna, Austria, Email erich@ai.univie.ac.at
[2] Kardiologische Universitätsklinik, Garnisongasse 13, A-1090 Vienna, Austria

Abstract. Neural networks are usually seen as obtaining all their knowledge through training on the basis of examples. In many AI applications appropriate for neural networks, however, symbolic knowledge does exist which describes a large number of cases relatively well, or at least contributes to partial solutions. From a practical point of view it appears to be a waste of resources to give up this knowledge altogether by training a network from scratch. This paper introduces a method for inserting symbolic knowledge into a neural network–called "concept support." This method is non-intrusive in that it does not rely on immediately setting any internal variable, such as weights. Instead, knowledge is inserted through pre-training on concepts or rules believed to be essential for the task. Thus the knowledge actually accessible for the neural network remains distributed or –as it is called– subsymbolic. Results from a test application are reported which show considerable improvements in generalization.

Keywords: Neural Networks, Connectionism, Preprogramming, Application

1 Introduction

The common view of neural networks and rule-based approaches to diagnosis or classification tasks in AI is that the former always acquire their knowledge through training, while in the latter case knowledge is pre-programmed as rules. Thus, each method has its type of applications where they appear most appropriate, in the case of neural networks applications where no or little explicit knowledge exists or is known. As a result, neural networks are usually trained with random inital configurations, the only source of knowledge being the training examples. In many real world cases, however, partial symbolic knowledge on how to solve the problem exists beforehand and is already formalized. It seems to be a waste of effort not to make use of this knowledge. The following are possible reasons why finding a way of inserting explicit knowledge into a neural network can be desirable.

- Learning from scratch (*tabula rasa*) is a very costly process. When starting with randomly distributed weights, the training examples have to be presented to the network many times before any success becomes visible.

- The number of training samples needed to train an "empty" network can be very large, which helps in overcoming the problem of small training sets one is often faced with.
- Not all the necessary knowledge might actually be contained in the training samples themselves. Existing rules could be used to replace this missing part.
- Pre-programming can prevent spurious states or local minima the network might otherwise be prone to reach.
- It can be easier to interpret or debug networks into which rules have been injected.

This paper reports on results of applying a specific technique on inserting symbolic knowledge into a network, henceforth called *concept support*. One of the basic properties of concept support is that it is a method of programming neural networks in a non-intrusive fashion, i.e. without immediate alterations of their internal structure, such as weight matrices. This method and its variations—support of rules, and support of related concepts—are introduced emphasizing their advantages and value for practical applications. Concrete results from using a test application in the medical domain are described and discussed.

2 Concept Support Techniques

We call methods that try to incorporate a priori knowledge into neural networks without immediate access to the internal structure (weights) *concept support techniques*. The basic idea is to pre-train the network on the basis of the symbolic knowledge, so as to obtain a weight matrix on which further learning with the training samples is based. This way the inserted knowledge–i.e. the knowledge actually usable or accessible for the neural network–is kept at least *weakly* distributed (see van Gelder 1990), or subsymbolic. No attempt at symbolically interpreting any internal entity (unit or connection) is necessary, as would be if weights were to be preset explicitly (cf. [Yang 90, Sethi 90]). The main goal is not so much to reduce training times, but rather to improve the generalization capabilites of the network.

Several variations on concept support can be distinguished:

1. the pretraining on the basis of rules describing a subset of cases of the desired input-output mapping. The network for pre-training in this case is the same as for the actual task and is trained in two phases; first on one or more rules, secondly on the training samples. Thus the rules complement the training samples in supplying the knowledge to the network.
2. the pretraining on the basis of symbolic concepts believed to be relevant for solving the task. This idea originated in the work by Wiklicky (1989) and gives the method its name–*concepts* relevant to the task are *supported* during training. In this case, the output layer of the network is different during the two phases. During pretraining the output represents the relevant concepts, during regular training it represents the desired output.

3. the pretraining with concepts as in (2), but with a smaller hidden layer, while at regular training additional hidden architecture is used. This is the original method introduced in Wiklicky (1989). This way, during regular training the inserted knowledge is confined to only a part of the network, leaving the rest more freedom to self-organize.

An important aspect for all methods of concept support–or all methods for inserting knowledge, for that matter–is that the knowledge supplied during pretraining need not be totally consistent, complete in any sense, or even correct in order to ensure usable results. In other words, "overwriting" or modifications of inserted knowledge should always be possible due to training with the application data. The worst case should be that training time is increased through misleading or incorrect knowledge. As concept support techniques do not affect the basic process of the neural networks, such a property comes almost automatically.

We have tested methods (1) and (2) on a specific application described below. Both methods have been proven to be useful. Especially in the case of supporting rules, considerable improvements of the generalization behavior could be observed. Before actually describing the application we take a brief look at related work.

3 Related Work

The importance of overcoming technical problems of neural networks which are related to nonsymbolic representation, a priori rules and concepts have been pointed out by several authors, e.g. [Gallant 88, Hendler 89]. While many of the proposed methods try to combine neural networks with symbolic methods there is not so much work on incorporating knowledge *and* keeping the nature of representation in the model distributed.

Methods which have shown to achieve both are described in Suddarth (1990) or Yeoung-Hu (1990). In both cases there is an additional output information during training that helps to guide the search for a solution to the training problem. Both methods not only use the desired output pattern during learning but expand the training pattern in order to train the network on a different but related task. One part of the training pattern represents the original task, the other one additional information about the input pattern. One difference to the method we describe below is that both parts of the output (original task and additional information) are presented within one single pattern. Moreover, our method always separates a concept support phase and a phase of training the network on the desired task. This has the advantage that initalization of a priori knowledge and later refinement can be performed separetely, which is useful for systematic engineering or security reasons.

The idea of creating a specific hidden unit representation which supports the generalization capability of the network has e.g. been proposed in [Lendaris 90]. A more redundant encoding scheme (compared to a straightforward one) is used as a representation in a hidden layer of the network. This representation makes it easier for the net to correctly learn the desired generalization, but leads to a local representation in one hidden layer. As opposed to our method, this technique can be regarded as actually combining two different networks connected by the designed hidden layer representation.

Solutions to the problem of creating networks that are specialists in a specific domain and methods of constructing *domains of expertise* and hierarchies are principally discussed in [Jacobs 88], but no practical methods or examples are mentioned there. Jacobs proposes to train the net on a series T_i of tasks which—very informally—*converge* to the desired task T_n. Our proposal of designing these tasks by means of existing rules (the *a priori* knowledge) is presented in the next sections.

4 An Example in the Medical Domain

Computer based image interpretation of thallium-201 scintigrams served as a testbed for incorporating rules into neural networks. The task to be performed by the neural network is the asessment of coronary artery disease (CAD) using the parallel distributed approach. Earlier endeavours to solve this problem with a neural network suffered from relatively low prediction rates and the lack of possibilities to incorporate *a priori* knowledge [Porenta 88]. Normally, the medical expert interprets the scintigram picture; he decides on the likelihood of CAD, number of affected vessels and location of affection. Results given by the expert can be verified by comparison with angiography. Thus two reference methods exist which can be chosen to generate the target patterns for the network.

The scintigraphical images of the heart-scan are converted into 45 numeric values representing scans under stress, redistribution, and the washout, which are input to the network. The network used for this study therefore consists of 45 input, 23 hidden, and 1 or 2 output units - depending on the task. It was trained by using error backpropagation.

A priori knowledge about the task consists of several heuristic symbolic rules. These rules either describe criteria for a patient to be classified as ill or for identifying the affected region of the heart and were obtained by consulting a medical expert. It must be stressed that all of these rules are very heuristic, i.e. cover only a limited percentage of the input space. Reasons therefore are inaccuracies in the input data, enormous physiological differences between patients and irregularities during recording patient data.

4.1 The Method of Rule Support

The method of supporting the network with the rule as mentioned above consisted of the following. In the first phase (which we call the "preprogramming phase") the network was trained on the rule alone. For this, the heart scans of the training samples were used as input, while the diagnosis (pathological or not) as calculated *by the rule* applied to this input was used as target for the generalized delta rule. After training the following values were computed for comparsion.

- the percentage of cases of the whole data set that the *rule* classified correctly (as compared to the reference method)—value a.
- the percentage of cases for which the network trained this way correctly predicted the outcome of the rule—value b. This is some kind of indication how well the network implemented the rule.
- the percentage of cases of the whole data set the *network* classified correctly, as compared to the reference method—value c.

After that a second training phase was added (which we call the "refinement phase"), in which the preprogrammed network was further trained on the regular training samples (i.e. the previous set of heart scans as input, and the diagnosis by the reference method as target). Again, the percentage of cases (in the test set) which the refined network classified correctly (compared to the reference method) was calculated (value d).

Learning was continued until all cases of the training set were classified correctly, while using a threshold of 0.5 for decision (i.e. everything above that threshold was interpreted as 1, everything below as 0). To calculate the said prediction rates (values a through d) the same threshold of (0.5) was used.

4.2 Diagnosing the Location of the CAD

To make the diagnosis more specific it is possible to distinguish between the left and the right region of the heart. This distinction of affected vessels is a more difficult task even for the medical expert. This is why angiography was used as reference method for this task. The network used two output units for the right/left distinction of the physiological region. 23 examples were used as a training set, 82 as the test set. Training the net on randomly selected examples achieved prediction rates of 44 % after 50 epochs.

The network was trained using the following symbolic rule with respect to physiological areas for the left/right-distinction.

If one scan value is below 60 or the washout rate is negative then classify the case as pathological.

A set of numeric values referring to the corresponding position of a vessel in the picture was tested on having one value below 60 or representing a negative washout rate. In Fig.1 prediction rates of the symbolic rule are compared with the normally trained net, the network trained on the rule and with the additionally refined network. The difference in the prediction rate between the symbolic rule alone (value a) and the network trained on the rule (value c) is 29 %. Additional training with the original task increased the prediction rate by another 4 % (value d). The rule itself was learned to 55 % (value b), i.e. the network correctly implemented the rule with this percentage.

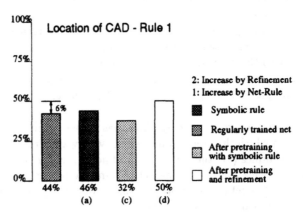

Fig. 1. Results of supporting rule 1 in a network trained to predict the location of disease. The prediction rate of a regularly trained network is compared to the rule itself (value a), the network trained by the rule (c), and the refined network (d). For a description of the values see text.

4.3 Support with a Relevant Concept

So far we have described the support of symbolic *rules*. As mentioned earlier the support of *concepts* relevant for the given domain can also be used to improve generalization. One idea about the heart-scan data is that there are differences in the scans of men and women. Thus, a patient's sex was decided to be a relevant concept with which the network should be supplied. Again, two training phases were conducted. In this experiment the task for the network consisted in predicting the disease without locating it. In the first phase a net with two output units was trained on the male/female distinction. In the second phase the output units were replaced by a single unit and the resulting network was trained on the original task. Fig. 2 shows the results. When taking the original threshold of 0.5, the percentage of correctly classified cases rose from 60 % to 73 % due to preprogramming with the concept.

Support with a Concept - 1 (m/f)

Fig. 2. Results from supporting the male/female-distinction as a relevant concept. The prediction rate of a network that was pretrained on this distinction is compared to a regularly trained network. The results are shown for two different output thresholds, i.e. the criterion to interpret the output as a binary value.

5 Discussion

The results show that applying the method of concept support consistently improves the generalization performance of a multi-layer feedfoward network trained on a classification task, compared to reference tasks with the same conditions but without support. It provides a feasible way of incorporating existing symbolic knowledge about the task domain into the network learning. Very often the task for an application of this kind is to obtain a neural network that generalizes as well as possible to novel cases, in order to make use of it in practice (in clinical routines, in our case). Introducing knowledge in the described way therefore proves a considerable advance toward achieving this task.

The two main effects of the method are that

- no alterations to the network architecture, or interpretation thereof, is necessary for achieving the results.
- the generalization increases after regular training on the data samples. This phase can therefore indeed be seen as a refinement of what was given by the rule. In this sense, rule and distributed network complement each other optimally.

In the following we attempt to give a qualitative explanation of the observed effects. A rule, by being symbolic and formulated by a human expert, covers some of the "obvious[3]" features in the input that lead to a certain diagnosis. At the same time the rule is *reductionist* in that it concentrates on a perspicuous part of the input. A network only trained on samples cannot easily profit from

[3] I.e. "easily" identifiable for the expert

such obvious dependencies but has to extract them from the presented patterns in a tedious and costly process. This is how the rule can help the network by "telling" it what features in the input to turn to.

In our particular case, during the preprogramming phase the network has to learn to classify as pathological only those cases that fulfill the obvious features in the input (such as "one value below 60"), therefore becoming sensitive to them. At the same time, however, the network always works in a *holistic* way in that it always considers all inputs during learning. So it is capable of discovering correlations among the not-so-obvious features in the input that also lead to the same diagnosis even in the absence of the obvious feature. The rule might also supply information about cases that might not be contained in the training set. The refinement phase then adds cases which are not covered by the rule or its fuzzy neighborhood, leading to a further increase (value d).

This property of a rule does not seem specific to this particular application but rather appears to be more generally the case for many problems which lend themselves to neural network solutions. If knowledge exists for such problems it mostly consists in a handful of heuristic rules (otherwise a rule-based approach would appear more feasible). Those rules can help the neural network approach in the described sense. In this way, even a single rule or a few rules can be of use. It was not even realistic to expect much more knowledge than that described in the previous section. Therefore, although it cannot formally be proven at this point, the approach appears to be viable for a great variety of practical applications. It is assumed that the method extends to larger sets of rules also. At least it can be proven that the method can never prevent the network from learning or make the overall generalization rate worse.

The following additional interesting observations can be made

- The training time for the combined training (pre-training with rules or concepts plus regular training with the sample data) was comparable to the training time without concept support. The important result is that it is not increased considerably.
- In any case, training times to improve results in the second phase tend to be short. In other words, refinement of the performance achieved through learning the rule to higher levels based on the real-world examples is rather quick.
- The rules or concepts used during the support phase need not be checked on their consistence, relevance, or completeness. Rules, even only crude ones, or concepts that are in some sense relevant lead to at least some improvement. Totally irrelevant rules at worst increase training time, but usually cannot disturb the final results (in our case, it was even improved slightly, probably for reasons of random matching of the "nonsense rule"). As a result, any piece of knowledge, including heuristics, can be helpful in improving the results.

– The usual search for an optimal training set, which usually plagues an application with the above-mentioned goals (a good generalizer), can be reduced considerably. The results have shown that concept support can refine the performance even for training sets that are less representative as needed for learning from scratch.

6 Conclusion

This paper has introduced a method for incorporating knowledge into a neural network during the coarse of training. By training the network on the symbolic realization of the knowledge (rules or single concepts) this knowledge is transformed into a distributed version, of which the network can make optimal use. The results of several experiments in a medical diagnosis task have shown that the method consistently improves generalization performance considerably above the levels reached by crude training from scratch. Thus it has proven as a viable and useful method for combining symbolic knowledge with subsymbolic techniques, which is an important general goal in recent artificial intelligence endeavors.

7 Acknowledgements

This research is part of the ESPRIT-II project NEUFODI (Neural Networks for Forecasting and Diagnosis Application). Neufodi is sponsored by the EC commission and the Austrian Industrial Research Promotion Fund as ESPRIT-II project No.5433 and is conducted in cooperation with the Babbage Institute for Knowledge and Information Technology (Belgium); Lyonnaise des Eaux Dumez (France); Elorduy, Sancho y CIA, S.A.; Laboratorios de Ensayos e Investigaciones Industriales (both Spain).

References

[Gallant 88] Stephen I. Gallant 1988. *Connectionist Expert Systems*. Comm. of the ACM, Vol. 31(2):152-169, Feb. 1988.

[vanGelder 90] Tim van Gelder 1990. *Why Distributed Representation is Inherently Non-Symbolic*. In: Georg Dorffner (Ed.), Konnektionismus in Artificial Intelligence und Kognitionsforschung, Proc.of the 6th Austrian AI-Conference, Springer Berlin 1990, pp. 58-66.

[Hendler 89] J.A.Hendler 1989. *On the Need for Hybrid Systems*. Connection Science 3(1), pp.227-229.

[Jacobs 88] Robert A.Jacobs 1988. *Initial Experiments On Constructing Domains of Expertise and Hierachiers in Connectionist Systems*. In: D.S.Touretky (Ed.) Proc.of the Connectionist Models Summer School 1988, Morgan Kaufman, San Mateo, CA, pp.144-153.

[Lendaris 90] George C.Lendaris, Ihab A.Harb 1990. *Improved Generalization in ANN's via Use of Conceptual Graphs: A Character Recognition Task as an Example Case.* In: Proc.IJCNN 1990, San Diego, CA, 1990, pp.I 551-555.

[Porenta 88] Gerold Porenta, G.Dorffner, J.Schedlmayer, H.Sochor 1988. *Parallel Distributed Processing as a Decision Support Approach in the Analysis of Thallium-201 Scintigrams.* In: Proc. Computers in Cardiology 1988, Washington D.C., IEEE.

[Sethi 90] I.K.Sethi 1990. *Entropy Nets: from Decision Trees to Neural Networks.* Proc.of the IEEE, vol.78, 10, Oct.90, pp 1605-1613.

[Suddarth 90] S.C. Suddarth, Y.L. Kergosien 1990. *Rule-injection hints as a means of improving network performance and learning time.* In: L.B. Almeida, C.J. Wellekens (Eds.), Neural Networks, Proc. of the 1990 EURASIP Workshop, Springer, Berlin, 1990.

[Yang 90] Qing Yang, Vijay K.Bhargava 1990. *Building Expert Systems by a Modified Perceptron Network with Rule-Transfer Algorithms.* Proc.of the IJCNN 1990, San Diego, CA, pp.II 77-82.

[Yeoung-Ho 90] Yu Yeoung-Ho, Robert F.Simmons 1990. *Extra Output Biased Learning.* Proc.of the 1990 IJCNN, San Diego, CA, 1990, pp.III 161-164.

[Wiklicky 90] Herbert Wiklicky 1990. *Neurale Strukturen: Möglichkeiten der Initialisierung und symbolisches Wissen.* Thesis, University of Vienna, 1990.

A Heuristic Inductive Generalization Method and its Application to VLSI-Design

Jürgen Herrmann[1], Renate Beckmann[2]

Universität Dortmund, Informatik I[1] / Informatik XII[2]
Postfach 500 500, 4600 Dortmund 50

Abstract. The system LEFT is presented that learns most specific generalizations (MSGs) from structural descriptions. The new inductive multi-staged generalization algorithm is based on several new or enhanced concepts that improve the quality of generalization and make it applicable to real-world problems: LEFT evaluates the quality of each generated MSG using weighted predicates. The algorithm distinguishes between important and less-important predicates. Built-in predicates are used to improve the resulting hypothesis. The system has been applied successfully to chip-floorplanning - a subtask of VLSI-design.

1 Introduction

Complex design tasks like VLSI design belong to the most difficult real-world problems that are supported by software-systems and differ from analysis tasks significantly. There are very few tools that support the acquisition of design-knowledge [Booz89], even less tools support complex design tasks. One main goal for the development of *machine learning* systems is to support and partly automate the acquisition of knowledge. For the following reasons conventional inductive learning systems are not suitable for the acquisition of knowledge about complex design tasks:

- *The complexity of the generalization process is too high.*
 Complex design problems must be described by structural descriptions that represent composite examples consisting of various objects. Attribute-based descriptions that represent only simple features of the considered examples are not sufficient. Learning most specific generalizations (i.e. maximally-specific descriptions that are consistent with all known examples) from structural descriptions is a very complex task. There may be many different MSGs for an example set. Haussler [Haus89] has shown that the size of the set of MSGs can grow exponentially in the number of examples for an instance space defined by n attributes, even when there are no binary relations defined and each example contains only two objects. As complex design descriptions typically represent multiple objects and their relations the complexity problem becomes even worse1. As a consequence for these descriptions it is not feasible to create the complete set of MSGs as systems like LEX [MiUB83] or X-search [WaRe90] do.

- *The generated MSGs cannot be evaluated properly.*
 To create only the most favourable MSGs the intermediate generalizations must be evaluated. Conventional systems use simple domain-independent biases to create a

[1] There are multiple different ways to assign the objects of one example consistently to the objects of another one. Each of these *combinations of object bindings* can lead to a different MSG. For two examples with n objects there can be up to n! different combinations.

subset of all MSGs. They have no domain-dependant heuristics to evaluate the quality of each MSG. This draw-back can impair the quality of the learned concept.

• *Numerical and symbolic information cannot be combined.*
Many structural induction systems can only handle symbolic values. For complex design tasks *numerical* as well as *symbolic* information must be represented.

In this paper a new inductive learning system is presented that generalizes structural descriptions based on several heuristics, evaluates the generated MSGs and overcomes the limitations of conventional systems. The system LEFT has been applied successfully to floorplanning - a subtask of VLSI design that deals among other things with the placement of cells on a two-dimensional area.

2 Existing Systems that Learn MSGs

One of the classical systems that learns MSGs is SPROUTER [HaMc77, DiMi83]. The system determines consistent object assignments (no many-to-one bindings). The representations consist of expressions that are called *case frames* and are basically predicates that have as arguments only constants denoting distinct objects. Other kinds of arguments (with numerical or symbolic values) are not used. To reduce the complexity of generalization SPROUTER creates only a constant number of MSGs. Two simple heuristics are used to select the intermediate generalizations that are proceeded further: Generalizations that (i) cover many properties and (ii) need few distinct parameters to be instantiated get a high rating. There is no domain-dependant background information to guide generalization.

The system INDUCE 1.2 [DiMi83] treats non-unary and unary predicates differently. The underlying assumption is that the structure-specifying predicates are more important than the unary ones. This heuristic can be interpreted as a simple chunk of domain knowledge. INDUCE 1.2 has a lexicographic evaluation function that selects intermediate generalizations according to criteria like the maximization of the number of covered examples, the maximization of the length of the description and the minimisation of the cost of a description according to the difficulty of measurement for each descriptor.

ABSTRIPS [Sace74] is a problem solver that works an a hierarchy of abstraction spaces. It starts with a very abstract state space and moves to less abstract spaces stepwise: ABSTRIPS tries to achieve a goal using at first only some selected predicates to create a rough plan. Taking into account some other predicates this plan is refined successively. If more than one alternative is found on one abstraction level, the selection is postponed and *all* alternatives are passed to a lower level.

The system X-search [WaRe90] generates the set S of the most specific conjunctive generalizations for a one-sided version space [MiUB83]. The program uses three effective methods to prune branches of the search tree for MSGs. Nevertheless all MSGs are found. As Haussler has shown, (see above) the size of S can grow exponentially. Because of that X-search cannot be used for complex design tasks.

KBG [Biss92] is a system for conceptual clustering. It performs logic-based structural induction, inspired by the structural matching algorithm [KoGa86]. For generalization it utilizes background knowledge formulated as rules of inference. In this way simple syntactical matching as it is performed by systems like SPROUTER is prevented. On the other hand the applied saturation procedure decreases the performance of the generalization. The example representations use predicates with various value types (symbolic and numerical). The system uses *weighted* predicates to represent the importance of the different properties. KBG has an interesting way to

evaluate numerically the distance between two instances for the same predicate: For two instances of the same N-ary predicate it is defined as the average of the similarity between the N pairs of arguments. Based on the similarity of instances the similarity of objects and examples is measured. KBG does not enforce consistent bindings for the objects of the M examples. Many-to-one bindings are allowed. This is not feasible for the learning of knowledge about *complex design* tasks.

Malefiz [HeBe89] learns design rules for floorplanning, a subtask of VLSI design. The system uses a SPROUTER-like generalization algorithm that has been modified to work with weighted predicates and different value types for the arguments. The generalization algorithm does not distinguish between crucial and additional facts. This is one reason for its poor performance. It can generalize only very small floorplanning examples.

3 An Algorithm that Learns from Complex Structural Design Descriptions

This section describes the new LEFT (LEarning Floorplanning Tool) algorithm for learning from complex real-world examples. LEFT uses a predicate description with symbolic and numerical value types.

3.1 Motivation

As Haussler has pointed out for complex design tasks many MSGs (of different quality) may be created from structural descriptions. Therefore a mechanism is necessary to evaluate intermediate generalizations. The quality of a generalization depends on the corresponding facts in both input descriptions according to a certain list of consistent object bindings. Typically for complex design tasks each description consists of some important facts and many additional ones describing detail informations. A good MSG must prefer the important ones, i.e. the selection of the object bindings must be dominated by the important facts.

Example: Two different lists of object bindings
For the two examples shown in Figure 1 a lot of possible combinations of object bindings, called *binding lists*, exist.Two of them are e.g.
L1: (A:1, B:2, C:3, D:4, E:5, F:6, G:7) or
L2: (A:5, B:1, C:3, D:7, E:4, F:2, G:6)

Figure 1: Two simple floorplans

The first one binds objects according to the structure of the floorplans. Corresponding blocks have the same relative positions and neighbours in both floorplans. For the second list (L2) area and shapes of the blocks determine the bindings. If the is main goal of the floorplanning process is to minimize the total connection length, the structure of a floorplan is more relevant than the shape of the blocks. Nevertheless the shapes must be considered, too. Therefore a mechanism is needed that expresses the importance of each feature and relation.

3.2 Weighted predicates

A *typical* predicate description for a design example consists of several hundred facts. As has been shown by the example some of them describe the principle structure and properties of the example, others deliver additional information that is important only in certain situations (and cannot be omitted in general). To make this distinction explicit and usable for the learning system the predicates used by LEFT have user-defined *numerical weights* (integers) that express their importance.

The numerical weights are used to evaluate each (intermediate or final) generalization. The weight of a generalization is the sum of the weights of its facts. This method implies that not necessarily the generalizations with the heighest number of facts but those with many important facts get the highest ratings. In this way the best description that is used for further generalization steps can be determined heuristically.

The calculation of a numerical weight for a generalized fact F is similar to the formula used in KBG [Biss92]. Let $F1 = p(A_1, A_2, \cdots, A_n)$ and $F2 = p(B_1, B_2, \cdots, B_n)$ be the two facts from the two considered examples E1 and E2 that are generalized into F. F1 and F2 are instances of the same predicate p. The weight of F is

$$\text{weight (F)} = \text{weight (p)} * \prod_{i=1}^{n} \text{sim}(A_i, B_i)$$

The similarity value for any pair of arguments ranges from 0 to 1. The calculation of $\text{sim}(A_i, B_i)$ depends on their type. For two *objects* it is equal to 1, for two *numerical values* it is the quotient of their minimum and their maximum.

Example: Influence of predicate weights on the evaluation of binding lists
The examples in Figure 1 are described with the predicates 'area', shape' and 'connection', each example description consists of seven instances of each predicate. Depending on the selected binding list some of these properties are generalized and become part of the resulting generalization, the other ones (that are not valid for the corresponding blocks in *both* examples) have to be dropped.

For the bindings of the list L1 all seven *connections* of the first example correspond to that ones of the second example but only the two pairs of blocks A and 1 resp. C and 3 have the same *shape*. The *areas* of most blocks differ heavily. For the bindings of list L2 all blocks bound to each other have the same area and shape but there is no connection according to this binding list. They are dropped by the dropping condition rule. Therefore more predicate instances "vote" for L2. For equally weighted predicates this would lead to the selection of list L2.

If the predicates are weighted differently, for example 'area' with 10, 'shape' with 20, and 'connection' with 30, L2 gets a weight of $7*10 + 7*20 = 210$ (the connection facts are dropped). For L1 the similarity of the numerical predicate 'area' is calculated as described above and two of the seven 'shape' facts as well as all 'connection' facts are consistent with the binding list. This leads to a weight of $5*10 + 2*20 + 7*30 = 300$ for L1. So L1 gets the higher rating in this case.

This shows that weighting of predicates is an useful mechanism to represent the importance of descriptors. The next section describes a mechanism to increase the effect of important facts further.

3.3 Multi-staged generalization

The most important and time-consuming part of structural inductive generalization is to determine which objects of the first example can be bound to the objects of the second one. Like SPROUTER LEFT first determines all pairs of object bindings (called *elementary bindings*) occuring in the example descriptions. Then these bindings are combined to form *maximal consistent binding lists* i.e. lists of consistent object bindings (only one-to-one bindings) that cannot be enlarged further consistently.

To increase the quality and the speed of generalization LEFT uses a new *multi-staged generalization* algorithm. The algorithm increases the effect of the most important facts on generalization.

```
Let D1 resp. D2 be the predicate descriptions of the
examples E1 and E2.
Split the set of predicates into two disjoint sets, the
set of important predicates I and, the set of additional
predicates A.
initial  match:
  Create descriptions D1' and D2' of D1 and D2 using only
  instances of predicates of I.
  Create the set of maximal consistent binding lists B
  from D1' and D2'.
  Create the subset B' of B with the n best binding
  lists.
completed  match:
  Create descriptions D1'' and D2'' of D1 and D2 using
  only instances of predicates of A.
  Create the set of maximal consistent binding lists B''
  from D1'' and D2'' that complete the binding lists of
  B'.
  Create the subset B'' of B' with the n best binding
  lists.
```

Figure 2: The multi-staged generalization algorithm

In the **first stage** (the initial match) only parts of the two example descriptions are matched: the important facts. This is done because only a part of the predicates are particularly important. To point out their importance the corresponding (user-defined) weights are higher than a special threshold value. Only these predicate instances are matched to guarantee that they will determine the most important object bindings. The resulting binding lists form the basis of the following steps.

In the **second stage** called the *completed match* the binding lists of the preceding stage are completed by matching the additional facts (not used in the first stage), i.e. the construction of the completed consistent binding lists is started with these lists. So only binding lists that are extensions from that ones of the preceding stage will be created.

Here a multi-staged generalization algorithm with two stages has been described. It is also possible to divide the process into three or more stages by partitioning the set of predicates into three of more disjoint sets.

3.4 Evaluation of the multi-staged generalization

The new algorithm improves the *quality* and *efficiency* of generalization:

(i) The hypothesis and the instance space are split into two (or several) disjoint parts corresponding to the different stages of the algorithm. So the search space for the lists of object bindings is also split into an *initial* and a *secondary* subspace. First the search for highly weighted binding lists is performed only in the initial space, then the secondary space is searched for *additional* bindings. As only the best elements of the initial space are combined with elements of the other space it is easy to see that the two-staged (or N-staged) search is significantly less complex than a search in the original space. These spaces are different from ABSTRIPS [Sace74] abstraction spaces. LEFT's initial space is not a subspace of the secondary one. The sets of descriptors in these two spaces are disjoint.

(ii) In general it cannot be guaranteed for systems creating only *some* MSGs that the best one (according to an evaluation criterion) is found. Heuristics are needed to guide the selection of the best intermediate generalizations. The other ones are dropped. For description languages consisting of (clearly distinguishable) sets of *important* and of *additional* facts (like our language for the floorplanning domain, see below) the splitting of the search space explained above is a powerful heuristic. It improves the *quality* of the results in comparison with a conventional single-staged algorithm using the same predicate weights. This has the following reason: Only the important predicates are useful to determine the bindings of those relevant objects occuring as parameters in these descriptors. The other predicates are mainly interesting for objects already bound to each other. They are needed to make the resulting generalization more discriminant and prevent overgeneralization. Besides that they determine the bindings for the remaining objects. If all descriptors would be considered at the same time, the complementary facts could "outvote" the important ones, even if they had a low weight and would lead to an unfavourable object binding. (In the description language for our domain the number of complementary facts is in the square of the number of objects in an example.)

Our tests have shown (see Section 4) that multi-staged generalization improves the generalization speed drastically. For several examples our algorithm founds the best object bindings (according to experts' opinions) that were not found by a single-staged generalization algorithm.

3.5 Built-in predicates

After the multi-staged generalization only the N best binding lists are kept (possibly with identical weights). To discriminate these lists the next step of the whole generalization algorithm is the construction of some additional facts from predefined, *built-in predicates* that do not belong to the example description language. This kind of symbolic background knowledge can be used without a complete theory of the domain.

For each built-in predicate there is a procedure that checks, if the same predicate is valid for the two example descriptions with objects that correspond to each other consistently according to one of the binding lists. In this case a new fact is created and the weight of the according binding list is increased by the weight of the built-in

predicate. After all these built-in predicates are checked, the binding list with the highest weight is determined to be the best one. Because of the additional weights of the built-in predicates this phase is able to determine one of the competing (approximately equal weighted) binding lists to be the best. The new facts that are valid for this binding list will be included in the MSG that is created in the last step of the generalization algorithm (see below).The built-in predicates are not part of the example description language because they would blow-up the example descriptions significantly. LEFT uses e.g. the following built-in predicates:

between (A1, A2, A3) block A1 is placed between the A2 and A3

max_area_unplaced (A1) block A1 is the block with the greatest area
 that has not yet been placed

3.6 Creation of the resulting generalization

The last step is the creation of the *generalization* of the two examples descriptions. From the selected maximal consistent binding list a MSG can be created in a straightforward manner.

4 LEFT - A System that Learns Floorplanning-Rules

The multi-staged generalization algorithm described in the previous section has been applied to floorplanning in the early phases of VLSI-design. Floorplanning synthesizes a geometrical hardware description from a structural one (a netlist of functional blocks on register-transfer level). The blocks are placed on a two-dimensional area and connected to each other. The objectives of this task are the minimisation of the consumed chip-area and the minimisation of the total length for the connections.

Floorplanning may be divided into two steps: The *topology planning* that performs a rough, relative placement of the blocks and the *geometry planning* that destines the exact floorplan geometry based on this topology.

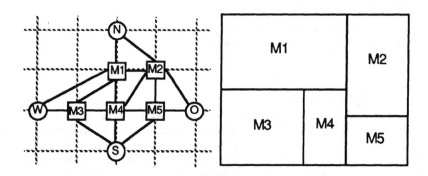

Figure 3: Grid Graph and the Corresponding Geometry

The implemented floorplanning system LEFT (LEarning Floorplanning Tool) incrementally acquires rules that create a floorplanning topology[2]. The topology is

[2] The geometry planning is more straight-forward and can be calculated by a conventional

represented as a *grid-graph* [Wata87], a graph with (square) nodes that are marked with positions on a two-dimensional grid. The nodes represent the floorplan blocks, grid-positions stand for the relative placement of the blocks. Two blocks are connected by an edge, if there is a corresponding connection in the netlist. Four circular nodes represent the boundary of the floorplan. Figure 3 shows a topology plan and the corresponding geometry.

LEFT is organized as a learning apprentice system [MiSM85]. The system has been developed as a floorplanning tool that learns rules during its use as an interactive editor. The system offers the user a set of operators to create a topology plan. LEFT tries to learn from the example floorplanning steps selected by the user in which situations it is useful to apply the different operators. In this way a knowledge base is constructed.

4.1 Design cycle

To understand how the system works the phases belonging to a single floorplanning step (design cycle) are described now (see Figure 4):

Figure 4: The design cycle of LEFT

First LEFT transforms the net list it into an internal, object oriented representation. The topology plan is represented as a grid graph. In this step the initialization of the graph is done to build up the initial state.

Then LEFT checks if there is an operator that can be applied to the current situation. This is done by searching for a rule that can fire. Some of the currently implemented floorplanning operators are listed below:

- place (block, x-position, y-position)
- place_beside (block1, direction, block2)
- place_between (block1, block2, block3)
- connect (block1, block2)
- move (block, direction, number)
- remove_block (block)
- enlarge_grid (number, side)

A rule consists of a then-part respresenting the operator to be applied, an if-part describing the situations the operator can be applied to successfully and a without-part containing a list of situation descriptions the rule should not be applied to.

If a rule is found, its operator is shown to the user. If he/she accepts, the operator is applied to the situation. Otherwise the selected rule has to be specialized. In this case or if no rule was found, the user is asked to give an operator that should be applied using a graphical interface. If already a rule exists containing this operator in its then-part, LEFT generalizes its if-part to make the rule applicable to a situation like the current one next time. Otherwise a new rule is created with the current situation description in the if-part and the operator in the then-part. Now the operator is applied

algorithm [Wata87].

and a new state is achieved.

After an operator has been applied LEFT enters the next design cycle searching for a rule that is applicable to the new intermediate state.

The system stops after all blocks and connections have been placed.

4.2 Results

The LEFT system is the result of research carried out within a 1-year student project [Left 91] at the University of Dortmund, Department of Computer Science. The implemented system has been tested on a set of training examples of different complexities. The system acquires and generalizes floorplanning rules successfully that can be used for the creation of suitable floorplanning topologies with high quality according to the main objectives (minimisation of floorplan size and total connection length). Figure 5 shows the original topology of a floorplan for the IBM S360/370 CPU and an alternative solution created completely by application of rules that LEFT had acquired previously[3]. LEFT's result has about the same quality as the original solution. This example shows clearly that the system is able to acquire and represent meaningful and useful heuristic floorplanning rules that describe complex classes of similar floorplanning situations and create good results according to the floorplanning objectives mentioned above.

Figure 5: topology of a floorplan for the IBM S360/370 CPU:
Original solution (left hand side) and LEFT's solution (right hand side)

The implementation of the multi-staged generalization algorithm for floorplanning operates with *three* stages. The multi-staged generalization turned out to be significantly quicker than a conventional (single-staged) generalization. We compared our three-staged algorithm to another version that is limited to a single stage, i.e. all predicates are considered during one single generalization stage (see Figure 6). Both versions used the same predicate weights. As SPROUTER cannot learn from weighted predicates and cannot evaluate the resulting MSGs a direct comparison with this

[3] To make the result comparable with the original solution we have transformed the grid-graph that has been created by LEFT into a more common topology representation. The transformation was done in a straight-forward manner.

program was not possible. The results show that the multi-staged generalization algorithm can improve the run time for inductive generalization from real-world design examples significantly. (Only for very small examples the single-staged generalization is quicker). Besides that the tests show that the multi-staged generalization improves the quality of the gained learning result. It selected the appropriate MSGs (according to experts' opinions) for several test cases that could not be generalized correctly by the single-staged generalization algorithm. LEFT determines the "best" MSGs heuristically, but it can guarantee the created generalizations are MSGs. Also the built-in predicates

Figure 6: Comparison of Run-Times for the Single- and the Multiple-Staged Generalization

play an important role in the generalization of the examples. For some examples the construction of additional features leads to the selection of a better MSG.

5 Conclusion

The multi-staged generalization algorithm presented in this paper learns most specific generalizations. The algorithm is tailored to the acquisition of knowledge for complex design tasks with no or only rudimentary background knowledge.
LEFT is based on several *new concepts* :

- The new evaluation function for MSGs makes it possible to select good MSGs heuristically. It uses numerical weights for predicates.

- The introduced new multi-staged generalization algorithm speeds up generalization and improves the quality of the generated hypothesis. It can be applied to instance spaces that permit a separation into an initial, abstract space (with the important facts) and and a secondary space (with the additional facts).

- The built-in predicates support the selection of the best MSGs and make the hypothesis language more expressive without blowing-up the example descriptions.

LEFT has been tested successfully on a real-world design problem: floorplanning for integrated circuits.

The presented multi-staged generalization algorithm is controlled by a significant amount of numerical and symbolic information. It is an interesting topic to find out

which parts of this control information can be acquired automatically. This could be e.g. the selection of predicate weights.

Acknowledgements: We would like to thank Katharina Morik for useful comments and discussions.

References

[Biss92] G. Bisson: Conceptual Clustering in a First Order Logic Representation, Proceedings of ECAI 1992

[Booz89] J. H. Booze: A Survey of Knowledge Acquisition Techniques and Tools, Knowledge Acquisition Journal Vo.1, 3-37, 1989

[DiMi83] T.G. Dietterich, R.S. Michalski: A Comparative Review of Selected Methods for Learning from Examples, in: R. S. Michalski, J. G. Carbonell, T. M. Mitchell (Eds.), Machine Learning: An Artificial Intelligence Approach, Tioga Press, Palo Alto, 1983

[KoGa86] Y. Kodratoff, J.-G. Ganascia: Improving the Generalization Step in Learning, in: R. S. Michalski, J. G. Carbonell, T. M. Mitchell (Eds.), Machine Learning: An Artificial Intelligence Approach, Vol II, Morgan Kaufmann, 1986

[Haus89] D. Haussler: Learning Conjunctive Concepts in Structural Domains, Machine Learning Journal Vol 4, 7-40, 1989

[HaMc77] F. Hayes-Roth, J. McDermott: Knowledge Acquisition from Structural Descriptions, Proceedings of the 5th IJCAI, 1977

[HeBe89] J. Herrmann, R. Beckmann: Malefiz - A Learning Apprentice System that Acquires Geometrical Knowledge about a Complex Design Task, Proceedings of the Third European Knowledge Acquisition Workshop, Paris 1989

[Left 91] Endbericht der Projektgruppe LEFT, Internal Report, University of Dortmund, 1991 (in German)

[MiSM85] T.M. Mitchell, S. Mahadevan, L. Steinberg: LEAP - A Learning Apprentice for VLSI design, Proceedings of the 9th IJCAI, 1985

[MiUB83] T.M. Mitchell, P.E. Utgoff, R. Banerji: Learning by Experimentation: Acquiring and Refining Problem-Solving Heuristics, in: R. S. Michalski, J. G. Carbonell, T. M. Mitchell (Eds.), Machine Learning: An Artificial Intelligence Approach, Tioga Press, Palo Alto, 1983

[Sace74] E.D: Sacerdoti: Planning in a Hierarchy of Abstraction Spaces, Artificial Intelligence Vol 5, 115-135, 1974

[Srir87] D. Sriram: Knowledge-Based Approaches for Structural Design, Computational Mechanics Publications, Boston Massachusetts 1987

[WaRe90] L. Watanabe, L. Rendell: Effective Generalization of Relational Descriptions, Proceedings of AAAI 1990

[Wata87] Hiroyuki Watanabe: FLUTE - An Expert Floorplanner for Full-Custom VLSI Design, IEEE Design & Test, Feb. 1987

Learning Plan Abstractions

Ralph Bergmann

German Research Center for Artificial Intelligence
Erwin-Schrödinger-Str., Bau 57
D-6750 Kaiserslautern, Germany

E-Mail: bergmann@informatik.uni-kl.de

Abstract. Abstraction has been identified as a powerful means to reduce the complexity of planning problems. In this paper, a formal model and a method are described for learning abstract plans from concrete plans. In this model, the problem of plan abstraction is decomposed into finding a *state abstraction mapping* and a *sequence abstraction mapping*. The definition of an *abstract planning world* and a *generic state abstraction theory* allows a totally different terminology to be introduced for the description of the abstract plans. Thereby, not only generalizations but real abstractions can be established which require a shift in representation. With the described explanation-based learning procedure PABS, deductively justified abstractions are constructed which are tailored to the application domain described by the theory. The proposed abstraction methodology is applied to learn from machine-oriented programs. An abstract program can be acquired on a higher programming level which is characterized through the use of abstract data types instead of machine-oriented data representations.

1 Introduction and Motivation

Michalski and Kodratoff [1990] have recently pointed out that abstraction has to be distinguished from generalization. While generalization transforms a description along a set superset dimension, abstraction transforms a description along a level-of-detail dimension which usually involves a change in the representation space. In recent machine learning literature a few methods have been proposed to generate abstractions of concepts by use of domain theories. Giordana, Saita and Roverso [1991] have introduced semantic abstraction to deductively change the representation of an example while reducing its level-of-detail. Mozetic and Holzbaur's [1991] abstraction operators allow the elimination of details in a generalized concept description obtained by explanation-based learning [Mitchell et al., 1986]. Both methods are restricted to the description of static concepts and cannot handle planning problems.

Abstraction has been identified as a powerful method to overcome the computational intractability for planning. In hierarchical planning [Sacerdoti, 1974; Wilkins, 1984] abstract planning spaces are introduced in addition to the concrete planning level, to allow a solution to a planning problem to be constructed at a less detailed level before refining it towards a concrete solution. If an optimal hierarchy of abstraction layers can be constructed, hierarchical planning can reduce the planning complexity from exponential to linear time [Korf, 1988; Knoblock, 1989]. Unfortunately, this analysis is based on several assumptions according the structure of the problem domain which are very unlikely to be fulfilled for real-world domains (as already recognized by Knoblock). One of the most restrictive assumptions is the

downward solution property, which states that an abstract solution can really be refined at the next detailed layer. For real-world planning problems, such an optimal hierarchy of abstraction levels can usually not be found or even be constructed automatically (as proposed by Knoblock [1989]) to achieve a dramatic complexity reduction by hierarchical planning. Consequently, hierarchical planning cannot be called the ultimate approach for solving practical planning problems.

In human problem solving, many complicated planning problems (e.g. in mechanical engineering or in programming) are not solved from scratch. More often, previous successful solutions are reused in a more or less abstract manner [Spur, 1979; Jeffries, 1988; Schmalhofer et al., 1992]. Besides case-based reasoning [Kolodner, 1987], skeletal plan refinement [Friedland et al., 1985] is an approach which closely relates to this observation. For planning, generalized plans are retrieved from a data-base and refined according to a new problem specification. A library of abstract plans which provide a heuristic decomposition of a complex planning problem into several smaller subproblems can maintain some of the complexity results obtained from the analysis of hierarchical planning even if the Knoblock's limiting assumptions do not hold in a problem domain. An appropriate set of abstract plans avoids the construction of a problem solution at an abstract level from scratch. This is especially important, if a large number of abstract operations have to be supported in a domain, so that planning at the abstract level becomes a complicated task too. Even if an abstract plan can be found by search, it cannot be guaranteed that such a plan describes a useful problem decomposition so that it can really be refined to a concrete solution.

However, abstract plans which have been proven useful in previous problem solving experience, promise to be successfully applicable for the new problems as well. But therefore abstractions are needed which use a terminology that is already established in the problem domain. Abstraction by simply dropping conditions of the concrete level as usually performed by hierarchical planning, is not sufficient for that purpose.

For learning such abstract plans, from concrete planning cases, no method has been established until now. This article proposes the extension of methods of knowledge intensive learning to produce domain tailored abstractions, but not only generalizations. In machine learning literature, many explanation-based learning approaches have been developed to learn from plans [Fikes et al., 1972; Minton et al., 1989; Schmalhofer et al., 1991; Bergmann, 1992a] or programs [Bergmann, 1992b] to allow them to be reused in novel situations. All these approaches are able to construct generalizations of plans but they are unable to result in abstractions because no knowledge about abstract operations is contained in the domain theory. To overcome this problem, methods must be found to efficiently utilize domain knowledge about abstract operations and planning goals in order to produce deductively justified abstractions.

In the next section a formal model of plan abstraction is introduced. A five-phase procedure for constructing abstract plans is proposed in section three. An example application of this method for abstracting a machine level program is demonstrated and finally the limitations of the approach and further research perspectives are discussed.

2 Formal Model of Plan Abstraction

The core idea of abstraction is to achieve a reduction of the level-of-detail of a description and thereby to change the representation language into a simpler language than the original [Plaisted, 1981; Tenenberg, 1987; Giordana et al., 1991; Mozetic et al., 1991]. A plan or a program is composed of operations which are executed in a specific order and thereby change the state of a world. Therefore, plan abstraction has two independent dimensions: On the first dimension a change in the level-of-detail for the representation of single states is described. On the second dimension a change in the level-of-detail is declared by reducing the number of states contained in a plan. As a consequence, a change of the representation of the state description and a change of the operations which describe the state transitions is required.

2.1 The Problem of Abstraction

Since the goal is to construct domain tailored plan abstractions, a concrete and an abstract planning space is assumed to be defined. Each of the two planning spaces is represented as a STRIPS world. Note, that a totally different terminology will usually be employed to represent the concrete and the abstract world. The commonly used notation for the description of worlds, states and plans (e.g. [Fikes et al., 1972; Lifschitz, 1987; Knoblock, 1989]) is further assumed:

Definition 1: A *STRIPS world* W is a Triple (R,T,Op) over a first-order language L, where R is a set of essential sentences [Lifschitz, 1987] which describe the dynamic aspects of a state of the world. T is a static theory which allows to deduce additional properties of a state in the world. Op is a set of operators represented by descriptions $<P\alpha, D\alpha, A\alpha>_{\alpha \in Op}$, where $P\alpha$ is the precondition formula, $D\alpha$ is the delete list and $A\alpha$ is the add list [Fikes et al., 1972].

As usual, a *state s* of a world W is described by a subset of the essential sentences from R. The theory T is implicitly assumed to be valid in all states of the world. Let $S = 2^R$ be the set of all states of the world. A *plan p* in a world W is a sequence $(o_1,..., o_n)$ of operators from Op. In a world W an initial state $s_0 \in S$ and a plan $p=(o_1,..., o_n)$ *induce* a sequence of states $s_1 \in S,...,s_n \in S$ where $s_{i-1} \cup T \vdash P_{o_i}$ and $s_i = (s_{i-1} \setminus D_{o_i}) \cup A_{o_i}$. Two plans $p=(o_1,...,o_n)$ and $p'=(o_1',...,o_n')$ are called *equivalent* iff in every state $s_0=s_0' \in S$ follows that $s_i = s_i'$, $i \in \{1,...,n\}$ for the states induced by the plans.

The abstraction of a plan requires a reduction of the level-of-detail for the description of the world states and a reduction of the number of states that describe the problem solution. Both changes in the level of detail imply a change of the representation for states as well as for operators. Therefore, two world descriptions, $W_c = (R_c,T_c,Op_c)$ (the concrete world) and $W_a = (R_a,T_a,Op_a)$ (the abstract world), are assumed to be given. The problem of plan abstraction can now be described as transforming a plan p_c from the concrete world W_c into a plan p_a in the abstract world W_a, with several conditions being satisfied. This transformation can formally be decomposed into two mappings, a *state abstraction mapping* a, and a *sequence abstraction mapping* b as follows:

Definition 2: A *state abstraction mapping* $a: S_c \to S_a$ is a mapping from S_c, the set of all states in the concrete world, to S_a, the set of all states in the abstract world, that satisfies the following conditions:

a) If $sc \cup T_c$ is consistent then $a(sc) \cup T_a$ is consistent for all $sc \in S_c$.

b) If $sc \cup sc' \cup T_c$ is consistent then $a(sc \cup sc') \supseteq a(sc) \cup a(sc')$ for all $sc, sc' \in S_c$.

Definition 3: A *sequence abstraction mapping* $b: N \to N$ relates an abstract state sequence $(sa_0,...,sa_n)$ to a concrete state sequence $(sc_0,...,sc_m)$ by mapping the indices i of the abstract states sa_i onto the indices j of the concrete states sc_j, so that the following properties hold:

a) $b(0) = 0$ and $b(n) = m$: The initial state and the goal state of the abstract sequence must correspond to the initial and goal state of the respective concrete state sequence.

b) $b(u) < b(v)$ iff $u<v$: The order of the states defined through the concrete state sequence must be maintained for the abstract state sequence.

Definition 4: A plan p_a is an *abstraction* of a plan p_c if there exists a state abstraction mapping $a: S_c \to S_a$ and a sequence abstraction mapping $b: N \to N$, so that:

If p_c and an initial state sc_0 induce the state sequence $(sc_0,...,sc_m)$ and $sa_0 = a(sc_0)$ and $(sa_0,...,sa_n)$ is the state sequence which is induced by sa_0 and the abstract plan p_a, then

$a(sc_{b(i)}) = sa_i$ holds for all $i \in \{1,...,n\}$.

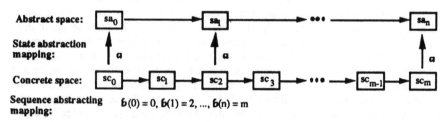

Abstract space: sa_0 — sa_1 — $\bullet\bullet\bullet$ — sa_n

State abstraction mapping: a a a

Concrete space: sc_0 → sc_1 → sc_2 → sc_3 → $\bullet\bullet\bullet$ → sc_{m-1} → sc_m

Sequence abstracting mapping: $b(0) = 0, b(1) = 2, ..., b(n) = m$

Figure 1: Demonstration of the plan abstraction methodology

This definition of abstraction is demonstrated by Figure 1. The concrete space shows the sequence of m operations together with the induced state sequence. Selected states induced by the concrete plan (i.e. sc_0, sc_2, and sc_m) are mapped by the state abstraction mapping a into states of the abstract space. The sequence abstraction mapping b maps the indices of the abstract states to the indices of the corresponding states in the concrete world. It becomes clear, that plan abstraction is defined by a pair of abstraction mappings (a,b). This is because these mappings uniquely define an equivalence class of abstract plans according to the defined plan equivalence (if their exists an abstract plan at all).

2.2 State Abstraction Mappings with Deductive Justifications

For the construction of domain tailored abstraction mappings, a justification of the state abstraction mappings by knowledge of the domain is necessary. Such domain knowledge should state which kinds of useful abstractions usually occur in a domain, and how they can be defined in concrete terms. Thereby, the construction of abstraction mappings is a priori restricted to possibly useful ones.

Generic abstraction theories for semantic abstraction, as introduced by Giordana, Roverso and Saitta [1991] relate atomic formulae of an abstract Language L' to terms of a corresponding concrete language L. Similarly, in this article, a generic state abstraction theory T_g is defined as a set of axioms of the form $\Psi \leftrightarrow D_1 \vee D_2 \vee ... \vee D_n$, where Ψ is an essential sentence of the abstract world and $D_1,...,D_n$ are conjunctions of sentences of the concrete world. For the deductively justified state abstraction mapping a it is required that: if $\Psi \in a(sc)$ then $sc \cup T_c \cup T_g \vdash \Psi$. The reverse implication, namely that every essential sentence for which $sc \cup T_c \cup T_g \vdash \Psi$ holds is an element of $a(sc)$, is not demanded, since a minimal consistent state abstraction mapping (according to the \supset - relation) should be reached.

3 PABS: A Procedure for Constructing Plan Abstractions

As described in section 2, the task of constructing an abstraction of a plan can be seen as the problem of finding a deductively justified state abstraction mapping and a sequence abstraction mapping so that a related plan in the abstract world exists. This section describes PABS (Plan Abstraction), a five-phase procedure which supports the automatic construction of plan abstractions. In the first phase of PABS, the execution of the concrete plan p_c is simulated and the sequence of the induced states in the concrete planning space is computed. In the second phase, for each of these states, an abstract description is derived by utilizing the generic abstraction theory. In third phase, for each pair of the abstract planning states, it is checked, whether there exists an abstract operation which is applicable and which the transforms abstract states into each other. A directed graph of candidate abstract operations is finally constructed in this phase. In phase four, a complete and consistent path from the initial abstract state to the final abstract state is searched. With this path a state abstraction mapping and a sequence abstraction mapping can be determined. Finally, explanation-based generalization is applied in phase five of PABS, to generalize the sequence of abstract operations into an abstract plan with corresponding application conditions.

3.1 Phase-I: Simulation of the Concrete Plan

By simulating the execution of the concrete plan p_c, the state sequence $(sc_1,...,sc_m)$ is computed (see Figure 1), which is induced by the plan p_c and a given initial state sc_0. During this simulation, the definition of the operators Op_c and the static theory T_c are applied to derive all those essential sentences which holds in the respective states. The proofs that exist for the applicability of each operator can now be seen as an explanation for the effects caused by the operations. Such a step is also performed in procedures for plan generalizations [Fikes, 1972; Schmalhofer et al., 1991; Bergmann, 1992a] and for constructing programming schemes from symbolic traces [Bergmann, 1992b].

3.2 Phase-II: Construction of State Abstractions

The second step performs a prerequisite for the composition of the deductively justified state abstraction mapping. With the generic state abstraction theory T_g, an abstract state description sa'_i is derived for each state sc_i which was computed in the first step. Essential sentences R_a of the abstract world description W_a are checked, whether they can be inferred from $sc_i \cup T_c \cup T_g$. If for $\Psi \in R_a$: $sc_i \cup T_c \cup T_g \vdash \Psi$ holds, then Ψ is included into the state abstraction sa'_i. If both, the concrete and abstract world descriptions consist of a finite set of essential sentences, and if the type of the theories T_c and T_g allow to decide the truth of a sentence, then the abstract state descriptions can be generated automatically. By allowing some user support in this phase more concise abstract state descriptions may be obtained, thereby reducing the overall search in subsequent phases.

3.3 Phase-III: Constructing State Transitions with Abstract Operations

The goal of the third phase is to identify candidate abstract operations for the abstract plan. For each pair (sa'_u, sa'_v) with $u < v$, it is checked, if there exists an abstract operation O_α described by $<P_\alpha, D_\alpha, A_\alpha>$ which is applicable in sa'_u and which transforms sa'_u into sa'_v. If $sa'_u \cup T_a \vdash P_\alpha$ and if every sentence of A_α is contained in sa'_v and none of the sentences of D_α is contained in sa'_v then the operation O_α is noted to be a candidate for the abstract plan. A directed graph is constructed, where the nodes of the graph are built by the abstract states sa'_i and where links between the states are introduced for those operations that are candidates for achieving the respective state transitions. The proofs that exist for the validation of P_α in sa'_u are stored together with the corresponding operation.

3.4 Phase-IV: Establishing a Consistent Path of Abstract Operations

From the constructed graph, a complete and consistent path $p_a = (o_1,...,o_n)$ from the initial abstract state sa'_0 to the final state sa'_m is searched. The consistency requirement for a path expresses, that every essential sentence which guarantees the applicability of the operator o_{i+1} ($sa'_i \cup T_a \vdash P_\alpha$) is created by a preceding operation (through the add-list) and is protected until o_{i+1} is applied, or the essential sentence is already true in the initial state and is protected until o_{i+1} is applied. This condition assures that the plan represented by the path p_a is applicable, which means that the application conditions for all operations are satisfied in the states in which they are executed. This consistency requirement can be verified by analyzing the dependencies of the involved operations.

Through the selected path $p_a = (o_1,...,o_n)$, a sequence abstraction mapping b is implicitly defined through: $b(i) := j$ iff the i-th abstract operation of the path connects state sa'_k with sa'_j. Additionally, a corresponding sequence of minimal abstract state descriptions $sa_0,...,sa_n$ with $sa'_{b(i)} \supseteq sa_i$ is determined. These minimal abstract states contain exactly those sentences which are necessary to guarantee the applicability of the operations in the path. Thereby $sa_0,...,sa_n$ represents the state sequence which is induced by p_a. Note that a state abstraction mapping a is also implicitly defined

through: $\alpha(sc) = \{\Psi \mid sc \cup T_c \cup T_g \vdash \Psi$ and $\exists\ i\in\{1,...,n\}$ with $\Psi \in sa_i\}$. So, the abstract plan is completely defined according to definition 4.

For realistic planning situations, the abstract world description will likely consist of a large number of essential sentences and abstract operations at many different levels of abstraction. Therefore it is expected that more than one plan abstraction can be found according to the above definition. In this situation a heuristic criterion (e.g. a good ratio n/m of the number of abstract to concrete states) can be chosen or the user has to decide which of the paths from the initial to the final state represent the intended abstraction. Additionally, the number of possible abstract plans can be reduced to those which are valid for a larger set of concrete plans. Such *shared abstract plans* [Bergmann, 1992c] are supposed to be more useful for solving the future planning problems.

3.5 Phase-V: Constructing the Final Abstract Plan with Application Conditions

From the path p_a and the dependency network which justifies its consistency, a generalization of the abstracted plan can be established. With the dependency network, which functions as an explanation structure, explanation-based generalization can be applied to compute the least subexplanation which justifies all operations of the abstract path. The proofs that correspond to the justification of the abstract states by the generic abstraction theory are pruned. Thereby, the boundary of operationality [Braverman et al., 1988] for the learned concept is determined by the essential sentences and the operators available in the abstract world. Within this subexplanation, the remaining derivations are generalized by standard goal regression as used by Mitchell et al. [1986]. Thereby, constants are turned into variables. The final generalized explanation thus only contains relations which describe the generalized operations together with a generalized specification of the application conditions for the operator sequence.

4 An Example: Abstracting a Machine Level Program

To demonstrate the introduced terminology and the proposed method, the abstraction of an example program is followed through the five phases of PABS. The goal is to find an abstraction for a computer program which is formulated in terms of a machine language and contains only simple assignments of logical operations on boolean variables. For that purpose, the concrete and the abstract world descriptions as well as the generic state abstraction theory must be defined first. Figure 2[1] shows a fraction of this domain knowledge. The concrete world describes the semantics of the operations of the machine language (and,or,...) in which the program, to be abstracted, is written. For example "and(x,y,z)" specifies the assignment "z := x and y". In the formalization, the precondition states that the input-arguments of the operations must have already been bound to a boolean value (t1, t2). The sentence in the add-list

[1] x,y,z,t1,..,t4,s1,...,s3 stand for variables.

specifies the result (t3) of the operations ,while the delete-list removes all earlier assignments to the output variable that differ from the new value[2].

Figure 2: Domain knowledge for plan abstraction

The abstract world determines the high-level operations of the domain (add, div2,...) from which the abstraction is composed. These are some numeric operations on natural numbers. The generic abstraction theory represents abstract data types (natural numbers) and their implementation (two or three-bit values).

$P_{average}$:
1. xor(x1,x3,x5) 5. and(x2,x4,x7) 9. or(x7,x9,x7)
2. and(x1,x3,x8) 6. and(x2,x8,x9) 10. set(x6,x5)
3. xor(x2,x4,x6) 7. or(x7,x9,x7) 11. set(x7,x6)
4. xor(x6,x8,x6) 8. and(x4,x8,x9) 12. set(0,x7)

Figure 3: $P_{average}$: An example program for abstraction

The concrete plan to be abstracted is a computer program which consists of 12 sequential steps as shown in Figure 3. This program computes the average of two natural numbers which are represented as two-bit values. The variables $x1,...,x4$ represent the input values, $x5,...,x7$ represent the output value, and $x8, x9$ are additional auxiliary variables.

Figure 4 shows the five phases of PABS which are applied for the abstraction of the example program: In phase-I, the simulation of $P_{average}$ through symbolic execution [Bergmann, 1992b] results in the concrete state sequence $sc_0,...,sc_{12}$. Each of the states is described by the actual value of the relevant boolean variables (bitEq) which depend from the symbolic program input $t_1,...,t_4$. In the goal state sc_{12}, the program output specification is derived. In phase-II, each of the concrete states is abstracted by deriving essential sentences of the abstract state (the "natEq" predicates) by utilizing the generic abstraction theory. The generic abstraction theory describes

[2] This operator formalization is a slight extension of the traditional STRIPS-representation.

the possible kinds of data abstraction by representing natural numbers as bit-vectors. The states sa'$_0$,....,sa'$_{12}$ computed in phase-II contain the derived descriptions in terms of the abstract world. For example, the sentence "natEq(y1, nat_of(t1)+2*nat_of(t2))" in state sa'$_0$ expresses, that there exists a natural number y1 whose value is computed from the value of the bits x1 and x2. The first clause of the generic abstraction theory from Figure 2 was applied to derive this data abstraction.

Figure 4: The five phases of PABS for the abstraction of P$_{average}$

In phase-III, the graph of the candidate abstract operations is expanded. For example, the link from sa'$_0$ to sa'$_9$ labeled with "add(y1,y2,y6)" specifies that the add-operation is applicable in the abstract state sa'$_0$ and creates some of the effects (here: natEq(y6,...)) which are contained in the state sa'$_9$. Using this graph, a consistent path from sa'$_0$ to sa'$_{12}$ is searched in phase-IV. In the example the path sa'$_0$-->sa'$_9$-->sa'$_{12}$ is selected to describe the intended abstraction. Note that the path sa'$_0$-->sa'$_{12}$ is also a consistent path which is assumed to be rejected. Through the selection of the path, a

sequence abstraction mapping $b: N \to N$ is defined by: $b(0) = 0$, $b(1) = 9$ and $b(2) = 12$. The corresponding state abstraction mapping a is defined as follows[3]:

$a(\{ bitEq(x1,T1), bitEq(x2,T2) \}) = \{natEq(y1, nat_of(T1)+2*nat_of(T2)\}$

$a(\{ bitEq(x3,T1), bitEq(x4,T2) \}) = \{natEq(y2, nat_of(T1)+2*nat_of(T2)\}$

$a(\{ bitEq(x5,T1), bitEq(x6,T2), bitEq(x7,T3) \}) =$
$$\{natEq(y6, nat_of(T1)+2*nat_of(T2)+4*nat_of(T3))\}$$

Note that a exactly creates those preconditions and effects that are required for the abstract operations in the path. In phase-V, an explanation-based generalization computes the final abstract plan. This generalization is responsible, for example for the replacement of the constant "nat_of(t1)+2*nat_of(t2)" by the variable A. The completely abstracted plan expresses that whenever the average of the natural numbers T1 and T2 has to be computed, the sequence of adding T1 and T2 and dividing the result by two is an appropriate abstract plan. This is exactly the plan which a programmer had in mind when he designs the program $P_{average}$.

5 Discussion

Abstraction has been recognized as an important mechanism in planning as well as in machine learning. In this paper a new formal model for the description of plan abstraction has been presented. The PABS procedure for learning deductively justified abstract plans from concrete plans has been delineated and demonstrated for a realistic example. One major advantage of the proposed method is, that it allows a totally different terminology to be introduced for abstraction. Thereby it permits the construction of real domain oriented abstractions which require a shift in the representation language.

This is in contrast to Knoblock's method for learning abstract planning spaces [Knoblock, 1989], where abstraction always occurs by dropping sentences of the concrete world. This kind of abstraction is only a special case of the type of abstractions, allowed by the proposed model. The restrictions can be characterized by limiting state abstraction mappings to those, where $a(s) \subseteq s$ is satisfied.

Unlike other well known techniques for explanation-based learning of search control rules for planning (PRODIGY) [Minton et al., 1989], PABS can acquire domain-oriented problem decompositions rather than more or less restricted operator selection rules. Search control rules can guide the search in a single problem space but cannot reduce planning complexity by switching to an abstract problem description.

Plan abstractions how they are derived by PLANEREUS [Anderson et al., 1988] or by Tenenberg's approach [Tenenberg, 1986] can also be shown to be a special type of the abstractions created by PABS. The former systems use a taxonomic hierarchy of operations (which is learned in the case of PLANEREUS) to construct an abstract plan from a concrete plan. Plan abstraction occurs by generalizing each operator according to the hierarchy. Therefore, the number of operations contained in the resulting abstract plan is not reduced. In PABS, this type of abstraction can be described by a special sequence abstraction mapping defined by b(i) := i.

Within the Soar framework, Unruh & Rosenbloom [1989] have proposed an abstraction technique which they characterize as a general weak method, in that it uses no domain-specific knowledge about how to perform abstractions. This is in contrast

[3]T1,..,T3 stand for boolean variables.

to the PABS approach, since PABS draws power from the knowledge about useful domain specific abstractions which have been proven to be successful in human problem solving. On the other hand, the requirement of this abstract domain knowledge may be difficult to fulfill for domains which are less well understood as programming. In this case, interactive knowledge acquisition methods [Schmalhofer et al., 1991] can be applied for eliciting problem class descriptions [Bergmann et al., 1991] and hierarchies of abstract operations [Schmidt, 1992] from a domain expert to establish the concrete and the abstract world descriptions. This becomes possible, since Korf's requirements [Korf, 1988; Knoblock, 1989] on abstract world models need not to be fulfilled for learning abstract plans.

Acknowledgment

I would like to thank Franz Schmalhofer, Stefan Boschert and Andreas Dannenmann for helpful discussions and comments on earlier drafts of this paper as well as Wolfgang Wilke for implementing the prototypical learner. This research was supported by grant Schm 648/1 from "Deutsche Forschungsgemeinschaft".

References

Anderson, J. S. and Farley, A. M. (1988). Plan abstraction based on operator generalization. In *Proceedings of the 7th National Conference on Artificial Intelligence* (pp. 100-104), Morgan Kaufmann, San Mateo.

Bergmann, R. and Schmalhofer, F. (1991). CECoS: A case experience combination system for knowledge acquisition for expert systems. *Behavior Research Methods, Instruments and Computers, 23*, 142-148.

Bergmann, R. (1992a). Knowledge acquisition by generating skeletal plans. In Schmalhofer, F., Strube, G., and Wetter, T. (Eds.). *Contemporary Knowledge Engineering and Cognition* (pp. 125-134). Heidelberg: Springer.

Bergmann, R. (1992b). Explanation-based learning for the automated reuse of programs. In *Proceedings of the IEEE-Conference on Computer Systems and Software Engineering, COMPEURO92, pp. 109-110.*

Bergmann, R. (1992c). Learning abstract plans to speed up hierarchical planning. In *Proceedings of the ML'92-Workshop "Knowledge Compilation and Speedup Learning"*, Aberdeen, Scotland.

Braverman, M. and Russell, S. (1988). Boundaries of operationality. *Proceedings of the 5th International Conference on Machine Learning* (pp. 221-234). Ann Arbor, MI: Morgan Kaufmann.

Fikes, R.E., Hart, P.E., and Nilsson, N.J. (1972). Learning and executing generalized robot plans. *Artificial Intelligence, 3*, 251-288.

Friedland, P.E. and Iwasaki, Y. (1985). The concept and implementation of skeletal plans. *Journal of Automated Reasoning.*

Giordana, A., Roverso, D., and Saitta, L. (1991). Abstracting background knowledge for concept learning. In Kodratoff, Y. (Ed.), *Lecture Notes in Artificial Intelligence: Machine Learning-EWSL-91* (pp. 1-13). Berlin: Springer.

Jeffries, R. Turner, A.A., and Polson, P.G. (1988). The processes involved in designing software. In J.R. Anderson (Ed.) *Cognitive Skills and their Acquisition* (pp. 255-283). Hillsdale, NJ: Lawrence Erlbaum.

Knoblock, C.A. (1989). A theory of abstraction for hierarchical planning. In *Proceedings of the Workshop on Change of Representation and Inductive Bias* (pp. 81-104). Boston, MA: Kluwer.

Kolodner, J. L. (1987). Extending problem solver capabilities through case-based inference. Proceedings of the 4th International Workshop on Machine Learning (pp. 167-178). Irvine, CA: Morgan Kaufmann.

Korf, R.E. (1988). Optimal path-finding algorithms. In Kumar (Ed.), *Search in Artificial Intelligence* (pp. 223-267). New York: Springer.

Lifschitz, V. (1987). On the semantics of STRIPS. In *Reasoning about Actions and Plans: Proceedings of the 1986 Workshop* (pp. 1-9). Timberline, Oregon.

Michalski, R.S. and Kodratoff, Y. (1990). Research in machine learning: Recent progress, classification of methods, and future directions. In Kodratoff, Y. and Michalski, R.S. (Eds.), *Machine learning: An Artificial Intelligence Approach* (Vol. 3, pp. 3-30). San Mateo, CA: Morgan Kaufmann.

Minton, S., Carbonell, J.G., Knoblock, C.A., Kuokka, D.R., Etzioni, O., and Gil, Y. (1989). Explanation-based learning: A problem solving perspective. *Artificial Intelligence*, **40**, 63-118.

Mitchell, T.M., Keller, R.M., and Kedar-Cabelli, S.T. (1986). Explanation-based generalization: A unifying view. *Machine Learning*, 1 (1), 47-80.

Mozetic, I. and Holzbaur, C. (1991). Extending explanation-based generalization by abstraction operators. In Kodratoff, Y. (Ed.), *Lecture Notes in Artificial Intelligence: Machine Learning-EWSL-91* (pp. 282-297). Berlin: Springer.

Plaisted, D. (1981). Theorem proving with abstraction. *Artificial Intelligence*, 16, 47-108.

Sacerdoti, E.D. (1974). Planning in a hierarchy of abstraction spaces. *Artificial Intelligence*, 5, 115-135.

Schmalhofer, F., Bergmann, R., Kühn, O., and Schmidt, G. (1991). Using integrated knowledge acquisition to prepare sophisticated expert plans for their re-use in novel situations. In Christaller, T. (Ed.), *GWAI-91: 15. Fachtagung für Künstliche Intelligenz*, Informatik Fachberichte (pp. 62-71). Springer-Verlag.

Schmalhofer, F., Globig, C., and Thoben, J. (1992). The refitting of plans by a human expert. In Schmalhofer, F., Strube, G., and Wetter, T. (Eds.). *Contemporary Knowledge Engineering and Cognition* (pp. 122-131). Heidelberg: Springer.

Schmidt, G. (1992). Knowledge acquisition from text in a complex domain. In *Proceedings of the Fifth International Conference on Industrial & Engineering Applications of Artificial Intelligence and Expert Systems*, Paderborn, Germany (in press).

Spur, G. (1979). Produktionstechnik im Wandel. München: Carl Hanser Verlag.

Tenenberg, J. (1986). Planning with abstraction. In *Proceedings of the 6th National Conference on Artificial Intelligence* (pp. 76-80), Philadelphia, PA.

Tenenberg, J. (1987). Preserving consistency across abstraction mappings. In McDermott, J. (Ed.), *Proceedings of the 10th International Conference on Artificial Intelligence* (pp. 1011-1014). Los Altos, CA: Morgan Kaufmann.

Unruh, A. and Rosenbloom, P. S. (1989). Abstraction in problem solving and learning. In *Proceedings of the International Joint Conference on Artificial Intelligence-89* (pp. 590-595). Detroit, MI: Morgan Kaufmann.

Wilkins, D. (1984). Domain-independent Planning: Representation and plan generation. *Artificial Intelligence*, 22, 269-301.

On Discontinuous Q-Functions in Reinforcement Learning

Alexander Linden

AI Research Division
German National Research Center for
Computer Science (GMD)
P. O. Box 1316
W-5205 Sankt Augustin
Germany
email: Alexander.Linden@gmd.de

Abstract. This paper considers the application of reinforcement learning to path finding tasks in continuous state space in the presence of obstacles. We show that cumulative evaluation functions (as Q-Functions [28] and V-Functions [4]) may be discontinuous if forbidden regions (as implied by obstacles) exist in state space. As the infinite number of states requires the use of function approximators such as backpropagation nets [16, 12, 24], we argue that these discontinuities imply severe difficulties in learning cumulative evaluation functions. The discontinuities we detected might also explain why recent applications of reinforcement learning systems to complex tasks [12] failed to show desired performance. In our conclusion, we outline some ideas to circumvent the problem.

Keywords: Machine learning, reinforcement learning, evaluation functions, temporal difference learning, backpropagation nets, robotics, path finding, continuous state space, obstacles.

1 Introduction

In robotics and artificial intelligence, path finding is generally included under the heading "path planning". In path planning, one looks for ways of, among other things, generating collision-free and efficient paths for robot manipulators and autonomous vehicles. Its scope also includes issues of traditional control problems and problem solving tasks. Standard methods like heuristic search suffer from their combinatorial complexity and inflexibility in changing environments. To get rid of these deficiencies, heuristic evaluation functions can be used. The method consists in directly selecting actions on the basis of the evaluation, which estimates the success of an action w.r.t. accomplishing a given goal. If this estimation is computed without search in state space and only on the basis of current state information, then "path planning" appears to be an improper expression; instead the term "path finding" has been used in the literature [14].

In the field of reinforcement learning one is concerned with systems that incrementally learn such heuristic evaluation functions through interaction with the environment. Indeed it can be shown that, under certain conditions, the learning algorithms converge to the optimal evaluation function [21, 27, 28, 7]. With an appropriate action generation mechanism, they form the core to path finding. Furthermore, such evaluation functions may be dynamically adapted to changes of the environment [23].

Currently most work on reinforcement learning has been done in the domain of finite and discrete state and action spaces [5, 23, 26, 27, 33, 32]. Tesauro [25] had great success in applying this learning method to the game of backgammon. Much less research has been done on applications requiring continuous state space representations [1, 2, 12]. Here only quite limited tasks have been examined. To the best of our knowledge, reinforcement learning has never been applied to the problem of optimal path finding with changing goals, obstacles and with continuous state and action space. In this context we have observed discontinuous cumulative evaluation functions, that have not yet been recognized elsewhere.

The paper is structured as follows: In the next section, we review learning with delayed reinforcement. Section 3 provides a general formulation of the path finding task. We argue that the optimal cumulative evaluation function should reflect the costs of the optimal path to the goal. Section 4 gives some path finding examples, illustrating the existence of discontinuous cumulative evaluation functions. In section 5, we discuss why the learning of evaluation functions in domains with continuous state spaces is quite problematic. We conclude with considerations for future research in order to circumvent these problems. The result of this paper may explain why recent applications of reinforcement learning to quite complex tasks [12] failed to show the desired performance.

2 Short Review of Reinforcement Learning

The general computational approach to learning from reward and/or punishment is known as reinforcement learning [15]. Very recently strong connections between dynamic programming in operations research [6], heuristic evaluation functions in artificial intelligence [10], adaptive control [11], and reinforcement learning have been discovered [3, 27, 31]. This has caused a rapidly growing interest in this field[1]. Although a multitude of algorithms and architectures is available that implement reinforcement learning [21, 29, 34], we only consider reinforcement learning systems that deal with delayed reinforcement [5, 21, 28]. In addition, all these systems share a central mechanism that allows a computational agent to evaluate situations with respect to a prediction of the accumulated future reinforcement. Minsky [15] called this evaluation function "secondary reinforcement", we will call it *cumulative evaluation function*. Because our focus is the study of this function under certain conditions it is appropriate

[1] See also the May, 1992 special issue on Reinforcement Learning in the Machine Learning Journal

to review reinforcement learning by one exemplary architecture. For this purpose we have chosen the efficient and widely used Q-learning [27, 28, 12] architecture.

Let us consider a computational agent. At each time step t, it observes the state of its environment $s_t \in S$. Its current policy Π maps s_t onto an action $a_t = \Pi(s_t)$. This action is executed in the environment, which results in a transition $s_{t+1} = \delta(s_t, a_t)$. In addition, the agent receives some spontaneous evaluation[2] $e_t = e(s_t, a_t)$. Some actions might yield a much smaller spontaneous evaluation than others but in the long term be much more favourable. This is the phenomenon of delayed reinforcement. The mechanism of telling how good an action or state actually was in the long term is called *temporal credit assignment* [15].

In order to develop method for learning a policy that is optimal w.r.t. delayed reinforcement, we derive a cumulative evaluation function[3], which tells how good a given action a_t will be in some state s_t. If Π is fixed, the agent loops through a sequence of states s_{t+1}, s_{t+2}, \ldots and receives a corresponding sequence of spontaneous evaluations $e_t, e_{t+1}, e_{t+2}, \ldots$. The evaluation function relative to Π has the form of the discounted sum of future spontaneous evaluations

$$Q^{\Pi}(s_t, a_t) := \sum_{k=0}^{\infty} \gamma^k e_{t+k} \tag{1}$$

$$= e_t + \sum_{k=1}^{\infty} \gamma^k \cdot e_{t+k}$$

Note that the discount factor $0 \leq \gamma < 1$ assures the convergence of the infinite sum.

In this sense the optimal policy Π^* yields the maximal evaluation for all states and action pairs:

$$Q^{\star}(s_t, a_t) = e_t + \max \sum_{k=1}^{\infty} \gamma^k \cdot e_{t+k} \tag{2}$$

$$= e_t + \gamma \cdot \max \sum_{k=0}^{\infty} \gamma^k \cdot e_{t+1+k} \tag{3}$$

This immediately leads to Bellman's optimality equation in dynamic programming [3]

$$Q^{\star}(s_t, a_t) = e_t + \gamma \cdot \max_{a_{t+1}} Q^{\star}(\delta(s_t, a_t), a_{t+1}) \tag{4}$$

Watkins [27] has designed a learning rule for autonomous systems based on this equation[4]. Watkins proved that this learning rule is convergent under specific assumptions:

[2] Often it is also called reinforcement, reward, immediate payoff, outcome

[3] Also called quality (Q) function by Watkins [27]

[4] Also Werbos [30, 31] has outlined learning algorithms in the framework of dynamic programming.

- The state space S is finite and discrete.
- In each state $s \in S$, only a finite number of actions is allowed.
- The environment is ergodic, this means that each state can be reached from every other state.
- The distribution of spontaneous evaluations $e(s, a)$ does not change over time.
- Each action in each state will be tried infinitely often. This property can be encoded in the action selection mechanism by the boltzmann distribution.

The algorithm uses a lookup table to store the estimated cumulated evaluations \hat{Q}. It works as follows:

1. Initialization:
 a) $\forall_{s,a} \hat{Q}(s, a) := 0$.
 b) The agent starts randomly in some state s_t.
2. Action selection by random exploration:
 a) The agent uses its Q-prediction to score each possible action a^i in $s(t)$ with m_i.
 b) The boltzmann distribution chooses actions randomly with the following probabilities.

$$\text{Prob}(a^i) = e^{m_i/T} / \sum_k e^{m_k/T}$$

The probability that action a^i is selected increases with its score m_i, but as $T \to \infty$ these differences vanish, and as $T \to 0$ the action with the highest score is chosen with probability almost 1.
3. The execution of action a_t results in a new state s_{t+1} and a new spontaneous evaluation e_t.
4. The prediction \hat{Q} is updated with the following learning rule

$$\Delta \hat{Q}(s_t, a_t) := \eta \cdot \left[e_t + \gamma \cdot \max_{a_{t+1}} \hat{Q}(s_{t+1}, a_{t+1}) - \hat{Q}(s_t, a_t) \right] \qquad (5)$$

If the difference on the right hand is zero for all s, a then the equation 4 also holds true. The learning rule is a kind of temporal difference learning rule investigated first by Samuel [17, 18] and reformulated and studied intensively by Sutton [21, 22].
5. Increase t, decrease T and goto 2.

3 The Path Finding Domain

In this section, we transfer the ideas of reinforcement learning to the path finding domain with continuous state spaces. This is not to show any implementation and experiments but to have a framework for illustrating a remarkable property of cumulative evaluation functions in this domain.

In general, a path finding task can be formulated as follows:
There are

- a set S of states,
- a nonempty set $G \subset S$ of goal states,
- a set A of actions,
- a transition function $\delta : S \times A \rightarrow S$ that maps a state and an action to a successor state,
- a spontaneous evaluation function $e : S \times A \rightarrow I\!R$ that assigns real-valued costs to the execution of some action in some state. The costs are a kind of (negative) reinforcement or punishment. In this case one wishes to choose those actions with lead to minimal cumulative evaluation. This is implemented by taking the minimum over equations 2, 4, and 5 instead of the maximum.

δ and e may be partial so that setups can be covered where not all actions are executable in every state, for example if obstacles are in the way.

The task consists in finding a sequence of actions that leads the agent from some given start state to a goal state. In addition, this sequence should be kept as cheap as possible by minimizing the cumulative evaluation function.

4 Path finding in continuous state spaces

The framework above may apply analogously to state spaces which are subsets of continuous spaces, however the convergence theorem of Watkins (see section 2) does not work here.

We can show by illustration that nearly all tasks with forbidden regions (in our case implied by the obstacles) in state space have a discontinuous evaluation function. We illustrate this first by the simplest scenario we could think of.

Let the agent be a robot arm with one revolute joint (fig. 1). Its workspace contains a goal and an obstacle. The states are the positions of the arm and are represented by pairs of angles $(\varphi_{\text{ge}}, \varphi_{\text{oe}}), \varphi_{\text{oe}} \neq 0$, thus containing information about the location of the goal and the obstacle relative to the end effector position. The pairs with $\varphi_{\text{oe}} = 0$ form the forbidden region here. Goal states are all states with $|\varphi_{\text{ge}}| \leq \tau, \tau > 0$. Actions are limited joint transitions $a \in [-a_{\max}, -\varepsilon] \cup [\varepsilon, a_{\max}]$ with $a_{\max} < \pi$ and $0 < \varepsilon \leq \tau$, and $\delta((\varphi_{\text{ge}}, \varphi_{\text{oe}}), a) = (\varphi_{\text{ge}} + a, \varphi_{\text{oe}} + a)$. The actions are required to be at least of magnitude ε, so the arm is forced to move at each step so long the goal is not reached. $\varepsilon \leq \tau$ guarantees that the goal state interval cannot be jumped with a smallest step. The costs of an action in a state depend only on the action: $e(s, a) = |a|$. To prevent collisions with the obstacle, an action a is disallowed iff one of the following conditions holds:

- $\varphi_{\text{oe}} > 0$, $a < 0$, and $\varphi_{\text{oe}} + a \leq 0$
- $\varphi_{\text{oe}} < 0$, $a > 0$, and $\varphi_{\text{oe}} + a \geq 0$

This means that δ and e are only partial.

To be able to find a (nearly) optimal path to a goal state from every initial state that it is put into, the agent should learn a policy. This can be achieved

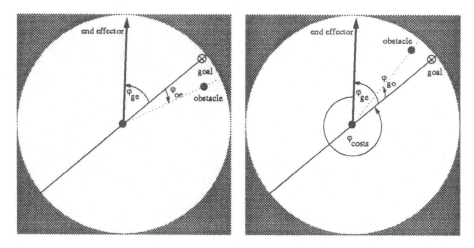

Fig. 1. LEFT: There is no obstacle between end effector and goal, therefore the best way is the direct way. RIGHT: As soon as the obstacle is in the way between end effector and goal the best and only way is the circumvention.

with Q-Learning using a slight modification of the algorithm in section 2: When a goal state is reached in step 3, the arm is set to a new non-goal state after step 4. This has the additional effect that γ becomes superfluous since the minimal costs are achieved by getting to a goal state with a finite number of actions, without changing the direction of movement. With the optimal policy, the Q-function is as follows (from now on, its second argument is always assumed to represent an allowed action):

$$Q^{\star}((\varphi_{ge}, \varphi_{oe}), a) = \begin{cases} 0, & \text{if } |\varphi_{ge}| \leq \tau \\ |a| + \max_{b \in A} Q^{\star}((\varphi_{ge} + a, \varphi_{oe} + a), b), & \text{otherwise} \end{cases} \quad (6)$$

The actual values then are as follows:

$$Q^{\star}((\varphi_{ge}, \varphi_{oe}), a) = \begin{cases} 0, & |\varphi_{ge}| \leq \tau \\ \varphi_{ge} - \tau, & \varphi_{ge} - \tau > 0 > \varphi_{oe} \\ -\varphi_{ge} - \tau, & \varphi_{oe} > 0 > \varphi_{ge} + \tau \\ \varphi_{ge} - \tau, & \varphi_{oe} > \varphi_{ge} - \tau > 0 \\ -\varphi_{ge} - \tau, & 0 > \varphi_{ge} + \tau > \varphi_{oe} \\ 2\pi - \varphi_{ge} - \tau, & \varphi_{ge} - \tau \geq \varphi_{oe} > 0 \\ 2\pi + \varphi_{ge} - \tau, & 0 > \varphi_{oe} \geq \varphi_{ge} + \tau \end{cases} \quad (7)$$

Obviously, the values of Q^{\star} are independent of the action. Figure 2 shows them graphically (to keep the graphics clear, we took $\tau = 0$ here) and demonstrates the existence of discontinuities.

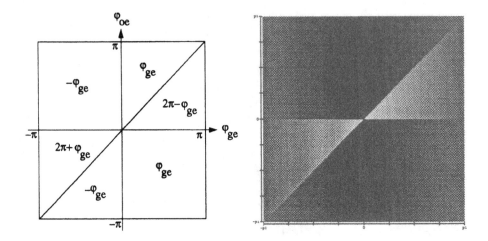

Fig. 2. LEFT: Values of Q^* for the one-jointed robot arm. RIGHT: Density plot of the left part of the figure. (dark = low costs, light = high costs)

If there were no obstacle (the state representation would then consist only in φ_{ge}), Q^* would be a continuous function with a maximum at $\varphi_{ge} = \pi$. The obstacle introduces two discontinuities, one with regard to φ_{oe} alone (due to the differences of positioning the obstacle on the shorter or the longer path between goal and agent), one with regard to both state components simultaneously (due to the, in general, different lengths of the optimal paths starting from states immediately left and right of the obstacle). If the obstacle position were not integrated in state representation, only the second discontinuity would remain.

Further examples for discontinuous evaluation functions are shown in Figure 3. In the left part of the figure, the discontinuity occurs if the horizontal position of the obstacle is integrated in the state description; the optimal path and its costs change dramatically when the corridor becomes too narrow. For a two-joint arm with two obstacles in its workspace (right part of the figure), there are discontinuities even if the position of the (point form) obstacles are not included in the state description (large cost differences between the second segment of the arm being right or left of obstacle$_1$, and between any segment being left or right of obstacle$_2$). But it gets a lot more complex if they are included; for example, the optimal path changes if obstacle$_2$ is moved to the left until the arm cannot pass obstacle$_1$ any more by turning the first joint a bit to the right and turning the second one to the left. Thus it has to take a different, much more costly path to the goal.

In all cases, the cumulative evaluation function is discontinuous in the states. Since all such functions are defined at least on the state space, the problem of discontinuities through forbidden regions applies to every method dealing with delayed reinforcement, not only to Q-Learning.

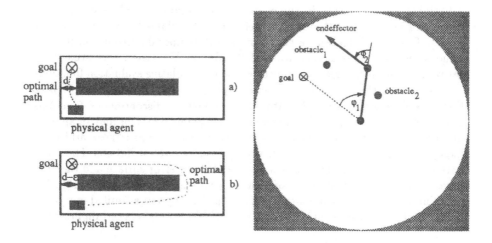

Fig. 3. LEFT: A robot has to decide whether to go to the corridor or to circumvent the big obstacle. Here the discontinuity is at the least d at which the robot can pass the way. RIGHT: A two-jointed robot arm with two obstacles has a very complex structure of discontinuities in its cumulative evaluation function.

5 The Problem of Learning Evaluation Functions in Continuous Domains

We have shown in the last section that optimal cumulative evaluation function may be discontinuous in the presence of forbidden regions in state space. Furthermore in the case of continuous state spaces, lookup tables are not very useful. They might store all evaluations to some degree of precision, but they cannot generalize between them. It is obvious that practical applications can require a degree of discretization resulting in impractical sizes of the lookup table.

These considerations have led many researchers to use compact representations [12, 25]. They allow the handling of continuous-valued inputs quite naturally. Examples of such compact representations are parameterized structures [24, 25] like a backpropagation net [16], a polynomial data fitter or other neural networks. They are able to generalize or more technically interpolate among states, which means that the agent needs only to explore a fraction of states and infers the evaluation of unseen states from experience.

There are some general problems known with the use of compact representations, which also apply to learning evaluation functions:

1. The function approximator might be theoretically incapable of representing the optimal evaluation function to a sufficient degree.
2. The gradient descent method usually applied to train the function approximator might get stuck in a local optimum, even if the above case does not apply.

Additional problems arise in the context of the temporal difference updating method. There is currently no convergence proof available for continuous input spaces. Thus it is unknown wether training with temporal difference in the continuous case converges at least to a local optimum. We expect this situation to get worse a lot in the presence of discontinuous cumulative evaluation functions.

Apart from these problems, function approximators such as backpropagation nets have severe difficulties to simply represent discontinuous functions. Backpropagation nets represent inherently continuous functions and an approximation of a discontinuous functions would require the weights to grow arbitrarily large [13]. In such a case, the weights would be subject to oscillations. The explanation is that large weights imply a steep and sharp error surface and therefore large error derivatives. With a fixed learning rate, an overshooting [9, 13] of local minima in at least some dimensions happens. Anyway a limited number of hidden units allows the approximation of any function only to a certain precision.

6 Conclusion

Currently we see two general kinds of approaches to circumvent the problem of discontinuity, problem dependent and independent ones. The two problem independent approaches are

- to use discontinuous function approximators. Known discontinuous function approximators are competitive mechanisms, which assigns different single function approximators to different input regions [8, 20, 19]. Unclear is whether they could detect regions of discontinuities in input space.
- to design relative cumulative evaluation functions, which has been already mentioned by Tesauro [25] for other purposes.

Approaches using domain knowledge include the proper choice of coding schemes and representation issues. At least in simpler cases, it seems feasible to encode the inputs in a way that make discontinuities vanish. With a reformulation of the task representation in terms of a hierarchy and a structure in state and action spaces, the discontinuities might play a less significant role.

Another point is that in the presence of sensor noise or actuator nondeterminism uncertainty arises. This uncertainty leads to estimates of evaluations that mediate between neighbouring states, which flaten the discontinuities. The more uncertainty exists the smoother the evaluation function surface will be.

From the outlook presented above, we are quite optimistic. Nevertheless it is obvious that discontinuities of evaluation functions are a limitation to the applicability of reinforcement learning procedures to domains characterized above. The can prevent a solution from being optimal. In this context it is our belief that the experiment of Lin [12] has discontinuities and thus failed to show the desired performance. But it is beyond the scope of this paper to prove this. The message should be instead that one has to be aware of possible discontinuities and take them into account.

Acknowledgements

I gratefully acknowledge many discussions with Frank Weber and all other members of our research group. Discussions with Long-Ji Lin and Sebastian Thrun at CMU contributed to the conclusion of this work.

References

1. C. W. Anderson. Learning and problem solving with multilayer connectionist systems. Technical Report COINS TR 86-50, Dept. of Computer and Information Science, University of Massachusetts, Amherst, MA, 1986.
2. A. G. Barto. *Simulation Experiments with Goal-Seeking Adaptive Elements.* COINS, Amherst, Massachusetts, 1984. AFWAL-TR-84-1022.
3. A. G. Barto, S. J. Bradtke, and S. P. Singh. Real-time learning and control using asynchronous dynamic programming. Technical report, University of Massachusetts, Departement of Computer Science, Amherst MA 01003, August 1991.
4. A. G. Barto, R. S. Sutton, and C. J. C. H. Watkins. Learning and sequential decision making. Technical Report COINS 89-95, Department of Computer Science, University of Massachusetts, MA, September 1989.
5. A. G. Barto, R. S. Sutton, and C. J. C. H. Watkins. Learning and sequential decision making. In M. Gabriel and J. W. Moore, editors, *Learning and Computational Neuroscience*, pages 539–602. MIT Press, Massachusetts, 1990.
6. R. E. Bellman. *Dynamic Programming.* Princeton University Press, Princeton, New Jersey, 1957.
7. P. Dayan. The convergence of TD(λ) for general λ. *Machine Learning Journal*, 8(3/4), May 1992. Special Issue on Reinforcement Learning.
8. D. Fox, V. Heinze, K. Möller, and S. B. Thrun. Learning by error driven decomposition. In *Proc. of NeuroNimes, France*, 1991.
9. G. E. Hinton. Connectionist learning procedures. *Artificial Intelligence*, 40:185–234, 1989.
10. R. E. Korf. Real-time heuristic search: New results. In *AAAI-88*, pages 139 – 143, 1988.
11. P. R. Kumar. A survery of some results in stochastic adaptive control. *SIAM Journal of Control and Optimization*, 23:329–380, 1985.
12. L.-J. Lin. Self-improving reactive agents based on reinforcement learning, planning and teaching. *Machine Learning Journal*, 8(3/4), 1992. Special Issue on Reinforcement Learning.
13. A. Linden. Untersuchung von Backpropagation in konnektionistischen Systemen. Diplomarbeit, Universität Bonn, Informatik-Institutsbericht Nr. 80, 1990.
14. J. del R. Millán and C. Torras. A reinforcement connectionist approach to robot path finding in non-maze-like environments. *Machine Learning Journal*, 8(3/4), May 1992. Special Issue on Reinforcement Learning.
15. M. Minsky. Steps toward artificial intelligence. In E.A. Feigenbaum and J. Feldman, editors, *Computers and Thought*, pages 406–450. McGraw-Hill, 1961.
16. D. E. Rumelhart, G. E. Hinton, and R. J. Williams. Learning internal representations by error propagation. In D. E. Rumelhart and J. L. McClelland, editors, *Parallel Distributed Processing. Vol. I + II*. MIT Press, 1986.

17. A. L. Samuel. Some studies in machine learning using the game of checkers. *IBM Journal on Research and Development*, pages 210–229, 1959. Reprinted in E.Å. Feigenbaum and J. Feldman (Eds.) 1963, *Computers and Thought*, McGraw-Hill, New York.

18. A. L. Samuel. Some studies in machine learning using the game of checkers. ii—recent progress. *IBM Journal on Research and Development*, pages 601–617, 1967.

19. F. J. Śmieja and H. Mühlenbein. Reflective modular neural network systems. Technical Report 633, GMD, Sankt Augustin, Germany, February 1992.

20. F.J. Śmieja. Multiple network systems (MINOS) modules: Task division and module discrimination. In *Proceedings of the 8th AISB conference on Artificial Intelligence, Leeds, 16–19 April, 1991*, 1991.

21. R. S. Sutton. *Temporal Credit Assignment in Reinforcement Learning*. PhD thesis, University of Massachusetts, 1984.

22. R. S. Sutton. Learning to predict by the methods of temporal differences. *Machine Learning*, 3:9–44, 1988.

23. R. S. Sutton. Integrated architectures for learning, planning, and reacting based on approximating dynamic programming. To appear in: Proceedings of the Seventh International Conference on Machine Learning, June 1990, 1990.

24. R. S. Sutton, A. G. Barto, and R. J. Williams. Reinforcement Learning is Direct Adaptive Optimal Control. In *Proceedings of the 1991 American Control Conference*, 1991.

25. G. Tesauro. Practical issues in temporal difference learning. *Machine Learning Journal*, 8(3/4), 1992. Special Issue on Reinforcement Learning.

26. S. B. Thrun. Efficient exploration in reinforcement learning. Technical Report CMU-CS-92-102, Carnegie Mellon University, Pittsburgh, Pennsylvania, January 1992.

27. C. J. C. H. Watkins. *Learning from Delayed Rewards*. PhD thesis, King's College, 1989.

28. C. J. C. H. Watkins and P. Dayan. Q-learning. *Machine Learning Journal*, 8(3/4), May 1992. Special Issue on Reinforcement Learning.

29. P. Werbos. Consistency of HDP applied to a simple reinforcement learning problem. *Neural Networks*, 3:179–189, 1990.

30. P. Werbos and J. Titus. An empirical test of new forecasting methods derived from a theory of intelligence: The predicition of conflict in latin america. *IEEE Transactions on Systems, Man, and Cybernetics*, SMC-8:657–666, 1978.

31. Paul J. Werbos. Backpropagation and neurocontrol: A review and prospectus. In *Proceedings of IJCNN89 Washington*, pages I 209–216, 1989.

32. S. D. Whitehead. A study of cooperative mechanisms for faster reinforcement learning. Technical Report 365, University of Rochester, Computer Science Department, Rochester, NY, March 1991.

33. S. D. Whitehead and D. H. Ballard. Active perception and reinforcement learning. *Neural Computation*, 2:409–419, 1990.

34. R. J. Williams. Reinforcement-learning connectionist systems. Technical Report NU-CCS-87-3, College of Computer Science, Northeastern University, Boston, 1987.

An intelligent tutoring system for classification problem solving

Karsten Poeck
Lehrstuhl für Informatik VI
Universität Würzburg
Allesgrundweg 12
8708 Gerbrunn

Martin Tins
Institut für Logik
Universität Karlsruhe
Postfach 6980
7500 Karlsruhe

Abstract: In this paper we present an approach to teach classification knowledge. Our system TUDIS allows students to perform the complete process of solving a classification problem with the hypothesize-and-test strategy, that means interpreting the initially given data to data abstractions, generating and evaluating hypotheses and selecting additional tests to valuate the hypotheses. The student's actions are compared to those of the underlying expert system and the correspondences and relevant discrepancies are presented to the student. These results may be explained further by invocation of the explanation component of the expert system or the hypertext component. TUDIS should be used in combination with a standard textbook introducing the domain to be learned, and a knowledge base representing the knowledge of the book. Students can study the book as usual and examine their understanding of the domain by use of TUDIS. To bridge the gap between the informal textbook and the formal knowledge base, we use a hypertext component, which allows to represent informal conventional representations such as text, pictures and tables in a computer and to link these between each other and also to objects of the knowledge base.

1 Introduction

The classical use of an expert system is the consultation, in which the system tries to solve a problem given by the user. However, more generally a knowledge base can be viewed just as another knowledge media, like books or movies, with the potency to actively apply its knowledge to given cases.

Although the idea is obvious, up to date there have been only a few attempts to combine intelligent tutoring systems (ITS) and expert system shells, especially those based on a strong problem solving method [Puppe 90], where the role any knowledge piece may play during the problem solving process is predetermined. The advantages of such an integration are the following (assumed that a good knowledge base is available):

- There already exists a good conceptual model of the human problem solving process, which is to be taught.
- The problem solving knowledge may be formalized in a very structured way in the knowledge base.
- The ITS is not domain dependent. For applying it to a new domain you simply have to exchange the knowledge base, while the rest of the system remains unchanged.
- One is not restricted to toy problems, but can teach relevant problems.
- It is not only possible to conserve valuable knowledge of an expert through the use of a knowledge base, but also new experts can be trained.
- Since the knowledge is executable, it is quite easy to critique the student's actions, by comparing them to the system's actions.

We used MED2/CLASSIKA as a starting point for TUDIS. In the next section, we briefly describe the knowledge model of MED2/CLASSIKA. More complete descriptions can be found in [Puppe & Gappa 92, D3 91] or in a KADS like fashion

in [Gappa & Poeck 92]. In the third section we describe how the knowledge to be learned should be presented to the student and in section 4 we show how the student's progress may be examined. In section 5 we describe advanced tutoring aspects and finally we compare our approach to others found in the literature.

2. The knowledge model of MED2/CLASSIKA

The application tasks of the classification shell MED2/CLASSIKA are those of *heuristic classification*, in which *diagnoses* (solutions) are identified because of *symptoms* (data) observed. The problem solving method is based on a hypothesize-and-test strategy: starting with the initially given data, the system generates *hypotheses* and scrutinizes them by asking for additional data (see fig. 1).

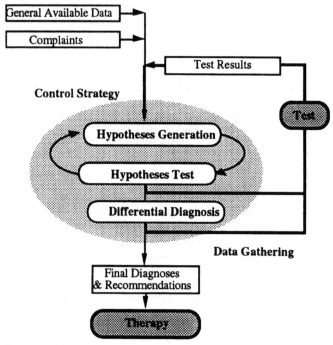

Fig. 1 Survey of MED2/CLASSIKA's problem solving method (from [Puppe & Gappa 92])

When new data is available, the *working memory* containing the actual hypotheses is updated again and a new set of data is requested. For the purpose of data gathering, questions are grouped into question sets representing basic case information, various *leading symptoms* (complaints) or results of *manual* or *technical examinations*. Once a question set has been selected, a questionnaire of related questions and - depending on the answers - follow-up questions are displayed on the screen and have to be filled in by the user. After initially entered complaints, the suspected diagnoses usually have too low evidence and must be confirmed. If the user doesn't want to have the initiative, the next question set is either selected directly by dialogue guiding rules or indirectly by a *costs-benefits-analysis* with a-priori and case-dependent costs and benefits computed for the currently suspected hypotheses. After the new question set is completed, the interpretation and question asking cycle starts anew until final diagnoses and recommendations are selected.

Fig. 2 An exemplary use of the electronic textbook in combination with the formal knowledge base in the domain of car diagnostics (the textbook is in German). The upper left window shows the result of the consultation of the knowledge base. Starting from this, the student may for example invoke the hypertext window, providing general information about the final diagnosis "air filter foul" = "Luftfiltereinsatz verschmutzt". The arrow icons represent links to the similar concept "Regelklappe für Ansaugluftvorwärmung" and the survey window "Vergaser Übersicht". The attention icon indicates a link to a window containing information about how to repair the detected fault. At the same time the student may have a look at the formal rules for deriving fault states of the component (lower left window). These rules may also be explained by hypertext windows and so on. (The quality of the reproduction of the hypertext window is poor in this paper due to technical limitations, but reads fine on a greyscale or colour screen.)

3. Presenting knowledge to the student

The presentation of the knowledge to the student is best achieved by a combination of an informal textbook and a formal knowledge base. Using the textbook the student may explore the domain in a conventional manner and then use TUDIS to examine his progress. Our hypertext component HyperXPert [Meinl 90] is a convenient mechanism to combine both different medias, allowing the author to represent parts of the textbook like texts, pictures and figures in hypertext windows, to link them not only in a linear but in a hypertext manner. These pictures can easily be related to objects of the knowledge base. The key idea is now to represent the whole or at least the main parts of the textbook in the hypertext component resulting in an electronic textbook. The latter may be further enhanced by additional information, for example by adding links about similar concepts. The student may either study the original or the electronic textbook. The advantage of the second one is that at any point she may inspect the formal expert system knowledge, e. g. for looking at the rules describing the symptoms of a diagnosis, and may again get informal explanations to the formal

rules by other windows (e. g. for explanation of the used knowledge embedding a rule, compare [Clancey 83]). This scenario is shown in figure 2.

Fig. 3a, 3b Student's justification of her current diagnoses by symptom/diagnosis associations and the critique of this justification by TUDIS. The rows and columns in the table of figure 3 are automatically constructed from the given symptoms and the student's current diagnoses. The student may fill in the relevant entries in the table. The selected entry means for example, that "exhaust gases" = "black" has a low positive influence to the diagnosis "air filter foul". The second figure shows the critique of the justification. In the column "Should" you find the strength of the associations computed by the system, in the column "Is" the users input, the last two columns show how many points the student could gain and actually has gained. A final explanatory text summarizes the results of the critique. To get further explanations of these results, the student may obtain a detailed derivation graph for the system's evidences between the symptoms and the diagnoses by a double click, or may invoke the explanation component and the electronic textbook.

4 Examining knowledge of the student

After the knowledge has been presented to the student, it should be examined in some way to either give the student positive feedback about his advances or to detect flaws in the learned knowledge. In contrast to conventional computer aided instruction programs we do not ask the student a couple of multiple choice questions or force her into a predetermined sequence of actions. For us active or explorative learning seems to be more promising. We realize this by presenting a case to the student, who may decide on her own which additional tests are necessary to find out the diagnoses and when to rate the diagnoses. In other words, what we want to examine with TUDIS is not only *result knowledge*, i. e. given a set of symptoms, which diagnoses may explain them, but also *process knowledge*, i. e. which symptoms should be obtained next to evaluate the current set of hypotheses. TUDIS simply follows the actions of the student and criticizes the student by rating her actions and compares them with the rating of its own actions. The critique can be more detailed, if the student provides justification for her actions.

4.1 Criticizing result knowledge

For the rating of diagnoses, the student selects the appropriate diagnoses from the diagnoses hierarchy. Instead of generating the *student model* indirectly by observing

her actions, at present the system allows the student to justify her actions at different levels of abstractions. The justifications are directly used as the student's model. In the first case, she may enter the weighted associations between the symptoms and the final diagnoses (fig. 3a) and in the second case she may construct a complete diagnostic structure using a derivation graph (fig. 4a).

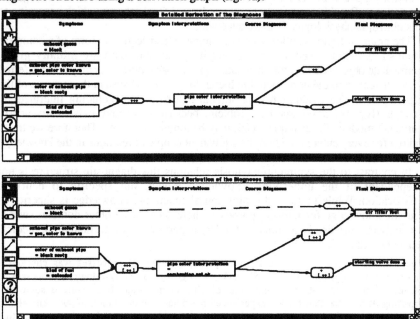

Fig. 4a shows the student's justification of the current diagnoses by a diagnostic structure, **4b** shows TUDIS' critique to her justification. The student states in the first figure, that the diagnoses "air filter foul" and "starting valve does not open completely" are suspected because the combustion is not ok, a symptom abstraction. It is derived because the "colour of exhaust pipe" is black sooty and the "kind of fuel" is unleaded. The second graph with the critique of TUDIS shows that this justification is mainly right, only one relation between the symptom "exhaust gases" = black and the diagnosis "Air filter foul" is completely missing, indicated by the dashed arrow. In addition the strength of the relations as computed by the system is added to those of the student, indicated in the figure by angle brackets.

The rating of the current diagnoses and, if given, the justification is then passed to the *evaluation component*, which compares the student's rating to that of the knowledge base. The results of this evaluation are simply presented to the user, there is no special *didactic component*. When the student has to justify her selected diagnoses simply by the symptoms relevant for them, she has to abstract from her knowledge representation and problem solving method, since the symptom/diagnosis relations can be extracted from every diagnostic model. The differences between the various models (e. g. heuristic, causal, case based) result from different justifications for the single 1 symptom/ 1 diagnosis relation. To compare the student's model to the one of the system, we obviously have to transform the knowledge base into these 1/1 relations. This is quite complicated since the knowledge base consists of symptoms, possibly intermediate objects, such as symptom abstractions and coarse diagnoses, and the final diagnoses which are connected through rules, which results in a relation

network. To transform the knowledge base, all possible paths between the specific symptom and the diagnosis are determined, the evidences of every complete path are multiplied and finally the evidences of the different paths are settled according to the MYCIN scheme yielding the final evidence. To represent the different strengths of relations, we use at present a 7 level scheme (3 positive, one neutral and 3 negative associations). But this may easily be adapted to a 3 level scheme, which according to [Ellstein 78] is physiologically more adequate.

The graph of figure 4a allows a more complete justification in form of a complete diagnostic structure. The symptoms and the final diagnoses are initially given, intermediate objects like symptom abstractions or coarse diagnoses may be transferred by the student from the corresponding hierarchies or by the system through use of the help function. The evaluation of a student's justification including intermediate concepts (fig. 4b) poses another problem, because there may exist many nearly equivalent models, for example a path may be longer or shorter. Therefore we try to find out for every entered relation the equivalent couple of relations in the knowledge base.

In contrast to the symptom/diagnosis relations this diagnostic structure is not independent of the underlying knowledge model, but specific to heuristic classification. While in some domains causal functional knowledge is superior to heuristic knowledge for tutoring purposes, there seem to be other domains, where associative knowledge is dominantly used by experts, e. g. for the domain of medical decision making:

"The item pertaining to consideration of pathophysiological processes was checked a relatively small portion of time. Since knowledge of pathophysiological processes is considered to be one of the foundations of clinical medicine, this result is somewhat surprising. It may be, that for the experienced physician, the utilization of such knowledge is so well established, that he is no longer consciously aware of its use in generating problem formulation. On the other hand, it is also possible, that the generation of problem formulation is essentially a cue-to-disease mechanism that does not require consideration of the pathophysiology underlying disease mechanisms. This second hypothesis receives some support from data being discussed under the topic "associative processes of problem formulation". [Ellstein 78, p. 193]

Therefore a multiple knowledge representation including several kinds of knowledge (heuristic, case based, causal) would be more flexible and is one of the major goals for extending TUDIS.

4.2 Criticizing process knowledge

For the problem solving process it is not only necessary to draw the right conclusions from the given data, but equally important to know which data should be obtained next to examine the current hypotheses. Using a window containing a test hierarchy, in technical terms a hierarchy of question sets, and some additional buttons, the student may either select the question set to be obtained next, ask the system for a comment on his selection, let the system choose the next question set, justify his selection or terminate the case. For the justification and its critique similar tables like the one in figure 3 are used, but those are not discussed in this paper.

The student may justify the current question set either directly from symptoms or diagnoses, which corresponds to dialogue guiding rules or may specify that the question set is used to scrutinize hypothesized diagnoses.

As in the case of rating diagnoses, the evaluation of the justification is not a trivial task. Again, we have to transform the knowledge base into the student model. Indication of question sets through symptoms or established diagnoses may be

represented in different ways in a heuristic knowledge base. For knowledge models other than heuristic classification a different transformation must be used, but is also possible:
- The symptoms and diagnoses may be contained in (transitive) preconditions of a dialogue guiding rule to the question set.
- The symptoms and diagnoses may have (transitively) contributed to suspect a diagnosis, which may be scrutinized by the question set.

The usefulness of a question set to scrutinize a suspected diagnosis may be explicitly coded in the knowledge base, or is only implicitly given by a question of the question set, which contributes (transitively) to the examination of the diagnosis.

Like in the rating of diagnoses, the results of the evaluation are directly presented to the student, who may invoke the explanation or the hypertext component for a detailed explanation of the results.

5 Advanced tutoring aspects

5.1 Student modelling

In order to criticize the student you have to derive an explanation for the student's actions (student model). The most important models found in the literature are:
- *stereotypes* categorize the student in predetermined classes like beginner, advanced, expert, etc. ([Rich 79] and [Chin 89]).
- *overlay models* extend the knowledge base by storing information for each entry estimating the student's awareness ([Carr & Goldstein 77]).
- *enumerative theories of bugs* ([Brown & Burton 78]) utilize a domain specific library of bugs to match with the incorrect student's behaviour.
- *reconstruction of bugs* ([Langley & Ohlsson 84]) by combining or specializing of basic operators, which can be used to construct correct and incorrect knowledge elements.
- *generation of bugs* ([VanLehn 87]) relying on a theory of types of bugs.
- combinations of the previous methods (e. g. [Fum et al. 90]).

A detailed comparison of the different models is found in [Wenger 87] and [Puppe 92].

We do not use stereotypes, because they are not expressive enough to represent the actual student's knowledge. The student may be for example very familiar with parts of the knowledge base and completely unaware of others. Similar problems arise with the bug based techniques, because typically the student may not be represented by one single but a couple of bugs, which are hard to detect. Our obvious choice has been to use overlay models, because they perfectly fit to the knowledge base, which is the background knowledge for the tutoring system.

There are three different possibilities for the basis of the overlay model:
- *original knowledge-base*: This model includes all parts of the knowledge base including intermediate concepts like symptom abstractions and coarse diagnoses.
- *n:1 model*: The diagnostic structure is dissolved into direct relations of symptoms relevant to one diagnosis respectively symptoms and diagnoses relevant for the indication of a test.
- *1:1 model*: All relations are dissolved into a level with direct 1 symptom/1 diagnosis relations and 1 diagnosis/1 test relations.

For a couple of reasons we decided to use the last model. The difficulty with the first model is, that many different but equivalent models may exist and it is hard to compare the student and the ideal model. The ideal n:1 model must be transformed

from the original knowledge base, which leads to a combinatory explosion and is therefore unappropriate. The main advantage of the 1:1 model, as already indicated in section 4.1, is the independence of the underlying knowledge model (e. g. case based, heuristic, causal). Besides it is easy to handle, the computational costs of the transformation are reasonable, and it is still expressive enough to model the student.

Up to now the student herself enters the 1:1 model by filling in tables like in figure 3a, which is very expensive for her. An obvious improvement to this is to generate this model by observation of the student's actions. In the following we sketch this generation for the result knowledge. The same technique may also be used for the process knowledge. We start from the ideal model transformed from the original knowledge base. According to an assessment of the student's capability we adapt this model, for example by deleting all entries under a specific threshold. This model is then used to predict the student's rating of the diagnoses for a given set of symptoms. If the prediction is correct, we keep the actual model, otherwise we have to adapt it further on. This can be done by standard machine learning techniques, for example backpropagation (suppose of the symptoms being the input and the rating of the diagnoses being the output neurons in a fully connected network).

5.2 Didactic extensions

At present we do not have a special didactic component, but we directly present the results of the evaluation to the student. The student herself is responsible for the next steps to correct her faults, for example she may decide to study the relevant parts of the electronic textbook. But by using the student model, we intend to assist the student in this task. If the expert weights the contents of the 1:1 model, we are able to automatically detect the most important differences of the actual student and the ideal model and the overall measure of discrepancy, which should be abstracted to a qualitative value. With both informations it is possible to select the necessary lessons at the appropriate level. The lessons consist of parts of the electronic textbook and specific cases, which may be used to test the forthcoming of the student. Note, that for the first time the expert has to specify tutoring knowledge and not problem solving process knowledge only.

The 1:1 model can also be used to detect more general faults than single relations. If differences between the student and the ideal model are found for nearly a whole column or row in the matrix representing the 1:1 model, the student lacks knowledge about all the relations of a diagnosis or a symptom. This can further be generalized by use of the test and diagnosis hierarchy until the appropriate level of abstraction is found. For these kinds of bugs, the expert should also define special lessons.

5.3 Multiple knowledge representation

As already stated, one important extension to TUDIS is the integration of other knowledge models than heuristic classification. In general it cannot be said that one kind of knowledge is superior to the others, but each has its specific purpose. For example it seems to be very useful to provide explanations in the form of causal knowledge. In contrast to that, it is too time consuming for the student to enter a causal justification, but preferable to give symptom/diagnosis relations like in figure 3a.

We actually have completed the integration of case based knowledge [Puppe & Goos 91] into MED2/CLASSIKA, the integration of set covering knowledge [Matzke 91] and functional causal knowledge [Papapostolou 92] is nearly finished.

5.4 Text generation for the critique of the student

It may seem that communication with the student through a natural language interface is the preferable choice. But since entering text using the keyboard takes too much time and the recognition of spoken language is still subject of current research, we prefer a graphical user interface with direct manipulation and a multiple window technique. Its main advantage is that the student may communicate with the system very comfortably with some mouse clicks. Because she uses a fixed vocabulary and may only select from some predetermined types of actions it is very easy to interpret and understand her actions. But a different point is providing the user with some explanatory text, which can be read by her very fast. We intend to change the criticizing comments of TUDIS (c. f. fig 3b) to some really useful longer explanations (e. g. "Your justification is mainly correct. You have detected all relevant symptom/diagnosis relations, but the weights of the associations differ slightly from your's. The main difference is the relation between "kind of fuel" = "unleaded" and the diagnosis "air filter foul""). This is feasible since text generation is much easier than text understanding.

6. Discussion of related work

As there are a number of intelligent tutoring systems, a lot of techniques included in this paper have been presented before; on the other hand they are often utilized in another context.

The global onset to combine expert systems and intelligent tutoring systems isn't unusual as systems as Sophie ([Brown 77], [Brown & Burton 86]), Neomycin ([Clancey 84] and [Clancey & Letsinger 81]) show. Clancey first introduced ([Clancey 83a]) the idea of "key factors" in rules, which we picked up to adapt the initial ideal student model to the stereotyped knowledge level of the learner. In the definition of typed links between knowledge base objects to electronic textbook windows we base on his research of types of clauses to detect all relevant types of links; the expert can express all relevant additional information for an object within the predetermined link types.

Where the work founding on Guidon ([Clancey 83b]) ended up with Image ([London 86]) and Odysseus ([Wilkins 86]) using an overlay, we introduced a new approach to student modelling with the presented 1:1 model.

Another system that influenced our work is ACM ([Langley & Ohlsson 84]), though it was mainly designed for teaching procedural skills. It introduces tutoring systems to production systems used in search spaces. As proposed generally we reduced the problem space of the process of heuristic diagnosis into subspaces of search for symptoms and their recognition, hypothesis generating and hypothesis validation so that we don't need to generate possible student plans saving an enormous effort. The documented computation times of ACM were another reason for us to use the 1:1 model. Our model has even more connections to machine learning than their approach, but we don't trim it to represent exactly the last action of the learner because of noisy data. Instead the model is only weighted a little more in this direction.

A very similar system is proposed by [Fum et al. 90] who likewise generate a complete student model with correct and incorrect knowledge, use a combination of modelling techniques and who base it on the same assumptions as we do: The problem solving process of the learner has to be the same as the system's and bugs can be modelled by perturbing the expert knowledge. Their concept of bug construction (which was introduced by [Sleeman 82]) with "meta-bugs" is very

powerful for n:1- and structure-modelling, but they have to use "backward model tracing" to find intermediate steps of the learner, resulting in a great computational effort and a low reliability of the model.

Summarizing we can say that the main originality of TUDIS stems from the integration of a hypertext component and a knowledge base to present the knowledge about a domain, the use of the proposed 1:1 model to represent the student's skill, which is independent of the underlying knowledge model and finally the fully graphical interface.

Acknowledgements

We would like to thank our colleagues Stefan Bamberger, Ute Gappa, Klaus Goos and especially Frank Puppe for providing us with helpful comments on an earlier draft of this paper and Annette Meinl who designed and implemented the hypertext component.

References

Brecht, B.; Jones, M. (1988): Student Models: The genetic graph approach, in International Journal of Man-Machine Studies, Vol. 28, pp. 483-504.

Brown, J. S. (1977): Uses of AI and advanced computer technology in education, in Seidel and Rubin (eds.): Computers and Communications: Implications for Education, Academic Press, New York.

Brown, J. S. (1986); Burton, R. R.: Reactive learning environments for teaching electronic troubleshooting, in Rouse (ed.): Advances in Man-Machine System Research, Jai Press, Connecticut.

Brown, J. S.; Burton, R. R. (1978): Diagnostic models for procedural bugs in basic mathematical skills, Cognitive Science 2, pp. 155-191.

Burton, R. R. (1982): Diagnosing bugs in simple procedural skills, in Sleeman and Brown (eds.): Intelligent Tutoring Systems, Academic Press, London.

Carr, B; Goldstein, I. P. (1977): Overlays: A theory of modelling for computer-aided instruction, AI Lab Memo 406, MIT.

Chin, D. N. (1989): KNOME: Modelling what the user knows in UC, in Kobsa and Wahlster (eds.): User models in dialog systems, Springer.

Clancey, W. J. (1983a): The Epistemology of a Rule-Based Expert System - a Framework for Explanation, Artificial Intelligence, Vol. 20.

Clancey, W. J. (1983b): Guidon, Journal of Computer-Based Instruction, Vol. 10, No. 1, pp. 8-14.

Clancey, W. J. (1984): Acquiring, representing and evaluating a competence model of diagnosis, Knowledge Systems Lab, Stanford University.

Clancey, W. J.; Letsinger, R. (1981): Neomycin: reconfiguring a rule-based expert system for application to teaching, Proceedings of the Seventh International Joint Conference on Artificial Intelligence, pp. 829-835, Vancouver.

D3 (1991): Bamberger, S.; Gappa, U.; Goos, K.; Meinl, A.; Poeck, K.; Puppe, F.: The classification expert system shell D3, Manual, University of Karlsruhe.

Elstein, A.; Shulman, L.; Sprafka, S. (1978): Medical Problem Solving, Harvard University Press.

Fum, D.; Giangrandi, P.; Tasso, C. (1990): Backward Model Tracing: An explanation-based Approach for Reconstructing Student Reasoning, Proceedings of the National Conference on Artificial Intelligence, pp. 426-433.

Gappa, U.; Poeck, K. (1992): Common Ground and Differences of the KADS and Strong-Problem-Solving-Shell Approach, Current developments in knowledge acquisition: EKAW-92, Wetter, Th., Althoff, K. D., Boose. J., Gaines, B., Linster, M. & Schmalhofer, F. (eds.), LNAI 599, Springer.

Goldstein, I. P. (1982): The genetic graph: a representation for the evolution of procedural knowledge, in Sleeman and Brown (eds.): Intelligent Tutoring Systems, Academic Press.

Langley, P.; Ohlsson, S. (1984): Automated cognitive modelling, Proceedings of the National Conference on Artificial Intelligence, Texas.

London, R. (1986): Student modelling with multiple viewpoints by plan inference, Thesis proposal, Stanford University.

Matzke, R. (1991): Integration of several strategies for set-covering classification into the expert system shell D3 (in German), Diploma thesis, University of Karlsruhe.

Meinl, A. (1990): HyperXPert (in German), Diploma thesis, University of Karlsruhe.

Papapostolou, A. (1992): Design, implementation and integration of an expert system shell for diagnosis with functional models (in German), Diploma thesis, University of Karlsruhe.

Puppe, F. (1990): Problem solving methods in expert systems (in German, translation to English in preparation), Springer.

Puppe, F.; Gappa, U. (1992): Towards knowledge acquisition by experts, The Fifth International Conference on Industrial & Engineering Applications of Artificial Intelligence and Expert Systems, Paderborn.

Puppe, F.; Goos, K. (1991): Improving case based classification with expert knowledge, Proceedings of the German Workshop of Artificial Intelligence, Springer, pp. 196-205.

Puppe, F. (1992): Intelligent tutoring systems (in German), Informatik Spektrum Band 15, Heft 4.

Rich, E. (1979): User modelling via stereotypes, Cognitive Science, Vol. 3, pp. 355-366.

Sleeman, D. H. (1982): Inferring (mal-) rules from pupils' protocols, Proceedings of the European Conference on Artificial Intelligence, France, pp. 160-164.

Tins, M. (1991): Tutorial use of hypermedia systems (in German), Workshop "Expertensysteme und Hypermedia", University of Kaiserslautern.

Tins, M.; Poeck, K. (to appear 1992): Tutorial use of expert systems to qualify users (in German), in Biethahn et al. (eds.): Knowledge Based Systems in industrial economics - Applications and Integration with Hypermedia, Gabler Verlag, Wiesbaden.

VanLehn, K. (1987): Learning one subprocedure per lesson, Artificial Intelligence, Vol. 31, pp. 1-40.

Wenger, E. (1987): Artificial Intelligence and Tutoring Systems, Morgan Kaufmann.

Wilkins, D. C. (1986): Knowledge base debugging using apprenticeship learning techniques, Proceedings of the Knowledge Acquisition for Knowledge-based Systems Workshop.

Knowledge-based Processing of Medical Language: A Language Engineering Approach

Martin Schröder

University of Hamburg
Computer Science Department, Natural Language Systems (NatS)
Bodenstedtstr. 16, W-2000 Hamburg 50, Germany
email: martin@nats4.informatik.uni-hamburg.de

Abstract. In medicine large amounts of natural language documents have to be processed. Medical language is an interesting domain for the application of techniques developed in computational linguistics. Moreover, large scale applications of medical language processing raise the need to study the process of *language engineering*, which emphasizes some different problems than basic research. The texts found in medical applications show characteristics of a specific *sublanguage* that can be exploited for language processing. We present the METEXA system (MEdical TEXt Analysis) for the analysis of radiological reports. To be able to process utterances of telegraphic style, the emphasis in system design has been put on semantic and knowledge processing components. However, a unification-based bottom-up parser is used to exploit syntactic information wherever possible. For semantic and knowledge representation a relevant part of the *Conceptual Graph Theory* by John Sowa has been implemented in order to yield a conceptual graph as the semantic representation of an utterance. This can be mapped e.g. to a database schema. A resolution-based inference procedure has been implemented to infer new facts from the analysed utterances.

Key words: Natural Language Processing, Text Analysis, Language Engineering, Parsing, Semantics, Conceptual Graphs, Medical Language Processing, Sublanguage.

1 Introduction

Medicine is a domain where large amounts of documents have to be written, stored and retrieved. The production of natural language documents is time-consuming, because usually they are spoken by physicians into a dictating machine. Afterwards they have to be typed on a typewriter or computer by a data typist. The storage and retrieval of natural language documents is difficult, because they usually do not conform to the fixed format of field definitions in database systems. In the last years several systems have been built in the field of *Medical Informatics* to solve some of the practical problems that arise with the processing of natural language documents. We will present an integrated approach to the production and knowledge-based analysis of medical documents on

the basis of a solid computational linguistics methodology. The METEXA system (MEdical TEXt Analysis) has been designed and implemented in order to analyse medical texts and to support the recognition of continuous speech input:

- Radiology reports are analysed on a lexical, syntactical, semantical and knowledge level. There are various tasks that need processing of natural language: mapping to a clinical database, mapping to a medical nomenclature for statistical purposes or the connection to a natural language dialogue system.
- A second goal is a component to support the recognition of continuous speech. The system supports the recognition by generating context-dependent expectations before a sentence is spoken. By limiting dynamically the number of currently selected words the quality of recognition can be increased. Because the medical domain is very sensitive with respect to recognition errors, it is desirable to achieve such a kind of semantic and pragmatic sensitivity.

In this paper we describe the knowledge-based analysis of radiological reports. A detailed description of the expectation-driven strategy can be found in [19]. Before we present the METEXA system in some detail, we will discuss the methodological approach we have chosen. First, the project can be viewed as a language engineering approach, which puts a different emphasis on some design decisions compared to basic research. Second, we will briefly review the field of medical natural language processing that provides an interesting testbed for methods developed in computational linguistics. Third, the sublanguage of radiological texts will be analysed, because the results have important implications for system design.

2 Language Engineering

In the last years, a number of natural language systems have found their way out of research laboratories into commercial applications. It has been recognized that many problems related to successful applications are different from the problems that are treated in computational linguistics research. The field that deals with the specific problems of natural language applications has been coined "Linguistic Engineering" or "Language Engineering".

In a panel on the application-specific problems of language technology at COLING-88 (*"Language Engineering: The Real Bottle Neck of Natural Language Processing"* [11]) Karen Jensen criticizes existing linguistic theories with respect to practical applications. Three of her most important arguments, which hold for language processing in general, are:

- Language Engineering has to deal with huge amounts of data. Existing linguistic theories play with small amounts of data. This is not only a quantitative, but also a qualitative dimension. Some processing problems only arise seriously with big knowledge sources, mainly the problem of ambiguity.

- Language technology is not interested in using the most constrained or restricted formalism. Linguistic theories generally are, because of supposed claims about language processing mechanisms.
- It is not only difficult, but rather useless to dinstinguish between "grammatical" and "ungrammatical" sequences of words. Practical systems need to process all, and not only the "grammatical" constructions of a natural language. As Jensen puts it with respect to syntax: *"We suggest that the proper goal of a working computational grammar is not to accept or reject strings, but to assign the most reasonable structure to every input string, and comment on it, when necessary."* [11, p. 448].

These points show that linguistic theories have rather different goals than practical applications of natural language systems: Theories must yield general and elegant solutions for the description of linguistic phenomena, while language technology has to employ cost-efficient solutions with respect to the phenomena occuring in the actual application. However, we think that it is desirable to use well-founded methods of computational linguistics whenever possible, because "spontaneous" software systems without any solid foundation have proved to be a failure. Additionally, practical systems have to obey common principles of software engineering like robustness, reliability, speed, portability, modifiability, and changeability to other natural languages, to name a few. See [5] for an approach to multi-functional, reusable linguistic software.

What does this discussion mean for the METEXA project? We will not build a natural language system ready for application, but we try to bridge the gap between theory and application. This approach is realized by three central issues:

- We start with a corpus of about 1500 radiological reports. These serve as a guideline for the design of our system. The linguistic and other characteristics of the specific sublanguage will influence the choice of computational methods.
- In order to process a considerable amount of real-life texts we aim at a coverage that goes considerably beyond the illustration of single linguistic phenomena. The size of the knowledge sources, which is restricted by the resources of such an investigation, is approaching 1000 forms in the lexicon, 100 grammar rules and 400 concept types in the domain model.
- General and elegant methods will only be chosen, if the importance and frequency of a linguistic phenomenon justify it.

3 Medical Language Processing

In the last 10 – 15 years many projects have been carried out with the goal of processing natural language in the medical domain. These project were mainly settled in *Medical Informatics*, although the topic is interesting for AI-oriented *Computational Linguistics* as well. Since the production and understanding of medical documents is obviously "knowledge-driven", medical NL systems are a natural application of knowledge-based systems. Moreover, issues of knowledge

representation are very important, because information systems, expert systems, image processing systems and natural language processing systems meet in the medical domain. Masses of empirical data are available, many of them already stored in machine-readable format.

From an application oriented viewpoint, work in computational linguistics is motivated as well: In medicine there is a real need to process masses of routine data, applicable solutions are very welcome. Applications related to NLP and AI include the analysis, storage and retrieval of patient records, the indexing of diagnoses for statistical purposes, the indexing of medical literature, the generation of discharge summaries and decision support by medical expert systems.

The projects that have been carried out to process natural medical language over the last years cover all linguistic levels. Although not all of them did use up-to-date methods of computational linguistics, they have tried to solve practical problems concerning certain linguistic levels, always using a mass of empirical data. One project that is remarkable because of its length and effort and the coverage of its knowledge sources is the Linguistic String Project (LSP) conducted by Naomi Sager [14]. The result is a system for the analysis of clinical narrative, e.g. patient records, with an emphasis on syntactic analysis. The syntactic structures are annotated with semantic information to be mapped to a database.

Other approaches include the work of Wingert [23] on morphology, a parser on the basis of left associative grammar for German cytopathological statements by Pietrzyk [13], semantic networks in INTERMED [10], conceptual graphs [2], and the UMLS project (Unified Medical Language System) to integrate several terminological systems using conceptual modelling techniques (e.g. [9]), to name only a few. Many more approaches can be found e.g. in [15] and the annual proceedings of SCAMC (e.g. [6]).

4 Sublanguage Analysis

The language style found in radiology reports shows the characteristics of a sublanguage [7]. Roughly speaking, sublanguages have a specific vocabulary and a modified, often a restricted and simplified structure compared to language as a whole. Here is an example of one of the radiological reports (in German), which are the basis for the following studies:

```
Thorax in 2 Ebenen:
Normaler Zwerchfellstand mit glatter Begrenzung und frei entfal-
teten costodiaphragmalen Sinus. Regelrechte Transparenz und
Gefaesszeichnung der Lunge, kein Infiltrat, kein tumorverdaech-
tiger Lungenherd. Herz nicht pathologisch vergroessert oder
fehlerkonfiguriert. Grosse Gefaesse altersentsprechend unauf-
faellig. Hilusstrukturen und Mediastinum normal. Dargestellte
Skelettanteile ohne pathologischen Befund.
Urteil:
Thoraxorgane ohne pathologischen Befund.
```

They can be characterized as follows:

- The texts are often written in *telegraphic style*. Verbs are frequently omitted. Utterances typically consist of coordinated noun phrases, prepositional phrases, and adverbial phrases. The syntax of noun phrases is complex (PP-attachment, genitive NPs). Often they have several syntactic interpretations, but semantics makes it easily understandable. When a verb is missing, a functional structure (subject, object) cannot be assigned to the utterance.
- The whole process of generating or analysing a report is highly determined by specialized domain knowledge. Many potential ambiguities or misunderstandings are avoided, because the physician usually expects certain anatomical locations and report specific phenomena to occur.

Although a certain percentage of the reports comes close to the use of text patterns, in general the narratives exhibit an extremely individual design. Phrases that consist of several words play an important role, they occur frequently in medical terminology and as idioms.

5 The METEXA System

In this section the METEXA system for the analysis of medical texts will be described. First, we give an overview of the main components and discuss some design issues that are a consequence of the sublanguage analysis of the previous section.

5.1 System Design

Figure 1 shows the main components of the METEXA system.

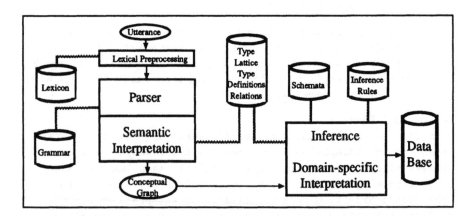

Fig. 1. System components

- In the *lexical processing* phase the lexical information of all input words is determined. Macros for the definition of lexical semantics are expanded. In the simplest case, the semantics of a lexeme is defined by a concept type or relation type, which in turn is defined in the knowledge base. However, it is possible to define the semantics of a lexeme by a complex conceptual graph (especially useful for compound words). Moreover, it is possible to identify multiple word lexemes in the input, which can be mapped e.g. to a single concept type. This is useful for Greco-Latin terms like *"Sinus phrenicocostales"*, other terms like *"freie Luft"* or standard phrases like *"altersentsprechend normal"*.

- *Parser and semantic interpretation* work in an interleaved fashion in order to realize a "semantic-oriented parsing". This will be discussed below. The result of this phase is a conceptual graph that represents the propositional content of the utterance.

- The conceptual graphs that have been produced are "language oriented". They have to be transformed in order to be mapped to a database, an expert system or a medical nomenclature. This is done in a phase of *inference and domain-specific interpretation*. We present examples of the knowledge structures and processes in this phase. A tight integration with a "real" database, however, still has to be done.

Which consequences can be drawn from the properties of the sublanguage for the design of the system? As the sublanguage is mainly semantically determined and the domain is narrow, a semantic grammar could be the right choice. But semantic grammars have several disadvantages that have been known for a long time (see [1, pp. 250] and [20, pp. 256]). On the other hand the task of the syntactic analysis must be limited, because most of the utterances lack a verb. A functional structure cannot be determined.

However, the parser has two important tasks: To find out constituents like noun phrases and prepositional phrases, and to make suggestions which constituent might modify which other one. Therefore, we have decided to build an interleaved syntactic and semantic analysis, which works in a generate-and-test fashion. The pure syntactic structure is highly ambiguous because of missing syntactic glue, but superfluous interpretations are ruled out by semantic means. The knowledge base is accessed during this semantic checking. The process of constructing the semantic representation of an utterance is basically compositional, but inferences can be drawn while constructing the semantic representation of a constituent.

5.2 Syntactic Analysis

The goal was to choose a parsing technique that is easy to implement, but runs rather efficiently. The most obvious choice was Definite Clause Grammars in Prolog. But we decided to use the bottom-up parser BUP [8], because we wanted to use left-recursive rules for grammar writing. A bottom-up parser does not allow ε-rules (see e.g. [4]), but because the grammar of the sublanguage often

has a recursive structure (e.g. genitive NPs), it is easier to avoid ε-rules than left-recursive rules. It is well-known that for every grammar with left-recursive rules there is a corresponding grammar without them that describes the same language, but this argument does not hold, if the task is to write a large grammar in a natural way. To build a preprocessor for that transformation would be an additional effort.

The parser keeps track of successful paths within an utterance (in the way of a *well-formed substring table*) and for unsuccessful paths as well, so that it works similar to a chart-parser with bottom-up strategy. The parser has been enhanced with graph unification to provide a means for building up an output structure and ruling out conflicting interpretations. The result is an attribute-value structure. The structures are not committed to any syntactic theory, mainly because in general a functional sentence structure (subject, object, etc.) does not exist. The names of the attributes are syntactic categories of lexemes and nonterminal identifiers. Up to now morpho-syntactic features are missing, but it is straightforward to add them. It has turned out that they are not important to analyse most utterances correctly, because semantic knowledge is predominant. Moreover, this approach allows to process "very telegraphic" utterances like *"Fraktur rechter Oberschenkel"*, where morpho-syntactic features fail to indicate a genitive NP, as they do in the "correct" phrase *"Fraktur des rechten Oberschenkels"*.

```
NP
    |NP
    |           |ADJ     regelrecht
    |           |N       Zwerchfellstand
    |KOORD
    |           |KONJ    und
    |           |NP
    |           |       |NP
    |           |       |           |ADJ     normal
    |           |       |           |N       Transparenz
    |           |       |MOD
    |           |       |           |NP
    |           |       |           |           |DET     der
    |           |       |           |           |N       Lunge
```

Fig. 2. Syntactic structure

Figure 2 shows, as an example, the output structure for *"regelrechter Zwerchfellstand und normale Transparenz der Lunge"*. The syntactic parser alone would find two interpretations, but with an interleaved access to the knowledge base only one interpretation is produced, as will be described in the next section. A technical description of the parser and the grammar is given in [17].

Writing grammar rules is a difficult and creative process. The main difficulty

is that adding grammar rules is non-monotonic in two ways: First, the addition of a set of rules can cause the retraction of some existing rules, if the new rules are a kind of generalisation of already existing ones. Second, a new set of rules may cause interferences with existing rules, so that ambiguities arise that the grammar writer had not in mind. Another question is how "general" a bunch of rules should be. When a certain sentence must be processed, there is always the choice between a solution that is taylored to that sentence and a more general solution. Specific solutions require additional work for each similar problem, but general solutions tend to produce ambiguities that were not foreseeable. Another problem is, how restricted the grammar should be with respect to "ungrammatical" constructions. We favour an unrestricted grammar, because the goal is to process as many utterances as possible, unless some "unrestricted rules" produce unwanted ambiguities.

5.3 Semantic Analysis

For semantic and knowledge representation the *Conceptual Graph Theory* by John Sowa ([20], see [22] for a summary) has been chosen (see [16] for a discussion). The basic knowledge structures are a lattice of concept types and relations between them. Relations are inherited via the subconcept hierarchy. These two conceptual graphs represent the semantics of the above sentence:

```
[ZWERCHFELLSTAND: #9]-            [TRANSPARENZ: #11]-
   (ZATTR)->[REGELRECHT: #7]         (XATTR)->[NORMAL: #10]
   (ZUSTAND)<-[ZWERCHFELL: #8].      (XCHAR)<-[LUNGE: #12].
```

Concepts are written in square brackets. They consist of a type label and an individual marker or a variable. Relations are written in round brackets.

The basic idea of semantic analysis is that each possible combination of syntactic constituents suggests to establish a semantic relation between the corresponding head concepts. If no relation can be found for a pair of concepts, this specific interpretation is rejected. Table 1 lists all possible connections between the syntactic constituents of our example sentence.

The semantic representation is constructed compositionally. Each time a pair of constituents is considered by the grammar (e.g. an adjective and a noun), the semantic interpretation will be called to check whether the head concept of one constituent has a conceptual relation to the head concept of the other constituent. In the case of two subsequent noun phrases (without punctuation or conjunction) the parser assumes that the second noun phrase modifies the first one. This way genitive noun phrases can be interpreted without knowing morpho-syntactic features (see above).

The phrase *"regelrechte Gefaesszeichnung und normale Transparenz der Lunge"*, which has the same syntactic structure than our example sentence, would result in two semantic interpretations, because the distributive reading is valid as well. In this case the system would prefer the solution with only one conceptual graph for the whole utterance, but this is the task of latter processing stages.

Table 1. Relations between head concepts

Constituent 1	Head Concept 1	Constituent 2	Head Concept 2	Relation
regelrechter	REGELRECHT	Zwerchfellstand	ZWERCHFSTAND	[ZWERCHFSTAND] ->(ZATTR) ->[REGELRECHT]
normale	NORMAL	Transparenz	TRANSPARENZ	[TRANSPARENZ] ->(XATTR) ->[NORMAL]
regelrechter Zwerchfellstand	ZWERCHFSTAND	der Lunge	LUNGE	<fail>
normale Transparenz	TRANSPARENZ	der Lunge	LUNGE	[LUNGE] ->(XCHAR) ->[TRANSPARENZ]

Since the semantic check on the knowledge base is interleaved with syntactic analysis, unplausible subtrees are cut away completely. According to [12] we distinguish between *explicit* and *implicit* occurences of conceptual relations. *Explicit* occurences are those that have a linguistic correspondent in the sentence, like prepositions and conjunctions. Conceptual relations that correspond to a syntactic role (subject, object, adj/noun etc) are called *implicit*. Implicit relations in general need more searching in the knowledge base, because the relation type is not known from lexical sources.

When a query for an appropriate conceptual connection between two concept types is sent to the knowledge base, an inference procedure is started. At present only inheritance of relations is supported, but in general more complex paths between two concept types might be found. In the above example, the XCHAR relation in *"Transparenz der Lunge"* is detected, because a so-called *canonical graph* `[LUNGE]->(XCHAR)->[LUNGE_XMERKMAL]` is defined, and TRANSPARENZ is a subtype of LUNGE_XMERKMAL.

Here is another utterance for illustration: *"Pulmonal kein Hinweis auf frische Infiltrate, eine Lungenstauung oder tumorverdaechtige Lungenherde."*.

```
[HINWEIS: #11]-
    (THEME)->
        [HERD: #10]-
            (PATTR)->[TUMORVERDAECHTIG: #8]
            (PATHO)<-[LUNGE: #9]
    (THEME)->[STAUUNG: #7]<-(PATHO)<-[LUNGE: #6]
    (THEME)->[INFILTRAT: #5]->(PATTR)->[FRISCH: #4]
    (NOT)->[NOT: #2]
    (LOC)->[PULMONAL: #1].
```

5.4 Domain Model

The basic domain model is a semantic network, consisting of a type lattice and relations defined between them. Valid combinations of concept types and relation

types are defined by *canonical graphs* [20, p. 91], expressing selectional restrictions. Concept types can be defined in terms of other concept types, however, at the current state of the system all concept types are regarded as primitives. In the next section we show how type definitions can be used for the transformation of conceptual graphs. Figure 3 shows a selection of the most important relations, and for each relation one example of a canonical graph.

```
PATHO links [ANAT] to [PATHO_ALT]      [LUNGE]->(PATHO)->[LUNGE_PATHO].
SIDE  links [ANAT] to [SEITE]          [ANAT]->(SIDE)->[SEITE].
LOC   links [ANAT] to [ANAT_LOC]       [ANAT]->(LOC)->[ANAT_LOC].
AATTR links [ANAT] to [AATTRIBUT]      [HERZ]->(AATTR)->[HERZ_ATTR].
XCHAR links [ANAT] to [XMERKMAL]       [LUNGE]->(XCHAR)->[XMERKMAL_LUNGE].
PATTR links [PATHO_ALT] to [PATTRIBUT] [STAUUNG]->(PATTR)->[STAUUNG_ATTR].
XATTR links [XMERKMAL]  to [XATTRIBUT] [XKONTUR]->(XATTR)->[XKONTUR_ATTR].
```

Fig. 3. Examples of relations and canonical graphs

The type lattice expresses subtype relations between all concept types of the system. Most concept types belong to the subdomains of anatomy, pathology, and radiology, but more general concept types like events, actions, properties, measures etc. are included as well. As an example, concept type ANAT (anatomical object) has KOERPERTEIL (part of the body), KOERPERREGION (body region), and HOHLRAUM (sinus) as subtypes; KOERPERTEIL in turn is divided into MUSKEL (muscle), KNOCHEN (bone), ORGAN (organ), GEFAESS (vessel) etc, and so on.

Type lattice and canonical graphs are the core of the system: They are referenced for the definition of lexical semantics, they are accessed when constructing the representation of an utterance, and as we will see in the next section, they are the basis for type expansion and contraction as well as for the inference engine.

It has (once again) turned out that the construction of the domain model is one of the most difficult and time-consuming tasks of the whole system design. Many arbitrary and obviously inconsistent decisions have to be made to get the system to work. The radiological texts serve as a starting point for knowledge acquisition. The use of a concept in a concrete utterance gives a hint as to what its semantics might be. However, physician's help is necessary during the knowledge acquisition phase. For a discussion of modelling problems in METEXA, see [18].

5.5 Inference

The purpose of analysing natural language reports is to map the resulting semantic representations to a background system for further processing. Such a background system could be a database system.

```
schema for FINDING(x) is
    [FINDING: *x]-
        (TOPIC)      -> [ANATOMY]
        (ANATOMY)    -> [ANAT]
        (LOCATION)   -> [ANAT_LOC]
        (FUNCTION)   -> [ANAT_FUNCTION]
        (RADIOLOGY)  -> [XCHAR]
        (PATHOLOGY)  -> [PATHO_ALT]
        (SEVERITY)   -> [ATTRIBUT]
        (SUBFIND)    -> [FINDING]
        (TIMEREL)    -> [PROP]
        (PATHOBOOL)  -> [BOOLEAN].
```

Fig. 4. DB-oriented schema definition

In Figure 4 we show a schema for the representation of findings that is close to a data model for a patient database. Besides that, a diagnostic expert system might use METEXA as a natural language front-end to acquire finding results for the fact database. In both cases, the semantic representations must be mapped to the conceptual model of the background system. If we look at the schema for findings in Figure 4, it is easy in some cases to fill the slots appropriately, e.g. the ANATOMY, PATHOLOGY, or RADIOLOGY slot. For other slots a lot of background knowledge and inferencing may be required. (For a deeper discussion of bridging the conceptual gap between databases, expert systems, and natural language, see [21].)

There are several operations for the manipulation of Conceptual Graphs (see [20]): To name the most important ones, *restrict* (used e.g. for inheritance), *join*, *projection* and *maximal join*. We will illustrate two other powerful methods that are useful for the mapping to another conceptual model: type expansion/contraction and deduction.

New types can be defined in terms of already existing types by a lambda abstraction. Let us assume that we want to define PLEURITIS as ENTZUEN-DUNG (inflammation) of PLEURA:

```
type PLEURITIS(x) is
    [ENTZUENDUNG: *x]<-(PATHO)<-[PLEURA].
```

If the utterance was *"Rechtsseitig leichte Entzuendung der Pleura"*, it could be transformed by *type contraction* in the following way:

```
[ENTZUENDUNG: #1]-                    [PLEURITIS: #1]-
    (PATTR)->[LEICHT: #2]                 (PATTR)->[LEICHT: #2]
    (PATHO)<-[PLEURA: #3]                 (SIDE)->[RECHTS: #4].
    (SIDE)->[RECHTS: #4].
```

The (nontrivial) algorithm is given in [20, p. 108]. The inverse of type contraction is *type expansion*, which replaces a concept type with its definition. Both

operations are useful in transforming a conceptual graph to fit a given conceptual model (see see [21]).

Deduction is a truth-preserving operation to derive new facts from known facts. Sowa gives *rules of inference* for Conceptual Graphs, which are equivalent to standard logic [20]. However, we agree with Fargues that the given set of inference rules *"seems too combinatorial to be used in practical systems"* [3]. Instead, Fargues has developed a Prolog-like resolution method for Conceptual Graphs, which we have implemented to be used in the METEXA system. The mechanism works similarly to a Prolog interpreter in which the terms are any conceptual graphs. A unification-like operation uses the lattice of concept types. The details of the algorithm can be found in [3].

We will illustrate the deduction mechanism with a simple example that shows how new facts can be derived from analysed sentences. The input sentence states *"Verschattung der Lunge."*:

> `[LUNGE: #1]->(XCHAR)->[VERSCHATTUNG: #2].`

The rule says, if an anatomical object x shows the "radiological characteristic" VERSCHATTUNG, then the same anatomical object x has some pathological alteration (that cannot be specified further at the moment):

> `IF [ANAT: *x]->(XCHAR)->[VERSCHATTUNG].`
> `THEN [ANAT: *x]->(PATHO)->[PATHO_ALT].`

Now we want to know from the input sentence, whether there is any anatomical object that shows a pathological alteration:

> `GOAL: [ANAT]->(PATHO)->[PATHO_ALT].`

First, the interpreter puts the initial goal onto the current goal stack and tries to infer the goal directly from the facts. Since this is not possible, an appropriate rule will be selected by use of a matching operation, substitutions are made, and the antecedens of the rule is put onto the current goal stack. Now the current goal can be inferred from the facts. Substitutions are made, and since the query was successful, they are propagated to the goal expression. The result is:

> `RESULT: [LUNGE: #1]->(PATHO)->[PATHO_ALT].`

6 Conclusion

We have presented a language engineering approach to the processing of natural language radiological reports. The design of the system is determined by the characteristics of the specific sublanguage. The METEXA system is able to process about 20 – 30 complete reports of the corpus at the current stage, and many single sentences. The ability of the system to process more reports grows rapidly as the knowledge sources are increasing. However, writing lexicon entries and developing the grammar and the domain model is a time-consuming process. Therefore, some support for knowledge acquisition is needed.

The METEXA system is written in *ProLog by BIM* on a *SUN SparcStation.* The basic operations for Conceptual Graphs have been implemented by Shahram Gharaei-Nejad. In general, *Conceptual Graph Theory* is not only a representation language, but has as well provided valuable help in designing the system and its knowledge sources.

References

1. James Allen. *Natural Language Understanding.* Benjamin/Cummings, Menlo Park, 1987.
2. R. H. Baud, A.-M. Rassinoux, and J.R. Scherrer. Knowledge representation of discharge summaries. In M. Stefanelli, A. Hasman, M. Fieschi, and J. Talmon, editors, *AIME-91*, volume 44 of *Lecture Notes in Medial Informatics*, pages 173 – 182, Berlin, 1991. Springer-Verlag.
3. Jean Fargues, Marie-Claude Landau, Anne Dugourd, and Laurent Catach. Conceptual graphs for semantics and knowledge processing. *IBM Journal of Research and Development*, 30(1):70–79, Jan 1986.
4. Gerald Gazdar and Christopher Mellish. *Natural Language Processing in PRO-LOG.* Addison-Wesley, Wokingham, England, 1989.
5. Gerhard Heyer. Elements of a natural language processing technology. In H. Haugeneder and G. Heyer, editors, *Language Technology and Practice of NLP.* Vieweg, 1992. (to appear).
6. Lawrence C. Kingsland, editor. *The 13th Annual Symposium on Computer Applications in Medical Care.* IEEE Computer Society Press, November 1989.
7. John Lehrberger. Sublanguage analysis. In Ralph Grishman and Richard Kittredge, editors, *Analyzing Language in Restricted Domains: Sublanguage Description and Processing*, pages 19–38. Lawrence Erlbaum Associates, Hillsdale, NJ, 1986.
8. Yuji Matsumoto, Hozumi Tanaka, Hideki Hirakawa, Hideo Miyoshi, and Hideki Yasukawa. BUP: A bottom-up parser embedded in Prolog. *New Generation Computing*, 1:145–158, 1983.
9. Alexa T. McCray. The UMLS Semantic Network. In Lawrence C. Kingsland, editor, *The 13th Annual Symposium on Computer Applications in Medical Care*, pages 503–507. IEEE Computer Society Press, November 1989.
10. Christian Mery, Bernhard Normier, and Antoine Ogonowski. "INTERMED": A Medical Language Interface. In J. Fox, M. Fieschi, and R. Engelbrecht, editors, *AIME 87*, pages 3–8, Berlin, 1987. Springer-Verlag.
11. Makoto Nagao. Language engineering: The real bottle neck of natural language processing (panel). In *COLING-88*, pages 448–453, 1988.
12. Maria Teresa Pazienza and Paola Velardi. A structured representation of word-senses for semantic analysis. In *European ACL 87*, pages 249–257, 1987.
13. Peter M. Pietrzyk. Survey of the Göttingen Medical Text Analysis System. In R. Hansen, B. G. Solheim, R. R. O'Moore, and F. H. Roger, editors, *Medical Informatics Europe 88*, volume 35 of *Lecture Notes in Medical Informatics*, pages 128–132, Berlin, 1988. Springer-Verlag.
14. Naomi Sager, Carol Friedman, and Margaret S. Lyman. *Medical Language Processing: Computer Management of Narrative Data.* Addison-Wesley, Reading, MA, 1987.

15. J. R. Scherrer, R. A. Côté, and S. D. Mandil, editors. *Computerized natural medical language processing for knowledge representation.* North Holland, Amsterdam, 1989.

16. Martin Schröder. Bemerkungen zur Auswahl eines Wissensrepräsentationsformalismus für ein System zur wissensbasierten Textanalyse. In W. Hoeppner et al., editor, *Materialien zum GWAI-91 Workshop "Wissensrepräsentation in natürlichsprachlichen Systemen"*, Bonn, 1991.

17. Martin Schröder. Ein semantisch-gesteuerter Bottom-Up-Parser in Prolog. Mitteilung FBI-HH-M-195/91, Universität Hamburg, FB Informatik, Mai 1991.

18. Martin Schröder. Knowledge based analysis of radiology reports using conceptual graphs. In *Proceedings of the 7th Annual Workshop on Conceptual Graphs*, Las Cruces, New Mexico, 8.–10. July 1992. New Mexico State University.

19. Martin Schröder. Supporting speech processing by expectations: A conceptual model of radiological reports to guide the selection of word hypotheses. In *KONVENS-92, 1. Konferenz "Verarbeitung natürlicher Sprache"*, Informatik aktuell, Berlin, 1992. Springer-Verlag.

20. John F. Sowa. *Conceptual Structures: Information Processing in Mind and Machine.* Addison-Wesley, IBM Systems Research Institute, 1984.

21. John F. Sowa. Knowledge representation in databases, expert systems, and natural language. In R. A. Meersman, Zh. Shi, and C-H. Kung, editors, *Artificial Intelligence in Databases and Information Systems (DS-3)*, pages 17–50. North Holland Publ. Co., 1990.

22. John F. Sowa. Towards the expressive power of natural language. In John F. Sowa, editor, *Principles of Semantic Networks: Explorations in the Representation of Knowledge.* Morgan Kaufmann Publ., San Mateo, CA, 1991.

23. F. Wingert. Morphologic analysis of compound words. *Methods of Information in Medicine*, 24:155–162, 1985.

Text Planning in ITEX: A Hybrid Approach

Heike Kranzdorf
Universität Bielefeld
Fak.f. Linguistik u.Literaturwissenschaft
- Computerlinguistik -
Postfach 10 01 31
D-4800 Bielefeld1
kranzdor@lili1.uni-bielefeld.de

Ulrike Griefahn
Universität Bonn
Institut für Informatik III

Römerstr.164
D-5300 Bonn 1
ulrike@uran.informatik.uni-bonn.de

Abstract

The main task of this paper is to present a text planning conception of stereotypical standardized text documents. The conception shows a kind of hybrid text planning by applying the two most familiar planning methods. The decision is motivated on the one hand by the attempt to use the advantages of each method and on the other hand by the attempt to take into account the variation in standardization of text documents.

1 Introduction

An ITEX[1](Integrated TEXt processing) system accepts a reduced syntactic input, converts the extracted knowledge into the representation of a deductive database and generates text documents on request.

In the ITEX project the main emphasis is put on the natural language generation of text documents. A deductive database system supports the generation process by offering an appropriate format of knowledge representation.

ITEX is applied to speech therapy reports[2]: These are final reports about the therapy of an aphasia patient in a clinic. On the one hand these reports are standardized to a large extent but on the other hand they must keep a high degree of flexibility as well because each treatment depends individually on the symptoms of a patient.

This paper deals with an appropriate text planning approach for multi-paragraph texts varying in their extent of standardization. We focus on two methods for the structuring of text: text schemata [McKeown 1985] and relations/plans [Hovy 1988,1991]. Both have gained acceptance in the last few years on the field of text generation.

[1] The ITEX project is supported by the Land of North Rhine-Westphalia as part of its joint research activity on "Applications of Artificial Intelligence".

[2] The data forming the basis of our research is the result of a cooperation with therapists of the "Zentrum für Sprachgestörte" in Bonn/Oberkassel.

Schemata [McKeown 1985] encoding standard domain-dependent patterns of discourse structure determine the content and the order of the clauses in paragraphs. But this planning method shows especially two limitations: schemata don't contain information about the way the various parts depend on each other and have an inherent rigidity.

RST (Rhetorical Structure Theory) [Mann/Thompson 1987, Hovy 1988] builds a tree structure that describes coherent dependencies between individual elements of a text. Thus, this approach offers flexibility. But then, even because of this flexibility the ordering of a large collection of data is inefficient.

2 Motivation of Hybrid Text Planning

The comparison of the schema- and the relationbased approach shows that they both have advantages and disadvantages. The planning with RST relations/plans is more flexible than it is with schemata, because relations/plans control smaller text spans than the schemata do. But it is more difficult to build an RST tree of a paragraph with a set of relations than it is to instantiate a schema.

Hovy's [1991] introduction of the growth points in the relations/plans shows that a close connection exists between both methods. Growth points keep the planning effort manageable by a large collection of data. Each plan represents a subset of rhetorical relations. It indicates in which order the relations have to be used. This application of a plan reminds on the application of a schema. Another possibility to handle growth points is expanding any of the RST relations at any point. Then, criteria for inclusion and exclusion of information have to be formulated in order to constrain the expanding process. But this approach has also a limitation: Relations/plans serve as text structurer and not as content planner.

This kind of hybrid text planning, i.e. integrating the concept of a schema in the relations, isn't sufficient for text planning in ITEX: In ITEX the task of the text planning approach should not only be the text structuring but also the determination of the content. Therefore we decided to operate another possibility of hybrid text planning. We also combine the schemabased method and the relationbased method to make use of the advantages of both methods. However, we use the approaches in parallel and not integratedly. Thus, the schema supports the selection of the content. Nevertheless it influences the selection of relations in the text structuring process.

In addition, the characteristics of speech therapy reports as application domain in ITEX confirm that both methods correlate. What makes these stereotypical text documents stand out is on the one hand a constant macrostructure, but on the other hand a far more flexible microstructure. In addition, they entail fixed standard formulations. Our hybrid approach of text planning considers these characteristics. The two methods are combined to maintain the selectivity of the schema particularly in the planning of the macrostructure as well as the dependencies of the relations/plans in the planning of the microstructure. Additionally, canned text is added in an appropriate way.

3 Text Planning in ITEX

Fig.1 shows the five stages of the natural language generation process. The generation component of the project ITEX can be described as a five-stage process: content planning, content structuring, message planning, clause planning and surface generation.

- **content planning**: The starting point of the generation process is the determination of the information which will be verbalized in the course of planning. Corresponding to a schema describing the macrostructure of the speech therapy reports, database queries extract information, which is relevant for the text to be generated.
The macrostructure of speech therapy reports looks as follows:

I. diagnosis of receipt
 1. syndrom classification
 2. symptoms
 a) speech components
 b) neuropsychological symptoms
 c) symptoms concerning the speech
 d) communication behaviour
II. measures of the treatment
 1. aim of the therapy
 2. measures of the therapy
 3. exercises
 4. form of the therapy
III. advances
IV. recommendations to further speech therapy

- **content structuring**: Database answers are embedded in rhetorical relations. Embedding strategies determine the application of the relations. If there are several database answers to one data base query the relationbased approach determines the arrangement. The resulting rhetorical relation structure describes the coherence of the text to be verbalized.

- **message planning**: This stage determines what will be verbalized in a message. Segmentation strategies provide for the division of the whole rhetorical relation structure in appropriate segments.

- **clause planning**: In the process of clause planning formal grammatical structures are produced (incomplete f-structures[3]) by verbalization strategies. With respect to the relations an appropriate connnective is selected. Standardized text constituents, which are also determined by verbalization strategies are added as partial f-structures.

[3] An f-structure is an unordered list of attribute-value-pairs which represents grammatical functions (e.g. SUBJ,OBJ) and features (f.e. CASE, NUM) of constituents.

- **surface generation**: The formal grammatical structures are completed by means of the LFG[4]-generator (Dörre, J. and S. Momma [1987]). During the surface generation the LFG-lexicon contributes lexical/morphological information and the LFG-grammar determines word order phenomena. Finally, natural language utterances are produced.

During the planning process the schema plays the dominant role. Its main task is to extract the knowledge out of the database. The knowledge serves as the basis for the verbalization of the report. Taking into consideration that the semantic terms of the knowledge representation reflect the macrostructure, the schema has further tasks. It controls the embedding of the extracted knowledge in rhetorical relations at the stage of content structuring and the appropriate addition of canned text at the stage of clause planning. Both the schema and the rhetorical relations, influence the choice of the other verbalization strategies.

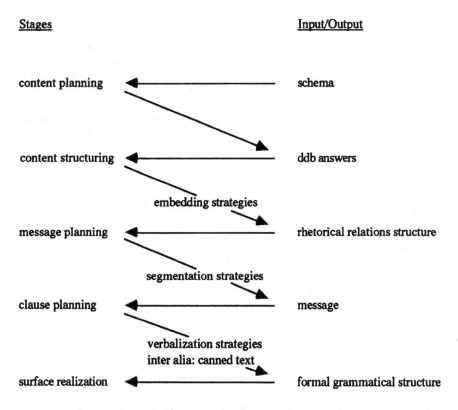

Fig. 1: The generation component

In the following the planning process is specified more precisely. To put it in concrete terms we show how the first two sentences of a fictious speech therapy report are generated.

To determine the content database queries corresponding to the macrostructure are asked. They describe the following facts: A speech therapy always begins with the diagnosis of the syndrom classification. Symptoms are described in order to elaborate this diagnosis. The symptoms can also be substantiated by examples. Hence, the elements of the diagnosis of receipt stand in hierarchical relations, which are represented in the following part of the schema[5]:

<div align="center">

Identification (syndroms)
Particular-Illustration (symptoms)+
{Particular-Illustration (example)}

Fig.2: Part of the schema

</div>

Fig.3 shows the database answers instantiating this part of the schema. The structure of the extracted knowledge reflects the structure of the schema: the introductory semantic terms indicate the assignment of the extracted knowledge to the corresponding part of the schema. In the example, the database contains two entries for the syndroms and for the symptoms. The knowledge is incrementally extracted and also incrementally embedded in rhetorical relations. If there is more than one database answer to one query, a relation between these answers is established. Then this partial relation structure will be integrated in the whole rhetorical relation structure which is constructed at that time.

([**(syndrome(syndrom(haupt**,broca_aphasie),**grad**(leicht))),
(syndrome(syndrom(neben,dysarthrie),**grad**(stark)))]).

([**(symptome(sprachliche_komponenten**(stoerungen(syntaktisch)),
keine_abtoenung,wertung(primaer))),
(symptome(sprachliche_komponenten(stoerungen(phonologisch)),
keine_abtoenung,wertung(primaer)))]).

<div align="center">

Fig.3: Database answers

</div>

Introductory semantic terms of the data base answers influence the choice of the rhetorical relations. Hence, the schema also controls the process of content structuring.

In general, a relation consists of two parts, the nucleus and the satellite. The nucleus carries the main information and the satellite carries additional information. But the sequence relation is a multi-nuclear relation. It combines several nuclei which

[5] The "{}" indicates optionality, "+" indicates that the item may appear one or more times.

refer to the same context. In ITEX, a sequence-relation is defined as a relation between database answers beginning with the same semantic term. Therefore, each of the answers, concerning the syndroms ('syndrome') and the symptoms ('symptome'), is at first embedded in a sequence-relation. Syndroms and the symptoms stand in an elaboration-relation. An elaboration-relation exists if the satellite is regarded as additional information to the nucleus. In ITEX, domain dependent knowledge determines the appropriate application of this relation. The hierarchical relation between syndroms and symptoms causes the choice of the elaboration-relation. This results in the following rhetorical relation structure:

Fig.4: Rhetorical relation structure

The rhetorical relation structure is completed if all database queries are processed. According to segmentation strategies which are defined for each relation the rhetorical relation structure is divided into appropriate messages.
In an elaboration-relation only one segmentation strategy is pursued: the verbalization of the nucleus and the satellite is carried out separately. In a sequence-relation we have two main segmentation strategies: intrasententiel and paratactical coordination.

1. It will be decided for an intrasententiel coordination, if
 a) the nuclei have the same semantic term or the same concept or
 b) one nuclei has the semantic term *haupt* and the other the semantic term *neben*
 (domain specific knowledge)
 i.e. the nuclei are transmitted as one segment.

2. It will be decided for an paratactical coordination, if
 a) a nucleus is a relation which is embedded in the sequence relation or if
 b) 1. has failed.
 i.e. the nuclei are transmitted as two different segments.

In the example the segmentation strategy 1.b) can be applied to the first sequence-relation and the segmentation strategy 1.a) to the second.

Corresponding to fig.4 the surface realization is:

Zu Beginn der Behandlung wurde bei dem Patienten eine leichte Broca-Aphasie mit starker Dysarthrie festgestellt. Es zeigen sich primär phonologische und syntaktische Störungen.

(*At the beginning of treatment it was diagnosed that the patient had a severe broca-aphasia with a slight dysarthry. Mainly phonological and syntactical disorders occur.*)

In the following we want to explain how the clause planning takes place. To support the construction of formal grammatical structures clause planning[6] combines object-oriented programming methods (Eikmeyer, H.J. [1987]) with methods of feature unification. Object-oriented programming makes it possible to form classes, to order these classes hierarchically, to transmit information between classes and to send messages[7] to classes. They help to control the selection of the concepts with partial f-structures containing lexical/syntactical information. Gradual unification provides for the construction of a formal grammatical structure. The unification of these partial f-structures guarantees the syntactical correctness of the concept combination. In addition, the unification provides a formal grammatical structure as input in the surface realization component.

The output of the stage of message planning is a 'generate' call, which determines the clause pattern to be used. In addition, not only the directly dominating relation and the message are given to the stage of clause planning but also a higher dominating relation, which is important for the determination of an appropriate connective.

Messages concerning syndroms ('syndrome') and symptoms ('symptome') provide for the choice of the following clause pattern:

diagnosis → visible_state
$\uparrow = \downarrow$

connective
$\uparrow = \downarrow$.

Clause patterns are structures that connect declaratively elementary text units. They are represented as rules in LFG-notation. These are similar to expansion rules such that they can easily be modified and enlarged. A compiler transmits the rules to system internal procedures, whose main part is the method 'generate'. This method corresponds to a 'message', which is sent to each category of a rule. This is possible,

[6] The stage of clause planning follows the corresponding stage in the KLEIST system. The project KLEIST has been carried out at the University of Bielefeld, too. (Peters, K. and H. Rutz [1991])

[7] This term 'message' is not identical to the term 'message' in 'message planning'.

because the categories are simultaneously represented as classes in a concept hierarchy (fig.5). The 'generate' method is defined as follows:

If a procedure (rule) is assigned to the receiver
 then carry out the procedure and unify the result with the variable instantiated to an attribute-value structure
 else check, whether the receiver has subclasses.
 If it has,
 then choose a subclass which is the new receiver of the message.
 else explicate the concept corresponding to the receiver and unify the result with the variable instantiated to an attribute-value structure.

On the left hand side of a rule stands the name of the clause pattern (e.g.'diagnosis' in the rule above). Terminal or non-terminal category form the right hand side. 'Visible_state' is a non-terminal category, which is connected with subconcepts in a hierarchy.

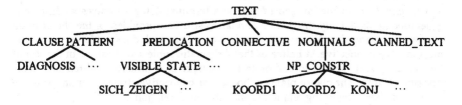

Fig. 5: Concept hierarchy

These subconcepts are verbs, which can describe a visible state: the diagnosis. There is a rule for each verb[8]. The rule shows the subcategorization of the verb.

sich_zeigen → np_construc
 (↑ subj) =↓

In this rule the verb subcategorizes a noun phrase (np) as subject, which has to be generated. The verb (receiver) has no subclasses. Hence, the concept lexicon is scanned to find an entry for this verb. The entry, declaratively represented in an LFG-notation, is connected with a partial f-structure which has to be merged to the whole structure.

 The next step of the clause planning process is the construction of the np. There are several rules that describe different structures of an np. The following rule provides for the construction of an intrasententiel coordination which is used if the symptoms of the speech component '(symptome(sprachl_komponenten...))' are embedded in a sequence-relation:

[8] We don't want to explain here how the appropriate verb is chosen.

np_constr → koord1
$\uparrow = \downarrow$

konj
(\uparrow modif)=\downarrow

koord2
(\uparrow modif koord)=\downarrow.

The annotation of the constituents describes their grammatical functions. For each of these categories it exists a corresponding verbalization strategy.
These strategies are used if the following conditions are valid:

- The dominating relation is a sequence-relation.
- The nuclei have the same semantic term or the same concept.

If the conditions met, partial f-structures of appropriate concepts[9] in the concept lexicon are merged to the whole structure.

A *Connective* in the 'diagnosis' rule is a terminal category corresponding to a generation method. Only the rhetorical relation structure provides for the choice of an appropriate connective. We treat the expletive *es* (it) which does not have a semantic meaning as a connective. It indicates that a rhematic subject will follow in the rest of the sentence and serves to elaborate the context of a situation which has been described before. The clause planner chooses the connective-strategy for an expletive *es* if the higher dominating relation is an elaboration-relation.

The schema causes the appropriate addition of canned text. The canned text in the first sentence is treated similarly to a connective. The canned text is added to the formal grammatical structure of the introductory sentence of a speech therapy report and can be recognized by the semantic term 'syndrom'.

The output of this stage is a formal grammatical structure, which is made up of essential lexical information and the grammatical functions. At the stage of surface realization the LFG-generator contributes further information. It completes the information by means of the LFG-lexicon and the LFG-grammar. The LFG-lexicon adds lexical and morphological information. The LFG-grammar determines the order of the constituents. Finally, a natural language utterance is produced.

4 Knowledge representation

We use a deductive database system to support the generation of text documents. The approach of deductive databases we follow was originally presented by Lloyd and Topor [1985]. It is based on a typed first order logic. The tight connection of first order logic to some subsets of natural language makes deductive databases interesting for natural language applications.

[9] In ITEX concepts appearing in the database representation also appear in the surface realization because the therapists prefer a speech therapy report which is individual to a certain degree.

Deductive databases can be regarded as an extension of relational databases which can in addition deal with complex terms and conditional information (rules). These features enable us to get a more natural representation of our domain of interest than it is possible with relational databases. A deductive database is provided with an inference mechanism which allows us to deduce information not explicitly stored in the database (even the transitive closure which cannot be expressed in relational algebra).

Using typed first order logic we are able to restrict the domain of arguments in relations. This has the advantage that spelling mistakes which often imply type errors can be detected at an early stage.

A deductive database is a finite set of database formulas $(A \leftarrow W)$ where A is an atomic formula and W a first order formula. The difference between normal programs (or PROLOG programs) and deductive databases is that the bodies of the database formulas allow quantifiers and connectives and that they are typed. Deductive databases can be transformed straightforwardly to normal programs which are executable on standard Prolog systems. A sound and efficient processing of negation as failure is guaranteed.

How can we exploit a deductive database in the ITEX project? An ITEX system accepts a syntactically reduced subset of natural language as input (e.g.: noun phrases like *leichte Broca-Aphasie* and *phonologische Stoerungen*). Written input is syntactically analyzed by means of an LFG parser. From the resulting f-structures semantic information is extracted and mapped onto the relations of the database.

To support an ITEX system the following kinds of knowledge have to be represented in the database (Griefahn [1991]):

- the macrostructure of the text that fixes the schemata of the database,
- the actual knowledge obtained from the natural language input, and
- some domain knowledge.

The syntactically reduced input can be mapped to terms (as defined in Lloyd [1987]) in a natural way. In the following we will explain the representation of the actual knowledge extracted from the input. In our prototypical implementation of a deductive database system (as supposed in Lüttringhaus [1987]) we use the type system to define a hierarchical structure corresponding to the macrostructure of the text. The following type definitions show a part of the type hierarchy for the application of speech therapy.

```
type text          =    {diagnose(diagnose),uebungen(uebungen),...}
type diagnose      =    {syndrome(stoerung,abtoenung),...
                        symptome(stoerung,abtoenung,wertung)}
type stoerung      =    {syndrom(syndromklasse,syndrom),...}
type syndromklasse =    {haupt,neben}
type syndrom       =    {broca_aphasie,...}
type abtoenung     =    {grad(grad),haeufigkeit(haeufigkeit)}
type grad          =    {leicht,stark,...}
```

On the top level the whole text is represented as a semantic unit. It consists of several sections, e.g. diagnosis and exercises (i.e. 'uebungen'). The section diagnosis is

further splitted into diagnosis of syndroms and diagnosis of symptoms. The words of the application domain are at the bottom of this hierarchy. For the input *leichte Broca-Aphasie* we obtain the term

```
diagnose(syndrome(syndrom(haupt,broca_aphasie),grad(leicht)))
```

The function symbols 'diagnose' and 'syndrome' of the term above are representing the macrostructure. With these function symbols it is possible to answer queries concerning arbitrary parts of the text. The constant symbols 'broca_aphasie' and 'leicht' are the words extracted from the natural language input. The remaining function symbols like 'syndrom' and 'grad' are needed by the type system for a clear assignment of types and function symbols. The constant symbol 'haupt' has to be inferred from the domain knowledge: syndroms are classified into a main ('haupt') and a minor ('neben') class. In this case the input is completed such that homogeneous knowledge can be delivered to the text planning.

5 Conclusion

The hybrid text planning approach in ITEX shows another way to combine the schemabased method and the relationbased method. It wants to take profit from the advantages of both methods. Instead of integrating the concept of the schema in rhetorical relations by growth points [Hovy 1991], we use the methods in parallel. Both methods influence the decisions to be taken during the planning process. Additionally, canned text is added at the stage of clause planning. This conception supports the planning of those text documents that vary in the extent of standardization. The application of feature-unification methods enables us to take the same format in clause planning and surface realization.

Using a deductive database we are able to obtain a knowledge representation which is developed with respect to the generation of text documents but which is also suitable for inferencing.

References

Bresnan, J. and R. M. Kaplan [1982]: Lexical Functional Grammar: A formal system for grammatical representation. In: Bresnan, J. (ed.): *The Mental Representation of Grammatical Relations*, pp.173-281, Cambridge: MIT-Press.

Dörre, J. and S. Momma [1987]: Generierung aus F-Strukturen. als strukturgesteuerte Ableitung. In: Morik, K. (ed.): *GWAI-87*, PP.54-64, Berlin: Springer.

Eikmeyer, H.J. [1987]: *CheOPS: An object-oriented programming environment in C-PROLOG. Reference Manual.* Kolibri Arbeitsbericht Nr.4. Universität Bielefeld.

Griefahn, U. [1991]: *Ein deduktives Datenbanksystem als Grundlage Integrierter TEXtverarbeitungssysteme.* ITEX-Bericht, KI-NRW 91-23.

Griefahn, U. and H. Kranzdorf [1991]: *ITEX: Systeme integrierter Textverarbeiung. Ein Gesamtüberblick.* ITEX-Bericht, KI-NRW 91-21.

Hovy, E. [1988]: Planning Coherent Multisentential Text. In: *Proceedings fo the Twenty-Siyth Annual Meeting of the Association for Computational Linguistics*, pp.163-169, State University of New York, Buffalo, New York.

Hovy, E. [1991]: Approaches to the Planning of Coherent Text. In: Paris, C., Swartout, B. and Mann, W. (eds.): *Natural Language Generation in Artificial Intelligence and Computational Linguistics*, pp.83-102, Kluwer Academic Publishers.

Kranzdorf, H. [1991]: *Textplanung in ITEX: ein hybrider Ansatz.* ITEX-Bericht, KI-NRW 91-22.

Lloyd, J.W. and R.W. Topor [1985]: A Basis for Deductive Database Systems. *Journal of Logic Programming*, 2:93-109.

Lloyd. J.W. [1987]: *Foundations of Logic Programming*. (2nd Ed.) Springer Verlag.

Lüttringhaus, S. [1987]: *Deduktive Datenbanksysteme: Theoretische und Praktische Aspekte*. Forschungsbericht Nr. 231 des Fachbereichs Informatik der Universität Dortmund.

Mann, W.C and S.A. Thompson [1987]: *Rhetorical Structure Theory: A Theory of Text Organization*. ISI Reprint Series ISI/RS-87-190, Information Sciences Institute.

McKeown, K.R. [1985]: *Text generation: Using Discourse Strategies and Focus Constraints to Generate Natural Language Text*. Cambridge: Cambridge University Press.

Peters, K. and H. Rutz [1991]: KLEIST - ein System zur Produktion von Wegbeschreibungen. In: Peters, K. et al.: *KLEIST. Textgenerierung in deutscher und japanischer Sprache*. Kolibri Arbeitsbericht Nr.26. Universität Bielefeld.

Yes/No Questions with Negation:
Towards Integrating Semantics and Pragmatics

Marion Schulz Daniela Schmidt

Universität Bielefeld
Fakultät für Linguistik und Literaturwissenschaft
- Computerlinguistik -
Postf. 100 131
4800 Bielefeld 1
e-mail: schulz@lili1.uni-bielefeld.de

Abstract

Yes/no questions with negation show that pragmatic considerations enter in the analysis of linguistic form: the negation marker in sentences like *"Don't you appreciate computational linguistics?"* cannot be interpreted in terms of a logical operator. Rather, it indicates the speaker's bias towards a positive or negative answer to the positive form of the question. German has a special particle *"doch"* instead of the usual agreeing *"ja"* for an unexpected positive answer.

We propose a treatment within the constraint-based approach developed by Fenstad et al. (1987). They suggest to gather information from various linguistic levels in a common "constraint pool". Our contribution concerns a pragmatic level.

Taking the formalism of LFG (Bresnan 1982) as our basis, we sketch for a tiny fragment of German yes/no questions with negation how the interaction between syntax, semantics and pragmatics is feasible within a single framework and that the different levels can still be treated separately.

1 Introduction

In the analysis of questions we can distinguish a propositional part - a set of alternatives that constitute the range of direct answers - and an illocutionary part that contains instructions how to "concoct some sort of direct answer therefrom"[1]. The latter is called "request" by Belnap/Steel (1976), the former "subject". They introduce "whether questions" as having a finite number of alternatives in their "subject". Yes/no questions then are treated as a special case of these with just two alternatives: "S v -S", where S is a state of affairs.

So yes/no questions admit only two answers - *"yes"* or *"no"* - as their name already suggests.[2] The question may be asked in positive or negative form, i.e. by either of the disjuncts S and -S. In Japanese[3] the answer depends on the truth conditions of S alone:

[1] Belnap/Steel (1976), 35

[2] A third answer *"I don' t know."* or *"I have no information about that."* should be added when we assume only partial knowledge (as situation semantics does).

[3] For Russian (which is similar to Japanese in this respect) cf. Restan (1968). For an overview consult Schmidt (1991).

Kyoo-wa atu-ku-na-i desu ka? - *Hai (, so desu ne).*
Is it not hot today? Yes (, so it is.)

 - *Iie, kyoo-wa atu-i desu.*
 No, it is hot today.

In German and English, however, the negation marker in the negative question must not be interpreted logically. This could be seen as another case of non-truthfunctional use of *"not"* that Horn (1989) calls "metalinguistic negation". He defends the view that negation is not semantically but pragmatically ambiguous.

The negation marker in German and English negative yes/no questions has the function of a modal particle[4] that indicates the speaker's bias towards an affirmative (or negative) answer to the positive form of the question. Rohrer (1971) therefore suggests that English answers negative questions by supposing the corresponding positive one. So, negative yes/no questions really serve two purposes: on the one hand, they mark a lack of information about whether a certain state of affairs holds or not, and, on a pragmatic level, they aim at confirmation or disproof of an assumption about just this question whether a state of affairs holds or not.

We propose a treatment within the constraint-based approach developed by Fenstad et al. (1987). They suggest to gather information from various linguistic levels in a common "constraint pool". As semantic representation format, they introduce so-called "situation schemata" founded on situation semantics (Barwise/Perry 1983). Our contribution concerns a pragmatic level. Taking the formalism of LFG (Bresnan 1982) as our basis, we sketch for a tiny fragment of German yes/no questions with negation how the interaction between syntax, semantics and pragmatics is feasible within a single framework. The different levels can still be treated separately.

2 Our pragmatic account

In German, the three answering morphemes *"ja"*, *"nein"* and *"doch"* are distributed as exemplified by the following sentences:

(1) *Gewann Kohl?* (Did Kohl win?) EXPECTATION: none
Ja, Kohl gewann. (Yes, he did.)
Nein, Kohl gewann nicht. (No, he didn't.)

(2) *Gewann nicht Kohl?* (Did Kohl not win?) EXPECTATION: he did
Ja, Kohl gewann. (Yes, he did.)
Nein, Kohl gewann nicht. (No, he didn't.)

(3) *Gewann Kohl nicht?* (Didn't Kohl win?) EXPECTATION: he didn't
DOCH, Kohl gewann. (Yes, he did.)
Nein, Kohl gewann nicht. (No, he didn't.)

In the negative questions (2) and (3) the particle *"nicht"* has no effect on the state of affairs asked for - (1) yields the same answers as (2) and (3). The choice between *"ja"*

4 see Thurmair (1989), 85ff, 160ff

and *"doch"* is motivated exclusively by pragmatic considerations. If the speaker expects an opposite answer, *"doch"* is used to reject these assumptions. In case the answer just confirms what is expected, *"ja"* is the good choice. Conrad (1978, 43) introduces the notion of "Antworterwartung" (roughly "expected answer") to account for this phenomenon.

Approaches based exclusively on logical form such as the one of Pope (1973) cannot cope with the pragmatic dimension of the relation between question and answer. For example, she holds that *"doch"* is always used in her constellation of "positive disagreement", neglecting the possibility of an answer with *"ja"*.

In our example sentences, the expectations are made explicit by the position of the negation marker. Furthermore, it is unstressed in (2) and stressed in (3). The stressed *"nicht"* is comparable to the particle *"etwa"* or *"vielleicht"*, unstressed[5] *"nicht"* ressembles in its function the modal particle *"doch"*[6].

This relation between question and answer becomes crucial when implementing a "question-answering system".[7] All the information relevant for the right interpretation of the question must be provided as well as knowledge about the appropriate form of the answer. In order to achieve this, we propose to add a pragmatic level to syntactic and semantic analysis levels put forward in the constraint-based framework of Fenstad et al. (1987) .

3 The constraint-based approach of Fenstad et al.

Unification-based (or constraint-based) formalisms - the current quasi-standard in NL syntax analysis - use recursive attribute value matrices, so-called feature structures, as their underlying representation format. Feature structures are partial in the sense that they don't fully determine a unique object, but merely constrain the range of described objects. Information for arbitrarily many (depending on the theory) non specified attributes can be added to fix more details.

The feature structures in turn are described by means of a system of constraining equations. Unification, then, plays the central role in solving these. The declarative nature of the unification operation constitutes one of the main advantages of the unification-based approaches. Equations from different sources (e.g. lexicon and phrase structure rules as in LFG) contribute to one and the same constraint pool that as a whole determines a feature structure. The evaluation process therefore is completely order-independent.

The idea of a constraint pool nourished by different sources can be extended beyond syntactic analysis: Information from syntax as well as phonology, morphology, semantics, pragmatics and so on can "flow together" to simultaneously constrain one comprehensive description (cf. Halvorsen 1986). This presupposes, of course, that all

5 and unstressable without a shift in meaning, as Thurmair (1989, 85ff.) points out. This condition presupposes knowledge of the context we neglect here.

6 see Helbig/Buscha (1991, 612): *"Sind Sie nicht Lehrer?"* (= *"Sie sind doch Lehrer."*) - *"Aren't you a teacher?"* (*"You are a teacher, aren't you?"*)

7 This work arose in the context of an interdisciplinary project (see Schulz 1990) within the framework of the joint research activity on "Applications of Artificial Intelligence" in North Rhine-Westphalia.

the other levels of linguistic analysis lend themselves equally well to a representation in terms of feature structures.

The framework of Lexical Functional Grammar (LFG, Bresnan 1982) is advocated here as a sound basis for the integration of semantic and pragmatic levels with syntactic ones. LFG provides a unification algorithm also usable to evaluate semantic as well as pragmatic equations. In turn, LFG is provided with a semantics and pragmatics. Equations in LFG are located mostly in the lexicon. They can also occur as annotations on nodes on the right hand side of phrase structure rules. The solution of the constraint pool constructed during parsing yields an f(unctional)-structure, describing the functional syntax. An additional attribute - for example "SEM" or "PRAG" - can easily be introduced within the f-structure. Functional, semantic and pragmatic description can then be generated in parallel. This so-called technique of "co-description" should, however, only be seen as an implementation device. The three levels involved remain separated as far as theory is concerned.

3.1 Situation Schemata as semantic level

Fenstad et al. (1987) undertake a synthesis of unification-based approaches and ideas from situation semantics (Barwise/Perry 1983), one of the currently leading approaches to NL semantics. Thus they develop what was introduced above as the semantic level of (e.g.) LFG. The link between them is established through the notion of partiality that is equally relevant in both frameworks: in situation semantics, a situation can be only partially described by a set of facts that hold in the situation or are explicitly excluded in it. This is handled by means of a polarity value, 1 or 0, respectively. A full description of a situation is impossible because of the infinite number of facts that can possibly be added to get a more detailed description.

A fact has the following format: "at l: r, a_1,, a_n; p". l determines the spatio-temporal location of the fact; p, the above mentioned polarity value, specifies whether the relation r holds between arguments a_1 to a_n or not. Fenstad et al. adapt the attribute-value representation familiar from the unification-based formalisms to fit the needs of the situation semantic primitives. A fact is described as follows in their notation (called situation schema):[8]

$$
\begin{bmatrix}
\text{REL} & \ldots \\
\text{ARG.1} & \ldots \\
\ldots & \ldots \\
\text{ARG.n} & \ldots \\
\text{POL} & \ldots \\
\text{LOC} & \ldots
\end{bmatrix}
$$

Fig. 1: General Format of a Situation Schema

We won't go into further details of the approach here, as we are merely concerned with the polarity attribute when talking about yes/no questions. It is exactly the value of this attribute that this type of question aims at: does the corresponding relation hold or not? Already Barwise/Perry (1983, 286) consider introducing an indeterminate for the

[8] HPSG (Pollard/Sag 1987) continues that idea rather along the same lines.

polarity value in order to be able to represent yes/no questions. This seems to us a suggestion well worth adopting for the framework of situation schemata.[9]

4 A proposal for a pragmatic level

We suggest furthermore that information about the "conversation mode" or the "speech act" involved should find its place in an independent pragmatic level outside the semantic one. Therefore we argue against the representation format for wh-questions advocated in Vestre/Fenstad (1988). They mark the argument(s) asked for by a "[SPEC WH]" in the situation schema:

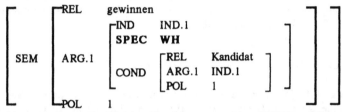

Fig. 2: Situation schema for "Welcher Kandidat gewann?" ("Which candidate won?")

This purely pragmatic information should rather be treated in a separate level. This pragmatic level can easily be realized by introducing a further attribute "PRAG" in the overall structure built up by LFG analysis. The path (e.g. "<SEM ARG.1>" for the example above) establishes a formal link between the semantic and pragmatic level[10]:

$$
\left[\text{PRAG} \begin{bmatrix} \text{MODE} & \text{question} \\ \text{TYPE} & \text{WH} \\ \text{WHAT} & \text{<path to situation schema>} \end{bmatrix} \right]
$$

Fig. 3: Pragmatic information of a wh-question

The sort of information entering it with respect to negated yes/no questions is as follows:

$$
\left[\text{PRAG} \begin{bmatrix} \text{MODE} & \text{question} \\ \text{TYPE} & \text{Y/N} \\ \text{EXPEC} & \{1,0\} \end{bmatrix} \right]
$$

Fig. 4: Pragmatic information of a yes/no question

The optional attribute "EXPECtation" takes the values "1" or "0" respectively, in case the speaker expects the relation in question to hold or not.

9 Vestre (1987) and Dyvik (1988) propose alternative solutions. However, they both treat negation in yes/no questions as logical operators. See Schulz (1991) for discussion.

10 cf. Allen (1987)'s treatment of "Y/N QUERIES"

The following tiny grammar fragment[11] is merely meant to illustrate the unified treatment of syntax, semantics and pragmatics. Therefore, we consider exclusively the expectations made explicit by the position of negation. Questions of focus and its interaction with negation[12] along with prosodic issues like stress are neglected. This restriction seems admissible for a small-scale question-answering system. Nevertheless, they could be taken into account introducing a further level.

$$
\begin{array}{lll}
\text{S} \rightarrow & \text{V} & \uparrow = \downarrow \\
& & (\uparrow \text{PRAG MODE}) = \text{question} \\
& & (\uparrow \text{PRAG TYPE}) = \text{Y/N} \\
& [\text{NEG} & \uparrow = \downarrow \\
& & (\uparrow \text{PRAG EXPEC}) = 1] \\
& \text{NP} & (\uparrow \text{SUBJ}) = \downarrow \\
& & (\uparrow \text{SEM ARG.1}) = (\downarrow \text{SEM}) \\
& [\text{NEG} & \uparrow = \downarrow \\
& & (\uparrow \text{PRAG EXPEC}) = 0].
\end{array}
$$

Fig. 5: Example rule for yes/no questions with possible negation

This (simplified) rule allows us to analyse sentences like

(1) *Gewann Kohl?* (Did Kohl win?)
(2) *Gewann Kohl nicht?* (Didn't Kohl win?)
(3) *Gewann nicht Kohl?* (Did Kohl not win?)
(4) *Gewann nicht Kohl nicht?* (Didn't Kohl not win?)

(1) results in a neutral yes/no question (No value is assigned to the path "<PRAG EXPEC>" which therefore doesn't appear in the output structure.). (2) is one of the biased cases where the speaker expects the relation in question not to hold (marked by "[PRAG EXPEC 0]"), (3) where he or she expects it to hold (marked by "[PRAG EXPEC 1]"). (4) finally is excluded by this rule because of conflicting values for "<PRAG EXPEC>".

In case the relation is found not to hold, the answer for (1), (2) and (3) is (5). The "<PRAG EXPEC>" value is crucial when an appropriate answer has to be formulated in the other cases. The special particle *"doch"* is used when objecting to the speakers contrary expectation ("[PRAG EXPEC 0]"). There is no special expression for consenting to it, so *"ja"* is used as in the case of a neutral question.

(5) *Nein, Kohl gewann nicht.* (No, Kohl didn't win.)
(6) *DOCH, Kohl gewann.* (Yes, he did.)
(7) *Ja, Kohl gewann.* (Yes, he did.)

Sentences like (4), however, don't seem to be entirely ungrammatical. Their acceptance grows with the distance between the two occurences of *"nicht"*. This fact is illustrated by the following example sentence, pointed out to us by an anonymous reviewer:

[11] in the notation of our LFG-parser (Kindermann 1987)
[12] see Löbner (1990), and especially Jacobs (82)

(8) *Ist nicht schon im letzten Jahr ein paper von Dir nicht akzeptiert worden?*
(*roughly:* Hasn't already last year a paper of yours not been accepted?)

The first *"nicht"* expresses a positive expectation as in (3), but the second one has undoubtedly the function of negating the proposition in question. Our approach is able to cope with this special case as well.[13] The following rule covers sentences like (4):

$$
\begin{aligned}
S \rightarrow \quad & V \qquad && \uparrow = \downarrow \\
& && (\uparrow \text{PRAG MODE}) = \text{question} \\
& && (\uparrow \text{PRAG TYPE}) = \text{Y/N} \\
& \text{NEG} && \uparrow = \downarrow \\
& && (\uparrow \text{PRAG EXPEC}) = 1 \\
& \text{NP} && (\uparrow \text{SUBJ}) = \downarrow \\
& && (\uparrow \text{SEM ARG.1}) = (\downarrow \text{SEM}) \\
& \text{NEG} && \uparrow = \downarrow \\
& && (\uparrow \text{SEM POL}) = 0.
\end{aligned}
$$

Fig. 6: Example rule for yes/no questions with double negation

Also in this case a rejection of the speaker's assumptions has to be introduced by the particle *"doch"* as in (10). The confirmation of the - negative - proposition is made by *"ja"*:

(9) *Ja, Kohl gewann nicht.* (Yes, he did not win.)
(10) *DOCH, Kohl gewann.* (No, he did win.)

A combination of "[EXPEC 0]" and a negative proposition, however, appears odd. It can much more easily be expressed by a positive expectation of the positive proposition.

So in the choice of the appropriate particle for the answer pragmatic considerations enter again. Furthermore, the tendency to accompany an answer with additional information (already noticed with neutral yes/no questions) will increase when it runs counter to the expectations implicit in the question.[14]

5 Conclusion

Starting from an analysis of German yes/no questions with negation, we have been arguing for the use of a uniform formalism in the description of semantics and pragmatics while still pleading for a neat separation of these levels. This allows on the one hand to channel all information relevant for the respective levels through one and the same analysis of linguistic form, and on the other hand to maintain separate levels where information from other sources (background knowledge, context, intonation...) can still be "unified in". Of course, our approach can only be a first approximation to the surely more complex phenomenon of indirect speech acts. However, it is interesting to explore how far it will take us on the way to the realm of pragmatics.

As a consequence, we argue against intertwining different levels of representation as e.g. proposed by Vestre/Fenstad (1988) with respect to the treatment of wh-Questions.

[13] We'd like to thank Michael Hussmann for his valuable comments.
[14] For the generation of cooperative answers see Marburger (1988)

Besides theoretical considerations, this neat separation has clear advantages for the practical evaluation of a query: the relevant information can be found entirely at the "PRAG" attribute. Adopting the Vestre/Fenstad proposal, possible "[SPEC WH]" marks have to be searched in and collected all over the whole situation schema before the evaluation process can start.

References

Allen, J. *Natural Language Understanding*. Menlo Park, CA: Benjamin/Cummings, 1987.

Barwise, J. and Perry, J. *Situations and Attitudes*. Cambridge, Mass. : Bradford, 1983.

Belnap, N. and Steel, T. *The Logic of Questions and Answers*. New Haven: Yale University Press, 1976.

Bresnan, J., ed. *The Mental Representation of Grammatical Relations*. Cambridge, Mass.: MIT, 1982.

Conrad, R. *Studien zur Syntax und Semantik von Frage und Antwort*. Berlin: Akademie Verlag, 1978.

Dyvik, H. *The PONS Project: Features of a Translation System*. University of Bergen. Dept. of Linguistics and Phonetics, Skriftserie Nr. 39, Serie B, 1990.

Fenstad, J. E., Halvorsen, P.-K., Langholm, T. and Van Benthem, J. *Situations, Language and Logic*. Dordrecht: Reidel, 1987.

Halvorsen, P.-K. "Natural Language Understanding and Montague Grammar," in: *Computational Intelligence* 1986 (2), 54-62.

Helbig, G. and Buscha, J. *Deutsche Grammatik. Ein Handbuch für den Ausländerunterricht*. Leipzig, 1991.

Horn, L. *A Natural History of Negation*. Chicago: University of Chicago Press, 1989.

Jacobs, J. *Syntax und Semantik der Negation im Deutschen*. München: Fink, 1982.

Kindermann, J. *Manual für das Bielefelder LFG-System*. Universität Bielefeld, 1987.

Löbner, S. *Wahr neben Falsch*. Tübingen: Niemeyer, 1990.

Marburger, H. *Generierung kooperativer natürlichsprachlicher Antworten in einem Dialogsystem mit Zugang zu relationalen Datenbanken*. Dissertation. Universität des Saarlandes. 1988.

Pollard, C. and Sag, I. *Information-Based Syntax and Semantics*. CSLI Lecture Notes 13. 1987.

Pope, E. "Question-Answering Systems" in: *Papers from the Ninth Regional Meeting, Chicago Linguistic Society*, April 13-15, Chicago, 1973, 482-92.

Restan, P. *Sintaksis voprositel'nogo predlozenija*. Universitetsforlaget Oslo - Bergen - Tromsö, Moskau, 1968.

Rohrer, C. "Zur Theorie der Fragesätze" in: *Probleme und Fortschritte der Transformationsgrammatik*. Referate des 4. Linguistischen Kolloquiums, Berlin, 6.-10. Okt. 1969, München 1971.

Schmidt, D. *Entscheidungsfragen mit Negation: semantisch-pragmatische Überlegungen im Rahmen des Situationsschemata-Ansatzes*. Bielefeld, 1991. KI-NRW 91-5.

Schulz, M. *Eine Fragetypologie für NALOG: die linguistische Perspektive und Verarbeitungsgesichtspunkte*. Bielefeld, 1991. KI-NRW 91-6.

Schulz, M. *Forschungsvorhaben NALOG: Erstellen und Verarbeiten von Situationsschemata*. Bielefeld, 1990. KI-NRW 90-14.

Thurmair, M. *Modalpartikeln und ihre Kombinationen*. Tübingen: Niemeyer, 1989.

Vestre, E. J. *Representasjon av direkte spørsmål*. Cand. Scient. thesis. University of Oslo. 1987. (in Norwegian)

Vestre, E. J. and Fenstad, J. E. *Representing Direct Questions*. University of Oslo, Dept. of Mathematics, COSMOS-Report 4, 1988.

AN EFFICIENT DECISION ALGORITHM
FOR FEATURE LOGIC

Esther König*

University of Stuttgart, Institute for Computational Linguistics
Azenbergstr. 12, 7000 Stuttgart 1, Germany
esther@ims.uni-stuttgart.de

Abstract. Feature terms are a common denominator of basic data-structures in knowledge representation and computational linguistics. The adaptation of the usual unification algorithms for first order terms is not straightforward, because feature terms may contain logical disjunction. Expansion into disjunctive normal form would reduce the problem more or less to unification of first order terms. But for reasons of efficiency, rewriting into disjunctive normal form should not be compulsory. In this paper, a sequent calculus is defined which gives a clear formal basis for proof optimizations: inference steps which require more than one subproof, i.e. which lead towards a "disjunctive normal form", are only performed when they are no longer unavoidable. It is shown that the calculus is sound and complete with respect to the so-called feature structure interpretations of feature terms.

1 Introduction

Both in general knowledge representation (e.g. Ait-Kaci/Nasr's LOGIN [2], [1]) and in computational linguistics (e.g. Pollard/Sag [10]), the data-structures for representing the terminological knowledge are usually more complex than first order terms. The main differences are the following

1. the argument positions are labeled with *feature* or *attribute names*
2. the number of arguments of a term is not fixed *(open arity)*
3. the term may contain *disjunction* operators

Terms which have these properties, among others, have been called *feature terms* [12]. The last mentioned property causes the decision problem of feature term consistency to be NP-complete (Kasper [7], Kasper/Rounds [8]). Due to the existence of disjunction, straightforward adaptations of first order unification algorithms are ruled out.

* This research was done while the author was granted a Monbusho-scholarship at Kyoto University. I wish to thank the researchers in Kyoto, in particular Makoto Nagao and Yuji Matsumoto, for the stimulating research environment they provided. I am in debt to Jochen Dörre and to three anonymous reviewers for pointing out deficiencies of an earlier version of this paper. The responsibility for errors resides with me.

The obvious, yet in general inefficient way to circumvent the conceptual difficulty caused by the presence of disjunction is to produce a disjunctive normal form and to handle the individual disjuncts by an adapted algorithm for first order term unification. Variants of this idea have been defined e.g. by Kasper [7], Johnson [6], and Smolka [12]. At least two computation-oriented proposals have been made which offer the possibility of early discovery of inconsistencies (Maxwell/Kaplan [9], and Eisele/Dörre [4]). Both approaches are formulated as systems of rewrite rules. From a theorem proving perspective, however, a system of (unconditional) rewrite rules seems to be too weak to describe disjunction in a conceptually adequate way. A rewrite rule can be seen as an inference rule with only one premise. However, in many logical calculi, the disjunction operator is treated by an inference rule with two premises, i.e. it causes non-trivial ramifications in derivation trees. This gives a basis to investigate the effects of disjunction by manipulating derivation trees as formal objects. Maxwell/Kaplan and Eisele/Dörre compensate for the lack of non-trivial ramifications by annotating the subformulas with indices which roughly reflect the proof branch where a subformula occurs. Thus, the meta-level of proof trees is merged with the object-level of formulas, a fact which does not ease the reasoning concerning further proof heuristics and extensions of the logic.

Improving on a proposal by Wedekind [14], we present a sequent calculus for feature logic. Wedekind represents structure sharing in feature terms by equations of "feature paths". The decision algorithm constructs a closure of those path equations. We avoid such a closure construction by using variables instead. Then Smolka's rules for rewriting non-disjunctive feature terms [13] can be accommodated to the sequent calculus quite easily.

The logic described in this paper is based on a version of a *feature logic* given in Smolka [13]. The logic includes a sort lattice, feature negation based on classical negation, and it admits circular terms[2]. Smolka provided an interpretation of feature terms in the domain of the so-called feature structures.

After the presentation of the syntax and semantic of the feature logic and of a sequent calculus, we prove its soundness and completeness with respect to the feature structure interpretations. Finally, some advantages of the calculus concerning efficient implementations are discussed.

2 Feature terms

Subsequently, the syntax and semantics of feature terms are defined. We adapt Smolka's definitions [12] in a way to come close to the textbook presentation of a deduction system for classical logic given by Fitting [5].

2.1 Syntax

First, we have to define the basic symbols, which are features and sorts, and the basic relation of subsort ordering.

[2] Smolka's full logic also includes existential quantification.

Definition 1. A *signature* has two components:

- a set **S** of *sort symbols* a, b, c (which includes the symbols ⊤ and ⊥) with the following characteristics
 - a subset **C** of **S** is called the set of *singleton sorts*
 - There is a decidable partial order ≤ on **S** with ⊥ and ⊤ the least and the greatest element, respectively. The *greatest common subsort* gcs of two sorts always exists as an element of **S**. Only ⊥ may be smaller than a singleton sort.
- a set **F** of *feature symbols* f, g

Furthermore, the symbols to construct feature terms include a set **V** of variables x, y, z and the logical connectives ¬, ∧, and ∨. The sets **S**, **F**, and **V** are disjoint.

The set of feature terms is defined by two context-free rules. A feature term is a variable which is possibly annotated with an *expression* e. In other words, every expression is attached to a location, i.e. to a variable.

Definition 2. The set of *feature terms t* (short: *terms*) is described by the rules

$$t \longrightarrow x \mid x[e] \qquad x \in \mathbf{V}$$

$$
\begin{array}{llll}
e \longrightarrow & x & x \in \mathbf{V} & \text{variable} \\
& \mid a & a \in \mathbf{S} & \text{sort symbol} \\
& \mid f : t & f \in \mathbf{F} & \text{selection} \\
& \mid \neg f : \top & f \in \mathbf{F} & \text{illegal feature} \\
& \mid \neg e & & \text{negation} \\
& \mid e_1 \wedge e_2 & & \text{conjunction} \\
& \mid e_1 \vee e_2 & & \text{disjunction}
\end{array}
$$

In this syntax, the inequation $x \not\doteq y$ is expressed by the term $x[\neg y]$. We may write $[e]$ instead of $x[e]$ if the variable x occurs only once in the whole term.

Example 1. Feature term

$$
x_0
\begin{bmatrix}
person & & & \wedge \\
sex & : (female \vee male) & & \wedge \\
mother : x_1 & \begin{bmatrix} person & \wedge \\ sex : female \end{bmatrix} & \wedge \\
father : x_2 & \begin{bmatrix} person & \wedge \\ sex : male \end{bmatrix} & \wedge \\
parent : (x_1 \vee x_2) & & \wedge \\
\neg(roof_shape : \top) &
\end{bmatrix}
$$

This example looks very similar to an example given in Ait-Kaci [1] but here it is not meant as a (recursive) definition of a *person*-data type. The symbol *person* is just a pointer into the sort lattice, not to a piece of code.

Definition 3. An expression e is *normal* if it is one of the following ($a \in \mathbf{S}$)

$$a \quad \neg a \quad \neg x \quad f : x \quad \neg(f : x) \quad \neg(f : \top)$$

A set T of feature terms is *normal* if all its expressions are normal and

1. $x[\neg\bot] \notin T$, $x[\neg\top] \notin T$, $x[\neg x] \notin T$
2. for $a \neq b$, not both $x[a] \in T$ and $x[b] \in T$
3. for $a \leq b$, not both $x[a] \in T$ and $x[\neg b] \in T$
4. for $a \in C$, not both $x[a] \in T$ and $x[f : y] \in T$
5. not both $x[f : y] \in T$ and $x[\neg(f : \top)] \in T$
6. for $y \neq z$, not both $x[f : y] \in T$ and $x[f : z] \in T$

A normal set of *positive* feature terms does neither include the term $x[\bot]$ nor any negative terms, i.e. terms with the shape $x[\neg e]$.

Example 2. Normal set of positive feature terms

$$
\left\{
\begin{array}{lll}
x_0[person], & & \\
x_0[sex : x_1], & x_1[female], & \\
x_0[mother : x_2], & x_2[person], & \\
& x_2[sex : x_3], & x_3[female] \\
x_0[father : x_4], & x_4[person], & \\
& x_4[sex : x_5], & x_5[male], \\
x_0[parent : x_2] & &
\end{array}
\right\}
$$

2.2 Semantics

Now we provide the syntactic components with their semantic counterparts.

Definition 4. An *interpretation* **I** for the language of feature terms **T** in a universe **U** performs the following mapping:

1. If $a \in S$ then $a^{\mathbf{I}} \subseteq \mathbf{U}$ (Every sort symbol is mapped on a set).
 (a) $\top^{\mathbf{I}} = \mathbf{U}$
 (b) $\bot^{\mathbf{I}} = \{\}$
 (c) If $a \in C$ then $|a^{\mathbf{I}}| = 1$
 (Every singleton sort is mapped on a singleton set).
 (d) If $gcs(a, b) = c$ then $c^{\mathbf{I}} = a^{\mathbf{I}} \cap b^{\mathbf{I}}$ (The intersection of the interpretations of two sorts a and b corresponds to their greatest common subsort c).
2. If $f \in F$ then $f^{\mathbf{I}}$ is a function $\mathbf{U}' \to \mathbf{U}$ where $\mathbf{U}' \subseteq \mathbf{U} \setminus \{a^{\mathbf{I}} \,|\, a \in C\}$ (Features are mapped on functions. The restriction on the domain of the function ensures that singleton sorts be not associated with features).

Definition 5. A *feature structure* is a subset T_x of a normal set of positive feature terms T constructed by the following function: (Start with "root" variable x, let $T' := T$ and $T_x := \{\}$.)

1. if there are no feature terms in T' for the variable x then return T_x
2. else pick a feature term $x[e]$ from T', let $T' := T' - \{x[e]\}$, T'_x be the subset of T' constructed for the remaining terms for x, return $T_x := T_x \cup \{x[e]\} \cup T_y \cup T'_x$ where
 (a) if $e = a$ then $T_y := \{\}$

(b) if $e = f : y$ then T_y is the subset of T' constructed by this function starting with root variable y

A feature structure can be seen as a rooted, directed graph: The variables are interpreted as *node* labels, and the features as labels of directed *edges*. Sort symbols are additional node labels. Feature structures are defined modulo renaming of variables.

Definition 6. Feature structure interpretation

1. the universe \mathbf{U} is the set of feature structures,
2. the interpretation \mathbf{I} is specialized in the following way:
 (a) $a^{\mathbf{I}} = \{T_x \in \mathbf{U} \mid \exists\, x[b] \in T_x \text{ and } b \leq a\}$ (A sort symbol is mapped on the set of feature structures whose roots are labeled with that sort or a smaller sort).
 (b) $f^{\mathbf{I}}(T_x) = T_y$ if $x[f : y] \in T_x$ (The value of a feature is the subgraph the feature points at).

An *assignment* \mathbf{A} in an interpretation \mathbf{I} with universe \mathbf{U} is a mapping from the set \mathbf{V} of variables to \mathbf{U}. The image of a variable x under an assignment \mathbf{A} is written $x^{\mathbf{A}}$.

Definition 7. Denotation of a feature term in an interpretation \mathbf{I} for an assignment \mathbf{A}.

1. $\lceil x[e] \rceil^{\mathbf{I},\mathbf{A}} = \{x^{\mathbf{A}} \mid x^{\mathbf{A}} \in \lceil e \rceil^{\mathbf{I},\mathbf{A}}\}$
2. $\lceil x \rceil^{\mathbf{I},\mathbf{A}} = \{x^{\mathbf{A}}\}$
3. $\lceil a \rceil^{\mathbf{I},\mathbf{A}} = a^{\mathbf{I}}$
4. $\lceil f : t \rceil^{\mathbf{I},\mathbf{A}} = \{a \in \mathbf{U} \mid f^{\mathbf{I}}(a) \in \lceil t \rceil^{\mathbf{I},\mathbf{A}}\}$
5. $\lceil \neg e \rceil^{\mathbf{I},\mathbf{A}} = \mathbf{U} - \lceil e \rceil^{\mathbf{I},\mathbf{A}}$
6. $\lceil e_1 \wedge e_2 \rceil^{\mathbf{I},\mathbf{A}} = \lceil e_1 \rceil^{\mathbf{I},\mathbf{A}} \cap \lceil e_2 \rceil^{\mathbf{I},\mathbf{A}}$
7. $\lceil e_1 \vee e_2 \rceil^{\mathbf{I},\mathbf{A}} = \lceil e_1 \rceil^{\mathbf{I},\mathbf{A}} \cup \lceil e_2 \rceil^{\mathbf{I},\mathbf{A}}$

A term t is *valid* if $\lceil t \rceil^{\mathbf{I},\mathbf{A}} \neq \{\}$ for all interpretations \mathbf{I} and for all assignments \mathbf{A}. A set T of feature terms is *satisfiable in an interpretation* \mathbf{I} provided that there is some assignment \mathbf{A} such that $\lceil t \rceil^{\mathbf{I},\mathbf{A}} \neq \{\}$ for all $t \in T$. The set T is *satisfiable* if it is satisfiable in some interpretation.

3 A calculus

Figure 1 shows a sequent calculus. A *sequent* is a set of feature terms whose positive terms are separated from the negative ones (written without their negation signs) by the symbol \rightarrow. The notation $[x/y](T_1 \rightarrow T_2)$ means that x is replaced for y throughout the sequent $T_1 \rightarrow T_2$. For our purposes, a sequent *derivation* is produced by applying inference rules in a "backward manner", i.e. starting

from the conclusion. A derivation is called a *proof* if all its leaves are labeled with instances of the axiom scheme l⊥.

The rules in figure 1 look numerous, but one has to consider the fact that this calculus combines the four modules of Smolka's rewrite system: the rules for negation normal form and disjunctive normal form, the decomposition into pre-normal form, and the final reduction to normal feature terms.

$$\frac{}{x[\bot],\, T_1 \to T_2}\mathrm{l}\bot \qquad\qquad \frac{x[\top],\, T_1 \to T_2}{T_1 \to T_2,\, x[\bot]}\mathrm{r}\bot$$

$$\frac{[z/y](x[f:y],\, T_1 \to T_2)}{x[f:y],\, x[f:z],\, T_1 \to T_2}\mathrm{l}ff \qquad\qquad \frac{x[\bot] \to}{T_1 \to T_2,\, x[\top]}\mathrm{r}\top$$

$$\frac{[x/y](T_1 \to T_2)}{x[y],\, T_1 \to T_2}\mathrm{l}x \qquad\qquad \frac{x[\bot] \to}{T_1 \to T_2,\, x[x]}\mathrm{r}x$$

$$\frac{x[\mathrm{gcs}(a,b)],\, T_1 \to T_2}{x[a],\, x[b],\, T_1 \to T_2}\mathrm{l}a \qquad\qquad \frac{a<b \qquad x[\bot] \to}{x[a],\, T_1 \to T_2,\, x[b]}\mathrm{r}a$$

$$\frac{a \in \mathbf{C} \qquad x[\bot] \to}{x[a],\, x[f:y],\, T_1 \to T_2}\mathrm{l}f\bot \qquad\qquad \frac{x[\bot] \to}{x[f:y],\, T_1 \to T_2,\, x[f:\top]}\mathrm{r}f\bot$$

$$\frac{x[f:y],\, y[e],\, T_1 \to T_2}{x[f:y[e]],\, T_1 \to T_2}\mathrm{l}f \qquad\qquad \frac{T_1 \to T_2,\, x[f:\top] \qquad x[f:y],\, T_1 \to T_2,\, y[e]}{T_1 \to T_2,\, x[f:y[e]]}\mathrm{r}f$$

$$\frac{T_1 \to T_2,\, x[e]}{x[\neg e],\, T_1 \to T_2}\mathrm{l}\neg \qquad\qquad \frac{x[e],\, T_1 \to T_2}{T_1 \to T_2,\, x[\neg e]}\mathrm{r}\neg$$

$$\frac{x[e_1],\, x[e_2],\, T_1 \to T_2}{x[e_1 \wedge e_2],\, T_1 \to T_2}\mathrm{l}\wedge \qquad\qquad \frac{T_1 \to T_2,\, x[e_1] \qquad T_1 \to T_2,\, x[e_2]}{T_1 \to T_2,\, x[e_1 \wedge e_2]}\mathrm{r}\wedge$$

$$\frac{x[e_1],\, T_1 \to T_2 \qquad x[e_2],\, T_1 \to T_2}{x[e_1 \vee e_2],\, T_1 \to T_2}\mathrm{l}\vee \qquad\qquad \frac{T_1 \to T_2,\, x[e_1],\, x[e_2]}{T_1 \to T_2,\, x[e_1 \vee e_2]}\mathrm{r}\vee$$

Fig. 1. A calculus for feature term insatisfiability

3.1 Soundness

As usual, we say that a leaf of a derivation is *satisfiable* if the set of terms on it is satisfiable. A derivation d is satisfiable if at least one branch of d is satisfiable.

Proposition 8. Any application of an inference rule to a satisfiable derivation yields another satisfiable derivation.

Proof. Suppose derivation d is satisfiable in an interpretation **I** under an assignment **A**, and an application of an inference rule to leaf l_i produces a derivation d'. Since d is satisfiable, d has at least one satisfiable leaf l_j. If $i \neq j$, then l_j is a leaf of d', hence d' is satisfiable. Otherwise, if $i = j$:

Rule $r\perp$. $\lceil x[\neg\perp]\rceil^{\mathbf{I},\mathbf{A}} = \{x^{\mathbf{A}} \mid x^{\mathbf{A}} \in \lceil\neg\perp\rceil^{\mathbf{I},\mathbf{A}}\} = \{x^{\mathbf{A}} \mid x^{\mathbf{A}} \in \mathbf{U}\} = \lceil x[\top]\rceil^{\mathbf{I},\mathbf{A}}$

Rule lx. Since $\lceil x[y]\rceil^{\mathbf{I},\mathbf{A}} = \{x^{\mathbf{A}} \mid x^{\mathbf{A}} \in \lceil y\rceil^{\mathbf{I},\mathbf{A}}\} \neq \{\}$, also $\lceil y\rceil^{\mathbf{I},\mathbf{A}} \neq \{\}$.

Rule la. Since $\lceil x[a]\rceil^{\mathbf{I},\mathbf{A}} = \{x^{\mathbf{A}} \mid x^{\mathbf{A}} \in \lceil a\rceil^{\mathbf{I},\mathbf{A}}\} \neq \{\}$ and $\lceil x[b]\rceil^{\mathbf{I},\mathbf{A}} = \{x^{\mathbf{A}} \mid x^{\mathbf{A}} \in \lceil b\rceil^{\mathbf{I},\mathbf{A}}\} \neq \{\}$ it holds that $\lceil a\rceil^{\mathbf{I},\mathbf{A}} \cap \lceil b\rceil^{\mathbf{I},\mathbf{A}} \neq \{\}$.

Rule lff. Since $\lceil x[f : y]\rceil^{\mathbf{I},\mathbf{A}} = \{x^{\mathbf{A}} \mid x^{\mathbf{A}} \in \lceil f : y\rceil^{\mathbf{I},\mathbf{A}}\} \neq \{\}$ and $\lceil x[f : z]\rceil^{\mathbf{I},\mathbf{A}} = \{x^{\mathbf{A}} \mid x^{\mathbf{A}} \in \lceil f : z\rceil^{\mathbf{I},\mathbf{A}}\} \neq \{\}$ it must be the case that $\lceil y\rceil^{\mathbf{I},\mathbf{A}} = \lceil z\rceil^{\mathbf{I},\mathbf{A}} \neq \{\}$.

Rule lf. Since $\lceil f : y[e]\rceil^{\mathbf{I},\mathbf{A}} \neq \{\}$, also $\lceil y[e]\rceil^{\mathbf{I},\mathbf{A}} \neq \{\}$.

Rule rf. $\lceil\neg f : y[e]\rceil^{\mathbf{I},\mathbf{A}} = \mathbf{U} - \{a \in \mathbf{U} \mid f^{\mathbf{I}}(a) \in \lceil y[e]\rceil^{\mathbf{I},\mathbf{A}}\} =$
$\mathbf{U} - \{a \in \mathbf{U} \mid (f^{\mathbf{I}}(a) \in \lceil\top\rceil^{\mathbf{I},\mathbf{A}}) \wedge (f^{\mathbf{I}}(a) \in \lceil y[e]\rceil^{\mathbf{I},\mathbf{A}})\} =$
$(\mathbf{U} - \{a \in \mathbf{U} \mid f^{\mathbf{I}}(a) \in \lceil\top\rceil^{\mathbf{I},\mathbf{A}}\}) \cup (\mathbf{U} - \{a \in \mathbf{U} \mid f^{\mathbf{I}}(a) \notin (\mathbf{U} - \lceil y[e]\rceil^{\mathbf{I},\mathbf{A}})\})$
$= (\mathbf{U} - \{a \in \mathbf{U} \mid f^{\mathbf{I}}(a) \in \lceil\top\rceil^{\mathbf{I},\mathbf{A}}\}) \cup \{a \in \mathbf{U} \mid f^{\mathbf{I}}(a) \in (\mathbf{U} - \lceil y[e]\rceil^{\mathbf{I},\mathbf{A}})\} =$
$(\mathbf{U} - \{a \in \mathbf{U} \mid f^{\mathbf{I}}(a) \in \lceil\top\rceil^{\mathbf{I},\mathbf{A}}\}) \cup \{a \in \mathbf{U} \mid f^{\mathbf{I}}(a) \in \{y^{\mathbf{A}} \mid y^{\mathbf{A}} \in \lceil\neg e\rceil^{\mathbf{I},\mathbf{A}}\}\}$
$= \lceil\neg f : \top\rceil^{\mathbf{I},\mathbf{A}} \cup \lceil f : y[\neg e]\rceil^{\mathbf{I},\mathbf{A}}$

Rules $l\neg$ **and** $r\neg$. Clear.

Rule $l\wedge$. Since $\lceil (e_1 \wedge e_2)\rceil^{\mathbf{I},\mathbf{A}} = \lceil e_1\rceil^{\mathbf{I},\mathbf{A}} \cap \lceil e_2\rceil^{\mathbf{I},\mathbf{A}} \neq \{\}$, neither $\lceil e_1\rceil^{\mathbf{I},\mathbf{A}} = \{\}$ nor $\lceil e_2\rceil^{\mathbf{I},\mathbf{A}} = \{\}$. Analogously for rule $r\vee$ with main term $\neg(e_1 \vee e_2) = \neg e_1 \wedge \neg e_2$.

Rule $l\vee$. Since $\lceil (e_1 \vee e_2)\rceil^{\mathbf{I},\mathbf{A}} = \lceil e_1\rceil^{\mathbf{I},\mathbf{A}} \cup \lceil e_2\rceil^{\mathbf{I},\mathbf{A}} \neq \{\}$, not both $\lceil e_1\rceil^{\mathbf{I},\mathbf{A}} = \{\}$ and $\lceil e_2\rceil^{\mathbf{I},\mathbf{A}} = \{\}$. Hence, at least one of the new leaves is satisfiable. Analogously for rule $r\wedge$ with main term $\neg(e_1 \wedge e_2) = \neg e_1 \vee \neg e_2$. \square

Theorem 9. *Soundness.* If $\rightarrow x[e]$ has a proof, then $x[e]$ is valid.

Proof. Suppose that the sequent $\rightarrow x[e]$ has a proof d but $x[e]$ is not valid. Since $x[e]$ is not valid there is an interpretation \mathbf{I} and an assignment \mathbf{A} in which $\lceil x[\neg e]\rceil^{\mathbf{I},\mathbf{A}} \neq \{\}$. Hence, the single node derivation $\rightarrow x[e]$ is satisfiable. According to proposition 8, its final derivation is satisfiable, as well. But this contradicts the assumption that d is a proof. \square

3.2 Completeness

For the termination proof we need an appropriate measure for the size of terms.

Definition 10. The *rank* $r(t)$ a feature term t is defined as follows:

1. $r(x[y]) = r(x[a]) = r(x[f : y]) = r(x[f : \top]) = 1$
2. $r(x[f : y[e]]) = r(x[f : y]) + r(y[e]) + 1$
3. $r(x[\neg e] = r(x[e]) + 1$
4. $r(x[e_1 \wedge e_2]) = r(x[e_1 \vee e_2]) = r(x[e_1]) + r(x[e_1]) + 1$

The rank of a set of feature terms is the sum of the ranks of the individual terms.

Lemma 11. The construction of a derivation will always terminate.

Proof. It is easy to check that each inference rule decreases the rank of the set of feature terms. □

Proposition 12. For every set of feature terms which is not normal an inference rule applies.

Lemma 13. For every derivation d, one can construct a derivation d' whose leaves are normal.

Proof. A single non-normal leaf can always be replaced by one or two new leaves according to proposition 12. From lemma 11 we know that there will be only a finite series of such replacements. □

Theorem 14. (Smolka [12]) A normal set T of feature terms which does not contain the inconsistent term $x[\bot]$ is satisfiable.

Proof. We show that there is a (feature structure) interpretation I where each variable x is assigned a feature structure T_x, and where none of the $\lceil t \rceil^{I,A}$, $t \in T$, is empty.

$x[a] \in T$. For this positive term, $x[a] \in T_x$. Hence $x^A \in a^I$.

$x[\neg a] \in T$. Suppose $x^A = T_x \in a^I$. But then $x[b] \in T$ for some b, $b \leq a$. This contradicts the fact that T is normal.

$x[\neg y] \in T$. Suppose $x^A = T_x$ and $y^A = T_y$ with $T_x = T_y$. This would mean that $x[y] \in T$ which has been ruled out.

$x[f : y] \in T$. Hence $f^I(x^A) = f^I(T_x) = T_y = y^A$.

$x[\neg f : \top] \in T$. Suppose f^I is defined on $x^A = T_x$. But then $x[f : z] \in T$ which contradicts the normal form property. □

Theorem 15. *Completeness.* If a feature term $x[e]$ is valid, then there is a proof for the sequent $\rightarrow x[e]$.

Proof. Assume, there is no proof for the sequent $\rightarrow x[e]$. From lemma 13, we know that the sequent possesses a derivation with normal leaves. Since the derivation is no proof, one of its leaves does not contain the term $z[\bot]$ and hence qualifies for being satisfiable according to theorem 14. This means that $x[\neg e]$ is satisfiable and $x[e]$ would not be valid. □

4 Implementation aspects

4.1 Avoiding disjunctive normal form

The main goal of setting up this calculus was to offer chances to avoid the expansion into disjunctive normal form and the redundant work it involves.

In the calculus, proof tree redundancies of the following kind exist:

$$\frac{\dfrac{\dfrac{}{y[\bot] \to}\text{l}\bot}{x[t_1], \ y[a], \ y[f:z], \ T_1 \to T_2}\text{l}f\bot \quad \dfrac{\dfrac{}{y[\bot] \to}\text{l}\bot}{x[t_2], \ y[a], \ y[f:z], \ T_1 \to T_2}\text{l}f\bot}{x[t_1 \vee t_2], \ y[a], \ y[f:z], \ T_1 \to T_2}\text{l}\vee \qquad (1)$$

permutes with

$$\frac{\dfrac{}{y[\bot] \to}\text{l}\bot}{x[t_1 \vee t_2], \ y[a], \ y[f:z], \ T_1 \to T_2}\text{l}f\bot \qquad (2)$$

Since there are no dependencies among reduction steps, one may choose the smaller proof tree which is obtained by favoring the rules which lead immediately to failure detection or increase such chances: $\text{r}\top$, $\text{r}x$, $\text{l}a$, $\text{r}a$, $\text{l}f\bot$, $\text{r}f\bot$, and $\text{r}\bot$, $\text{l}x$, $\text{l}ff$.

4.2 Structure sharing

In the rules l\vee and r\wedge, copies of the terms in the sets T_1 and T_2 must be provided which can be manipulated independently in each branch. However, actual copying can be avoided because the common trick of not carrying out variable substitutions but saving them as an "environment" works here, as well (cf. Boyer/Moore [3]). The list of variable renamings which have been produced along a branch constitutes such a binding environment. Then a sequent is represented as a pair consisting of a list of pointers to terms and an environment. The inference rules which affect a pair of terms have to be amended by an appropriate variable dereferencing mechanism. Different branches mean different environments. It is important not to take each feature term $x[t]$ as a substitution instruction, since this will compromise the clear division between the unification algorithm, i.e. the calculus, and the substitution mechanism.

4.3 Various optimizations

The calculus in figure 1 has been kept as simple as possible in order not to complicate the proofs of soundness and completeness. But the actual implementation of the theorem prover is based on an optimized version of the calculus and the underlying data-structures.

Compile reoccurring rule sequences into single rules Some obligatory sequences of rule applications might be compiled into single rules in order to make derivations somewhat shorter. For example, use the rule

$$\frac{[z/y](x[f:y], \ y[e_1], \ z[e_2], \ T_1 \to T_2)}{x[f:y[e_1]], \ x[f:z[e_2]], \ T_1 \to T_2}\text{l}f' \qquad (3)$$

to replace the following part of a derivation:

$$\cfrac{\cfrac{\cfrac{[z/y](x[f:y],\ y[e_1],\ z[e_2],\ T_1 \rightarrow T_2)}{x[f:y],\ y[e_1],\ x[f:z],\ z[e_2],\ T_1 \rightarrow T_2}\text{l}ff}{x[f:y],\ y[e_1],\ x[f:z[e_2]],\ T_1 \rightarrow T_2}\text{l}f}{x[f:y[e_1]],\ x[f:z[e_2]],\ T_1 \rightarrow T_2}\text{l}f \tag{4}$$

Long series of applications of the "term decomposition rules" $\text{l}f$, $\text{r}f$, $\text{l}\wedge$, and $\text{r}\vee$ are avoided if the syntax of feature terms is slightly extended by permitting sets of terms inside disjunctions: $e \longrightarrow T_1 \vee T_2$. Accordingly, the calculus has to include the rule:

$$\frac{T_3,\ T_1 \rightarrow T_2 \qquad T_4,\ T_1 \rightarrow T_2}{x[T_3 \vee T_4],\ T_1 \rightarrow T_2}\text{l}T\vee \tag{5}$$

Preprocessing of terms Processing speed can be increased drastically if certain redundancies have been removed from the input terms, e.g. by applying appropriate versions of the tautology

$$(a \wedge b) \vee (a \wedge c) \equiv a \wedge (b \vee c) \tag{6}$$

The example shows a term before and after the removal of redundant subterms (sets of feature terms are marked by curly brackets).

Example 3. Compressing a term

Original term:

$$x\begin{bmatrix} \{\,x[pred:y],\ y[leave], \\ \quad x[postp:z],\ z[kara]\,\} \\ \vee \\ \{\,x[pred:y],\ y[attend], \\ \quad x[postp:z],\ z[ni]\,\} \end{bmatrix}$$

Compressed version:

$$\left\{ \begin{array}{l} x[pred:y], \\ x[postp:z], \\ x\begin{bmatrix} \{\,y[leave],\ z[kara]\,\} \\ \vee \\ \{\,y[attend],\ z[ni]\,\} \end{bmatrix} \end{array} \right\}$$

Control the search for reducible terms In order to control the search for reducible terms, it is better to replace the sequent format, i.e. the separation into sets of positive and negative terms, by a separation into sets of "active" and "passive" terms T_1, T_2 respectively: $T_1 \bullet T_2$. Initially, all terms are "active". A term has to move to the passive side if it cannot serve as the main term of any rule:

$$\frac{T_1 \bullet T_2,\ t}{t,\ T_1 \bullet T_2}\bullet m \quad \text{if no rule applicable with } t \text{ as main term} \tag{7}$$

The inference rules have to be adapted to this new representation. For example, the rule $\text{l}\wedge$ which reduces a single term has to be redefined in the following manner:

$$\frac{x[e_1],\ x[e_2],\ T_1 \bullet T_2}{x[e_1 \wedge e_2],\ T_1 \bullet T_2}\bullet\text{l}\wedge \tag{8}$$

The rule $\text{l}\vee$ now has the shape:

$$\frac{x[e_1],\ T_1 \bullet T_2 \qquad x[e_2],\ T_1 \bullet T_2}{x[e_1 \vee e_2],\ T_1 \bullet T_2}\bullet\text{l}\vee \tag{9}$$

A rule which reduces a pair of positive terms has to be replaced by two rules:

$$\frac{x[f:y],\; z[y],\; T_1 \bullet T_2}{x[f:y],\; x[f:z],\; T_1 \bullet T_2}\bullet \mathrm{lf}f_1 \qquad \frac{x[f:y],\; z[y],\; T_1 \bullet T_2}{x[f:y],\; T_1 \bullet T_2,\; x[f:z]}\bullet \mathrm{lf}f_2 \quad (10)$$

And a rule which reduces a positive and a negative term corresponds to three rules in the new notation.

The construction of a branch terminates either with an instance of the axiom scheme or with an empty set of active terms

$$\frac{}{x[\bot],\; T_1 \bullet T_2}\bullet \mathrm{l}\bot \qquad\qquad \frac{}{\bullet T}\bullet n \qquad\qquad (11)$$

4.4 A unification algorithm

In order to use the calculus as an algorithm for the unification of two terms $x[e_1]$ and $y[e_2]$, produce a derivation d for $[y/x](\rightarrow x[\neg(e_1 \wedge e_2)])$. If all leaves of d are labeled with axioms then unification failed. Otherwise, the disjunction of the non-axiom leaves is the result.

Example 4. Unification of two terms

$$\cfrac{x[friday:y],\; y[14h] \rightarrow y[16h] \quad \cfrac{\cfrac{}{y[\bot] \rightarrow}\mathrm{l}\bot}{x[friday:y],\; y[16h] \rightarrow y[16h]}\mathrm{la}}{\cfrac{x[friday:y],\; y[14h \vee 16h] \rightarrow y[16h]}{x[friday:y[14h \vee 16h]],\; x[friday:z[\neg 16h]] \rightarrow}\mathrm{lf}'}\mathrm{l}\vee$$

$$\Uparrow$$

$$x[friday:(14h \vee 16h)] \quad x'[friday:\neg 16h]$$

5 Conclusion

An abstract decision algorithm for checking the inconsistency of (disjunctive) feature terms has been presented in the shape of a sequent calculus. This format allowed for optimizations on the proof-theoretic level before the actual implementation was carried out and questions concerning the calculus possibly would have been obscured by problems which are specific to the programming language.

Besides the means to delay the expansion steps for disjunctive normal form either until they become superfluous or until there are no other applicable inference steps, big increases of the efficiency were obtained by using preprocessed compressed terms, i.e. terms where disjunctions do not contain information represented elsewhere. Since the latter kind of optimization relies on the presence of variables, representations of the same compactness do not seem feasible for the sequent calculus given by Wedekind [14] which permits only feature paths but no variables. The method for compressing terms is reminiscent of the treatment of terms in the work of Eisele and Dörre, although the potential for fine-grained optimizations in their system has to be compared in more detail with what has been suggested here.

References

1. Hassan Ait-Kaci. An algebraic semantics approach to the effective resolution of type equations. *Theoretical Computer Science*, 45:293–351, 1986.
2. Hassan Ait-Kaci and Roger Nasr. LOGIN: A logic programming language with built-in inheritance. *Journal of Logic Programming*, 3:185–215, 1986.
3. R.S. Boyer and J.S. Moore. The sharing of structure in theorem proving programs. *Machine Intelligence*, 7:101–116, 1972.
4. Andreas Eisele and Jochen Dörre. Disjunctive unification. Report 124, Institute for Knowledge Based Systems, IBM Germany Science Center, Stuttgart, Baden-Württemberg, 1990.
5. Melvin Fitting. *First-Order Logic and Automated Theorem Proving*. Springer, New York, 1990.
6. Mark Johnson. *Attribute-Value Logic and the Theory of Grammar*, volume 16 of *CSLI Lecture Notes*. Center for the Study of Language and Information, Stanford, Ca., 1988.
7. Robert T. Kasper. *Feature Structures: A Logical Theory with Application to Language Analysis*. PhD thesis, University of Michigan, Ann Arbor, Michigan, 1987.
8. Robert T. Kasper and William C. Rounds. The logic of unification in grammar. *Linguistics and Philosophy*, 13:35–58, 1990.
9. John T. Maxwell III and Ronald M. Kaplan. An overview of disjunctive constraint satisfaction. In *Proceedings of the International Workshop on Parsing Technologies*, pages 18–27, Pittsburgh, PA, 1989.
10. Carl Pollard and Ivan Sag. *An Information-Based Syntax and Semantics. I. Fundamentals*, volume 13 of *Lecture Notes*. Center for Study of Language and Information, Stanford, Ca., 1987.
11. Stuart M. Shieber. *An Introduction to Unification-Based Approaches to Grammar*. Lecture Notes. Center for the Study of Language and Information, Stanford, Ca., 1986.
12. Gert Smolka. A feature logic with subsorts. Technical Report 33, IBM Deutschland, Institute for Knowledge-Based Systems, Stuttgart, Baden-Württemberg, 1988. To appear in Journal of Automated Reasoning.
13. Gert Smolka. Feature constraint logics for unification grammars. Technical Report 93, IBM Deutschland, Institute for Knowledge-Based Systems, Stuttgart, Baden-Württemberg, 1989.
14. Jürgen Wedekind. *Unifikationsgrammatiken und ihre Logik*. PhD thesis, Universität Stuttgart, Stuttgart, Baden-Württemberg, 1990. Sonderforschungsbereich 340, Bericht 8-1991.

Universally Quantified Queries in Languages with Order-Sorted Logics

Stefan Decker <sdecker@informatik.uni-kl.de>
Christoph Lingenfelder <lingenf@dhdibm1.bitnet>
IBM Deutschland GmbH
Postfach 10 30 68, D-6900 Heidelberg 1

Abstract

In many applications of Knowledge-Based Systems or deductive databases the user wants to be able to check whether a certain property $P(x)$ holds globally, i.e. whether it can be derived for all the individuals in the data base. Normally knowledge representation systems or logic programming systems cannot answer such requests. In this paper we show that the taxonomy of classes available in standard knowledge representation languages allows to solve this kind of query by dividing the proof into several cases according to the subsort structure present in the knowledge base.

1 Introduction

When working with Knowledge-Based Systems or deductive databases it is often necessary to test for certain global properties of the knowledge base. This corresponds to answering a query of the form $\forall x Px$. As an example consider the following simple form of the "four-eyes-principle" of access control described in more detail in the example of section 4:

Every important file must be readable by at least two distinct people.

In order to find out whether this property holds globally the user would like to obtain an answer to the corresponding universally quantified query. Queries of this type can not normally be dealt with by knowledge representation languages or logic programming systems. And full-fledged automatic theorem provers cannot handle such a request in the light of the domain closure assumption, but adhere to the classical interpretation of universally quantified formulae.

On the other hand most applications describe classes of individuals with finite – though often very large – domains. This is usually taken into account by adopting a different semantic framework, i.e. some form of domain closure assumption, but often it is not feasible to prove the queries by case analysis because too many cases must be checked.

Mancarella et al. [5] have introduced the notion of *term covering* based on *anti-instances* defined by Lassez et al. in [3], which works very well in the area of data structures, where all the members of a set can be constructed by the application of a small number of generating operators (or functions).

In this paper we will exploit the taxonomy inherent in most knowledge representation languages, as for instance in KL-ONE in order to reduce the number of cases that must be checked to obtain a complete proof of a universally quantified query. For this purpose we do not want to construct a new inference engine for a knowledge representation system, but rather want to make it possible to use an existing one unchanged.

2 Domain Closure Assumption in Sorted Logic

In this paper we will use standard first order logic. There are no differences from the usual way to define these concepts as done for instance in [1] or [4].

2.1 Order Sorted Logic

As an extension to standard first order logic we only assume the addition of sorts. As in most knowledge representation languages this means a taxonomy of classes, hierarchically structured as a lattice with maximal and minimal element. We can therefore compute the least upper bound of two sorts $(S_1 \sqcup S_2)$ and their greatest lower bound $(S_1 \sqcap S_2)$. This induces a partial ordering \leq on the sorts in the usual way.

Definition 2.1 *A sort S is called a* subsort *of a sort T, $S \leq T$, if $S \sqcap T = S$ holds in the sort lattice. A sort S is called a* direct subsort *of a sort T, $S \sqsubset T$, if $S \leq T$ and for any sort S' with $S \leq S' \leq T$, $S' = S$, or $S' = T$.*

Constants and variables always belong to a given sort. If this sort is not clear from the context we add the sort name as an index to the constant or variable as in $P(c_S)$ or $\forall x_S P(x)$. The fact that c belongs to S is written $c \in S$.

Throughout the paper we use capital letters S, T, \ldots to indicate sorts, x, y, z, \ldots for variables, t for terms, and c, d, \ldots as constants.

The semantics of a sort is reflected by a subset of the universe. Then $S_1 \sqcup S_2$ corresponds to the union of the interpretations of S_1 and S_2, and similarly $S_1 \sqcap S_2$ represents an intersection. $S_1 \leq S_2$ means that the interpretation of S_1 is a subset of the interpretation of S_2. Therefore $c \in S_1$ and $S_1 \leq S_2$ implies $c \in S_2$. For details see for instance [8].

Definition 2.2 *A constant c is called a* direct constant *of a sort S, if $c \in S$ and $S \leq S'$ for any sort S' with $c \in S'$. The set of all direct constants of a sort S is denoted by $dc(S)$.*

2.2 Domain Closure Assumption

The extension, i.e. the set of all elements of a sort is potentially infinite, but most real, non-mathematical applications describe classes of individuals with finite, though often very large domains.

Definition 2.3 *The* (strong) domain closure assumption *asserts that all the finitely many individuals of a given sort are known in advance. This can be described by the following additional axioms for the sorts $S = \{c_1, c_2, \ldots, c_n\}$:*

$$\forall x_S (x = c_1) \vee (x = c_2) \vee \ldots \vee (x = c_n) \qquad dca(S)$$

However, we do not want to adopt the strong domain closure assumption under all circumstances. An axiom of the form $\forall x_S P(x)$ is usually understood in the classical sense, as a generic statement for the sort S, holding for all potential members of S, even those that might be defined later. But we want to allow two different types of queries, with or without the domain closure assumption. To make this distinction we use \bigwedge as the universal quantifier whenever the domain closure assumption shall hold. So the formula $\bigwedge x_S P(x)$ is equivalent to the classical formula $dca(S) \Rightarrow \forall x_S P(x)$.

This means in fact to add the domain closure assumption temporally as an axiom, similar to adding an axiom A when $A \Rightarrow G$ has been asked for, cf. [6]. In the presence of the domain closure assumption the proof of a universally quantified theorem can obviously be done as a proof by case analysis, using as cases the disjuncts of $dca(S)$. In order to minimize the number of proof cases Mancarella et al. introduced the notion of "term coverings" in [5]. In the following definition we will apply this idea to sorts, which can be covered by a set of subsorts and constants.

Definition 2.4 *An* (exact) *subsort covering of a sort* S *is the union of a set* S^* *of sorts and a set* C^* *of constants such that* $c \in S$ *iff* $c \in C^*$ *or there is* $T \in S^*$ *with* $c \in T$.

Let S *be a sort with direct subsorts* S_1, S_2, \ldots, S_n. *Then the* direct subsort covering *of* S *is the set* $dsc(S) := \{S_1, \ldots, S_n\} \cup dc(S)$.

For a sort S, *a subsort covering* C *is* more specific (less general) *than* C' *if all constants in* C' *are also in* C *and all sorts in* C' *are covered by a subset of* C.

Now the Herbrand theorem tells us that a formula $\bigwedge x_S P(x)$ is valid if $\forall y_T P(y)$ is valid for all sorts T of a subsort covering of x and $P(c)$ is valid for all constants c in this subsort covering. Note that for an empty sort S the empty set is a covering, as S contains no ground terms to be covered. Then there are no cases to check and the formula $\bigwedge x_S P(x)$ holds trivially.

3 Solving Universally Quantified Queries

We know that a universally quantified theorem $\bigwedge x_S F(x)$ holds if proofs of the classical formula $\forall y_T F(y)$ succeed for all sorts T and proofs of $F(c)$ succeed for all constants in a subsort covering of S. The problem remains to find a suitable subsort covering with as few elements as possible.

Finding a subsort covering for one variable is a canonical procedure according to the above definitions. So we can introduce a depth-first algorithm to determine the most general suitable subsort covering. The following algorithm solves a universally quantified query by trying proofs by case analysis for increasingly specific subsort coverings.

In the algorithm we need a procedure c-prove(query, resources) to determine whether a query holds in the context of the classical semantics. The parameter resources is introduced to ensure the termination of c-prove. By a finite value for resources one might for instance limit the search depth or the search time for c-prove.

It is possible to extend the algorithm to handle more than one universally quantified variable, i.e. queries of the form $\bigwedge x_{S_1}, \ldots, x_{S_n}$ query. Now the number of ground cases to be checked in the worst case is the product of the cardinality of the sorts involved, because the query must hold for all combinations of constants in the instantiated query.

Algorithm : procedure **dca-prove**($\bigwedge x_S$ query)

1. if S is empty then return TRUE
2. if c-prove($\forall x_S$ query, N) = TRUE % finite N, restricting for
 then return True % example the search depth
3. if query doesn't contain x_S
 then return UNKNOWN
4. if for any constant $c \in dsc(S)$ % the query must hold for
 c-prove(query$[c/x_S]$, ∞) = UNKNOWN % all constants in dsc(S)
 then return UNKNOWN
5. if for any sort $T \in dsc(S)$ % the query must recursively
 dca-prove($\bigwedge x_T$ query$[x_T/x_S]$) = UNKNOWN % hold for all sorts in dsc(S)
 then return UNKNOWN
 else return TRUE % now TRUE for dsc(S)

Contrary to the case with one variable there is no longer a unique direct subsort covering, because there is an additional choice of the next sort to expand. The possible choices can be organized in an AND/OR-Graph. In figure 1 this graph is depicted for the sorts S and R with direct subsorts S_1, S_2, S_3, and R_1, R_2, respectively.

Much depends on the order in which the subsort coverings are tried. But there seems to be no optimal solution without some knowledge about the probabilities of being able to (classically) prove certain universally quantified queries. So one needs to use heuristic functions to estimate how probable it is that such a formula can be derived. These heuristic functions can then be used to drive an AO*-Algorithm, cf. [7].

Figure 1: AND/OR-GRAPH OF SUBSORT COVERINGS

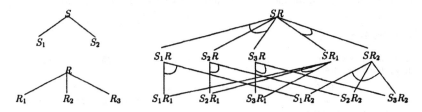

4 Implementation and Experiences

The algorithm described in this paper has been implemented in the project KBSSM applying knowledge-based methods to the field of access control in computer systems. The knowledge representation language L_{LILOG}, cf. [2], is used to formalize security policies and actual access rights on an IBM RS/6000 work station.

As an additional feature the user may ask for counter-examples before the actual algorithm is started. He may also interactively choose a subsort covering to continue with before the next sort is expanded, especially in the case with more than one variable.

A significant reduction of the number of cases to prove was observed in the example of the "four-eyes-principle" of access control, which is presented in a simplified form below. Assuming a sort hierarchy defining the different types of data stored in a computer system, an administrator wants to find out whether certain global security constraints are valid, for instance if all important files (of sort I), i.e. personnel data, system files, and confidential data, are accessible by at least two distinct persons. Given a predicate $access(p, f)$, meaning that person p has access to file f, he makes the following inquiry:

$$\bigwedge f_I \; \exists p_1, p_2 \; access(p_1, f) \wedge access(p_2, f) \wedge p_1 \neq p_2$$

With the rule, that for all system files the "four-eyes-principle" holds because the system administrator and his assistent both have access to these files, there is no need to check the goal for all single system files on the constant level.

The sort structure of the knowledge base is arranged such that the files are grouped according to their contents or usage, which makes it more likely that files of the same sort have similar properties. If instead they were grouped by creation date, the taxonomy could not help in answering the global query.

Even with a well-structured sort hierarchy the author of the knowledge base may not have thought of inserting general rules where appropriate. This may also be the case if the global properties in question are not intended but hold accidentally. In this case the generation of rules by inspection of the knowledge-base would help; they could be derived in a bottum-up fashion (learning by generalization), propagating a property from constants to their sorts and from sorts to their direct supersorts.

Alternatively one might check a certain set of properties whenever a local change of the knowledge base is performed and propagate the results through the class hierarchy. This procedure will speed up later queries, but it depends on knowing the possible universally quantified queries in advance. To handle the administration of these queries one would furthermore have to control these global rules by a truth-maintenance system.

References

[1] J. H. Gallier. *Logic for Computer Science — Foundations of Automatic Theorem Proving.* Harper & Row, New York, 1986.

[2] O. Herzog and C.-R. Rollinger, editors. *Text Understanding in LILOG: Integrating Computational Linguistics and Artificial Intelligence*, volume 546 of *Lecture Notes in Artifical Intelligence.* Springer Verlag, Berlin, Heidelberg, 1991.

[3] J-L. Lassez, M.J. Maher, and K. Marriott. Unification revisited. In Jack Minker, editor, *Foundations of Deductive Databases and Logic Programming*, pages 587–625. Morgan Kaufmann Publishers, Los Altos, 1987.

[4] D. W. Loveland. *Automated Theorem Proving: A Logical Basis.* North Holland, 1978.

[5] P. Mancarella, S. Martini, and D. Pedreschi. Complete logic programs with domain-closure axiom. *Journal of Logic Programming*, 5:263–276, 1988.

[6] D. Miller. Lexical scoping as universal quantification. In *Proc. of the 6th ICLP*, 1989.

[7] N. J. Nilsson. *Principles of Artificial Intelligence.* Tioga, Palo Alto, 1980.

[8] M. Schmidt-Schauß. *Computational Aspects of an Order-Sorted Logic with Term Declarations.* Lecture Notes in Artificial Intelligence. Springer-Verlag, 1989.

A Semantic View of Explanation

Justus Meier

Universität Bielefeld
Fakultät für Linguistik und Literaturwissenschaft
Postfach 8640, D-4800 Bielefeld, Germany
jmeier@techfak.uni-bielefeld.de

Abstract. Explaining expert systems requires explicit and rich representations of the underlying knowledge. As a step towards reaching adequate representation models have been proposed as the basis for the knowledge processing needed for explanation. The main problem is the description of problem solving processes. If that is achieved explanation methods can be conceived as quite general, semantic operations on models.

1. Explanation and models

Providing expert systems with flexible explanation facilities has proven to be a very difficult task. The knowledge used to solve certain problems does not necessarily suffice to explain the problem solving. Explanation is not just another functionality of an expert system but a new problem requiring expertise itself.

Attempts at explanation have shown that it is impossible or at least impractical to define explanation methods on an expert system itself, understood as its code and records of its behavior. In the project DIAMOD [9] we explore the possibilities of explanation for model-based expert systems. Our object system is OFFICE-PLAN (which assigns employees to rooms respecting their requirements, characteristics, functions etc., [15]) which has been built using the KADS (knowledge acquisition and documentation system, [16]) methodology. Models have two advantages. (1) They can be at the right level of abstraction for human understanding whereas the real system must be efficiently interpretable by a machine. (2) They can be organized towards explanation relevant issues so as to make possible the definition of efficient automatic explanation methods whereas the real system may be so complex or diverse in terms of knowledge levels that implementing such procedures becomes intractable.

What justifies the use of models is that they are, especially in KADS, connected with the process of developing the expert system. Just as an expert system has grown out of exploring a domain and devising problem solving procedures for it, so should a model of the expert system build upon the model of the domain capturing the ways in which a human expert acquires his competence. Just as the expert system´s usefulness lies in solving problems in the real domain, so does the expert system model´s meaningfulness arise from its being connected to the model of the domain. The domain (the problems and problem solutions in it) is what is behind the problem solving system (cf. [16] p.497, [2] p.32).

KADS proposes to use models throughout knowledge acquisition and expert system design which can be made executable, e.g. using MODEL-K ([15]). According to KADS the conceptual model of an expert system consists of a model of the domain and a model of the problem solving processes employed. (The latter I term "XPS model" for the moment, reserving the expression "model of the expert system" for the combination of the two models.) In KADS terms, the domain model consists of objects and relations plus domain dependent inference rules (the latter are usually not accounted for in KADS). The domain model is the representation of the domain for the expert system. It may be conceived independently but of course must fit the needs of problem solving. The XPS model contains meta-classes and knowledge sources. Meta-classes conceptualize domain data (concepts, relations, facts). Knowledge sources represent elementary (with respect to the level of abstraction chosen) procedures on domain data. The XPS model carves up the world in such a way that solving the problem becomes possible and implements problem solving processes. In general there is a hierarchy of processes, the more simple ones being manipulations of domain data, the more complex ones being goal-directed tasks. In KADS complex processes are organized into tasks, the hierarchy of knowledge sources and tasks being determined by the goals they help to achieve.

Explanation being communication, presentation is as important as representation. In DIAMOD natural language is the medium of explanation. The advantages are threefold. (1) Natural language is a very flexible means of presentation, placing important constraints on knowledge processing. (2) It allows for dialogue, as a step towards realizing explanation as cooperative human-computer-interaction. (3) It seems to be the best guideline available today for developing natural, simple, and explicit representations of expert systems for explanation.

2. Semantics

In order to define explanation methods on models we must identify meaningful units and relations in the domain and XPS models to be combined into explanations. I describe them as semantic units and relations, proposing to view explanation basically as getting at the meanings of expert system actions.

The first layer of semantic relations connects the domain model with the real domain. The meaning of a model entity is given by its extension and intension. The extension of a concept or relation is the thing or property in the real world that it stands for, its intension is what it "means" in the framework of the domain theory, that is the conceptual or terminological information it allows to be gained. Abstract concepts represent classes of things. The extension of an inference rule is a real world regularity, a stable cooccurrence of things and properties, its intension is what it "means" in the domain theory, that is which inferences (domain theorems) it allows to be drawn.

The second layer of semantic relations connects the XPS model with the domain model. The extension of a meta-class is a concept or relation in the domain model, its intension is how these domain model entities are used in problem solving procedures, which must be extractable from the name of the meta-class and its connections to knowledge sources. Combining the semantics of problem solving with the semantics of the domain we can assign to a meta-class a secondary extension, the thing, or class of things, or property, or state of affair in the real domain that its primary extension represents, and a secondary intension: how things in the domain are treated in problem solving.

This kind of secondary interpretation, however, can only be given, if there is a direct connection between XPS model and domain. Some meta-classes serve only or mainly system internal purposes, thus lacking secondary meaning. One advantage of KADS models is precisely that they provide abstract models of problem solving which make internals of a system describable without recourse to the domain.

The extension of a knowledge source describing an expert system action (the action may be purely informational, such as inferring one fact from another) is the inference rule in the domain model on which it is based, its intension is how it contributes to the task of achieving a goal. Its secondary extension (if there is one) is the change in the domain effected by the action, its secondary intension

(if there is one) is how that change contributes to bringing about the goal state of affairs in the domain.

The extension of a task is the sequence of actions intended to achieve the associated goal, its intension is the goal it (partially) achieves. Its secondary extension (if there is one) is the change in the domain effected by the actions, its secondary intension (if there is one) is how that change contributes to bringing about the goal state of affairs in the domain.

Note the asymmetry in my description of the meanings of knowledge sources and tasks. While they have similar intensions the extension of a task is a set of knowledge sources rather than a composition of the inference rules they are based upon. The reason for this is that tasks and goals are "higher" theoretical entities of the XPS model. This could be made explicit in a third layer of semantic relations connecting the XPS model to a model of explanation (or reflection, or expert system use, or human computer interaction, cf. [12]) where tasks would represent types of problem solving in a theory of expert systems, that is a theory-guided way of carving up the world of problem solving. As I have nothing to say about such a third model I shall keep tasks and goals in the XPS model and take care of their special status.

3. Model-based explanation

Apart from identifying the above units and relations as a semantic ground level models must possess some overall properties on which no consensus has been reached so far (cf. e.g. [15]). To make model-based explanation possible we must at least demand (a) that expert systems are modeled in an adequate conceptual framework, which is (b) translatable into natural language or another medium of explanation, and (c) that a semantics of problem solving is available exihibiting a sufficient degree of compositionality. Then explanation methods can be defined as model operations. Explanation is then the task of selecting those meaningful units that have explanatory value in answering a user's question.

3.1. Explanation types based on semantic relations

Explanation begins with giving information. Any kind of knowledge missing from the user's picture of what is going on may have explanatory value. Completing the user´s knowledge is done by mentioning or describing things in the domain, or in the domain model, or in the XPS model. This may be done to tell the user

something new about the domain or only to draw his attention to certain aspects of it, or to explain to the user how the system views the domain, or what parts it consists of and how they connect, respectively. The aim is to let the user build up his own compatible picture of the domain and the system.

Mentioning an entity is to name it, describing it is to say which parts it is made of and how they connect. In the case of model entities describing them amounts to giving a definition. Deciding between mentioning and describing and determining the depth of description are user dependent tasks as has been investigated in e.g. [7] and [11].

More interesting kinds of explanation make clear how expert system entities, especially procedures, are justified, how they work together, what system internal goals they achieve and what difference they make with respect to the domain:

(1.) Justifying an expert system action by giving the extension of the knowledge source, the inference rule.

(2.) Functionally characterizing a knowledge source or task by giving its intension.

(3.) Describing the effect of an expert system action or actions by giving the secondary extension of the knowledge source or task.

(4.) Describing the course of a solution by giving the extension of the task. Unless we have dynamic models with a memory this requires having access to a trace which is not easy to incorporate into the model-based approach (cf. [3]).

3.2. Example

Let us look at an example to see how explanation can exploit semantic relations and how explanation strategies can be approximated to model operations. For this purpose I assume a model of the expert system OFFICE-PLAN that embodies a full semantics as outlined above. Then on the basis of the user's interpreted question, the user model, and the whole model of the expert system, an explanation strategy has to determine the information that is to be expressed in an adequate answer. Both for finding relevant information and for assessing its adequacy semantic relations can be exploited. What follows is a piece of semantic analysis, not a specification of procedures.

3.2.1. Determining relevant information

The question may refer to entities in the model by their names or by predications corresponding to abstract classes found in the representation. The question may also refer to (assumed) facts, so relations between entities come into play. If the ontology of the model is close enough to natural language it can be directly used for interpreting the question. The interpretation of a sentence is a relation (role) plus all its arguments (concepts). The interpretation of an individual is a concept plus its immediate superconcept. The shaded area in the lower part of fig.1 shows the interpretation of the question "Why is A in R1?" in an excerpt from a simplified KLONE style model for OFFICE-PLAN. (The question mode is not represented in the expert system model.)

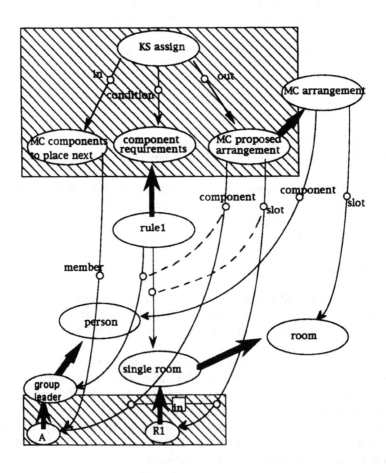

figure 1

The why-question calls for the justification of an expert system action but the action is not named. So the explanation strategy has to first follow the semantic relation described under (3.) above to get from the domain fact to the knowledge source which has this fact as its secondary extension. If the user does not know this knowledge source it should be described to him. In OFFICE-PLAN this is the knowledge source `assign`. The shaded area in the upper part of fig.1 yields an XPS model description of `assign`. Then, according to type (1.), the inference rule `rule1` is found which provides the justification. Fig.2 shows the model entities which constitute the content of the explanation answering the user's question. It allows to generate "`A` is in `R1` because the knowledge source `assign` proposed this arrangement observing the rule that groupleaders must be in single rooms."

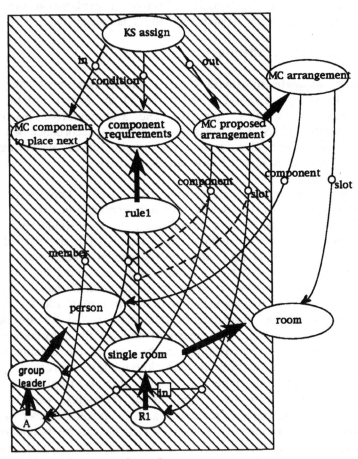

figure 2

Apart from the difficulties of determining in general what is to be considered a complete meaningful unit, especially when parts of the domain and the XPS model are combined, the main question is whether such operations can be systematically defined. M. Sprenger has defined a set of strategies for content selection (currently being implemented) which exploit the relations between pieces of knowledge that can be assumed for KADS models ([13]). He also shows when and where such strategies can cross the boundaries between models which is easier to do in the integrated KADS modeling framework than e.g. in the difficult to relate knowledge structures used in EES ([10]). Although the strategies may have to be refined in order to provide exactly those chunks of knowledge we want to express in natural language text, and although the required semantic (or causal and functional) relations must be made precise, they are a solid basis for solving the problem of explanation. In particular they prove that the levels of knowledge provided by KADS models allow for the systematic definition of explanation strategies capable of producing the content of natural language text.

3.2.2. Assessing adequacy

Selecting adequate information for a given user must take into account knowledge external to the model of the expert system, such as pragmatic principles, linguistic and argumentative resources, and a user model. Still this has to be done in accordance with the world. I shall here discuss only the pragmatics of answering the question "Why is A in R1?" (for details cf. [4]).

Following assumptions concerning the user's knowledge and pragmatic principles an overly explicit explanation like "A was placed in R1 because A is a groupleader, R1 is a single room, and groupleaders must be in single rooms" (again from the shaded part of the model shown in fig.2) may be reduced in several ways. For a user who (a) knows that A is a groupleader mentioning the inference rule rule1 "Groupleaders must be in single rooms" may suffice on the grounds that (b) the applicability of the rule to A and R1 can be pragmatically inferred (principle of relevance, A and R1 are salient being mentioned in the user's question) and (c) the information that R1 is a single room is contained in the part of the domain model describing the application of the knowledge source assign (semantic relation of type 2.3.), and this is implied by the information that the roles of the output meta-class of assign, proposed arrangement, point to A and R1. If, on the other hand, it is assumed that (d) the user knows rule1 he can be pragmatically expected to provide the connection on his own. The adequate answer may be "A is a groupleader and R1 is a single room" on the grounds

that (e) it is these properties of persons and rooms the inference rule is based on.

While conditions (a), (b) and (d) must be checked in the user model or follow from the pragmatic principle of cooperation, (c) and (e) concern facts in the model of the expert system. For (c) to be true the model must make explicit that the application of rule1 to A and R1 implies that A is a groupleader and R1 is a single room. (e) is true, as the meaning of the concept rule1 is that it links the roles of proposed arrangement to groupleader and single room respectively which are the immediate superconcepts of A and R1 (see fig.2). So apart from expressing the meaning of entities a model must also support making inferences. The general point is that pragmatic implicature is not a purely linguistic matter or a self-contained principle of human interaction but always relies on world knowledge. This is why it is so important to have the expert system model easily inspectable and interpretable for the natural language generation component responsible for tailoring an explanation.

4. Conclusion

The work presented here should be seen in the context of the ongoing discusssion on KADS models where a turn to a more semantically oriented knowledge representation can be observed concentrating on how to connect the different layers of a conceptual model. Linster [6] demands meta-classes to be defined on the domain layer. Angele et alii [1] regard meta-classes as views on the domain layer and employ generic descriptions of knowledge sources. Möller [8] develops tools for declaratively programming generic knowledge sources so as to directly link inference processes with terminology. Operations and views between them give rise to semantic relations similar to those I have proposed.

I have presented a view on knowledge representation, knowledge processing for explanation and natural language generation which emphasizes the fact that the processes in these fields are fundamentally content-based and as such require good models to work on. Explanation is impossible unless the meanings of expert system entities, especially with respect to the domain, are made clear. This means to precisely (more precise than my above sketch) specify semantic relations. The easiest way to exploit them is to use techniques from natural language semantics. After the semantic turn may well come a linguistic turn.

This point can be made stronger if one puts semantic relations in context with causal, functional, argumentative and rhetorical relations in order to see which of these can be implemented in models. Furthermore the scope of applications can be extended from content selection, as presented above, to areas like grouping of propositions, text structure and lexicalization. This has been proposed by Horacek in [5] although he does not go into issues of expert system modeling.

The KADS framework can help to develop models which are partially independent from implementation concerns and which adhere to natural language ontology in their conceptualization. If the ontology is fine enough to give a meaning to entities and to provide semantic relations between entities in the domain and XPS models it will be possible to use general methods as developed in natural language generation for the manipulation of propositions and for expressing them in sentences, rather than special purpose search procedures or canned text.

5. References

[1] J. Angele et al., KARL: An executable language for the conceptual model, in: *Proc. 6th Banff Knowledge Acquisition for Knowledge-Based Systems Workshop*, Banff 1991, 1-20.
[2] J.A. Breuker et al., *Model-Driven Knowledge Acquisition: Interpretation Models*, Deliverable task A1, Esprit Project 1088, 1987.
[3] S. Heider, G. Wickler, *Tracing von MODEL-K und OFFICE-PLAN als Grundlage für dynamisches Erklären*, DIAMOD Bericht Nr.6, GMD 1991.
[4] H. Horacek, Exploiting conversational implicature for generating concise explanations, *EACL 1991*, 191-193.
[5] H. Horacek, *An integrative view of text planning*, DIAMOD-Bericht, Universität Bielefeld 1992.
[6] M. Linster, *Declarative Problem Solving Procedures as a Basis for Knowledge Acquisition: A First Proposal*, Technical Report 448, Arbeitspapiere der GMD, St. Augustin 1990.
[7] K. McKeown, M. Wish, K. Matthews, Tailoring Explanations for the User, 794-798.
[8] J. Möller, Towards Declarative Programming of Conceptual Models, to appear in: *Proc. 2. Workshop Informationssysteme und Künstliche Intelligenz*, Ulm 1992.
[9] B.S. Müller, M. Sprenger, *Dialogabhängige Erklärungsstrategien für modellbasierte Expertensysteme - Das Projekt DIAMOD*, DIAMOD Bericht Nr. 2, GMD 1991.

[10] R. Neches, W.R. Swartout, J. Moore, Explainable (and maintainable) expert systems, *IJCAI 1985*, 382-388.

[11] C. Paris, Combining Discourse Strategies to Generate Descriptions to Users Along a Naive/Expert Spectrum, *IJCAI 1987*, 626-632.

[12] G. Schreiber et al., *Designing Architectures for Knowledge-Level Reflection*, REFLECT Report RFL/UvA/III.1/4, University of Amsterdam 1991.

[13] M. Sprenger, *Explanation Strategies for KADS-based Expert Systems*, DIAMOD Bericht Nr.10, GMD 1991.

[14] W.R. Swartout, S.W. Smoliar, Explanation: A Source of Guidance for Knowledge Representation, in: K. Morik (ed.), *Knowledge Representation and Organization in Machine Learning*, Berlin 1989, 1-16.

[15] A. Voß et al., *Operationalization of a synthetic problem*, REFLECT Report RFL/GMD/I.2/5, GMD 1990.

[16] B.J. Wielinga, J.A. Breuker, Models of Expertise, *ECAI 1986*, 497-509.

GOAL–DRIVEN SIMILARITY ASSESSMENT[*]

Dietmar Janetzko[1] and Stefan Wess[2] and Erica Melis[3]

[1] Dept. of Cognitive Science University of Freiburg
[2] Dept. of Computer Science University of Kaiserslautern
[3] Dept. of Computer Science University of Saarbrücken

Abstract. While most approaches to similarity assessment are oblivi-
ous of knowledge and goals, there is ample evidence that these elements
of problem solving play an important role in similarity judgements. This
paper is concerned with an approach for integrating assessment of simi-
larity into a framework of problem solving that embodies central notions
of problem solving like goals, knowledge and learning. We review empir-
ical findings that unravel characteristics of similarity assessment most of
which have not been covered by purely syntactic models of similarity. A
formal account of similarity assessment that allows for the integration
of central ideas of problem solving is developed. Given a goal and a do-
main theory, an appropriate perspective is taken that brings into focus
only goal-relevant features of a problem description as input to similarity
assessment.

1 Introduction

In recent years, there has been an upsurge of interest in case-based reasoning
(CBR), i.e. reasoning techniques that are based on the use and reuse of previous
problem solving experience [Kol91]. One of the key issues of case-based reason-
ing (Fig. 1) is the question how a previous case, i.e. a *source*, is selected given a
current case, i.e. a *target*. This retrieval step calls for estimating similarity be-
tween source and target cases. The majority of previous approaches to similarity
assessment resort to measures of similarity that have been developed within the
province of categorization and clustering (e.g. in biology [Dic45]), but not within
the realm of problem solving. These approaches have been termed *syntactic*, as
they confine similarity assessment to the objects given in the *problem descrip-
tion* and refrain from using purposes or goals. In contrast, these factors on the
side of the *problem-solver* are at the heart of the so-called *pragmatic* approaches
(e.g. [Hol85]) to similarity. We take the view of similarity as a genuine part
of problem solving. Within this conceptual framework similarity assessment is
influenced by two types of characteristics: syntactic characteristics, e.g. num-
ber of common features, on the side of the objects of similarity assessment and

[*] This research was supported by the "Deutsche Forschungsgemeinschaft" (DFG),
"Sonderforschungsbereich" (SFB) 314: "Artificial Intelligence and Knowledge-Based
Systems", projects X9 and D3.

pragmatic characteristics, e.g. goals, on the side of the subject of similarity assessment.

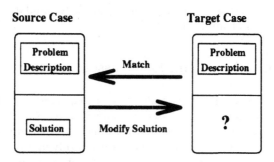

Fig. 1. Basic steps of CBR

The aim of this article is to develop a model that links pragmatic and syntactic approaches to similarity. The model we propose does not give priority to any of the two accounts on similarity assessment. It is, however, motivated by the fact that the quality of similarity assessment heavily depends on focusing on relevant features. Applying a syntactic approach implicitly requires that relevant features are known before assessing similarity. In contrast, this implicit assumption becomes an explicit part of goal-driven similarity assessment, such that the relevance of features is determined by a knowledge-based process. Reduced to its kernel, our model (Fig. 2) starts with a pragmatic account using a problem solving *goal* and a *domain theory*. Following this, a *perspective* (*cf.* [Str91]) is developed which brings into focus features that are important for goal-achievement. Finally, similarity of a given object to other objects can be computed by applying a syntactic similarity measure e.g. [Tve77] to the goal-relevant features.

Fig. 2. Goal-driven similarity assessment

In what follows, we first discuss the characteristics of similarity that bear on problem solving, especially case-based reasoning and analogical reasoning. This is done in agreement with cognitive science findings that give rise to an enlargement of approaches to similarity developed for the purpose of classification tasks. Second, we give a formal account of an approach to similarity that captures these characteristics of similarity.

2 Characteristics of similarity assessment

Whenever measures of similarity tailored to categorization tasks are used in problem-solving tasks, e.g. case-based reasoning, a general blindness of these measures towards goals, knowledge and learning is to be complained. To identify crucial characteristics of similarity in problem solving we review some cognitive science findings on similarity. The characteristics of similarity assessment in problem solving discussed below are by no means exclusive or complete. They highlight, however, characteristics of similarity in problem solving that are usually neglected in the above mentioned syntactic approaches to similarity.

Similarity as a goal–driven process Similarity assessment has been shown to be strongly influenced by goals ([SMAR86, FR88]). For example, given a plan and a number of different goals related to that plan, e.g. developing a cheap solution, or developing an extension, the assessed similarity to other plans is assumed to vary depending on the goal.

Similarity as a knowledge–based process Research on experts and novices demonstrates that similarity judgements depend on the availability of suitable knowledge. It has been shown repeatedly (e.g. [BFVS89]) that assessments of similarities change as a function of growing knowledge such that people become sensitive to features and dimensions that otherwise escape their attention.

Similarity as a selective process Experts when asked to pick up two similar descriptions of problems from a set of descriptions, tend to base their similarity assessment on a subset of the set of features and ignore others. In a series of experiments, Holyoak & Koh [HK87] and Chi, Feltovich & Glaser [CFG81] demonstrated that experts prefer structural features, i.e. features that play a causal role in generating a problem solution in order to establish the similarity between two objects. In contrast, novices tend to use surface features, i.e. features that play no causal role in problem solving, to assess the similarity between two objects.

Similarity as a constructive process Polya [Pol45] was among the first to advocate the idea of similarity assessment as a constructive process. For example, he suggested that a problem solver can address a three-dimensional geometrical problem by transforming it into a two-dimensional one. As a result, it is often much easier to find a similar two-dimensional geometrical problem, retrieve the corresponding solution and adapt it to the problem that triggered this cycle of analogical reasoning. Additional empirical evidence that assessing similarity

assessment involves construction processes on the side of the target was provided by Clement [Cle82] who analyzed protocols of problem solvers dealing with physics problems.

Similarity as a context–sensitive process The claim that similarity assessment varies across contexts is in line with empirical results obtained e.g. by Tversky [Tve77] and Barsalou [Bar82]. In one of Barsalou's experiments the assessed similarity between pairs of animals, e.g. raccoon and snake, has been shown to be greater within no context condition than in a context of pets.

Taken together, cognitive science studies of similarity assessment provide convincing evidence that purely syntactic approaches fall short of capturing basic characteristics of similarity.

3 Formal preliminaries

In the sequel, we begin by giving a formal account of basic notions that are necessary to develop a model of goal-driven similarity assessment. This is important in a domain like CBR which mostly relies on ad hoc concepts that lack a clear-cut definition. Furthermore, this step is inevitable when applying well-known methods to similarity assessment in case–based reasoning as will be shown later.

The basic idea of of goal-driven similarity assessment is to filter out a set of features that is relevant for goal achievement. In the subsequent section we outline how to determine the relevant features within our model. We settle on a a first-order language \mathcal{L} that has a finite number of symbols for constants, predicates and functions and is our basis for describing the underlying domain.

Definition 1 Description. Let \mathcal{L} be a first order language for knowledge representation. A finite, consistent subset $D \subseteq \mathcal{L}$ of literals (without free variables) is called a description.

We have to use literals for the desription so that we are able to employ a similarity measure that is genarally in common use when assessing similarity (e.g. [Tve77]). The consequence of this decision is that our approach is confined to application domains which can be expressed by using literals only.

One of the basic concepts of CBR is the notion of a case. Seen from a cognitive science point of view, cases are abstractions of problem solving behavior that occured in a specific situation. In this sense, cases include implicit problem solving heuristics which can be interpreted with respect to different purposes.

Definition 2 Case. Let $\mathcal{L}_P \subseteq \mathcal{L}$ and $\mathcal{L}_S \subseteq \mathcal{L}$ be first order languages for knowledge representation with $\mathcal{L}_P \cap \mathcal{L}_S = \emptyset$ and let $\Sigma \subseteq \mathcal{L}_P \cup \mathcal{L}_S$ be a domain theory. A case is defined as an ordered pair $C = (P, S)$, where $P \subseteq \mathcal{L}_P, S \subseteq \mathcal{L}_S$ are descriptions and $\Sigma \cup P \cup S$ is consistent.

With regard to the notions of case-based reasoning, P is a description of a problem and S is a description of the corresponding solution.

Definition 3 Case Base. Given Σ, \mathcal{L}_P, \mathcal{L}_S, then a finite set of cases is called a case base $CB = \{C_1, C_2, \ldots, C_n\}$. The elements C_i of CB are called source cases.

Definition 4 Target Case. A case without a solution $C_T = (P, \emptyset)$ is called a target case.

Often, it is not necessary or even misleading to judge the similarity between complete case descriptions. In what follows, we introduce the notion of *aspects* as parts of the case description.

Definition 5 Aspect. Let \mathcal{C} be a set of cases and \mathcal{L} be the underlying language. An aspect A is a partial function from \mathcal{C} into the powerset of \mathcal{L}-literals $Lit(\mathcal{L})$ such that A maps cases to finite sets of literals.

Defining aspects as partial *functions* implies that values of aspects may vary between different cases. Whenever a previously unknown value of an aspect is acquired, the *partial* function can be extended. In what follows, if there is no danger of confusion, only the notion *aspect* is used for the function and their values. Depending on their role in problem solving, two special types of aspects, *goals* and *perspectives*, may be distinguished, both of which will be introduced in subsequent sections.

3.1 Goals

One of the concepts that have not been used in similarity assessment up to now is the notion of a *goal*. Goals refer to the reasons for a specific kind of problem solving. In addition and more relevant to the present concerns, goals imply which part of the description of a problem is actually used for goal-achievement. Within the framework of our model of similarity assessment the notion of a goal serves two purposes:

- First, it provides a means to express that similarity assessment is hardly ever done without a special purpose.
- Second, by virtue of this capacity it constrains the vast amount of possibilities that arise when comparing two objects in order to estimate the similarity between them.

In our model, goals are aspects of the solution description.

Definition 6 Goal. A goal \mathcal{G} is a particular aspect A_S with $\mathcal{G}(C) \subseteq \mathcal{L}_S$.

Once a goal is adopted, it places specific restrictions on the kind of features of the problem description P that are taken into consideration. We use the term *perspective* in reference to features used for problem solving that involves similarity assessment.

3.2 Perspectives

Given a goal the problem-solver is committed to, the set of features by which a problem is described is reduced to a consistent and finite subset of literals. In our model, perspectives are aspects of the problem description.

Definition 7 Perspective. A perspective \mathcal{P} is a particular aspect A_P such that that for each case $C = (P, S)$ is $\mathcal{P}(C) \subseteq P$.

To make similarity assessment goal-driven is to find an appropriate perspective, which boils down to single out only goal-relevant literals. A necessary requirement to do this is a domain theory that highlights relationships between parts of the case and the goals within a domain. Depending on the goal pursued, we end up with different perspectives. Thus, given a goal \mathcal{G} the perspective that is based on this goal is written as $\mathcal{P}_{\mathcal{G}}$.

3.3 Similarity

Our notion of similarity assessment will be developed in two steps. First, we start by introducing an intuitive and desirable approach to similarity assessment. But this approach is faced with difficulties when actually applied to case-based reasoning. This is the reason why, second, a different computational approach to similarity assessment is introduced that is tailored to the specific demands of case-based reasoning and problem solving.

In what follows, $sim : CB^2 \to [0, 1]$ denotes similarity as to be defined by a syntactic measure of similarity (e.g. [RW91], [Tve77]) that is used in combination with our pragmatic model. A binary similarity relation \sim is introduced e.g. by

$$x \sim y \iff sim(x, y) \geq \delta \quad x, y \in CB; \delta \in [0, 1].$$

This first view of similarity is motivated by the fact that for problem solving we are interested in solutions of previous cases which are easy to transform according to the current problem. The underlying similarity measure sim could be defined by the costs of modification which are necessary to transform a solution S_i into a solution S_j. That is, *given a similarity measure sim for solutions, then two cases $C_i = (P_i, S_i)$ and $C_j = (P_j, S_j)$ are said to be similar if the corresponding solutions S_i and S_j are similar with respect to sim.*

However, in case-based reasoning this intuitive approach to similarity assessment cannot be pursued in a direct way since a new problem P_k that lacks a solution S_k is to be solved. According to the view provided above, similarity becomes an a posteriori criterion, because it is only after having determined the solution S_k that we can judge whether the underlying cases are similar.

To assess similarity for retrieval in CBR we have to look for a definition of a similarity relation which compares the problem descriptions P_i, P_k instead of S_i, S_j and captures the spirit of this approach.

The goal-driven approach is intended to close the gap between similarity of solutions and similarity of problem descriptions. The main point of our approach is to determine which perspective we have to choose, so that similarity between problem descriptions is useful for deriving a solution for the target case.

Definition 8 Similarity in Aspects. Let *sim* be a similarity measure on sets of literals. Two cases C_i and C_j are said to be *similar* with respect to an aspect A, expressed by $C_i \sim_A C_j$, if $A(C_i) \sim A(C_j)$.

Equality is the most obvious kind of similarity. Interpreting \sim as identity (i.e. $\delta = 1$) transforms similarity assessment into a test of part-identity (*cf.* [Smi89]). Similarity is then represented as equality on an abstract level.

3.4 Connections

A part of the domain theory Σ that is used to find out the relevant features on the basis of a specific goal is formulated by means of *connections* [Mel90]. A connection represents knowledge about the – sometimes vague – causal or the like relation between two aspects of a system. Formally, a connection is an ordered pair of aspects $[A_l, A_k]$.

Definition 9 Connections. Given a similarity relation \sim and a case base CB, an aspect A_l is called connected to an aspect A_k with respect to \sim, written as $[A_l, A_k]$, if for all cases C_i and C_j of CB, which are similar with respect to the aspect A_l, i.e. $C_i \sim_{A_l} C_j$, C_i and C_j are similar with respect to the aspect A_k, i.e. $C_i \sim_{A_k} C_j$.

In general, connections are not laws in a strong domain theory but default knowledge about relations between aspects. Connections do not guarantee correct inferences but capture the heuristic and experimental nature of this kind of knowledge (*cf.* Russell's *determinations* [Rus89]). Implications may be expressed as a strong kind of connection. Examples of well known connections are [function, structure], [cause, effect], [situation, behaviour]. Russell's determinations for example are connections of an implicational type.

4 A model of goal-driven similarity assessment

Putting things together, goal-driven similarity assessment starts on the basis of a syntactic similarity measure *sim*, a domain-theory Σ, a set of *goals* \mathcal{G}_i, a *target case* C_T and a *case-base* CB with source cases C_j. Given a target case C_T, a goal \mathcal{G}, and a connection $[\mathcal{P}_\mathcal{G}, \mathcal{G}]$, the specific perspective $\mathcal{P}_\mathcal{G}$ can be chosen under which the similarity to different source cases $C_j \in CB$ is assessed.

In general, however, the specific connection $[\mathcal{P}_\mathcal{G}, \mathcal{G}]$ is not given explicitly. A possible approach, which is used in our implementation to derive the connection $[\mathcal{P}_\mathcal{G}, \mathcal{G}]$ is to use explanation-based generalisation (EBG) (*cf.* [MKKC86]) to

bridge the gap between the goal \mathcal{G} and the perspective $\mathcal{P}_\mathcal{G}$; i.e. techniques stemming from EBG are applied to select a set of relevant features \mathcal{F} that pertains to a goal \mathcal{G}. For a case $C = (P, S)$ the perspective $\mathcal{P}_\mathcal{G}$ is defined as $\mathcal{P}_\mathcal{G}(C) = \mathcal{I}(\mathcal{F}) \cap P$, where $\mathcal{I}(\mathcal{F})$ is the set of all possible instantiations of literals in \mathcal{F}.

In this way, similarity assessment becomes a knowledge-based process. That is, knowledge specified in a domain theory is used to arrive at an explanation why a set of features is required to accomplish a goal. The elements of EBG are used in our model as follows:

Goal: Existing goal \mathcal{G} in the problem solving process which should be achieved.

Example: Description P_T of the target case \mathcal{C}_T.

Domain Theory: Σ with knowledge about relationships between the objects in the domain, e.g. connections.

Operationality Criterion: Goal \mathcal{G} must be expressed in terms of features which are already used in the description of the problem P_T of the target case \mathcal{C}_T.

Determine: A set of features $\mathcal{P}_\mathcal{G}$ of the target case \mathcal{C}_T which is sufficient to accomplish the goal \mathcal{G} with a solution S of a source case $C = (P, S)$ are to be singled out.

This is done by looking successively for preconditions of the goal (*goal regression*) until the operationality criterion is met. In contrast to the original work of Mitchell, Keller and Kedar–Cabelli our domain-theory may contain connections, i.e. experience, as well as facts and rules.

If the target case \mathcal{C}_T and a source case C_i are similar with respect to the perspective $\mathcal{P}_\mathcal{G}$, the goal \mathcal{G}_i may be achieved in the target case \mathcal{C}_T by using the solution S_i of the source case C_i.

Given: Σ, \mathcal{G}, \mathcal{C}_T, CB, sim
Searching: S_i to achieve \mathcal{G} in \mathcal{C}_T

1. Derive the goal–dependent perspective $\mathcal{P}_\mathcal{G}$ by using the domain theory Σ and \mathcal{G}.
2. Use the perspective $P_\mathcal{G}$ to assess similarity between the source cases $C_i \in CB$ and the target case \mathcal{C}_T, i.e. according to the used syntactic approach to similarity assessment compute whether $\mathcal{P}_\mathcal{G}(\mathcal{C}_T) \sim \mathcal{P}_\mathcal{G}(C_i)$.
3. Look for the *most similar* $C_i = (P_i, S_i) \in CB$ with respect to $\mathcal{P}_\mathcal{G}$ and the similarity measure *sim*.
4. Use the solution S_i in particular $\mathcal{G}(C_i)$ to achieve the goal \mathcal{G} for the target case \mathcal{C}_T, i.e determine $\mathcal{G}(\mathcal{C}_T)$.

4.1 Combination of goals

As discussed above, a single goal provides the basis for focusing similarity assessment. In general, however, the overall goal of a task may be decomposed into an ordered set of subgoals. As a consequence, our model has to be extended in order to make similarity assessment goal-driven when a multitude of goals

is given. Given a set of goals $\{\mathcal{G}_1, \mathcal{G}_2, \ldots \mathcal{G}_m\}$, and a task–dependent ordering \preceq over goals, a straightforward approach is to compute similarity stepwise for each \mathcal{G}_i. Starting with $i = 1$ and the whole case base CB, cases which are *most similar* according to the current goal \mathcal{G}_i are selected. This set of cases is carried over to the subsequent run of similarity assessment according to the next goal \mathcal{G}_{i+1} according to the given odering \preceq. This procedure continues until each goal \mathcal{G}_i is used for similarity assessment or the set of selected cases contains no more elements. The best scoring cases of the last run are accepted as the result of the retrieval process. The ordering \preceq of goals is highly dependent on the specific task and the domain. In planning, the difficulty of achievement and costs of modification of a goal \mathcal{G}_i respectively are appropriate criteria for establishing the ordering \preceq.

5 An example

To demonstrate the central notions of goal-driven similarity assessment let us discuss a short example of case-based reasoning strategies that can be used for finding a workplan for rotational parts in mechanical engineering. For simplicity, we concentrate on those parts of an example of a real-world application, which are necessary to flesh out our model of goal-driven similarity. Nevertheless, our model applies to other domains as well. This is possible if cases can be expressed in literals and the application comes up with a domain theory that links problem solving goals to features of cases within the domain. In the sequel, the notion *feature* applies to details of the application, whereas the term *literal* refers to the corresponding logical representation.

The overall task is to generate a process plan for manufacturing a workpiece by using data provided by a CAD (Computer-Aided Design) system. In practice, in most mechanical engineering planning tasks human experts try to reuse old plans by adapting them to a new situation (*cf.* [SBKS91]). This is not surprising because planning from first principles is very difficult in a complex real-world domain such as production planning. Plans which are constructed by human experts are for the most part based on specific problem solving experiences. Thus, case-based reasoning is an adequate problem solving paradigm to reflect this common practice.

However, retrieving appropriate cases for complex tasks like planning is a crucial step in CBR because *similarity* can be assessed with regard to a number of perspectives. Each *perspective* - and as a consequence each *similarity assessment* - is tied to a special *goal* of the overall planning process, e.g. finding a fixture to clamp the workpiece. As part of their domain-theory or from experience, experts know *connections*, e.g. "Similarity in the outline of the workpieces entails using similar fixtures."

5.1 The target case

Suppose, we want to build a process plan for manufacturing the workpiece given in figure 3. The workpiece is described by a set of features which may be extracted

```
fixture(F)     :- fixture_fc21(F).
fixture(F)     :- fixture_fc23(F).
...
fixture_fc21(F) :- shoulder(X,P,Y),
                   cylinder(Y),              *
                   quality_ok(Y),
                   F = fc21.

shoulder(X,P,Y) :- connected(X,P,Y),        *
                   greater_diameter(Y,X),   *
                   connected(Y,S),          *
                   circular_area(S).        *

quality_ok(X) :- surface_quality(X,Q1),     *
                 Q1 > 7,
                 tolerance(X,Q2),           *
                 Q2 > 5.
```

Fig. 5. Some parts of the domain theory

Fig. 6. The workpiece of the source case

The result of the explanation-based process is a set of features \mathcal{F} which are sufficient (with respect to the domain theory) to use the fixture given in a source case C_i in the target case C_T[4]:

$\mathcal{F} = \{$ cylinder([Y]),
 circular_area([S]),
 connected([[X,Z,Y],[Y,S]]),
 greater_diameter([Y,X]),
 surface_quality([Y,Q1]),
 tolerance([Y,Q2]) $\}$

Explanation: For clamping we need a cylinder at the end of the workpiece (1,2,3). The workpiece should be fixed at the cylinder with the greatest diameter because of the transmission of the rotational force (4). The surface quality of the part where the workpiece is fixed should not be too high as clamping a workpiece destroyes high surface quality (5,6).

[4] In the domain theory (Fig. 5) marked with a *.

from an object-oriented CAD system (Fig. 4). The problem solving process is made up of several steps. One of the goals which must be achieved during the planning process is to determine a fixture to clamp the workpiece and to prepare it for the cutting process to follow. In our example, we focus on this specific goal \mathcal{G} as an aspect of the solution: $A_S(C_i) = \{\texttt{fixture(X)}\}$

Fig. 3. A primitive workpiece

5.2 Selection of the perspective

As mentioned earlier, human experts know as part of their knowledge and experience that the kind of fixtures which shall be used to clamp a workpiece depends on its outline. The fixtures are similar if the outlines of workpieces are similar. This may be formalized as a connection [outline,fixture] which is part of the experts domain theory. In addition, experts know a lot of technical details about the working process, the tools and the machines they use.

```
% PROBLEM: description of the workpiece
 casename(workpiece2).
% Geometry:
 circular_area([s1,p1,p2,s2]).
 cylinder([e1,e2,e3]).
 greater_diameter([[e2,e1],[e3,e2]]).
 connected([[s1,e1],[e1,p1,e2],
           [e2,p2,e3],[e3,s2]])
% Technology:
 material([[all,c47]]).
 surface_quality([[e1,15],[e2,10],[e3,13]]).
 tolerance([[e1,11],[e2,20],[e3,20]]).
 ...
```

Fig. 4. The problem description

In our model, applying experience and knowledge to solve a current problem is viewed as an explanation-based process. Using the domain theory (Fig. 5) and the operationality criterion, we derive a perspective \mathcal{P}_G. If source and target-case are similar under \mathcal{P}_G the goal \mathcal{G} may be achieved by using the solution given in the source case.

```
% PROBLEM: Description of the workpiece
casename(workpiece1)
% Geometry:
 circular_area([s1,p1,s2])
 cylinder([e1,e2])
 greater_diameter([[e2,e1]])
 connected([[s1,e1],[e1,p1,e2],[e2,s2]])
% Technology:
 material([[all,c45]])
 surface_quality([[e1,10],[e2,15]])
 tolerance([[e1,11],[e2,10]])
 ...
% SOLUTION: Workplan
 use_machine(m44)
 chuck([b],fixture(fc21))
  change_tool(t1)
   cut([s1,a,p1],roughing)
 chuck([a],fixture(fc21))
  change_tool(t2)
   cut([s2,b],roughing)
 unchuck
```

Fig. 7. Description of the source case

An example of a similar source case containing an executable workplan for man-
ufacturing the workpiece given in figure 6 is depicted in figure 7. The intersection
between all possible instantiations of literals in \mathcal{F}, called $\mathcal{I}(\mathcal{F})$ and the problem
description P of the given source case $C = (P, S)$, leads to the specific perspec-
tive $\mathcal{P}_{\mathcal{G}}(C_i)$:

$$\mathcal{P}_{\mathcal{G}}(C) = \{\texttt{cylinder}([e2]), \dots, \texttt{tolerance}([e2, 10])\}$$

With the derived connection $[\mathcal{P}_{\mathcal{G}}, \mathcal{G}]$ we can clamp the workpiece given in the
target case C_T (Fig. 3) by the use of the fixture **fc21** provided in the workplan
of the source case (Fig. 7).

5.3 Retrieval of cases

In our example, there is just one source case given. Usually, there is a great num-
ber of different source cases C_i available in the case base. Having determined the
relevant features \mathcal{F} of a source case C_i according to the given goal \mathcal{G} a syntactic
similarity measure *sim* like the *contrast-* or *ratio-model* proposed by Tversky
[Tve77] is applied to compare for every case $C_i \in CB$ the computed perspective
$\mathcal{P}_{\mathcal{G}}(C_i)$ with the perspective $\mathcal{P}_{\mathcal{G}}(C_T)$ of the given target case C_T and look for
the best fitting source case according to the current goal given.

Specifying criteria for selecting syntactic similarity measures *sim* depending on the domain is is still an open question and out of the scope of this work. Instead, in this paper we concentrate on determining relevant features by employing both goals and a domain theory for a given syntactic similarity measure *sim*. Finding relevant features for an efficient similarity assessment is a task which is independent of the specific syntactic similarity measure used.

6 Related work

The ideas introduced in this paper are closely related to Kedar–Cabelli's model of purpose–directed analogy [KC85]. Kedar–Cabelli aims at integrating the influence of pragmatics, e.g. purposes, into the generation of analogies. Although purpose-directed analogy shares with goal-driven similarity the intuition of pragmatic factors to be important for similarity, a comparison shows striking differences: Kedar–Cabelli's work is rooted in the framework of analogical reasoning, thereby focusing on analogical mapping and concept formation as a result of analogical reasoning. Additionally, purpose–directed analogy reconstructs the target in terms of the source. In contrast, goal–driven similarity singles out features that are deemed necessary to be taken into consideration when assessing similarity. Our model concentrates on similarity assessment as to be used in various forms of reasoning. In a word, Kedar–Cabelli elaborates on pragmatic-driven analogical mapping and we concentrate on pragmatic-driven retrieval.

In an attempt to improve indexing in CBR, Barletta & Mark [BM88] use *explanation-based learning* (EBL) to determine features that play a causal role in finding a solution to a target case. Based on the domain theory, the problem specification and the solution to that problem the system aims at explaining the goal concept, i.e. one or a sequence of actions that lead to a solution. The explanation of the goal concept is guided by a hypothesis tree that is provided by the domain theory. The differences to our own work results from the fact that Barletta & Mark's approach is exclusively concerned with indexing cases that enter the case library. The featural description of cases they use is made up of the description of a problem and its solution. On this account, the assessment of similarity of a target to a source and the use of goals instead of solutions is not touched by their work.

Cain, Pazzani & Silverstein [CPS91] describe an approach to integrate domain knowledge in the assessment of similarity between source and target cases. This is accomplished by using explanation-based learning as a means to judge the relevance of features. Their measure of similarity combines the *nearest-neighbour technique* that counts the number of identical features with a measure that counts the number of matching relevant features according to EBL. In this way, similarity between two cases will be deemed high if they share a great number of common features or a great number of relevant features. If EBL does not arrive at an explanation for the solution of a case, this measure of similarity boils down to the nearest–neighbour technique. Contrary to our study, Cain et al. do not use concepts like goal or perspective when assessing similarity. They take EBL to

explain the features that are required to reach a solution and do not use goals as we do. Thus, the model of Cain et al. starts with by preselecting cases based on a pure feature-overlap measure of similarity. Then EBL is applied to determine features relevant to reach a solution. EBL is limited to source cases since - by definition - only they have a *known* solution.

7 Conclusions and future work

The work introduced in this paper has two related foci: First, we discuss cognitive science findings that show why human similarity assessment is both a powerful and flexible capability. Second, we present a formal model that accounts for most of the chararcteristics in human similarity assessment we discussed. A first version of our model has been implemented in PROLOG. Currently, an extended version of this implementation in the domain described above is under preparation.

At the most general level, our model is an example in which way empirical findings can be used as a starting point to contribute to the development of formal models that may be used as building blocks in AI systems. Among the four characteristics of similarity discussed above, there are three that are supported by our model of goal–driven similarity assessment: First of all, our model exploits the notion of *goals* when assessing similarity. Additionally, by using a domain theory to focus on goal–relevant aspects our model has been proven to be a *knowledge-based* one. Finally, because of its capacity to develop connections and corresponding perspectives the process of goal–driven similarity assessment may be referred to as *constructive*. To make similarity assessment *context-sensitive* remains as a possible extension of the work described in this paper. Thus, our model gives a fairly good account as far as cognitive modelling of basic characteristics of similarity assessment is concerned.

Mention ought to be made, however, of several issues that as yet remain open. On a formal account, our model is restricted to literals. In section 4.1 a schema has been introduced that allows for similarity assessment if a multitude of goals is given. This schema, however, is not fully satisfying. The difficulty with this approach is that a cut-off value determining which subset of cases is used when assessing the subsequent goal has to be supplied in a hand-coded way. Currently, we concentrate on an extension of our model to a multitude of goals that can do without this shortcoming.

The present version of our model focuses on goal-relevant aspects which may be referred to as abstraction by reduction. By using hierarchies of aspects abstraction may be achieved by substituting an aspect by a more abstract one. In this way, goal-driven similarity assessment becomes independent of specific instantiations since similarity assessment is performed on a more abstract level.

Apart from open questions just mentioned, goal-driven similarity assessment comes up with some issues we consider as strengths of our model. More specifically, by incorporating goals our model offers four advantages that go beyond models of similarity assessment that are oblivious of pragmatic factors like goals:

First, similarity assessment and retrieval is improved. This is achieved by considering only those features of a case that pertain to a goal. Distorting similarity assessment due to an overlap of aspects that do not pertain to a goal is avoided because of a more focused similarity assessment. As a result, the computational effort for applying the syntactic similarity measure decreases since the number of features to be considered is reduced to the relevant ones. On the side of the pragmatic approach the computational costs to determine a set of relevant features is independent of the number of cases given since EBG is performed only once no matter how large the case base is. Thus, the utility of investing computational effort in EBG increases with the number of cases.

Second, similarity assessment is tied to the goal of a problem-solver and may vary along with a change of goals.

Third, goal–driven similarity assessment allows for a multiple use of cases which depends on a variation of goals or an improvement of the domain theory. For example, a case-based reasoner in toxicology that is equipped with a device for goal-driven similarity assessment, is able to use knowledge represented in cases in a variety of ways. Again, this is done by performing a specific similarity assessment according to different goals like *determine the toxin* or *work out a therapy*.

Fourth, in the case where no explicit goals are given, a failure when applying EBG, or a defective or totally missing domain theory occurs, goal–driven similarity boils down to the pure syntactic approach to similarity assessment that is used in linkage to our model.

8 Acknowledgements

This work was done while Dietmar was a visiting scientist at the University of Kaiserslautern. The authors are indebted to Klaus P. Jantke, Michael M. Richter, Jörg H. Siekmann, Gerhard Strube and the reviewers for their comments on earlier versions of this paper.

References

[Bar82] L. W. Barsalou. Context-independent and context-dependent information in concepts. *Memory & Cognition*, 10:82–93, 1982.

[BFVS89] J. D. Bransford, J. F. Franks, N. J. Vye, and R. D Sherwood. New approaches to instruction: because wisdom can't be told. In Stella Vosniadou and Andrew Ortony, editors, *Similarity and Analogical Reasoning*, pages 470–497. Cambridge University Press, 1989.

[BM88] R. Barletta and W. Mark. Explanation-based indexing of cases. In *Proceedings of 7.th National Conference on Artificial Intelligence*. Minneapolis, 1988.

[CFG81] M. T. Chi, P. J. Feltovich, and R. Glaser. Categorization and representation of physics problems by experts and novices. *Cognitive Science*, 5:121–152, 1981.

[Cle82] A. Clement. Spontaneous analogies in problem solving: The progressive construction of mental models. In *Proc. Meeting of the American Education Research Association*, New York, 1982.

[CPS91] Timothy Cain, Michael J. Pazzani, and Glenn Silverstein. Using domain knowledge to influence similarity judgements. In Ray Bareiss, editor, *Proc. of the 1991 Workshop on CBR*, Washington D.C.,USA, May 1991. DARPA, Morgan Kaufmann Publishers.

[Dic45] L. R. Dice. Measures of the amount of ecologic association between species. *Journal of Ecology*, 26:297–302, 1945.

[FR88] J. Fanes and B. Reiser. Access and use of previous solutions in a problem solving situation. In *Proc. of the tenth Annual Conference of the Cognitive Science Society*, pages 433–439, Montreal, 1988.

[HK87] K. J. Holyoak and K. Koh. Surface and structural similarity in analogical transfer. *Memory & Cognition*, 15:332–340, 1987.

[Hol85] K.J. Holyoak. The pragmatics of analogical transfer. In G. Bower, editor, *The psychology of learning and motivation*. Academic Press, New York, NY, 1985.

[KC85] S. Kedar-Cabelli. Purpose-directed analogy. In *Proc. of the Cognitive Science Society*, Irvine, CA, August 1985.

[Kol91] Janet L. Kolodner. Improving human decision making through case-based decision aiding. *AI Magazine*, 91(2):52–68, 1991.

[Mel90] E. Melis. Study of modes of analogical reasoning. Tasso-Report Nr. 5, Gesellschaft für Mathematik und Datenverarbeitung mbH (GMD), 1990.

[MKKC86] T. M. Mitchell, R. M. Keller, and S. T. Kedar-Cabelli. Explanation-based generalization: A unifying view. *Machine Learning*, 1(1), 1986.

[Pol45] G. Polya. *How to solve it*. Princeton University Press, Princeton, NJ, 1945.

[Rus89] S. J. Russell. *The use of Knowledge in Analogy and Induction*. Pitman Publishing, London, 1989.

[RW91] Michael M. Richter and Stefan Wess. Similarity, uncertainty and case-based reasoning in PATDEX. In Robert S. Boyer, editor, *Automated Reasoning*, Essays in Honor of Woody Bledsoe, pages 249–265. Kluwer Academic Publishing, 1991.

[SBKS91] F. Schmalhofer, R. Bergmann, O. Kühn, and G. Schmidt. Using integrated knowledge acquisition to prepare sophisticated expert plans for their reuse in novel situations. In *Proc. KAW-91*, Banff, Canada, 1991.

[SMAR86] C. Seifert, G. McKoon, R. Abelson, and R. Ratcliff. Memory connections between thematically similar episodes. *J. Exp. Psych. Learning Memory Cognition*, 12:220–231, 1986.

[Smi89] Linda B. Smith. From global similarities to kinds of similarities: the construction of dimensions in development. In Stella Vosniadou and Andrew Ortony, editors, *Similarity and Analogical Reasoning*, pages 146–178. Cambridge University Press, 1989.

[Str91] G. Strube. Dynamic perspective in distributed representations. *Zeitschrift fuer Psychologie*, 199(4/91):289–298, 1991.

[Tve77] A. Tversky. Features of similarity. *Psychological Review*, 84:327 – 352, 1977.

Delegated negotiation
for resource re-allocation*

Jacques H. J. Lenting and Peter J. Braspenning

University of Limburg, Department of Computer Science (FdAW),
P.O. Box 616, NL-6200 MD Maastricht, The Netherlands

Abstract. Whereas the oldest negotiation framework in distributed artificial intelligence, the Contract Net metaphor, embodies a truly distributed negotiation procedure, some of the younger approaches to negotiation are distributed to a lesser degree, relying on a mediator to resolve conflicts between agents. In this paper, we present *delegated negotiation* as a more distributed alternative for mediated negotiation. Rather than a sophisticated mediator agent, delegated negotiation features a relatively dumb manager agent, whose task is restricted to the aggregation of problem statements from individual agents into global problem profiles. The aggregated information enables the agents to take collective interests into account without being aware of another agent's individual goals.

1 Introduction

The Contract Net metaphor [4] envisions a distributed approach to coordination by means of bidding on contracts. Bidders are presumed to specify the eligibility of their bids using locally available information. Whereas the metaphor has been applied successfully in a number of cases, it is sometimes difficult to determine (global) eligibility with only local information. An example of a problem domain which resists a Contract Net approach in this sense is that of resource reallocation. Sathi and Fox [3] claim a mediated approach to be preferable for a resource reallocation problem involving constraints depending on multiple resource offerings. In their approach, a central mediator, supplied with a global view on the problem, is used to overcome the problem of locality of information. Whereas this is surely capable of improving global coherence, it also implies that many of the drawbacks of centralized problem solving (e.g., computation bottlenecks) are re-introduced.

Instead of letting a mediator have an ongoing discussion with the agents to assist them in coordination, our approach involves a manager, whose sole task is to aggregate data received from the agents into relevant global problem characteristics. This information is passed back selectively to the agents in a manner that allows them to reach an adequate solution by themselves, without

* This research was supported by the Netherlands Foundation for Scientific Research NWO under grant number 612-322-014.

further guidance of the manager. The aggregated information is similar to the problem textures communicated among agents in the Cortes architecture [6], in the sense that it enables the agents to take collective interests into account without being aware of another agent's individual goals. The problem, resource *re*-allocation, is considerably different, however.

2 The Problem Context: Resource Reallocation

Sathi and Fox [3] situate the resource reallocation problem in the context of a software engineering company comprising teams working on different projects. Each team has a number of resources at its disposal for the duration of a project. Resources, in this context, are computer workstations, whereas the agents are project teams. It is – implicitly – assumed that the teams, or at least a considerable subset thereof, embark on new projects simultaneously. Under the assumptions that the company possesses several types of workstations, and that different projects may require different types of workstations, a multi-agent resource re-allocation problem occurs whenever a set of new projects is to be initiated.

In this paper, we grossly adhere to the description of the resource reallocation problem as it was presented by Sathi and Fox [3].

3 Subtasks of Resource Reallocation

In [3], an agent's desires with respect to resource reallocation, are expressed in terms of buy and sell constraints with the following three characteristics.

- Buy and a sell constraints may be combined into a conditional constraint. An agent may be willing to relinquish a type-A resource *provided that* it receives a type-B one in return;
- resources are reconfigurable (against some cost). If necessary, disk drives, memory, or color managers can be exchanged between between workstations;
- reallocation constraints may be relaxed. Agents are presumed to be prepared to concede on some points in order to get what they want on others.

These three problem characteristics give rise to the subtasks of combination (matching sell and buy constraints), reconfiguration, and relaxation, respectively. Sathi and Fox do not clearly specify to what extent these subtasks are interwoven in their approach. We postulate that, whereas reconfiguration and relaxation may be interrelated in a complex manner, taken together they are essentially orthogonal to composition, and can therefore be executed independently, either before or after the latter. In Sect. 9, we shall describe how relaxation may be performed prior to composition, within the same framework that we use for composition.

4 A Negotiation Framework for Resource Reallocation

Resource reallocation is relatively difficult to handle in a distributed fashion, because some problem characteristics are inherently non-local. This is apparently so for the subproblems of relaxation and reconfiguration, but the existence of conditional constraints also impedes distributed solution of the composition problem. In the following, we show where the Contract Net approach [4] fails in solving such a composition problem effectively.

The Contract Net approach is based on the metaphor of contractors soliciting for assignments by offering to do the job for a certain amount of money. It focuses on the distribution of tasks (alias subproblems) among available agents. In the Contract Net approach, an agent that wishes to contract out a task, broadcasts a task announcement message. A potential contractor (any agent interested and capable of performing the task described in the message) replies with a "bid". The bid contains information which enables the manager of the task (i.e., the agent that broadcasted the task announcement) to compare the eligibility of potential contractors. Consequently, it is able to pick a contractor which is optimally equipped for the task at hand. An award message is then sent back by the manager to such a contractor.

In applying the Contract Net approach to a composition problem, conditional constraints can be revealed to other agents as a task announcement. Apart from the inappropriateness of the term "task announcement" in this context, this is not problematic. The problem arises in the next phase of the bidding, when potential contractors (e.g., agents interested in buying the resource offered) are to respond to the announcement. The Contract Net approach requires them to provide eligibility information with their bid, so as to allow the seller to choose between candidate buyers. In the context of resource reallocation, the only *locally* available eligibility information is the type of resource which the buyer is willing to offer in return (if any). Assuming that the *global* goal of constraint composition is to satisfy as many constraints as possible, this kind of eligibility information is insufficient: From a global perspective, the value of the resource offered "in return" depends on the number of agents interested in this resource, and, recursively, the eligibility of *their* bids.

As an example, consider a reallocation problem involving four agents with conditional constraints $A|B$, $B|A$, $B|C$, and $C|A$, respectively. If resource A is handed over by the first to the second agent, only the first two constraints can be satisfied, whereas handing over A to the fourth agent enables the composition of constraints 1, 3 and 4. Consequently, the fourth agent is more eligible to receive resource A than the second agent is, but this can not be concluded without deliberation of the third agent's constraint. In other words, the eligibility information for constraint composition is essentially nonlocal.

To overcome this problem, Sathi and Fox [3] propose to use a central mediator, which first collects all of the agents constraints, and subsequently mediates in pairwise negotiations between the agents. Whereas we agree with Sathi and Fox that the degree of local computation embodied in the Contract Net is apparently too extreme for the approach to be effective for resource reallocation,

the choice in favor of a central mediator seems another extreme.

Our delegated negotiation framework embodies an intermediate degree of distribution. Like in mediated negotiation, a distinguished agent collects the information required to determine eligibility. However, in order to prevent this "manager" from remaining a bottleneck in the entire computation that follows, it aggregates collected data into *global* "market profiles", and selectively transmits this global information back to the agents, in order to enable them to solve the composition problem on their own, in a completely distributed fashion.

5 Delegated Negotiation for Constraint Composition

In this section, we shall focus on the most well-defined subtask in resource reallocation: the composition of individual constraints into cascades. In other words, we presume that relaxation and reconfiguration have either already taken place or will take place later, involving only the leftovers (if any) of composition.

The composition task involves determination of who should hand over what resource to whom so as to arrive at an optimal solution. For now, we shall define "optimality" from a global point of view, as "satisfying as many constraints as possible". Contrary to mediated negotiation, delegated negotiation comprises a straightforward, completely distributed solution procedure for the composition problem after relatively little pre-processing (data aggregation by the manager). The task of the manager is restricted to the *initiation* of the distributed computation.

Though this may seem equivalent to the first of three alternative solution procedures described by Sathi and Fox [3], it is not. The crucial difference is that delegated negotiation is greedy only if this is guaranteed not to jeopardize solution quality.[2]

As shown in Fig. 1, delegated negotiation consists of four phases.

In the first phase, nodes communicate their reallocation desires to the manager in terms of resource requests ("buy constraints") and resource offerings ("sell constraints").

In the second phase, these constraints are aggregated by the manager into global resource demand and resource scarcity (demand minus supply) values. In addition to these "market statistics" the manager composes resource sellers lists.

In the third phase, the sellers lists are communicated (selectively) to the associated buyers, and relevant resource statistics are communicated to sellers and buyers of scarce resources. These statistics in fact dictate the behavior of agents in the fourth phase, in which the actual negotiation process takes place in a distributed fashion, without participation of the manager.

6 The Communication Protocol

In the following, we specify the communication protocol for the distributed negotiation which takes place in phase 4 (cf. Fig. 1). We distinguish resource trade

[2] *viz.*, in dealing with constraints which do not involve any undersupplied resources.

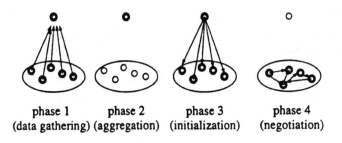

| phase 1 | phase 2 | phase 3 | phase 4 |
| (data gathering) | (aggregation) | (initialization) | (negotiation) |

(boldface circles denote active components)

Fig. 1. The four phases of delegated negotiation

constraints from bids. The former express the wishes of agents, thus representing
the initial state of the negotiation process, whereas the latter refer to the actual
messages that are transmitted among the agents in the final negotiation process
(phase 4). Trade constraints are either conditional or unconditional.

In mediated negotiation, conditional constraints are considered to express an
agent's desire. In that case, a conditional constraint $X|Y$ can be interpreted as
expressing "I am prepared to sell resource X, provided that I can buy resource
Y". In the framework of *delegated* negotiation however, they are interpreted
differently. We presume that, initially, an agent does not formulate its desires
in conditional form. It simply conveys to the manager what resource realloca-
tion it would consider best suited for its own purposes. This locally preferred
re-allocation is more naturally expressed as a set of unconditional constraints.
Conditional constraints do occur in delegated negotiation in a later stage. They
are *composed* by the agent with the purpose of improving its chances of acquir-
ing scarce resources. The idea is that the agent will be more *eligible* for a scarce
resource, if he can offer another scarce resource in return. The agent thus com-
poses conditional constraints on the basis of considerations on resource scarcity.
As such, an agent's conditional constraints may be interpreted as a representa-
tion of the agent's *strategy* to get the most out of negotiation. In this respect,
the agents in delegated negotiation take the initiative, whereas, in mediated ne-
gotiation, the initiative is generally taken by the mediator. At the same time,
the agents in the delegated negotiation framework are less stubborn, in the sense
that the association between the two parts of a conditional constraint is much
less absolute. In the bidding process, the buy- and sell-parts of a conditional
constraint are treated independently. The relation between the two parts of the
conditional constraint $X|Y$ exerts only an implicit influence on this process, in
the sense that the eligibility attributed to a buy-option on Y is determined by
the scarcity of resource X. The association between the *resources* involved thus

exists only *within* the agent that sends the option. This reduces the verbosity of messages as well as the complexity of the problem. It also enables us to specify the bidding protocol for buying and selling completely separately. The other side of the coin is that a conditional constraint may be violated in the negotiation process. In associating a buy bid on X with a scarce resource Y, which was not yet announced to the manager as being for sale, an agent improves on his chances of acquiring X, but it also takes the risk of losing Y without getting X in return. Thus, in delegated negotiation, there is no absolute adherence to the conditionality of the commitment $X|Y$.

An unconditional constraint involves the desire to either sell or buy a resource. A desire to buy resource X is notated as $|X$, a desire to sell it as $X|$, thus reflecting that a buy constraint is equivalent to a conditional constraint with empty sell part, and vice versa.

We use five types of messages in negotiation, three of which (the buy bids) are sent from buyers to sellers, the other two (sell bids) in the opposite direction. The contents and purpose of message types are summarized in Table 1. The buyers of resources initiate the negotiation process by sending option messages to *all* agents that possess a resource they would like to acquire. The behavior of agents in the negotiation that follows is described in some detail in appendices A and B.

Table 1. The five types of messages involved in the negotiation process

type	class	contents	semantics
option	buy bid	sender, type, option-id, resource, eligibility	offer to buy a resource
commitment	buy bid	sender, type, option-id	commitment to an option
retraction	buy bid	sender, type, option-id	retraction of an option
election	sell bid	sender, type, option-id	election of an option
rejection	sell bid	sender, type, option-id	rejection of an option

Apart from the information an agent has received from the manager (scarcity and demand of resource types they offer, and selling address lists of resource types they require), selling agents keep track of the number of options received for resource types with positive scarcity, the number of resources not yet committed (for each resource type they offer), as well as the number of unanswered election messages sent out. Buying agents keep track of the number of resources they still have to acquire for each resource type.

The key element in the protocol is that buyers incorporate an eligibility value in their options on undersupplied[3] resource types. This enables the sellers of such resources to grant them to buyers that have sent options with high eligibility.

[3] We define undersupplied resource types as those for which demand exceeds supply, and scarce resource types as those for which supply does not exceed demand.

The eligibility of an option on X, related to a conditional constraint $X|Y$ is defined (for undersupplied X) as the scarcity of Y (demand minus supply) if this is a non-negative value, and -1 otherwise. The eligibility of an option originating from an unconditional constraint is -1. This definition of eligibility is motivated so as to promote the global effectivity of the resource market. Agents requiring undersupplied resources can improve their chances of acquiring these resources by associating them (internally) with a scarce resource they are willing to offer "in return". Zero-scarcity resource types are treated as scarce also, because withdrawal of the offer to sell such a resource would be detrimental to the effectivity of the market. As such, the eligibility definitions promote market effectivity analogously to a pricing mechanism. The definition of eligibility given here is not the only possible one. One could also choose to define the eligibility as the *sign* of the scarcity of the associated resource type, for example. We plan to investigate the merits of various options for relaxation purposes in future research.

7 An Example Market

Tables 2, 3, and 4 provide an example of delegated negotiation on a simple composition problem. The example problem is not fully satisfiable. There is an undersupply of resource types A and B, and an oversupply of resources D, H and G. The specification of the composition problem in Table 2 can be thought of as one resulting from partially successful relaxation of the initial reallocation problem.

Note that it does make sense for agent 1 to combine constraints $C|$ and $|B$ into a conditional constraint $C|B$ since C is a scarce resource. If agent 1 would have chosen $\{A|B, C|, |B\}$ as its strategy, it would take the chance of losing B to agent 4. In fact, if agent 4 had composed its conditional constraint more intelligently, using $\{H|, |E, F|B, H|, |A\}$ as its strategy, agent 1 would have lost one type-B resource to agent 4 with certainty when bidding according to $\{A|B, C|, |B\}$. Conversely, with the current bidding strategy for agent 1, agent 4 would at least have had a *chance* to acquire resource B if it had used the more intelligent strategy. The above illustrates that delegated negotiation should not be regarded as distributed computation in a community of *mindless* agents. It does pay for agents to behave intelligently in the negotiation process.

Table 2. A composition problem specification in terms of the bidding strategies

agent	bidding strategy					
1	$A	B, C	B$			
2	$D	,	A$			
3	$B	A, E	C$			
4	$F	E, H	, H	,	B,	A$
5	$B	F, G	,	H$		

Table 3. Resource statistics of the example market

resource	demand	scarcity	sellers	buyers
A	3	+2	1	2, 3, 4
B	3	+1	3, 5	1, 4
C	1	0	1	3
D	0	-1	2	
E	1	0	3	4
F	1	0	4	5
G	0	-1	5	
H	1	-1	4	5

Table 4. One of possible outcomes of negotiation on the example composition problem

$A|B(1) \;\Leftarrow\; B|A(3)$

$B|F(5) \;\Leftarrow\; F|E(4) \;\Leftarrow\; E|C(3) \;\Leftarrow\; C|B(1)$

$|H(5) \;\Leftarrow\; H|(4)$

unresolved:
 agent 2: $D|A$
 agent 4: $|B,\ |A,\ H|$
 agent 5: $G|$

8 Multi-Level Composition

The fact that the manager does not participate in the bidding process of phase 4 in Fig. 1 offers the opportunity to let the manager perform other tasks, while its agents are engaged in negotiation to solve the composition problem. In the context of a large number of agents, it could be proficient to divide the agents into groups, each group being assigned a separate manager. While the group members solve their composition problem, the manager may engage in a similar negotiation with other managers, initiated analogously by a higher level manager. The manager is able to provide the necessary information to *its* manager, because the resource scarcities computed in phase 3 (see Fig. 1) determine completely which resources will be left over after solution of the local composition process by the agents it manages. It can thus try to trade these resources within the

community of base level managers. This approach would be especially appropriate for resource re-allocation in large organizations with a hierarchical structure, cleanly separating the overall composition problem into smaller subproblems.

9 Relaxation prior to Composition

In this section, we sketch how relaxation may be performed in the framework of delegated negotiation. In principle, relaxation can be performed both before and after composition. If one opts for the latter, this more or less implies a decision to include only those constraints in relaxation that are left unresolved by composition. If there are only few such constraints, as in the example given earlier, relaxation may prove to be a rather hopeless task, due to mismatches which are simply too large to persuade agents to accept them. Supposing, for example, that a reallocation problem involves resource types ranging from a primitive PC via more powerful PCs and moderately sophisticated workstations to NEXT workstations, all of which have zero scarcity, except for one Commodore-64 PC offered and one NEXT workstation requested. It seems somewhat blunt to ask the agent requesting a NEXT workstation to accept a Commodore-64 instead. A relaxation procedure aiming at small concessions by many agents seems preferable in such a case, even if it involves more elaborate negotiation. At the other extreme, in a situation where only a small fraction of the constraints can be combined without relaxation, it will be easier to achieve satisfactory relaxation after composition, but composition will have to be performed repeatedly, wasting much communication effort on unresolvable bids.

All in all, it seems preferable to perform relaxation prior to composition. The framework sketched in Fig. 1 offers a good opportunity to do this. The relaxation process we think of comes down to repeated execution of phases 1, 2 and 3 in Fig. 1. In the first cycle, agents transmit their basic wishes in terms of the number of resources required or offered of a specific type (phase 1). Like in delegated composition, the manager then computes resource scarcities (phase 2), which are transmitted back (phase 3) to the agents or a subset thereof (e.g., only the agents which mentioned scarce resources). The agents addressed by the manager may then attempt to relax their constraints with respect to resources which are under- or over-supplied. The eligibility definition is the incentive herein. This three-phase process is repeated until a satisfactorily balanced market situation is reached. Since the manager is continually involved in the relaxation process, the relaxation process can not be referred to as "completely distributed". However, the fact that strategies are deliberated by the agents themselves, while the manager only needs to perform a comparatively simple data aggregation task, will prevent the latter from becoming too much of a bottleneck in the relaxation process.

In comparison with pure composition, reallocation *with* relaxation requires more verbosity on the part of the manager. Agents engaged in relaxation also need information on the scarcity of resources which they did not mention to the manager. Without such information, they would be severely restricted in their

ability to estimate the value of deliberated relaxations.[4] On the other hand, if smart agents possess too accurate knowledge of market scarcities, this may induce overcompensation, slowing down convergence towards market equilibrium (cf. [2]). To cope with this phenomenon, various methods are conceivable. One could introduce a manipulatory component in the manager, allowing it to send slightly different market profiles to different agents. Or, alternatively, the audience (the subset of agents receiving an updated market profile) could be made progressively smaller upon each cycle. As a third possibility, the agent community could be composed of heterogeneous agents, embodying different patterns of relaxation responses to equal market profiles. We plan to investigate the relative merits of such methods in the near future.

10 Metaphorical Background

The approaches towards the subtasks in mediated, constraint-directed negotiation [3] are inspired by interhuman negotiation. Relaxation, for example, is implemented in accordance with "logrolling", implying that a set of relaxations is accepted only if it is profitable to all parties, that is, each party gains in the process. This unwillingness to sacrifice anything unless something more important is gained in return implies that the agents lack any form of social conscience. Hence, in political terms, the approach could be labeled as anarchistic. The advantage of such an approach is that it requires neither rigid laws specifying in what circumstances agents should relax their demands, nor communication of individual utilities in order to weigh conflicting interests. The disadvantage of the approach should be clear also. Under the assumption that, in the long run, the probability of a certain distribution of projects and resources between two agents will equal that of its mirror image, both agents will be better off if they do compare their respective utilities. This could either be achieved via more verbose negotiation, which is flexible but time-consuming, or, alternatively, effectuated via shared rules. Assuming that pairwise comparisons are not sufficient to achieve optimal relaxation, the latter approach will probably turn out to be more efficient. It is, however, also more rigid.

The approach we propose for composition is clearly of the latter type. It could be labeled metaphorically as "legislation enforcement". We enforce in our agents an absolute obedience to the legislation implied by the protocol and the definition of eligibility. They are presumed not to deviate from the protocol, nor to send options with an incorrect eligibility value. The constraints we thus impose on the agent's freedom of choice are chosen so as to render uniform satisfaction of agents in sufficiently favorable circumstances. Somewhat less cryptically, if supply and demand are in equilibrium for all resources involved in the bidding, all constraints will be satisfied in the induced negotiation process. In a nonequilibrium market, agent satisfaction is biased in favor of agents with more valuable contribution to the society as a whole, provided that all agents are

[4] Actually, for reliable estimation of the *risk* associated with a specific conditional bid, some global information on resource demand, or total trade volume is also required.

sufficiently smart to avoid suboptimal bidding strategies. It should be noted that this does not *guarantee* composition problems to be solved optimally, the definition of eligibility in terms of scarcity being a *heuristic* one.

The enforcement of obedience to "the rules of the game" does *not* imply that the behavior or proficiency of agents is completely determined by the framework and the problem at hand. The proficiency of the agent in acquiring the resources it desires depends to a considerable extent on the bidding strategy embodied in its conditional constraints. Within the specified rules, the agent still has considerable freedom left to determine a strategy in terms of conditional constraints. As we observed in our discussion of the example composition problem, its decisions may have considerable impact on its degree of success. Furthermore, reliable assessment of the risk associated with a strategy requires a nontrivial reasoning capacity in the agent. Consequently, though the behavior of our agents within the delegated negotiation framework is specified more precisely than that of the agents involved in mediated negotiation, the former are not unintelligent. Sathi and Fox [3] suggest that agents will generally only be prepared to relax a demand in favor of some other agent, if *that* agents has something valuable to offer in return. This assumption embodies a rigidity that we suspect to be more detrimental to the flexibility of the system, than the obligation to adhere to a tight protocol.

11 Summary and Conclusions

We have described an alternative approach to constraint-directed negotiation for resource reallocation, which involves delegated, rather than mediated negotiation.

Some practical advantages of this approach are apparent for the composition part of the reallocation problem. They involve independence of the manager in the actual negotiation, and, in connection with this, the perspective of relatively straightforward decomposition of the problem for large organizations.

This paper does not describe the relaxation procedure in detail. However, on the basis of the rough descriptions given, we conclude that the delegated approach to relaxation seems a promising one. The interpretation of conditional constraints as the outcome of an agent's strategic deliberations makes way for a more active role for individual agents in searching for suitable relaxations of constraints involving a resource with non-zero scarcity. For one thing, this transfer of responsibility to the individual agents implies a greater degree of modularity, with the associated advantages for software development and maintenance.

From a metaphorical point of view, our approach embodies a relatively strong influence of community interests on the behavior of individual agents. While constraint-directed negotiation seems inspired by barter trade and troublesome negotiation between employers and trade unions, delegated negotiation is modeled after a money market and negotiations with a more perceptive attitude towards the circumstances of the community as a whole. As such, the approach

fits in well with the growing interest in social laws as a means to simplify coordination [5].

Apart from the practical advantages in terms of execution speed, software development and maintenance, the delegated negotiation framework also possesses interesting features for experimental research in agent-oriented programming. A number of algorithmic components, like the bidding strategies of agents and the homogeneity thereof, seem sufficiently nontrivial to justify the labeling of agents in homomorphic terms like "intelligent" and "conscientious". At the same time they *can* be kept sufficiently simple and perspicuous to allow for purposeful experimentation. These characteristics are important assets of the approach as a basis for experimental research on emergent "intelligence" in agent-oriented programming.

References

1. Durfee, E.H.: Coordination of Distributed Problem Solvers. Kluwer Academic Publishers (1988)

2. Kephart, J.O., Hogg, T., Huberman, B.A.: Dynamics of Computational Ecosystems: Implications for DAI. In: L. Gasser and M. Huhns (Eds.), Distributed Artificial Intelligence, Vol. 2, Morgan Kaufmann Publishers (1989)

3. Sathi, A., Fox, M.S.: Constraint-Directed Negotiation of Resource Reallocations. In: L. Gasser and M. Huhns (Eds.), Distributed Artificial Intelligence, Vol. 2, Morgan Kaufmann Publishers (1989)

4. Smith, R.G.: The Contract Net Protocol: High-Level Communication and Control in a Distributed Problem Solver. IEEE Transactions on Computers (1980) 1104-1113

5. Shoham, Y., Tennenholtz, M.: On Traffic Laws for Mobile Robots. In: Proceedings of the 9th National Conference on Artificial Intelligence, MIT Press (1992)

6. Sycara, K.P., Roth, S.F., Sadeh, N., Fox, M.S.: Resource Allocation in Distributed Factory Scheduling. IEEE Expert, February (1991)

7. Van Dyke Parunak, H.: Manufacturing Experience with the Contract Net. In: M. Huhns (Ed.), Distributed Artificial Intelligence, Vol. 1, Morgan Kaufmann Publishers (1987)

A Response Protocol for Buyers

```
CASE m.type OF

"election":
  r := m.resource
  IF resource-count[ r ] = 0 THEN
    send-to( m.sender, ( my-address, retraction, m.option-id ) )
  ELSE
    send-to( m.sender, ( my-address, commitment, m.option-id ) )
    decrement( resource-count[ r ] )
  FI

"rejection":
/* NO RESPONSE REQUIRED */

ESAC
```

B Response Protocol for Sellers

```
CASE m.type OF

"option":
  r := m.resource
  IF resource-counter[ r ] = 0 THEN
    send-to( m.sender, ( my-address, rejection, m.option-id ) )
  ELSE
    IF scarcity[ r ] <= 0 THEN
      IF election-counter[ r ] < resource-counter[ r ] THEN
        send-to( m.sender, ( my-address, election, m.option-id ) )
        increment( election-counter[ r ] )
      ELSE
        push( option-queue[ r ], m )
      FI
    ELSE /* SCARCE RESOURCE */
      push( option-queue[ r ], m )
      increment( option-counter[ r ] )
      IF option-counter[ r ] = demand[ r ] THEN
        WHILE election-counter[ r ] < resource-counter[ r ] DO
          m2 := best-option( option-queue[ r ] )
          remove-from( option-queue[ r ], m2 )
          send-to( m2.sender, ( my-address, election, m2.option-id ) )
          increment( election-counter[ r ] )
        OD
      FI
    FI
  FI

"commitment":
  r = m.resource
  decrement( resource-counter[ r ] )

"retraction":
  r := m.resource
  IF empty( option-queue[ r ] ) THEN
    decrement( election-counter[ r ] )
  ELSE
    IF scarcity[ r ] > 0 THEN /* SCARCE RESOURCE */
      m2 := best-option( option-queue[ r ] )
      remove-from( option-queue[ r ], m2 )
    ELSE
      m2 := pop( option-queue[ r ] )
    FI
    send-to( m2.sender, ( my-address, election, m2.option-id ) )
  FI
ESAC
```

Towards a Specification Language for Cooperation Methods

Paul de Greef [*], Keith Clark[†] and Frank McCabe[†]

[*]SWI, University of Amsterdam, Roeterstraat 15, 1018 WB Amsterdam
[†] Dep. of Computing, Imperial College, Queen's Gate, London, SW7 2BZ

Abstract. This paper presents a formal language for interaction protocols involving many agents. It is intended as a specification language for cooperation methods: interaction protocols agents can use to cooperate with other agents in a flexible way. The language is a further development of Flores and Winograd's network-style specifications and it can be regarded as a language for fixed multi-agent plans. It can serve as a tool for analysis and modelling of cooperation and collaboration. It may also be used to bring different protocols reported in the literature into a common framework.

1 Introduction

We are interested in methods agents can use to pool their knowledge, skill and information, regardless whether agents are human or computational. We are interested in how to specify and program these *cooperation methods,* so they can be used in multi-agent systems and in tools for Computer Supported Cooperative Work. For this purpose we want a high-level language for interaction protocols that meets the following criteria:

(a) suitable for cooperations involving more than two agents,
(b) absence of details that are not relevant for interacting agents,
(c) ease of use and ease of defining interaction knowledge by users and programmers,
(d) transformability to an already implemented language.

In a broad literature survey [1] we found no language that would satisfy these criteria, but the state-transition network used by Flores and Winograd [7,5,6] to explain their COORDINATOR system provide a first approximation. Their network describes a method one agent can use to get another agent to do a subtask. The arcs of their networks are annotated with expressions like $A : request$ and $B : promise$. Figure 1 shows such a Winograd and Flores network for two agents haggling over a price. These networks are attractive, people find them easy to use, as we experienced in several workshops, and such a network can indeed be used to specification of a cooperation method. The problem then is how to improve on this, how to make the specification formal and how to say more in a specification.

The network-style specification has deficiencies; at least four questions remain unanswered:

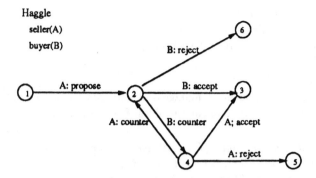

Fig. 1. A Winograd and Flores network for haggling over a price

(i) How can one model mixed initiative?
(ii) What data is passed between the agents, and when?
(iii) What sort of decision-making and learning is done by the agents?
(iv) How can conversations among more than two agents be specified?

Despite these deficiencies, the networks are a good starting point. Below we present a language that improves on it. Our language provides a solution to (ii) and (iv) and partly (i). Our specification language:

(a) inherits most, if not all, features of a logic programming language,
(b) provides sets,
(c) provides notion of an agent, and
(d) provides communication mechanisms.

We believe a formal semantics can be defined, but this is outside the scope of this paper.

Section 2 below introduces the novel features of the language (b,c and d). Section 3 presents example specifications. First we show how the language can be used to specify the haggling interaction shown in figure 1. Then we present an example of an interaction protocol exhibiting a form of mixed initiative. We continue with an interaction protocol from the literature that qualifies as a cooperation method: Contract Net [3,4]. In this example there are more than two agents involved and agents talk about a task and task-allocation, a situation our language can deal with quite easily. The fourth and final example shows how the language could be used to create a design model for a Computer Supported Cooperative Work system: a diary management application.

2 The Language

Most programming languages and languages for plans can be used to define "plan-schemas". For example, in Prolog one could write something like:

$$percentagize(Part, Whole, Percentage) : -$$
$$divide(Part, Whole, Fraction),$$
$$multiply(Fraction, 100, Percentage).$$

We can start from such a language and add something to assign parts of a plan-schema to agents or to agent variables. For example:

$$Agent1, Agent2 : percentagize(Part, Whole, Percentage) : -$$
$$Agent1 : divide(Part, Whole, Fraction),$$
$$Agent2 : multiply(Fraction, 100, Percentage).$$

Obviously, one needs something for the communication of data from one agent to another. Below we first introduce the notation for exchanging messages and then we provide a few example specifications.

2.1 Exchanging messages

We continue with a Prolog-like syntax, as used in the example above, with one exception: Arguments or variables that bind to a set have a name that starts with an uppercase character; otherwise we use lowercase.

The exchange of a message is written as:

$$sender : message(arg1, .., argN) \rightarrow receiver \qquad (1)$$

A message can be sent to a set of receivers, meaning that copies of the same message will be sent to each receiver:

$$sender : message(arg1, .., argN) \rightarrow Receivers \qquad (2)$$

The converse is not possible, but a receiver can collect similar messages from different senders. This would be written as:

$$Msgs = \{(s, arg1, ..., argN) \mid s : message(arg1, .., argN) \rightarrow receiver\} \qquad (3)$$

Read this as: There is a set of terms $(s, arg1, ..., argN)$ such that s has has sent a message of type $message$ with arguments $(arg1, .., argN)$ to $receiver$. One would never want to use this form, because collecting messages from anyone without a deadline would never finish. To specify the senders one could write the right-hand side of (3) as follows:

$$\{(s, arg1, ..., argN) \mid s : message(arg1, ..., argN) \rightarrow receiver, s \in Senders\} \qquad (4)$$

When $Senders$ is a finite set of agents, (4) would terminate after all members of $Senders$ have sent a message that satisfies the message pattern. In general one cannot be sure that all agents will send a message or that all messages that have been sent will indeed arrive. To make sure that (3) or (4) terminate, one must include a deadline and one would write the right-hand side of (3) as follows:

316

$$\{(s, arg1, ..., argN) \mid s : message(arg1, ..., argN) \rightarrow receiver \text{ before } time\} \quad (5)$$

The value of *time* is like a deadline, it is measured on the clock of the receiving agent, because the time between sending and receiving of messages is uncertain.

Set definitions like (3),(4) and (5) can be made more specific, one may include arbitrary logical constraints. For example, to collect messages having a single argument-value greater than 10 one would write:

$$\{(s, arg) \mid s : message(arg) \rightarrow receiver, \text{ before } deadline, arg > 10\} \quad (6)$$

Given a relation $R = \{(a, x) \mid a \in Agent\}$ one can write that agent b sends x to a for all $(a, x) \in R$:

$$\forall(a, x) \in R \ (b : message(x) \rightarrow a) \quad (7)$$

Below we try to specify various cooperation method using these ideas.

3 Examples

3.1 Haggle

In this example we show a specification of a protocol for haggling or bargaining over a price. We start from the network specification shown in Figure 1, and we transform it to a a control structure in the extended Prolog-like language, and then we can add constraints on the contents of various messages:

$seller, buyer : haggle(price) =$
(1) $seller : propose(p) \rightarrow buyer,$
(2) $seller, buyer : continue_haggle(p, 0, price).$

$seller, buyer : continue_haggle(ask, bid, price) =$
(1) ($buyer : reject \rightarrow seller$
(2) | $buyer : counter(newbid) \rightarrow seller, bid < newbid < ask,$
(3) ($seller : reject \rightarrow buyer$
(4) | $seller : counter(newask) \rightarrow buyer, newbid < newask < ask,$
(5) $seller, buyer : continue_haggle(newask, newbid, price)$
(6) | $seller : accept \rightarrow buyer, price = newbid$
)
(7) | $buyer : accept \rightarrow seller, price = ask$
).

3.2 Pause for question

In human discourse, when one participant informs or explains something to the other participant, the speaker tells a part and then inserts a small pause to allow the other participant to take the initiative when he or she needs explanation. If the other does not act, the first participant, after a little while, continues. This example thus provides a model for a mixed initiative interaction:

$speaker, hearer : transfer([x|Rest])) : -$
(1) $speaker : inform(x) \rightarrow hearer,$
(2) ($hearer : request(y)$ **within** 1sec,
(3) $speaker, hearer : transfer(y)$
(4) | $not(hearer : request(y)$ **within** 1sec)
(5)),
(6) $speaker, hearer : transfer(Rest))$

This example clearly illustrates how our language can deal with time-dependent aspects of agent interaction. The next example shows a model involving sets of agents and coordination of both planning and execution of tasks.

3.3 Contract Net

In the well-known Contract Net Protocol [3,4] there is a manager agent who has a task and who wants to contract it to another agent. The manager first requests bids from a set of agents. Some or all of these "Workers" reply with a bid, and the manager selects the bidder with the best bid as contractor.

$manager, Workers : contractnet(task, deadline, better_eq, contractor, result) : -$
(1) $manager : request(task) \rightarrow Workers,$
(2) $Bids = \{(b, v) \mid b \in Workers, b : bid(v) \rightarrow manager$ **before** $deadline\},$
(3) $manager : (contractor, v) \in Bids,$
(4) $manager : \forall (b, v') \in Bids(better_eq((contractor, v), (b', v'))),$
(5) $manager : award \rightarrow contractor,$
(6) $manager : reject \rightarrow \{b \mid (b, v) \in Bids, b \neq contractor\},$
(7) $contractor : result_of(task, result),$
(8) $contractor : report(result) \rightarrow manager.$

Notes Line (6) is a contraction of:

(6.1) $manager : reject \rightarrow Rest$
(6.2) $Rest = \{b \mid (b, v) \in s, b \neq contractor\}.$

The *better_eq* parameter in the header stands for the name of a function that can be used to compare bids. It could be left out of the header and lines (3) and (4) could be replaced by something like:

(3') $manager : select_contractor(Bids, contractor),$
(4')

As a final example below we show how the language can be used in the design of a Computer Supported Cooperative Work application: a diary management system that helps a group of users to organize meetings.

3.4 Organize Meeting

Time is divided in a number of discrete intervals ("times") and the *organizer* asks a set of *invitees* which times of a set of possible meeting times they are free. The invitees can reply within a given time period and after that the organizer has, for example, data like below ('x' means free):

Alice	x		x	
Bob	x	x		
Charles				
Dianne		x	x	x
	t_1	t_2	t_3	t_4

First the organizer tries to select a time when all invitees are free. If there is no time when all are free, the organiser can use two strategies: (a) the organizer may select a time when most invitees are free and try to coerce the busy invitees to make themselves free, or (b) the organiser can try again with a different set of possible times.

$organizer, Invitees : org_meeting(meeting, PossTimes, timeout, time, Participants)$
(1) $organizer : propose(meeting, PossTimes) \rightarrow Invitees,$
(2) $FreeTimes = \{(i, T) \mid i : refine(T) \rightarrow organizer \textbf{ within } timeout,$
 $i \in Invitees, T \subseteq PossTimes\},$
(3) $SharedTimes = \bigcap(FreeTimes \downarrow 2),$
(4) ($SharedTimes \neq \emptyset,$
(5) $select_time(SharedTimes, time),$
(6) $organizer : meeting(time) \rightarrow Invitees$
(7) | $SharedTimes = \emptyset,$
(8) (here a call to a coercion method
(9) | $newtimes(PossTimes, NewPossTimes),$
(10) $organizer, Invitees : org_meeting(meeting, NewPossTimes,$
 $timeout, time, Participants)$
)
).

The operator $\downarrow n$ is called projection. If $X = \{(alice, \{t_1, t_3\}), (bob, \{t_1, t_2\})\}$, then $X \downarrow 2 = \{\{t_1, t_3\}, \{t_1, t_2\}\}$ and $\bigcap(X \downarrow 2) = \{t_1\}$.

4 Conclusion

The examples above show how the language can be used to specify complex examples in a succinct way. To a large extend it is due to the use of a logic programming language as a basis. Another important reason is the use of sets. Sets are a convenient means of expression for cooperations involving sets of agents, where agents belong to certain roles and when they can change roles. For

each role there is a set and role changes can be expressed as simple set operations. The use of sets to model roles and role changes has also been suggested for electronic conferencing systems [2].

Specifications in the language do not provide a complete description of behaviour. This has a reason: agents can be involved in many different cooperations in parallel and it is up to the individual agents to decide whether and how they will continue a certain cooperation. The protocols as specified provide the agent with legal moves, but they do not prescribe the move the agent should take.

The treatment of the formal language in this paper has been quite informal. In the future we hope to improve on this using graphs of sets of messages as an underlying model.

Acknowledgement This research has been partly funded by the European Community as ESPRIT project 5362 (IMAGINE). Partners in this project are: Imperial College, Intrasoft, Keele University, Roke Manor Research, Siemens, Steria and the University of Amsterdam,.

References

1. P. de Greef, D. Mahling, M. Neerincx, and S. Wyatt. Analysis of human-computer cooperative work. ESPRIT Project P5362 Deliverable D I.2, Leiden University, 1991.
2. F DePaoli and F. Tisato. A model for real-time co-operation. In L. Bannon, M. Robinson, and K. Schmidt, editors, *Proceedings of the Second European Conference on Computer-Supported Cooperative Work*, pages 203–218, Amsterdam, The Netherlands, 1991. Kluwer Academic Publishers.
3. R.G. Smith. The contract net protocol: High-level communication and control in a distributed problem solver. *IEEE Transactions on Computers*, 29:1104–1113, 1980.
4. R.G. Smith and R. Davis. Frameworks for cooperation in distributed problem solving. *IEEE Transactions on Systems, Man and Cybernetics*, 11:61–70, 1981.
5. T. Winograd. A language/action perspective on the design of cooperative work. In I. Greif, editor, *Cooperative Computer Supported Cooperative Work: A book of readings*. Morgan Kaufmann, 1988.
6. T. Winograd. Where the action is. *BYTE*, 1988.
7. T. Winograd and F. Flores. *Understanding Computers and Cognition*. Addison Wesley, Reading, MA, 1986.

Improving Operating System Usage

Martin Kramer

FernUniversität Hagen
Praktische Informatik II
Postfach 940
5800 Hagen 1, Germany

Abstract: In the area of 'Human Computer Cooperative Work' research is done to solve problems arising when humans and computers cooperate with each other in any combination. This paper emphasizes the aspect of cooperation between humans and computers. For novice and inexperienced users complex operating systems are still rather difficult to handle. Frequently, the knowledge about the structure and the functions of an operating system necessary to perform a particular task is not adequate to the intended task. The intelligent operating system interface IFOS cooperates with the user in order to compensate for his lack of knowledge. IFOS supports the user in formulating his tasks, and developing plans to perform these tasks, as well as it, on behalf, executes the chosen plans and monitors their execution. The paper discusses the concepts of a first IFOS kernel, which has been implemented as a user interface to a UNIX workstation.

1 Introduction

'Human Computer Cooperative Work' (HCCW) deals with problems arising when several humans work together and use their computers in doing this. There are three main topics concerned in this complex area. First, the cooperation of several humans has to be supported. Research in this area is subsumed by the name 'Computer Supported Cooperative Work' (CSCW). Second, the particular humans have to collaborate with their computer system. Much work in this area is done by researchers who develope user friendly interfaces, especially 'Intelligent User Interfaces' (IUI). Last, the involved computer systems should cooperate in autonomously performing low level tasks in order to take some of the load off their users. Similar problems are researched in 'Distributed Artificial Intelligence' (DAI). The goal of research in HCCW is to combine (and improve) the results of CSCW, IUI and DAI in order to get uniform, comprehensive systems being able to optimally support humans in cooperating with others as well as with their computers.

This paper mainly describes a system module to improve a user's work with his/her computer system, especially with the operating system. It discusses the main concepts of a part of our intelligent operating system interface IFOS (Interface For Operating Systems).

In spite of the progress made in the area of graphical user interfaces (e.g. Microsoft

Windows or X-Windows), to handle complex operating systems is still rather difficult for novice and inexperienced users. The knowledge (about the structure and the functions of an operating system) needed to perform a particular task is frequently not adequate to the intended task. In 1988, we started a project to develop an intelligent operating system interface, which compensates for these deficiencies. An initial study resulted in the following list of requirements: A complete intelligent operating system interface should

- provide the user with easy to use input facilities,
- provide well understandable output to the user,
- give individually customized explanations on user questions,
- syntactically and semantically correct incorrect user input,
- explain error situations on the semantic level of its users,
- advise the user how to use available commands,
- understand natural language input.

The above requirements refer to two main aspects of user interface design. On the one hand, there are requirements, which address technical communication facilities (e.g. easy to use input facilities, well presented output), on the other hand there is a need for new functions to increase the intelligence of such an interface (e.g. for explaining error situations or advising the user). Obviously, it is necessary to ensure a close cooperation between the user and the new intelligent components in order to enable every user to take full advantage of his computer system.

The paper is organized as follows. First, the design of the complete system is introduced. Having briefly described the tasks of each module, a kernel system selected from the overall structure is presented. Afterwards, we discuss the concepts of the individual modules of this kernel, which was implemented as a prototype. Last, we provide an overview, how the user negotiates his goals with the system.

2 The System Design

Figure 1 illustrates the overall structure of our interface design. The arrows in the figure express the relationship "uses functions from", or "initiates cooperation with" in case of cooperative components. Which of the components do work cooperatively or can be designed to work cooperatively, is discussed below.

The *user communication* module on top of the module structure provides all facilities for sophisticated user input/output. All communication between the user and the interface, or the operating system, is supported by this module. However, it merely provides technical support and establishes no cooperation with the user of its own.

The *correction* module tests the user input for (syntactical and semantic) errors and either corrects them automatically in easy cases or interacts with the user to fix ambiguities.

The *error handling* module explains a user, why an error (really) occurred. The *user advice* module advises a user how to fulfil a particular task. It negotiates a goal specification with the user, which satisfies the user's requirements as well as the abilities of the operating system.

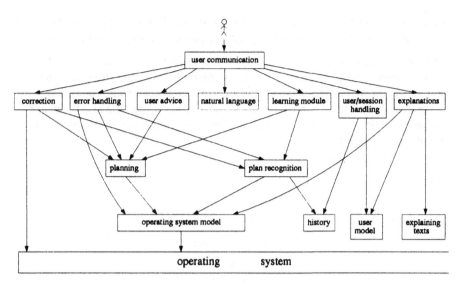

Fig. 1. The Overall Structure

The *planning* module constructs a command sequence to achieve a given goal.

The *plan recognition* module extracts the user's goal from a given command sequence. For this purpose, it can interact with the user to fix ambiguities.

The *operating system model* represents the planning domain, i.e. the underlying operating system interface.

The *learning* module gradually improves the planning knowledge of the system. It observes the user's actions, recognizes the user's goal and the corresponding plan, and compares the user's plan with a plan produced by the planning module. If the user's plan is the better one, the knowledge about this plan is kept in a planning knowledge base. It is further the task of the learning module to derive new standard plans from user actions.

The *user/session* module is responsible for all questions concerning the actual user and the actual session. It manages a *user model* for each user as well as a *history* object about the actual session. The user model and the history object allow other modules to customize their actions to the actual user and the actual session.

The *explanations* module supplies explanatory texts about the concepts of the underlying operating system, its interface, objects and commands. For this purpose, it uses information from the operating system model and the *explanatory texts* knowledge base. This knowledge base can be regarded as a sophisticated retrieval module for an extended on-line manual. It also uses the user model for customization purposes.

The natural language module is mentioned in the overall structure for completeness only. So far, the project does not address natural language input at all.

Principally, all modules on the first level below the user communication module are intended to cooperate with the user to improve their performance. The modules on

the medium level are conventional function modules. The modules on the last level are knowledge or databases providing other modules with necessary information.

Obviously, the above design is too complex as to realize the interface in a single step. So we designed a kernel system, which can easily be extended stepwise to the full system. As the kernel system was intended to become a working prototype as soon as possible as well as to support the user from the beginning, and since planning is the basic function needed for almost all intelligent services of the interface, the kernel system was designed as shown in figure 2.

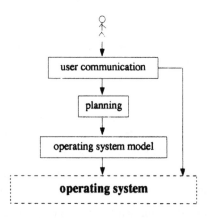

Fig. 2. The kernel system

The following chapters provide an overview over the general concepts underlying the modules of the kernel system, whereas cooperative aspects are emphasized.

3 The Communication Interface

The user communication module provides the user with a sophisticated textual and graphical input/output interface. As an example, figure 3 shows a UNIX interface as presented to the user. (As the graphic is a hardcopy of the german interface version, some general terms are in german.)

Since the communication module merely provides technical support, a detailed description is left out. For more information see [6].

4 The Planning Module

The planning module is the most important one with regard to improving the intelligence of the user interface. It serves as a basis for sophisticated user advice, and it is used by the correction and error handling modules for developing alternative plans, as well as by the learning module for judging user actions. Thus, the quality of the whole interface heavily depends on the quality of the planning module.

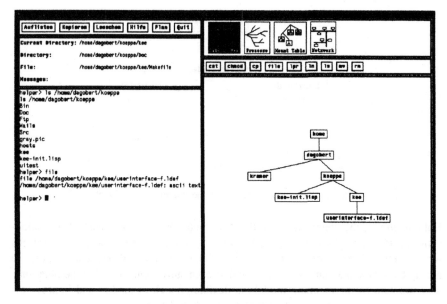

Fig. 3. The UNIX Communication Interface

The purpose of the planning module is to develop command sequences for achieving given goals. Its internal function corresponds to the role of a human expert, who suggests plans for a given problem. Thus, the module has to meet the following requirements. It has to be

- efficient enough to provide plans in due time, i.e.
 - standard problems should be solved quickly
 - solvable problems should be solved in reasonable time with regard to the difficulty of the particular problem
 - unsolvable problems should be recognized early

- flexible enough
 - to react on a variety of planning problems
 - to meet the requirements of all modules in the final implementation.

Unfortunately, none of the known planning methods is able to completely meet all these requirements. Therefore, our approach is a combination of two planning methods, namely of hierarchical planning [10] and scriptbased planning [2]. In our combination, which we denote as *script-supported hierarchical planning*, the hierarchical approach guarantees a fast solution of solvable problems as well as an early recognition of unsolvable problems. Scriptbased planning is used to react as fast as possible on standard problems.

Figure 4 illustrates the modularisation of the planning component.

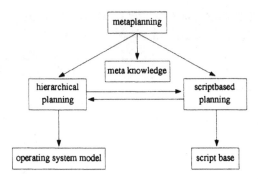

Fig. 4. The modularisation of the planning component

Both planning subsystems are controlled by a metaplanning component. This component decides on the basis of knowledge about goal characteristics and stored scripts, which method looks more promising. Switching between both methods is possible during the whole planning process as well as each subsystem can enlist the other one. The structure of the planning module is flexible enough to modify and improve the existing components or to add new methods when required.

Naturally, such an approach requires compatibility between the structures representing operators and scripts. In order to achieve this compatibility, we decided to represent nonlinear plans through sequential and parallel operator groups. An operator group itself may contain single plan operators as well as operator groups of the opposite kind. Though this construction does not allow to represent arbitrary operator sequences, it does not restrict the set of solvable problems.

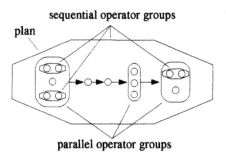

Fig. 5. The plan representation structure

We define a script as a sequential operator group with its own pre- and postconditions. This definition has the advantage, that a script may be treated as a macro operator, which in turn implies, that the hierarchical planning submodule already contains almost all functions needed for scriptbased planning. Furthermore, this approach guarantees easy cooperation between hierarchical and scriptbased planning processes.

Scripts can be used in each hierarchical planning step, scripts with abstract operators can be refined by methods of the hierarchical planning submodule.

The concept of hierarchical planning is to generate a 'rough' plan on a high level of abstraction first and then to refine this plan stepwise to a concrete plan. This proceeding has the advantage, that only a limited amount of details has to be considered simultaneously, which implies an acceleration of the planning process.

Hierarchical planning systems use abstract operators on various planning levels. In conventional hierarchical planning systems, abstract operators are either concrete operators with less preconditions or fixed operator sequences, i.e. in fact they are merely macro operators. Unfortunately, these approaches do not work in problem domains with numerous operators like operating systems. Thus, we had to develop a new method to create abstract operators [7, 8]. In our approach, we automatically generate a type hierarchy of operators (see fig. 6), where an abstract operator subsumes all the effects possibly resulting from any combination and variation (due to possible options and parameters) of its constituting more concrete operators. Thus, as opposed to other approaches (e.g. [1, 5]), our abstract operators do not solve just a particular problem, but represent an abstract solution for a class of similar problems. They are well suited for use in a nonlinear, hierarchical planning process.

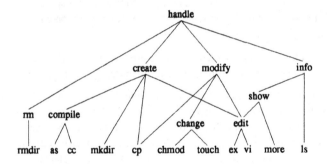

Fig. 6. An example UNIX operator hierarchy

Our abstraction method has some desirable properties:

- The number of operators considerably decreases from abstraction level to abstraction level.
- Unsolvable problems can be recognized at a very early stage of the planning process.
- The abstraction method enables an efficient representation of command options. It merely takes an effort linear to n to describe an operator with n options and all possible option combinations.
- As abstract operators are allowed to be contained in scripts, it is easy to extend the planning system by a casebased reasoning component. Scripts with abstract operators are well suited to represent solutions for classes of similar problems.

The task of the metaplanning submodule is to select the best planning method for each problem. We believe, that a rulebased system is best suited to fulfil this task. So the metaplanning is based on rules like:

- If the goal specification is very brief, then the corresponding plan will probably be very short as well (one or two operators) and therefore probably no suitable script is stored (since it is not worthwhile to store very brief scripts).
- If the best choice is not obvious, the standard approach is to try scriptbased planning first, and (if no suitable script exists) to use hierarchical planning afterwards.

The design of the metaplanning component is very flexible. A rule base is easy to modify, if additional knowledge about the special problem domain is available or if a complete planning method is to be added or removed.

5 The Operating System Model

The operating system model serves as a knowledge base, which provides all other modules with necessary information about the underlying operating system. In our current kernel system, its task is especially to inform the planning module and the communication module about the current operating system state, and to inform the planning module about the operators available. Since some response time constraints have to be met by the planning module, the knowledge in the operating system model has to be structured efficiently.

Operating systems are represented by structured objects. This method allows to specify objects, operators, system states and planning problems in a uniform way.

The rigid separation between the model module and the other modules, realizing task specific functions, enables the interface to be applied to other problem domains as well. By simply exchanging the model module, IFOS can be used e.g. as a user interface for DOS or VMS, a front-end for construction and manufacturing planning systems, or even as an intelligent control system for power plants.

As the construction of abstract object classes and abstract operators is of interest for every cooperative system, a short description of the used formalisms is given in the following.

5.1 Basic Modelling Concepts

The problem domain is represented by (model) states and operators. A state is a set of objects. Operators may add or remove objects to/from the set, or change object attributes. Objects are instances of object classes. We use the following terminology:

- A pair (attr-name,domain) is called an *attribute space* (as);
- A finite set of uniquely named attributes is called a *structure* (struct);
- A pair (class-name,structure) is called an *object class* or *class* (ocl);
- A valid *object attribute value* is a subset of its domain.

Two attribute spaces as_1 and as_2 are *comparable*:

$$as_1 \approx as_2 ::= \text{attr-name}(as_1) = \text{attr-name}(as_2)$$

Object classes may be related to each other. In contrast to object oriented programming, in our approach a subclass is more specific than its superclass:

Let $ocl_1 = (name_1, struct_1)$ and $ocl_2 = (name_2, struct_2)$ be object classes. Then ocl_1 is a *subclass of* ocl_2 (and ocl_2 is a *superclass* of ocl_1):

$$
\begin{aligned}
ocl_1 \sqsubseteq ocl_2 \quad &::= \quad struct_1 \prec struct_2 \\
struct_1 \prec struct_2 \quad &::= \quad \forall as_1 \in struct_1 \, \exists as_2 \in struct_2 : \\
& \qquad as_1 \preceq as_2 \wedge struct_1 \neq struct_2 \\
as_1 \preceq as_2 \quad &::= \quad as_1 \approx as_2 \\
& \qquad \wedge \text{ domain}(as_1) \subseteq \text{domain}(as_2)
\end{aligned}
$$

Object classes are *comparable* ($ocl_1 \approx ocl_2 \approx \cdots \approx ocl_n$):

$$\exists ocl : \forall ocl_i \in (ocl_1, \ldots, ocl_n) : ocl_i \sqsubseteq ocl$$

Planning systems need a declarative, formal semantic description of their operators. In state space representations, the semantics are described by pre- and postconditions on system states. Conditions may either reference state components or operator parameters (starting with a $ symbol).

An *attribute condition* (ac) on an attribute attr is a tupel (attr-name,rv,iv) with rv, iv \subseteq domain(attr) and $rv \cap iv = \emptyset$. The sets rv (required values) and iv (invalid values) determine the *set of valid values*:

$$VV_{ac} ::= \{ vv \subseteq dom \mid vv \cap rv = rv \wedge vv \cap iv = \emptyset \}$$

For instance, (access,{r},{x}) is an attribute condition which specifies, that the regarding object has to be readable, but must not be executable. Hence, with dom = {r,w,x} only {r} and {r,w} are valid values.

As a shorthand, the @ symbol means "domain \ iv" when being used as rv-component and "domain \ rv" when used as iv-component.

An *object condition* is a tupel (obj-ref,class,attribute-conditions), where obj-ref denotes an access mechanism which, when applied to a state, provides access to an object.

For instance, the description of an action which sets the attribute 'access' of a file object to 'readable and writable' could read:

```
($file,file,{(access,{r,w},@)})
```

The existence of objects can be specified in the following way: The condition

```
(obj-ref,class,{(exist,{f},{t})})
```

is true, if obj-ref does not reference an existing object, the condition

```
(obj-ref,class,{(exist,{t},{f}),
        further attribute-conditions})
```

is true, if obj-ref references an object which meets the additional attribute conditions.

If it is the task of an operator to provide information about the attributes of an object, the postcondition for that operator contains an object condition of the form

```
(obj-ref,class,{(info,{attr-names},@)}).
```

A *state condition* is a finite set of object conditions. The semantics of operators are described by pre- and postconditions, which themselves are specified by state conditions. The following example illustrates the description of an operator, which lists the contents of a text file.

```
pre: {($tfile,text-file,{(exist,{t},{f})
                         (access,{r},{})})}

post: {($tfile,text-file,{(info,{content},@)})}
```

The model description is very simple and based on few general concepts. Yet, it allows the description of all relevant properties of an operating system in rather brief terms and allows to specify complex computation rules in terms of simple set operations. For more information, especially about variable handling and the description of 'recursive' operators, see [6].

5.2 Operator Abstraction

The basis of our abstraction algorithm are *purpose descriptions* describing the effect of an operator on a very abstract level. They can be automatically derived from an operator's pre- and postcondition. We assume:

- Each operator refers to a single main object, called its *central object*.
- All operations an operator may perform on its central object can be grouped into the *purpose types* create, destroy, modify, and info (= retrieve information).

Depending on its type, an operator *purpose* is specified by one of the following schemes:

- create *<class>* [*<inputclass>*]: create a *<class>* object, possibly using an input object.
- destroy *<class>*: destroy a *<class>* object.
- modify *<class>* *<set-of-attr-names>*: change attributes of an object.
- info *<class>* *<set-of-attr-names>*: retrieve information about attributes of an object.

A purpose description may include several purposes.

Purpose descriptions are used to define several degrees of similarity between operators. Generally, operators are the more similar the better their purpose descriptions match:

Let $op_1,...,op_n$ be operators with sets-of-purposes $purp_1,...,purp_n, p_i \in purp_i$ be a purpose of operator op_i, and $p = (p_1,...,p_n)$.
$op_1,...,op_n$ are *type-i-similar-with-regard-to-p*, $i = 1,...,4$:

$$\overset{1}{\sim}(op_1,...,op_n)(p) \quad :\Leftrightarrow \quad \exists p_1 \in purp_1,...,p_n \in purp_n : p_1 = ... = p_n$$

$$\overset{2}{\sim}(op_1,...,op_n)(p) \quad :\Leftrightarrow \quad \exists p_1 \in purp_1,...,p_n \in purp_n :$$
$$type(p_1) = ... = type(p_n)$$
$$\wedge\, class(p_1) = ... = class(p_n)$$

$$\overset{3}{\sim}(op_1,...,op_n)(p) \quad :\Leftrightarrow \quad \exists p_1 \in purp_1,...,p_n \in purp_n :$$
$$type(p_1) = ... = type(p_n)$$
$$\wedge\, class(p_1) \approx ... \approx class(p_n)$$

$$\overset{4}{\sim}(op_1,...,op_n)(p) \quad :\Leftrightarrow \quad \exists p_1 \in purp_1,...,p_n \in purp_n :$$
$$class(p_1) \approx ... \approx class(p_n)$$

Operators are *similar*, if they are similar of type i, i=1,...,4.

Using these various degrees of similarity, the abstraction algorithm combines stepwise the abstraction hierarchy of operators (see fig. 6).

As mentioned above, an abstract operator subsumes all the effects of its constituting more concrete ones. We briefly describe the definitions used to generate abstract postconditions.

As postconditions (i.e. state conditions) are structured, it has to be determined first, which of the substructures can be combined, and which not: Attribute conditions $ac_1,...,ac_n$ are *comparable*: $ac_1 \approx ... \approx ac_n := attr\text{-}name(ac_1) = ... = attr\text{-}name(ac_n)$. Object conditions $oc_1,...,oc_n$ are *comparable*: $oc_1 \approx ... \approx oc_n := obj\text{-}ref(oc_1) = ... = obj\text{-}ref(oc_n) \wedge class(oc_1) \approx ... \approx class(oc_2)$. The following definitions lead step by step to the notion of an abstract union of state conditions, which is used to construct postconditions of abstract operators.

The sets of valid values specified by attribute conditions restrict the domain of an attribute in two ways: by stating required domain elements and by stating forbidden domain elements. In order to combine attribute conditions, both components have to be considered separately. For combining them in such a way, that the result does contain only those restrictions the initial attribute conditions have in common, the corresponding rv- and iv-components have to be intersected: Let $AC = \{ac_1,...,ac_n\}$ be a set of comparable attribute conditions. Then their *abstraction* is:

$$\bigodot_{i=1}^{n} ac_i := \left(attr\text{-}name(ac_1), \bigcap_{i=1}^{n} rv(ac_i), \bigcap_{i=1}^{n} iv(ac_i) \right).$$

For two operands, the infix notation $ac_1 \odot ac_2$ can be used as well.

For instance, let $ac_1 = (access, \{r,w\}, \{\})$ and $ac_2 = (access, \{r\}, \{x\})$ be attribute conditions from different postconditions addressing the same object. Then their abstraction is $(access, \{r\}, \{\})$.

Object conditions include sets of attribute conditions. Therefore, it has to be defined first how to abstract attribute condition sets: Let $AC_1, ..., AC_n$ be finite sets of attribute conditions, and let be $i,j \in 1, ... n$. Then, their *abstract union* is:

$$AC_i \sqcup AC_j := AC_i \sqcap AC_j$$
$$\cup \{ac_i \in AC_i \mid \not\exists ac_j \in AC_j : ac_j \approx ac_i\}$$
$$\cup \{ac_j \in AC_j \mid \not\exists ac_i \in AC_i : ac_i \approx ac_j\}.$$

and:

$$\bigsqcup_{i=1}^{n} AC_i := AC_1 \sqcup ... \sqcup AC_n.$$

The following definitions are straightforward: Let $OC = \{oc_1, ..., oc_n\}$ be a finite set of comparable object conditions. Then their *extending abstraction* is:

$$\bigotimes_{i=1}^{n} oc_i := \left(obj-ref(oc_1), \bigotimes_{i=1}^{n} class(oc_i), \bigsqcup_{i=1}^{n} acs(oc_i) \right),$$

where $\bigotimes_{i=1}^{n} class(oc_i)$ is a function to determine the appropriate object class of the abstract object condition. For two operands, the infix notation $oc_1 \otimes oc_2$ is used as well.

Corresponding to the abstract union of attribute condition sets, we define: Let $OC_1, ..., OC_n$ be state conditions and $i,j \in 1, ... n$. Then their *abstract union* is:

$$OC_i \sqcup OC_j :=$$
$$\{oc \mid oc = oc_i \otimes oc_j, \forall oc_i \in OC_i, oc_j \in OC_j : oc_i \approx oc_j\}$$
$$\cup \{oc_i \in OC_i \mid \not\exists oc_j \in OC_j : oc_j \approx oc_i\}$$
$$\cup \{oc_j \in OC_j \mid \not\exists oc_i \in OC_i : oc_i \approx oc_j\}.$$

and:

$$\bigsqcup_{i=1}^{n} OC_i := OC_1 \sqcup ... \sqcup OC_n.$$

Let, for instance, $post_1$ and $post_2$ be

```
{($fse,directory,{(access,{$rights},@)})}
```
and
```
{($fse,file,{(source,{sfile},@)})}.
```

Then $post_1 \sqcup post_2$ results in:
```
{($fse,fs-element,{(access,{$rights},@)
                   (source,{sfile},@)})}
```

Abstract preconditions are defined in an analogous way mainly by exchanging 'union' operators by 'intersection' operators.

A detailed description of the abstraction method is contained in [7].

5.3 Representation of Operators with Options

When representing problem domains like operating systems, it is important not only to establish an efficient representation for lots of operators, but to find an adequate representation for valid combinations of options as well. A method to consider options is to create a new operator for each option and each option combination. Although this simple method is rather frequently used, it is not really applicable, since it requires 2^n different operator descriptions for an operator with n options. For example, the UNIX-command 'cc' with about 18 options would need more than 250,000 complete descriptions. Even if not every possible combination is valid, there would still be several thousands of operator descriptions needed to represent just a single UNIX command. Hegner [3] describes a different method. He uses a basic description of the optionless command and for each option specifies the modifications the option causes. This solution indeed diminishes the descriptions to a number linear to the number of options, but only allows to specify effects of single options or of combinations of independent options. Thus, in more general cases this method is not applicable either.

We developed a specification method for operators with n options, which requires only $O(n)$ different description elements and at most than $O(n)$ algorithmic steps to decide whether an operator is suited for a particular task and which option combination to choose. The basic idea is to describe an operator with options as an abstract operator which subsumes the effects of all possible operator-option-combinations and then to add option specifications describing restrictions with regard to the (new) operator's abstract pre- and postconditions. (A paper describing more details is in preparation.)

6 Goal Negotiation

IFOS is intended to support especially novice and inexperienced users. One of its main features is to find solutions for user defined tasks. But, how should a user define his task precisely, if he does not know very much about the system? Of course, he will have some imagination about the things he wants to do, but if he exactly knew he would not need a support at all. Thus, IFOS and the user have to cooperate to define a task formulation which satisfies user's wishes as well as requirements of the system concerning correct denotations, existence of addressed objects, etc.

Formally, a goal specification is a state condition. This allows to negotiate goals as follows. The system offers a set of objects on the highest abstraction level to the user. Starting with one of these objects, the user can go down within the abstraction hierarchy and select that object fitting best for his purposes. Afterwards, the object's attributes are presented. Having selected the desired attribute(s), the system provides information about possible attribute values and checks the user input against validity. This process is iterated until the goal description is complete.

7 Summary

This paper provides a conceptual overview over our current project IFOS. Having introduced the overall structure, we discussed some new concepts of those modules, which together form the current kernel for the future complete system.

A prototype of the kernel system has been implemented in 1990 with the software development tool KEE 3.1 on a Sun 3/60 machine under the UNIX operating system SunOS 4.0.3. This prototype proofed the validity of the concepts. Presently, making use of our experiences with this first prototype, we reimplement an improved kernel system for Sun Sparcstations under Solaris.

We aim to extend our system step by step to the full interface. Currently, a plan recognition module is under research [9]. Besides, we intend to apply our planning module to a variety of different problem domains. For instance, we started a discussion for integrating IFOS and STRICT, a blackboard based DAI advisory system supporting the design of distributed production planning and control applications [4].

References

1. Fink, E., and Yang, Q. Automatically abstracting the effects of operators. In *Artificial Intelligence Planning Systems: Proceedings of the First International Conference (AIPS92)* (College Park, Maryland, June 1992), J. Hendler, Ed., Morgan Kaufmann.

2. Friedland, P. Knowledge-based experiment design in molecular genetics. In *Proceedings of the 6th International Joint Conference on Artificial Intelligence, IJCAI-79* (Tokyo, Japan, August 22-25 1979), pp. 285-287.

3. Hegner, S. J. Plan realisation for complex command interaction in the UNIX help domain. Technical report, Department of Computer Science and Electrical Engineering University of Vermont, Burlington VT 05405, 1989.

4. Kirn, S., and Schneider, J. STRICT: Selecting the "right" architecture. In *Industrial and Engineering Applications of Artificial Intelligence and Expert Systems: Proceedings of the 5th International Conference , IEA/AIE-92* (Paderborn, Germany, June 1992), F. Belli and F.-J. Rademacher, Eds., no. 604 in Lecture Notes in AI, Springer, pp. 391-400.

5. Knoblock, C. *Automatically Generating Abstractions for Problem Solving.* PhD thesis, School of Computer Science, Carnegie Mellon University, 1991.

6. Kramer, M. *Ein planungsorientiertes Betriebssystemmodell (A Planning-Oriented Operating System Model).* PhD thesis, University of Hagen, 1990. Published 1991 by Verlag Dr. Kovac, Hamburg. *In German.*

7. Kramer, M. Type-oriented operator abstraction for hierarchical planning. *Submitted for publication,* May 1992.

8. Kramer, M., and Unger, C. Abstracting operators for hierarchical planning. In *Artificial Intelligence Planning Systems: Proceedings of the First International Conference (AIPS92)* (College, Maryland, June 15-17 1992), J. Hendler, Ed., Morgan Kaufmann.

9. Pleschka, S., and Unger, C. Planerkennung zur Unterstützung von Mensch-Computer-Dialogen. Research report 123, University of Hagen, February 1992.

10. Sacerdoti, E. D. The nonlinear nature of plans. In *Proceedings of the 4th International Joint Conference on Artificial Intelligence* (1975), pp. 206-214.

The role of user models for conflicts in a constraint-based model of generation

Matthias E. Kölln

Universität Hamburg
Fachbereich Informatik
AB Natürlichsprachliche Systeme
Bodenstedtstraße 16
D-2000 Hamburg 50
e-mail: koelln@nats4.informatik.uni-hamburg.de

Abstract. In recent natural language generation research there has been a push towards representing knowledge in a declarative and modular way, resulting in constraint-based architectures for generators. This paper discusses the role of information about the user in a constraint-based model of text generation. We describe an application where it is crucial for the system to anticipate the user's interpretation process. Given this setting we investigate conflicts in the generation process that are due to information about the user. We demonstrate how conflicts arise and we try to point out solutions for them. Finally, we briefly present directions for future research.

1 Introduction

After a long time of natural language research dealing almost entirely with analysis, the number of activities in the field of natural language generation has considerably grown in recent years.[1] A variety of different applications like text generators, expert system interfaces and generation components of dialog systems have been developed. Nowadays it is hardly possible to compare these approaches because of different methods that are adopted in building the systems. Furthermore, there is a certain lack of clarity about the suitable initial structures and the nature of the decisions involved in natural language generation at all (Dale et al. [4]). As Paris/Maier [24] point out, it is a frequent weakness of current approaches to text generation that the set of alternatives is not sufficiently restricted by the resources themselves, thus rendering an eventual decision more complex than necessary. Consequently, Paris/Maier argue for a clear separation of declarative knowledge (resources) and procedural knowledge (decisions[2]). By expressing the resources as well as their interactions in terms of constraints, the entire generation process can be thought of as uniformly as planning. This approach enhances the modularity and transparency, and furthermore, conflicts occuring between text planning and sentence planning are avoided.

[1] For an excellent overview see Kempen [15].

[2] A decision is defined as a choice made by the system where the information provided by the resource is not sufficient to make one distinct choice.

Hovy et al. [9] describe a text planner which follows the outlined paradigm. The authors distinguish between two different kinds of resources. First, there are resources that contain information about the order of some planning operations. Currently, these resources are:

1. *Discourse relations* must hold between sentences or segments of text in order for a text to be coherent.
2. *Theme development information* describes the potential theme developments and shifts of focus.

These resources are implemented as systemic networks. Second, there are resources that provide information which the planner uses to make decisions. So far there are three of these resources which are implemented as property-inheritance networks:

1. *Text types* represent the genre of a text.
2. *Communicative goals* are descriptions of the speaker's discourse purpose.
3. *Schemata* consisting of several communicative goals capture a stereotypical text structure.

Each node in either type of network is associated with one or more *realization operators* which indicate the effects of choosing the node. Through these realization operators the resources impose constraints on each other. Text planning starts from a communicative goal which describes the discourse purpose. Next, a text type is selected that entails constraints for the following generation process. In the basic planning cycle the realization operators are processed until there remain no more discourse goals on the planner's goal stack and a complete *discourse structure* has been built.

The remainder of this paper investigates the role of knowledge about the user in a constraint-based architecture like the one of Hovy et al. [9]. After a short survey of approaches in the field of exploiting user models for natural language generation, an application with specific requirements in this area is presented. The central part of the paper examines conflicts in a constraint-based model of generation that are caused by information about the user. Finally, we briefly present directions for future research.

2 User modeling for natural language generation

User models have been utilized for text planning as well as for (grammatical) realization. A classical work of the former is the TAILOR system by Paris ([23]), where definitions of complex physical entities are tailored to the individual user depending on his domain knowledge. Paris [23] states that the user's level of domain knowledge not only affects the amount but also the kind of information to be conveyed. She has developed two different discourse strategies that are biased towards naive and expert users. By dynamically mixing the strategies it is possible to provide responses to users anywhere along the knowledge spectrum.

Another important system is the ROMPER system by McCoy ([19]), which corrects misconceptions (misclassifications or misattributions) of the user. According to the kind of misconception the system selects one of several strategies associated with each class of misconception to generate a response.

A recent approach by Bateman and Paris [2] tries to tailor even the phrasing to the individual user. The authors employ registers which specify usage patterns for different classes of users and sub-grammars to describe the dependencies between the user and the syntactic form of an utterance. The approach of Reiter [25] allows the customization of object descriptions according to the user's domain and lexical knowledge. The resulting descriptions are accurate (truthful), valid (fulfill the speaker's communicative goal) and free of false implications (do not give rise to unintended conversational implicatures).

A special case of exploitation of the user model is its use in *anticipation feedback loops*. Natural language systems (e.g. dialog systems) containing anticipation feedback loops use their analysis and interpretation components to simulate the user's interpretation of an utterance which they try to verbalize. The HAM-ANS system (Jameson/Wahlster [12]) adopts this strategy to ensure that the system's utterances are not too short and thus possibly ambiguous or misleading. Cawsey [3] uses plausible inference rules which guess what the hearer could infer given a particular statement for the generation of concise or biased object descriptions. Zukerman [28] demonstrates the exploitation of a user model for the anticipation of possible learning impairments in the tutor-system WISHFUL. Her system employs forward inferences to evaluate the impact of an intended message on the user while backward chaining is utilized to generate rhetorical devices that counteract learning impairments which are likely to take place. However, these processes are separated from the text organization which renders her approach less general.

After some years of research concerning the exploitation of user models for natural language generation there are two different views on this topic:

1. The "conservative" position of Sparck Jones [13] and Moore/Swartout [22].
 The authors claim it to be unlikely that systems are able to build a complete and correct user model. Therefore, the exploitation of information about the user for generation purposes should be carefully constrained. Otherwise, there is a great danger of mistakes that, in the long run, are critical for the acceptance of the systems.

2. Approaches that heavily rely on exploiting user models for generation, e.g. Cawsey [3] and Zukerman [28].
 These approaches investigate scenarios where the information about the user is instrumental for successful communication. Therefore, the authors argue for an intensive exploitation of user models despite the possibility of errors. Cawsey [3] for example points out, that as long as the user can ask follow-up questions in a dialog, none of those errors are really crucial. Furthermore, by correcting misconceptions of the system the user supports the system with new information.

As we will show in the next section, the exploitation of a user model is of special concern in the communicative setting we are investigating. Therefore, we will adopt the second view in the remainder of the paper.

3 Biased object descriptions

Kölln [16] investigates a conversational setting that is similar to the *evaluation-oriented dialogs* Jameson [11] is concerned with. There are two participants in the discourse, the speaker acting as an informant and the hearer acting as an evaluator. The task at hand for the speaker is to volunteer information about some journal. More specifically, the speaker intends to establish a positive impression of the journal in order to win a new subscriber. To behave appropriately, the speaker must be able to make some reasonable assumptions concerning the evaluation standards of the hearer. For instance, the speaker has to anticipate which topics the hearer is likely to be interested in. He must be anxious to infer as well as change (if necessary) the attitudes of the potential customer. In doing so he is not obliged to be honest or cooperative.[3] Thus the speaker will rarely volunteer information about a journal which cause an impression shift in the negative direction even if this comment is highly relevant for the customer.

While the speaker has a strong dialog motivation, there is little possibility to predict the motivation of the hearer. At the beginning of the discourse his attitude towards subscribing to a journal can be positive as well as negative. This possible lack of hearer's interest in the topic contrasts to the situation Jameson [11, section 3] describes and raises some important consequences for the speaker, as we will see in section 4.4.

In order to investigate conflicts arising from this scenario, we want to make use of a constraint-based text generator shown in Figure 1:

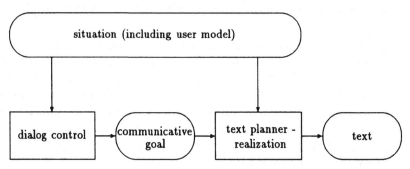

Fig. 1. Architecture of a hypothetical constraint-based text generator

[3] This is the most important difference to the related work of Sarner/Carberry [26] who present a strategy for the generation of definitions in task-oriented dialogs. The approach draws on a dynamically inferred model of the user's domain knowledge, task-related plans, and receptivity to different kinds of information.

Like Moore/Swartout ([22]) we believe that the tasks of determining the text content and building the text structure are mutually dependent. The text generator has to choose what to say from the knowledge base as well as how to turn it into a coherent text. As shown in Figure 1, we enhance the architecture of Hovy et al. [9] by introducing a hypothetical component for dialog control which also contains the system's problem-solving knowledge. This component determines a communicative goal from an abstract representation of the situation which consists of:

- The domain knowledge relevant for the situation.
- Knowledge about the discourse participants and their relationship: The system model most importantly contains the discourse purpose like selling a suitable journal to the user or selling one particular journal at any price. Following Kass/Finin [14] the user model consists of four kinds of knowledge:

 1. The *goals* of the user which do not appear to be very important in this setting.
 2. The *capabilities* of the user like having enough money to buy a particular journal.
 3. Most importantly, the user's *attitudes* towards the relevant concepts in the domain under consideration. These anticipated evaluation standards of the user comprise the user's preferences like his special areas of interest as well as his attitudes towards prominent properties of the journals. In general, these features serve as *decision-properties* (Sparck Jones [13]) in the reasoning process of the system.
 4. The *knowledge* and *beliefs* held by the user: The user's general world knowledge, his domain knowledge and his knowledge about other agents.

- Features concerning the communicative setting and the function of the text. These features subsume the time which is available for communication as well as the role of language in the discourse. While a speaker's goal mirrors his real intentions, the language role specifies how a hearer perceives the text on the surface (Bateman et. [1]). Although the language role and the speaker's goal look very similar (e.g., either informing or convincing) the values of both factors might deviate as we will show in section 4.3.

We will assume that the above specification of the situation is defined declaratively and furthermore, that our hypothetical system can draw on this specification as well as on the resources Hovy et al. [9] have identified.

Before we can start a case study of conflicts arising in our constraint-based model of generation, we have to present two basic definitions. First, we define a *constraint* as a relation on a set of variables. Secondly, we define the *solution of a constraint satisfaction problem* as an assignment of values to every variable so that all constraints are satisfied for this value combination.

For the sake of simplicity, we only want to employ a small set of variables that have proven useful in various generation systems (cf. Hovy [7] and

Moore/Swartout [22]). These variables represent *restrictive goals* (cf. Hovy [8]) that enable the text generator to select from a number of acceptable options:

- **user's opinions of the topic** — *good, neutral, bad*
 This variable summarizes the result of a complex evaluation process which indicates the suitability of some journal for the user. By comparing the anticipated areas of interest with the content of some journal, the problem-solving knowledge determines a value for the **user's opinions**. As a default, the system tries to find a journal the user will probably like.
- **time** — *much, some, little*
 The time available for generating an utterance. As a default, the system uses **time** = *little*.
- **system's actual opinions of the topic** — *good, neutral, bad*
 This variable indicates the attitudes of the system towards the topic of discussion. As a default, the system uses **system's actual opinions of the topic** = *good*.
- **system's projected opinions of the topic** — *good, neutral, bad*
 This variable indicates the attitudes the system wants the user to perceive. The assignment of a value to this variable involves the anticipation of the user's evaluation process. As a default, the system uses **system's projected opinions of the topic** = *neutral*.
- **verbosity** — *verbose, terse*
 This variable represents a stylistic goal ("be verbose"). Like a similar selection heuristic outlined in Moore [21, page 147], this variable controls the inclusion of optional material into the text. As we will show, the value of the variable is constrained by the value of some other variables.
- **coherency** — *high, low*
 This variable also represents a stylistic goal ("be coherent"). Just like it is the case for the **verbosity** variable, there is a corresponding selection heuristic by Moore [21, page 146].

4 Conflicts in a constraint-based model of text generation

A conflict according to our underlying constraint-based model of generation arises when constraints given in a situation do not allow a successful termination of text planning, thus causing the generation process to fail. For instance, if the attitudes of the system and the user are incompatible there might be nothing left to say for the system.[4]

As a strategy for recovery either one or more constraints have to be relaxed, or variables relevant to these constraints have to be instantiated to alternative values. This utilization of backtracking results in a depth-first search of the space of possible utterances. However, for natural language generation we need more efficient and more intelligent strategies.

[4] This situation is described in detail by Hovy [7].

4.1 A conflict with reference to the selection of the content of an utterance: The situation doesn't allow a suitable selection of information.

A reasonable strategy for the speaker is to select a suitable journal for his potential customer. So, the speaker has to compare his assortment with the anticipated evaluation standards of the hearer. If he realizes that he has no suitable journal at his disposal he has at least two alternatives. Either he can give up on his selling efforts or he can try to sell just any journal without considering the hearer's characteristics.

A similar kind of strategy is utilized in the approach of Moore/Swartout [22, page 22] on explanation facilities for expert systems. Moore/Swartout treat constraints that refer to the user's knowledge not as rigid constraints but as uncertain assumptions of the system. As a default, the text planner prefers choosing operators that require no assumptions to be made.[5]

Within our architecture, the conflict indicates that the dialog control is not able to derive a communicative goal from the representation of the situation. The dialog control has taken **user's opinions of the topic** = *good* as a default when searching in the knowledge base. However, because there are few correspondences between the user's areas of interest and the content of the journals the search for a suitable journal fails. In order for the dialog to be continued the requirement on the **user's opinions** has to be weakened to **user's opinions of the topic** = *neutral* (and possibly, to *bad*) to find a solution. To use this strategy of *intelligent backtracking*, there has to be an evaluation criterion comprising the relevance of situation parameters, crucial for solving the conflict. Furthermore, there has to be a distinction between *hard* constraints that are required to be satisfied referring to the situation and *soft* constraints that are less strict. As we have seen in this section, information from the user model is likely to be taken as a default and thus to be expressed in terms of soft constraints. Relaxing these constraints reduces the system's sensitivity to the individual user, but might enable the system to continue the discourse in a sensible way.

4.2 A conflict with reference to the selection of the level of detail: The achievement of the communicative goal takes more time than would be suitable in the situation at hand.

Due to time limitations the speaker is forced to make a very concise and adequate selection of content. Instead of including all available information about some journal into the description, the speaker has to restrict his contribution to those things that are absolutely necessary to achieve his goal. Possibly, he has to give

[5] However, under certain circumstances an operator that requires one or more assumptions to be made might be chosen. In these cases, the assumptions are recorded because they are likely candidates for misunderstanding. If the user asks a vaguely-articulated follow-up question indicating a lack of understanding, the system plans to make these assumptions true.

up the text coherence, resulting in a loose enumeration of informations about some journal.[6]

For the necessary selection processes several guidelines have been proposed. Sarner/Carberry [26], investigating cooperative dialogs, suggest a *principle of usefulness* for the user to find out the appropriate level of detail. Cawsey [3] and Horacek [6] on the other hand argue for employing common-sense rules to allow the implicit and thus effective presentation of information.

In our model there is a conflict between constraints according to the variables **time** and **user's opinions of the topic**. On one hand, there is little time for the text generator to achieve its discourse goal. So, the text has to be terse (**verbosity** = *terse*). On the other hand, if the **user's opinions** are assumed to be *bad*, the text has to be verbose (**verbosity** = *verbose*), resulting in an elaborated utterance. In our scenario the constraint on the **time** variable is considered hard and a terse text will be generated.

In addition to the constraints outlined, plausible inference rules have to be employed for the selection of information. Using these devices when selecting schemata or communicative goals, the system anticipates which information is most relevant for the user,[7] and how it can be expressed in a concise way. After the verbalization appropriate constraints can be used to block the further elaboration of the utterance. It should be noted that this strategy establishes the need for the generation system to monitor the effects of its utterances on the user. This type of monitoring requires the interleaving of text planning and realization resulting in an *incremental* model of generation. A simple strategy proposed in Moore [21, chapter 6] is to begin this interleaving of planning with realization in sentence-sized increments.

4.3 A conflict with reference to the selection of the kind and perspective of the presentation: Actual and projected bias are very different

Sometimes it seems favorable for a speaker in a particular communication scenario to appear objective towards a topic although there is actually a positive or negative bias (Jameson [11]). In general, this enhances the credibility of his contributions. The speaker, for instance, can pretend to describe a journal in an objective way to focus on its positive properties.

Before we describe the realization in our model, we have to give a remark on the severe consequences for the design of natural language generators that are involved with allowing such a strategy. Instead of producing cooperative and sincere discourse, the systems would now try to achieve their built-in goals in the most effective way without any care of the user. Although this might be the way humans act in corresponding situations, the ethics of generating misleading text is questionable. In our work, we are investigating non-cooperative dialogs

[6] In section 4.4 we will show a second reason for adopting this strategy.

[7] Precisely speaking, this means the selection of information that optimally fit the intentions of the system according to the user.

to find a more precise characterization of cooperative behavior. Moreover, we are interested in psychological evidence for our generator for academic purposes only.

Finally, using this strategy in our model again necessitates the anticipation of the hearer's interpretation process. There has to be, as it is quite common in the field of discourse modeling (cf. Lambert/Carberry [18]), a distinction between *goals* capturing the illocutionary effects (e.g. informing) and *effects* capturing the perlocutionary effects (e.g. convincing) of some discourse goal. As we have seen in section 3, this dichotomy has to be realized in the representation of the situation, as it is done with the distinction between system's goals and the role of the language.

A conflict emerges because of different values assigned to the variables **actual opinions of the topic** and **projected opinions of the topic**. In order to cope with this conflict, the system has to plan its contributions according to its **actual opinions** and has to use the **projected opinions** as a constraint. As Jameson [11] points out, the system will sometimes be forced to make some utterance other than the one with the highest rating, since the preferred one would be inconsistent with the impression to be projected.

4.4 A conflict with reference to the text structure

The hearer's attention is crucial for the speaker in order to achieve his intended goals. Therefore, the speaker must ensure that his contribution is of sufficient interest for the hearer. This decision depends on features of the situation like e.g. the relationship between speaker and hearer and the interest of the hearer in the topic.

If the hearer doesn't pay attention to what the speaker says, the speaker has to plan for getting the attention via rhetorical devices. One way for the speaker to get and keep the hearer's attention is to violate the expectations which the hearer has built up in the previous discourse (Kreyß [17]). Ideally, these violations cause inferences from the hearer to restore the coherence of the discourse and thereby his attention. If, for instance, a coherent description of a journal seems to be boring for the hearer, the speaker can simply give up the coherence of his contribution resulting in a loose enumeration of information about some journal.[8]

A feasible strategy for the integration of the user's attention in our model is representing attention in the communicative goals. Each relevant communicative goal can be associated with several, alternative schemata which entail specific applicability conditions.[9] It seems possible to develop a schema that results in a coherent description of a journal as well as it seems possible to define a schema that is likely to maximize the hearer's attention by simply enumerating extraordinary things about the journal. The choice between the schemata depends on

[8] see also section 4.2.

[9] Kreyß [17] as well as Wu/Lytinen [27] point out that commercials often have a stereotypical discourse structure. So, the utilization of schemata for the description of these discourse structures is a straightforward way of modeling.

the **user's opinions of the topic**. If it is assumed to be *bad*, then the variable **coherency** is set to *low*, overriding the default value *high*. In this approach the schemata are not used to ensure coherence but to maximize the communicative adequacy of the system's contribution according to its build-in intentions. It should be noted that this utilization of schemata is consistent with the definition given in McKeown [20, chapter 2][10] which bears no direct relation to the notion of coherence.

5 Conclusions

In recent years, the number of activities in the field of natural language generation has considerably grown and a lot of quite sophisticated generation systems have been implemented. However, different approaches have been adopted in building these systems. Moreover, there is a certain lack of clarity about the suitable initial structures for generation and the nature of the decisions involved in generation.

This results in a strong need to compare previous approaches and to develop a commonly agreed set of terms and paradigms in order to be able to deal with rather complex environments current natural language generation research is focussing on. As a consequence, there has been a push towards representing knowledge in a declarative and modular way, resulting in constraint-based architectures for generation systems.

In this paper, we investigated problems emerging from the integration of a user model into a constraint-based model of text generation. Even if we assume (as we did) that we are able to determine all of the relevant constraints for text generation, we encounter at least two problems when we are trying to find a suitable constraint satisfaction algorithm. First, we have to develop strategies in case the constraint-satisfaction problem has no solutions as it happens when conflicts arise. Second, we need further evaluation criteria and constraints in case the constraint-satisfaction problem still has several solutions. In both cases there is a necessity for an intelligent search with suitable criteria.

In order to solve the problems outlined, we have identified some points that must be further elaborated on:

- There is s strong need for additional, explicit evaluation criteria to deal with conflicts (also cf. Horacek [5]). The notion of *relevance* seems to be crucial for the kind of conversational setting we are investigating. As we have seen the representation of the situation (including the user model) as well as the information to be expressed must be rated in terms of relevance for achieving the system's discourse purpose.
- In order to employ constraint relaxation for solving conflicts a distinction has to be made between hard constraints required to be satisfied, and soft

[10] A schema is a representation of a standard pattern of discourse structure which efficiently encodes the set of communicative techniques that a speaker can use for a particular discourse purpose.

ones that are less strict. As we have seen, informations from the user model might often be treated as soft constraints.

- There is psycholinguistic evidence that speakers monitor the effects of their utterances. Therefore, it seems plausible to integrate a monitoring mechanism into future text generators. This strategy requires the interleaving of text planning and realization resulting in an incremental model of generation.
- Complex environments establish the need for the generation system to anticipate the user's analysis processes. There are at least two alternative ways for doing this. First, the system might use a *local anticipation feedback loop* which only deals with some specific part of the interpretation process. As we have seen, Cawsey [3] and Horacek [6] utilized this method for generating concise utterances. Second, a very ambitious method involves the use of a complete analysis and interpretation component by the generator, resulting in an integrated system architecture.

 In general, the scope of generation is becoming much wider than it has been seen earlier. Generation is nowadays seen as integral part of a complex process of problem solving during communication (Dale et al. [4]). Therefore, the interface between generation and other processes of reasoning as well as suitable initial structures for generation are of special concern. Ishizaki [10] suggests that the utilization of a uniform framework (like planning) supports the interaction between high-level reasoning and linguistic processes without an ad-hoc interface.

Summing up, the utilization of constraint-based techniques for natural language generation is by no means a solution to the problems outlined in this paper, but it can be seen as an important step towards an investigation of the two points Horacek [5] has identified as main directions for future research:

1. A more systematic and unified representation of the search space of generation systems. In addition, if there is a clear distinction between decisions and resources expressed in terms of constraints, the transparency of the generators are enhanced thus rendering the comparison of the systems much easier.
2. The application of skillful search techniques and explicit evaluation strategies for the case of conflicts. This will become essential for complex environments entailing a huge search space.

Using constraint-based techniques, a formalism which is well-suited for both tasks is at hand.

Acknowledgements

I would like to thank Stephan Busemann, Wolfgang Hoeppner, Helmut Horacek, Kai Hübener, Jutta Kreyß, Corinna Mohnhaupt and Martin Schröder for many helpful comments on earlier versions of this paper.

References

1. John A. Bateman, Elisabeth Maier, Elke Teich, and Leo Wanner. Towards an architecture for situated text generation. In *Proceedings of the International Conference on Current Issues in Computational Linguistics*, pages 289 – 302, Penang, Malaysia, 1991.

2. John A. Bateman and Cécile L. Paris. Phrasing a text in terms the user can understand. In *Proceedings of the 11th International Joint Conference on Artificial Intelligence (IJCAI)*, pages 1511 – 1517, Detroit, MI, 1989.

3. Alison Cawsey. Using plausible inference rules in description planning. In *Proceedings of the 5th Conference of the European Chapter of the Association for Computational Linguistics (EACL), Volume 1*, pages 119 – 124, Berlin, Germany, 1991. ACL.

4. Robert Dale, Eduard H. Hovy, David D. McDonald, and Dietmar Rösner. Panel-discussion on the initial specifications for generation. In *Proceedings of the 3rd European Workshop on Natural Language Generation*, pages 107 – 118, Judenstein, Austria, 1991.

5. Helmut Horacek. Decision making throughout the generation process in the systems WISBER and DIAMOD. In *Proceedings of the IJCAI-91 Workshop on Decison Making throughout the Generation Process*, pages 65 – 74, Sydney, Australia, 1991.

6. Helmut Horacek. Exploiting conversational implicature for generating concise explanations. In *Proceedings of the 5th Conference of the European Chapter of the Association for Computational Linguistics (EACL), Volume 1*, pages 191 – 193, Berlin, Germany, 1991. ACL.

7. Eduard H. Hovy. Some pragmatic decision criteria in generation. In Gerard Kempen, editor, *Natural Language Generation: New Results in Artificial Intelligence, Psychology and Linguistics*, chapter 1, pages 3 – 17. Martin Nijhoff Publishers, Dordrecht, Boston, Lancaster, 1987.

8. Eduard H. Hovy. Two types of planning in language generation. In *Proceedings of the 26th Annual Meeting of the Association for Computational Linguistics*, pages 179 – 186, Buffalo, NY, 1988. ACL.

9. Eduard H. Hovy, Julia Lavid, Elisabeth A. Maier, Vibhu Mittal, and Cécile L. Paris. Employing knowledge resources in a new text planner architecture. In Robert Dale, Eduard H. Hovy, Dietmar Rösner, and Oliviero Stock, editors, *Aspects of Automated Natural Language Generation*, pages 57 – 72. Springer, Berlin, Heidelberg, New York, 1992.

10. Masato Ishizaki. Linguistic realization through planning. In *Proceedings of the IJCAI-91 Workshop on Decison Making throughout the Generation Process*, pages 26 – 33, Sydney, Australia, 1991.

11. Anthony Jameson. But what will the listener think? Belief ascription and image maintenance in dialog. In Alfred Kobsa and Wolfgang Wahlster, editors, *User Models in Dialog Systems*, chapter 10, pages 255 – 312. Springer, Berlin, 1989.

12. Anthony Jameson and Wolfgang Wahlster. User modeling in anaphora generation: ellipsis and definite description. In *Proceedings of the 1st European Conference on Artificial Intelligence (ECAI)*, pages 222 – 227, Orsay, France, 1982.

13. Karen Sparck Jones. What does user modeling in generation mean? In Cécile L. Paris, Bill Swartout, and William C. Mann, editors, *Natural Language Generation in Artificial Intelligence and Computational Linguistics*, chapter 8, pages 201 – 225. Kluwer Academic Publishers, Boston, Dordrecht, London, 1991.

14. Robert Kass and Tim Finin. Modeling the user in natural language systems. *Computational Linguistics - Special Issue on User Modeling*, 14(3):5 – 22, 1988.

15. Gerard Kempen. Language generation systems. In Istvan S. Bátori, Winfried Lenders, and Wolfgang Putschke, editors, *Computational Linguistics - An International Handbook on Computer Oriented Language Research and Applications*, chapter 36, pages 471 – 480. de Gruyter, Berlin, New York, 1989.

16. Matthias E. Kölln. Generating natural language from discourse goals. FBI-HH-M-196/91, University of Hamburg, Computer Science Department, May 1991.

17. Jutta Kreyß. Comprehension processes as a means for text generation. Universität Hamburg, Graduiertenkolleg Kognitionswissenschaft, Schriftenreihe des Kollegs, Bericht Nr. 5, Januar 1992.

18. Lynn Lambert and Sandra Carberry. A tripartite plan-based model for dialogue. In *Proceedings of the 29th Annual Meeting of the Association for Computational Linguistics*, pages 47 – 54, Berkeley, CA, 1991. ACL.

19. Kathleen F. McCoy. Highlighting a user model to respond to misconceptions. In Alfred Kobsa and Wolfgang Wahlster, editors, *User Models in Dialog Systems*, chapter 9, pages 233 – 254. Springer, Berlin, 1989.

20. Kathleen R. McKeown. *Text generation: Using discourse strategies and focus constraints to generate natural language text*. Studies in natural language processing. Cambridge University Press, Cambridge, U. K., 1985.

21. Johanna D. Moore. *A reactive approach to explanation in expert and advice-giving systems*. PhD thesis, University of California, Los Angeles, CA, 1989.

22. Johanna D. Moore and William R. Swartout. A reactive approach to explanation: taking the user's feedback into account. In Cécile L. Paris, Bill Swartout, and William C. Mann, editors, *Natural Language Generation in Artificial Intelligence and Computational Linguistics*, chapter 1, pages 3 – 48. Kluwer Academic Publishers, Boston, Dordrecht, London, 1991.

23. Cécile L. Paris. The use of explicit user models in a generation system for tailoring answers to the user's level of expertise. In Alfred Kobsa and Wolfgang Wahlster, editors, *User Models in Dialog Systems*, chapter 8, pages 200 – 232. Springer, Berlin, 1989.

24. Cécile L. Paris and Elisabeth A. Maier. Knowledge sources or decisions? In *Proceedings of the IJCAI-91 Workshop on Decison Making throughout the Generation Process*, pages 11 – 17, Sydney, Australia, 1991.

25. Ehud Reiter. Generating descriptions that exploit a user's domain knowledge. In Robert Dale, Chris Mellish, and Michael Zock, editors, *Current Research in Natural Language Generation*, chapter 10, pages 257 – 285. Academic Press, London, 1990.

26. Margaret H. Sarner and Sandra Carberry. A new strategy for providing definitions in task-oriented dialogues. In *Proceedings of the 12th Conference on Computational Linguistics (COLING)*, pages 567 – 572, Budapest, Hungary, 1988.

27. Horng Jyh P. Wu and Steven L. Lytinen. Coherence relation reasoning in persuasive discourse. In *Proceedings of the 12th Annual Conference of the Cognitive Science Society*, pages 503 – 510, Cambridge, MA, 1990.

28. Ingrid Zukerman. Towards a failure-driven mechanism for discourse planning: a characterization of learning impairments. In *Proceedings of the 12th Annual Conference of the Cognitive Science Society*, pages 495 – 502, Cambridge, MA, 1990.

Criteria in Natural Language Generation: Minimal Criteria and Their Impacts

Ernst Buchberger

Austrian Research Institute for Artificial Intelligence, Vienna
Email: ernst@ai.univie.ac.at

Abstract. Given the enormous increase of research in the field of natural language generation, the need for a systematic account of criteria for assessing natural language generators is stressed. This paper tries to give an answer to a number of recently addressed topics regarding criteria, laying special emphasis on which criteria are necessary and relevant and how they influence design decisions for natural language generators. A minimal number of four closely interrelated criteria is presented. It is argued that values for these criteria are usually available before design decisions are made, and the direct impact of these criteria on selecting alternatives in various dimensions of natural language generation is shown together with selected examples. Finally, problems associated with the classification proposed are addressed and directions for future research in this relatively new field of impact assessment are pointed out.

1 Introduction

The field of natural language generation has experienced an enormous increase in interest in the last years. While in the early years of natural language processing, generation has been seen as a sort of poor cousin to parsing, computational linguistics conferences nowadays have whole sessions devoted to the topic. The subfield of generation itself tends to split up into a number of different paradigms, as can be seen most prominently on special meetings devoted solely to generation: Generation workshops are being held in the meantime on a regular basis, including the biannual international workshops (the last one having been held in Italy: [5]) and the European workshops on natural language generation (with its most recent event in Austria: [11]).

The sheer number of publications and/or systems developed leads quite naturally to the demand for a systematic account of research in this field. Two related aspects have to be mentioned in this regard: the evaluation of natural language generators, and the development of a set of criteria for systematizing and classifying research topics, projects and results.

The aspect of evaluation has been addressed in a AAAI Workshop on Evaluation of Natural Language Generators in 1990 [20], and, more recently, at the DANDI/HCRC/ELSNET Evaluation Workshop 1992 [6]. Evaluation calls for criteria according to which natural language generators may be assessed, but criteria may also act as a guideline for making design decisions, and it is this aspect which we are concerned with in this paper.

The question of criteria for natural language generation has been the theme of a GWAI-92 workshop. Some of the topics to be addressed in this workshop were:

1. to aim at a **systematic description of criteria**, laying the foundation for a uniform terminology, putting existing terms in their place and investigating their relations,
2. to work out the **contribution of single criteria and their interaction** regarding selection of alternatives, especially in the case of conflicts, and
3. to find out **consequences for processing** in a generation system.

These questions act also as guidelines for the present paper. Question one sets the stage: In chapter 2 the notions of criteria and their use are briefly sketched. Question three is shown to be a special case of question two and is subsumed there. Thus, the central part of the paper, chapter 3, is concerned with question two.

We distinguish between criteria and dimensions: while only four criteria are postulated, there exist a number of dimensions that are influenced by them. The interrelatedness of the criteria is treated in chapter 3.1, influences on each of the dimensions are listed in chapter 3.2. Chapter 4 concludes by stating open questions and pointing out directions for further research.

2 Systematic Description of Criteria

2.1 A First Clarification of Terms

In order to establish a uniform terminology, one should start at the meta-level: what do we regard as a systematic account, and what is meant by the term criterion.

A *systematic account* of natural language generation has recently been presented in [2], insofar as it attempts to catalogue existing approaches to natural language generation in an ordered way and to present their mutual interrelations. The last point is of special importance: as is pointed out in the work quoted, a purely hierarchical classification would not suffice.

The term *criterion* is defined in [23] as a "canon or standard by which anything is judged or estimated". In German the term is used in a slightly different way. Here, *Kriterium* is defined as "Prüfstein, unterscheidendes Merkmal, Kennzeichen" [9]. Now, "unterscheidendes Merkmal" means "distinguishing feature". In everyday language this term is treated ambiguously: on the one hand it is used to specify *values* of features, on the other hand the *features*[1] themselves.

In the following, criteria are treated according to this definition as something which characterizes or distinguishes different natural language generators. The aspect of standard ("Prüfstein") refers to implications, resp. consequences, of the criteria which we shall talk about in chapter 3.

[1] This ambiguity is also present in English where "feature" is used to mean "value", like in the well-known saying "this is not a bug, it is a feature". What is meant is a certain behaviour of the system, namely an instance (value) of the behaviour feature.

2.2 Different Kinds of Criteria

At a purely quantitative level we can distinguish whether a large number of criteria shall be postulated, or if a small number suffices. Pattabhiraman and Cercone [24] (henceforth P&C) opt for the first solution. They list 11 evaluation criteria, stressing the fact that this list is by far incomplete. In detail, they name

- expressibility
- efficiency
- modularity
- quality of text-output
- complexity of task domain/setting
- complexity of text produced
- extensibility
- parsimony and simplicity
- predictive value
- tailorability
- empirical coverage

Opposed to that, we argue for a minimalistic approach: First, we propose two very general criteria (in the following A-criteria), that of *minimal* and that of *maximal adequacy*. These terms mean that the methods to be used shall on the one hand suffice to solve the problems posed, and on the other hand not be overly complex.

In a next step, four criteria (B-criteria) that directly influence various parameters of generation can be identified (cf. chapter 3). These criteria are

- (complexity of the) domain
- quality of the text to be generated
- response time and
- effort or development cost[2].

The criteria mentioned refer mainly to application systems. In the case of basic research other criteria may be relevant, e.g. if the research aims at investigating a specific grammatical theory, a domain of application is often secondary and usually not fixed in advance, etc.

If we compare A- and B-criteria, we find out that these are different kinds of criteria: A-criteria are not decision criteria proper, they constitute a (very general) quality measure, in that a system should conform to them as much as possible.

B-criteria are of a totally different nature. They are (at least in application systems) usually fixed beforehand and provide means for deciding on design issues for the generator to be implemented.

One might ask, why (two plus) four criteria are sufficient, when P&C cannot confine themselves to 11. My point is that P&C provide a good starting point

[2] Under this header, we subsume various resources, especially the manpower allocated to the project.

but are missing a good systematics. To be fair, one has to be reminded that P&C consider also aspects of basic research whereas this paper stresses the applicability of the criteria for application-oriented systems only.

If we attempt to map between our 4 criteria and P&C's list of 11, we see that complexity of the domain and quality of text output are present in both lists, whereas response time and development cost are not among P&C's criteria. Of course, response time depends also on implementational aspects (software and hardware specifics) and not only on methodological features.

To continue with P&C's criteria, expressibility may be seen as a special case of quality, and the same holds for empirical coverage (P&C restricted their use of the term quality mainly to the aspect of coherence). Efficiency as well as parsimony and simplicity are quite similar in that they refer to what we have termed maximal adequacy. Modularity and predictive value are mostly theoretically motivated (on the other hand, modularity also influences maintainability which is closely connected to our criterion of development cost). Extensibility and tailorability are implied by the domain criterion.

3 Contributions of the Criteria to Selection of Alternatives, and Their Interaction

3.1 Interrelatedness

P&C name three possible relations between criteria: overlap, independence, and conflict. In our minimal approach, there is only the case of conflict which holds between each two of the four criteria[3] — effort, domain, quality, response time — proposed. These conflicts or tradeoffs can be characterized as follows:

effort vs. other criteria This case is quite clear. It should be noted that there are limits as to what may be gained by pushing any one criterion to extremes: Given the current state-of-the-art, you cannot get, e.g., a high-quality machine translation system for literary texts even if you take the largest efforts.

domain vs. quality In a restricted domain it is easier to produce texts of better quality. A well-known example is the PROTEUS system [7] whose domain is explaining moves in the (trivial) game of Tic-Tac-Toe. PROTEUS has been (with regard to quality) the best text generator at its time of development, and the quality of the text it produced had not been surpassed for many years after. On the other hand, in unrestricted domains like universal machine translation, the achievable quality has been known to be relatively poor.

domain vs. response time It is quite evident that in a domain of low complexity good response times can be achieved by using simpler methods tailored to the domain. An example for a compromise is the UNIX Consultant project [28], a system, whose domain is not a microworld, but is nevertheless limited in a way to allow for acceptable results.

[3] In the following, "criteria" is used to refer to what we have named B-criteria, if not otherwise mentioned.

quality vs. response time A similar argument holds for the opposition between quality and response time: Speediness may be traded in by giving up claims to good quality. Such a decision would be correct, e.g., when generating error messages in critical real time systems: with such applications a quick information of the user is of higher importance than the need for stylistically perfect text. (Interactive) dialogue systems need not be so quick in their response, nervertheless it has been known for a long time that response time is an important factor for the acceptance of such systems by their users: An inquiry of potential customers [21] showed that more than 80 % of them expect a system response to "easy" questions in less than 30 seconds.

McKeown's TEXT system [19] is an example for a system where the focus has been laid on good quality output, neglecting acceptable response time. Such a decision can even more strongly be argued for with batch systems: When producing technical reports automatically (as with ANA [16] or SEMTEX [25]), quality is more important than speed.

3.2 Impacts

A number of dimensions has been shown to be relevant for natural language generation. They are[4]:

- depth of the initial representation
- symbolic vs. subsymbolic paradigm
- processing model
- grammar and lexicon
- word choice
- text planning
- stylistic aspects
- multimodality

As mentioned above, values for the criteria are fixed beforehand, and they influence the dimensions listed here. We shall now briefly treat the implications of the criteria on each of the dimensions:

depth of the initial representation Two cases are to be distinguished: the initial representation may have been fixed alredy, like in the case of the generator to be used as a back end for an existing system, or the decision for an initial representation may still be left open.

In the first case, there are immediate consequences for other dimensions, like the choice of a grammar formalism compatible with the initial representation[5].

[4] For details about research concerning each of these dimensions, we refer to [2].

[5] Thus, one would tend to use a unification-based grammar formalism if the elementary knowledge representation formalism is also a complex feature-based one.

In the second case, the choice of the initial representation depends on the interaction with other system components. From the generator's point of view, the internal representation strongly influences deep generation and word selection. In the extreme case, a one-to-one mapping reduces the problem of word choice to a trivial one. More generally, representations that are closer to the surface reduce necessary efforts in the realization of the what-to-say component. At one ends of the spectrum we can think of representations very remote from the surface, as e.g. in the domain of visual data, where the generation system has to make decisions about relevance of data for the user (e.g., based on salience [4]). At the other end we find radically surface-oriented representations, as in the case of paraphrasing certain forms of natural language DB queries, where one may opt for doing without a what-to-say component altogether, resulting in a simpler system [3].

symbolic vs. subsymbolic paradigm Given the current state-of-the-art, for commercially usable systems symbolic methods have proven more successful. However, research in the field of subsymbolic processing is rapidly increasing. One problem when using subsymbolic methods is the initial representation: if the generator has to be coupled to another system using symbolic representation, we are faced with coupling subsymbolic to symbolic representation. Recently, there have been proposals for a hybrid approach combining symbolic and subsymbolic representation for understanding (like [27]), and the hybrid approach may also turn out useful for generation.

processing model The unmarked case of processing, a collection of paradigms which many generators have been following, may be seen in non-incremental, sequential, unidirectional generation.

Opposed to non-incremental generation is the incremental processing paradigm, which has been motivated mainly by cognitive relevance. Utterances are created in a piecemeal fashion, and decisions cannot be taken back ("indelibility"). As a consequence, it may turn out that sentences once started cannot be completed in a correct way. This may lend the systems a more human-like flavour. On the other hand, if simplicity is asked for, non-incremental systems fare better.

The opposite of the sequential model is parallel generation. This model is motivated by psycholinguistic research on the one hand, and by processing speed on the other hand. Note that the term parallelism is used for (at least) three different aspects: simultaneous processing of utterances to be generated in different stages, like conceptualization, formulation, and articulation in form of a cascaded model, e.g., that of incremental procedural grammar [14], simultaneous processing of *different* parts of output (e.g., different noun phrases) in order to gain speed, or the simultaneous processing of the *same* structure by the same module, trying various realizations and selecting one in the end. The different methods pose different claims for modularization and realization of the control structure which in any case will be more complex than with a serial approach. The latter is therefore to be favoured if the system is to be constructed under pressing time constraints.

Bidirectionality is concerned with the interrelation of parsing and generation. Apart from theoretical arguments, a bidirectional model eases consistency of data structures for both processes, thus lending itself naturally for dialogue systems. However, even in systems dedicated solely to generation, bidirectionality may be an issue: Psycholinguistic investigations claim that language production is always coupled with analysis processes, an aspect which has been modelled by certain system architectures [22].

grammar and lexicon The choice of a grammar formalism is based on theroetical grounds as well as on other aspects already mentioned, like that of bidirectionality. If the latter is wanted, unification-based grammars are a good choice. Some grammar formalisms, like systemic grammar [18], have been developped especially for generation. This advantage is compensated by the loss of bidirectionality[6]. In limited domains one can dispense with the claim for a universally usable grammar, possible also influenced by the desire to use forms compatible with phrasal lexica.

The structure of the lexicon bears a close connex to questions of word selection. The target language (which usually is fixed beforehand, like the domain) influences methods to be used for morphologic synthesis. In the case of language independence this may result in the choice of two-level-morphology [15]. If response time is critical, a good choice is to refrain from using a morphologic component and making use instead of a lexicon containing all inflected variants.

word selection The relation between initial representation and word choice has been referred to above. In limited domains (e.g., stock market [16] or labour market [25] reports), phrasal lexica may be used, thus solving also the problems of co-occurrence and stylistic aspects. Of course, these systems cannot claim universal usability.

The effort to be put into creating referring expressions also depends strongly on the domain. There are systems whose almost sole task consists in the creation of noun phrases or anaphora (some cases of natural language responses to database queries), on the other hand there are applications where referring expressions are of minor importance (some cases of paraphrasing).

Anaphora also bear a close connex to text quality and to text planning. Deictic references make sense only in systems with a graphical component.

text planning The kinds of text to be produced determine the effort necessary for text planning. For longer texts one cannot do without some text structuring methods like rhetorical structure theory [17] or text schemata [19] or a combination thereof [12]. If the generator has to produce only single sentences, a text planning component can be spared. Intrasentential cohesion can be brought about by simpler methods (e.g., [10]).

stylistic aspects Stylistic aspects are directly related to the criterion of text quality. Qualitatively better texts are naturally preferred. Given the tradeoffs mentioned, however, there are situations where other aspects have to be given priority. One might also argue in a slightly paradoxical manner that

[6] Recently, there have been experiments with parsers for systemic grammars, like [13].

for database paraphrases worse text quality would be better, since it tends to reflect the structure of the original query more adequately.

multimodality Multimodal presentation is useful in a number of tasks, especially in the combination of text and graphics [1], [26]. Of course, multimodal generation increases expenses. In general, the need for this form of generation is dictated by the task / domain, as there are tasks where one can also do without graphics (machine translation, generation of abstracts). As for other modes of generation, the need for acoustic output is also often dictated by the domain (as e.g. in [8]).

4 Open Questions and Future Research

Above, we have shown the relations between criteria and the dimensions of natural language generators that are influenced by these criteria. These influences have been demonstrated only on a very rough scale. Details have still to be worked out. In particular, there are two general problems having to do with specifics of the criteria mentioned, namely fuzziness of values for the criteria and their quantifiability.

The problem of fuzziness arises with the criteria response time and development cost. Clearly, it is not useful to specify exact points but ranges, like response time less than two seconds or development effort between one and three person years. The question for meaningful interval boundaries arises nevertheless. The basic interdependencies are quite clear, like small development effort implying stylistically worse text. What is not clear is, up from how many person years may we afford to develop and use more complex algorithms (and which ones).

The problem of quantifiability arises with the criteria domain and quality. Obviously, quality cannot be judged quantitatively in an exact manner. Possibly methods from literary critics may be used also for automatic text generation. As for the domain, the question is, if a purely quantitative assessment of domain size (e.g., number of tables and/or entities in a database interface) will suffice and what role is played by the domain type.

Acknowledgements

I should like to thank Harald Trost for many talks out of which some of the ideas presented in this paper developed. Gerhard Widmer helped with constructive criticism that allowed to express some of my ideas in a clearer and more precise way. Prof.Robert Trappl has always supported my research in the field of natural language generation by his interest as well as from an organizational point of view. The Austrian Research Institute for Artificial Intelligence is financially supported by the Austrian Ministry for Science and Research.

References

1. André E., Finkler W., Graf W., Rist T., Schauder A., Wahlster W.: WIP: The Automatic Synthesis of Multimodal Presentations, in Maybury M.T.(ed.), Intelligent Multimedia Interfaces, AAAI Press, Menlo Park, 1992.
2. Buchberger E.: Eine Systematik natürlichsprachiger Generierung und ihre Anwendung, Ph.D. Dissertation, Univ. of Technology, Vienna, 1992.
3. Buchberger E., Auterith A.: Generating German Paraphrases from SQL Expressions, in Trappl R.(ed.), Cybernetics and Systems '88, Kluwer, Dordrecht, pp.885–892, 1988.
4. Conklin E.J., McDonald D.D.: Salience: The Key to the Selection Problem in Natural Language Generation, in Proceedings of the 20th Annual Meeting of the Association for Computational Linguistics, pp.129–135, 1982.
5. Dale R., Hovy E.H., Rösner D., Stock O.(eds.): Aspects of Automated Natural Language Generation, Lecture Notes in Artificial Intelligence No.587, Springer, Berlin, 1992.
6. Dale R.: Evaluating Natural Language Generation Systems, in Thompson H.S.(ed.), The Strategic Role of Evaluation in Natural Language Processing and Speech Technology, Record of the Workshop, Human Communication Research Centre, University of Edinburgh, UK, 1992.
7. Davey A.: Discourse Production: A Computer Model of Some Aspects of a Speaker, Edinburgh University Press, 1978.
8. Dorffner G., Trost H., Buchberger E.: Generating Spoken Output for an Expert System Interface, ÖGAI-Journal 7(3–4)36–41, 1988.
9. DUDEN Fremdwörterbuch, Bibliographisches Institut, Mannheim, 1974.
10. Granville R.: Controlling Lexical Substitution in Computer Text, in Proceedings of the 10th International Conference on Computational Linguistics, pp.381–384, 1984.
11. Horacek H., Zock M.: New Concepts in Natural Language Generation, Pinter, London, 1993.
12. Hovy E.H.: Approaches to the Planning of Coherent Text, in Paris C.L., et al.(eds.), Natural Language Generation in Artificial Intelligence and Computational Linguistics, Kluwer, Dordrecht, pp.83–102, 1991.
13. Kasper R.T.: An Experimental Parser for Systemic Grammars, in Proceedings of the 12th International Conference on Computational Linguistics, pp.309–312, 1988.
14. Kempen G., Hoenkamp E.: An Incremental Procedural Grammar for Sentence Formulation, Cognitive Science 11(2)201–258, 1987.
15. Koskenniemi K.: A General Computational Model for Word-Form Recognition and Production, in Proceedings of the 10th International Conference on Computational Linguistics, pp.178–181, 1984.
16. Kukich K.: ANA's First Sentences: Sample Output from a Natural Language Stock Report Generator, in Williams M.E., Hogan T.H.(eds.): Proceedings of the Fourth National Online Meeting, New York, 1983.
17. Mann W.C., Thompson S.A.: Rhetorical Structure Theory: Description and Construction of Text Structures, in Kempen G.(ed.), Natural Language Generation, Martinus Nijhoff, Dordrecht, pp.85–95, 1987.
18. Matthiessen C., Bateman J.A.: Text Generation and Systemic-Functional Linguistics, Experiences from English and Japanese, Frances Pinter, London, 1991.
19. McKeown K.R.: Text Generation: Using Discourse Strategies and Focus Restraints to Generate Natural Language Text, Cambridge University Press, Cambridge, 1985.

20. Meteer M.(ed.): AAAI90 Workshop on Evaluating Natural Language Generation Systems — Workshop Notes, 1990.
21. Morik K.: Customers' Requirements for Natural Language Systems. Results of an Inquiry, Report ANS-19, Forschungsstelle f. Informationswissenschaft und Künstliche Intelligenz, Universität Hamburg, 1983.
22. Neumann G.: A Bidirectional Model for Natural Language Processing, in Fifth Conference of the European Chapter of the Association for Computational Linguistics, pp.245–250, 1991.
23. Little W., Fowler H.W., Coulson J., Onions C.T.(eds.): The Shorter Oxford English Dictionary, Clarendon, Oxford, 1978.
24. Pattabhiraman T., Cercone N.: Natural Language Generation Systems and Theories, CSS-IS TR 90-10, Simon Fraser University, 1990.
25. Rösner D.: The Automated News Agency: SEMTEX - A Text Generator for German, in Kempen G.(ed.), Natural Language Generation, Martinus Nijhoff, Dordrecht, pp.133–148, 1987.
26. Stock O.: Natural Language and Exploration of an Information Space: The Al-Fresco Interactive System, in Proceedings of the 12th International Conference on Artificial Intelligence, Morgan Kaufmann, San Mateo, pp.972–978, 1991.
27. Wermter S.: A Hybrid and Connectionist Architecture for a Scanning Understanding, in Neumann B.(ed.), Proceedings of the Tenth European Conference on Artificial Intelligence (ECAI92), Wiley, Chichester, UK, pp.188–192, 1992.
28. Wilensky R., Chin D.N., Luria M., Martin J., Mayfield J., Wu D.: The Berkeley UNIX Consultant Project, Computational Linguistics 14(4)35-84, 1988.

Terminological Representation,
Natural Language & Relation Algebra

Renate A. Schmidt

Max-Planck-Institut für Informatik, Im Stadtwald
W-6600 Saarbrücken 11, Germany

Abstract. In this paper I establish a link between KL-ONE-based know-ledge representation concerned with *terminological representation* and the work of P. Suppes (1976, 1979, 1981) and M. Böttner (1985, 1989) in computational linguistics. I show how this link can be utilised for the problem of finding adequate terminological representations for given information formulated in ordinary English.

1 Introduction

KL-ONE (Brachman and Schmolze 1985) is a knowledge representation system that R. J. Brachman started developing in the mid-seventies. KL-ONE has many variants. Examples are KRYPTON (Brachman, Gilbert and Levesque 1985), NIKL (Schmolze and Mark 1991), LOOM (MacGregor 1991), BACK (Nebel and von Luck 1988), CLASSIC (Borgida, Brachman, McGuinness and Resnick 1989) and \mathcal{KRIS} (Baader and Hollunder 1991). Early research focussed on providing formal syntactic and semantic definitions for the different systems (in accordance with the criticism of Woods (1975), Hayes (1977) and McDermott (1978)). This led to the discovery that inference in NIKL (Patel-Schneider 1989) and KL-ONE (Schmidt-Schauß 1989) is undecidable. The debate on the tradeoff between tractability of inference and expressiveness of language in, e.g., Levesque and Brachman (1987) and Doyle and Patil (1991) initiated the analysis of the computational complexity of the family of *attributive concept description languages*, also called \mathcal{AL}-languages. The investigations of Schmidt-Schauß and Smolka (1991), Donini, Lenzerini, Nardi and Nutt (1991) and also Nebel (1988), among others, give some indication on the effect that including different syntactic operators in a representation language has on the computational cost of inference. These investigations show that tractability can only be achieved at the cost of considerably reducing the expressiveness of the representation language. However, expressively limited systems don't seem to be very useful in practice. According to Doyle and Patil (1991) and Schmolze and Mark (1991) users tend to find expressive but intractable systems more useful than systems that are tractable but expressively impoverished. Especially Doyle and Patil (1991) argue against the bias towards computational tractability. Instead they argue in favour of expressiveness of language. After all, usually a domain of application is specified in ordinary natural language. And natural language is expressively very powerful.

Reflecting on the history of knowledge representation and discussion future directions in research Brachman (1990) notes that natural language specific issues have received less attention than they should have. He says (p. 1091):

> It would not hurt at this point to go back and spend some time thinking about the relation of KR [knowledge representation] to natural language, for example—after all, that was in part responsible for the birth of the field in the first place.

In this paper I do just that. I relate terminological representation to natural language and show how the work of P. Suppes (1976, 1979, 1981) and M. Böttner (1985, 1989) in computational linguistics can be utilised.

The setting of my discussion is an algebraic one. In Brink and Schmidt (1992), Schmidt (1991) and Brink, Britz and Schmidt (1992) we showed that terminological representation languages can be interpreted algebraically. The algebras we use are Tarski's (1941) *relation algebras*, Brink's (1981) *Boolean modules* and new algebras called *Peirce algebras*. These algebras are closely related to the algebras Suppes (1976) uses in his semantic analysis of a fragment of the English language. Suppes presents a system for translating natural language phrases and sentences as relation algebraic expressions. As these can be associated with terminological expressions I propose that the work of Suppes and also Böttner be taken as a formal basis for finding adequate terminological representations for domain information formulated in English, and vice versa, for finding the English formulations for terminological expressions.

In Section 2 I give a brief account of the relation algebraic semantics of terminological representation languages as presented in Brink and Schmidt (1992), Brink et al. (1992) and Schmidt (1991). In Section 3 I outline the relation algebraic analysis of the English language by Suppes (1976, 1979, 1981) and Böttner (1985, 1989). And in Section 4 I show by way of examples how their analysis is relevant to terminological representation.

2 Terminological Representation and Relation Algebra

KL-ONE-based knowledge representation systems have two components: a TBox and an ABox. Each component has its own representation language and inference system. *Terminological representation* is concerned with the TBox which contains information defined as interrelationships among *concepts* or *roles*. Concepts are interpreted as sets and roles as binary relations. In this paper I denote concepts by C and D and roles by R and S. The ABox contains *assertional representations*. It contains information about elements of concepts and roles.

The different terminological representation languages distinguish themselves by the syntactic operators they provide for constructing complex concept and role descriptions. In column one of Figure 1 I list a subset of operators available in the language \mathcal{U} of Patel-Schneider (1987) and the language \mathcal{KL} of Woods and Schmolze (1992). These are very expressive terminological languages. Most terminological languages like the \mathcal{AL}-languages provide only a selection of these operators.

Fig. 1. Algebraic Semantics for terminological constructs

Concept-forming operators on concepts		Set-theoretic operations (modelled in Boolean algebra)	
Top concept	\top	Universe of interpretation U	
Bottom concept	\perp	Empty set	\emptyset
Conjunction	(and C D)	Intersection	$C \cap D$
Disjunction	(or C D)	Union	$C \cup D$
Negation	(not C)	Complement	C'
Role-forming operators on roles		Relation-theoretic operations (modelled in relation algebra)	
Top role	∇	Universal relation	U^2
Bottom role	Λ	Empty relation	\emptyset
Role conjunction	(and R S)	Intersection	$R \cap S$
Role disjunction	(or R S)	Union	$R \cup S$
Role negation	(not R)	Complement	R'
Identity role	self	Identity relation	Id
Inversion	(inverse R)	Converse	R^{\smile}
Composition	(compose R S)	Relational composition	$R\,;S$
Concept-forming operators on roles		Set-forming operations on relations (modelled in Boolean modules)	
Existential restriction	(some R C)	Peirce product	$R:C$
Universal restriction	(all R C)	Involution	$(R:C')'$
Role-forming operators on concepts		Relation-forming operations on sets (modelled in Peirce algebra)	
Role restriction	(restrict R C)	Range restriction	$R \rfloor C$

Concepts can be interrelated by the *subsumption* relation. Subsumption is interpreted as the subset relation (or, depending on the point of view as the superset relation). I write $C \sqsubseteq D$ if C is subsumed by D. Concepts can also be defined to be *equivalent* or *disjoint*. Two concepts C and D are said to equivalent, written $C \doteq D$, if they mutually subsume each other. Disjoint concepts C and D, specified with (disjoint C D), are interpreted as disjoint sets. Interrelating concepts by subsumption, equivalence and disjointness is often limited in some way. The left hand side of a subsumption or equivalence specification is commonly restricted to be a *primitive* concept, that is, a concept not defined as a compound concept term. Also, usually only *primitive* concepts can be defined to be disjoint. For roles subsumption, equivalence and disjointness are defined similarly.

I now discuss the algebraic semantics. An *interpretation* of a terminological representation language is given as usual by a pair $(U, \cdot^{\mathcal{I}})$. U is the *domain of interpretation* and $\cdot^{\mathcal{I}}$ is the *interpretation function*, mapping any concept C to a subset of U (i.e., to an element in 2^U, the powerset of U) and any role to a binary relation over U (i.e., to an element in 2^{U^2}). I abbreviate $C^{\mathcal{I}}$ and $R^{\mathcal{I}}$ by C and R, respectively. Now, instead of defining the meaning of the terminological operators model-theoretically (in terms of first-order logic), as it is usually done, Brink and Schmidt (1992) and Brink et al. (1992) show that the semantics can be equivalently defined in terms of algebraic operations. The alternative algebraic semantics is given in the second column of Figure 1 in which each terminological operator is associated with a set-theoretic operation. The Figure is subdivided according to the different kinds of operators with which new concepts and roles arise from primitive ones:

Concept-forming operators on concepts: These include the designated concepts *top* and *bottom* (here regarded as nullary operators) and the *conjunction*, *disjunction*, and *negation* operators. Each is associated with a set-theoretic constant or operation. Namely, the top concept with the domain of interpretation U, the bottom concept with the empty set \emptyset, conjunction with intersection \cap, disjunction with union \cup and negation with complementation $'$ taken with respect to U. Just as the set-theoretic operations are characterised in *Boolean algebras*, their corresponding terminological operators are also characterised in Boolean algebras. For the set of concepts is partially ordered with respect to the *subsumption* relation in a *concept taxonomy*. If each pair of concepts has a meet and a join (that is, both their conjunction and disjunction exist) the concept taxonomy forms a lattice. It forms a Boolean algebra if each concept has a complement (that is, the negation exists) and meet and join distribute over each other.

The conjunction operator is available in most terminological systems. But few terminological representation systems provide also the disjunction and negation operators.

Role-forming operators on roles: Even fewer terminological representation languages provide conjunction, disjunction and negation also for roles. As for concepts the Boolean operators on roles are interpreted by their Boolean counterparts, this time applied to binary relations. Other operators on roles forming new roles are *inverse* and *composition*. For these, the respective relation-theoretic counterparts are the *converse* relation (denoted \smile) and *relational composition* (denoted ;). Given two binary relations R and S the converse of R is defined by

(1) $R^{\smile} = \{(x, y) \,|\, (y, x) \in R\}$

and the composition of R and S is given by

(2) $R \,;S = \{(x, y) \,|\, (\exists z)[(x, z) \in R \,\&\, (z, y) \in S]\} \,.$

The designated role **self** has the *identity relation Id* over U as relation-theoretic counterpart. The characterising algebra for binary relations interacting in this

way is Tarski's (1941) *relation algebra*. A relation algebra is a Boolean algebra endowed with a nullary operation (the identity), a unary operation (the converse operation) and a binary operation (the composition) satisfying certain equational axioms. A formal definition of relation algebra can be found in introductory material by Jónsson (1982) and Maddux (1991a, 1991b). Relation algebras provide then also a characterisation of role-forming operators on roles.

Concept-forming operators on roles: New concepts also arise through interactions with roles. The commonly available operators of this kind are *existential restriction* some and *universal restriction* all. (Commonly used alternative notations for (some R C) and (all R C) are $\exists R : C$ and $\forall R : C$, respectively.) These operators have algebraic versions as well. The algebraic version of the some operator is the *Peirce product* (denoted :). Applied to a relation R and a set C the Peirce product yields the set

(3) $R : C = \{x \mid (\exists y)[(x, y) \in R \,\&\, y \in C]\}$.

The algebraic version of the all operator is a variant of Peirce product (called *involution*). Namely:

(4) $(R : C')' = \{x \mid (\forall y)[(x, y) \in R \Rightarrow y \in C]\}$.

Algebras that axiomatise the Peirce product are *Boolean modules*. A Boolean module is a two-sorted algebra of a Boolean algebra and a relation algebra endowed with an operation (corresponding to Peirce product) from the relation algebra to the Boolean algebra satisfying certain equational axioms. A formal definition can be found in Brink (1981) where Boolean modules are introduced. This context also provides an algebraic characterisation for the some and the all operator. Other concept-forming operators on roles that can be accommodated in Boolean modules are *role value maps* and *structural descriptions*. For more details, see Brink et al. (1992) and Schmidt (1991).

Role-forming operators on concepts: Concepts and roles can also be combined to form new roles. An example of such a combination is *role restriction*. Its algebraic version is *range restriction* (denoted ⌋). The restriction of a relation R to a range C is given by:

(5) $R \rfloor C = \{(x, y) \mid (x, y) \in R \,\&\, y \in C\}$.

Algebras formalising this kind of interaction, in particular, range restriction and also role restriction, are *Peirce algebras* which are introduced in Brink et al. (1992). A Peirce algebra is a Boolean module with an additional operation from the Boolean algebra to the relation algebra satisfying certain equational axioms. Other terminological operators that can be accommodated in this context are the operators domain and range of \mathcal{KL} (Woods and Schmolze 1992).

The corresponding relationships to the subsumption (\sqsubseteq) and the equivalence (\doteq) relations for concepts (respectively for roles) are inclusion and equality in Boolean algebra (respectively in relation algebra). Disjointness corresponds to an inequality of a meet with the zero element (interpreted as the empty set) of the relevant algebra.

3 Natural Language and Relation Algebra

In (1976) and other papers (1973, 1979, 1981) Suppes aims at a systematic analysis of the model-theoretic semantics of fragments of natural language. In Suppes (1979, p. 49) he says:

> The central idea is that the syntax of first-order logic is too far removed from that of any natural language, to use it in a sensitive analysis of the meaning of ordinary utterances.

Instead he proposes an algebraic approach, using so-called *extended relation algebras*. An extended relation algebra $\mathcal{E}(U)$ over a domain U (a non-empty set), is a subset of $2^U \cup 2^{U^2}$ closed under the operations of union, complementation, converse, relational composition, image and domain restriction. Complementation of sets is taken with respect to U and complementation of relations with respect to U^2. The *image* of a relation R from a set C is the set

(6) $R\text{''}\,C = \{y \,|\, (\exists x)[(x,y) \in R \,\&\, x \in C]\}\,,$

or equivalently, $R^{\smile}:C$. The *domain restriction* of a relation R to a set C is given by $R^{\smile} \rfloor C$. Extended relation algebras are of model-theoretic nature. As both image and domain restriction can be expressed with Peirce product and range restriction extended relation algebras provide standard models for Peirce algebras.

With extended relation algebras Suppes characterises the semantics of English language sentences and phrases. The syntax of natural language is defined by a *phrase structure grammar* G. A grammar is specified in terms of a set of production rules like, for example:

(7) (i) S \longrightarrow NP + VP
 (ii) VP \longrightarrow TV + NP
 (iii) NP \longrightarrow Adj + N
 (iv) NP \longrightarrow PN.

The symbols S, NP, VP, TV, Adj, N and PN denote 'start symbol', 'noun phrase', 'verb phrase', 'transitive verb', 'adjective', 'noun' and 'proper noun', respectively. Accordingly the syntactic structure of the phrase *male vegetarian* and the sentence *John loves Mary* are represented by the respective syntactic *derivation trees* of Figures 2.

Suppes defines the semantics in two steps. First, he extends the grammar G to a so-called (*potentially*) *denoting grammar*. This is done by associating each production rule of G with a semantic function. The denoting grammar then determines the meaning of phrases and sentences. For example, the semantics of the phrase *male vegetarian* and the sentence *John loves Mary* are determined by the following semantic associations of the above production rules.

Fig. 2. Grammatical derivation trees for *male vegetarian* and *John loves Mary*

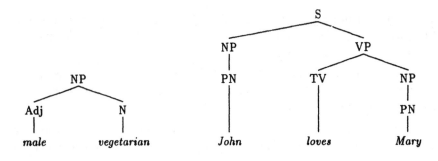

(8) Lexical Production Rule Semantic Association

 (i) $S \longrightarrow NP + VP$ $[NP] \subseteq [VP]$

 (ii) $VP \longrightarrow TV + NP$ $[TV] : [NP]$

 (iii) $NP \longrightarrow Adj + N$ $[Adj] \cap [N]$

 (iv) $NP \longrightarrow PN$ $[PN]$

The square brackets indicate the interpretation function. If the adjective *male* is interpreted as the set of male people and the noun *vegetarian* as the set of vegetarians, the intersection $[male] \cap [vegetarian]$ defines the meaning of *male vegetarian*. This can also be read off at the root of the annotated grammatic derivation tree for *male vegetarians* in Figure 3. This tree is called a *semantic tree*. It is derived from the syntactic derivation tree by annotating each node with the appropriate semantic assignment. According to (8) (ii) the verb phrase *loves Mary* is interpreted as the set of lovers of Mary, given by the Peirce product $[love] : [Mary]$. The interpretation $[love]$ of *loves* is a binary relation and the interpretation $[Mary]$ of *Mary* is a singleton set. (In (ii) Suppes actually uses a variant of the image operation, which coincides with Peirce product.) The semantics of the sentence *John loves Mary* is therefore given by:

(9) $[John] \subseteq [love] : [Mary]$.

It is also given by the relevant semantic tree in Figure 3. This illustrates how meaning is assigned to a phrase or sentence by converting its grammatic defini-tion, viewed as a grammatic derivation tree, to a semantic definition, viewed as a semantic tree, via the denotational assignments to the production rules which determine the syntax of the phrase or sentence.

In the second step a *model structure* (U, v) is defined for the phrase structure grammar G. U is any non-empty set regarded as the domain or universe and v, called a *valuation*, is a (partial) function from the vocabulary of terminal symbols in G to the extended relation algebra $\mathcal{E}(U)$. That is, v maps terminal symbols to either sets in 2^U or binary relations in 2^{U^2}. As we have seen in the two examples above, nouns and adjectives are mapped to subsets of U, with proper nouns being mapped to singleton sets, and (transitive) verbs are mapped

Fig. 3. Semantic trees for *male vegetarian* and *John loves Mary*

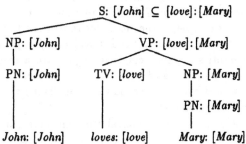

to binary relations.

This algebraic approach has the advantage that it is free of variables and quantifiers over variables. Consequently, according to Suppes (1981, p. 405) the analysis of the semantics of natural language fragments can be carried out directly in English, avoiding the translation into another language (e.g., into the first-order language). Furthermore, it allows the development of a syntactic derivation system for direct inference in the English language. I won't elaborate on this system, but see Suppes (1981).

Since Suppes and Böttner translate English language phrases and sentences as algebraic expressions which, as is evident from Section 2, can be associated with terminological expressions, their work is relevant to the problem of finding adequate terminological representations for information formulated in English and vice versa, for finding English translations for terminological expressions.

In (1976, 1981) Suppes also demonstrates how phrases and sentences with quantifier words (such as *all*, *some* and *no*) in object and subject position are interpreted in the framework of extended relation algebras. For example, the following verb phrases

(10) Verb phrase Algebraic interpretation

 (i) *eat all fruit* $([eat]' : [fruit])'$

 (ii) *eat (some) fruit* $[eat] : [fruit]$

 (iii) *eat no fruit* $([eat] : [fruit])'$

are interpreted by variants of the image operation, here appropriately translated as variants of Peirce product. When each of these verb phrases is combined with quantified subjects the semantics of the resulting sentences is of the form similar

to that of the sentences

(11)　　　　　　Sentence　　　　　　　Algebraic interpretation

　(i) *Some persons eat (some) fruit*　　$[persons] \cap [eat]:[fruit] \neq \emptyset$

　(ii) *All persons eat (some) fruit*　　$[persons] \subseteq [eat]:[fruit]$

　(iii) *No person eats (some) fruit*　　$[persons] \cap [eat]:[fruit] = \emptyset$

This gives rise to nine forms of quantified sentences. In (1979) Suppes investigates the algebraic interpretation of negation in verb phrases. The meaning of negated verb phrase like *do not eat (some) fruit* is ambiguous and depends on which word is stressed. For example, if the word *eat* is stressed the interpretation is $[eat]':[fruit]$. Or, if the word *not* is stressed it is $([eat]:[fruit])'$. In (1981) Suppes also defines the semantics of sentences that begin with a demonstrative verb, e.g., *there* as in *There are some birds* and *There are no birds*, and of sentences in which a noun is modified by a relative clause as in *Triangles that cover squares that are projections are isosceles.*

Of particular interest to terminological representation (in particular to the interpretation of the all construct) is the semantics of phrases of the form

(12) *eat only fruit.*

Böttner (1985) interprets this phrase by $[eat]:[fruit] - [eat]:[fruit]'$, or equivalently,

(13) $[eat]:[fruit] \cap ([eat]:[fruit]')'$.

As Böttner pointed out in (1990), $([eat]:[fruit]')'$ alone inadequately interprets (12). If *eat only fruit* were to be interpreted as $([eat]:[fruit]')'$ one would not be able to deduce that persons who eat only fruit are also persons who eat (some) fruit, since in general

(14) $([eat]:[fruit]')' \not\subseteq [eat]:[fruit]$.

For suppose $[fruit]$ is empty. Then $[eat]:[fruit]$ is empty, but $([eat]:[fruit]')'$ is not necessarily empty, since $([eat]:\emptyset')' = ([eat]:U)' = (\mathrm{dom}([eat]))'$. (For R a relation, $\mathrm{dom}(R)$ denotes the domain of R.) We can show the following:

(15) $([eat]:[fruit]')' \subseteq [eat]:[fruit]$ iff $\mathrm{dom}([eat]) = U$.

But to decree that the domain of each relation must be the entire universe of discourse does not seem feasible. For example, we would not want to include the instances of $[fruit]$ in the domain of $[eat]$. However the interpretation (13) suggested by Böttner is contained in $[eat]:[fruit]$, ensuring that persons eating only fruit also eat some fruit.

In the paper (1985) Böttner not only analyses the semantics of sentences like *John loves only Mary* with *only* in object position, but also of sentences like *Only John loves Mary* and also like *All boys except John love Mary*. In other papers (1989, 1992) he investigates the algebraic interpretation of anaphoric expressions and English imperatives. Examples of anaphoric expressions are *John loves himself, John and Mary like each other* and *John likes his toys*. In his most

recent work (1991) he also accommodates sentences with verbs in passive form, which he interprets as converse relations.

4 Terminological Representation and Natural Language

Finding adequate terminological representations for the fragment of the English language Suppes and Böttner accommodate in the relation algebraic framework is now straightforward. Words and phrases that Suppes interprets as sets can be represented as concepts. And those he interprets as binary relations can be represented as roles. Take for example the phrase *male vegetarians*. According to Figure 3 its algebraic representation is $[male] \cap [vegetarian]$ which according to Figure 1 translates to (and male vegetarian) with male and vegetarian denoting concepts respectively representing the set of males and the set of vegetarians.

As subset relations correspond to subsumption relations and Peirce product corresponds to a some term, a terminological representation of the sentence *John loves Mary* as interpreted in (9) is

(16) John \sqsubseteq (some love Mary).

Recall that proper nouns are mapped to singleton sets. Accordingly, John and Mary denote concepts interpreted as singleton sets. As an aside, (9) can also be represented as an ABox statement. Namely:

(17) (assert-ind John Mary love).

This representation is equivalent to the terminological representation in (16). Here, John and Mary denote ABox elements, that is, elements of concepts. In general, an assertional statement of the form (assert-ind a b R) is interpreted as $(a, b) \in R$, where $a, b \in U$ are the interpretations of the ABox elements a and b.

Terminological formulations for the quantified verb phrases in (10) are:

(18)	Verb phrase	Terminological representation
(i)	*eat all fruit*	(not (some (not eat) fruit))
(ii)	*eat (some) fruit*	(some eat fruit)
(iii)	*eat no fruit*	(not (some eat fruit))

Observe that the algebraic interpretation (10) (i) of verb phrases quantified with *all* is not the variant (4) of Peirce product that is associated with the all operator. For representing verb phrase of this form we need a representation language that provides for roles to be negated. With the exception of the languages \mathcal{U} and \mathcal{KL} most terminological languages (including \mathcal{ALC}, BACK, CLASSIC and \mathcal{KRIS}) don't.

The all construct is useful for representing verb phrases such as *eat only fruit*. According to the semantics given in (13) a linguistically adequate terminological representation is the conjunction:

(19) (and (some eat fruit) (all eat fruit)).

Quantified sentences like those in (11) can be formulated as subsumption, equivalence and disjointness relations on concepts. The terminological representations for (11) are:

(20) Sentence Terminological representation

 (i) *Some persons eat (some) fruit* (and persons (some eat fruit)) $\neq \perp$

 (ii) *All persons eat (some) fruit* persons \sqsubseteq (some eat fruit)

 (iii) *No person eats (some) fruit* (disjoint persons (some eat fruit))

The inequality in (i) is strictly speaking not a well-formed terminological definition. However, for any concept C, C $\neq \perp$ is semantically equivalent to

(21) (some ∇ C) \doteq T.

This follows as for any set C the following is true: $C \neq \emptyset$ iff $U^2 : C = U$. Hence we may use the inequality of (20) (i) as an abbreviation for

(22) (some ∇ (and persons (some eat fruit))) \doteq T.

The work of Suppes and Böttner can also be utilised to provide valuable assistance for the reverse translation process from given terminological expressions (formulated with those operators that have algebraic associations), into their English formulations. For example, given the terminological statement

(23) (disjoint boys (not (some love girls)))

its algebraic representation is

(24) $[boys] \cap ([love] : [girls])' = \emptyset$

which translates to *No boy loves no girls* according to Suppes' denoting grammar. Note that there are algebraic representations without corresponding natural language formulations. Examples are algebraic representations of the form $[noun]'$ and $[verb] : [noun]'$. Thus, not every terminological expression has a English translation in the fragment analysed by Suppes and Böttner.

Nevertheless, I believe the work of Suppes and Böttner provides a useful link between natural language and terminological representation. Their work provides a formal basis for simplifying the translation process between representational expressions and natural language. It shows the extent to which English formulations can be expressed with the set of terminological operators listed in Section 2. And it contributes to a better understanding of the different terminological operators. For example, from a linguistic point of view the all construct is often used incorrectly. Here is a typical example from the literature. In Patel-Schneider (1990, p. 14) the term

(25) (and person (all child lawyer))

is said to define 'the class of people whose children are all lawyers'. This description is ambiguous. People whose children are all lawyers could refer to people who are parents of all lawyers, that is, people who for each person who is a lawyer are parents of that person. Or it could refer to people who are parents only of

lawyers. The intended meaning is the latter. But according to Böttner, the representation (25) is not adequate. See the discussion on the semantics of *eat only fruit* in Section 3 according to which a linguistically adequate representation of the set of 'people who are parents only of lawyers' is

(26) (and person (some parent lawyer) (all parent lawyer)).

Note that the assumed reading of the role child in (25) is different from the reading I assume in this paper. In (25) child represents the relation 'has as child' (and not 'is a child of') whereas in (26) parent represents 'is a parent of'.

I conclude with some loose observations. First, I believe the translation processes from natural language statements of the kind accommodated in the algebraic context to terminological representations could be automated. I envisage an implementation with three components. Given some natural language expression one component computes the syntactic structure (in the form of a syntactic derivation tree, for example) in accordance with a phrase-structure grammar. The second component then constructs the semantic representation (in the form of a semantic tree, for example) thus deriving the algebraic representation. And in the third component the algebraic representation is transformed into a terminological representation. Of course, as natural language is ambiguous the derived terminological representations needn't be unique. Negated verb phrases, for example, have more than one possible representation. The reverse process of generating the English language formulations for terminological representations would proceed in the opposite direction. Note however, as not every terminological expression has a natural English language formulation this process will be incomplete.

Second, the fragments of the English language representable in the representation languages U and KL are supersets of that fragment representable in the algebraic language. In U and KL we can also define *number restrictions* of the form *John loves at least 3 girls*, *John loves at most 2 girls* and *John loves exactly 1 girl*. These have no relation-algebraic representations.

Third, in (1981) Suppes proposes a natural deduction calculus for 'direct inference in English'. Whether terminological reasoners exist that may be used for this purpose requires further investigation. Systems with expressive terminological languages like U and KL are candidates. However, to my knowledge neither U nor KL are implemented in a knowledge representation system. Inference in such a system would be undecidable. Schild (1988) showed that there is no algorithm for deciding whether a subsumption relationship of U is true.

Fourth, the work of Suppes and Böttner may also be relevant in other areas besides KL-ONE-based knowledge representation. There is a link to the work of McAllester and Givan (1989) and Givan, McAllester and Shalaby (1991) who (similar to Suppes (1981)) aim at the development of a formalism for direct inference in natural language. Their representation language is related to the language of Montague (1974) and provides separate operators for quantification of the kind in (10) (i).

Finally, I want to stress that not every linguistic phenomenon can be characterised in the algebraic framework. This was not Suppes' intention. His intention

was to analyse the extent to which natural language can be accomodated in the context of (extended) relation algebra. As there is a direct link between relation algebra and terminological representation Suppes' and Böttner's investigations also cast some light on the extent to which natural language can be accomodated in the context of terminological representation formalisms.

5 Acknowledgements

I would like to thank the following people for many useful comments: Michael Böttner, Chris Brink, Bernhard Hollunder, Franz Baader, Ullrich Hustadt, Hans Jürgen Ohlbach and Barbara Zimmermann. For financial support I thank the Deutsche Forschungsgemeinschaft, SFB 314 (TICS).

References

Baader, F. and Hollunder, B. (1991), *KRIS: Knowledge Representation and Inference System*: System description, *Technical Memo TM-90-03*, Deutsches Forschungszentrum für Künstliche Intelligenz, Kaiserslautern, Germany.

Borgida, A., Brachman, R. J., McGuinness, D. L. and Resnick, L. A. (1989), CLASSIC: A structural data model for objects, *Proceedings of the ACM SIGMOD-89 International Conference on Management of Data*, Portland, Oreg., pp. 58–67.

Böttner, M. (1985), Variable-free semantics for 'only' and 'except', Manuscript, Institut für Kommunikationsforschung und Phonetik, Universität Bonn, Germany.

Böttner, M. (1989), Variable-free semantics for anaphora, Manuscript, Department of Mathematics, University of Cape Town, South Africa. To appear in *Journal of Philosophical Logic*.

Böttner, M. (1990). Personal communication.

Böttner, M. (1991), Boolean modules and extended relation algebras, Manuscript, Institute for Mathematical Studies in the Social Sciences, Stanford University, Stanford, California.

Böttner, M. (1992), State transition semantics, *Theoretical Linguistics* 18(2/3), 239–286.

Brachman, R. J. (1990), The future of knowledge representation, *Proceedings of the National Conference on Artificial Intelligence (AAAI)*, pp. 1082–1092. Extended Abstract.

Brachman, R. J. and Schmolze, J. G. (1985), An overview of the KL-ONE knowledge representation system, *Cognitive Science* 9(2), 171–216.

Brachman, R. J., Gilbert, V. P. and Levesque, H. J. (1985), An essential hybrid reasoning system: Knowledge and symbol level accounts of KRYPTON, *Proceedings of the International Joint Conference on Artificial Intelligence (IJCAI)*, Los Angeles, California, pp. 532–539.

Brink, C. (1981), Boolean modules, *Journal of Algebra* 71(2), 291–313.

Brink, C. and Schmidt, R. A. (1992), Subsumption computed algebraically, *Computers and Mathematics with Applications* 23(2-9), 329–342. Special Issue on Semantic Networks in Artificial Intelligence.

Brink, C., Britz, K. and Schmidt, R. A. (1992), Peirce algebras, *Technical Report MPI-I-92-229*, Max-Planck-Institut für Informatik, Saarbrücken, Germany.

Donini, F. M., Lenzerini, M., Nardi, D. and Nutt, W. (1991), The complexity of concept languages, in J. Allen, R. Fikes and E. Sandewall (eds), *Proceedings of the Second International Conference on Principles of Knowledge Representation and Reasoning*, Morgan Kaufmann, San Mateo, CA, pp. 151–162.

Doyle, J. and Patil, R. S. (1991), Two theses of knowledge representation: Language restrictions, taxonomic classification, and the utility of representation services, *AI* **48**, 261–297.

Givan, R., McAllester, D. and Shalaby, S. (1991), Natural language based inference procedures applied to Schubert's steamroller, *Proceedings of the National Conference on Artificial Intelligence (AAAI)*, pp. 915–920.

Hayes, P. (1977), In defense of logic, *International Joint Conference on Artificial Intelligence* pp. 559–565.

Jónsson, B. (1982), Varieties of relation algebras, *Algebra Universalis* **15**(3), 273–298.

Levesque, H. J. and Brachman, R. J. (1987), Expressiveness and tractability in knowledge representation and reasoning, *Computational Intelligence* **3**, 78–93.

MacGregor, R. M. (1991), Inside the LOOM description classifier, *SIGART Bulletin* **2**(3), 88–92. Special Issue on Implemented Knowledge Representation and Reasoning Systems.

Maddux, R. D. (1991a), Introductory course on relation algebras, finite-dimensional cylindric algebras, and their interconnections, in H. Andréka, J. D. Monk and I. Németi (eds), *Algebraic Logic*, Vol. 54 of *Colloq. Math. Soc. J. Bolyai*, North-Holland, Amsterdam, pp. 361–392.

Maddux, R. D. (1991b), The origin of relation algebras in the development and axiomatization of the calculus of relations, *Studia Logica* **50**(3/4), 421–455.

McAllester, D. and Givan, R. (1989), Natural language syntax and first order inference, *Memo 1176*, MIT Artificial Intelligence Laboratory. To appear in AIJ.

McDermott, D. (1978), Tarskian semantics, or no notation without denotation!, *Cognitive Science* **2**(3), 277–282.

Montague, R. (1974), English as a formal language, in R. H. Thomason (ed.), *Formal Philosophy: Selected Papers of Richard Montague*, Yale University Press, pp. 188–221.

Nebel, B. (1988), Computational complexity of terminological reasoning in BACK, *Artificial Intelligence* **34**, 371–383.

Nebel, B. and von Luck, K. (1988), Hybrid reasoning in BACK, in Z. W. Ras and L. Saitta (eds), *Methodologies for Intelligent Systems*, Vol. 3, NH, pp. 260–269.

Patel-Schneider, P. F. (1987), *Decidable, Logic-Based Knowledge Representation*, PhD thesis, University of Toronto.

Patel-Schneider, P. F. (1989), Undecidability of subsumption in NIKL, *Artificial Intelligence* **39**(2), 263–272.

Patel-Schneider, P. F. (1990), Practical, object-based knowledge representation for knowledge-based systems, *Information Systems* **15**(1), 9–19.

Schild, K. (1988), Undecidability of subsumption in U, *KIT-Report 67*, Department of Computer Science, Technische Universität Berlin, Germany.

Schmidt, R. A. (1991), *Algebraic terminological representation*, M.Sc. thesis, Thesis-Reprint TR 011, Department of Mathematics, University of Cape Town, Cape Town, South Africa. Also available as Technical Report MPI-I-91-216, Max-Planck-Institut für Informatik, Saarbrücken, Germany.

Schmidt-Schauß, M. (1989), Subsumption in KL-ONE is undecidable, in R. J. Brachman, H. J. Levesque and R. Reiter (eds), *Proceedings of the First International*

Conference on Principles of Knowledge Representation and Reasoning, Morgan Kaufmann, San Mateo, CA, pp. 421–431.

Schmidt-Schauß, M. and Smolka, G. (1991), Attributive concept description with complements, *Artificial Intelligence* 48, 1–26.

Schmolze, J. G. and Mark, W. S. (1991), The NIKL experience, *Computational Intelligence* 6, 48–69.

Suppes, P. (1973), Semantics of context-free fragments of natural languages, *in* K. J. J. Hintikka, J. M. E. Moravcsik and P. Suppes (eds), *Approaches to Natural Language*, Reidel Publ. Co., Dordrecht, Holland, pp. 370–394.

Suppes, P. (1976), Elimination of quantifiers in the semantics of natural language by use of extended relation algebras, *Rev. Int. de Philosophie* 30(3–4), 243–259.

Suppes, P. (1979), Variable-free semantics for negations with prosodic variation, *in* E. Saarinen, R. Hilpinen, I. Niiniluoto and M. P. Hintikka (eds), *Essays in Honour of Jaakko Hintikka*, Reidel Publ. Co., Dordrecht, Holland, pp. 49–59.

Suppes, P. (1981), Direct inference in English, *Teaching Philosophy* 4, 405–418.

Tarski, A. (1941), On the calculus of relations, *Journal of Symbolic Logic* 6(3), 73–89.

Woods, W. A. (1975), What's in a link: Foundations for semantic networks, *in* Bobrow and Collins (eds), *Representation and Understanding: Studies in Cognitive Science*, Academic Press, pp. 35–82.

Woods, W. A. and Schmolze, J. G. (1992), The KL-ONE family, *Computers and Mathematics with Applications* 23(2–5), 133–177. Special Issue on Semantic Networks in Artificial Intelligence.

Linking Humans and Intelligent Systems
or:
What are User Agents Good for?

Andreas Lux and Michael Kolb

DFKI*,
PO-Box 2080,
6750 Kaiserslautern, Germany

Abstract. Thanks to rapid improvements in computer and communication technology the network of national and international business relationships is becoming more and more dense. Future generations of information processing systems will involve a large number of both humans and machine systems to solve complex tasks. Cooperation and collaboration are inherent characteristics within the problem solving process. Intelligent cooperation mechanisms are a necessary prerequisite for efficient cooperation. This paper addresses the integration of humans and machine systems in a general multi-agent framework to cooperate with each other. The integration is accomplished by the concept of user agents which build the interface to humans on one hand and to intelligent information systems on the other.

1 Introduction

Recent research in computer science in the past years has modelled both formal and informal cooperation; different approaches have been taken:

Research in CSCW has led to systems where team members can cooperate with each other even when separated by great distances. However, the computer plays only a supporting role in such systems ([Greef et al., 1991]); it does not participate *actively* in the problem solving process. Well-known CSCW-systems like 'THE COORDINATOR' ([Winograd and Flores, 1986]) support the human in the cooperation process by managing the activities and recording them for later retrieval and processing. Although those systems technically support the establishment and management of information important for cooperation purposes, they don't have the capability to cooperate with humans on an equal footing. Another major drawback of most CSCW-systems is that they incorporate cooperation concepts only in a very application specific, mostly ad hoc way. Knowledge to model cooperative processes is available only implicitly or in a hard-wired fashion with the specific cooperative needs of the application in mind, cf. [Haugeneder and Steiner, 1991].

* German Research Center for Artificial Intelligence

On the other hand, Distributed Artificial Intelligence (DAI) has enabled computers to cooperate with each other [Bond and Gasser, 1988]). Drawing on the domain of real-life human cooperation, methods have been developed and formalized which support cooperation among computers; typical examples of such methods are various forms of negotiation, contract net and master-slave.

DAI uses the term *agent* to denote any participant, man or machine, in a cooperative process.

What's currently missing is a connecting link between these two research directions to support cooperation between humans and machines, i.e. machines taking an active part in the cooperation process.

The development of systems supporting the cooperation processes between humans and intelligent computers is the purpose of 'Human Computer Cooperative Work' (HCCW, [Steiner et al., 1990]).

In this paper, we present a general framework in order to support cooperation between humans and machine systems. The framework is based on a generalized agent model and a domain-independent cooperation model. Special attention is given to the concept of *user agents* to integrate humans in the abstract and formal model.

2 Cooperation Model

Cooperation is always needed when an agent is incapable of solving a problem on its own. Within the community of agents we adopt a plan-based approach to problem solving extended to the distributed case. As a prerequisite of doing so, agents must be able to communicate about the components of distributed problem solving, such as goals, plans, schedules, agent task assignments, constraints, and resource allocation. We use the notion of *cooperation object* to yield a coherent representation for the subject matter which is exchanged among agents within a cooperation [Lux et al., 1992]. Thus, a cooperation object is considered shared among two or more agents. This provides sufficient expressive power to maintain the common subject matter even throughout a long-lasting sequence of communication steps. In other words, cooperation objects form the semantic framework for interaction in our approach to modelling HCCW scenarios.

2.1 Cooperation Primitives

We employ message types drawn from speech-act theory to provide the operational basis for interaction. We refer to messages of these types conveying cooperation objects (Figure 2.1) as *cooperation primitives*. These form the basic units of communication in our system.

In order to provide the flexibility required by human participants in a cooperative process, we allow for dynamic definition of new cooperation primitives. For example, one could introduce message types such as SUPPORT and OPPOSE in order to communicate about intentions and beliefs [Sidner, 1992, Grosz and Sidner, 1990, Cohen and Perrault, 1988].

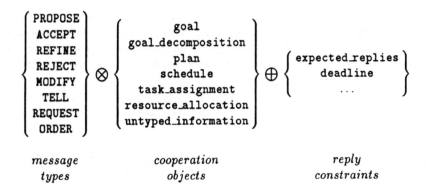

Fig. 1. Cooperation Primitives

2.2 Cooperation Methods

The cooperation primitives are the basic building blocks for cooperation. They can be composed to form structured *cooperation methods*, which provide a common framework for the participation of agents within a cooperation. They can be seen as procedures prescribing how the agents can efficiently conduct a cooperation.

Cooperation methods have parameters for the initiating agent, one or more other agents and an object of cooperation. An example from CSCW is the cooperation method used in THE COORDINATOR [Winograd and Flores, 1986]. The result of a successful application of this method is that the initiating agent and the other agent share the cooperation object, its assignment to the other agent, and that the result is to be reported to the initiating agent.

The main problem we have to face in our model is how a *single* cooperation message can be classified in the context of an ongoing cooperative interaction. Therefore, we define a set of rules that describes how to define methods by utilising the cooperation primitives.

The purpose of these rules is twofold. First of all, they determine the way how messages may be composed to obtain methods. Second, they serve as a basis for describing methods in an efficient manner, that is to allow communication of methods and to allow parsing the incoming message stream in order to decide if it (syntactically) fits the method at hand.

A high degree of flexibility is essential for the cooperation methods. For instance a *contract net* [Smith, 1980] is a flexible cooperation structure which, in the general case, neither determines the number of agents involved (in fact the number is unlimited) nor prescribes which of the agents will be members of the group. Obviously, predefined cooperation methods must be freely parameterisable. To simplify establishment of cooperation patterns that are likely to be

used frequently, predefined cooperation methods with partly or even completely specified parameters seem reasonable. They allow to recall standard cooperation structures involving the same set of agents and/or the same cooperative links thereby cutting short the usual preliminary negotiations concerning establishment of the cooperation structure.

So we may conclude that the mechanisms required for describing cooperation methods have to cover composition of messages as well as storage of default parameters.

3 Humans and Machines as Cooperative Agents

To utilize the concepts of cooperation primitives and cooperation methods to build real HCCW systems we use the multi-agent framework developed in DAI. Within the agent paradigm the possibility is given to represent the formal cooperation between humans and machines using our cooperation language. Our agent model distinguishes between the part of an agent which is responsible for the executive tasks (the *body* of the agent) and a part which is responsible for communication and coordination (the *head* of the agent).

The body consists of all skills and functionalities an agent is able to perform alone, i.e. without any cooperative embedding.

The head is the 'intelligent' part of an agent which can manage the participation of the agent within the cooperation process. With the help of this knowledge the agent can decide whether it can contribute to the solution of the overall problem, which cooperation method is the most appropriate for a given problem to solve etc. The goal is to be able to add a head to any existing software to create a cooperative agent.[2]

All artificial agents like e.g. sensors, printers, databases, expert systems etc. can be described within the above scheme. Humans, however, are more complicated agents and therefore deserve special attention.

4 The User Agent

Humans are different from machine agents in that they often do not require special hardware or software support to participate in cooperative activities. This is especially the case when humans are cooperating in a 'face-to-face' mode (informal cooperation). However, when humans cooperate with machine agents or less accessible humans (i.e. neither face-to-face nor audio nor video-connections) an appropriate interface is needed. The integration of humans into our model of cooperation is accomplished by the *user agent*[3]. Thus, a human agent in our multi-agent framework comprises the human together with her associated user agent.

[2] Our agent model is described in more detail in [Steiner et al., 1990].

[3] This term was first introduced in [Håmmåinen et al., 1990]. A similar concept is the 'personal assistant' as described in [Pan and Tenenbaum, 1991].

The user agent is designed according to the basic agent model, so it can interact with other agents using cooperation methods and primitives. It, however, provides extra powerful facilities:

- a graphical user interface presenting cooperation processes to the user and functionalities so that the human does not necessarily have to handle cooperation in terms of messages,
- knowledge about the human (preferences, skills, abilities),
- the ability to represent the human when she or he is not present, and
- sophisticated functionalities, from advising the human in selection of cooperation methods to relieving the human from having to deal explicitly with management of cooperation.

The user agent understands the basic cooperation primitives and methods and knows when and how to use them. Ideally, the user agent is able to handle and to complete routine tasks on its own and to present the others appropriately to the user. For example, simple tasks are forwarded automatically to a human subordinate or a machine agent, whereas complex tasks might need user input for further treatment. In doing so, it resembles a human secretary who is familiar with its ordinate's requirements and preferences. The user agent is, among other things, able to schedule and manage appointments, to respond to well-defined (formal) requests and to filter incoming mail.

As a future extension, the human will have the option to define new cooperation primitives or cooperation methods by virtue of the user agent. The user agent introduces these new cooperation methods to the multi-agent system so that other agents can apply it in future cooperative processes. Definition of new cooperation methods is currently reserved for humans.

4.1 Knowledge about the Human

The user agent can be seen as an image of its respective user as part of the overall multi-agent system. It, therefore, needs knowledge about the human it represents. When humans are involved in cooperative problem solving processes, two different aspects can be distinguished. The human can be involved in the problem solving process, i.e. creation, activation and monitoring of multi-agent plans, and in the execution of tasks to contribute to the achievement of the overall goal. The user agent has to support the human in both aspects. To take part in the problem solving process, it needs knowledge about

- the current goal(s), the user is trying to achieve at the moment
- the current plan(s), the user is pursuing
- the set of cooperation methods the user is able and allowed to use
- the user's abilities to execute tasks
- the user's responsibilities, i.e. a list of tasks currently assigned to her/him
- preferences for presentation of information
- preferences for tools useful for a certain task execution

- preferences to monitor cooperation processes
- the resources (tools, databases) the user can use within a cooperation
- the degree the user is occupied
- other agents, where they are located, how to contact them, their abilities and plans
- the overall organizational structure (relationships to other agents, rights)

The above mentioned knowledge is static to some extent (application independent) or has to be provided during a cooperation. Both the user and the user agent have to take care that the knowledge is as complete and up-to-date as possible.

4.2 The User Interface

The *user interface* is the specialised hardware and software used for interaction between the user and the system. It is a portion of the body of a user agent and is mainly responsible to

1. present the ongoing cooperation processes to the user,
2. provide a means to define new cooperation methods and
3. conduct an application specific cooperation by requesting input and presenting output data.

Here, we mainly concentrate on the first point, because it is the most interesting one from the view of cooperation.

In presenting ongoing cooperation processes, different aspects are conceivable:

- a graphical presentation of the involved agents within a certain cooperation context, thereby showing the flow of cooperation messages to solve the given (sub-) problem.
- a graphical presentation of the currently used cooperation method, e.g. as a tree whose nodes correlate to different agents or states and which are labelled with the names of the agents and the intermediate results of the cooperation method.

To provide the necessary information to build such graphical representations we need access to a special type of user agent, a so-called *monitor agent*. As its name suggests, it can trace all messages to and from the agents it has been told to monitor.

Different cases of monitoring are imaginable: A user may want to trace all messages

- sent to one or more agents,
- received by one or more agents,
- exchanged as part of a specific cooperation, or
- exchanged whenever a condition is satisfied (e.g. whenever a particular method type is invoked).

The monitor agent offers these services to the user. It carries out these services simply by maintaining a master-slave cooperation, ordering the relevant agents to copy their messages to it. It is then up to the user agent to transform these messages into the appropriate and desired graphical presentation formats. The main advantage of the monitor agent is that it can support every user agent in presenting the cooperation processes to their users.

The second point is a challenging task. For the modification of existing and the definition of new cooperation methods, a comfortable *method editor* should be available. As known from existing drawing tools with basic primitives like line, circle, triangle etc., the human should be able to construct cooperation methods by appropriate arrangement and linking of cooperation primitives. Syntax rules should be provided to avoid errors during construction or modification and to ensure correctness of the methods. The main problems we have to deal with is how far a cooperation object has to be specified and how the specification is transformed to new cooperation methods being then executable by humans and even machine agents.

The third point of processing user input and output doesn't really involve new concepts. Menus for user input and windows for presentation of results have to be developed as in any application; however, different menu entries for certain characteristics have to be provided to represent different preferences from prototypical users.

5 User Agents in a Group Scheduling Scenario

Scheduling group meetings with multiple participants is a complex and difficult task which requires intelligent cooperation support to become easier and more flexible [Lux, 1992]. Making appointments without computer support requires much cooperation effort between the participants and is often inefficient. At the moment, several rounds of phone calls, letters or electronic messages are necessary to arrange a meeting between a number of people with busy schedules. Organisational advantages arise, if the amount of cooperation is minimized. With the rapid progress of today's information processing technology, it should be possible to alleviate appointment management by intelligent computer support. Ideally, an intelligent appointment system should behave as a secretary who fixes dates and arranges meetings independently from its chief as far as possible.

To develop an intelligent appointment system, the following prerequisites must be given:

- The users have to maintain their personal calendars on-line and up-to-date.[4]
- A (graphical) user interface must exist to set up a meeting, to specify time preferences, to ask users for participation in a certain meeting etc.
- The user agents must have access to the users' personal calendars files.
- The user agents must have knowledge about

[4] The success of any system relying on user data is dependent from the extent the user is willing to provide these data.

- the users' preferences with respect to meeting times, meeting subjects, reserved time periods (e.g. lunch break, holidays) etc.
- the calendar tool used,
- location and format of the calendar data,
- the persons and their addresses it can negotiate with about a meeting arrangement.

If we look at the tasks the user agent is involved in, we shortly have to describe the process of scheduling group meetings.

A wide variety of different procedures are imaginable ranging from fully specified proposals (e.g. 2 hour meeting with Al and Don on Wednesday, 25th July from 10:00 - 12:00) up to very vague ones (e.g. 1 hour group leader meeting tomorrow, on Friday or next week).

The following parameters have to be taken into account:[5]

- participants
- possible time (set of disjunct time intervals)
- duration
- subject
- meeting priority

The user specifies the meeting parameters via a graphical user interface. The interface is extended by a menu for setting up user preference values effecting a certain user agent behaviour during the scheduling process. For example, the user can specify that in case of rejection the user agent automatically has to mark the time interval with the rejection reason as occupied; or in case of a longer absence (holidays, conference) the user can specify whether her/his user agent is allowed to agree to meetings without explicit inquiring. The preference values can be modified by the user at any time.

To decide the participants of a meeting, a list of single persons resp. special groups (e.g. all members of a certain project, all project leaders) is dynamically provided by the initiator's user agent which in turn has made it available from an agent directory service.

After having specified values for the above mentioned parameters, the initiator's user agent connects to the participants' user agents requesting information about their users' free time intervals. The participants' user agents automatically process their users' calendar files and return the requested information.

If some user answers are missing after a given time period (maybe because of a connection failure), the initiator's user agent takes respective steps. It informs the user about the failure and awaits user commands for further proceeding. If the user wants the same action to be taken several times, the user agent may even 'learn' its user's behaviour and invoke the command automatically the next time such a failure happens.

[5] Optional attributes might be: meeting type, place, frequency, general explanatory information.

If all participants' user agents have delivered their free time intervals[6], the initiator's user agent evaluates this information. Two results can emerge from the evaluation process: either a list of time intervals where all participants have free time, i.e. where the meeting contingently could take place[7] or no time interval is found where the meeting could take place.

In the first case, the initiator's user agent now proposes an entry out of the free time list -together with the other relevant meeting attributes- directly to the participants by poping-up a window on their machines. If all participants accept, the initiator's user agent orders the participants' user agents to insert the meeting to the participant's calendar file.

If a participant rejects s/he provides a reason for rejection to the initiator. Depending on the specified preference value, the user agent automatically marks the time interval with that reason as occupied; otherwise, the time interval is treated as free in a next meeting proposal.

If we differentiate between mandatory and optional participants of a meeting, we need not to reschedule in case an optional participant resp. her/his user agent rejected. The meeting can be scheduled without her/him.

If a mandatory person rejects or in the case where no commonly free time interval is found by the initiator's user agent rescheduling of meetings has to take place. The rescheduling process can also be supported by a user agent.

Taking the knowledge of the organizational structure into account, the problem can be approached from two angles:

- the status of the rejecting person(s) compared to the status of the initiator
- the priority of the meeting assessed by
 - the initiator
 - the rejecting person(s)

If the initiator is in an ordinate-subordinate relation to the participants, s/he can order the participants' user agents to reschedule the conflicting activity. If the activity is a meeting, successful rescheduling involves one or more instantiations of new appointment scheduling processes with the rescheduling person as initiator and the members of the rescheduled meeting as participants.

If the initiator and the 'conflicting' participants are in a peer-to-peer relation, they have to negotiate about the time conflict. In a first step, they might negotiate about the priority of the actually proposed meeting compared to the already fixed meetings. The priority of the meeting under negotiation has been assessed by the initiator when setting up the cooperation process and is therefore known by his/her user agent. The conflicting meeting also has an assigned priority. It can manually be modified by editing the personal calendar file or by predefined user rules depending on meeting attributes like type, topic, etc.

We don't want to go into greater detail with the discussion of meeting priority, because it can even be extended to the question what meaning it has. Does priority mean the importance of the meeting (which can vary from participant

[6] Also an empty list is possible in case the user is occupied the whole specified time.

[7] If no other meeting is scheduled to that time in the meantime.

to participant) or the hardness to move the meeting (which can also vary from participant to participant) or a mixture of both aspects (expressed in what computational form)?

From the above statements it should be clear, that the concept of a user agent is useful to support humans in the cooperative context of scheduling meetings. The user agent acts and behaves like the human's personal secretary in fulfilling that task. Because the user agent can integrate the human in many other cooperative scenarios, the described functionality is only a small part of the overall user agent functionality, namely that part responsible for scheduling appointments.

6 Implementational Issues

At the moment, a first version of an appointment scheduling system has been developed under the HCCW paradigm on a local area network of Unix workstations. The first prototype of user agents being able to schedule appointments was implemented on MECCA (Multi-Agent Environment for the Construction of Cooperative Applications). MECCA is based on a logical programming system combining PARLOG, Prolog [Clark and Gregory, 1987, Davison, 1990] [8], and NeWS, the Network extensible Window System from SUN.

The application-independent modules, i.e. a primary simple version of a general agent model, the cooperation primitives and the cooperation methods, are implemented in PARLOG. Communication, i.e. message passing between agents, takes place on top of the TCP/IP protocol with PARLOG/Prolog built-in TCP/IP primitives.

The PARLOG language provides a natural and efficient embedding of parallelism into logic programming, whereas Prolog backtracking and meta-level programming facilities are used to implement sophisticated reasoning.

NeWS turned out to be very useful to implement the user interface, see Figure 2. The main features of the NeWS system are:

- handling of most of the user interactions within the NeWS server by downloading code into the server, thus keeping the communication between server and client low
- possibility to design and test the user interface independently from the application
- simple client-server communication allowing easy access from the PARLOG/-Prolog system
- easy distribution across networked machines

The HCCW appointment system was implemented according to the general agent model with its modularisation into agent body, head, communicator.

The agent communicator mainly maps the high-level communication facilities down to TCP/IP primitives. The programmer need no longer worry about

[8] The Parlog/Prolog platform was built by Imperial College as part of IMAGINE, Esprit Project 5362.

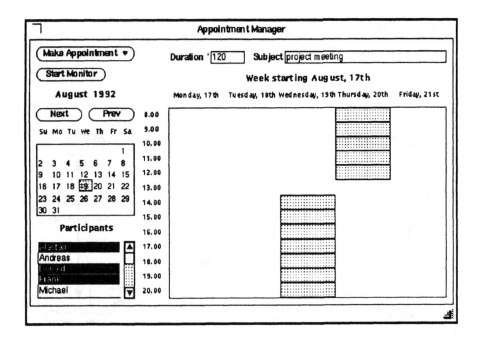

Fig. 2. User Interface for Appointment Scheduling

getting the network adresses of other agents and establishing connections. The communicator gets its information about other agents from its agent directory service. The ADS stores the name, type and network adress of each agent registered at the particular ADS and also the services an agent offers to the system. There may be several ADS's running in a scenario each managing a group of agents. Currently the ADS's do not communicate to each other, but they will be implemented as agents, i.e. group agents, so that an agent can require the services from agents that are not registered at its own ADS.

Incoming messages that trigger new cooperations are passed to the agent's head, where they are handled by a new process. The head of the agent handles cooperations with other agents. If the agent is involved in more than one cooperation at a time, these are managed by several parallel Parlog processes. The cooperation methods are described in MECCA's "Parlog Meta Code" that is compiled down into Parlog. This code is still under development and will ease the way the programmer has to specify cooperation methods.

The agent's body may consist of Parlog, PROLOG, C or NeWS code. Body functions are usually called from within a cooperation method.

Currently, there are three generic types of agents:

– machine agents
– user agents and

– monitor agents.

The cooperation of the different types of agents is shown in Figure 3.

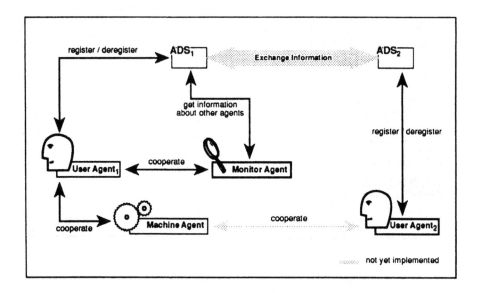

Fig. 3. Cooperation of Different Types of Agents

Machine agents are not directly controlled by the user. Their activities are triggered by cooperations with other agents. They may have a representation in the system's user interface, e.g. to watch their current activity or to display their state while debugging the system, but there is no direct interaction from the user with machine agents.

Humans participate in a scenario by means of their user agent. The user agent provides a graphical user interface, which is mainly implemented on the NeWS server side, and a control process on the Parlog side. The main purpose of the user interface is to allow the user to specify new tasks to the system in a graphical style. The user agent transforms the input from the user interface to a call of a specific cooperation method.

A special type of user agent is a monitor agent. It allows the user to monitor ongoing activities in the system. This monitoring process is implemented as any other cooperation by special cooperation methods. It simply maintains a master-slave cooperation to the relevant agents, ordering them to copy their cooperation messages to it.

For some applications it might be reasonable to introduce the concept of a user-interface agent (UIA), particularly when several agents are represented in one user-interface. This agent is designed to handle all user interactions on

a display and pass them to specific agents. The concept of UIA allows a simple implementation of a single user-interface supporting users distributed across several machines. A user-interface agent manages its own display and updates other displays via special update-cooperations with other user-interface agents. It also can restrict possible user interactions according to the current state of the multi-agent system scenario; e.g. during joint editing, the UIA might block editing actions while another display is currently being edited.

7 Conclusion and Outlook

The aim of this paper was to introduce a conceptual model to make a first step towards supporting cooperation among teams of both humans and machines. This allows the integration of machines into human working environments as intelligent assistants.

The understanding of the common language, in which humans and machines can talk to each other, is accomplished by the concept of the user agent, which can act on behalf of its user.

We claim that our approach is sufficiently *general* and *domain-independent* to model a wide variety of cooperative processes. It has a formal basis so that it can be used within the DAI multi-agent framework and provides the flexibility to be used in CSCW applications.

Beside the appointment management scenario, we are currently implementing multi-agent scenarios in the traffic area.

Based upon our experiences with developing these applications, we will fully specify and develop *MAIL*, a formal multi-agent interaction language.

Acknowledgement

The authors gratefully acknowledge F. Bomarius and A. Burt of the DFKI and D. Steiner of Siemens for their stimulating and fruitful comments on this paper.

References

[Bond and Gasser, 1988] A.H. Bond, L. Gasser. Readings in Distributed Artificial Intelligence. Morgan Kaufmann Publishers, San Mateo, CA. 1988.

[Clark and Gregory, 1987] K. S. Clark, S. Gregory. Parlog and Prolog United. *Proceedings of the 4th International Logic Programming Conference.* Melbourne, Australia. 1987.

[Cohen and Perrault, 1988] P. .R. Cohen, C. .R. Perrault. Elements of a Plan-Based Theory of Speech Acts. *in: A.H. Bond, L. Gasser. (eds.) Readings in Distributed Artificial Intelligence.* Morgan Kaufmann Publishers, San Mateo, CA. 1988.

[Davison, 1990] A. Davison. Hermes: A combination of Parlog and Prolog. ESPRIT Project 5362 IMAGINE. Technical Report #3. August 1990.

[Greef et al., 1991] P. de Greef, D. Mahling, M. Neerincx, S. Wyatt. Analysis of Human Computer Cooperative Work. ESPRIT Project 5362 IMAGINE. Technical Report #4. July 1991.

[Grosz and Sidner, 1990] B.J. Grosz, C. Sidner. Plans for discourse. *in: P. Cohen, J. Morgan, M. Pollack (eds.) Intentions in Communication.* Bradford Books at MIT Press. 1990.

[Håmmåinen et al., 1990] H. Håmmåinen, J. Alasuvanto, R. Måntylå. Experiences on Semi-Autonomous User Agents. *in: Y. Demazeau, J.-P. Müller (eds.) Decentralized Artificial Intelligence. pages 235-249.* Elsevier Science Publishers. North-Holland. 1990.

[Haugeneder and Steiner, 1991] H. Haugeneder and D. Steiner. Cooperation Structures in Multi-Agent Systems. *in: Proceedings 4. Intern. GI-Congress Knowledge-based Systems. DAI and Cooperative Work.* Munich. October 1991.

[Lux et al., 1992] A Model for Supporting Human Computer Cooperation. *in: Proceedings AAAI Workshop on Cooperation among Heterogeneous Intelligent Systems.* San Jose, CA. July 1992.

[Lux, 1992] A. Lux. A Multi-Agent Approach towards Group Scheduling. DFKI Research Report RR-92-41. Kaiserslautern. August 1992.

[Pan and Tenenbaum, 1991] Toward an Intelligent Agent Framework for Enterprise Integration. *in: Proceedings 9th National Conference on Artificial Intelligence. Volume 1. pages 206-212.* AAAI Press/MIT Press. 1991.

[Sidner, 1992] Using Discourse to Negotiate in Collaborative Activity: An Artificial Language. *in: Proceedings AAAI Workshop on Cooperation among Heterogeneous Intelligent Systems.* San Jose, CA. July 1992.

[Smith, 1980] R.G. Smith. The Contract Net Protocol: High Level Communication and Control in a Distributed Problem Solver. IEEE Transactions on Computers, 29, 1104-1113. 1980.

[Steiner et al., 1990] D. Steiner, D. Mahling, and H. Haugeneder. Human Computer Cooperative Work. In *Proc. of the 10th International Workshop on Distributed Artificial Intelligence.* MCC Technical Report ACT-AI-355-90. Austin/TX. 1990.

[Winograd and Flores, 1986] T. Winograd and F. Flores. Understanding Computers and Cognition: A New Foundation for Design. Addison Wesley, Reading, MA. 1986.

An Advisor for the Management of the Acute Radiation Syndrome

Kindler H.*', Densow D.', Fliedner T. M.'

*) Institute for Applied Knowledge Processing, University of Ulm
Postfach 2060, D-7900 Ulm, kindler@dulfawla.bitnet
') Institute for Occupational Medicine, University of Ulm

This research was partially founded by the AIM Programme of the Commission of the European Communities as project number A2034 (GAMES II). The partners of this project are SAGO (Florence, Italy), Foundation of Research and Technology (Heraklion, Greece), Geneva University Hospital (Switzerland), University of Amsterdam (The Netherlands), University College of London (UK), the University of Pavia (Italy), and the University of Ulm (Germany)

Abstract Many of real problems are such complex that one single agent only is not capable to solve them autonomously. Thus, co-operative problem-solving involving the interaction of human agents and machine agents is required to manage complex tasks, e. g., the acute radiation syndrome. A knowledge-based advisor supporting the physician in charge managing an acute radiation syndrome is presented. The advisor is needed to transfer the knowledge of the present experts into the future. The physician in charge is advised how to decompose the original problem into sub problems and to decide to whom the sub problems to be solved are distributed. The management of the acute radiation syndrome can be decomposed into tasks which are routinely done in every hospital and others which are in general not done in the hospital. Due to the fact that the knowledge-based advisor co-operatively distributes most of the routine tasks to humans and only solves a rare minority by itself the efficiency of the co-operative problem-solving process increases. By applying a cognitive problem-solving model implemented on a blackboard control architecture this behaviour is obtained. The patient card metaphor and the communication via forms, to which a physician is accustomed, facilitates the access for the medical personnel.

1. Introduction

The acute radiation syndrome is a rare disease. World-wide only 900 cases have occurred. Elder experts who are able to treat it have gained their experience in the 50-th and 60-th of this century. It is of interest to preserve their knowledge for the future. The training of young physicians with real cases on the medical management of the acute radiation syndrome is expensive due to its rare occurrence. Providing

the whole medical competence of the experts as an expert system is inefficient because the development and maintenance is very expensive. An efficient way of obtaining a future capability of a good medical management of the acute radiation syndrome is the construction of a knowledge-based co-operative advisor. Physicians normally never develop a medical management strategy for the acute radiation syndrome. This development of an individual management plan on an abstract level of cognitive adequate tasks could be performed by a knowledge-based advisor which can be constructed efficiently. Most of the tasks which form the management plan are routinely done in a hospital. Therefore, it is more efficient that a physician performs them than a knowledge-based advisor. Because the tasks belong to different medical disciplines the advisor has to support the physician in charge to co-ordinate the distribution of the tasks. Only a minority of the tasks of the management are unique to the acute radiation syndrome. These are more efficiently performed by the knowledge-based advisor itself.

In the future problem-solving capacity for the medical management of the acute radiation syndrome is needed. Training young physicians or to develop an expert system are two expensive solutions. It is much cheaper to choose a co-operative problem-solving approach. A knowledge-based advisor plans the management of the acute radiation syndrome according to the individual state of the patient based on tasks. It decides what tasks, the majority, should be left to physicians and which of the tasks, the minority, are better performed by itself. This must be done in a co-operative transparent way that the physician in charge can take the responsibility.

In the following co-operative problem-solving is discussed in general. A scenario in which a knowledge-based advisor mediates human agents in problem-solving is classified and discussed. The domain of the acute radiation syndrome is illustrated as a special example for this scenario. The requirements and architecture of the co-operative knowledge-based advisor are presented. A demonstrator of a knowledge-based advisor for this domain is described.

2. Co-operative Problem-Solving

Today problems and their solutions become more and more complex. This is due to legal restrictions, limited resources, and high requirements of the customers.

Therefore, the situation that the solution for one problem can be efficiently constructed by one agent who has enough competence and capacity is less frequently found today than in the past. The pretentious problems of today require a group of specialised agents to solve them.

A problem has to be decomposed reasonably into sub problems. For each of them must be decided which of the available agents can solve it the most efficiently. The solutions of the sub problems have to be integrated to the solution of the given problem.

Requirements for this co-operative approach of problem-solving are:

- At least one agent has to have the strategic knowledge how to tackle the whole problem and how to decompose it favourably into sub problems.
- For each sub problem must be available at least one agent to solve it.
- Knowledge is available if agents can solve a problem and how efficiently they can solve the problem within given constraints.

This proceeding is known from organisations where only human agents are involved. Management science, organisation science, and occupational psychology do research on how to optimise this co-operative work style. The questions of interest are how to map the skills to the sub tasks, how to decompose the problems, and the communication.

The function of these human organisations was imitated experimentally to let expert systems co-operatively solve complex problems [12]. The questions about the structure, the function, and the communication have to be stressed in the same way as in human organisations.

A third scenario is the co-operation of human agents and computer-based agents. A special case is the co-operation of one human agent with on computer-based agent [4]. In the following chapter we will discuss a special scenario in which several human agents and one knowledge-based advisor are involved. This is subsumed by computer supported co-operative work [6]. Here the questions about the interagent communication, the responsibility for the problem-solving, the decomposition of the problem, the distribution of the sub problems between the different agents, the initiative, and others have to be discussed.

3. A Special Scenario

The scenario is that one knowledge-based advisor and several humans are involved in co-operatively solving rare problems which are mainly composed of routine sub problems.

If an organisation in the past had to deal with seldom occurring problems it had to invest substantially into the education of staff to deal with this problems. After the mature of artificial intelligence techniques another solution would be to build an expert system to solve these problems completely. Training of personnel is very expensive and the implementation and evaluation of a full scale expert system is expensive, too. These two solutions would cost much money and hence be inefficient.

When examining these problems it can be found out for many of them that they can be decomposed into sub problems of which the majority are routinely solved. Only the strategic knowledge for how to tackle and decompose the problem and the knowledge how to solve the minority of rare sub problems are needed. Examples are rare diseases in medicine, e. g., the acute radiation syndrome, which will be presented below, export and import procedures for countries which do only little trade, the maintenance of special machines, and others.

Influenced by the problem structure depicted above a problem knowledge-based advisors can be built efficiently. Only the tasks which are seldom performed by humans are executed by the advisor. The tasks routinely performed by human agents are dedicated to them by the advisor. The effort to construct a full-scale expert system is significantly reduced. But, due to the system's function as co-operator and mediator it needs good communication facilities and supplementary knowledge about the efficiency of the human agents in solving the sub problems.

In the exemplar problems presented above one human in charge has to take the responsibility for the correct solution of the problem even when applying technical decision aids like technical advisors. Therefore, the knowledge-based advisor must be capable to give at least him the total insight into its problem-solving process that he can take the responsibility. It is advantageous to give an orientation about the problem-solving process to the other human agents, too. The exact specification of the sub problem and the result that shall be obtained after its solution have to be communicated to the human agents. This is of crucial importance.

By recording the abstract problem-solving plan and the data required by the advisor to do the planning a documentation of the problem-solving process is achieved.

4. The Domain of Application

The application domain is the medical management of the acute radiation syndrome. It is a very seldom occurring disease. Some 900 cases are known in the world including 250 Chernobyl cases, only. A limited number of experts on the world knows how to manage it. They have gained their expertise in the fifties and sixties when radiation accidents occurred more frequently. Today, young physicians rarely have the chance to gain experience about this medical management task. It would be very expensive to train them. On the other hand, it would be very expensive to develop an expert system to manage the acute radiation syndrome because to totally cope with the management of an irradiated patient it would be necessary to model competence in surgery, dermatology, intensive care, internal medicine, haematology, and the specialists' knowledge about the acute radiation syndrome. The development of Internist, an expert system for internal medicine, took many years [14].

When the problem-solving behaviour of an expert who manages an acute radiation syndrome is examined you find that the problem-solving strategy is sequential diagnosis [5]. The big task is hierarchically decomposed into sub tasks which is done dynamically.

These sub tasks are then solved in a sequential order. Many sub tasks are tasks which are routinely performed in a hospital, e. g., creating an antibiogram, treating skin burns, doing a bone marrow transplantation. Others are never performed in a normal hospital, e. g., developing dynamically the diagnostic and therapeutic strategy, determining the degree of the irradiation, taking into account the specialities of a bone marrow transplantation after an irradiation. Due to the many medical disciplines this is co-operative problem-solving even when no knowledge-based advisor is involved.

As mentioned before the most efficient way of problem-solving if several agents are involved is to distribute each task to the agent who can perform it the most efficiently. Because physicians especially have a lack in creating a management plan for the acute radiation syndrome the knowledge-based advisor must be able to advise the physician in charge. This key task and some small sub tasks which require relatively modest amounts of special knowledge about the acute radiation syndrome are normally not routinely solved by physicians. They could be well done by the knowledge-based advisor which nevertheless must be able to explain and justify its proposals to the physician in charge. During the dynamic creation of the management plan it has to be decided continuously how to distribute the tasks to the physicians of the hospital. For instance, the treatment of skin burns is given to a dermatologist, a bone marrow transplantation is done by a haematologist, taking of blood samples can be done by a nurse. All the tasks which are routinely done by physicians are given to the physicians. The group of physicians of one hospital can solve most of the tasks efficiently.

It is worth the effort to model the strategic and special knowledge about the acute radiation syndrome in a knowledge-based system because the experts will die out in the future and the special knowledge remains quite stable because the radiation syndrome occurs very rarely.

The modelling of the strategic knowledge is especially important because the physicians lack the expertise how to tackle the problem. For the planning the advisor needs exact and abstracted data on the patient which must be provided by the human agents.

One task a physician is not accustomed to is the grading of an acute radiation syndrome according to early indicators. Therefore, a knowledge-based advisor could perform this more efficiently. To do this job it needs data on the patient which have to be given to him by the human agents.

In contrast, it is not effective to let advise a knowledge-based system on how to perform a bone marrow transplantation. There are different though standardised approaches to perform a bone marrow transplantation. The knowledge about bone marrow transplantation grows continuously. Therefore, it would be difficult to keep a knowledge-based system at the (different) state(s) of the art. Nevertheless bone marrow transplantation is routinely done by haematologists, hence they know very well how to do it.

It would only be necessary to assist a haematologist to indicate a bone marrow transplantation. But, the system should give additional give advice on the differences between a normal bone marrow transplantation after iatrogen homogeneous irradiation done in the case of leukaemia and after accidental rather inhomogeneous irradiation. In the latter case you either need an exactly HLA-compatible donor or a supplementary conditioning regimen. This is knowledge a normal haematologist does not have.

5. Requirements and the Architecture of a Knowledge-Based Advisor

5.1 Cognitive Problem-Solving Model and Blackboard Control Architecture

For the co-operative problem-solving in the domain of the acute radiation syndrome a common management plan for the co-operation of the agents has to be created. This common plan must be developed by the advisor. Therefore, the knowledge-based advisor needs strategic knowledge on how to tackle the problem and to decompose it. This requires the explicit representation of strategic knowledge and virtual entities, i.e. the sub problems serving to control the reasoning.

The plan must be comprehensible to all human agents and especially to the physician in charge. Therefore, it must have a structure to which humans are accustomed to and the structural elements must be known to humans. It is a well-known fact in cognitive science that humans solve large problems by hierarchically decomposing them into sub problems until means are found to solve the latter [1]. Experts managing the acute radiation syndrome apply the strategy of sequential diagnosis [5], which can be mapped to the cognitive problem-solving model [11]. Current research [16] has shown that cognitive problem-solving models in medicine can be mapped to a philosophical problem-solving model, the ST-model, too. It has been shown for many problem-solving solving processes that they can be modelled with the KADS methodology [17].

The kernel of an advisor for a scenario as described above is knowledge on the problem-solving strategy. The advisor has to take over the leadership at the physician's request and has to initiate the tackling of the problem. The knowledge-based advisor therefore has to provide the competence to dynamically plan the management of an irradiated patient individually on an abstract level. It must be able to decompose the problem into a hierarchy of cognitively relevant sub problems. The explicitly represented management plan has to be shared between all agents involved in the problem-solving process.

A blackboard control architecture [8] is an appropriate mean to imitate human problem-solving behaviour by explicitly representing a dynamic problem-solving plan and controlling the problem-solving by the plan. Two blackboards contain the data in a blackboard control architecture.

The domain blackboard encompasses all the domain data forming the description of a case. For a better affinity with human imagination this is done as an object-oriented representation.

On the control blackboard all the objects can be found which serve to represent the problem-solving plan. In case of a knowledge-based advisor this is a task hierarchy representing a medical management plan developed according to the strategy of sequential diagnosis. The strategic knowledge is explicitly formulated as production rules and reads from the domain and control blackboard to do further planning and replanning by modifying the control blackboard.

A plan is a dynamic hierarchy of tasks. The problems are mapped to tasks to be solved.

Control tasks are decomposed by strategic knowledge into further sub tasks. The strategic knowledge to do the planning is collected in the knowledge-source "therapy-planning".

Terminal tasks cannot farther be decomposed further and agents are known to solve them. Those may either be knowledge-sources of the knowledge-based advisor or human agents. The execution of the tasks is passed to the agents according to the state of processing of the task hierarchy on the control blackboard. After solving a task, the agent passes back the information relevant to the advisor. A knowledge source in general consists of production rules.

In a federate blackboard control architecture the agents decide on their own when to become active. In the blackboard control architecture applied to build the advisor a central focus decides which agent has to solve which task. This is possible because the advisor supports the physician in charge who plays a central role.

5.2 Distribution of the Tasks

The central focus in the blackboard control architecture decides which agent performs the task which actually has to be executed. The agent is chosen which can execute the task most efficiently. In general this decision can be of any complexity if constraints like the cost of computation, salaries, the time of response etc. are taken into account. For the implementation of our first demonstrator for the knowledge-based advisor we could assume that for every task is exactly known the most efficient agent and that he is always at hand. This will be true in a hospital suitable for irradiated patients. The advisor must be able to distribute most of the medical sub problems to different medical specialists and some problems to its knowledge sources. Therefore, it has to know about a mapping of the sub problems and the agents. It has to be known which sub tasks can efficiently be solved by the human agents, by which human agents, and by which knowledge-sources, e. g., give the task to a surgeon, to a haematologist, or to the knowledge-source prognosis. It is marked for every type of task either by which knowledge source or by what human agent it shall be solved.

If a knowledge-source is activated it will read from the domain blackboard and will write to the domain blackboard. If a human agent is requested to solve a sub problem a communication task will be activated. It has to be known exactly what output has to be related to the human to enable him to perform the task correctly. Also, it must be known exactly which input is required from the human to be able to pursue the problem-solving process. If a problem-solving process is modelled according to the KADS methodology the communication between tasks will be modelled on an input and output level [18].

The transfer of communication between the humans and the advisor is done via forms [13]. This type of communication within a hospital is usual between human agents, therefore, they are accustomed to it. For every terminal task type it must be

either known the knowledge source of the knowledge-based advisor that can execute the task or a type of human agent who knows how to solve the task. The communication on the input and output level between the advisor and the human agent must be defined.

5.3 Communication

Due to legal restrictions the physician in charge has to take the full responsibility for the medical management. Therefore, the knowledge-based advisor must transparently share all its data on the patient and of the developed management plan with the physician. A disadvantage of former expert systems was the use of.TTY interfaces. Only minimal amounts of information could be transferred to the users. On the contrary, a patient card gives a physician a rapid overview over the state of the patient and his management plan. The immense information transfer capacity of human's visual sense can be utilised by applying graphical interfaces. An interactive graphical interface for the knowledge-based advisor has been chosen and the patient card metaphor has been applied to provide an interface which is easy to use by a physician because he is already accustomed to it. The knowledge-based advisor and the patient card user interface are coupled via a user interface management system [15].

On one of the cards the content of the control blackboard, which is a hierarchy of tasks, is visualised. This provides a good overview of the problem-solving process.

On several cards the content of the domain blackboard is illustrated. By this means the physician in charge, all the other personnel and the knowledge-based advisor have a common access to all the relevant data to manage a patient.

The communication between the system and the users is performed via forms which are used for the communication in human working groups, too. Because of the user interface management system both the human agents and the advisor have a representation at hand on which they can base their work.

5.4 Problem-Solving Capacity of the Advisor

The minority of the sub problems especially related to the acute radiation syndrome must be solved by the knowledge sources of the knowledge-based advisor itself. The knowledge-sources are composed of production rules. Due to the application of a control blackboard architecture one knowledge source only is activated at a given time. This reduces the conflict set and increases the efficiency of the rule-based reasoning in contrast to expert systems which do not use a blackboard control architecture.

5.5 Explanation

In medicine due to legal restrictions and medical conventions the physician in charge has to take personally the responsibility of the medical management even when applying a technical aid like an advisor. The advisor must be able to explain and justify its deductions in a comprehensible way and give an overview of the problem-solving process to the physician in charge. Of special importance are why- and how-questions.

Why-questions concern the deduction of the management plan:
Why is a certain task passed to a human agent? Why is a task repeated after two days? Why is a certain question asked?

How-questions concern the deductions about the state of the patient:
How was it deduced that the patient has an acute radiation syndrome of degree 3? How is it known that the bone marrow transplantation was not successful?

The facts for which questions are asked have either been deduced by strategic knowledge, by the knowledge sources of the advisor, or submitted to the advisor by human agents.

A truth maintenance system [3] can record and withdraw the relations of the data given to the advisor and all the deductions derived by the strategic and other rules of the advisor. For each fact a deduction tree can be produced which explains how the fact was deduced. Equally for each task a deduction tree can be produced which explains why the task was executed. Thus, the possibility to give explanations is provided by recording the relations between deductions, facts, and tasks using a truth maintenance system. Epistemological justifications of the deductive knowledge and definitions of the factual knowledge are rendered by deep modelling of the knowledge [10]. For instance a quotation justifies that blood samples have to be taken three times per day. Supplementary physiological knowledge justifies why the lymphocytes are a good indicator for the grading of the acute radiation syndrome, or it is justified why a bone marrow transplantation is better planned by a haematologist than by the advisor.

5.6 Documentation

The problem-solving process and the data about one case are automatically documented. Medical documentation has to be done due to laws. Hence, the necessary data for the management of the patient are available for all involved physicians.

6. Implementation

The demonstrator has been implemented on a Symbolics 3620 on KEE 3.1. Basic routines for the user interface, a truth maintenance system, a production rule

interpreter, and an object-oriented representation of the domain and inference ontology have been used. The rest was programmed. Due to limited memory capacity both the user interface and the reasoning are slowed down occasionally. In the months to come the demonstrator will be ported to a SPARC 2 and KEE 4.0. Henceforth, the performance is expected to increase. The truth maintenance system provides the information to give explanations and justifications. However, the production of the latter still requires additional work.

7. Conclusion

We are on the way to implement an advisor that meets the following goals:
- the user can apply it responsibly in conformity with legal restrictions,
- its construction is efficient,
- the maintenance will be easy,
- the human agents are only supported when necessary, and
- an efficient combination of man's skills and the skill of the knowledge-based advisor is obtained.

A first demonstrator is implemented as described above. It has not formally been evaluated yet. But, comments of experts in managing the acute radiation syndrome, either involved or not involved in the development of the system were positive. A database of case histories of the acute radiation syndrome is under completion. It will be used to evaluate the competence of the system. The ergonomics and the interfacing with the users will be tested with medical students and the staff of the Institute of Occupational Health.

We presume that in future only the medical knowledge-based systems solving problems in co-operation with humans as described above will be successful. The effort to model the competence of humans will decrease in comparison with classical expert systems. On the contrary, the effort for modelling the communication between the agents is expected to increase.

8. Literature

[1] Anderson J. R.: "Cognitive Psychology and its Implications", W. H. Freeman and Company, New York, 1985

[2] Carroll J. M., McKendree J.: "Interface Design Issues for Advice-Giving Expert Systems", Communications of the ACM, 30, 1987

[3] Doyle: "A Truth Maintenance System", Artificial Intelligence, vol. 12, North Holland, 1979

[4] Fischer G.: "Communication Requirements for Co-operative Problem-Solving Systems", Information Systems, 15, 1990

[5] Fliedner T. M.: "Strategien zur strahlenschutzmedizinischen, ambulanten Versorgung von "Betroffenen" bei kerntechnischen Unfällen", Thieme, Stuttgart, 1981

[6] Greif I. (Ed.): "Computer Supported Co-operative Work: A Book of Readings.", Morgan-Kaufmann, San Mateo, 1988

[7] Hayes-Roth B.: "A Blackboard Architecture for Control", Artificial Intelligence, vol. 26, North Holland, 1985

[8] Hayes-Roth B., Hewett M.: "BB1: An Implementation of the Blackboard Control Architecture", in Engelmore R. S., Morgan A. J. (eds.): "Blackboard Systems", Addison-Wesley, Wokingham, 1988

[9] Hammainen H., Alasuvanto J., Mantyle R.: "Experiences on Semi-Autonomous User Agents", Proceedings of the 1st European Workshop on Modelling Autonomous Agents in a Multi-Agent World", Cambridge, North-Holland, Amsterdam, 1990

[10] Kindler H., Densow D., Fliedner T. M.: "Better Justifiability and Less Rules by Using Deep Knowledge", Proceedings of the 10th MIE 91, Vienna, Springer, Heidelberg, 1991

[11] Kindler H., Densow D., Fliedner T. M.: "RADES - Medical Assistance System for the Management of Irradiated Persons", Proceedings of the 2nd DEXA 91, Berlin, Springer, Vienna, 1991

[12] Kirn S., Scherer A., Schlageter G.: "FRESCO: Föderative Kooperation in Verteilten Wissensbasierten Systemen", Künstliche Intelligenz 1/92, 1992

[13] Lane C. D., Walton J. D., Shortliffe E. H.: "Graphical Access to Medical Expert Systems: II. Design of an Interface for Physicians", Methods of Information in Medicine, vol. 25, Schattauer, 1986

[14] Miller R., Pople P., Myers J.: "INTERNIST1, an Experimental Computer-Based Diagnostic Consultant for Internal Medicine", New England Journal of Medicine 308, 1982

[15] Perlman G.: "Software Tools for User Interface Development", in Helander M. (ed.): "Handbook of Human-Computer Interaction", North-Holland, Amsterdam, 1988

[16] Ramoni M., Stefanelli M., Magnani L., Borosi G.: "An Epistemological Framework for Medical Knowledge-Based Systems", IEEE Transactions on Systems, Man, and Cybernetics, to appear 1992

[17] Schreiber G., Akkermans H., Wielinga B.: "On Problems with the Knowledge Level Perspective", Proceedings of the AISB, London, Springer, Heidelberg, 1991

[18] van Heijst G., Terpstra P., Wielinga B., Shadbolt N.: "Using Generalised Directive Models in Knowledge Acquisition", Proceedings of the EKAW-92, Heidelberg, Springer-Verlag, Heidelberg, 1992

Authors Index

Springer-Verlag
and the Environment

We at Springer-Verlag firmly believe that an international science publisher has a special obligation to the environment, and our corporate policies consistently reflect this conviction.

We also expect our business partners – paper mills, printers, packaging manufacturers, etc. – to commit themselves to using environmentally friendly materials and production processes.

The paper in this book is made from low- or no-chlorine pulp and is acid free, in conformance with international standards for paper permanency.

Printing: Weihert-Druck GmbH, Darmstadt
Binding: Buchbinderei Schäffer, Grünstadt

Lecture Notes in Artificial Intelligence (LNAI)

Lecture Notes in Computer Science